PRADA

CATWALK

PRADA

CATWALK

The Complete Collections

Text by Susannah Frankel

Yale University Press

Contents

The Collections

Introduction

Fashion, Feminism, Femininity

Miuccia Prada is certainly among the most influential fashion designers of our time. That she is a woman should not in itself be significant were it not for the fact that, despite an aesthetic that thrives on contrast and even contradiction, as neatly expressed time and time again through her clothes, a profound consideration of the role of women in contemporary society is central to her narrative. While she has been designing menswear since the mid-1990s, her exploration of the manifold guises of femininity – a woman's politics, a woman's role, a woman's history, a woman's suffrage – appears to be the most consistent source of inspiration behind her life and her work. She was, to begin with, a reluctant participant in the leather-goods business her grandfather started in 1913, at least partly for that reason. A member of the Unione Donne Italiane (Union of Italian Women) and a campaigner for women's rights during feminism's second wave, she had a love-hate relationship with the métier she ultimately chose to move into, one all too often denigrated as 'lightweight'. She now knows otherwise and has proved without doubt that fashion – and women's fashion, specifically – may be anything but.

Prada changed the way the world saw fashion: among many other things opting not for a single look that identified her brand, but instead ricocheting from one idea to another – and another, and another – every season, forcing the rest of the world to run to keep up with her. She demonstrates an instinct for what is right at a certain moment that is second to none. Yet this aforementioned element – the complex interrelationship of femininity and feminism with fashion – remains the same, perhaps the only constant and defining element in her work. 'Women have more facets,' she said backstage following the showing of her Autumn/Winter 2016 collection. 'We are so much more complex. We are lovers, mothers, workers.'

There is nothing earnest about her approach. However, her restless, almost skittish desire to move alongside, or repeatedly ahead of, the zeitgeist and her self-professed attraction to the superficiality and whimsy that are an integral part of women's dress especially – and of the fashion industry more broadly – are underpinned by an authenticity and emotional content that make her more than an intellectual designer. She was labelled that as far back as the early 1990s, at which point at least some struggled to understand what they saw as her conceptual viewpoint. That Prada is well-educated and knowledgeable – about art, film, music, culture, present and past – is clear. Her references are layered and complex. Still, there is an open-mindedness, curiosity and warmth to her that is equally important. It is felt in her physical

presence and in the bravery of everything from her words to her collaborations, and from the films, exhibitions, books and retail environment she has developed to the merchandise displayed therein. She is hugely courageous and her output is intensely personal.

'This last twenty years, since the '90s, or even '80s, in every field people have become obsessed with the past,' she said in 2016. 'Obsessed? Probably curious is a better way of putting it, wanting to learn. I studied history but never retained names and dates, though I tried many times. I am more interested in the concept, though, and so the concept stays. So, as a concept, this past year was for me about people in general, the fatigue, the effort, the difficulties of their lives, what they have to go through. Or what we carry on our shoulders as women and how difficult – more difficult than for men, I think – our life is. I have to say that I personally am lucky. I work in a civilized company. I was young during the feminist revolution so I never really had a problem. But that doesn't mean that problems don't exist. I was in a very privileged position.'

It is now common to talk about fashion brands as responsible not only for the creation of clothes but also entire worlds: universes. It's small wonder that the job is all-encompassing. In this, too, Miuccia Prada was ahead of her time. Her breakthrough design was the initially unbranded nylon backpack that immediately established her as a force to be reckoned with. It was the most apparently understated 'It bag' in history, but also paved the way for minimalism and a questioning of the notion of status in designer fashion in a wider sense for years to come. From there, Prada moved on to a more studiously jarring aesthetic. She was pleased when the fashion trade paper *Women's Wear Daily* described her Spring/Summer 1991 collection as 'the Flintstones meet the Jetsons', she once told me, and this despite the fact that it was not obviously intended as a compliment. The designer was not quite so happy with the more simplistic 'ugly chic', which was how her Spring/Summer 1996 show was widely labelled. She was interested in elevating the banal, she said for her part, in explanation of the sludge colours and hybrid Art Deco-meets-vintage American Formica prints that defined the collection, which she would go on to revisit on more than one occasion. In a 2003 interview in *Dazed & Confused* magazine, she noted: 'It's very easy to know what I like and also easy to do just that. But I tend to have good taste. When I do ugly things it's completely intentional. In the end, if you always do only what you like, it becomes boring, you don't grow, you don't learn anything new. That is why I introduce the "bad"...'

As Prada grew, she moved on to 'sincere chic' (this time, these were her own words). Radical in its conservatism, here was a modernized take on the haute bourgeoisie inspired at least in part by Yves Saint Laurent, whom Prada has always admired and whose clothes she wore as a young woman. She favoured men's clothes too back then, and shopped at

exclusive children's outfitters, Ferrari, in her hometown of Milan also. Her obsession with uniform – military, surgical, scholastic and more – is ongoing. Since she expanded into women's ready-to-wear in 1988, however, she has only ever worn her own designs. She is their best advocate.

In later collections, Prada turned her talent to the reinvention of a more conventional expression of beauty, striving to modernize embellishment, taking fabrication and surface detail to unprecedented heights, fusing plastic with precious silks, showing cable knit alongside cable knit prints and cable knit embroideries, imagining and then realizing her own spectacular brocades offset by humble cottons borrowed from menswear. She has argued that she isn't interested in introducing haute couture to the Prada lexicon. Given the volume of product she is today responsible for, she has many of the world's most accomplished technicians at her fingertips and can see new ideas executed in material form almost overnight. Compared to that, couture is simply old-fashioned. There is absolutely nothing old-fashioned about Miuccia Prada.

However different her ideas may be at any given time, they are immediately identifiable as her own: the knee-length skirt, knife or carwash pleated, straight or A-line; the studiously heavy shoe often worn with highly distinctive knee-high socks, elaborate or hefty; the strange colour juxtapositions, pink and brown, mustard and purple, flame and chartreuse; the duster coat; the references to the 1950s and to the French futurist fashions of Courrèges, Cardin and Rabanne, neo-realist Italian cinema and film noir. Such clarity of vision is, of course, the holy grail of fashion. And in Prada's case it applies to clothing, accessories, jewelry, eyewear, sportswear and also to her catwalk space, today re-imagined for each show. Even the cocktails and canapés served to guests upon arrival are signifiers, providing clues for the main event to come. Studded clothes; foie gras studs, say.

In 1993, Prada expanded her world to encompass the Fondazione Prada, which she co-chairs with her husband of more than forty years, and joint Prada CEO, Patrizio Bertelli. The Fondazione found a permanent home in Milan that opened to the public in 2015 and was designed by Rem Koolhaas and OMA. It is a magnificent, almost metaphysical place. Originally a distillery dating back to the early twentieth century, the gallery comprises seven existing buildings and three new structures offsetting a sense of modernism, the raw power of the unfinished and the industrial shades of grey that characterize so much of the Italian fashion capital with the more opulent 24-carat-gold-leaf-covered 'haunted house' and wilfully bizarre Wes Anderson-designed Italianate café, Bar Luce, which harks back to the 1950s. The Fondazione is as visually arresting and unlike anything else of its kind as the collection

of art it contains, the exhibitions staged within its walls and, of course, the fashion that bears the Prada name. It is important to her. 'I was educated through literature, theatre and cinema,' she has said. 'Art came very late. I realized, though, that in the end if you know about theatre, literature and movies, the thematics are the same. And so I studied. Me and my husband, we really studied. A friend said, why don't you use one of your industrial spaces to exhibit art. We began meeting artists, it was a big education, and it lasted twenty years and still goes on.'

The Fondazione is today a vibrant and vital part of Milan's cultural landscape. The shows there are disparate and cover all forms of media. Again, any cohesion there may be is a relevance to the woman who presides over the whole. Miuccia Prada has an extraordinary team of creatives around her, which includes everyone from the gifted curators here to her design studio, but it is her own sensibilities – contrasting almost childlike interactive installations with more challenging subject matter focusing on the difficulties of a seemingly ever more hostile world – that are reflected in the content. An ability to shift effortlessly between high and low culture, and to acknowledge the equal importance of both, is pivotal. 'When it comes to ideas and solutions about art display, Miuccia is definitely one of the most experimental people I have ever met,' Germano Celant, Artistic and Scientific Superintendent of Fondazione Prada, stated in *AnOther Magazine*. 'She never settles for the latest exhibition trend but always aims to achieve more extreme results. Her interest and passion for everything visual leads her to radical solutions.'

Rem Koolhaas, who has worked on Prada Epicenter stores in addition to the aforementioned show spaces, concurs: 'A weakness of architecture and maybe also in fashion today is that they only are about beautiful things. What I think is crucial in terms of understanding Prada is that there is always a dialectic between beauty and non-beauty, which gives it a depth. Working with Mrs Prada, she can be determined, but also very open to others. There is an ambition to do things in a different way. She has the courage to go against the obvious, against the expected, even against the commercial. All of that gives her an aura of independence.' That she is the founder, creator and front person of one of the world's most well-known brands makes the aura in question all the more remarkable. Her process – and the behaviour of Prada the company – is more in line with that of an independent, avant-garde name but, on 24 June 2011, her fashion business became the first of its kind to float on the Hong Kong stock exchange.

A gaping maw, a void, takes pride of place in Miuccia Prada's office in the company's Via Fogazzaro headquarters in south Milan. It is an opening to a curling metal slide created by the artist Carsten Höller: the designer has been known to push hapless visitors down it, not to

mention rocketing down herself. And why not? It's fun. As time goes by, that side of her nature – and aesthetic – seems to develop alongside the more ponderous side. From that point of view, too, she is an inspiration, equally comfortable in her skin however fragile or formidable she may, at any given moment, choose to be. When, in 2010, she presented the Turner Prize in London, she did so wearing a pair of banana earrings straight off her catwalk, crafted in bright yellow plastic. Today she is also entirely at ease with her role as a fashion designer: there seems to be little of the conflict there once was. 'When I work on fashion, I like the pleasure of just doing fashion, thinking about my job,' she has said. 'So, as a woman, how do you want to dress next? That always draws me. The pleasure of clothes.' Not that everything is quite that simple. 'I have this discussion: why people like fashion. Even some very clever women say it's because they want to seduce but I don't think we always dress because we want to seduce. When I want to seduce somebody, I know that I am dressing to seduce that person. That's for sure. But often it's the last thing I'm thinking about. I'm dressing because I have to dress – in uniform.'

As is commonly the case with creatives, many of Miuccia Prada's 'obsessions' (she uses this word recurrently) are rooted in her own past. For Prada – who was called Miu Miu by those close to her, after which, in 1993, she named the Miu Miu brand – the good times began when she was about 15. 'Then I started really having fun. I was out, out, out. I remember turning my skirt into a miniskirt on the stairs before going to school and taking it down again before coming back.'

In 2004, for an interview in the *Independent* newspaper, she described the way her mother used to like her to dress until then. 'Super traditional. Blue pleated skirts. Blue, red, beige.' Luisa Prada, who headed up the Prada label for twenty years before her daughter took over, wore more obviously fashionable clothes and haute couture, as on occasion did her daughter. 'But nothing frivolous,' Miuccia Prada said. 'I remember being mad about having a pair of pink shoes. I grew up envying pink shoes.' Her shoes at that time were more sensible: brown and flat. It is surely no coincidence that the Prada shoe archive boasts more than its fair share of designs in those self-same colours – frivolous pink, staid brown – frequently both in a single pair. Neither is it a matter of chance that pink is known to be among the most successful colours commercially, while brown is just the opposite. That, the designer has stated more than once, is why she likes it. Her early life must also surely have shaped her interest in convention and conservatism: as has already been seen, on the one hand she embraces it; on the other, she kicks against it as if her existence depended upon it.

There are few who understand Prada's mindset better than Fabio Zambernardi, who arrived at the company in 1989 and has been design

director at Prada since 2002. 'It's very much conversational at the beginning. Miuccia is not a designer who sits down and sketches. She never does that. She's very visionary, very fast. Words are faster. Miuccia might be inspired by an emotion, a woman, something human, something very personal. So we start with a concept, which is the most important thing, and then try and make sense of it. We have a great team and they do that for us with a first prototype. Then you evolve that prototype, look into details and fabrics of course. When you get to the technicalities, you see the materials, then you can get obsessed with a stitch, but before that it's all about the impression and that makes it more modern somehow. And that's why we look at things designed here and they don't always seem precise: it's like that, but it's not like that, that dress should look like that but not really be that. It's all about an impression. Miuccia is an impressionist.'

It is a highly intuitive way of working. 'It's fun but she is also very demanding, not only of other people, but also of herself. She's always doubting and it's a lot about instinct. That's why when we work we are all open, at ease, we talk. There's always that sense of being on the edge of making sure that what you do makes sense. There's a little bit of stress, too, of course, because you have her as your point of reference and everybody wants to make sure that what they have to say is relevant to Prada.'

Above all, 'Prada is an institution, it's institutional because it's a huge brand,' Zambernardi says. 'But it is also total anarchy; it has an anarchic approach to elegance and to fashion. Miuccia to me is an anarchist but she's conservative. The beauty of it is that you have to have that background to be free, to be anarchic, to be wrong. It makes everything believable.'

The fashion industry has changed immeasurably since Miuccia Prada started out. At that point, designers were talking only to the insider few. Now, they are speaking to everyone, at an ever-increasing pace and addressing the entire world. That her work has adapted to that with elegance and intelligence is without question.

'To do fashion for a small world, mostly European/American white and rich, was very, very easy,' is how she puts it. 'But now we have to face a far more complicated world, a far more complicated mentality, different concepts, different religions and races. So, for me the problem is still how to create something meaningful for this new world.'

She is more than intelligent enough to know that some collections may be more successful than others and is usually the first to admit as much. Nevertheless, as a whole, her contribution to contemporary fashion is unrivalled. She is one of the defining designers of our time; her tastes,

her likes and dislikes, have shaped popular consciousness. And so we believe her because, however maverick, rebellious and contrary she may be, she too ultimately believes in what she does.

As the *New York Times* stated in regard to the Fondazione Prada in 2018, 'What we should fear is inertia, and we should combat it with the tools Miuccia Prada herself wields: discipline, rigor, gravity, style.'

Miuccia Prada

A Short Biography

Miuccia Prada was born in Milan on 10 May 1948. She still works in that city and lives in the apartment she grew up in as a child. Her father, Luigi, was a wealthy businessman in his own right; her mother, Luisa, was heir to the family business, founded by her father – and Miuccia's grandfather – Mario and his brother, Martino, in 1913. Fratelli Prada, as it was then known, was famed for its suitcases, handbags, steamer trunks and glassware, all popular with the Italian aristocracy.

The Prada family was well-off, though not ostentatiously so, conservative and Catholic. Miuccia Prada graduated from La Statale university in Milan with a doctorate in political science in 1970, having, by her own admission, put in the 'minimum effort needed to pass'. Her thesis was based on 'Il Partito Comunista e la Scuola' (the Communist Party and School). Throughout the political upheavals of the 1970s she was a member of the Unione Donne Italiane (Union of Italian Women) and engaged in campaigning.

Theatre was her future, she thought. She studied mime at the highly respected Piccolo Teatro under director Giorgio Strehler for five years, which she credits with teaching her the discipline required to practise her profession now. Her career in fashion began designing accessories before she, in turn, inherited Fratelli Prada from her mother in 1978. By that time, Luisa Prada had run it for twenty years. Miuccia Prada met her business partner and later husband, Patrizio Bertelli – who came from a family of lawyers, and owned two companies, also specializing in leather goods – that same year. They married in 1987 and have two adult sons.

Miuccia Prada and Patrizio Bertelli started working together in the late 1970s, laying the foundation for the future international expansion of the Prada Group. Bertelli pioneered the introduction of a new business model in the luxury industry, based on direct control of all processes and rigorous quality standards at all stages of production. This business model went seamlessly with Miuccia Prada's maverick creativity.

It was with Bertelli that the company's breakthrough backpack – minimally branded, and made out of Pocono, an army-grade nylon more generally used for military parachutes and tents – was conceived in 1984. Four years later, Prada moved into women's ready-to-wear. The Prada brand expanded rapidly during the 1990s and 2000s. Men's ready-to-wear, Prada eyewear and fragrances were introduced, and today the brand includes men's and women's leather goods, clothing, footwear and accessories.

Miuccia Prada's innovative approach was not confined to fashion. Art, philosophy, architecture, literature and film are just some of the cultural disciplines that represent continuous sources of inspiration for her, and also offer opportunities to challenge expectations. She was one of the first designers to commission both Rem Koolhaas and Herzog & de Meuron, engaging them to create Prada's Epicenter stores in New York, Tokyo and Los Angeles. She also collaborated with Koolhaas on the creation of her show space and on the design of Fondazione Prada. In addition, she has collaborated with numerous film directors, including Wes Anderson, Ridley Scott, Roman Polanski, David O. Russell and Alejandro González Iñárritu.

In 1993, Prada and Bertelli's passion for contemporary art led them to create the Fondazione with the aim of presenting radical contemporary art and culture to the people of Milan and any interested visitors. The Milan arm opened to the public in 2015. A second exhibition space is located in an eighteenth-century palazzo – Ca' Corner della Regina – on Venice's Grand Canal. A third venue, dedicated to photography, is the Osservatorio, an outpost located in Galleria Vittorio Emanuele II in Milan. Another important location is Prada Rong Zhai in Shanghai, a meticulously restored early twentieth-century mansion that serves as a unique site for the company's diverse activities in China as well as Fondazione Prada exhibitions.

In 2000, Miuccia Prada received an honorary doctorate from the Royal College of Art in London. In 2004, the Council of Fashion Designers of America presented her with the International Award. She was named one of *Time* magazine's 100 most influential people in the world the following year. In 2006, she was named Officier of the Order of Arts and Letters by the French Ministry of Culture. In 2012, Prada – together with Elsa Schiaparelli – was the subject of 'Impossible Conversations', an exhibition at the Metropolitan Museum of Art in New York. The following year, Prada was honoured by the British Fashion Council, receiving the International Designer of the Year Award. In 2015, she was granted the title of Knight of the Grand Cross, the highest Order of Merit of the Italian Republic, in recognition of her international success and contribution on behalf of Italy to the fields of creativity, fashion and style, as well as in recognition of Prada's cultural values, which her Fondazione promotes. In 2018, the British Fashion Council presented her with the Outstanding Achievement Award.

In 2011, Prada became the first Italian company to float on the Hong Kong stock exchange, having sold 20 per cent of its stock. Today, Miuccia Prada is designer and chief executive officer of the Prada Group, a pivotal name in the luxury industry, currently including Prada, Miu Miu, Church's, Car Shoe and Marchesi 1824 brands.

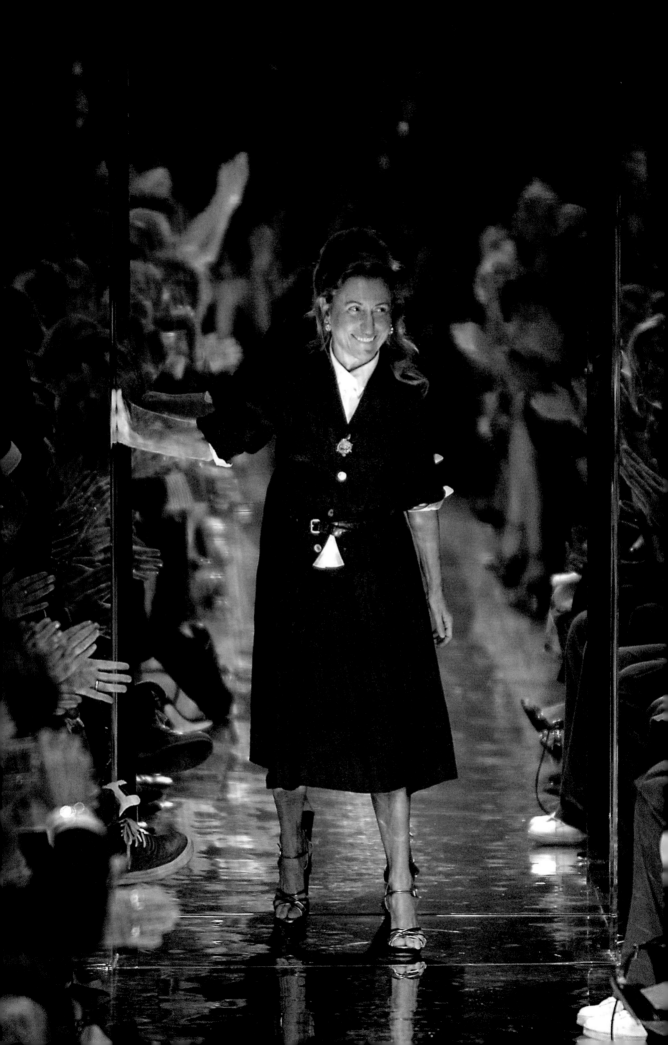

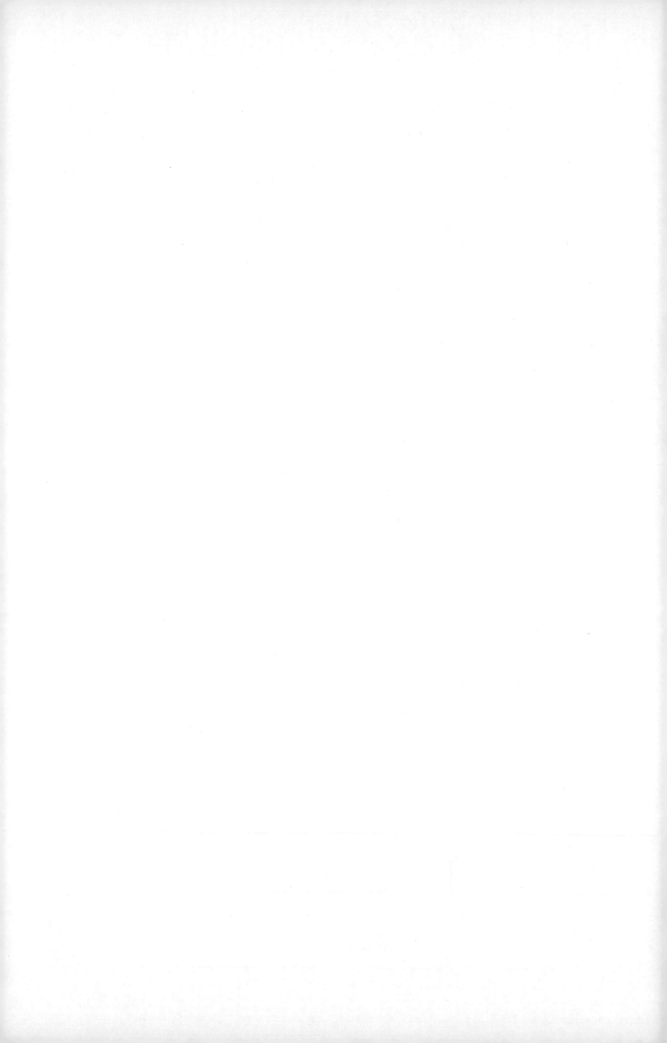

The Collections

On 26 February 1988, a small item in the fashion industry trade bible *Women's Wear Daily* announced Prada's plans to offer a women's ready-to-wear line of seventy pieces to be shown in Milan in March for the Autumn/Winter 1988–1989 season. 'The line will be designed by Miuccia Prada, designer of Prada accessories,' it read. By this point, these unassuming, if proudly utilitarian shoes and bags were well established, to the insider at least. According to a spokesperson, the new collection in question would be 'high-priced and classical, making use of the best fabrics, and will include knitwear'.

Right from the start, certain tropes were in place. There was indeed a sense of classicism at play, and of luxury too – not to mention the odd Prada cardigan – but equally significant was the buttoned-up simplicity of references to school uniform and the spirit of Italian neorealist cinema, both of which hinted at a certain wildness within that undercut the values of other high-end designer clothing, and of status-driven fashion more broadly.

Prada had married the company's now-CEO, Patrizio Bertelli, the year before in a military-grey cotton dress, made by the Ferrari sisters, Milan's most exclusive makers of children's clothes, and a man's overcoat. Throughout her career, her collections would refer to her own taste and wardrobe, even if they were often in opposition to that. Here, the connection was clear cut. No-frills tailoring inspired by menswear in black and brown (the latter being a Prada signature because, in the designer's own words, 'it is the least commercial colour') was seen alongside 1950s-line dresses and skirts in bright red and hot pink – the ultra-feminine and, by contrast, frivolous shades Prada dreamed of wearing as a child but was never allowed to.

And then there were the shoes: predominantly flat, mannish, the kind of shoes women could run in. In a deceptively quiet and modest manner, the seeds were being sown for the paradoxes that would characterize the designer's work increasingly over the years to come.

'Since the beginning, with her 1988–1989 collection for Autumn/Winter, her ready-to wear shows have frequently had a schoolgirl theme,' wrote Ingrid Sischy in the *New Yorker* in 1994. 'The models have been styled to look like the kind of girls that are considered trouble: the ones who are a bit too bohemian as far as their teachers and parents are concerned, who sleep with a guitar-playing dropout, or who smoke, or spend too much time on art class and not enough on math.'

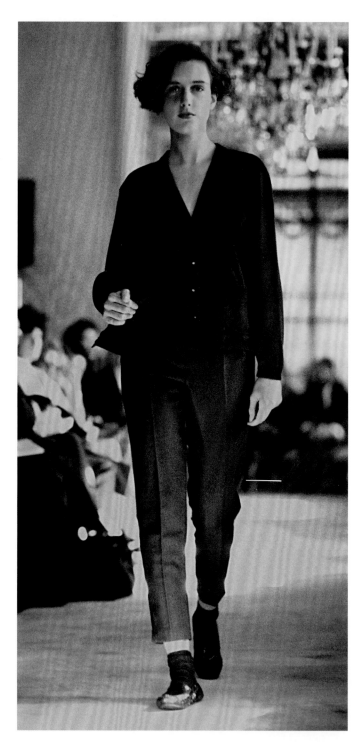

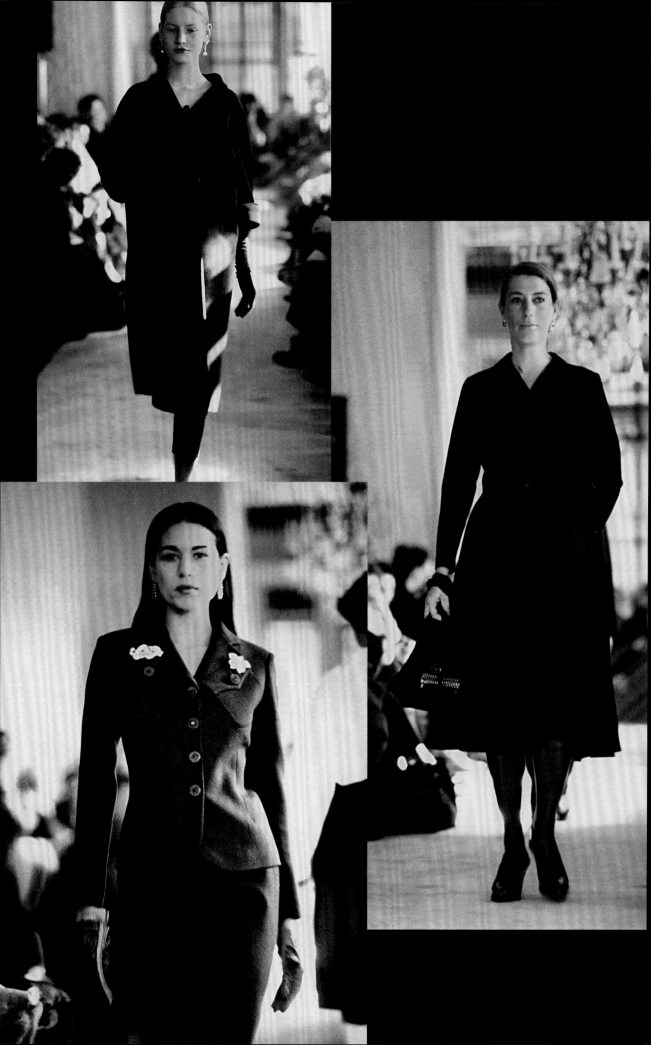

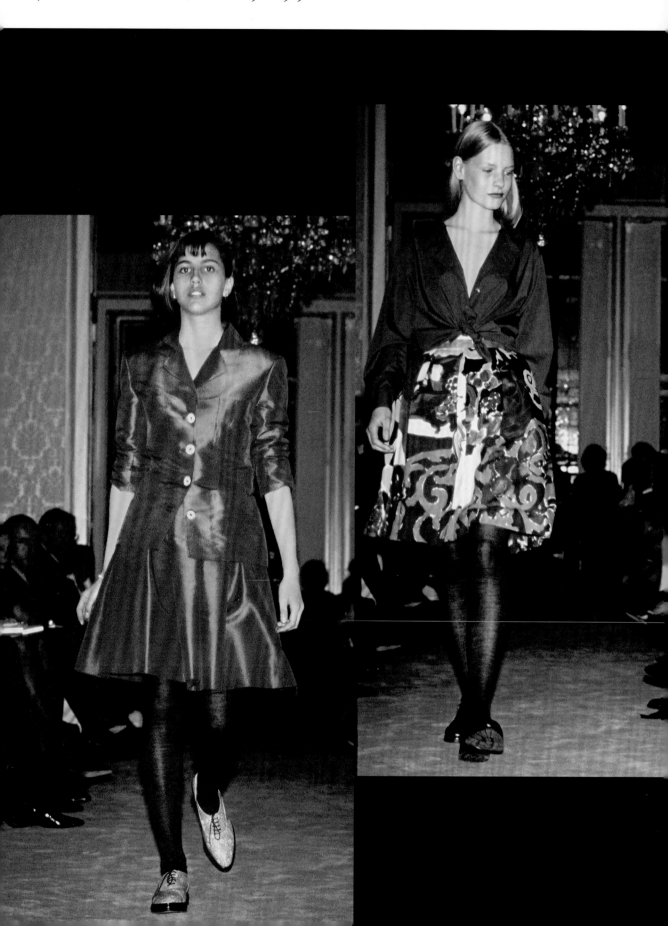

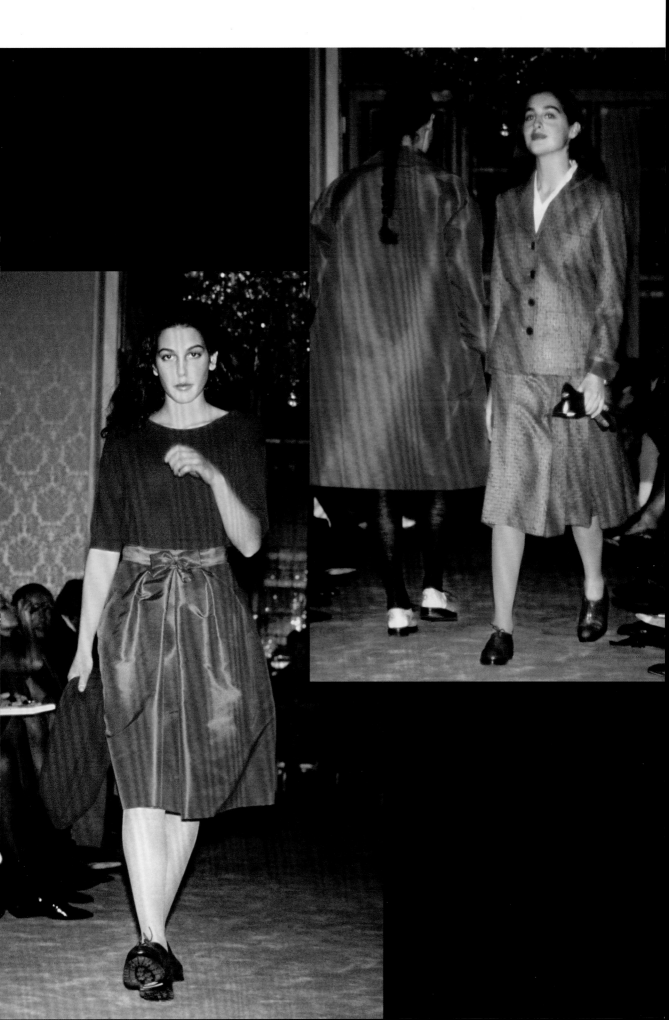

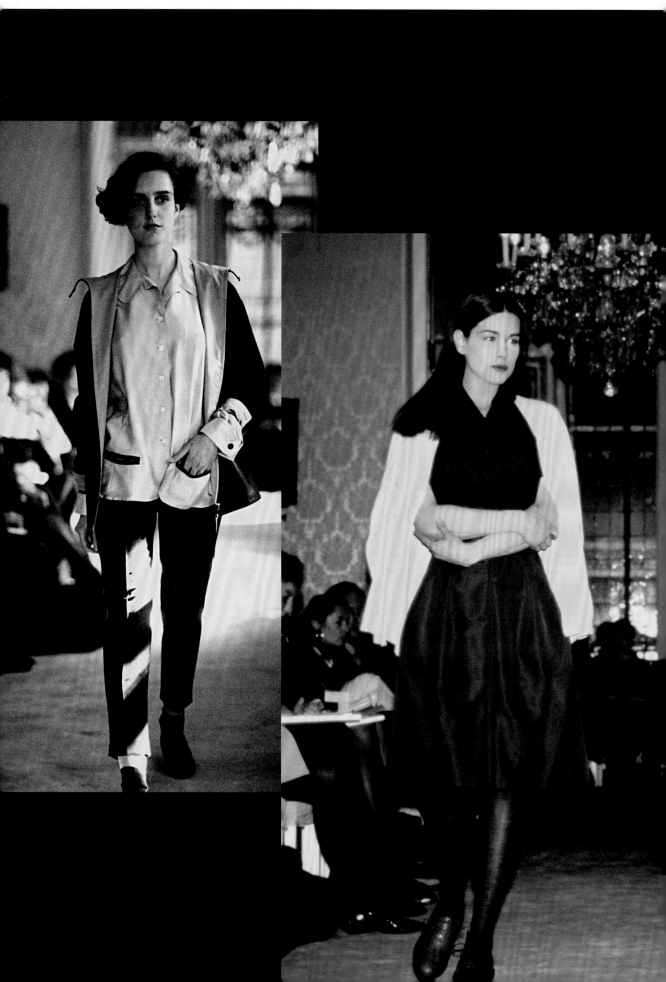

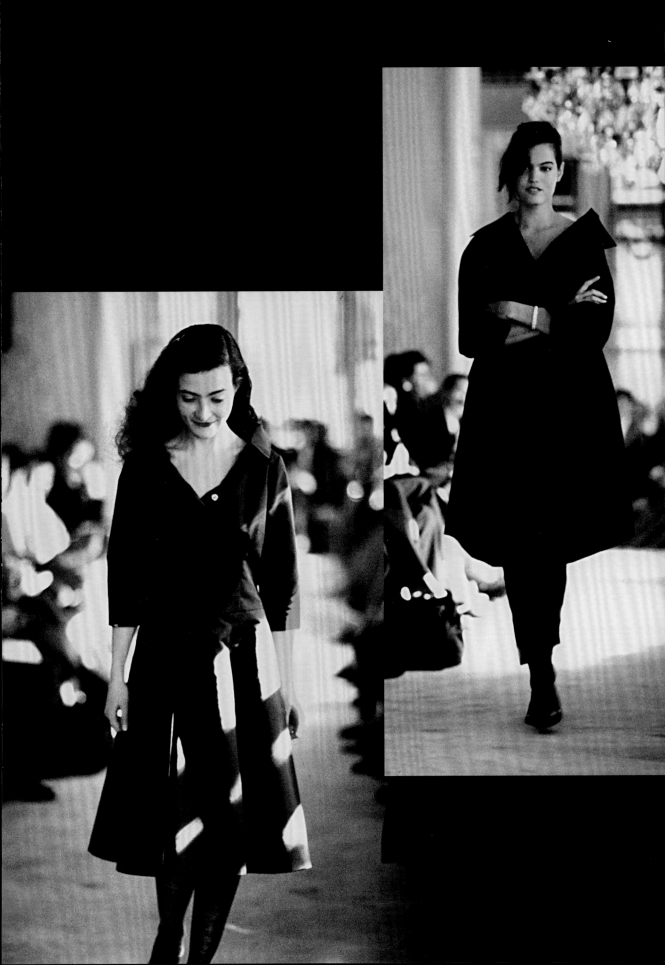

On this occasion again, a mid-twentieth-century silhouette was juxtaposed with a more boxy and masculine line: lace dresses, all be they with a significantly demure neckline, and more in jewel-coloured silks with eased tailoring, monochromatic cotton shirt-dresses and loose-fitting shifts boasting barely any embellishment. The latter seemed almost plain – un-designed. With the exception of a bare midriff, which Prada would return to again and again, the look was covered up, even prim, particularly in relation to both French and Italian designer fashion at this moment. Sturdy double-strapped flat sandals may be ubiquitous today but, in the late 1980s, on the Milanese runway, they were unheard of.

Though discreet at this point, there is the spirit too of conservatism – the good wife, the good mother, the rather grand Italian lady behaving just as might be expected – as well as of the creative, the misfit, Miuccia Prada the mischief maker. That would debatably remain the central paradox that unified the whole. Prada was not a naughty child, but the sense is that she might have liked to be one.

Emerging also was the filmic gesture – the hands gathering a garment to the torso, the arms crossed at the waist – which imbued even the most stripped-back wardrobe staples with romance and the idea not only of a woman's intimate relationship with her own clothing but also of her playing with (and owning) the concept of overt glamour over and above being a slave to it. This seems nowhere more apparent than in Albert Watson's cinematically lit black-and-white print campaigns of the period.

For all the intellectual analysis her designs have always attracted, there was an ease to Prada's clothes, a freedom of movement, categorization and restraint. Indeed, the fact that a female designer – a feminist designer who grew up at the height of that movement's second wave – was the force behind them was palpable.

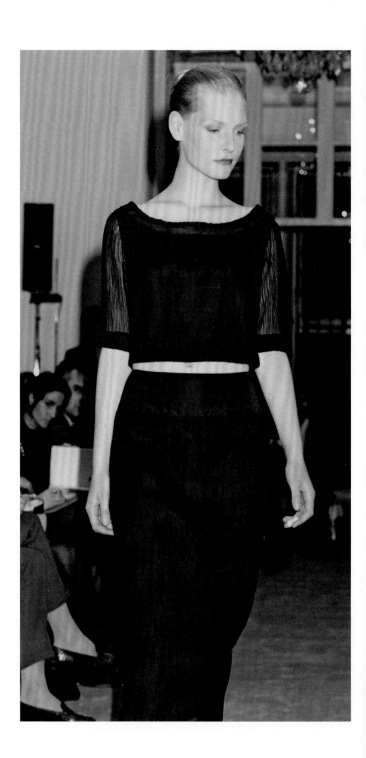

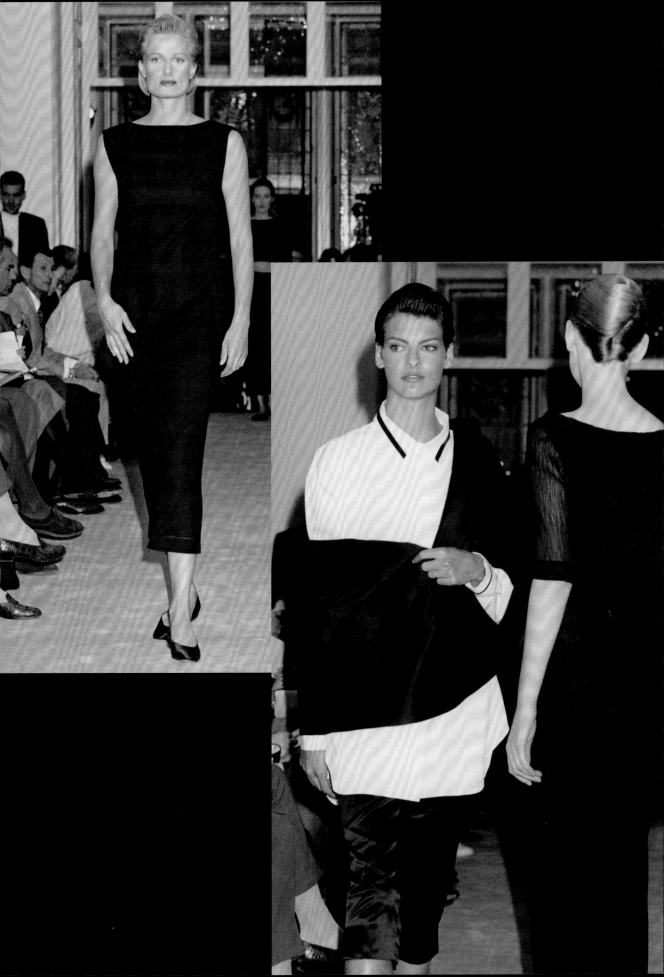

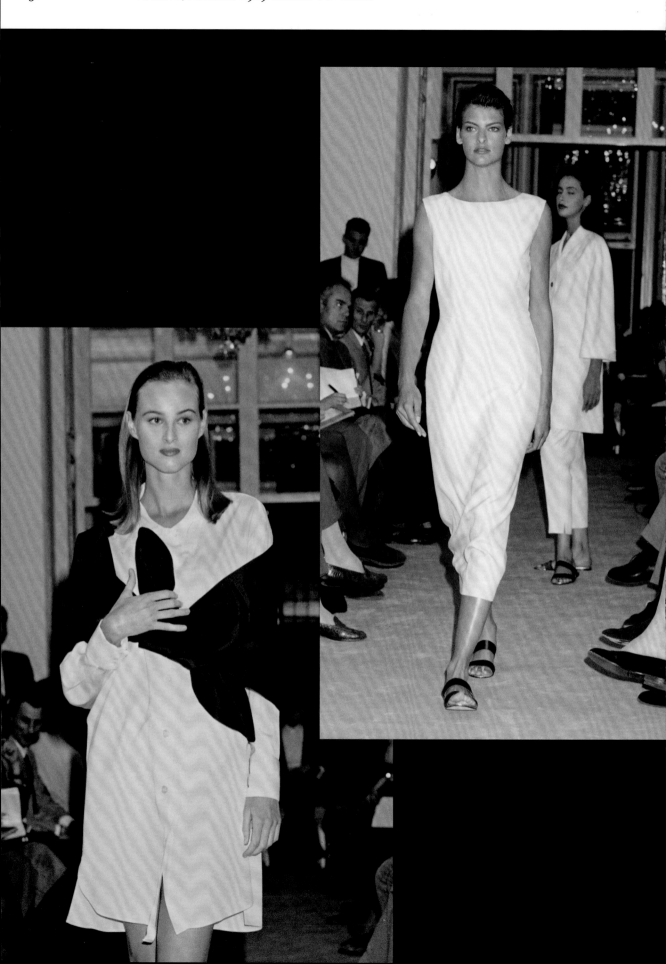

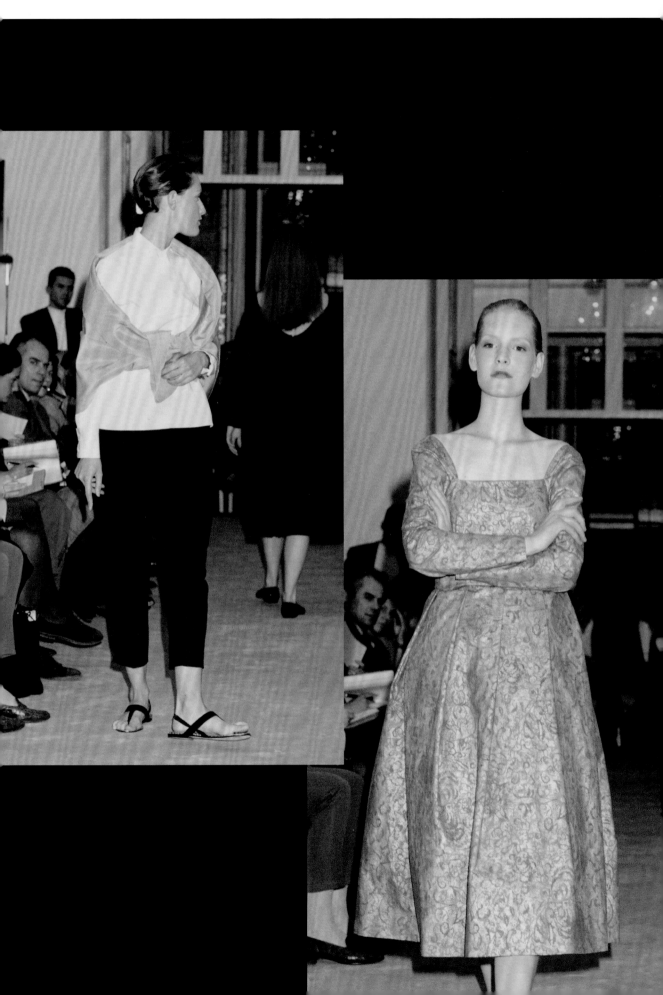

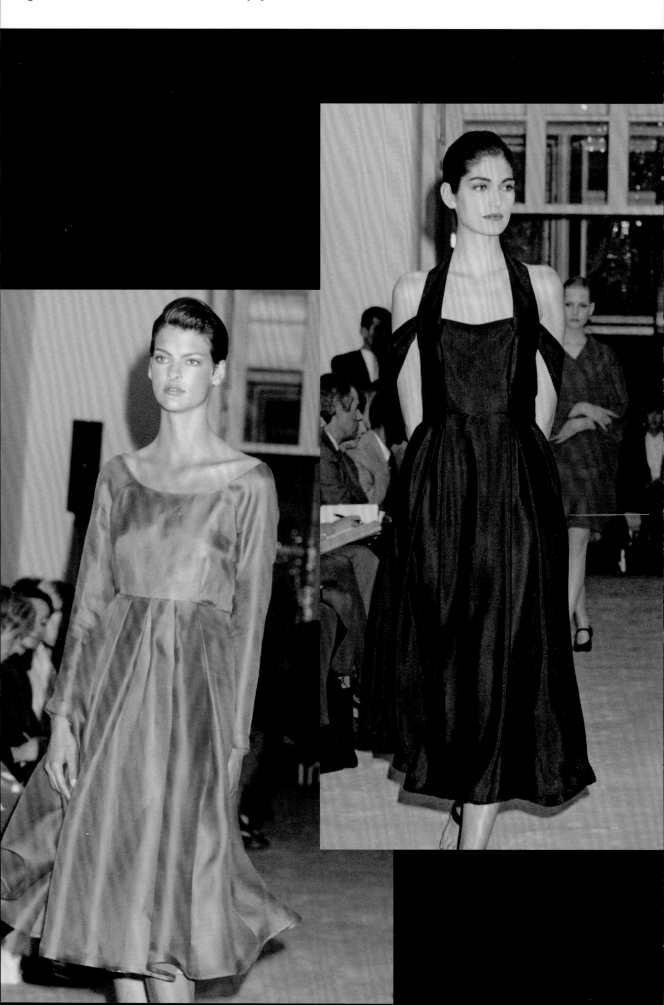

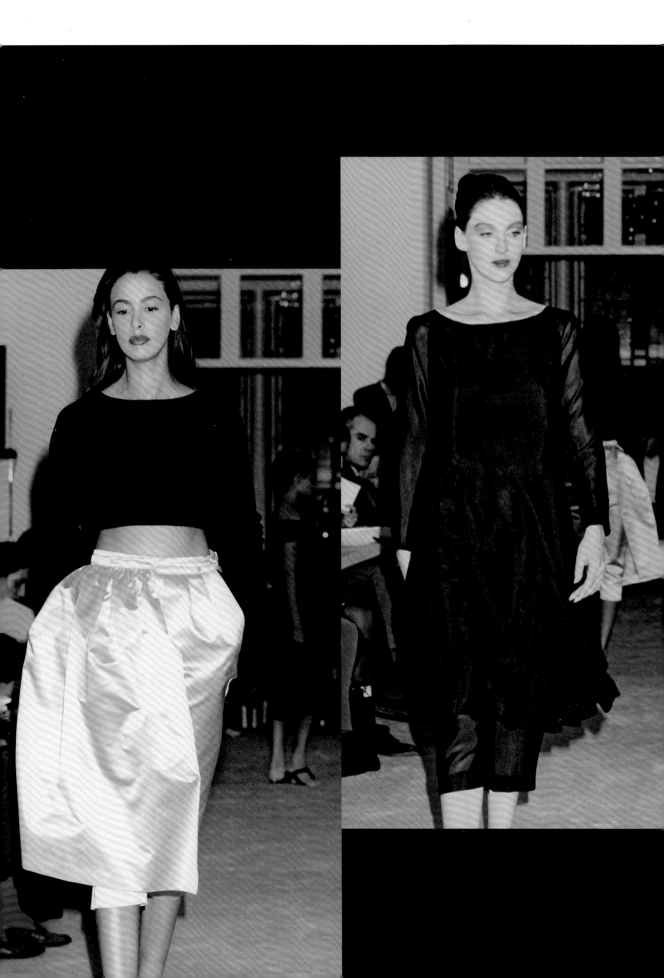

It is the mark of a great designer that they are able to stand back and criticize their own work. With that in mind, Miuccia Prada made no secret of the fact that she disliked this collection intensely. This, after all, was the woman who insisted that the first black nylon backpacks, introduced in the early Eighties, were branded only by an understated metal triangle bearing the company name and derived from historic Prada steamer trunks. It is therefore surprising – not to mention consciously commercially driven – that buttons here were shaped to spell out the name Prada. Power-shouldered tailoring, while still prevalent elsewhere – the ultimate symbol of the 1980s working woman's wardrobe – was, equally, an unlikely silhouette for this designer to turn to.

'The whole time I was working, I hated everything,' she told the *New Yorker*. 'It was not me. It was a nightmare. If it's my mistake, it's okay. In fact, I like mistakes because mistakes are what life's about – they tell you something's alive. Yes, this was something that made me crazy. For ten days, I was mad. I hated all the people around me and I told them it was the last time others would push me to do what I didn't want.' Prada was already at the forefront of a movement that bore the tag of minimalism. This collection appeared at odds with that.

'At the start, there was Versace, there was Armani, and everything was much louder than what Miuccia was doing. No one paid much attention,' design director Fabio Zambernardi, who arrived at the company at around this time as designer of Prada shoes, told *AnOther Magazine* in 2017. 'The attention started to happen when the shows became a little more out there with ideas and concepts that seemed more shocking, shocking in the use of the wrong materials, the use of nylon no longer just for bags and the exploration of ugliness versus beauty.'

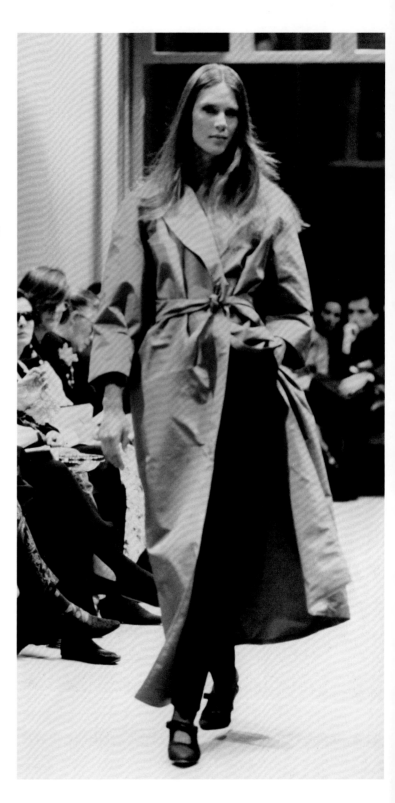

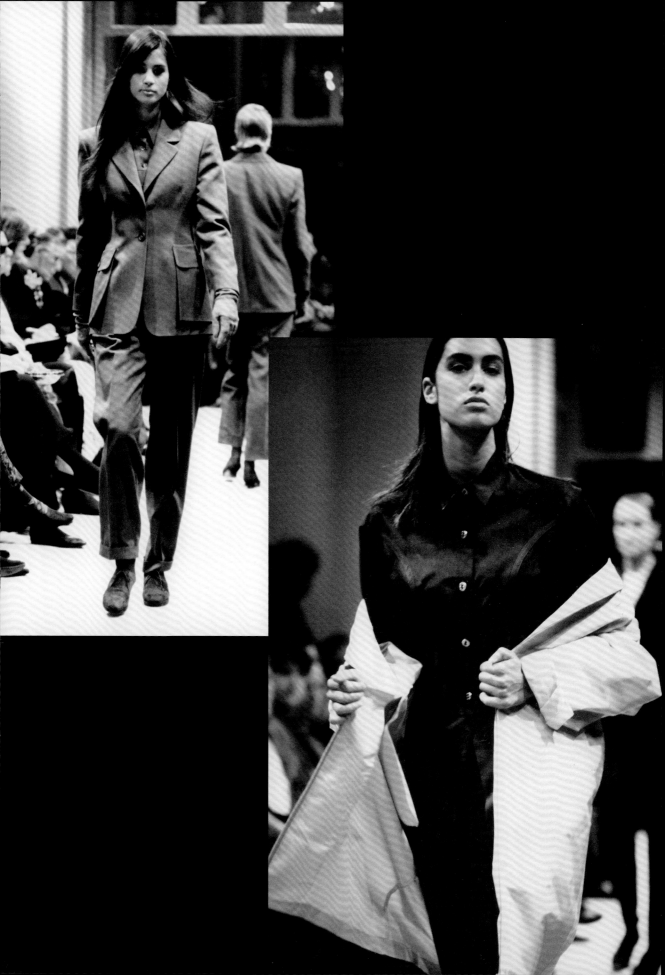

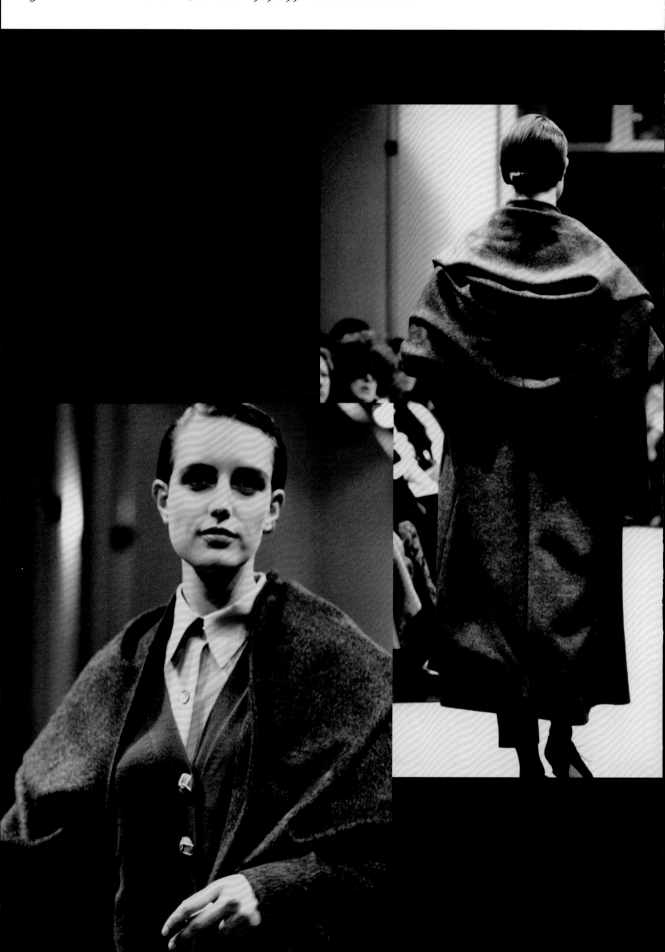

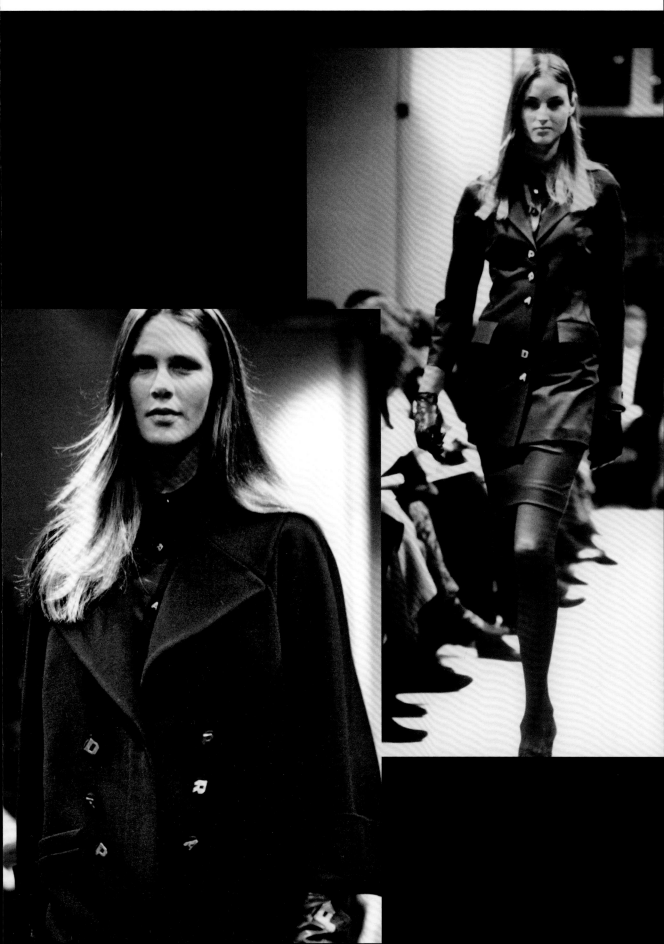

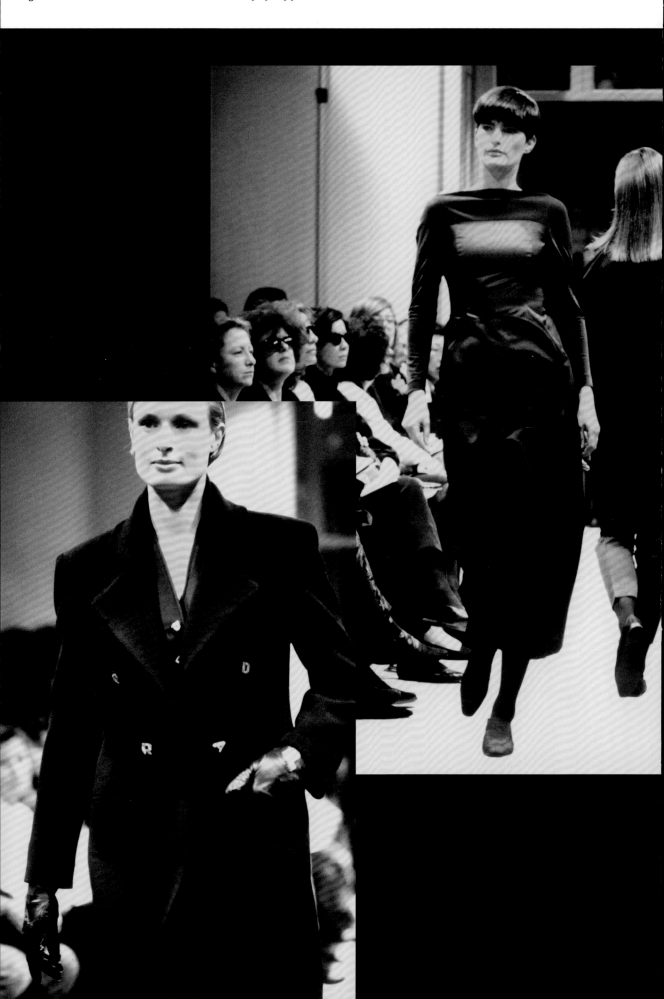

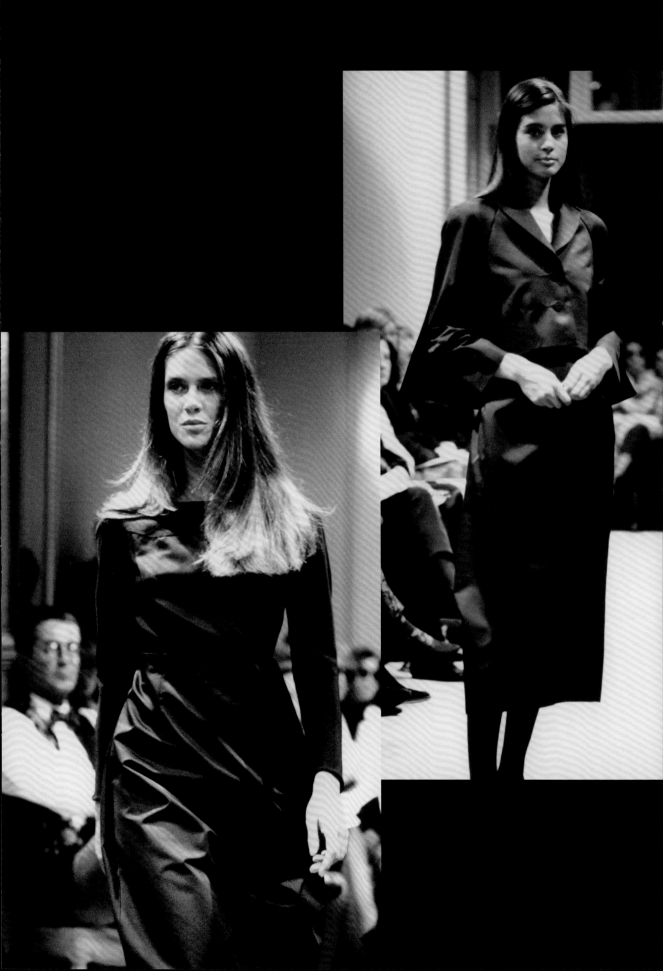

The overt exploration of ugliness and beauty that
design director Fabio Zambernardi spoke of (see p. 34)
didn't take off until a little later, although Miuccia
Prada's view of femininity was unconventional from
the outset. In this instance, the crumpled and raw
silks, delicate layered chiffons, crochet knits, peacock
feather and wooden-bead embroideries, and rich
but always slightly muted colour palette with an
abundance of white were very much of the moment –
perhaps unusually so given that this is not a designer
known for running with the pack.

The collection was shown in January 1990, amid global
economic downturn, when for obvious reasons the
focus in fashion in general was on natural resources
and the beauty of not only the environment but also
the woman within. 'Bloomingdale's lost no time in
planning a youth-directed new-age shop,' wrote
Ruth La Ferla in the *New York Times*, 'complete
with piped-in metaphysical rock and well stocked
with stretch clothes, sweatshirts, yin-yang symbols,
decals and sequined fanny packs.' In Europe, too,
anti-materialist T-shirts and rock-crystal pendants
allegedly rejecting consumerism sold for hundreds
of pounds.

Certainly, Prada was also considering these ideas
and – unusually for her – ethnic references, although
never literally. *Women's Wear Daily* described this
show as 'the sleeper hit of the week. Shapes went from
fluid pajama pants and full long skirts to cigarette-
slim pants and capris with slim tunics.' There were
duster coats, too, split up the back like hospital gowns
(these would become a Prada signature), python print
and more than a little brown. Shimmering gold
cocooned the female form, whispering of celluloid
heroines and the power of glamour imagined. Shoes
remained flat and embellishment for the most part
quiet, compared to predominantly more decorative
taste elsewhere.

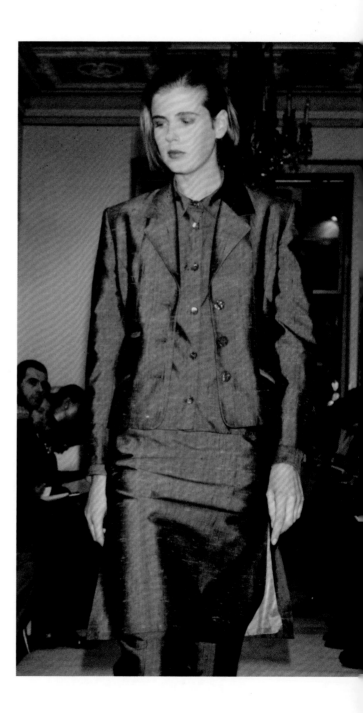

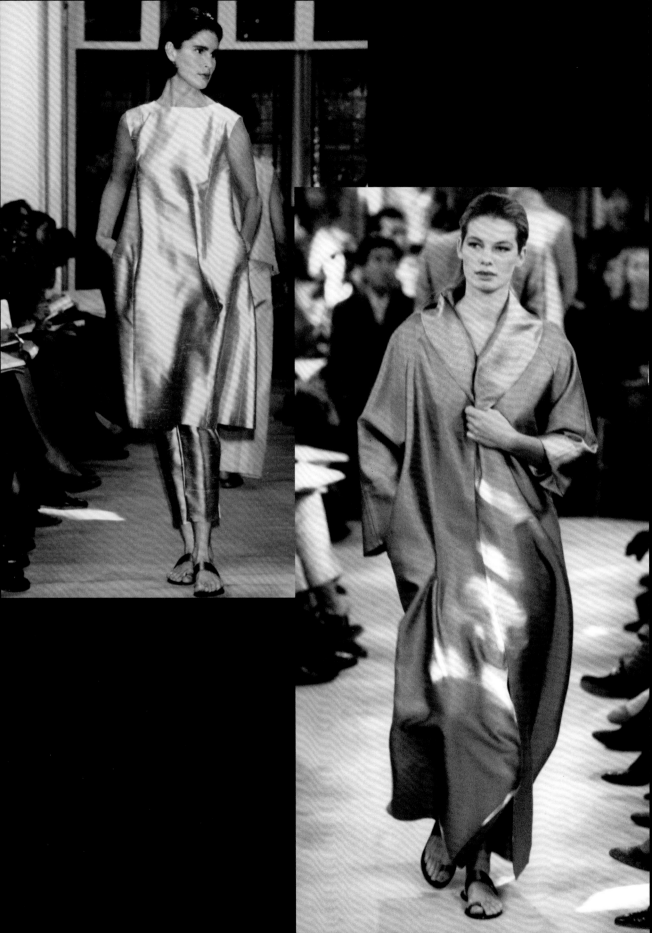

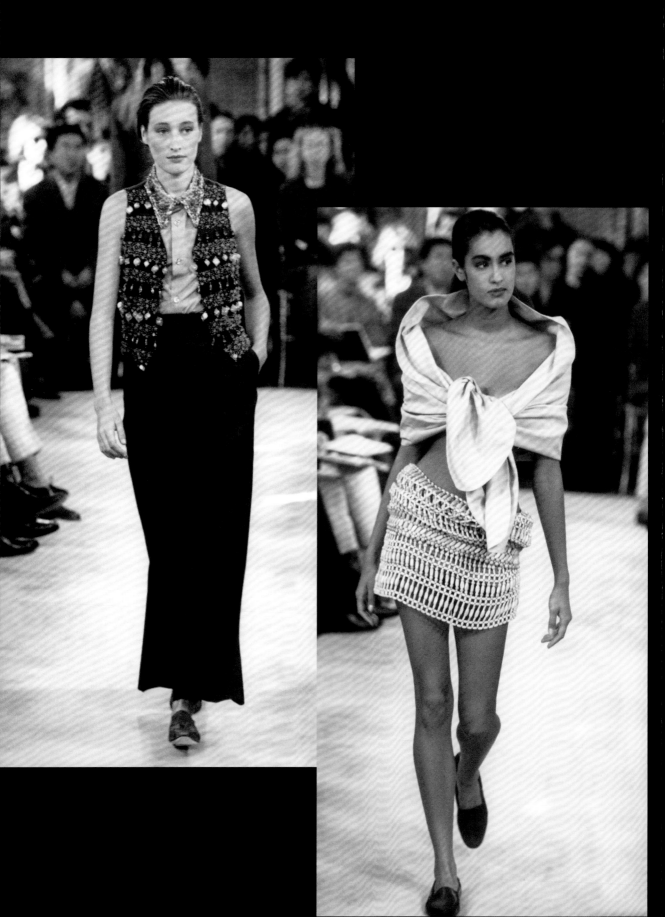

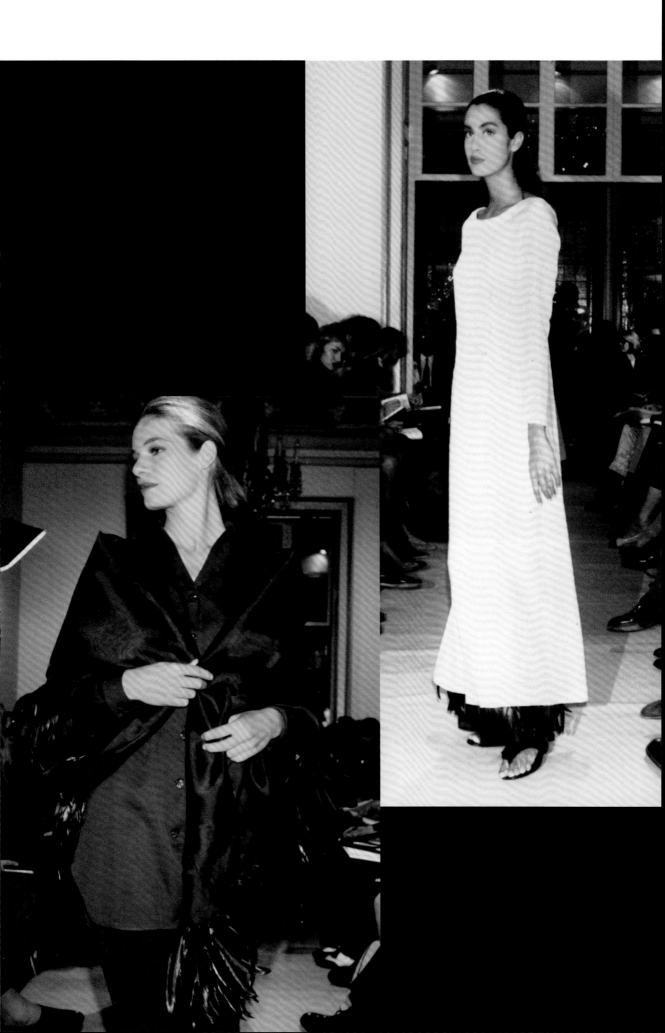

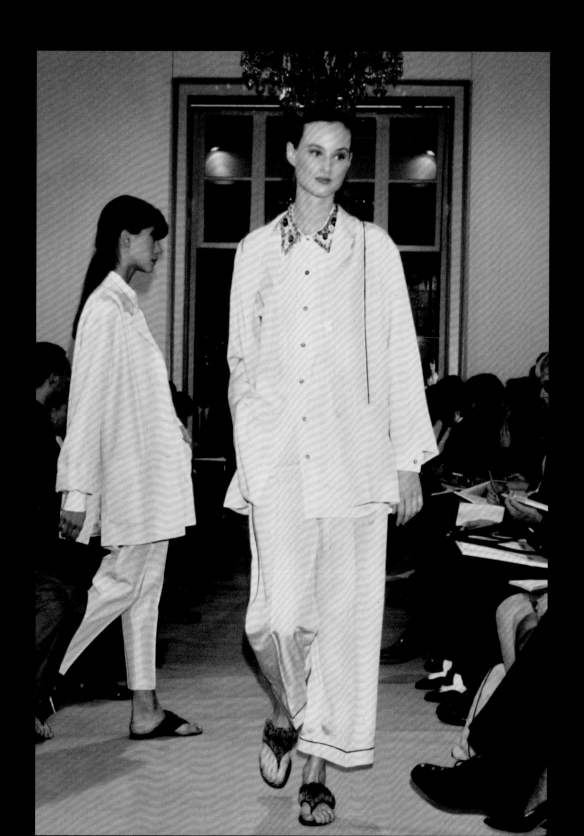

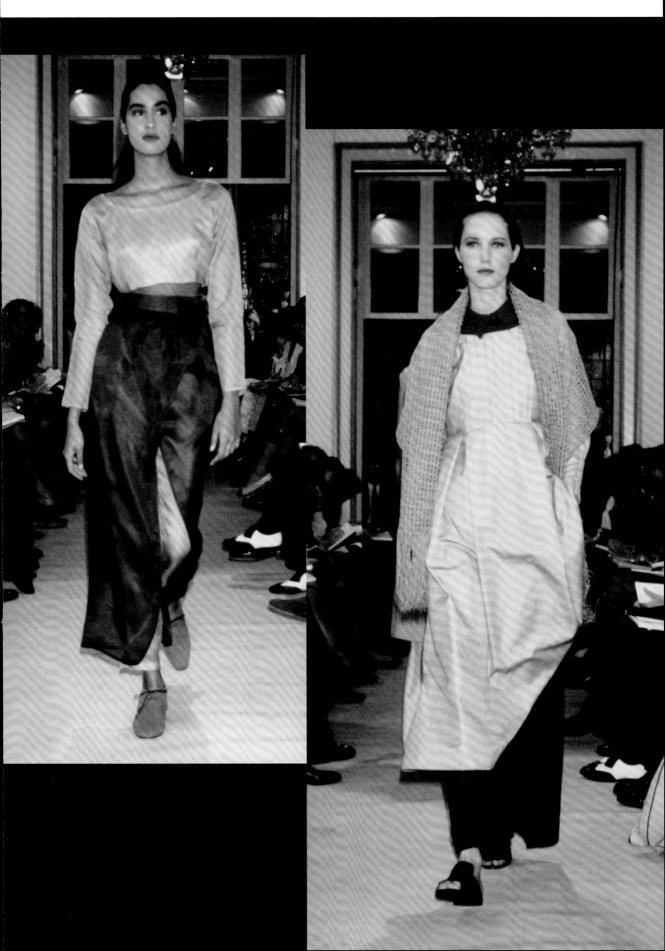

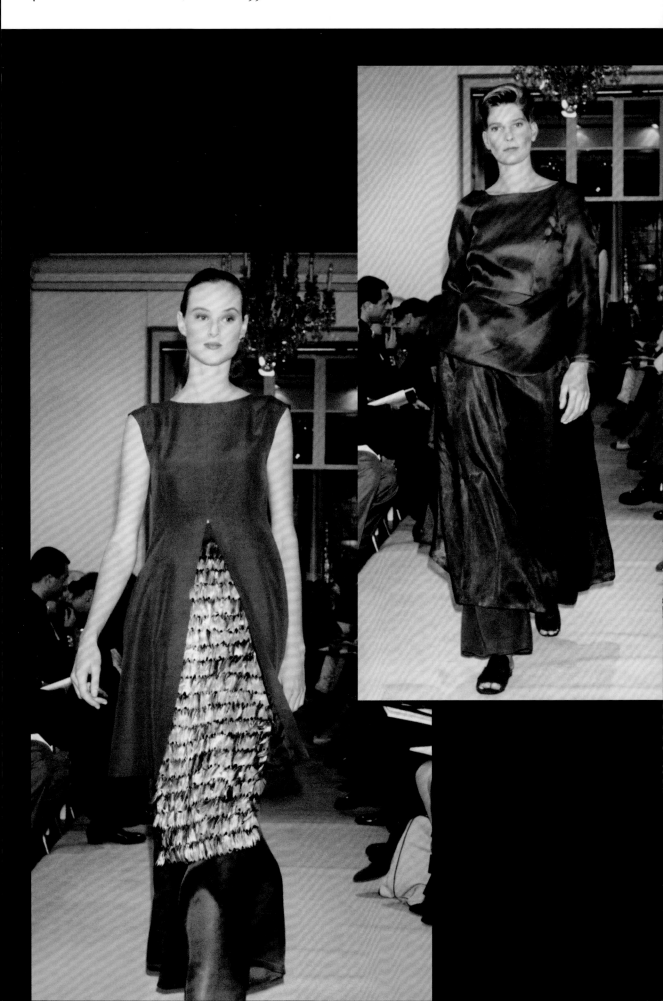

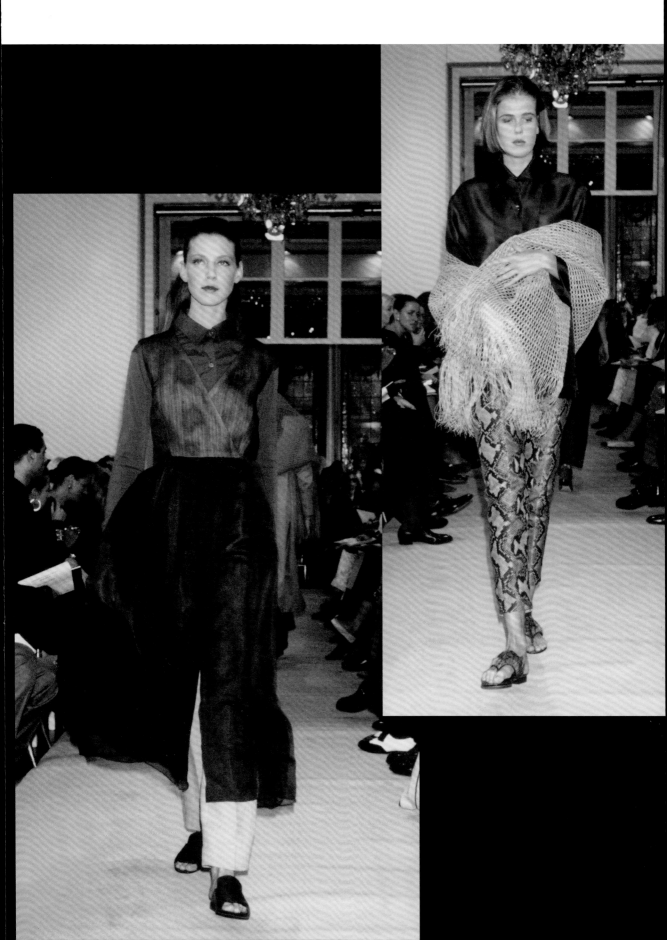

The simplicity – and even austerity – of the silhouette drew attention to the opulence of the fabrication here. This was the focus of Prada's ready-to-wear collections at this point, and of her Autumn/Winter collections in particular: upholding a deceptively pared-back line but in the most luxurious materials. Years later, this aesthetic would be labelled 'stealth wealth', and Prada spearheaded the look which, in her case, became increasingly layered and often twisted but nonetheless prevailed. On this occasion, sleek silks and satins, plump ultra-soft wools and velvets came in a principally neutral colour palette, enriched by an intense Renaissance red.

Although it seems overly straightforward today, as this designer would be the first to argue, until well into the mid-Nineties masculine-inspired tailoring was the uniform of choice for women looking for an alternative to the frills and furbelows of French fashion. Prada, who had long borrowed from menswear for her own wardrobe, in much the same way as she did from school uniform, was among the frontrunners where this was concerned also. In this instance, that viewpoint was developed with the inclusion of wildly lavish touches – fur sweaters and fluffy fur collars on pale riding jackets, to name just two.

While this collection was not one to shout conventional glamour from the rooftops it was, in fact, hugely glamorous. Here, though, was a woman who dressed not to impress others but to please herself. There was a gentle romance – even chastity – to some of the clothes in the collection.

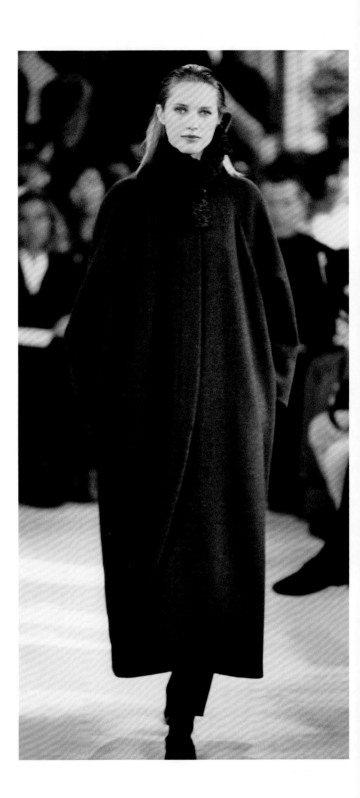

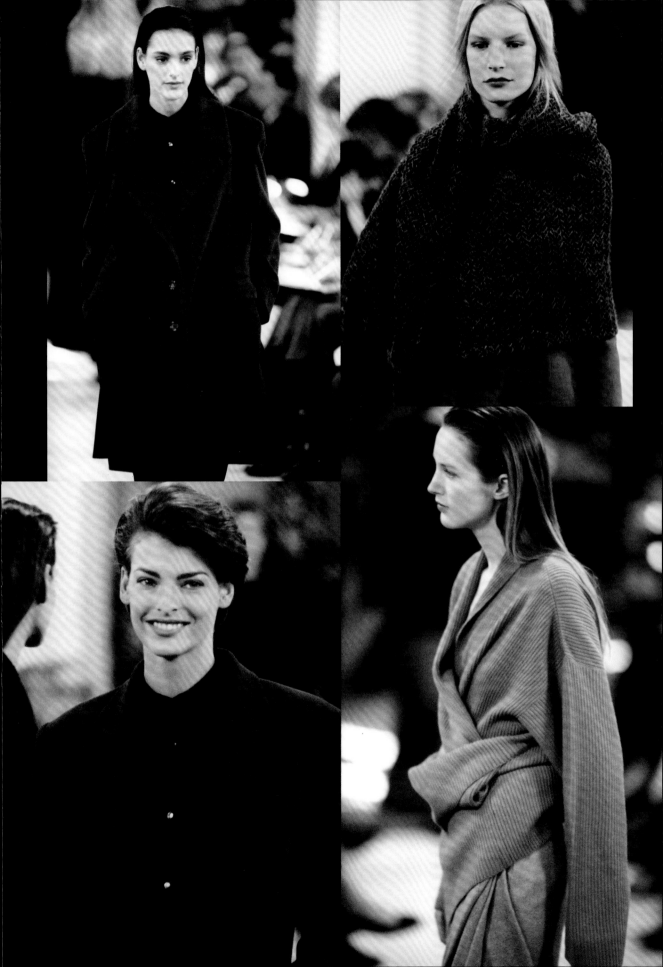

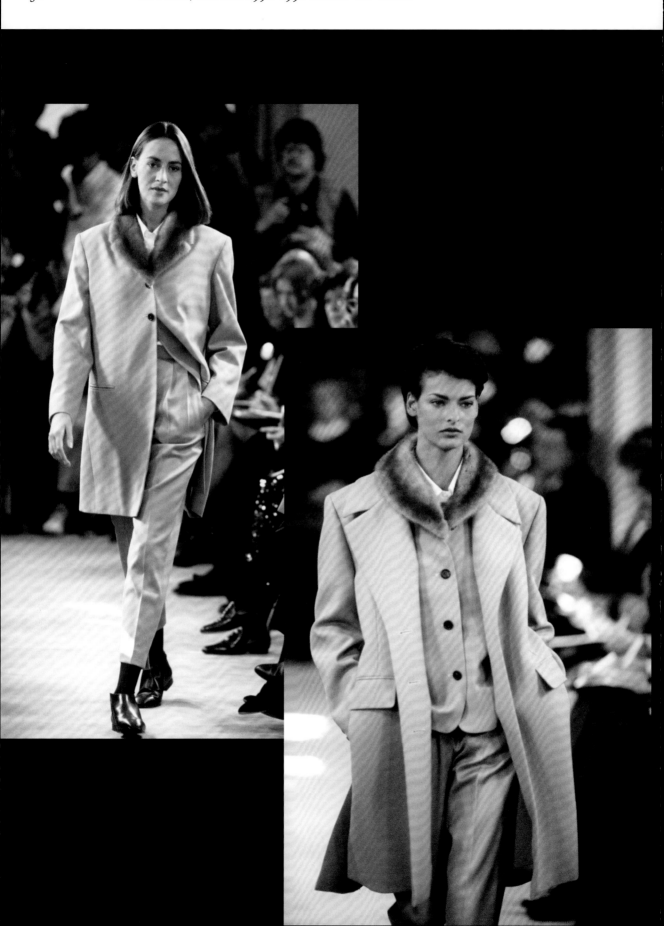

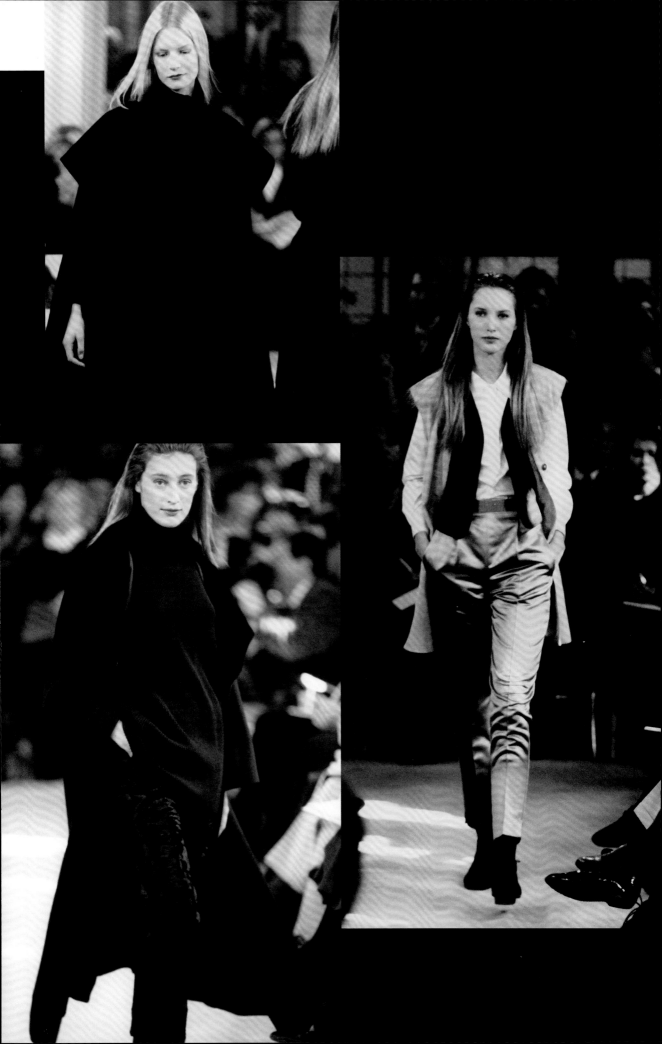

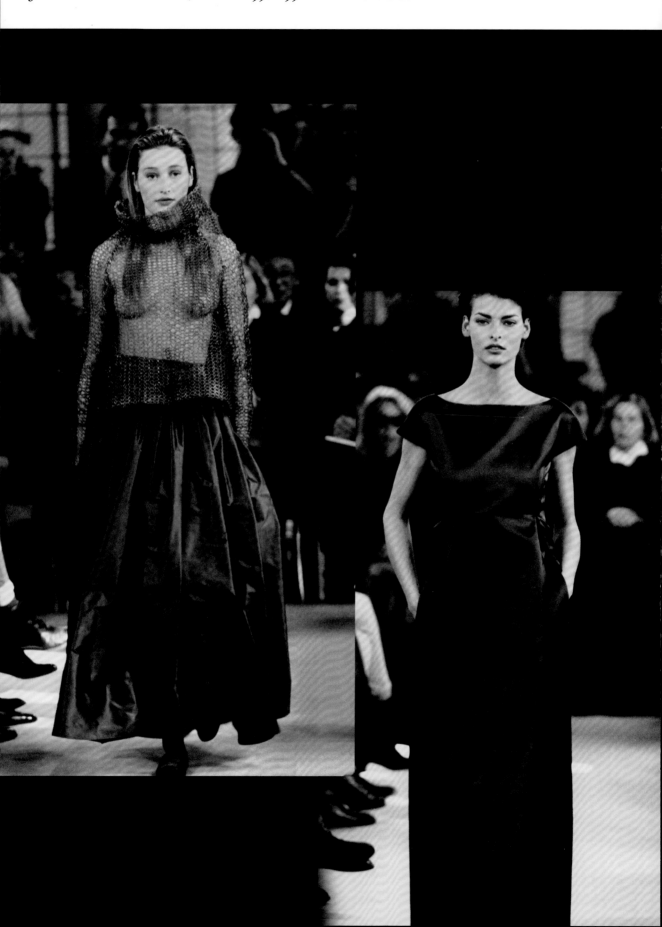

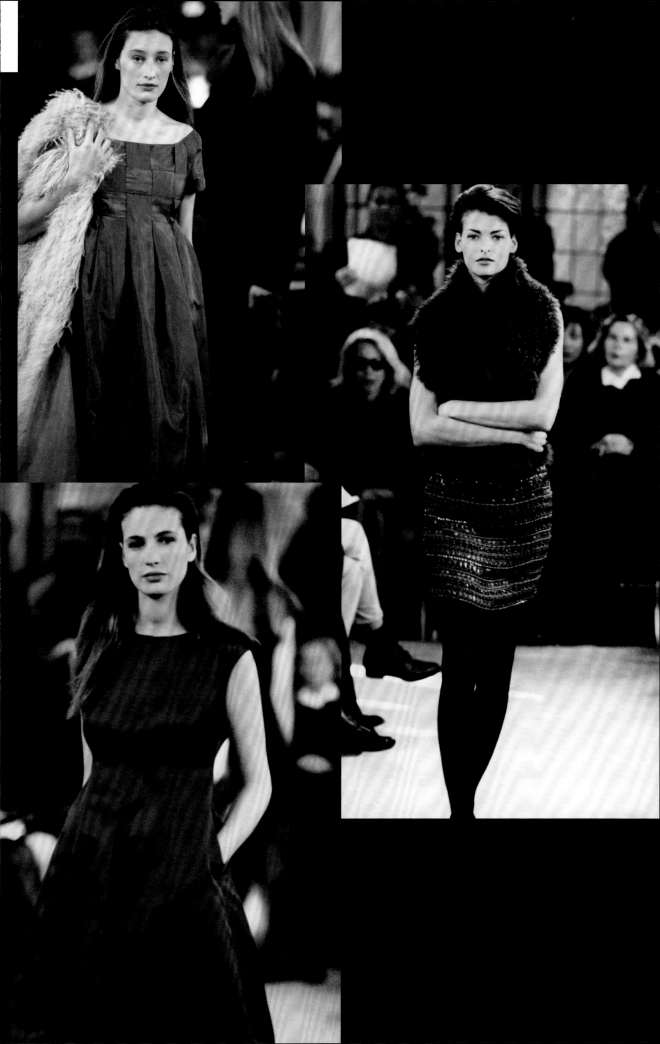

'The Flintstones meet The Jetsons,' reported *Women's Wear Daily* of this collection when it was first shown. 'There were brown and white cow skin miniskirts, shorts and hip-hugger pants with tan suede chamois apron tunics, as well as shorts and mini-dresses made of shells. It was all fun, but only Pebbles could wear these clothes. For Judy Jetson there were square silver metal cutout hot pants and multilayers of chiffon triangles on grey trapeze smocks: these were too far out.'

More than ten years afterwards, Miuccia Prada would refer to this very review. 'I remember a review that described one of my first collections as "The Flintstones meet The Jetsons",' she told the *Independent*. 'It was meant in a very negative way but, of course, that was exactly what I loved about it!'

And so the tension between, and exploration of, perceived ugliness and its supposed opposite, beauty – fashion that jarred with what the audience was used to seeing and that pushed boundaries – began to gather momentum. There was a strangeness to many of Prada's designs which made her audience question their taste levels ... until, that is, the rest of the world caught up with her. Today, and unquestionably with the most elegant taste, she is among the world's most respected designers, and her courage in tackling such broad concepts has changed the way women – and indeed men – dress.

Many of the obsessions (a word Prada uses often) that would continue to inform her work began to take shape seriously here. The aforementioned bared midriff (see p. 28) was almost omnipresent; teeny tiny skirts and hot pants, too, have been revisited again and again – notably, Prada tends to show them with legs strong and bared. Her woman is emancipated, anything but arm candy. Here, too, were memories of French futurist fashion – Paco Rabanne, André Courrèges and Pierre Cardin – in the use of metal and more industrial materials, optic white and a short, A-line silhouette, all contrasted with a more *sauvage*, rough-hewn aesthetic. As for the seashells, later this idea would also be revisited using crushed bottle-tops (see p. 356): 'trash couture' was how Prada described it on that occasion. While the world inevitably pondered the so-called wearability of such garments, the designer behind them was clearly more interested in the 'fun' part of the equation.

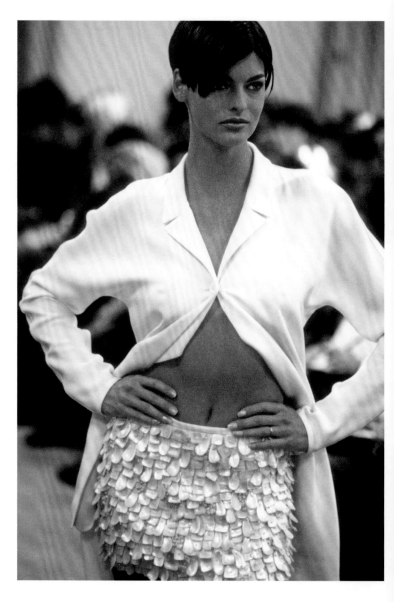

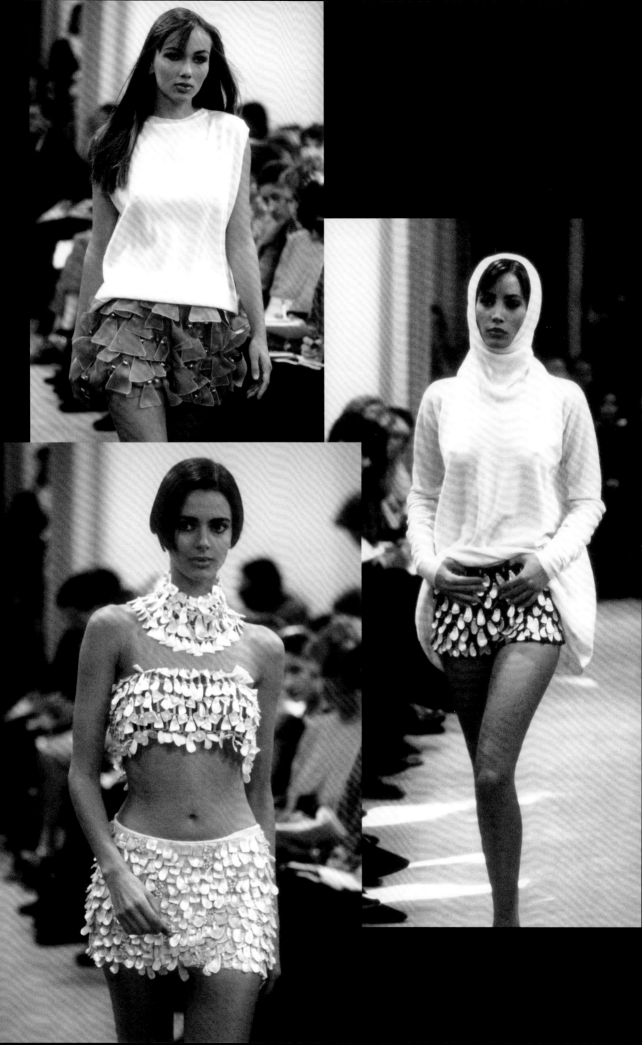

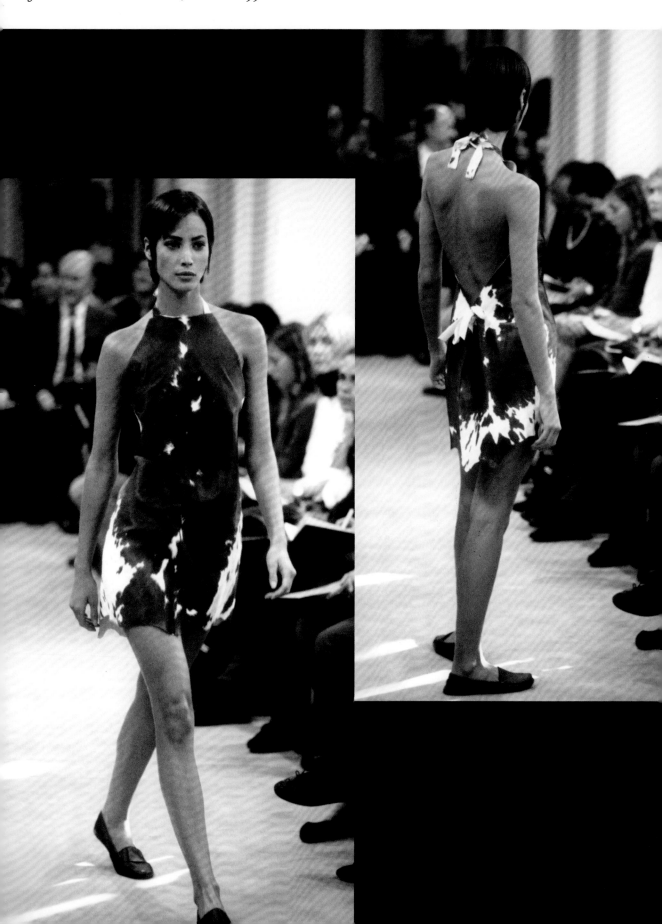

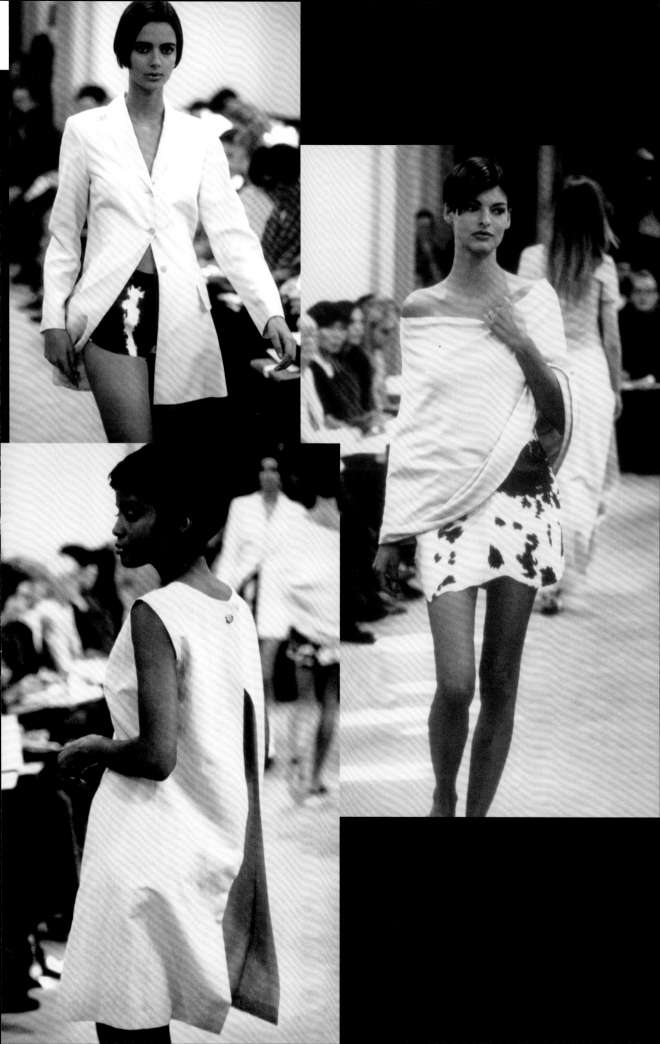

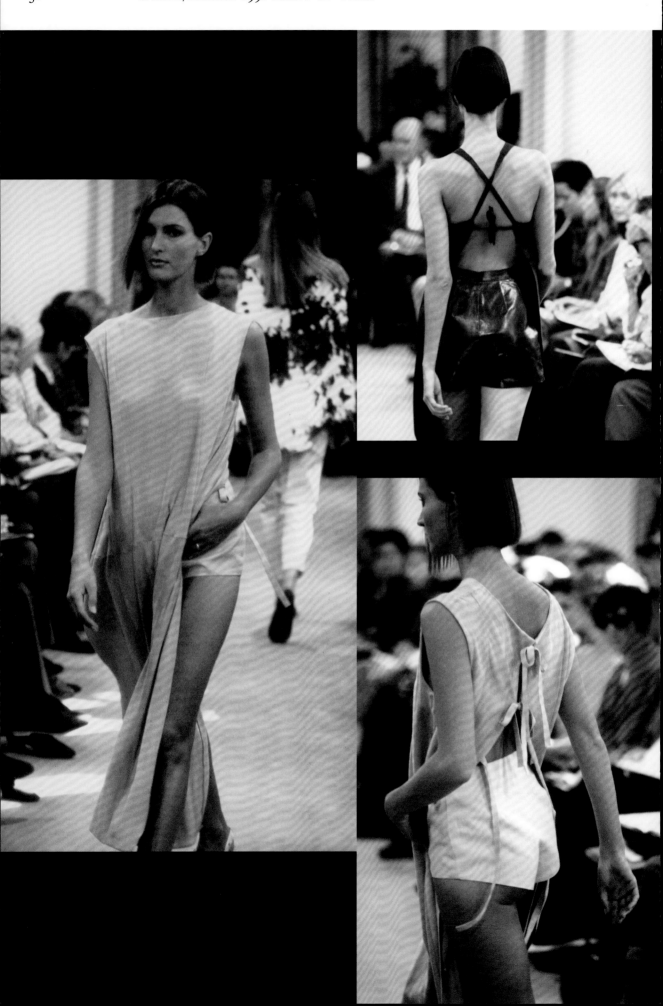

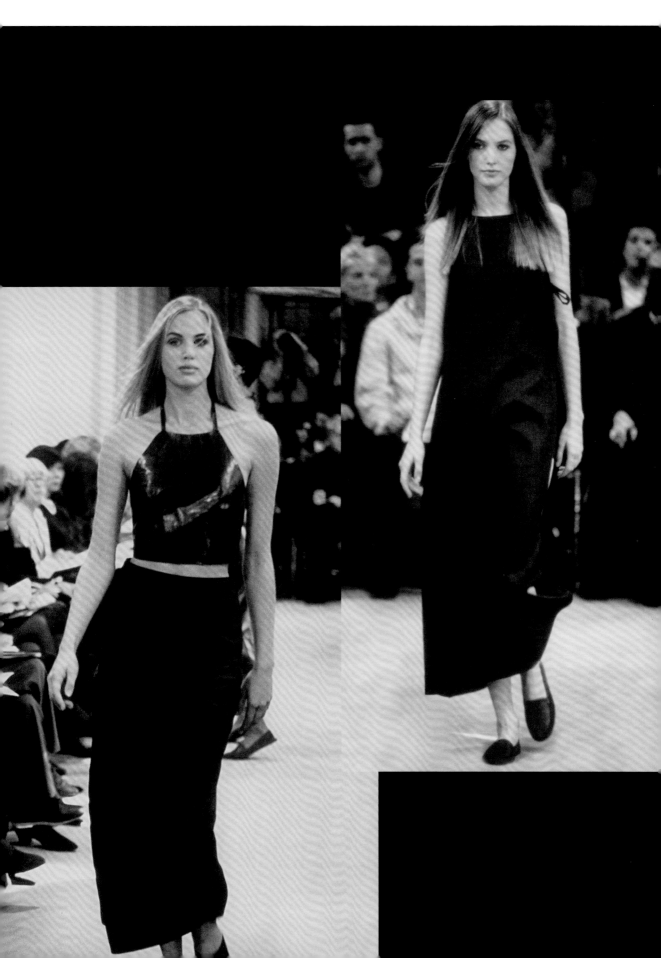

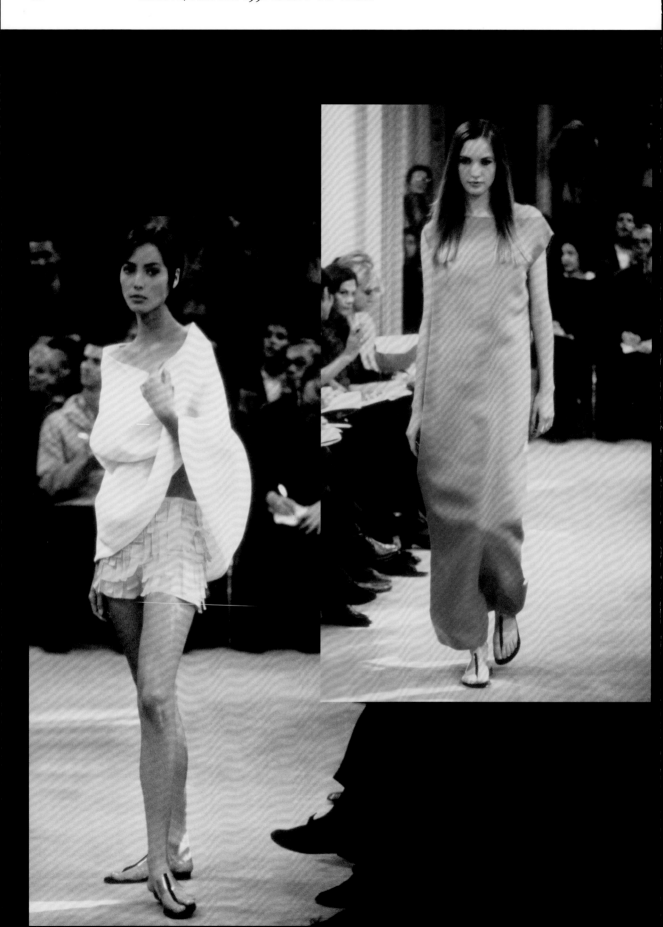

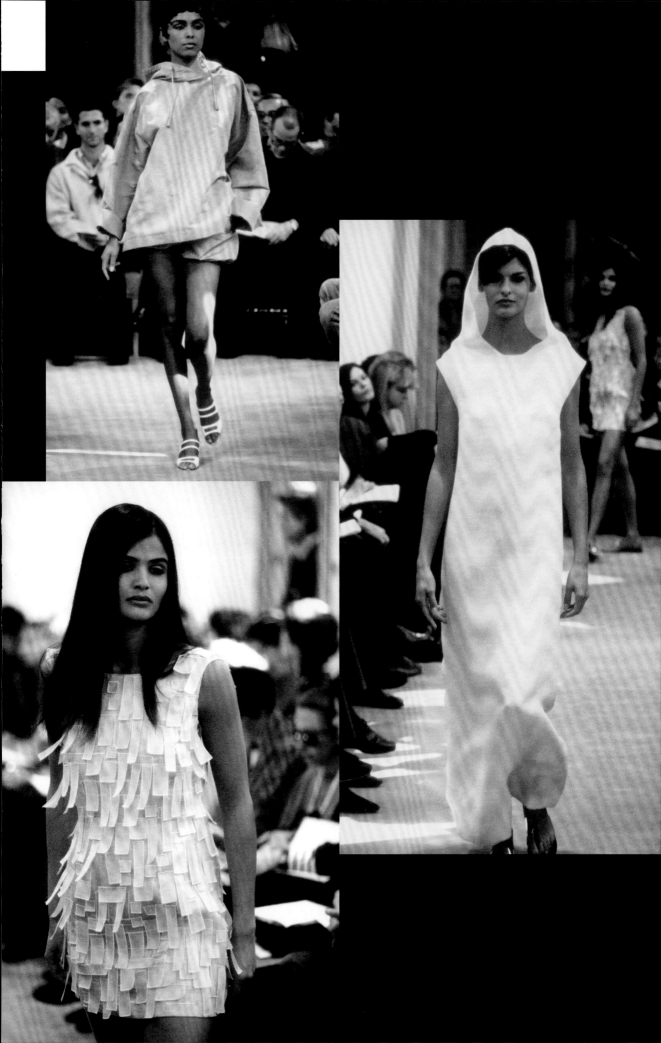

'If you choose to wear Prada,' wrote Iain R Webb
in the *Guardian*'s European collections report for
Autumn/Winter 1991–1992, 'you think of anything
but clothes: Proust, the meaning of life, or just what
did that granite obelisk symbolise in 2001: *A Space
Odyssey*?' Of course, this is a joke – and a good one
at that – but it was at around this point that Prada's
work became identified as 'intellectual'. In fact, she
has always worked just as much with her instincts as
with her intellect, all be that considerable: she has a
doctorate in political science and is among the most
culturally aware of her profession. A dress cannot be
intellectual, however, even if the person who created
it may be.

That said: 'There's this idea that if you're doing
fashion, you are required not to think, that it is all
about cliché,' she told the *Independent*. 'Every designer
has their own understanding of society and their
own vision. You can't actually do fashion unless you
have that.'

'Prada create clothes so simple they hardly exist,'
Webb, for his part, continued. 'Exquisitely cut
short-sleeved shift dresses in cream and palest grey,
ankle-flapping slashed skirts in black satin ciré and
tiny wrap-flash skirts over knitted leggings, white
fur balaclavas optional.'

The interest in dressing women for an active life
expressed right from the start – in dressing
independent women like herself, then – was very
much in evidence in zip-fronted bombers, hooded
wool tunics and tomato-red baseball caps worn with
matching broad-shouldered double-breasted suit
jackets, without skirts. As for the white fur balaclavas,
they looked especially fine worn with Sixties-style
shift dresses (also in white), with geometric shapes
cut out of their backs, exposing the spine (see p. 68).
In years to come, Prada would deride overt sexual
provocation in dress, and in Italian dress in particular,
preferring her own, more subtle peek-a-boo form
of eroticism that endured.

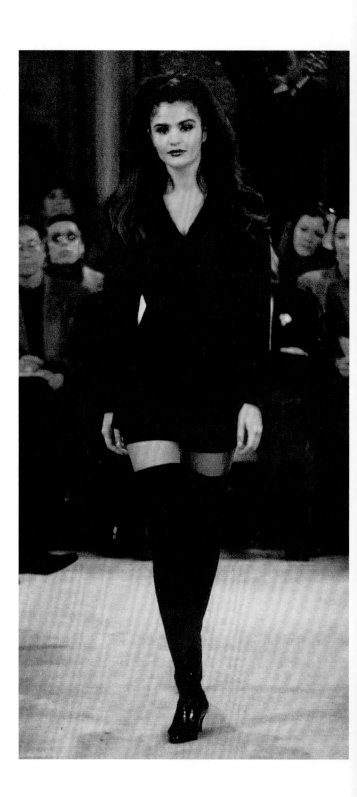

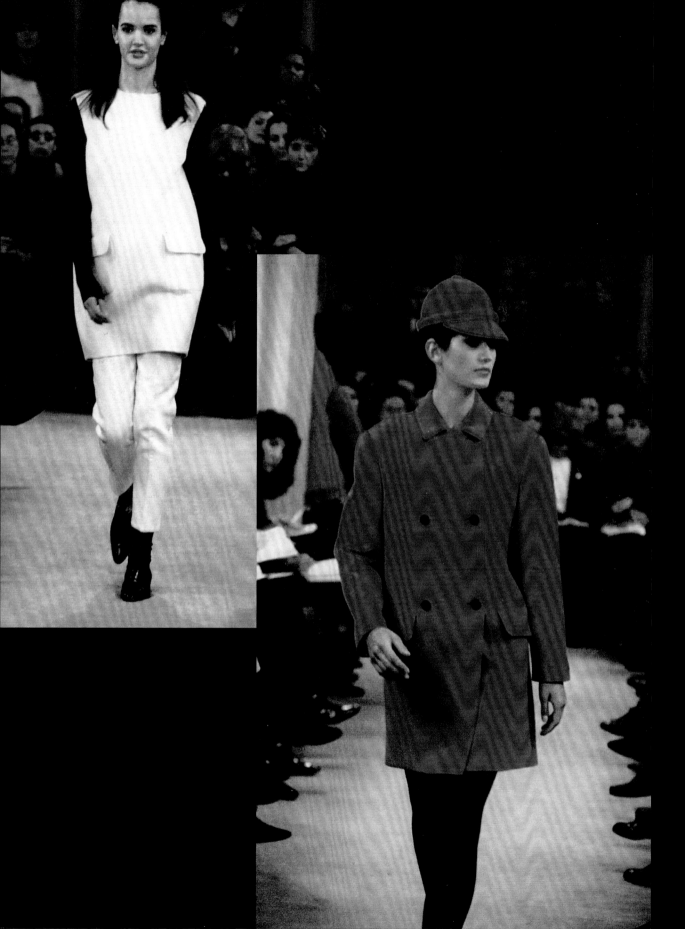

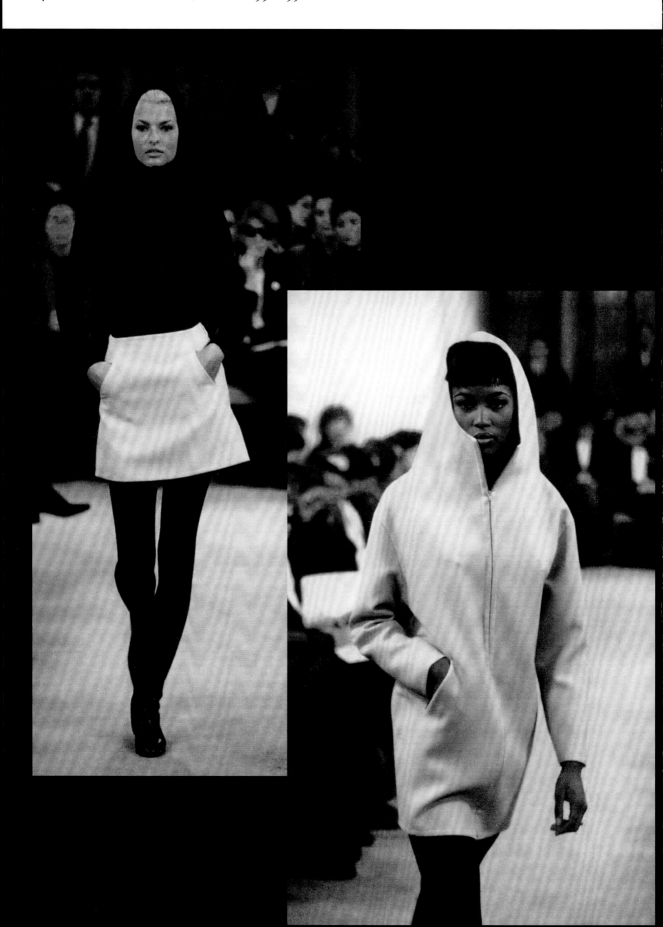

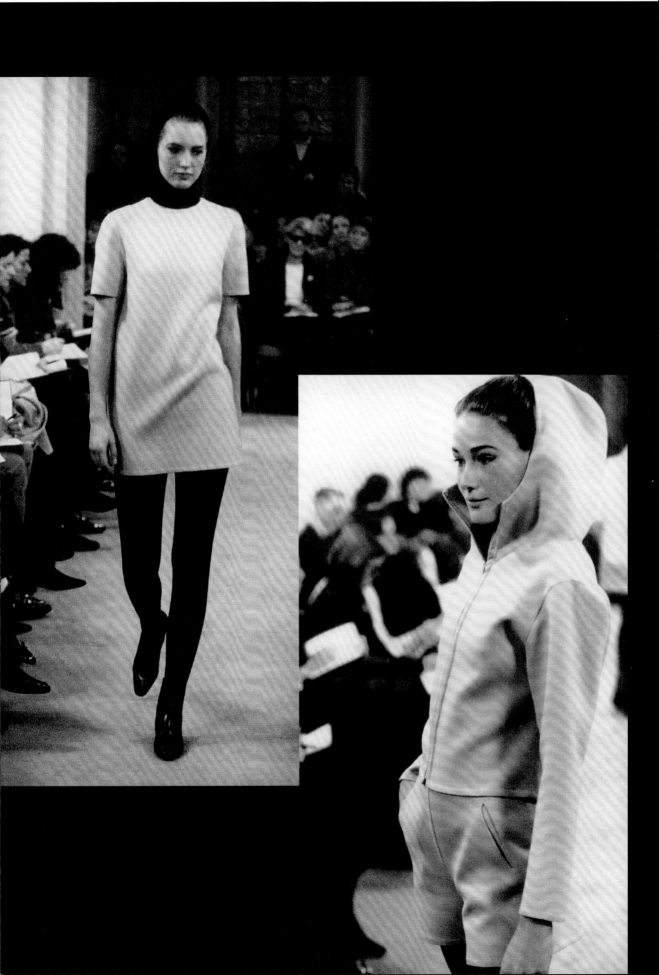

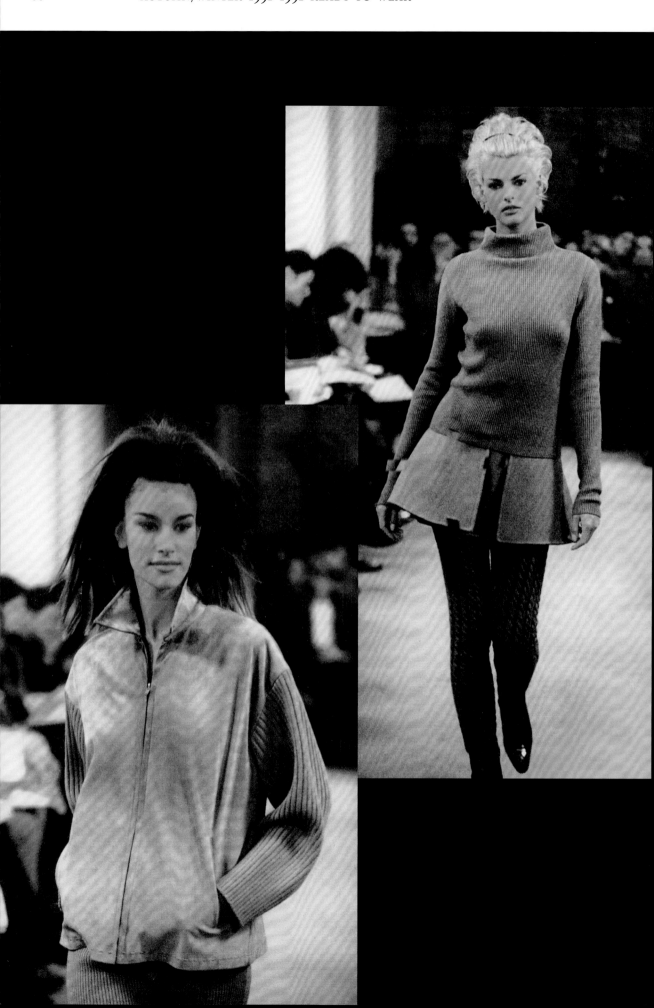

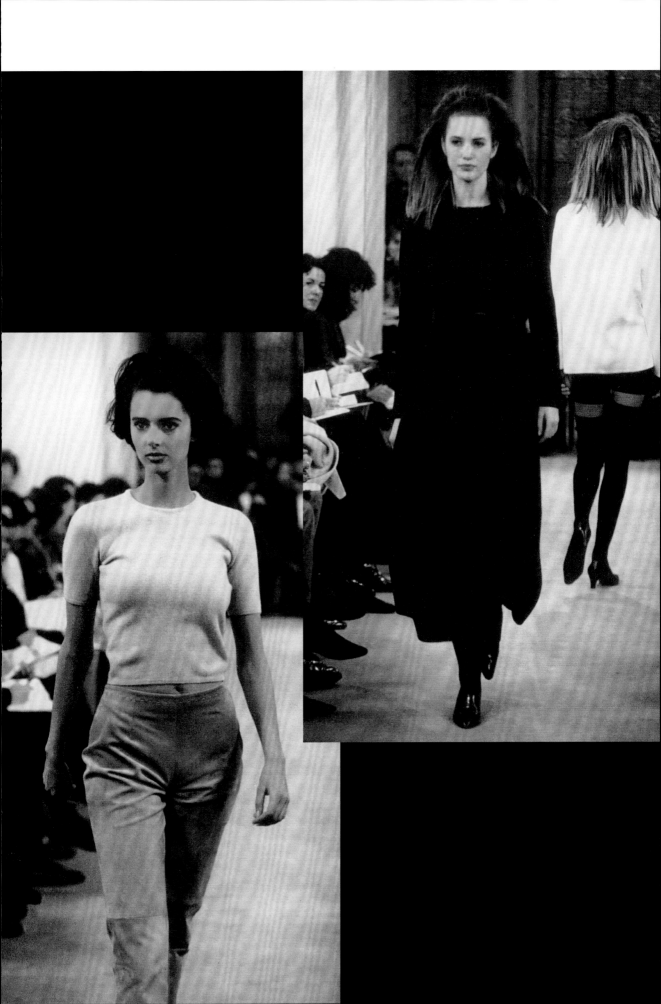

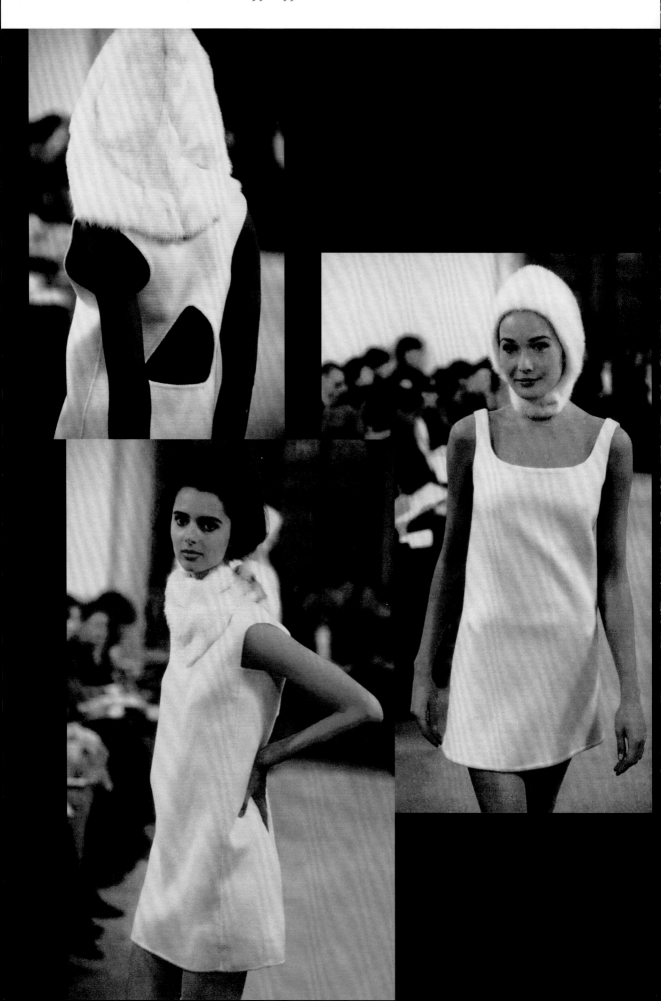

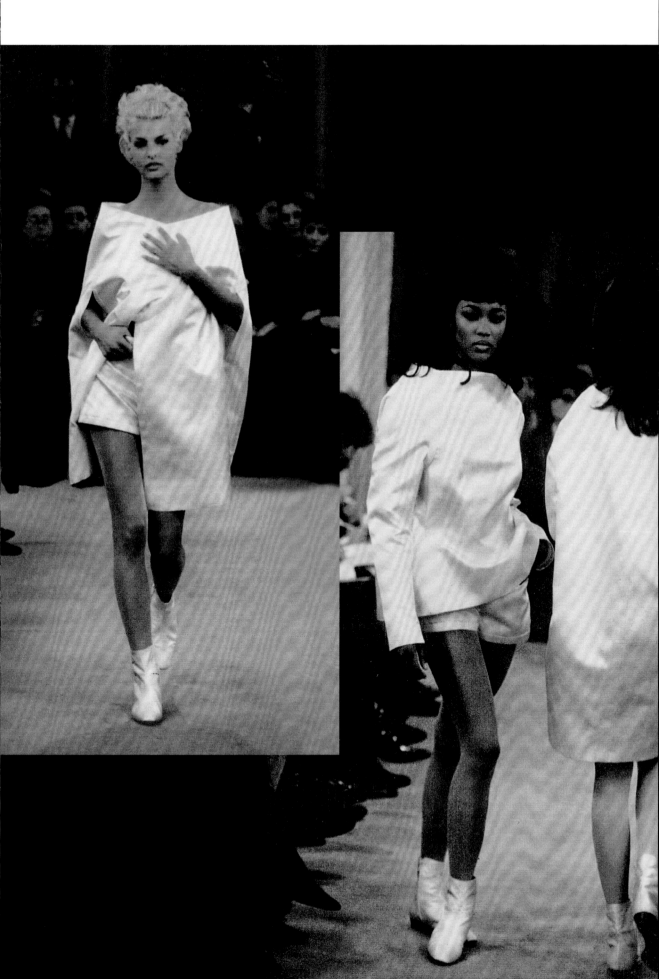

With the exception of her Spring/Summer 1991
Flintstone/Jetson collection which gained quite some
attention, even notoriety (see p. 54), it is interesting
to note that, in Milan, Gianni Versace and Giorgio
Armani were still responsible for the blockbuster
shows, with all other names covered as not much more
than after-thoughts. That was soon to change, but,
in the meantime, here's what Woody Hochswender
of the *New York Times* had to say of this collection:
'Prada, a company known for its smart little sacks,
showed a collection with a Cote d'Azur spirit: Riviera
awning-stripe coats and shorts, beach cover-ups,
sun dresses and playsuits. It was a small show that
worked.'

For the most part, Prada remained best known and
loved for accessories. Still, this collection was entirely
characteristic, featuring many of the signatures that
Prada had by now made her own: white floral swim
caps (p. 77; the new season's answer to that fur
balaclava, see p. 62), bare midriffs, A-line miniskirts,
duster coats, white cotton shirting. The final sequence
was less minimal, however. Baby doll chiffon dresses
in girlish, fondant shades and appliquéd with garlands
of flowers (pp. 78–79) were a witty, pretty twist, the
kind of feminine cliché that the designer was to
become increasingly drawn to … delivered, of course,
with a hefty dose of irony, not least when worn over
big knickers (or 'panties', as Prada describes them)
defiantly on show. These were, in the end, more
Barbara Cartland for the grunge generation than
Coco Chanel, circa Biarritz.

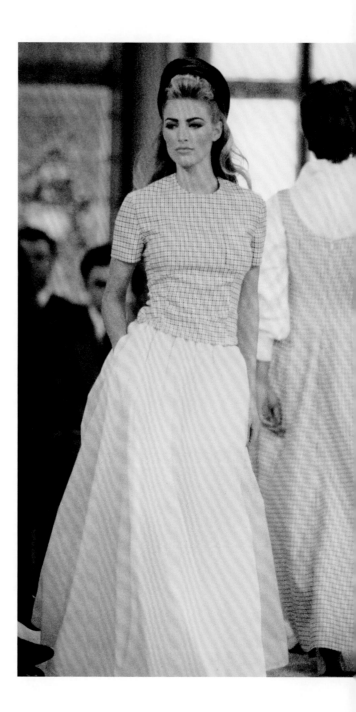

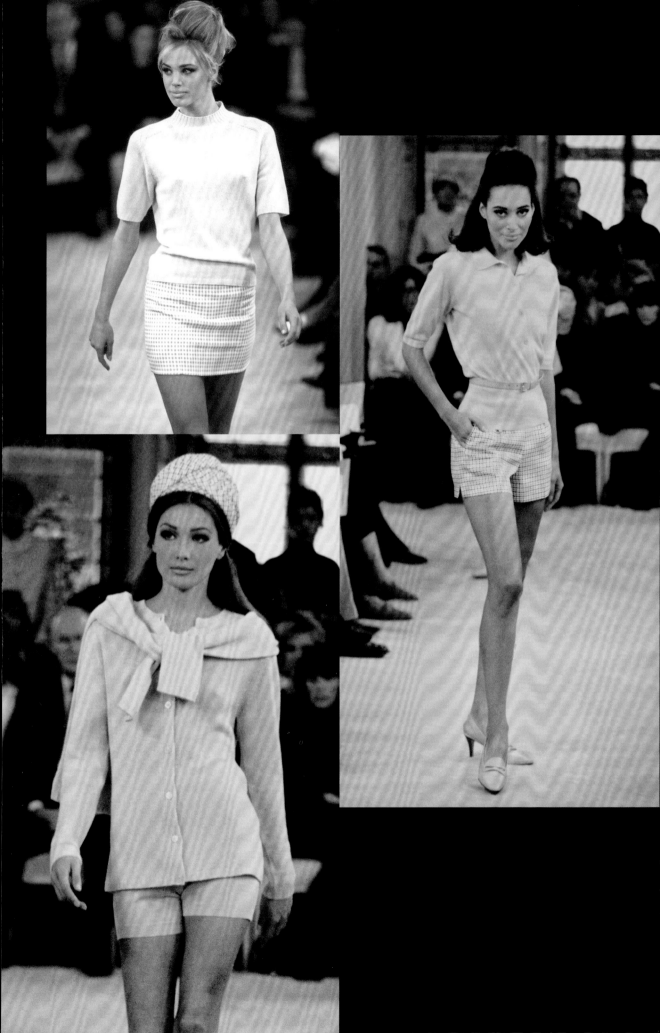

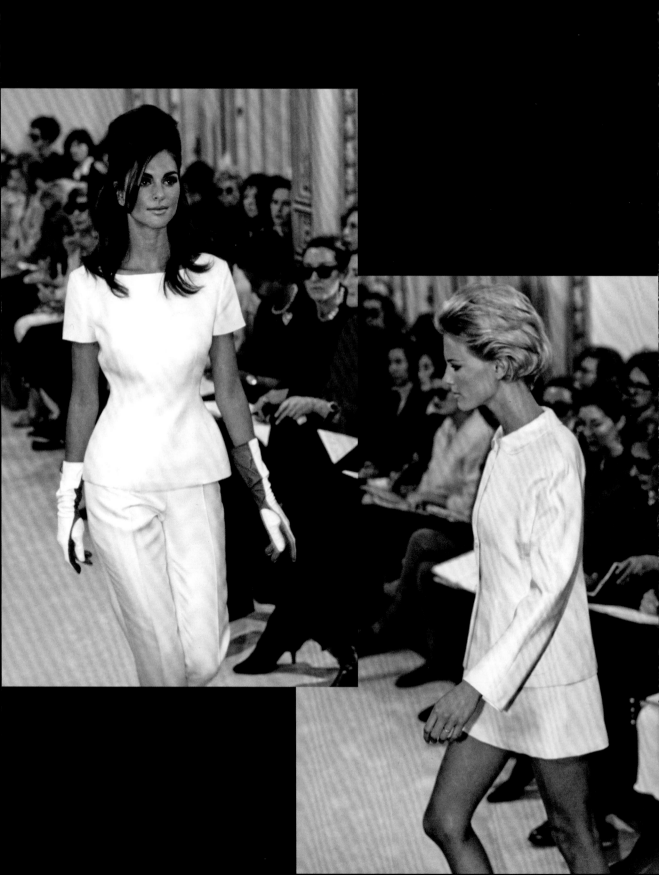

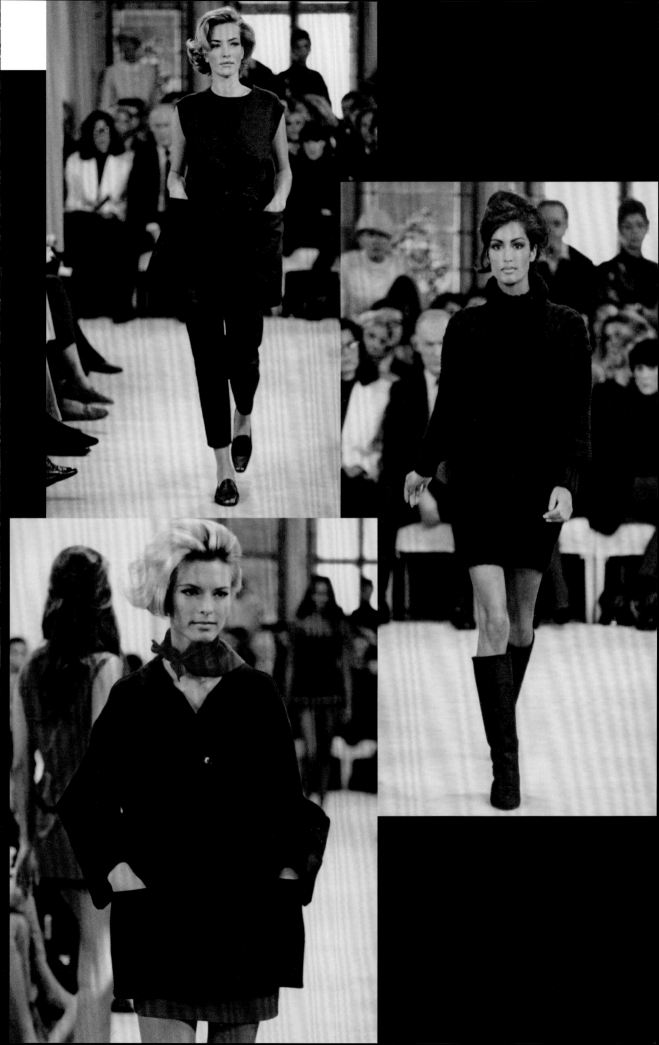

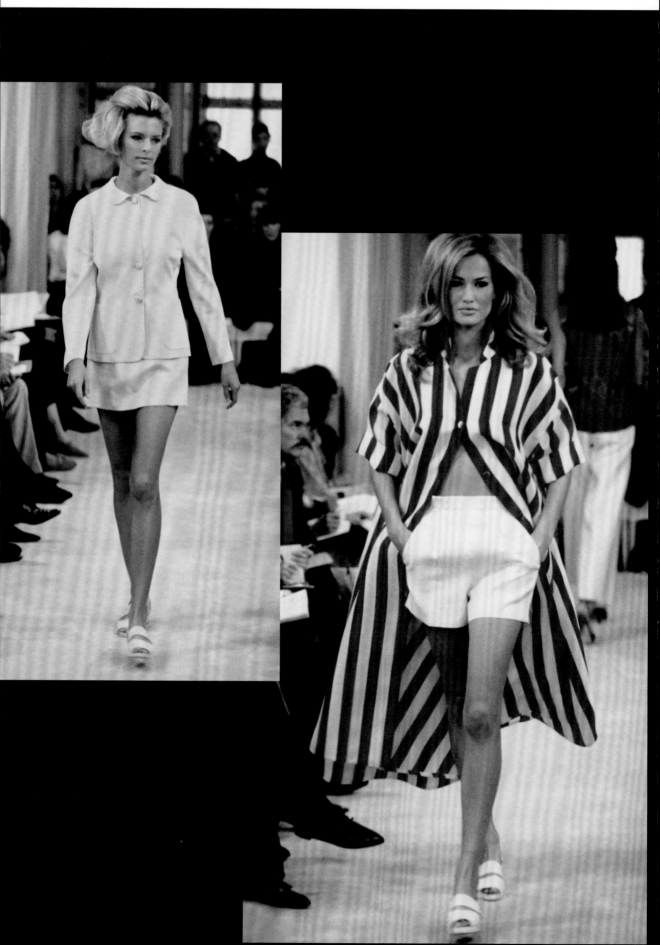

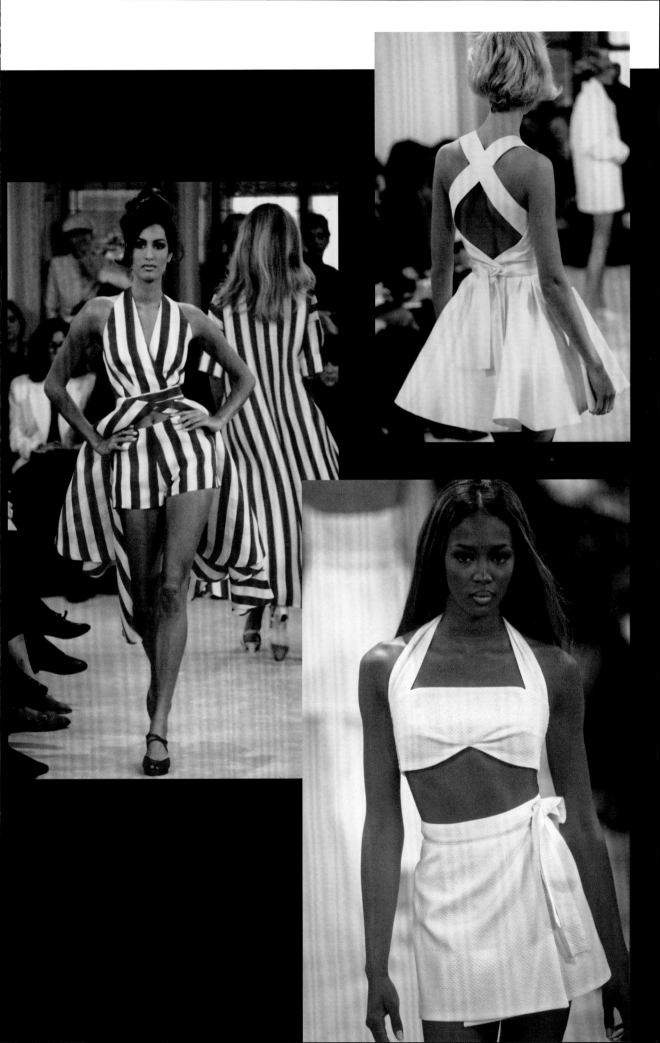

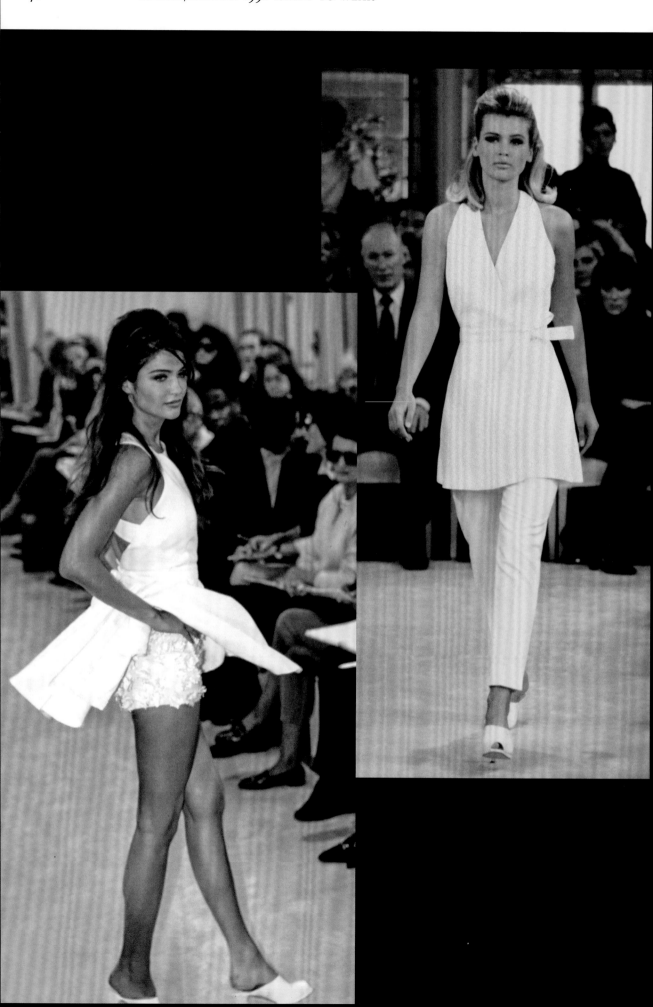

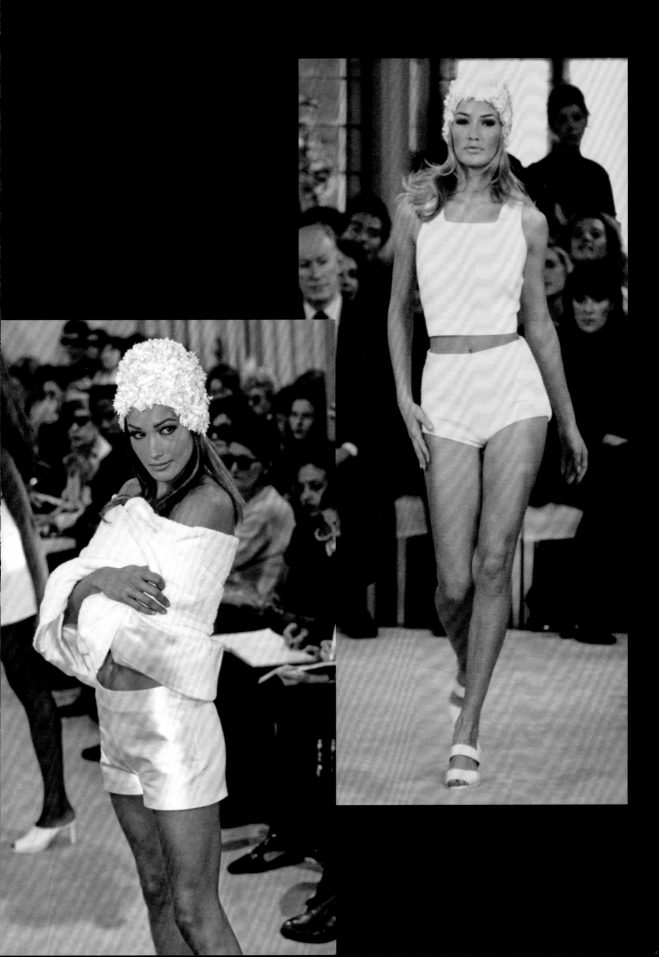

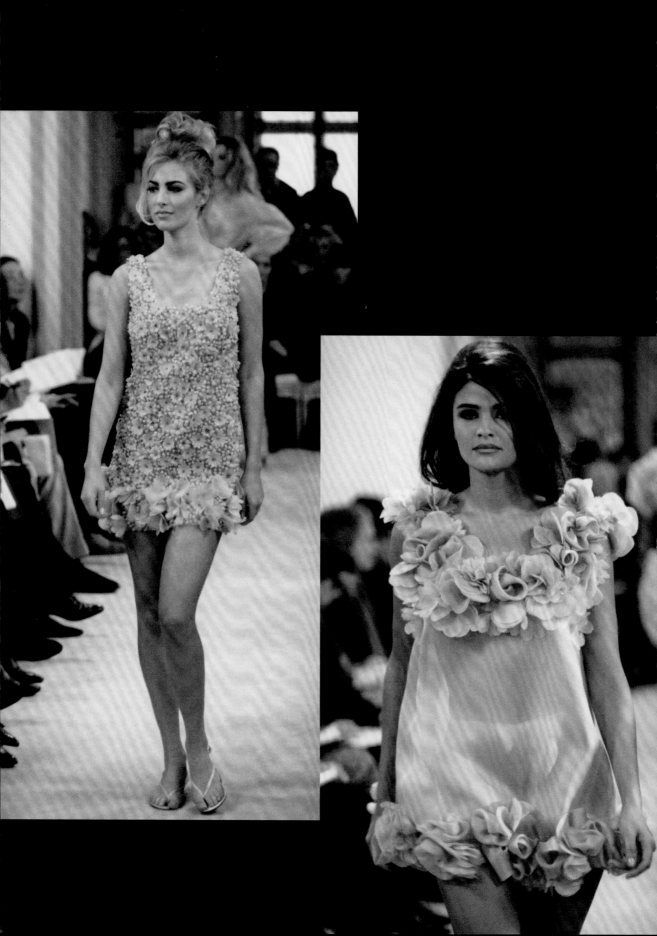

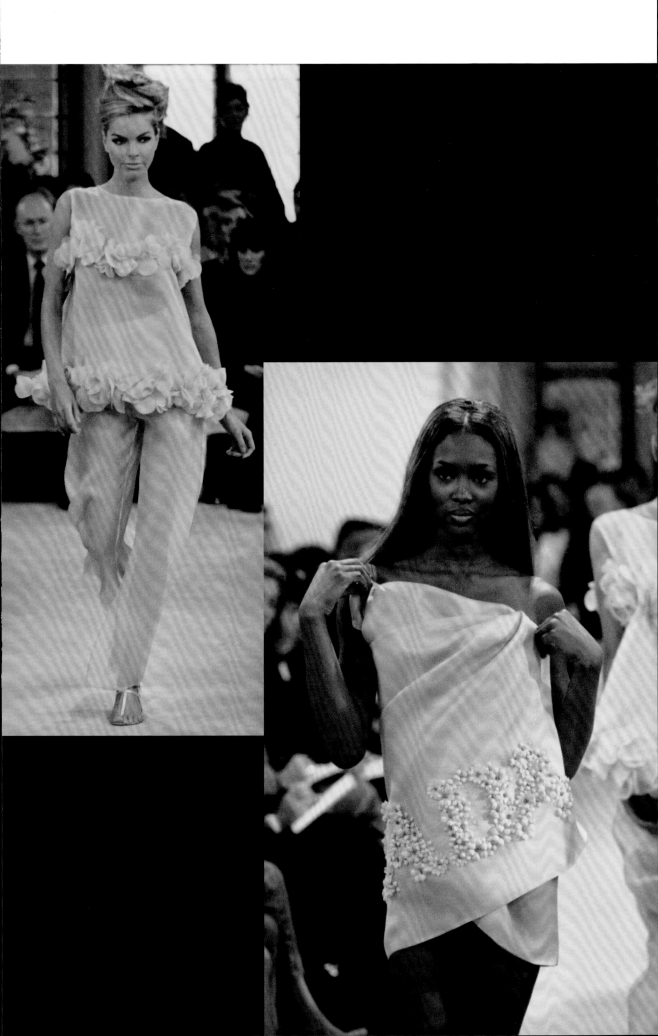

'It could have been a moment straight out of the
Seventies – the ambience, the model, the little shift.
In fact, it's one of Miuccia Prada's favourite A-line
dresses whipped up in beige alpaca for fall [p. 82,
left]. She's got the fashion world talking with her
simple clothes – always in great fabrics and great
colours.' In less than ten seasons, by 29 April 1992,
Prada's ready-to-wear collection had travelled the
route from barely-there announcement buried
among more high-profile names to the front page
of *Women's Wear Daily*.

Slowly but surely her reputation was building, and
as it did so she became increasingly innovative –
increasingly brave. True, there was a sense of the
Seventies here; there often is. Prada's decades of
choice, as far as looking back to move forward is
concerned, are the Fifties, Sixties and Seventies.
As is often – if not always – the case with designers,
these were her formative years. That said, the fact
that the above-mentioned neutrally hued A-line shift
was crafted in alpaca is distinctively Prada. She likes
clothes that are, as she herself has put it, 'hairy' –
particularly when said hairs sprout from a silhouette
that one wouldn't naturally expect to be that way.

While this collection came complete with luxurious
chunky rib knits, camel tailoring, tufted tartans and
fur trims, these appeared in almost direct contrast
to more conventionally sexy designs also in place.
From time to time throughout her career, Prada has
explored this aesthetic: bras and bra motifs, in
particular, are a signature. Here they came mainly
in black, sequinned and with just a trace of Allen
Jones-style kink, all aimed squarely at the thinking
woman's night out (see p. 87, left). In the opposite
corner: a knitted camel and grey all-in-one with
matching camel and grey cardigan (right) was
about as sexless as it is possible to imagine.

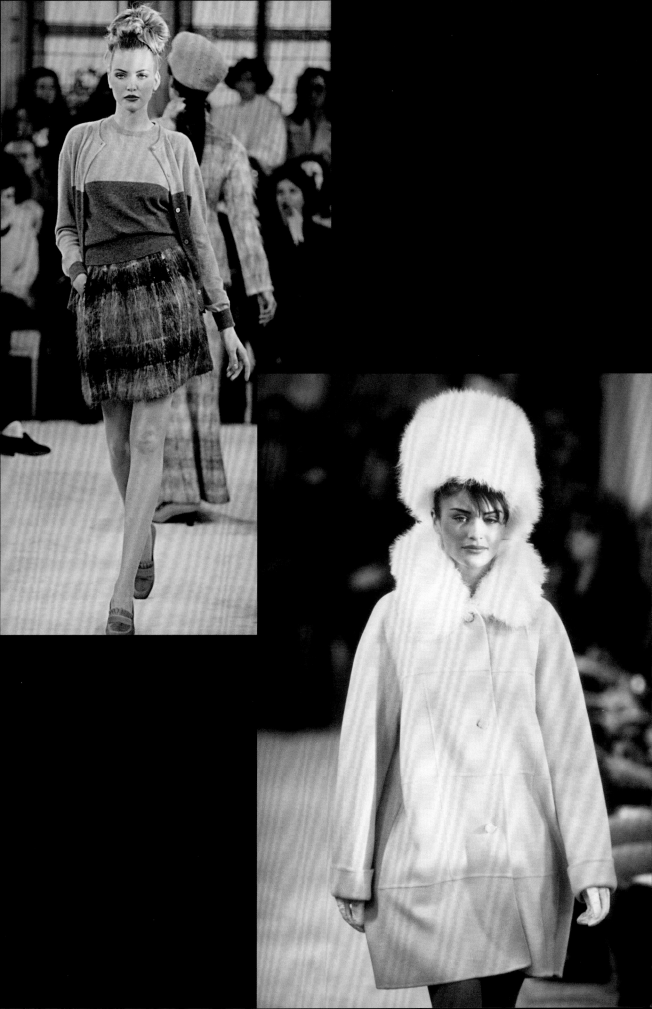

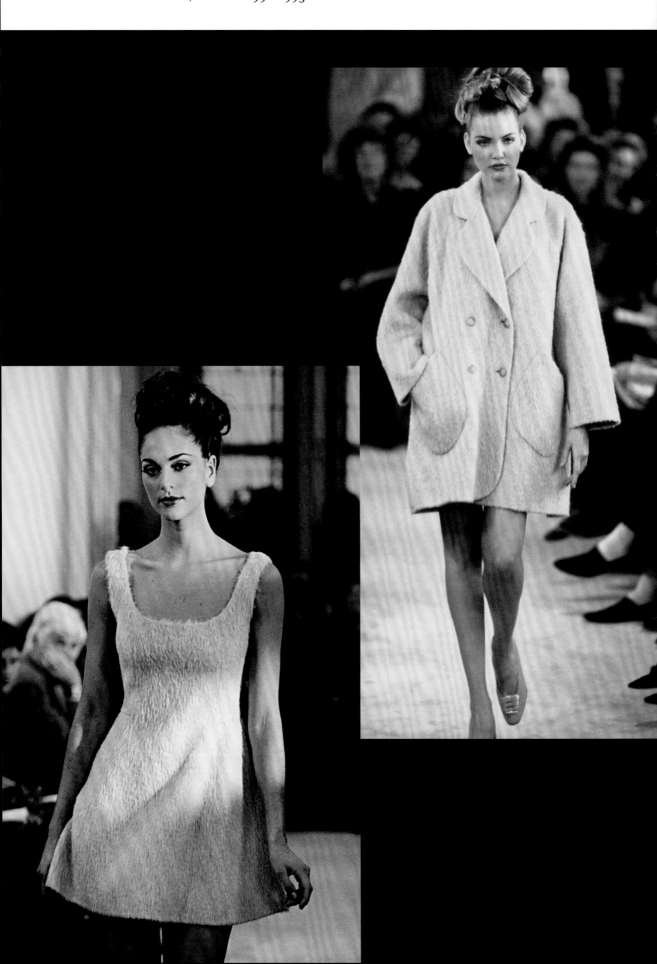

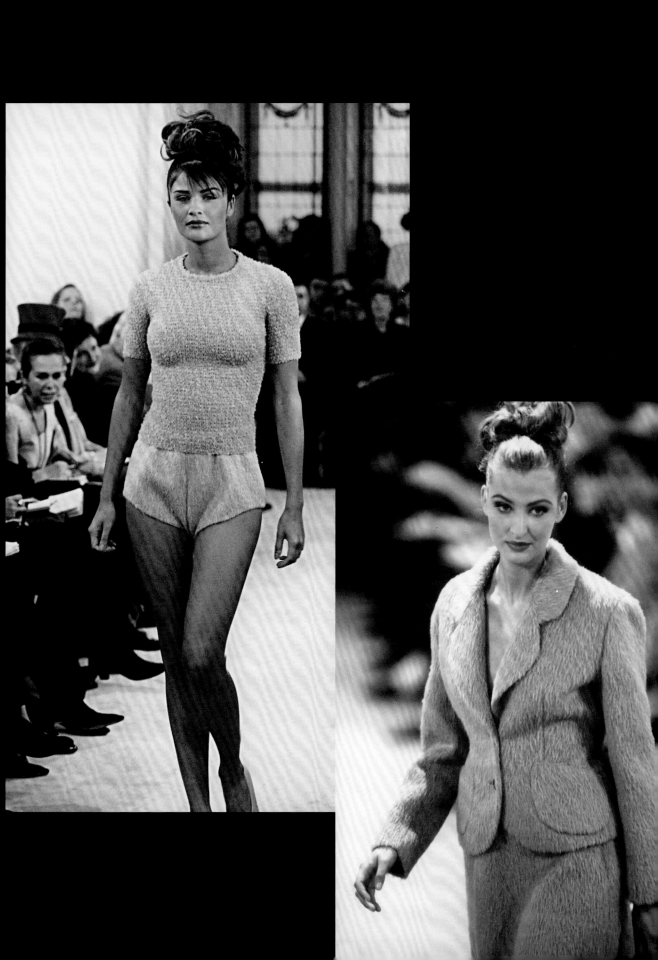

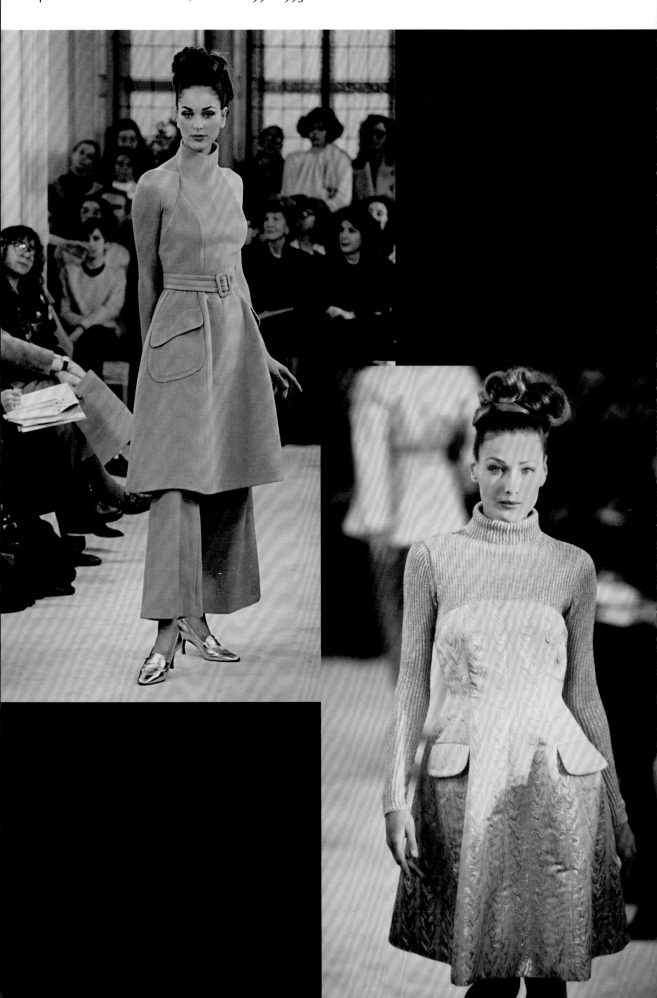

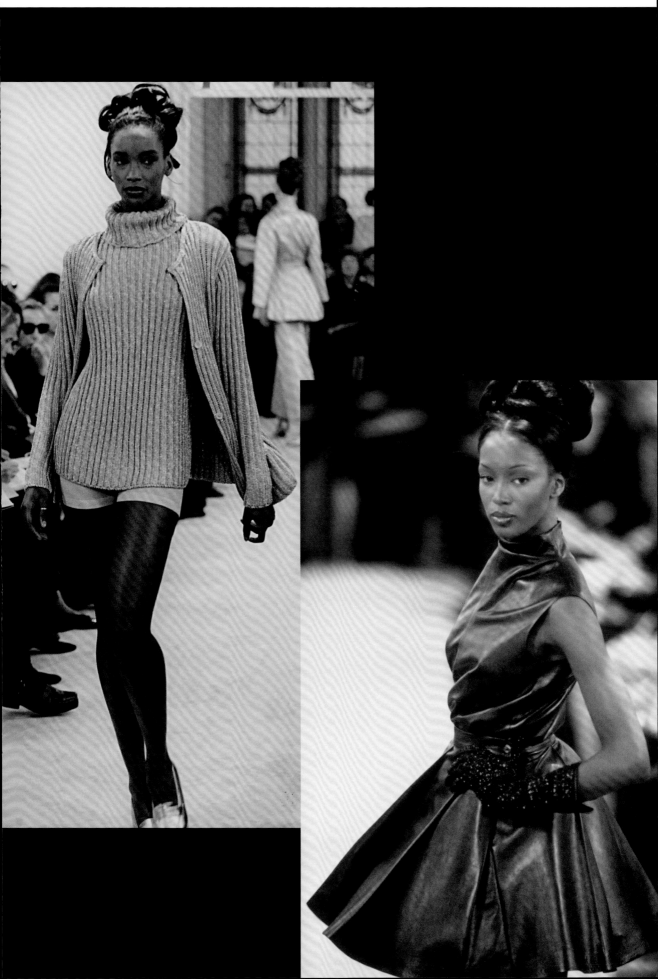

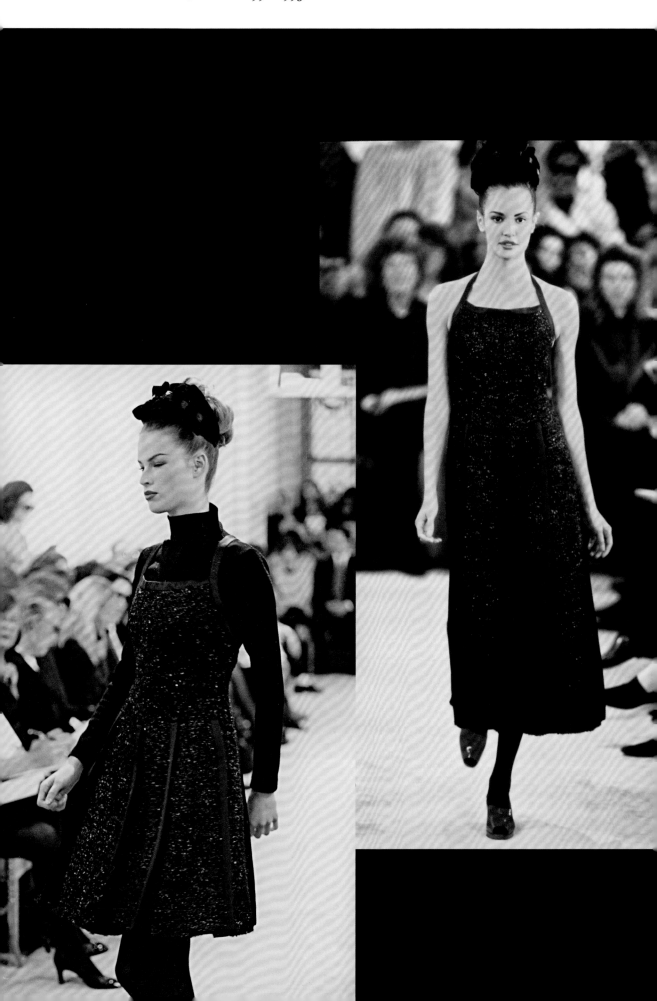

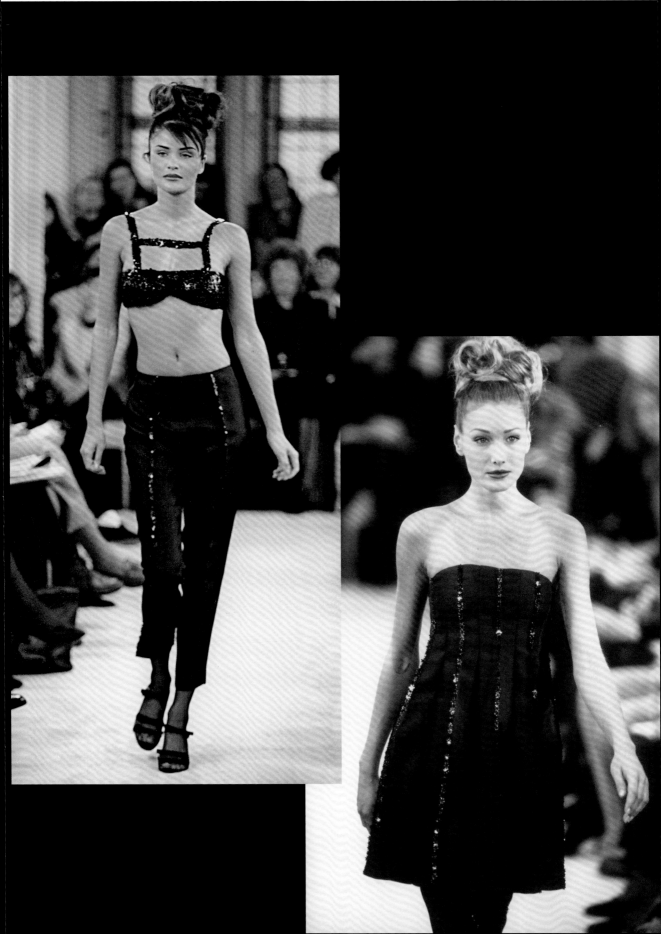

If 1970s fashion had been minimal – which with the notable exceptions of Halston and, at times, Saint Laurent it predominantly wasn't – then this might have been what it looked like. That decade was referenced across the board in Milan this season, but in this case it was seen through the lens of a 1990s eye.

With their hair ironed and neatly parted, models wore brown single-breasted trouser suits with bell-bottom trousers, emerald-green suede waistcoats and jackets with high-waisted flares. Nodding to the homespun artsy-crafty spirit of that decade, though still relatively stripped back, were tiered or layered maxi-dresses with petticoat straps, and more, of differing lengths, with rows of stars at neckline and hem, and, finally, miniskirts, maxi-skirts, dresses and trousers the surfaces of which were embroidered with fringing.

This was a simple but clever show which gave a decade not always known for its sophistication just that. Long skirts and dresses in neutral shades were lined with fuchsia, yellow or orange organza: the brighter shade merely glimmered until a strip of vivid colour showed clearly – popped – at the hem (see p. 93). Moving away from only the most high-end materials, humble hopsack was worked into various elegant guises. Sandals were flat – Jesus-style – or platform-soled and heeled and laced right up to the knee. Such elevated footwear designs would return to the Prada runway more often perhaps than any other style.

'You know, I had to have a lot of courage to do fashion,' Miuccia Prada told the *Independent*. 'In theory it is the least feminist work possible and at that time, in the late Seventies, that was very complicated for me.' She took over the company in 1978. 'I was young in the 1960s. Italian society was becoming obsessed with consumerism but my big dreams were of justice, equality and moral regeneration.'

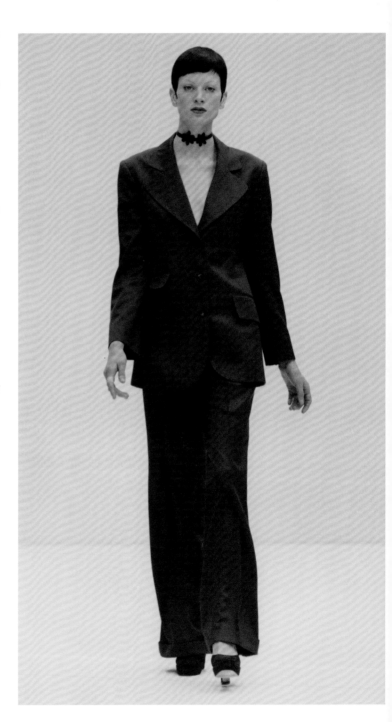

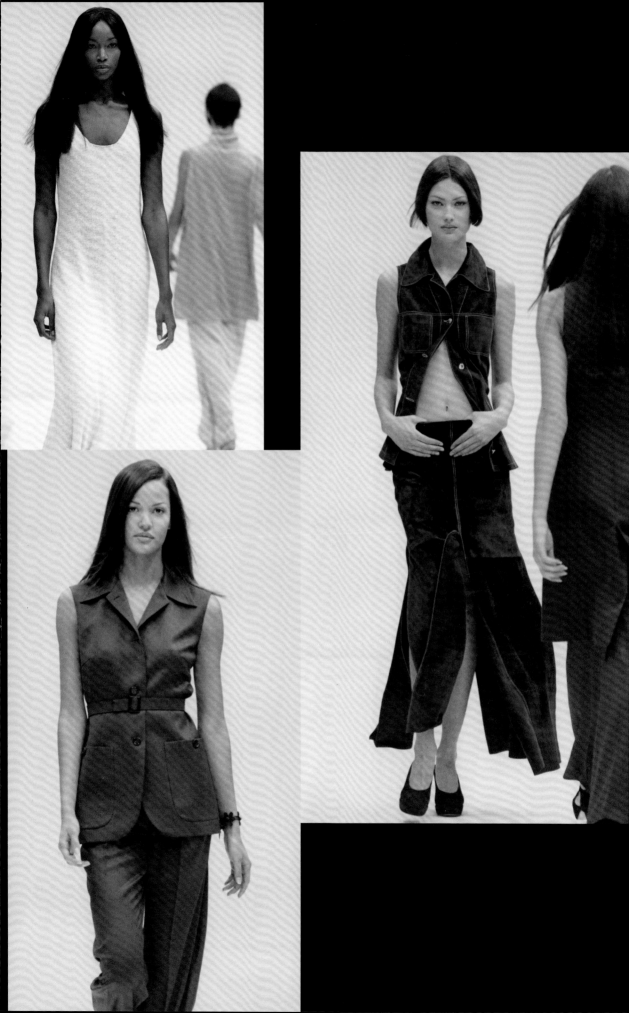

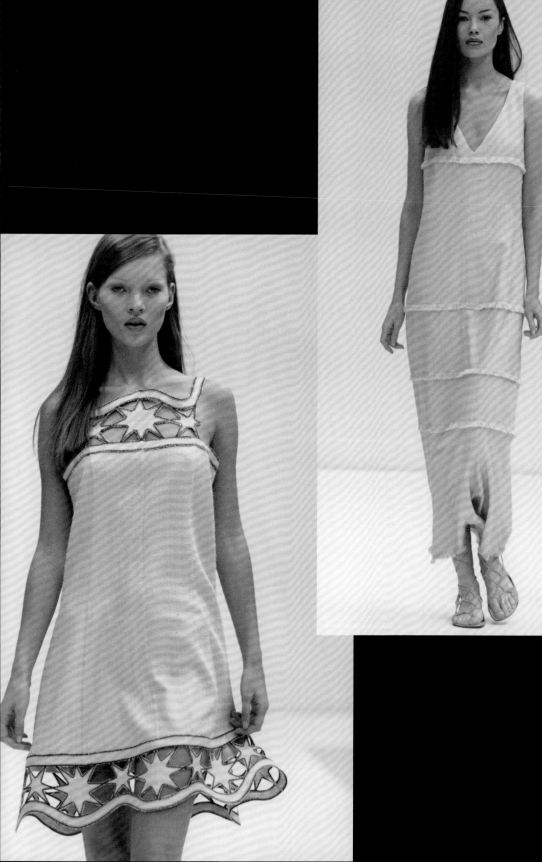

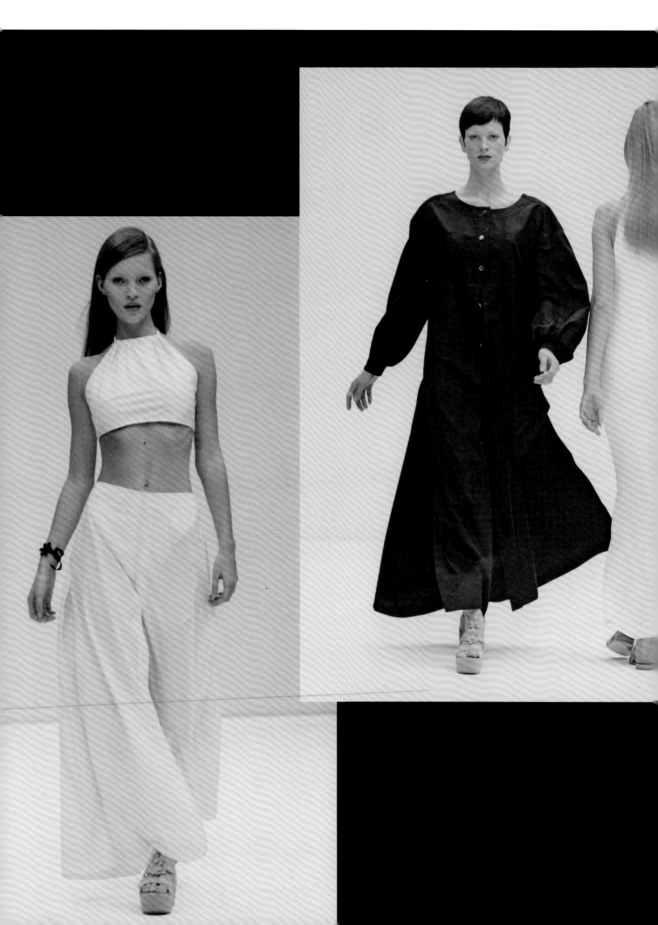

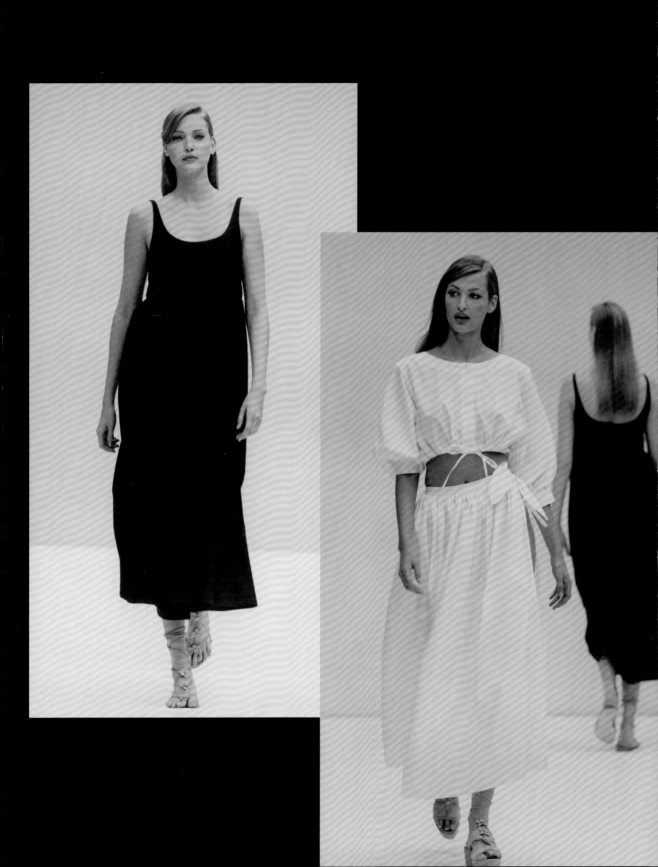

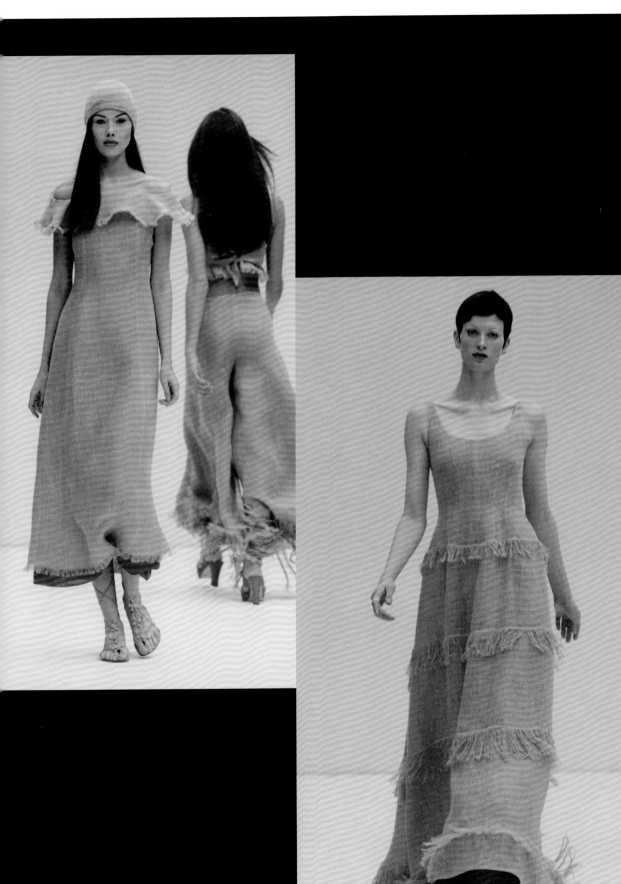

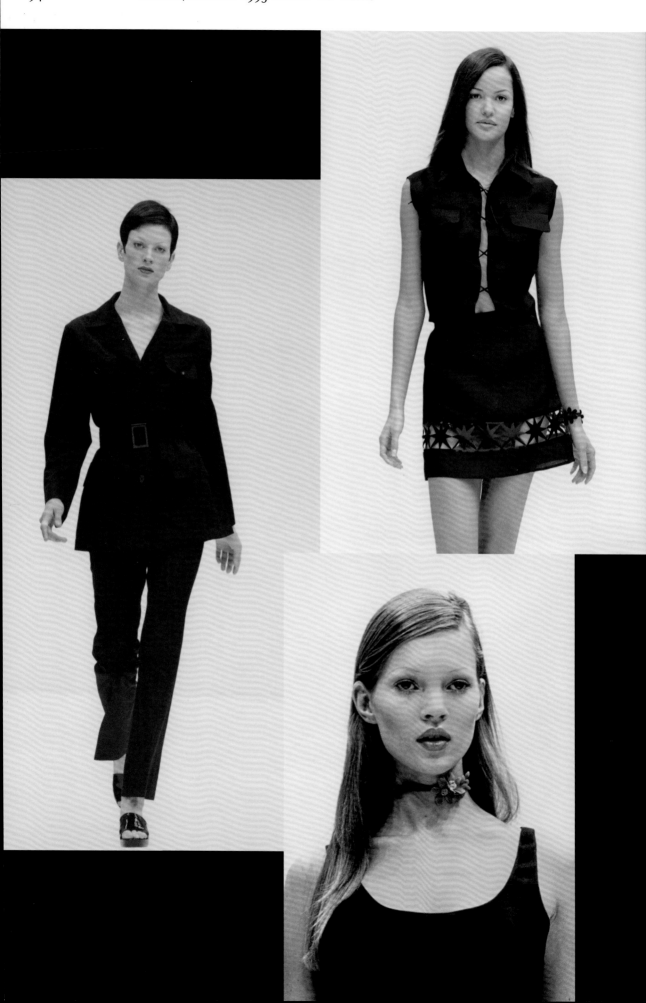

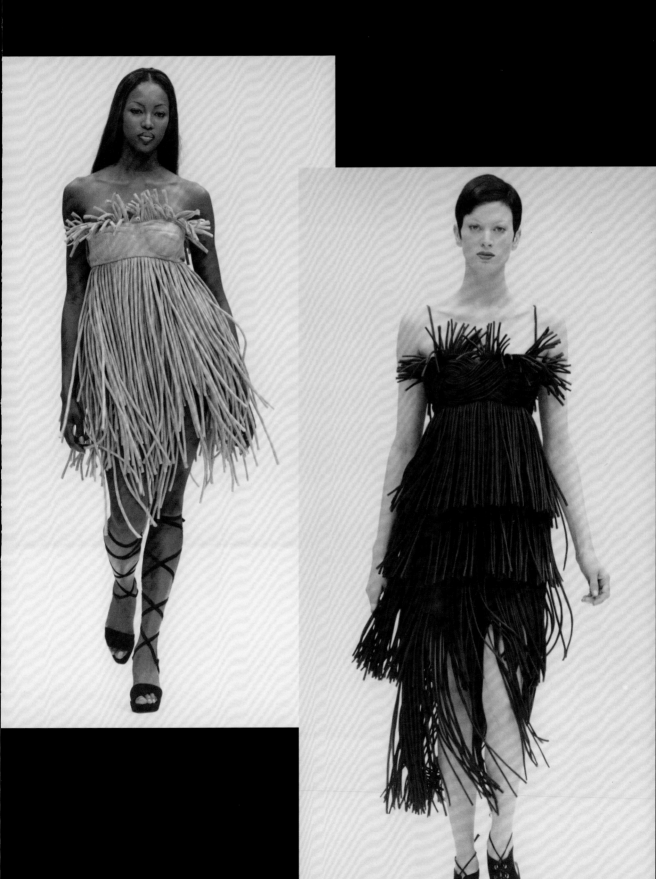

'One editor here called Prada "haute hobo",' wrote
Amy Spindler in the *New York Times* in March 1993.
'It's difficult to say whether that was a compliment
or an insult.' Italian designers' love affair with the
Seventies appeared to be ongoing. Miuccia Prada,
as has already been seen (pp. 80, 88), had a more
refined understanding of the decade than most.

If the hobo part of the conversation was debatable,
no one would deny that this collection was haute.
'It was as if Robin Hood and Maid Marian had mixed
their wardrobes,' *Women's Wear Daily* reported. If that
sounds flip, such an effortless fusion of the masculine
and feminine is far from easy. That the languid line
of the Seventies is indebted to medieval dress is well
known, harking back to a time when women were
unlikely to roll their sleeves up and earn their own
living but were certainly respected, even idolized, by
men. Here, crushed velvet jackets were worn under
the softest suede coats, grey wool tailoring was
trimmed with green velvet, leather was crocheted
into supple patchwork vests layered over skinny
knits, romantic silk blouses were topped with
leather bustiers and velvet knickerbockers were
tucked into knee-high boots.

Opinions regarding the merits of Prada ready-to-
wear remained divided. True, everyone loved the
accessories and the nylon bags especially. There was
a subtlety, depth and slight perversity to the clothes,
however, which meant they were an acquired taste –
too strange for classicists and too classical for the
left field.

'I try to express the contemporary woman and I do
it through fashion because that is my instrument,'
Miuccia Prada said in the *Independent*. 'I'm used
to criticism and think it is mainly a good thing.
Especially at the beginning, conservative people were
very disturbed because Prada looked conservative but
was obviously not, and for avant-garde people it was
never avant-garde enough.' In the end, the designer
had every reason to be happy with the somewhat
disorienting nature of that.

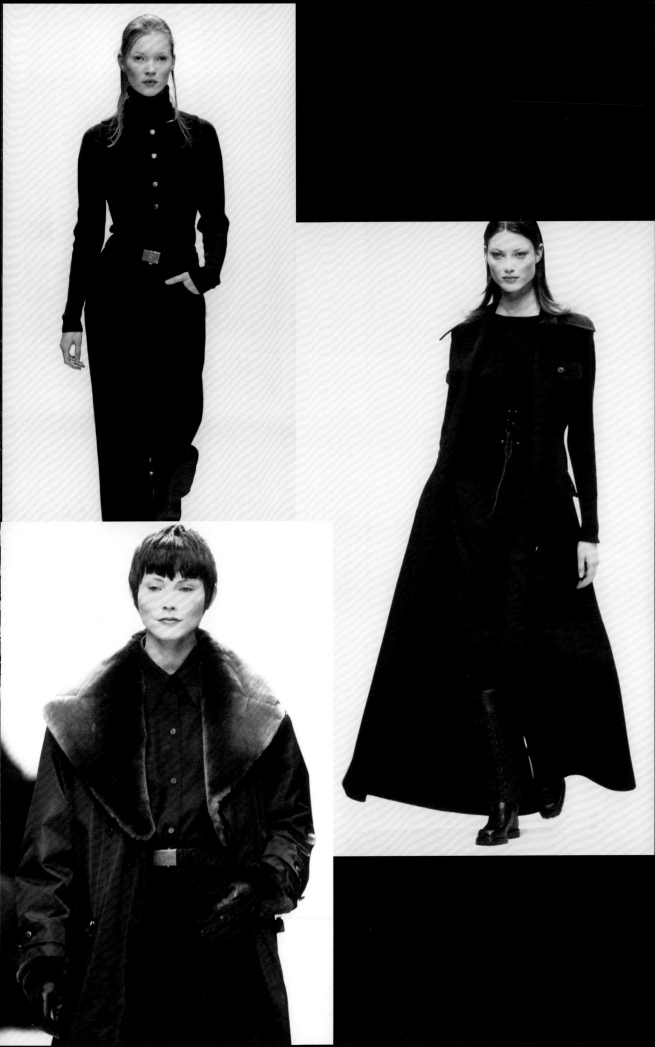

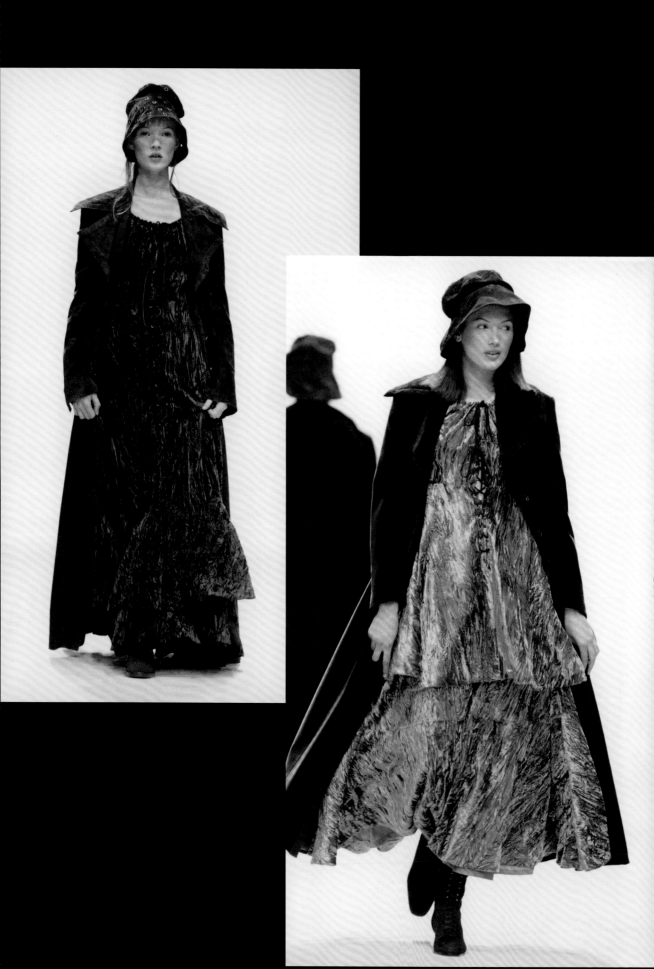

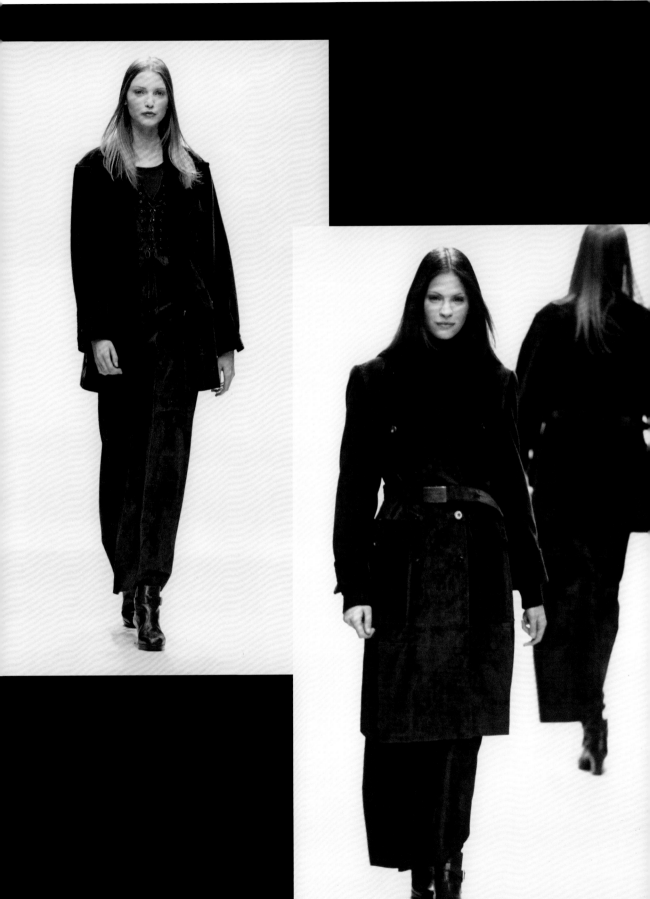

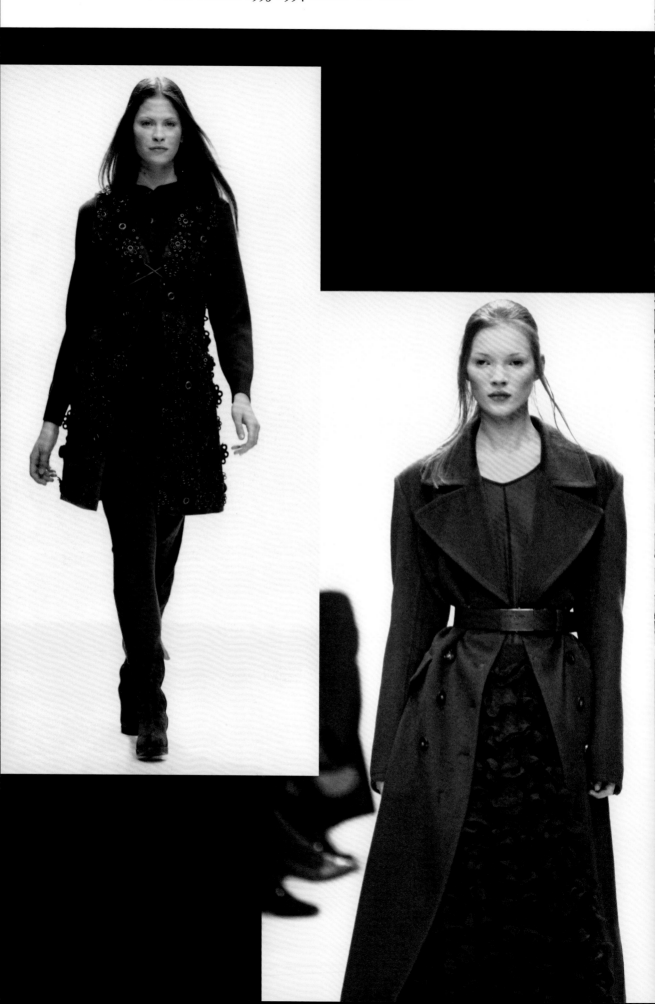

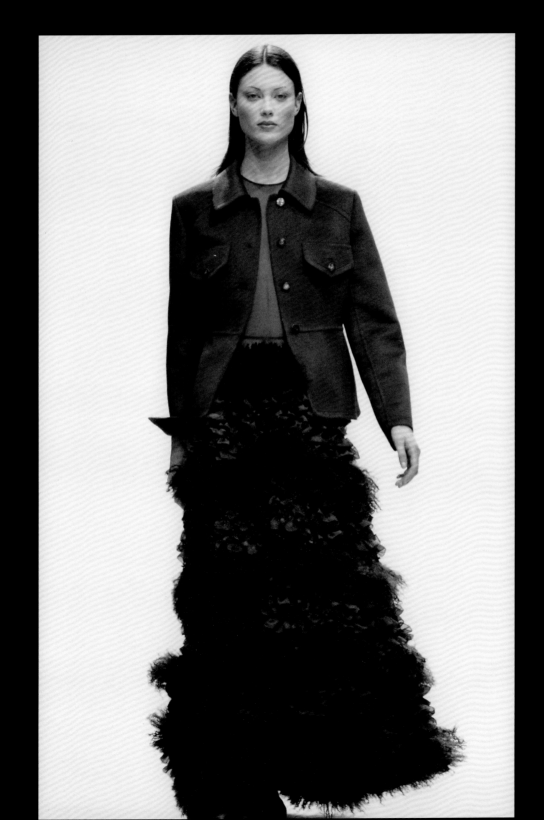

Talking to *Women's Wear Daily*, Miuccia Prada herself described this collection as a combination of 'the lady and the Chinese valet' or 'the tennis player and the nurse', unifying the whole with the phrase 'elegant ambiguity'. That could be a moniker for her aesthetic as a whole. Here, what looked like a playful young girl in clothes pilfered from both her mother's and father's wardrobes, strode out, once again, in masculine shoes or Mary Janes, here worn with over-the-knee, knee-high or ankle socks.

The woman in question thought nothing of slipping on a sheer chiffon shift with her underwear showing clearly beneath it or a tunic so brief it barely grazed the thigh. Cage and crinoline detailing nodded to Victoriana but with none of the heaviness, submission or restriction that reference might imply. More masculine pieces included military overcoats, jackets and knits (a turtle-neck, cropped sweater and hot pants), oversized bright white tailoring which appeared to suggest an almost forensic lack of embellishment, and more in navy openly riffing on Mao (see p. 106, left).

Prada was now among the most influential names on the Milan schedule, still small as a business in comparison to more established Italian names, but widely copied nonetheless as minimalism increased its hold. Clothing which was plain to the point of being anti-fashion and which started life on this runway was now being referenced across the board. So, what next?

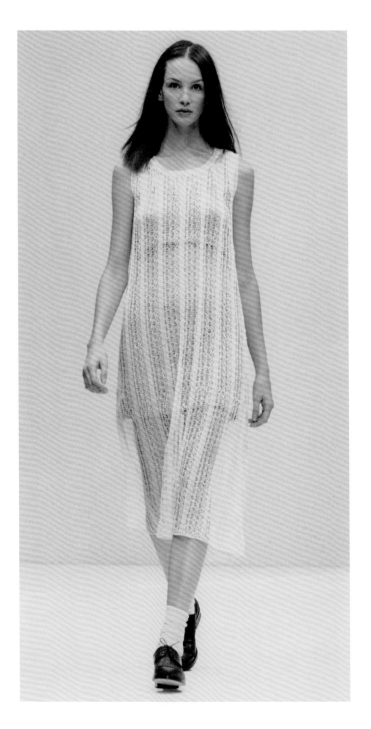

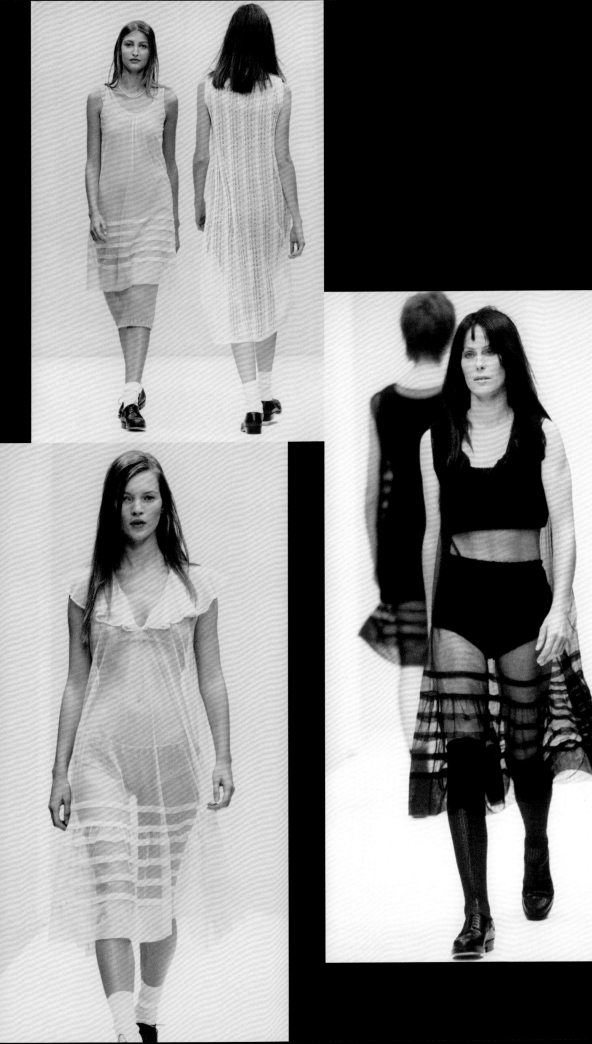

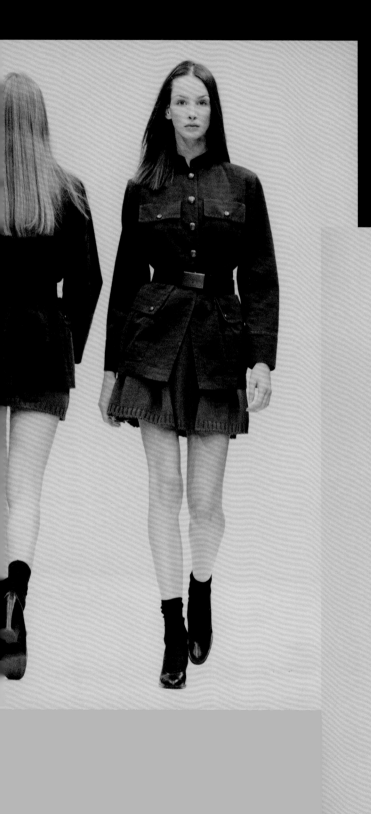

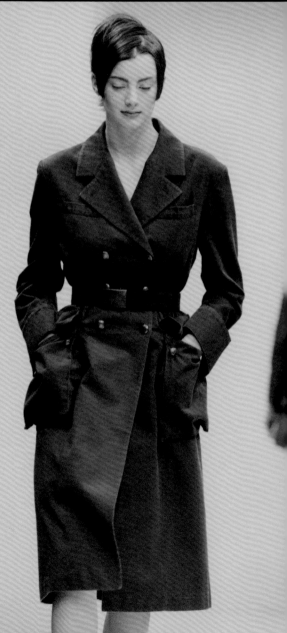

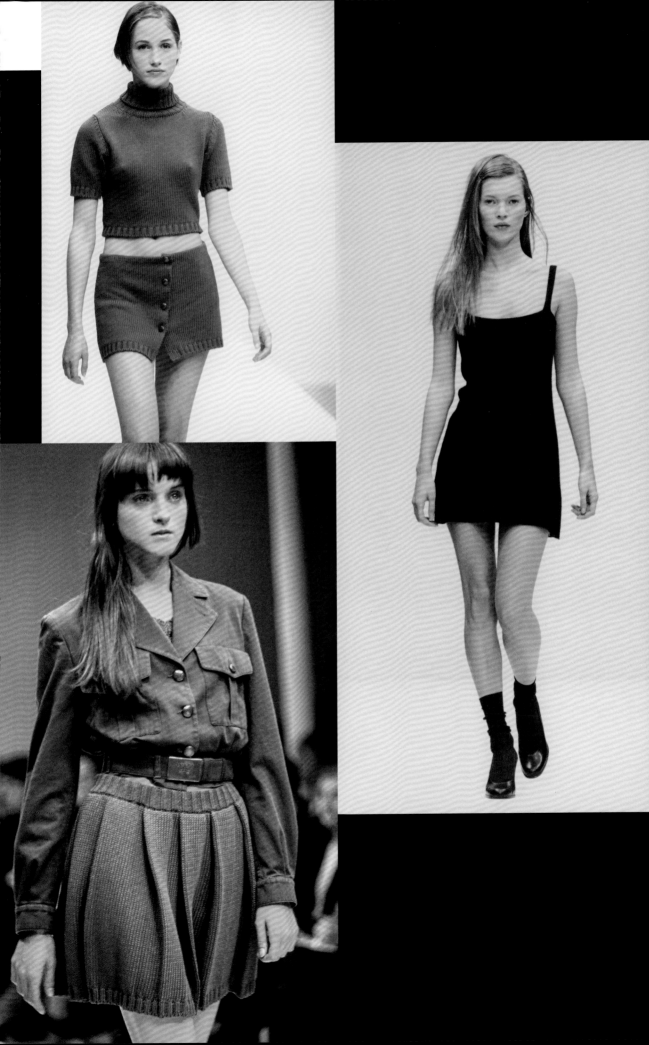

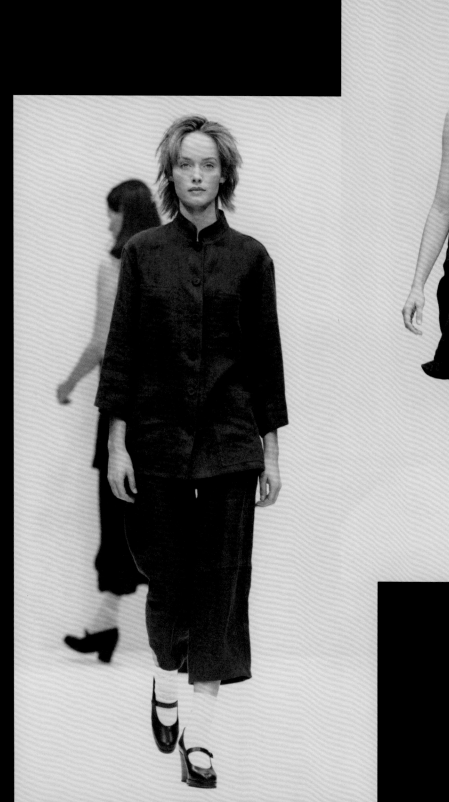
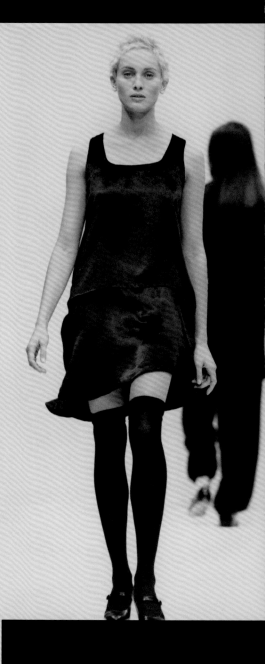

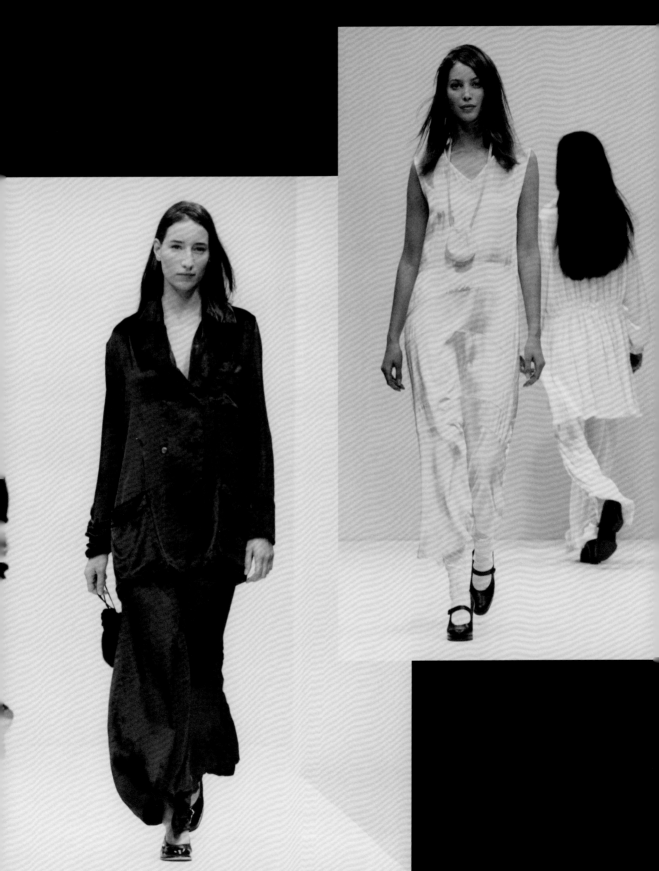

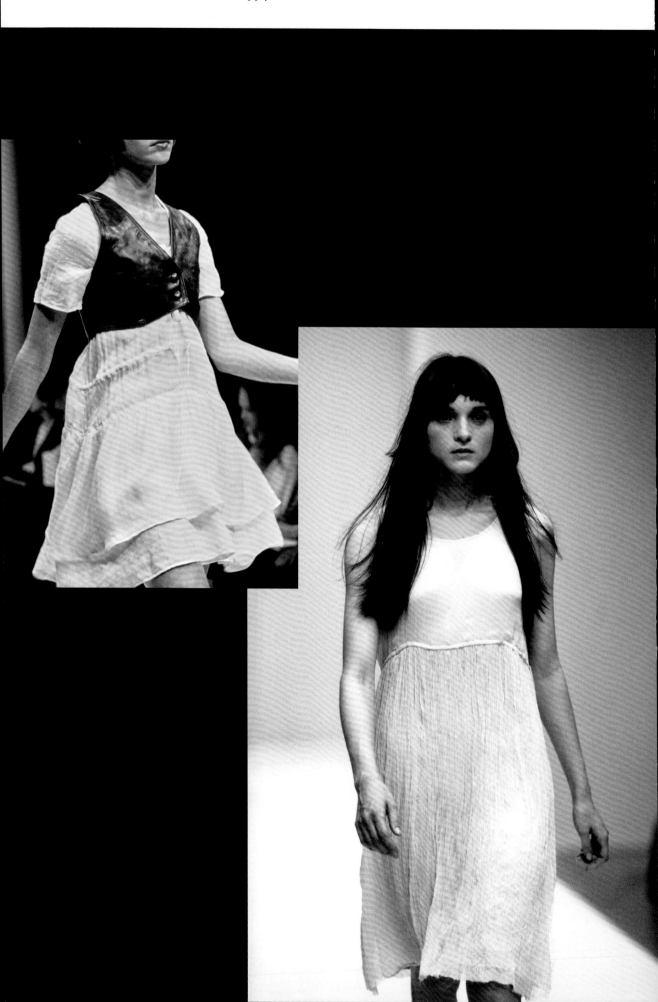

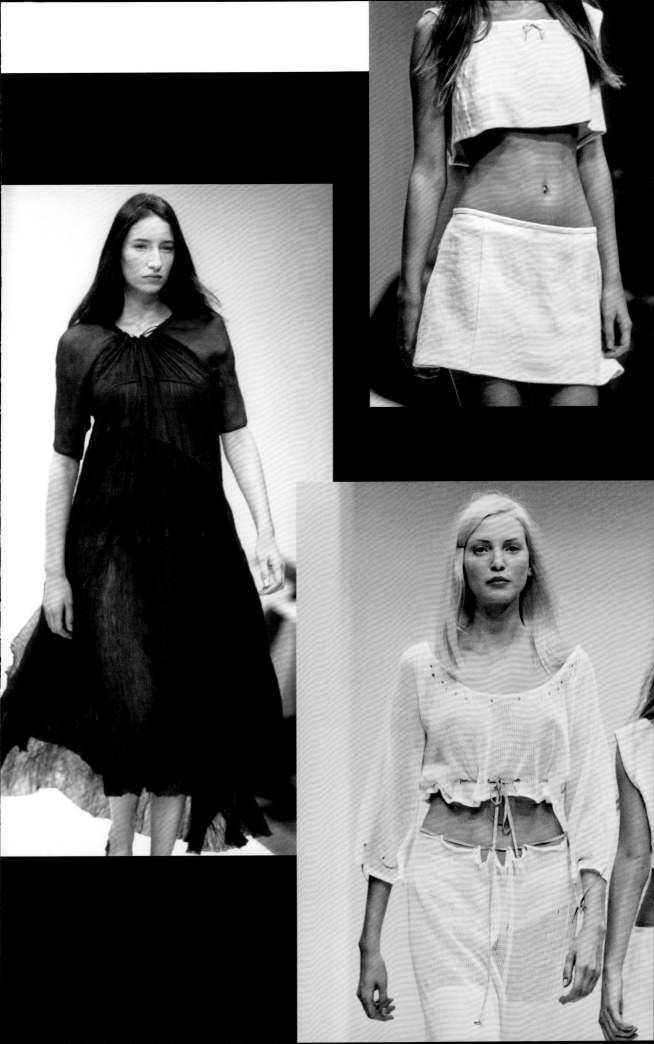

For pragmatic reasons, Prada chose not only to show in Milan, but also to take her collection to New York around a month later this season. It made sound business sense: she was focusing on expansion into the US market. The fact that the septuagenarian New York social arbiter C. Z. Guest modelled in the show (p. 112, left), staged at Bryant Park, also indicated the ever-increasing power of the label.

Prada's was far from the fresh-faced minimalism normally associated with American designers including Claire McCardell and Bonnie Cashin, however, both of whom dressed motivated young women for more mobile lives decades before. Instead, according to the show notes, these clothes mined wartime Germany for inspiration and 'the atmosphere of German cabaret during the war', and were therefore firmly rooted in Europe. It was quite a statement. With slicked-back ponytails and a strong, red lip, models wore clothes that upheld military references including zip-fronted knee-high boots, a high neat shoulder, a monochromatic palette and embellishment as strictly controlled as the silhouette.

As, some time later, the collection began to make its way from the runway to the stores, Prada was credited with introducing a new 'librarian' skirt length, one that hovered around the knee. 'To the fashion pros, the on-the-knee hemline is the Prada length,' wrote Suzy Menkes in the *International Herald Tribune* in September this year. 'Miuccia Prada, the founder of the Milanese fashion house, has pioneered the median way... "I started doing it for me," Prada said... Significantly,' Menkes continued, 'Ms Prada described the knee-length skirts as modest, suggesting a retreat from the overt sexiness of the permissive society that the mini was taken to symbolize in the Swinging Sixties.' A knee-length skirt, either pencil-thin, straight or more A-line, was indeed broadly associated with Prada more than any other designer from this point forward.

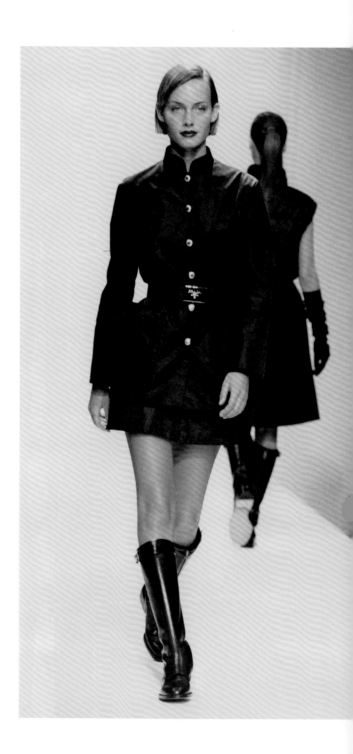

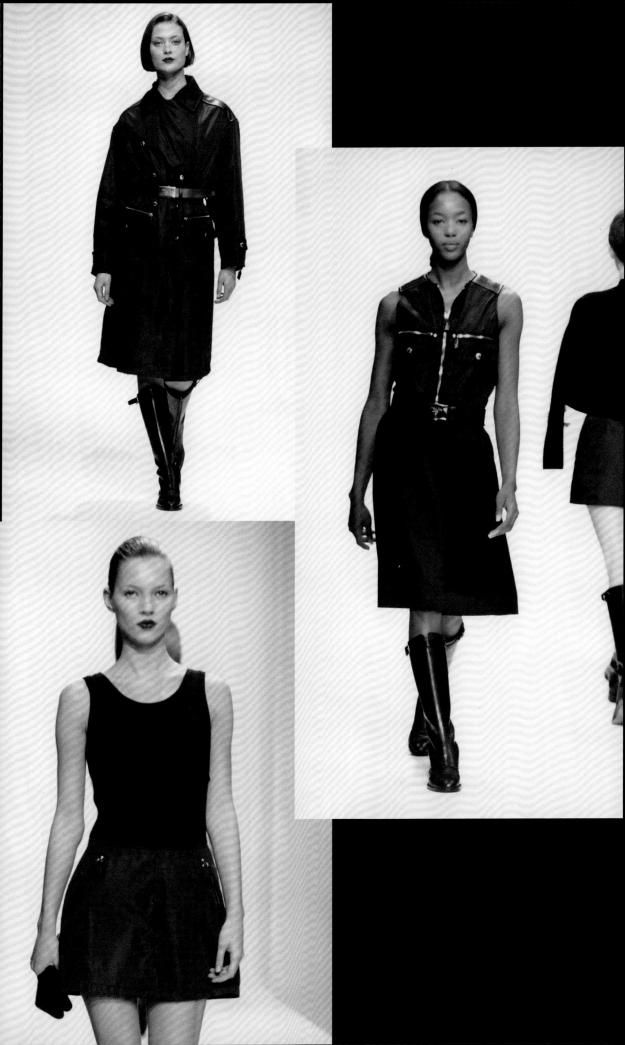

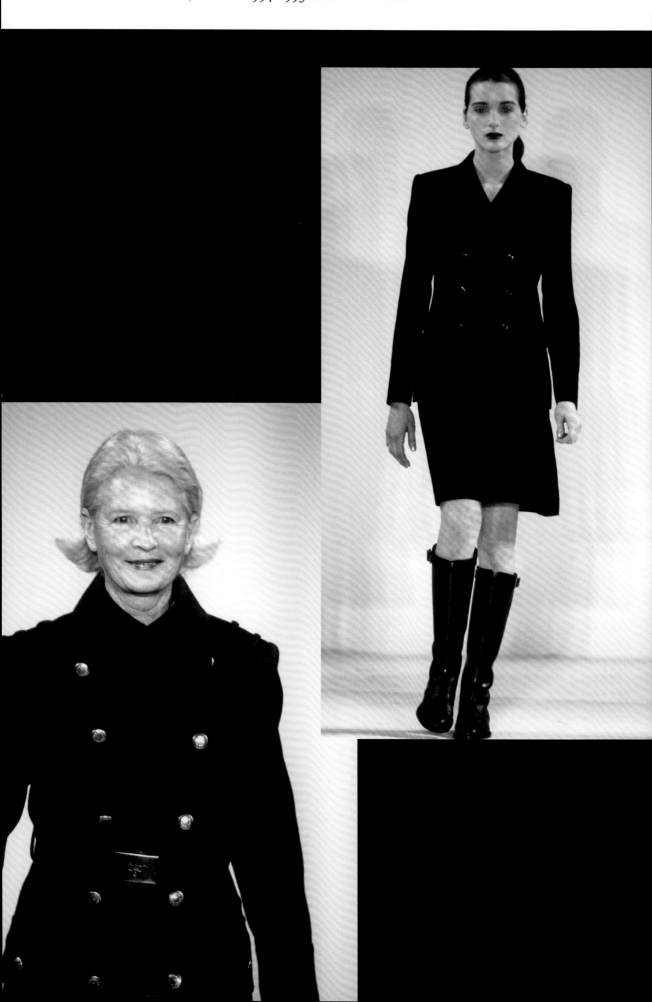

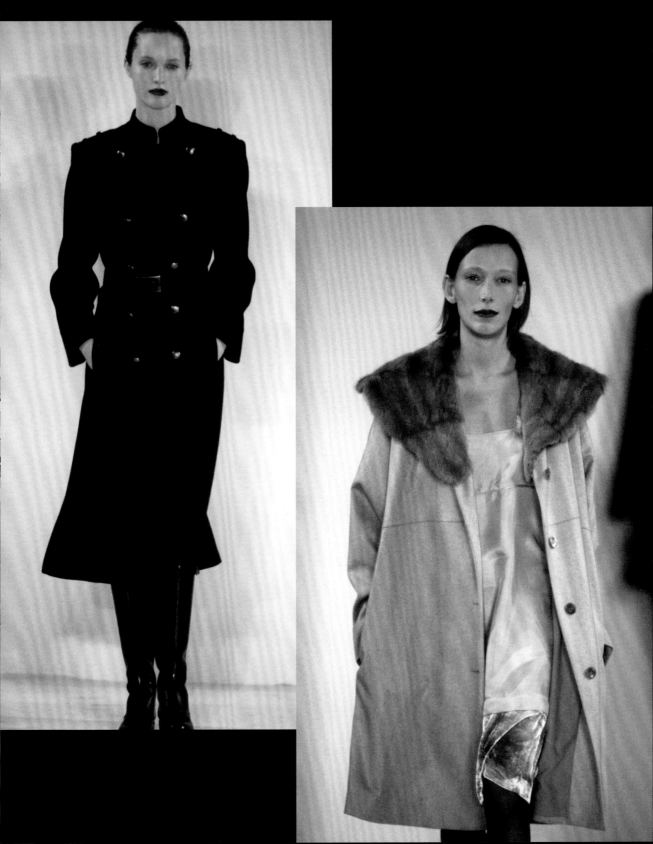

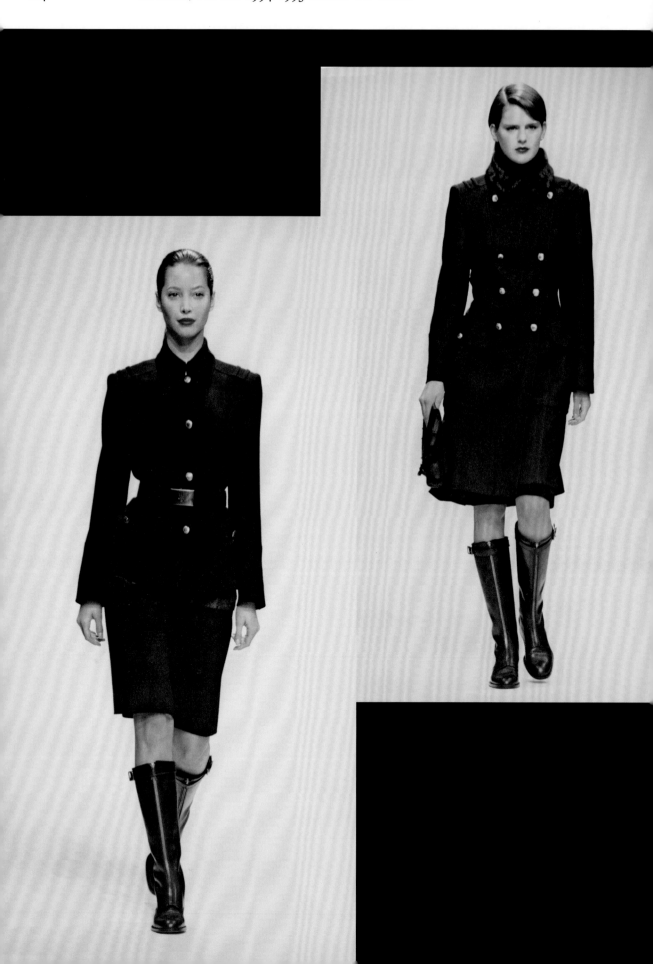

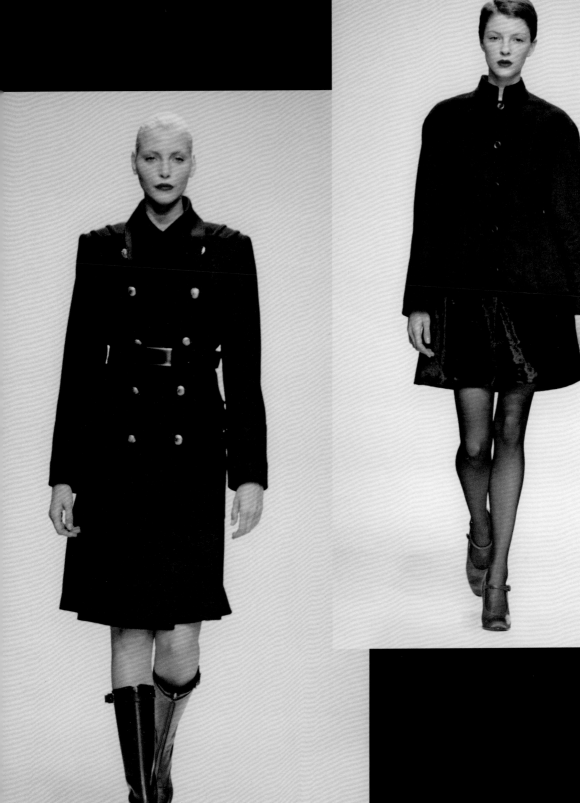
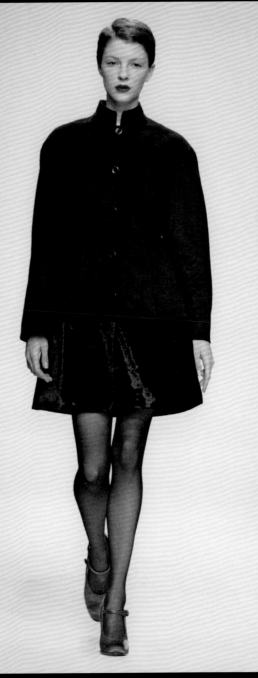

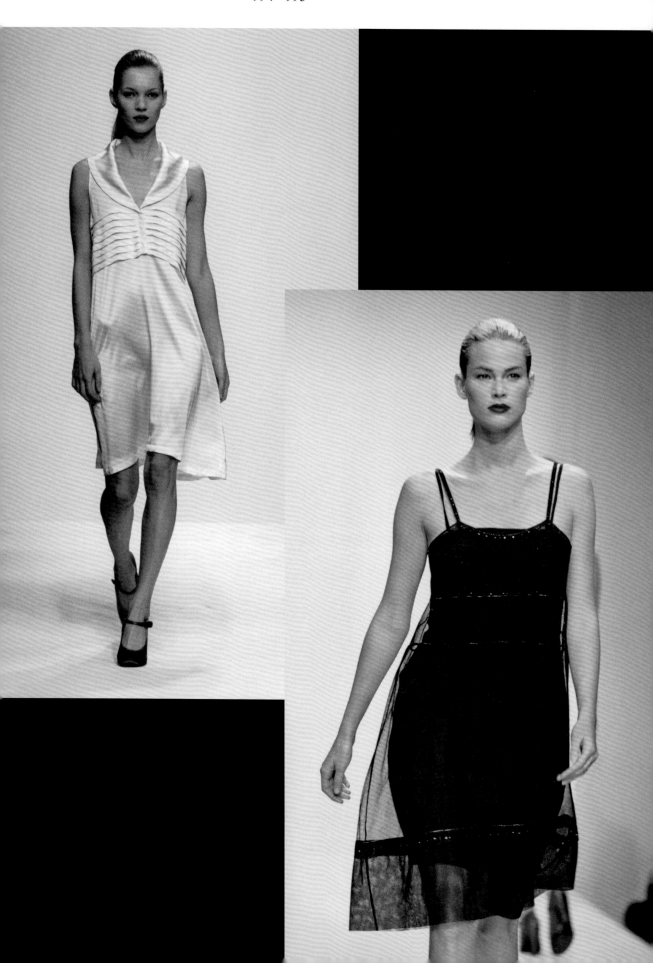

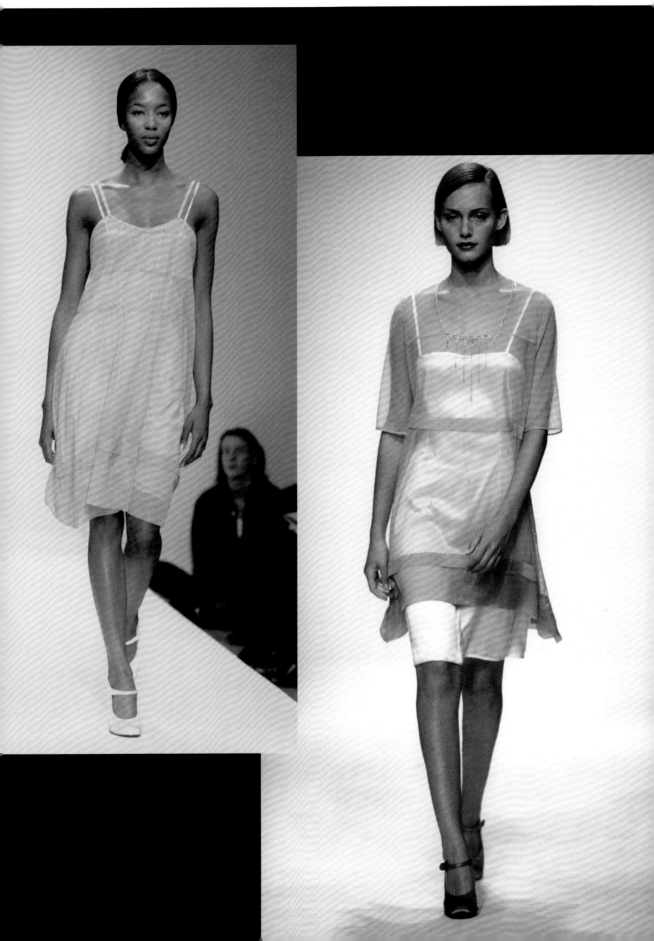

The black nylon parachute fabric that had made Prada famous had already migrated from bags to clothes to a certain extent. However, for Spring/Summer 1995, it came to the fore. The look was sharper and more uncompromisingly industrial than ever before. The show notes described it as 'clinical chic', 'lab white' and 'fashiontherapeutic', not terms readily associated with the frivolity of fashion. For all the rigour, it was not lacking in sex appeal either: 'Marilyn meets Courrèges', was how Prada put it, talking to *Women's Wear Daily* post-show.

For now the designer was fully committed to a knee-length skirt from start to finish (see p. 110). The stiffness of black nylon finished with gleaming silver zips was offset by delicate black, white and palest pink embroidered organza, cut to resemble halterneck Thirties or Fifties vintage finds, worn over big knickers once again or under skinny ribbed knits and gently cinched at the waist with narrow black or white patent leather belts with a flat, matt silver buckle. The belted jacket, sweater, cardigan and shirt is today another well-known Prada motif. Dresses, meanwhile, were as simple as lining slips.

There were subtle moves forward, away from the Mary Jane pumps that were almost as widely copied as the aforementioned bags, towards a wedge-heeled sandal and a clear plastic purse with a second nestling inside (see right). 'The Prada show,' reported *Women's Wear Daily*, 'was dazzling in its restraint. While many designers in Milan rely on fashion hype and fly-by-night trendiness, Miuccia Prada delivers real style.'

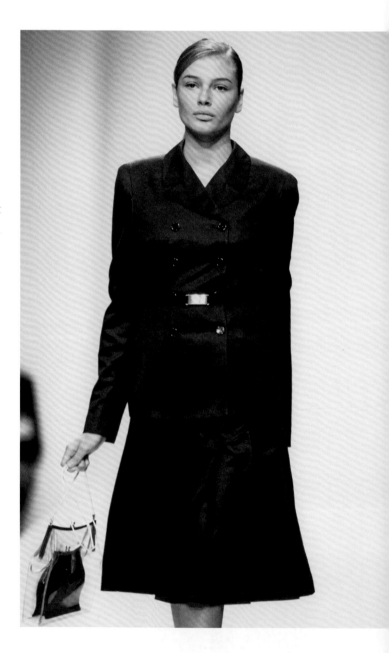

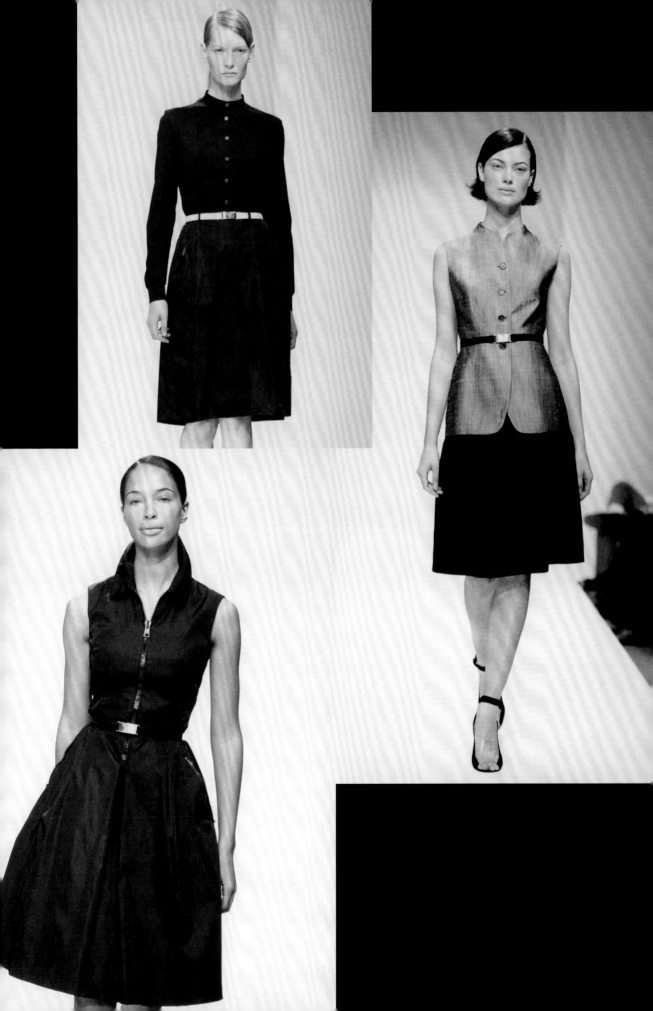

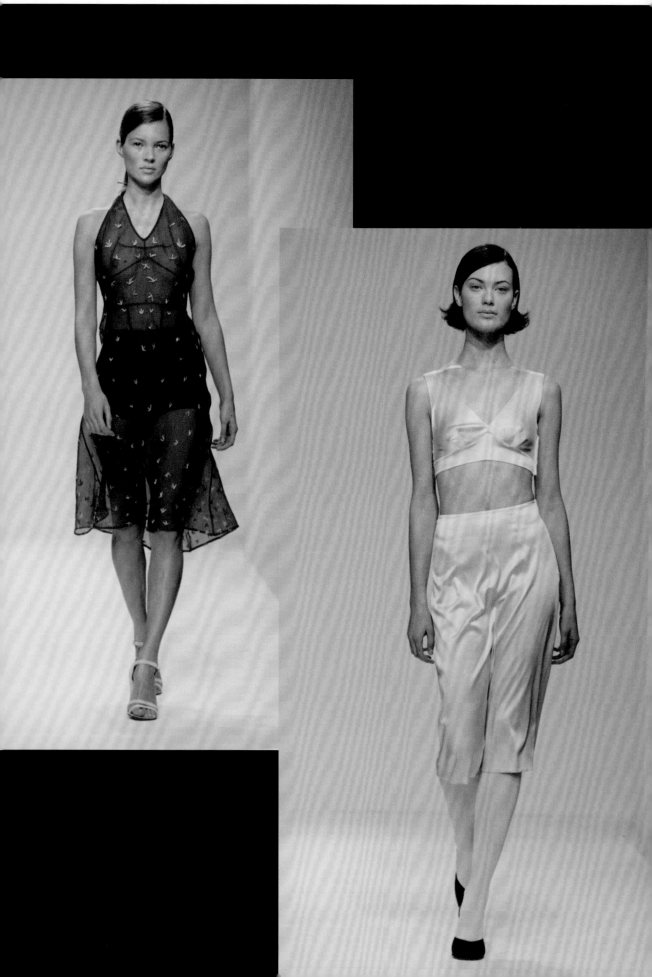

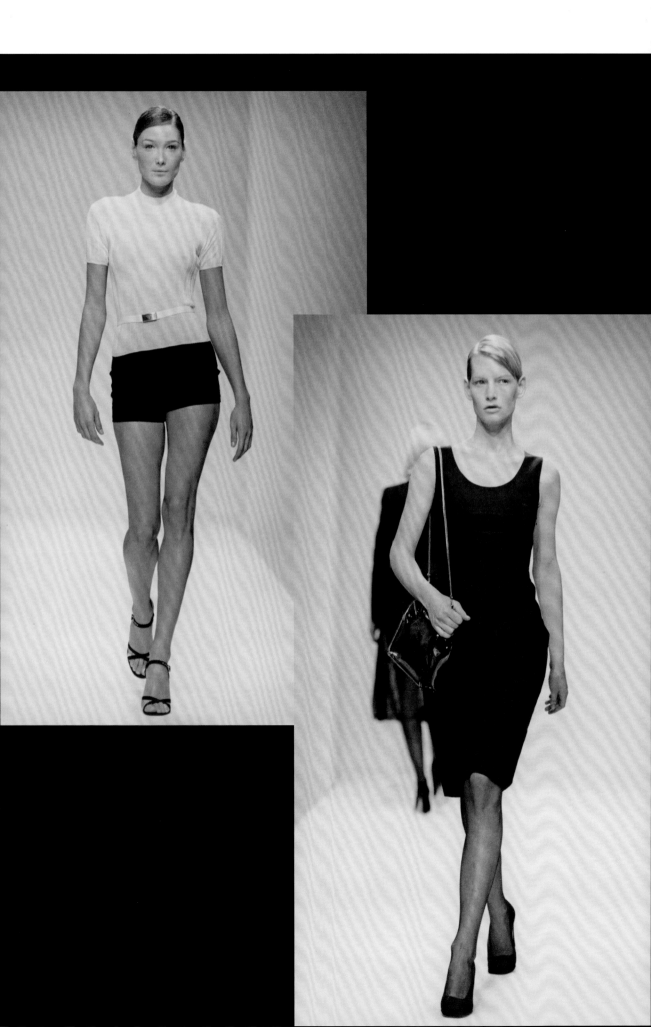

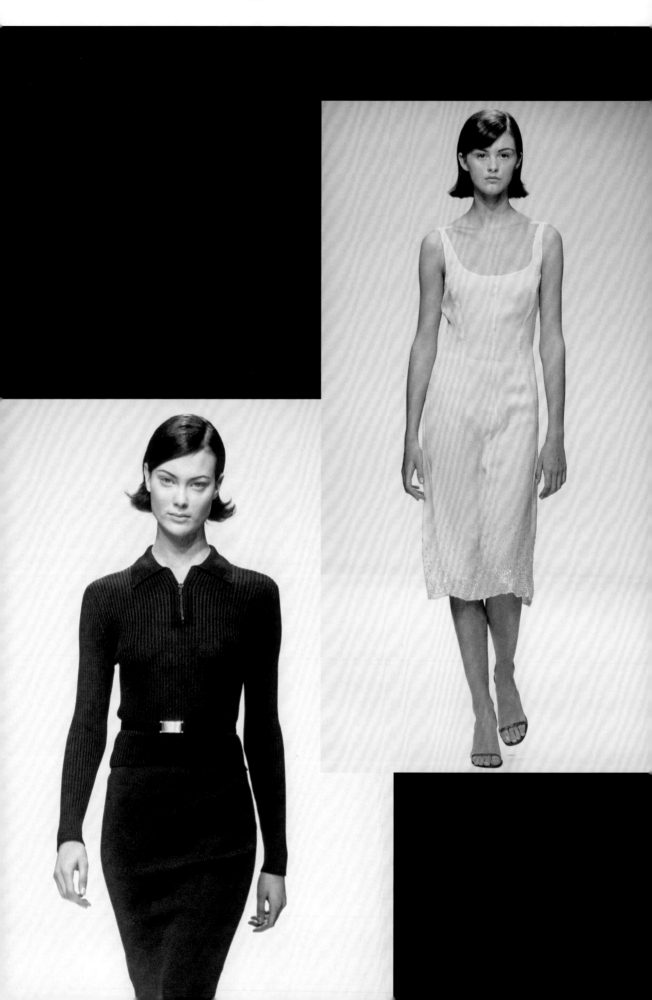

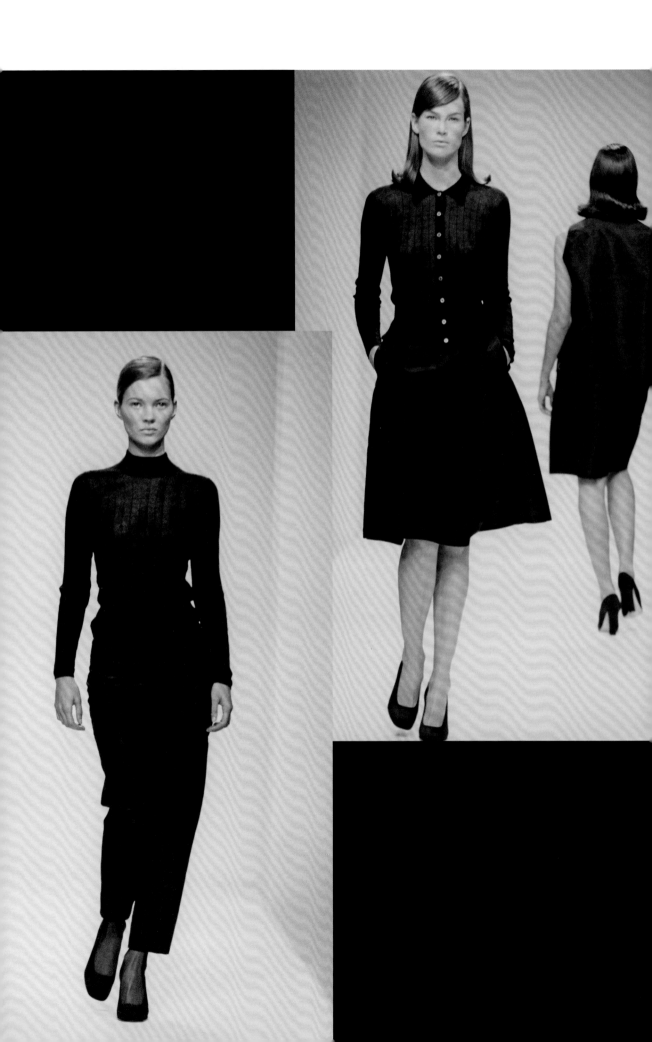

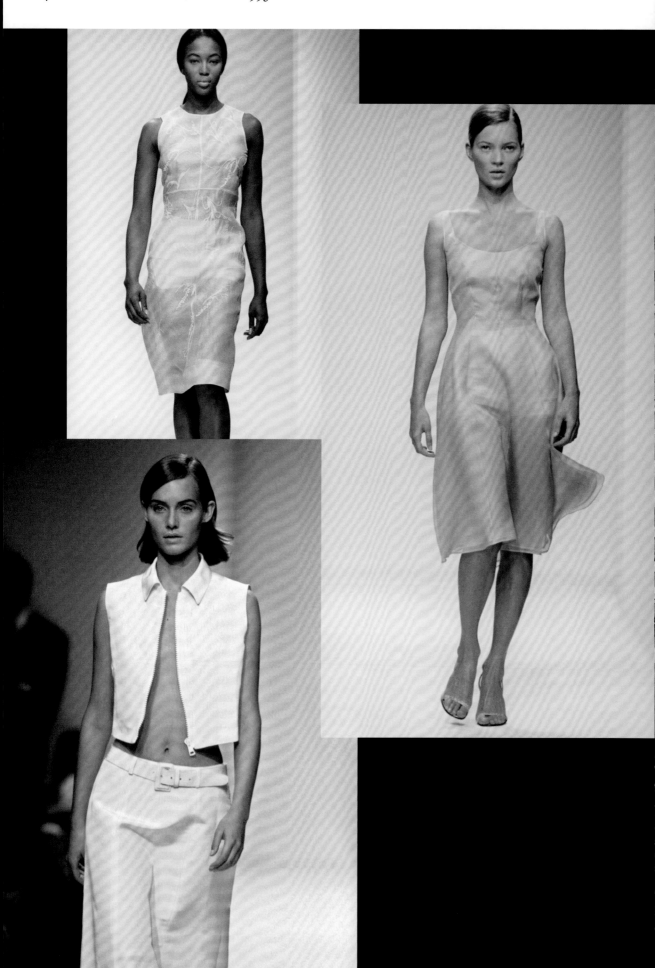

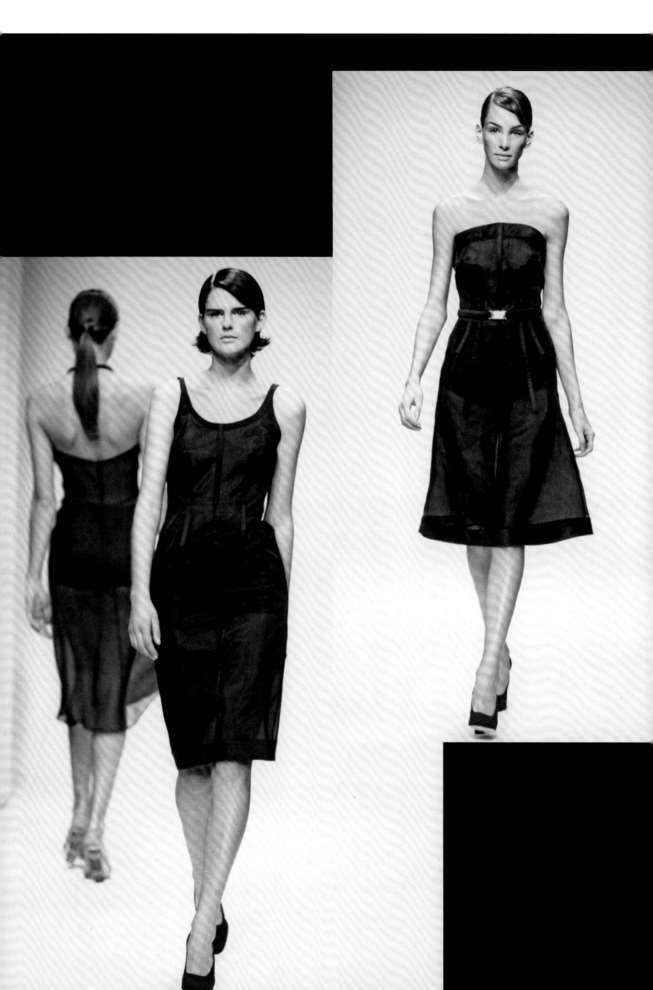

As black nylon began to crop up on other designer runways, Miuccia Prada, with her eye firmly on the future, moved on. There was barely a trace of it for Autumn/Winter 1995–1996. Instead, the designer turned her cool, clear gaze once again towards the past, to a 1950s silhouette and to the sort of feminine cliché that is best worn by the young and free-spirited who, by their very nature, subvert it. In spike-heeled court shoes, with scrubbed clean faces and WASP-ish glossed hair, models may have had the type of pretty pink rosebuds reminiscent of the baby girl's nursery printed across their duster coats, prom dresses and pajama suits (see p. 131) but they seemed more likely to be looking for trouble than a glass of warm milk.

'If you're not careful with these clothes, you can look dowdy and a little broad around the beam,' noted *Women's Wear Daily*, a warning that has been issued to Prada devotees almost from the start. As her career progressed, the designer made no secret of the fact that she wasn't even remotely interested in making clothes simply to flatter, however. That was boring.

'Much of Milan fashion, but especially Prada, looked like updated versions of Monica Vitti's wardrobe in Michelangelo Antonioni's movies,' wrote Amy Spindler in the *New York Times*. Courrèges' architectural approach to fashion, according to this journalist, was an influence again also. 'Courrèges fits well with Ms Prada's obsession with architecture, which first drew her to the sculptural nylon. Now, she has worked that sculpturing into other fabrics, even cashmere, which was double-faced for simple sleeveless dresses that looked as if they were made of billiard table felt [opposite, left].'

The show notes decreed: 'Gloria Vanderbilt seated in a Joe Colombo chair. Philip Johnson. A 1966 table lamp by Gae Aulenti. Fuller's geodesic dome, 1967.' And, Spindler concluded, 'As much as those references can be realized in fabric, she succeeded.'

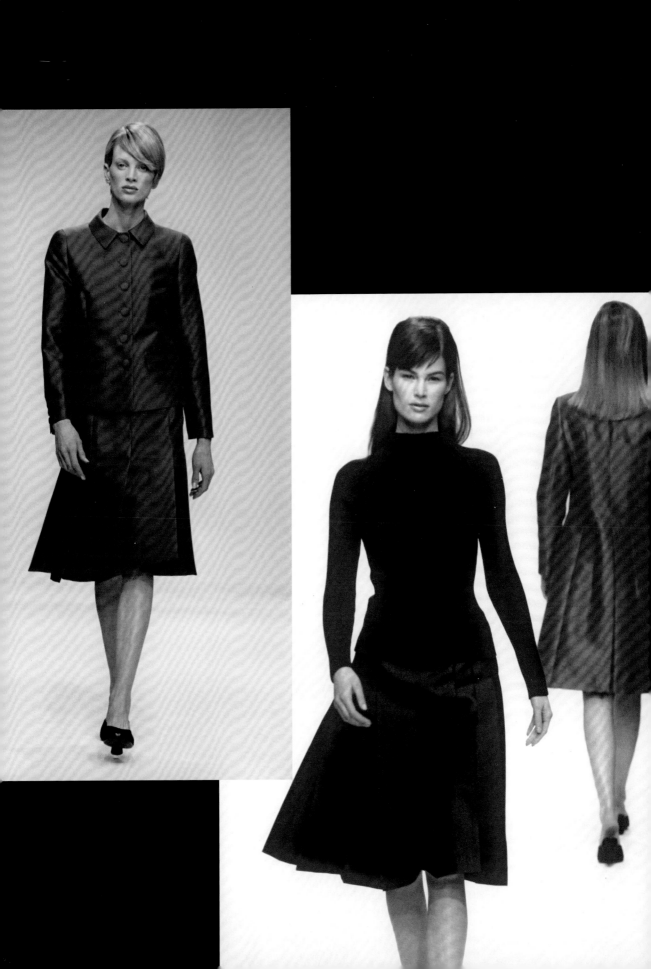

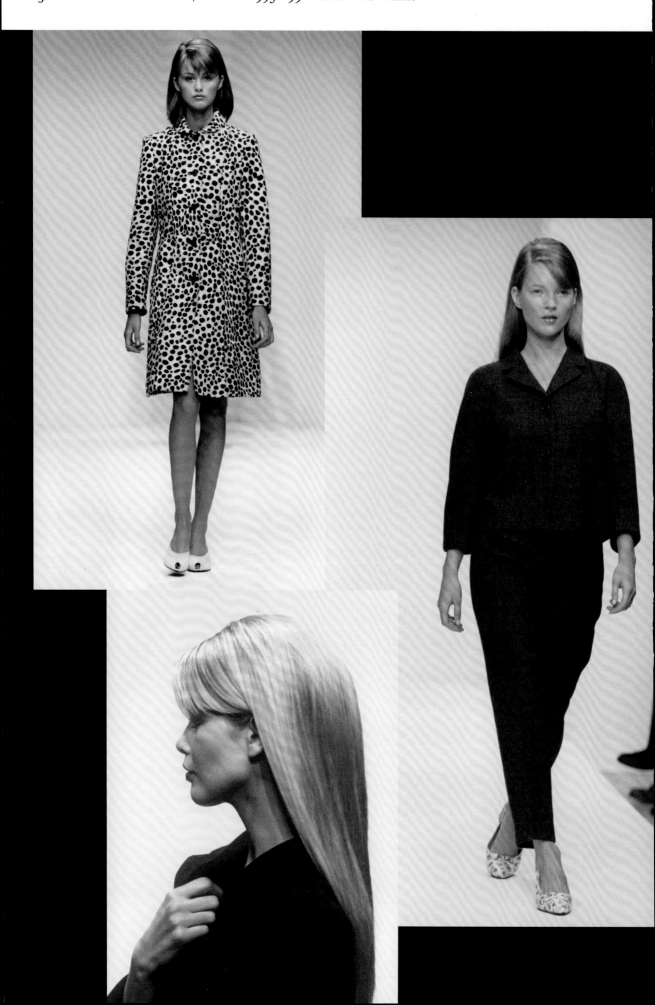

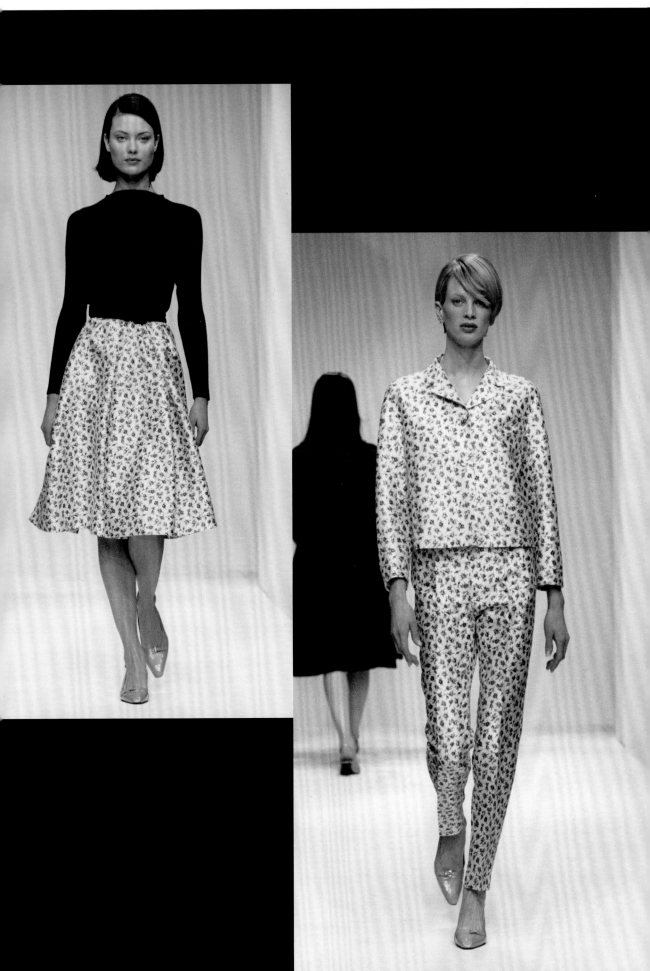

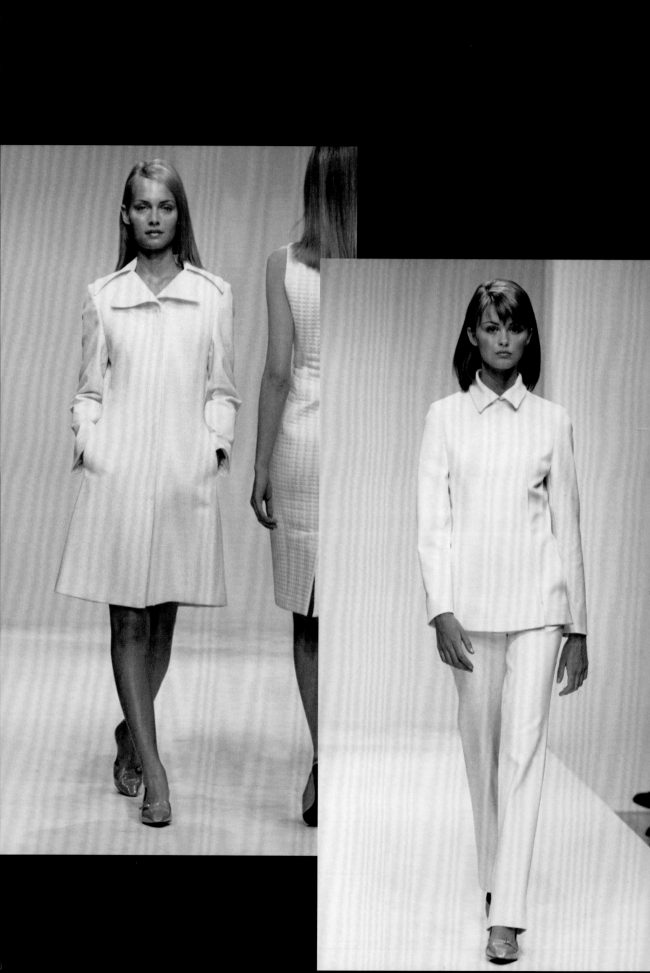

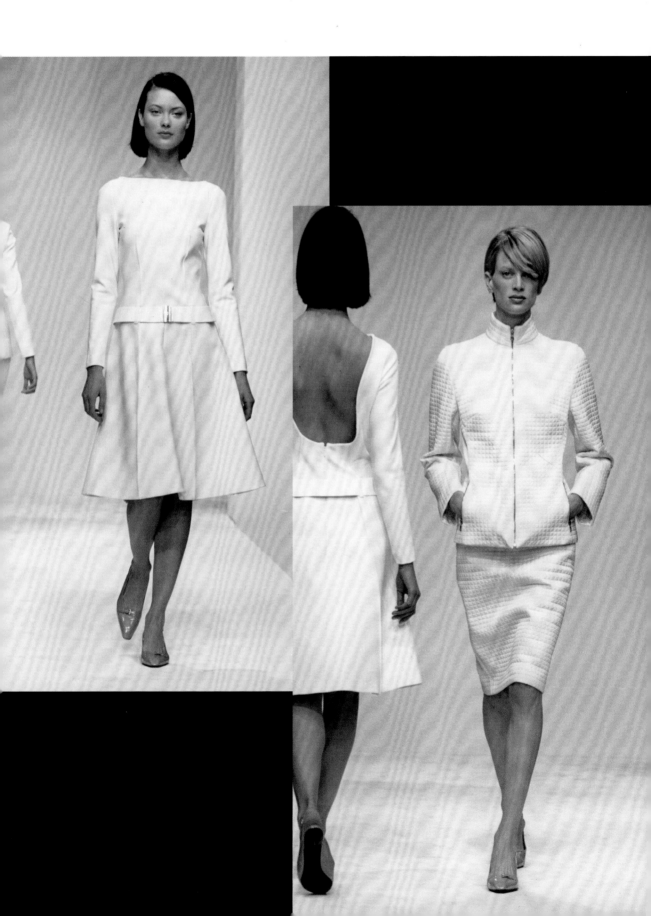

Fashion criticism – in fact, all criticism – thrives on contrast; defining one thing is easier when it is seen in opposition to another. Over the past decade, Italian fashion had been dominated by Armani's relaxed take on tailoring and all that was greige, and by Versace's high-octane, baroque form of glamour. Now Prada was the most studied and imitated designer label in Italy, if not the world, but Tom Ford's Gucci had also broken through and it was the turn of these two names to be played off against each other. The thinking at the time was that Prada was intellectual, Gucci sexual. Obviously, that was reductive. Whether she was aware of – or cared about – any of this, Miuccia Prada ramped things up a level.

It took quite some nerve for the designer to state that her inspiration for this collection was banality or, more specifically and printed in the show notes, when 'banal design was elevated to "Banal Art" in a show at the Venice Biennale in 1980'. This translated as geometric prints on stiffened materials in studiously jarring and far from obviously enticing shades: mustard yellow, purple, rust and flat brown. The silhouette was as simple as ever: button-down jackets, shirts and shirt-dresses done up to the throat, fine gauge V-neck knits, straight knee-length skirts and equally straight-laced trousers. There were shades of the Seventies to the colour spectrum and of Fifties American diners, too – the prints were swiftly dubbed 'Formica'. Shoes were heavy, in equally off hues to match.

As is so often the case with the shock of the new, this latest offering was branded 'ugly' or 'ugly chic'. In 2015, in an interview in *Document* magazine, the designer said: 'They thought it was in horrible taste – the famous show about "Ugly Chic", which I think is a terrible phrase, but that's how it came out. In fashion, what was well-developed in literature, in movies, in art, was considered badness. Still now, I think that a part – the more conservative part – of the fashion world thinks that they'll stick with the idea of glamour and beauty that is so obvious, so old. Even now, it's not so different.'

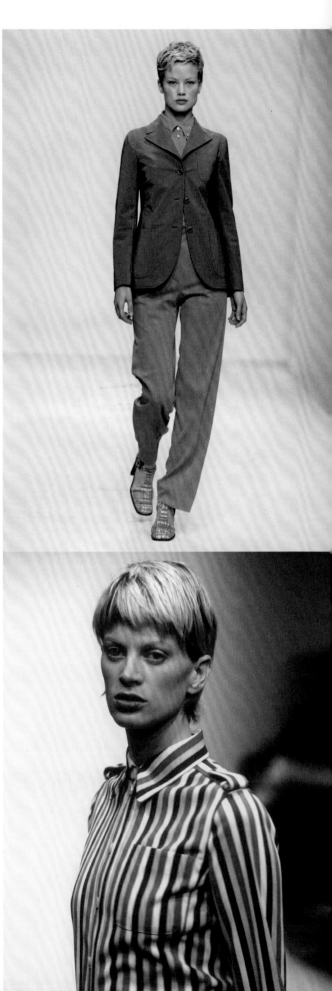

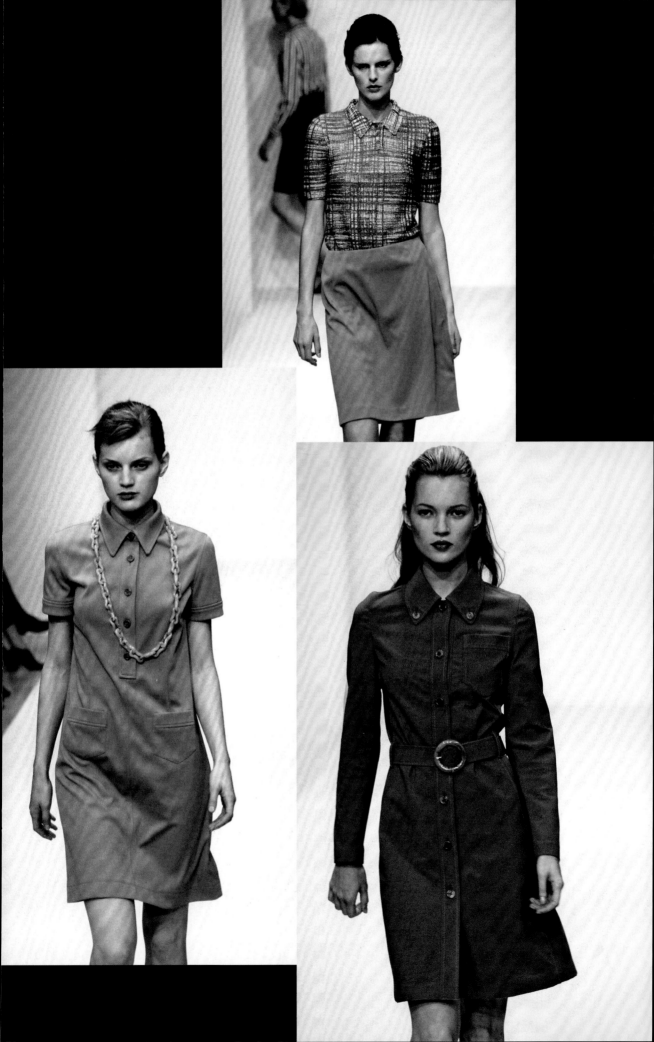

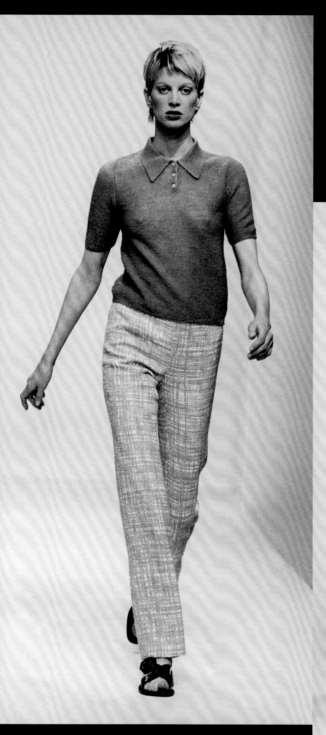

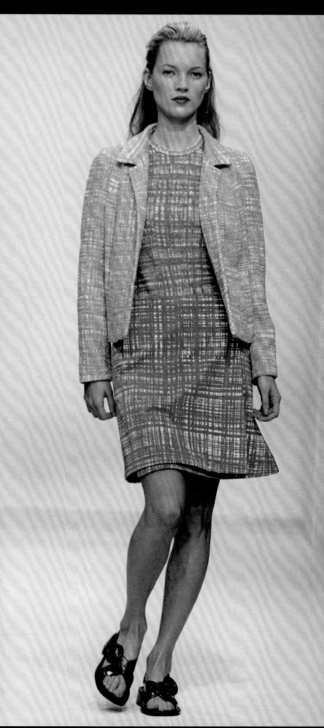

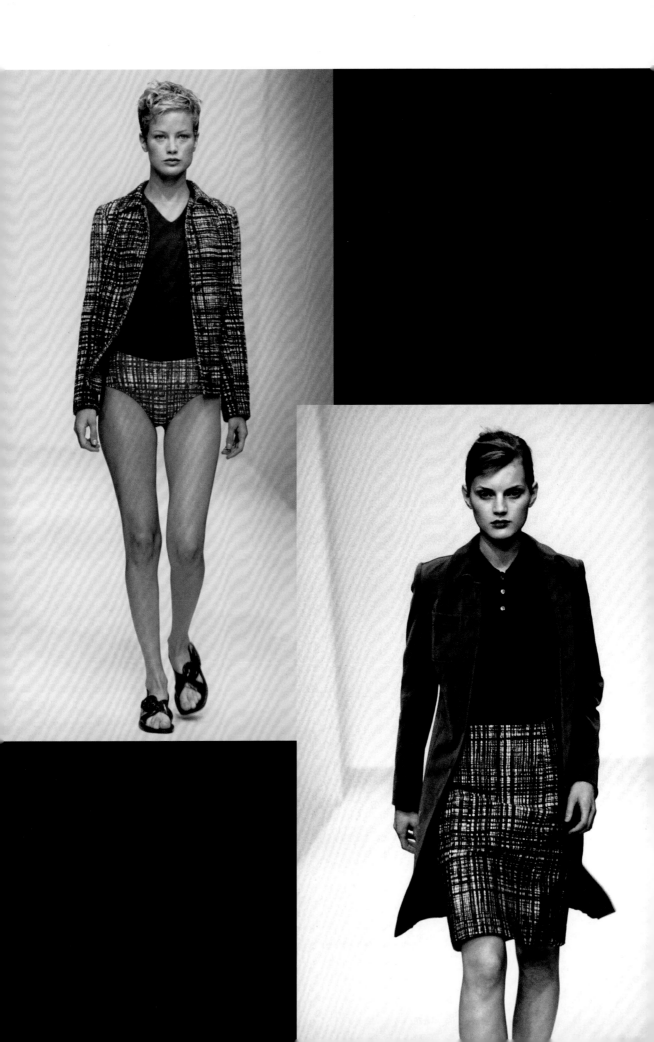

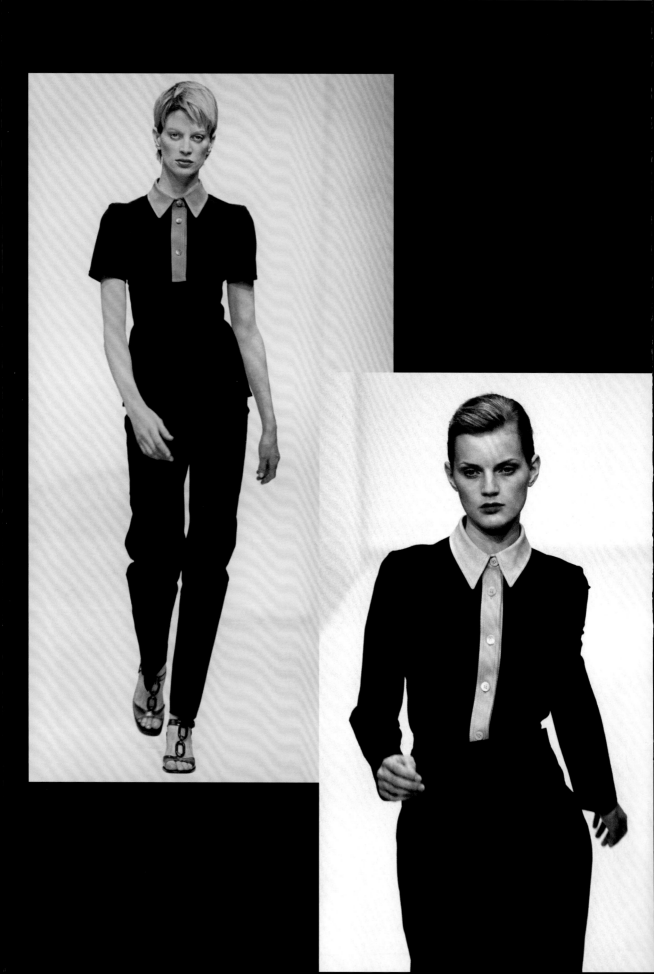

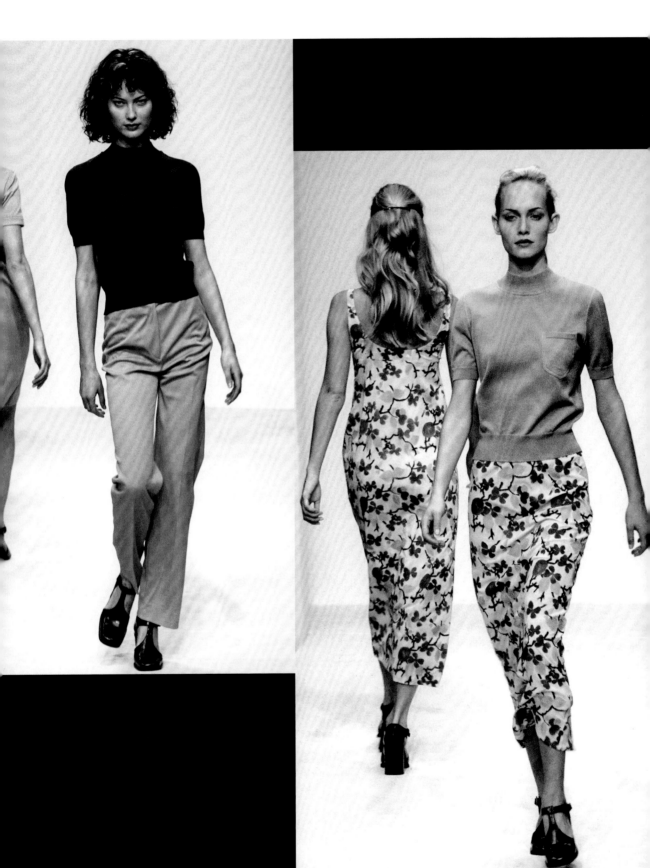

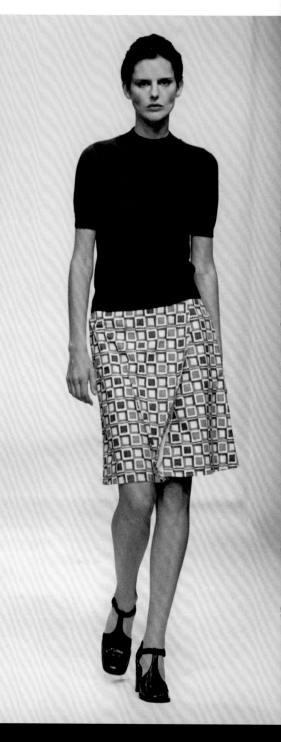

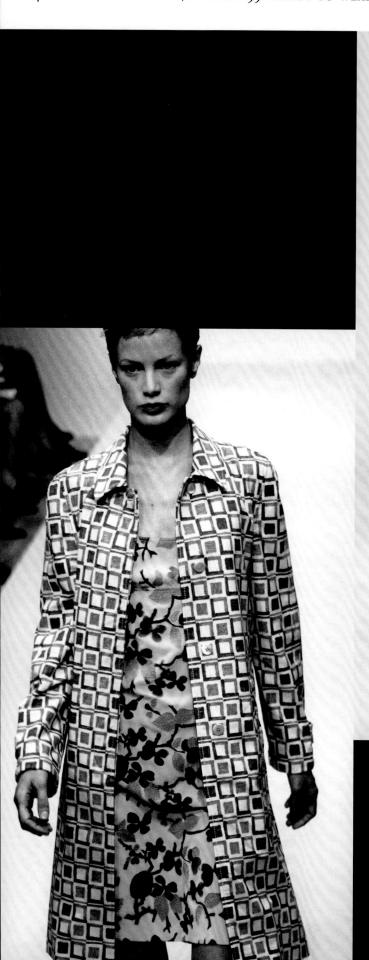

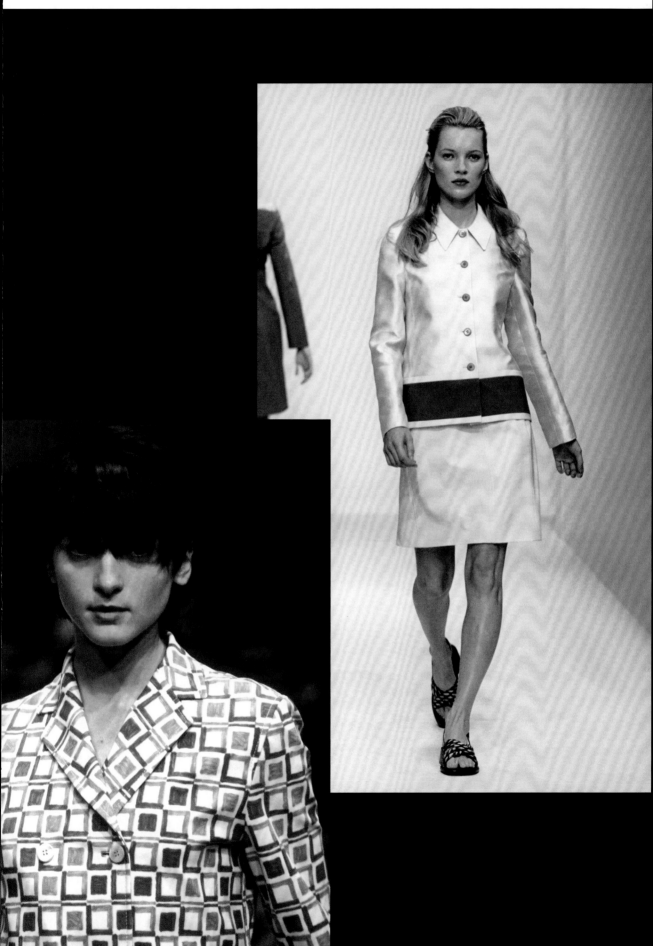

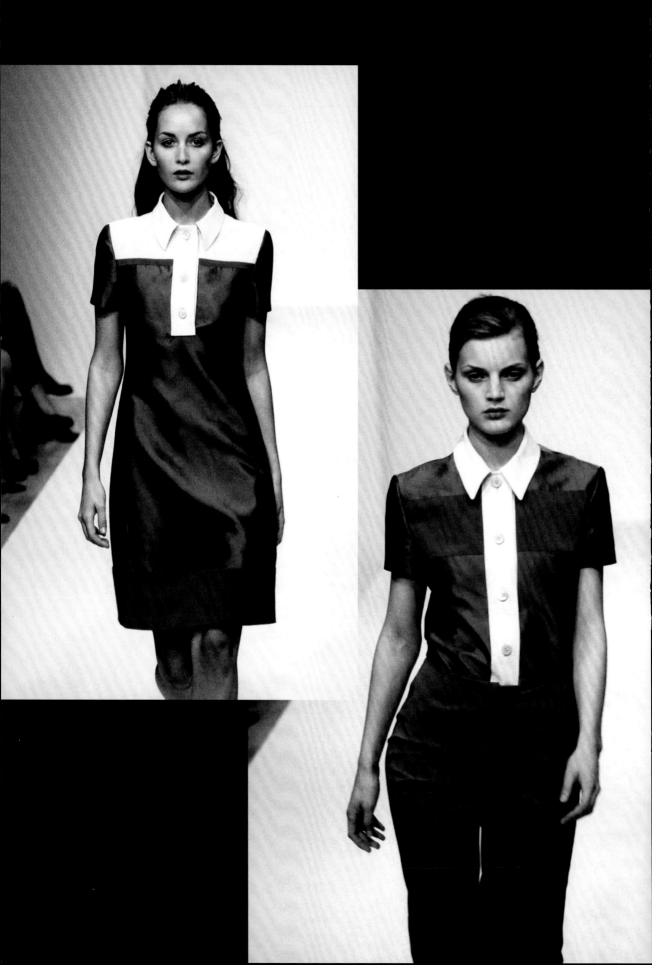

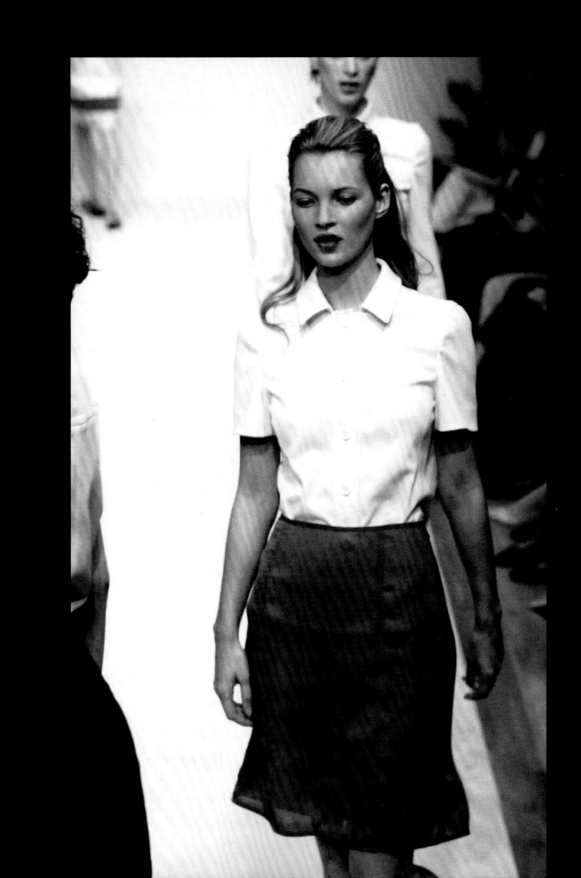

'Borders and lines are very important – they are
the things that interest me the most, because they are
defining volumes,' Miuccia Prada said in the *New York
Times* this season, which, with more naïve prints and
a less stiffened but still pared-back silhouette, edged
and punctuated with said borders and lines, was
ultimately an extension of the last (p. 134).

'For the outsider – who has not yet seen Ms Prada's
oddly pleasant hues, her Boy Scout suits, her
geometric prints – it is good to have a second season
to adjust,' wrote Amy Spindler, then that paper's
fashion editor, 'especially since all the copyists
in Milan shouldn't be able to profit from Ms Prada's
ideas before she moves on.' Fast fashion was on the
rise and more than a little destabilizing for high-end
designers who had yet to accept that imitation was
the most sincere form of flattery, as, Prada included,
they mostly do now.

While print and palette were both arguably a
reprise, skirts now fell to mid-calf: if knee-length
was potentially dowdy, this was more challenging
still. The new Prada trousers, meanwhile, puddled
on the floor. Chiffon, conspicuous by its absence
for Spring/Summer, made a return that was more
conventionally feminine by contrast: slender slips
were decorated with rectilinear embroideries or
were geometrically printed again. Shirts in that
same fabric, though buttoned to the throat and
in sludge shades, were lined with tiny frills.

Strappy sandals and high-heeled Mary Janes –
familiar Prada territory – were given a makeover
worn with thick crochet-knit tights in black, beige
and Prada's favourite brown.

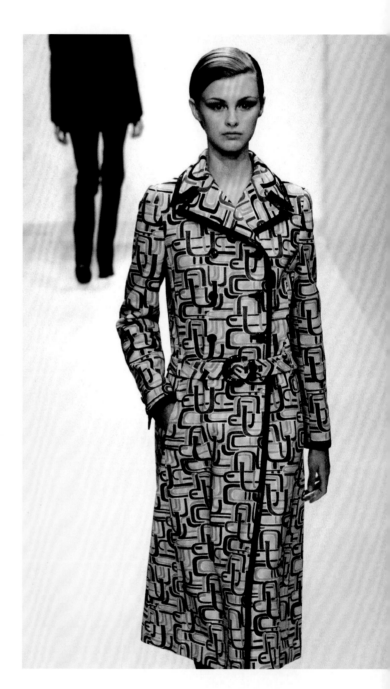

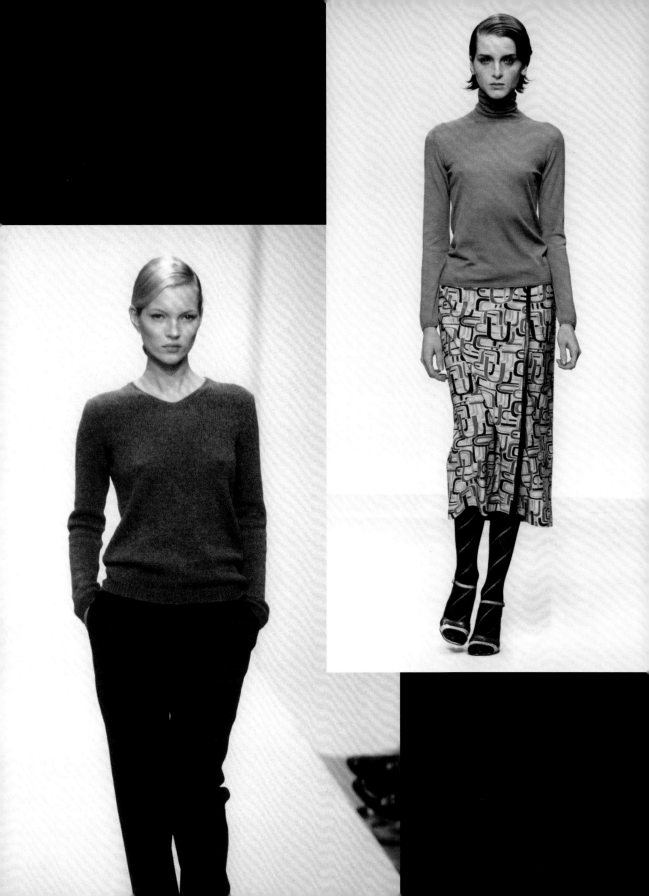

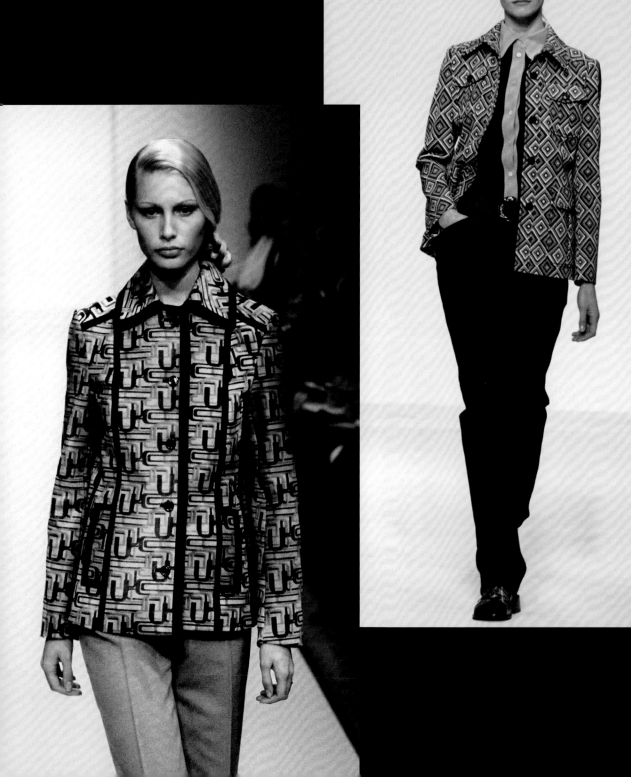

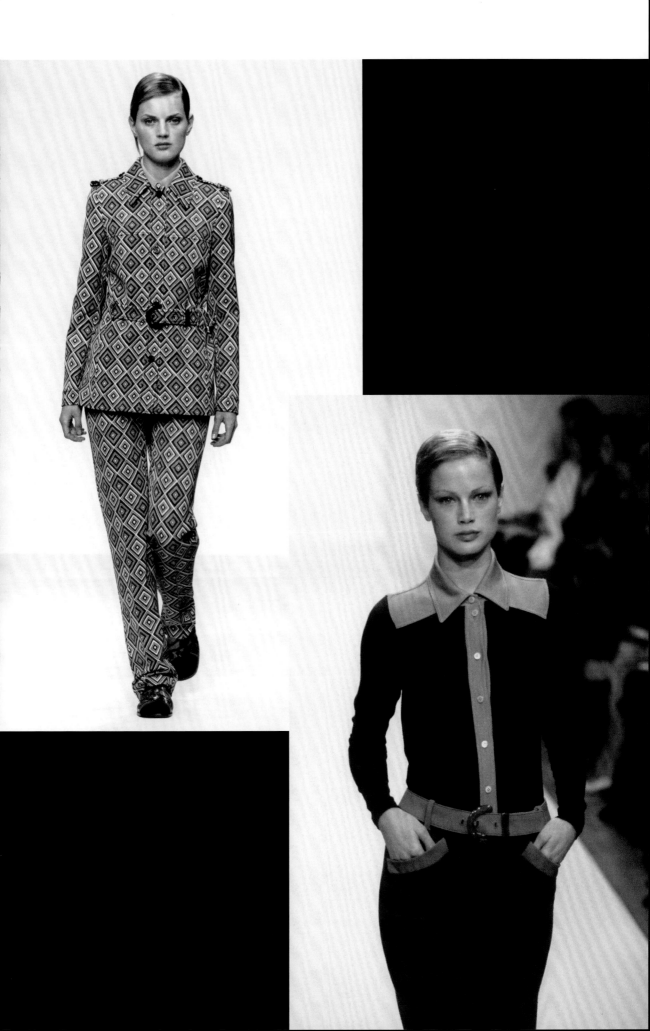

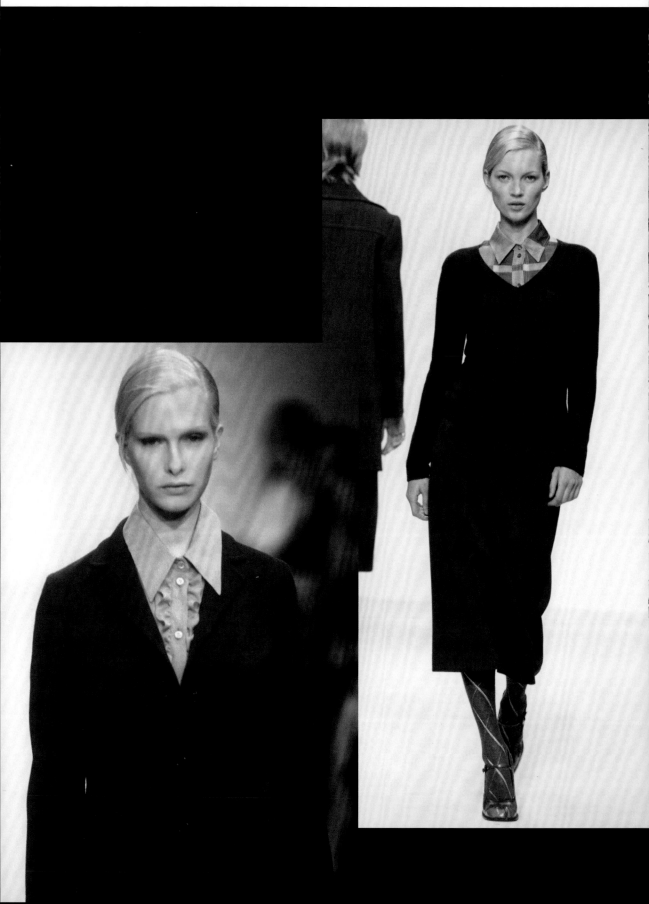

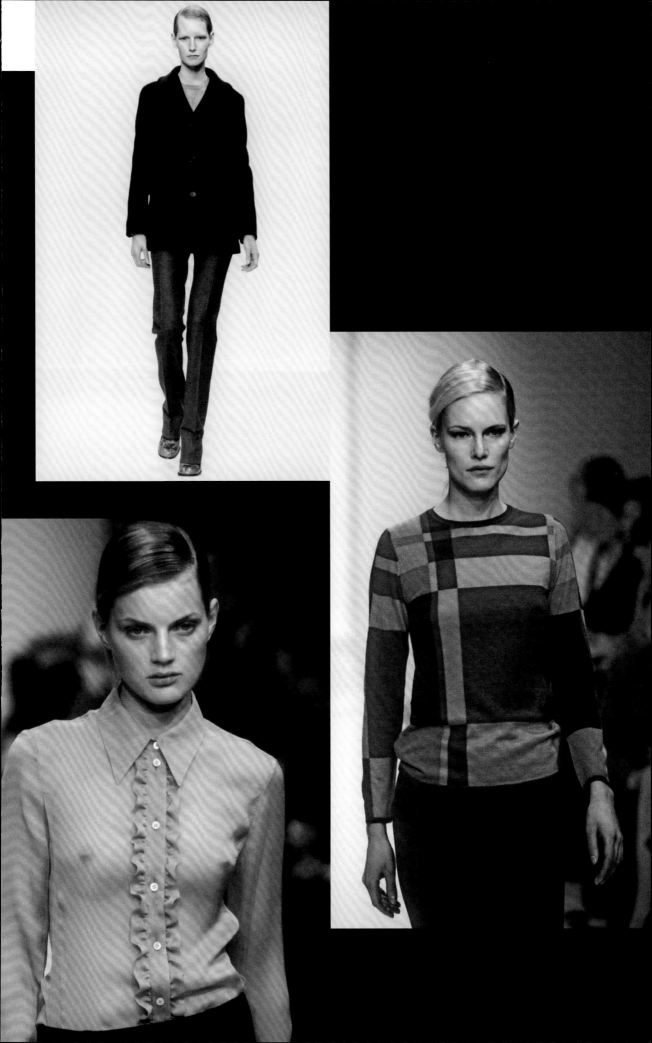

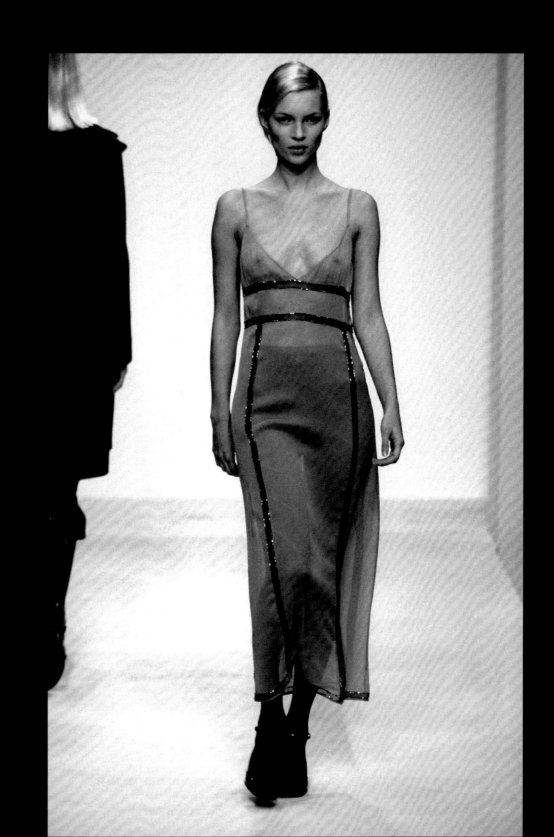

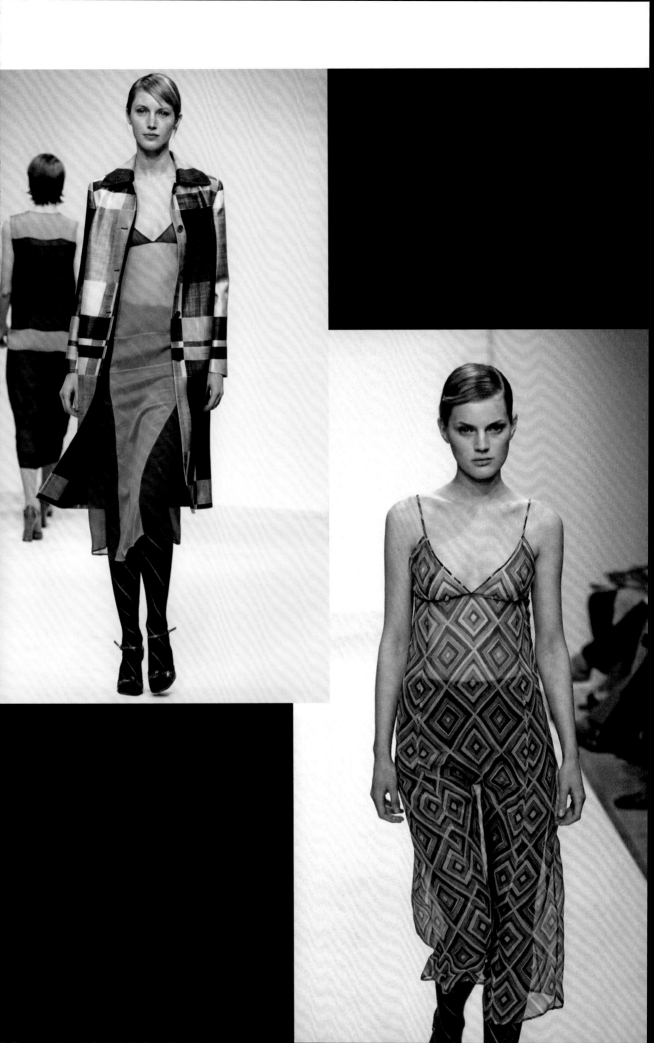

Everything was about lightness for this collection, which put aside any stiffness and studied eccentricity for a show that concentrated almost entirely on flou and cast out the distinctive prints of the past two seasons, replacing them with delicate embroideries and jacquards. Silhouette, too, moved forward. The designer focused on a fitted, vaguely nineteenth-century line that appeared almost skeletal, fragile and never restricting.

Dresses were predominantly lingerie-inspired, from short with petticoat straps to ankle-length and buttoned through, but such atypically feminine designs came in deep shades of plum and navy. New, too, were Chinoiserie silks – split-sided skirts and Nehru-collared shirts – in those same dark hues, all offset by more typical, covered-up, masculine and military-inspired tailoring in black, red and khaki.

With her bags, 'Ms Prada singlehandedly brought back designer logos, made them tasteful,' wrote Amy Spindler in the *New York Times* in October 1996, 'then brought back prints and made them intentionally distasteful. But her collection for next spring – Ophelia meets Suzy Wong in the barracks – has none of the black nylon or computer-generated modernist prints of the past.'

Instead, with their smoky eyes and pretty piled-up plaited hair, there was an ethereal beauty to the models' appearance that was quite a departure. Such unbridled romance and optimism was perfectly encapsulated by Glen Luchford's photographs of Amber Valletta for the new season Prada print campaign.

Meanwhile, as her vocabulary continued to expand and exert its considerable power, the 'Time and Fashion' exhibition, curated by Germano Celant and Ingrid Sischy, opened in Florence featuring Miuccia Prada's first public art collaboration. With Damien Hirst, the designer created a miniature farm in her pavilion, complete with music by Jarvis Cocker melded with the sounds of live goats, geese, a horse, and some chickens and rabbits.

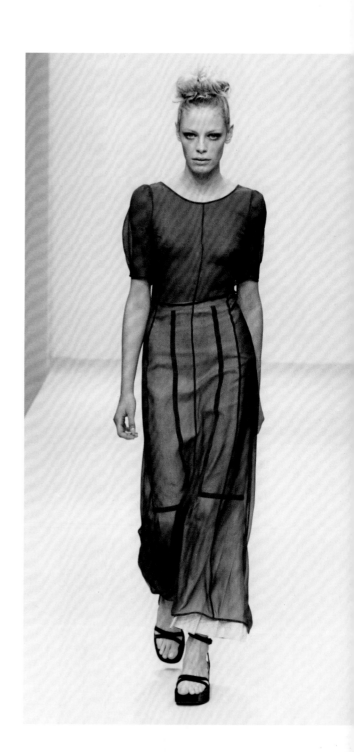

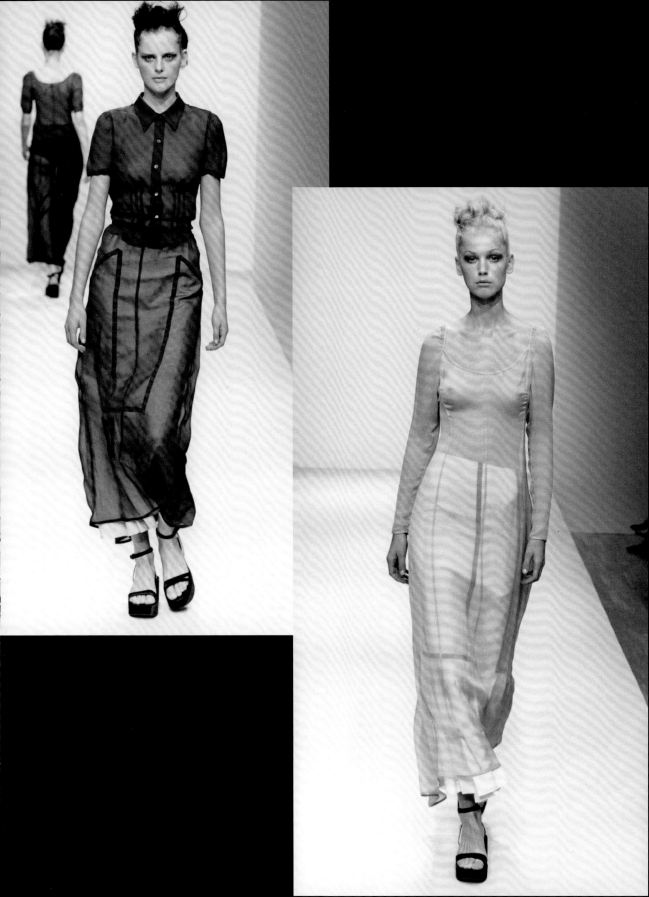

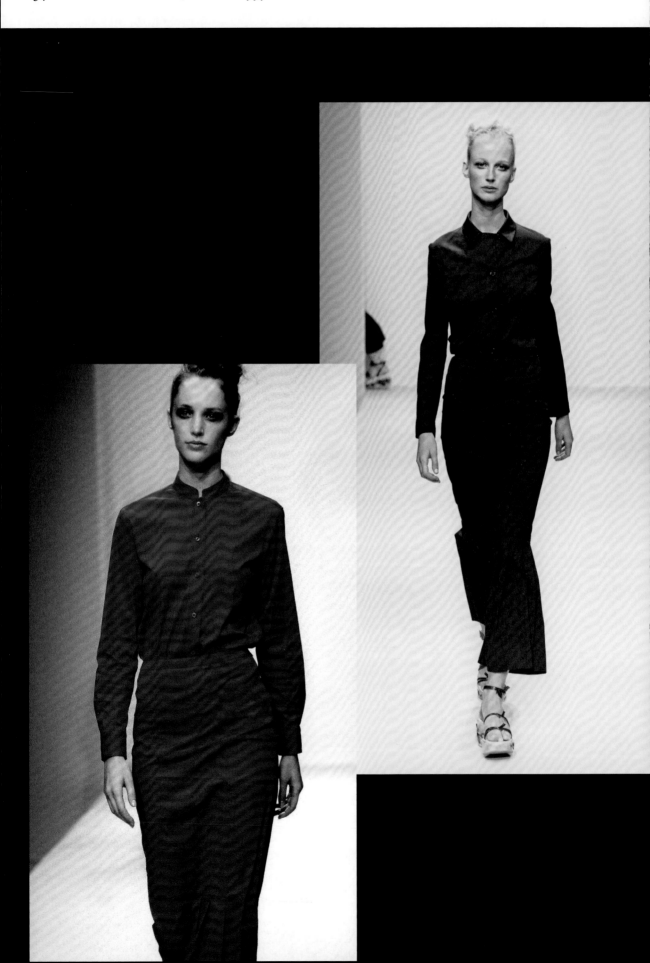

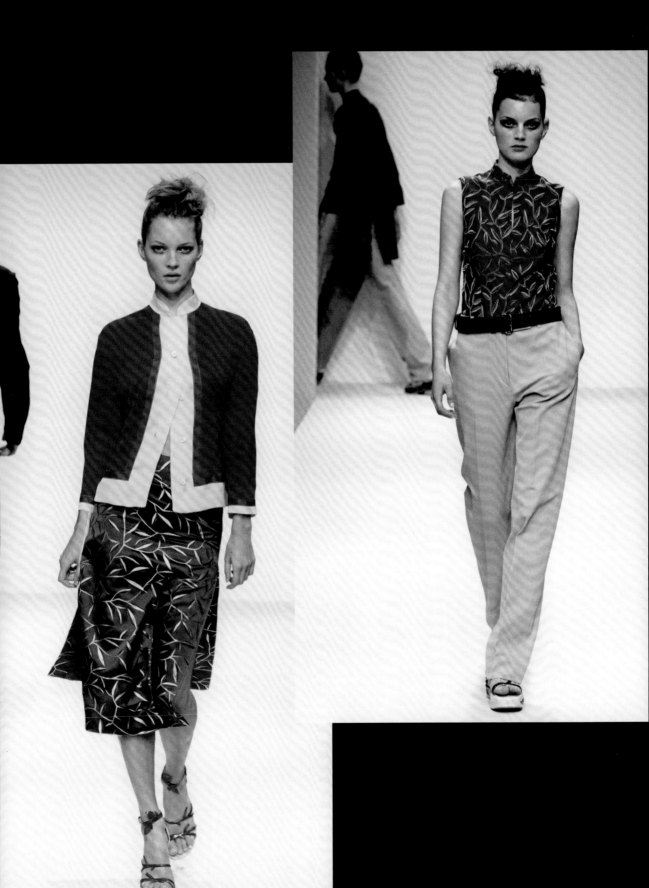

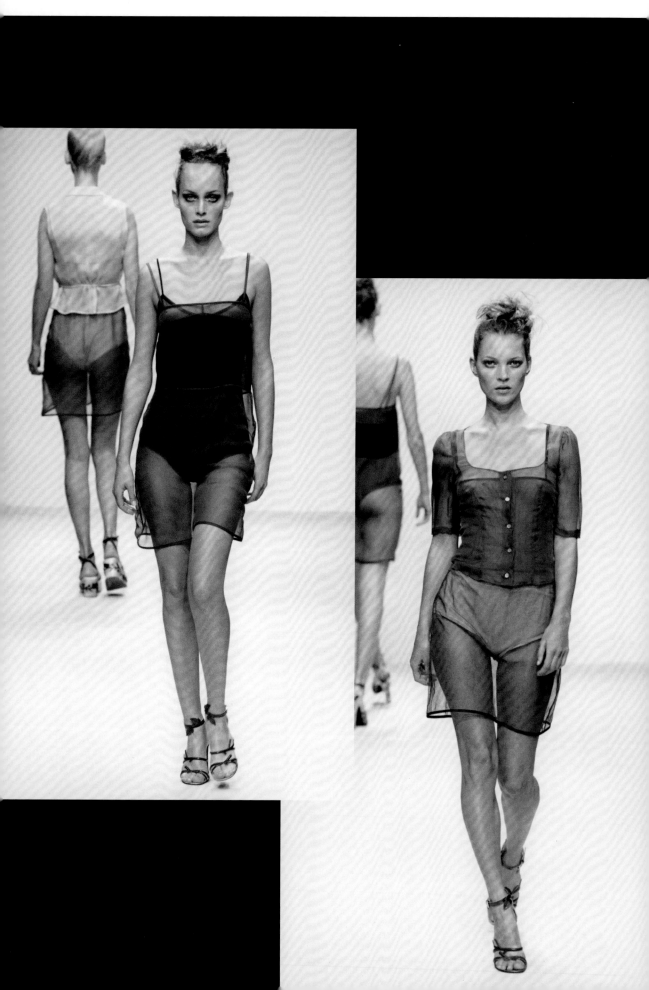

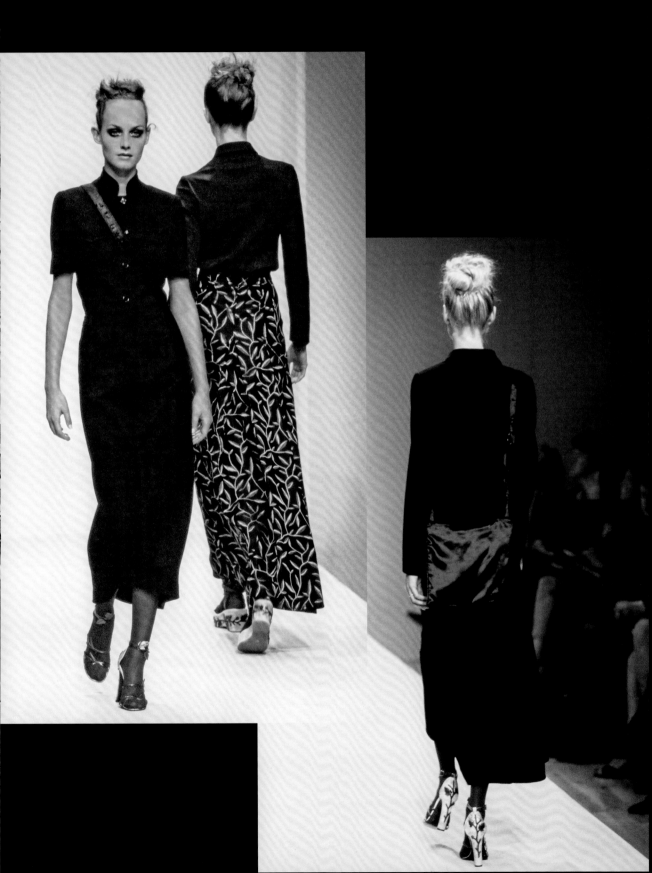

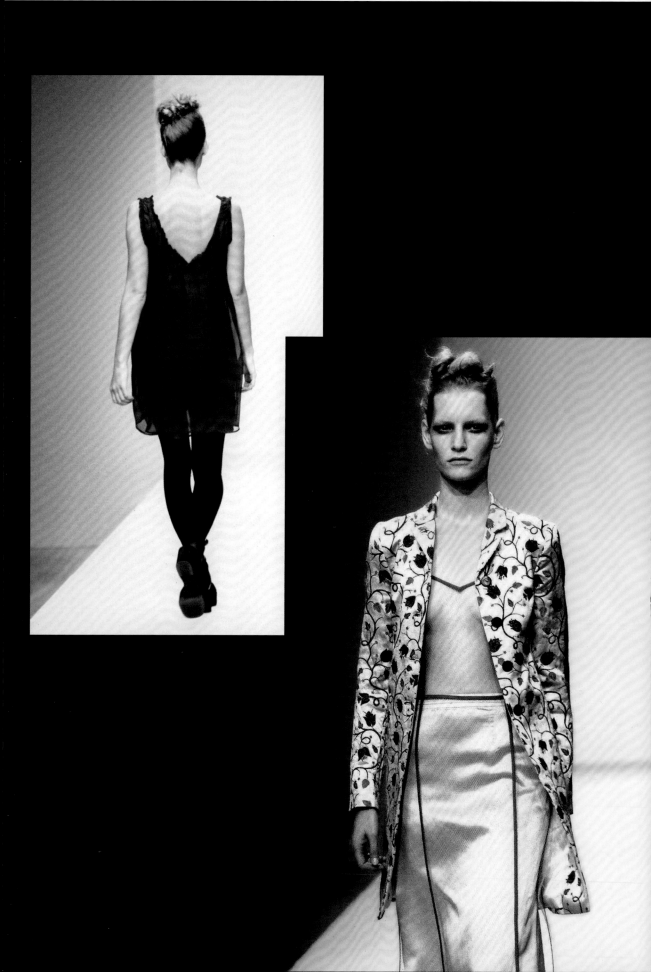

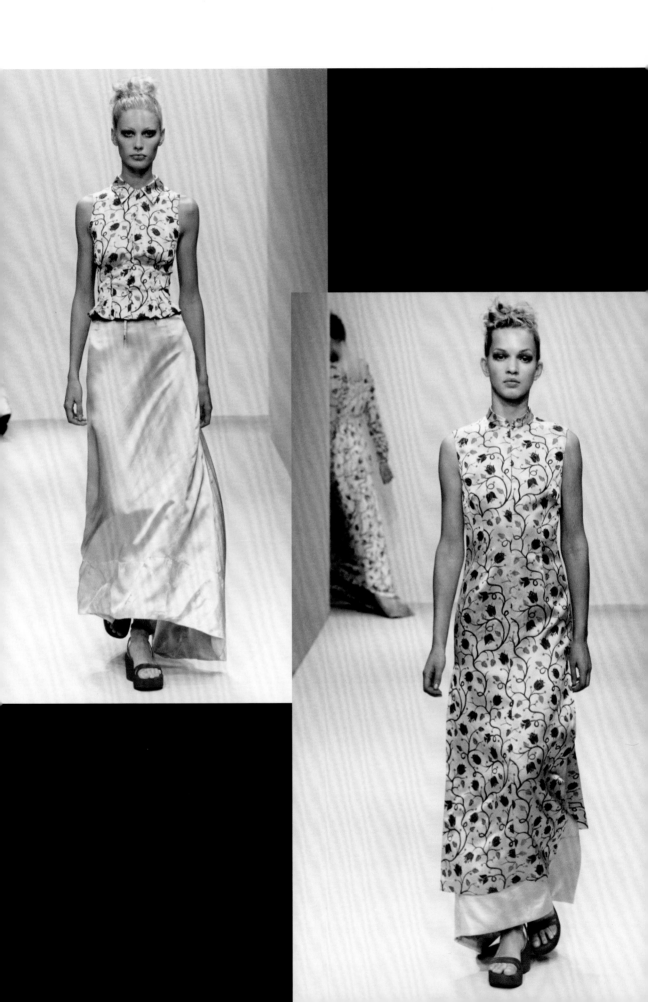

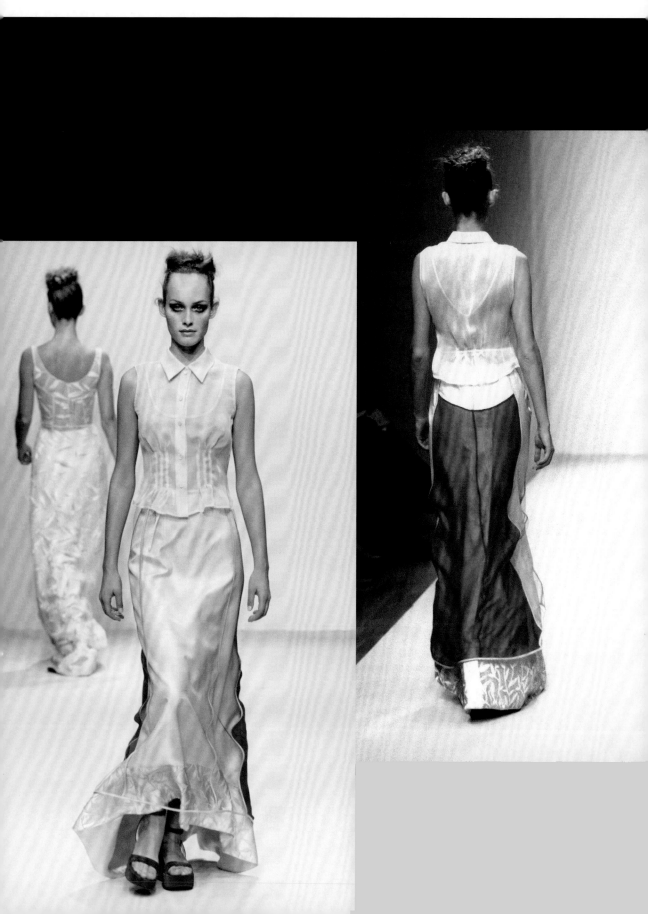

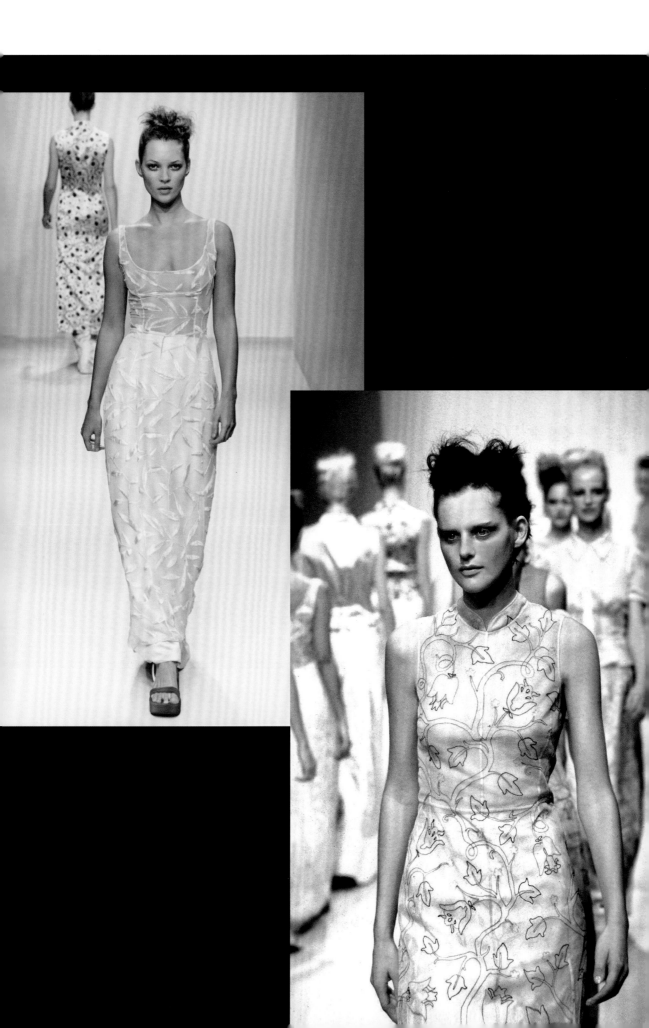

By this time Miuccia Prada was the undisputed leader
of the pack, the first lady of Italian fashion who set the
tone for other designers for seasons to come. As has
been identified, the counterpoint between masculine
and feminine was among the enduring paradoxes
on the Prada runway, and one that had been present
since the designer's ready-to-wear debut. Here it was
the driving force behind the collection, developed to
a new level of sophistication, subtlety and lightness
of touch.

Classic tailored men's jackets and slim trousers
were mixed with silk tulle skirts and camisoles
embroidered with rows of crystals and shimmering
bugle beads. Men's tartan trousers and a white men's
undershirt were worn with a loose lavender kimono
coat (p. 167, left), or an athletic, zip-front shirt with
a fragile jewel-edged skirt (p. 168, right).

For the time being, there appeared to be a more
conventional, less confrontational appeal to Prada's
collections. Although her search for what is and
isn't widely considered to be beautiful continued
– and continues to this day – this marked a period
of relative quiet, not to mention straightforward
loveliness, from the black tattoo embroideries
on white empire line or shift dresses (p. 164) to
the sweetheart necklines of black tanks. There was
nothing obviously discordant about this collection
either. Colour was gorgeous, from raspberry
to emerald; legs were toned and bared; and high-
heeled court shoes with a pointed toe were
unashamedly elegant.

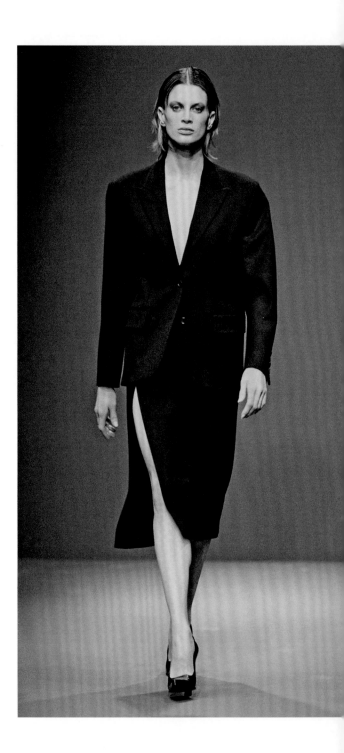

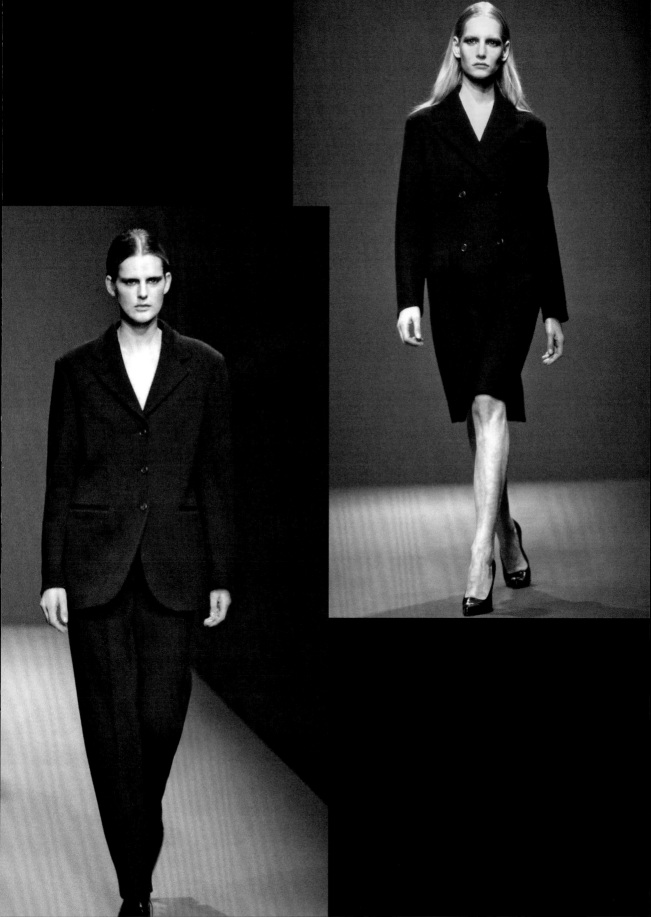

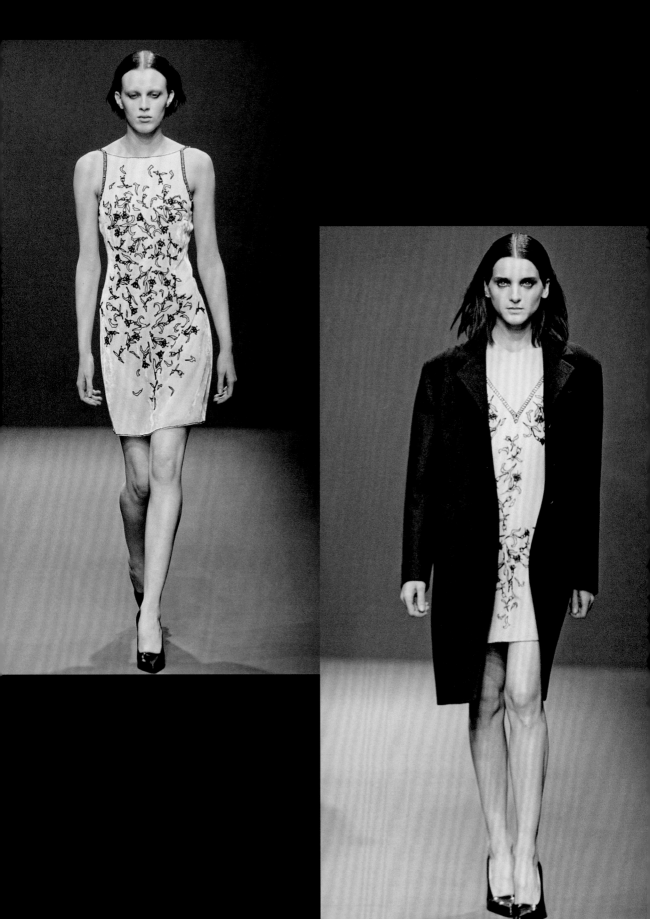

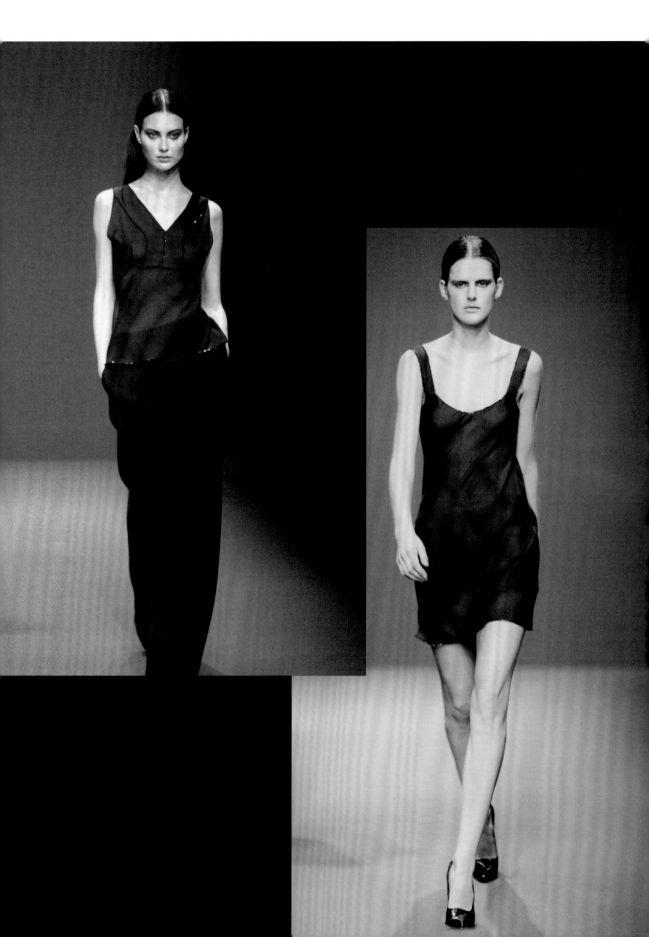

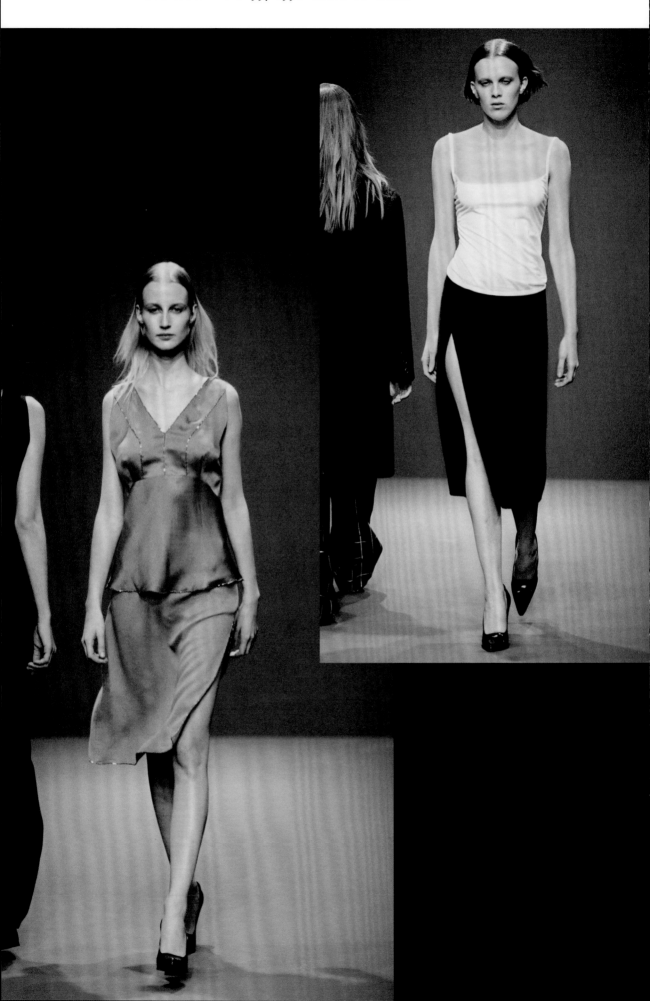

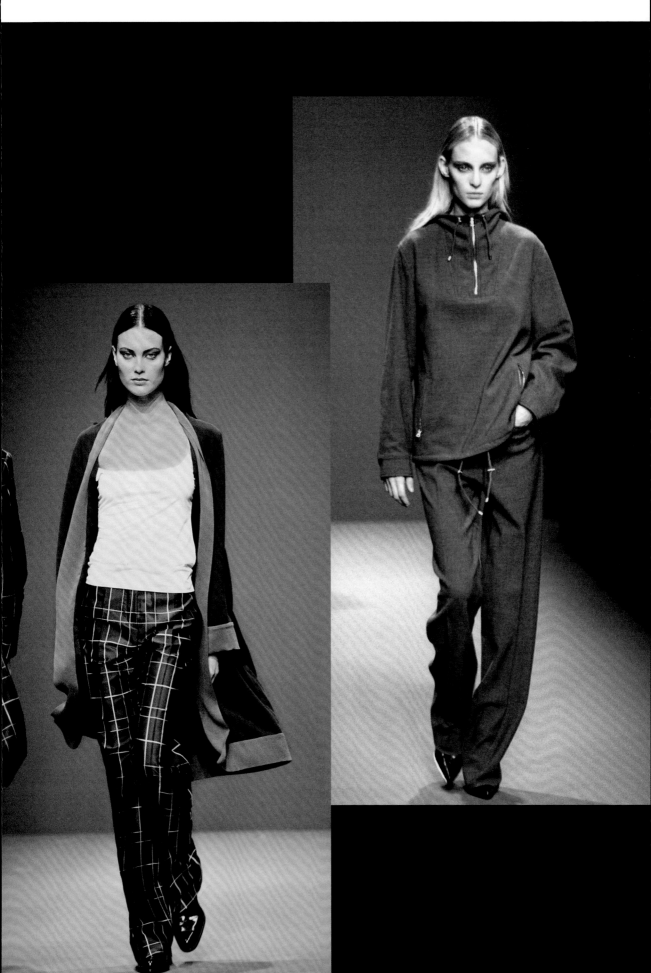

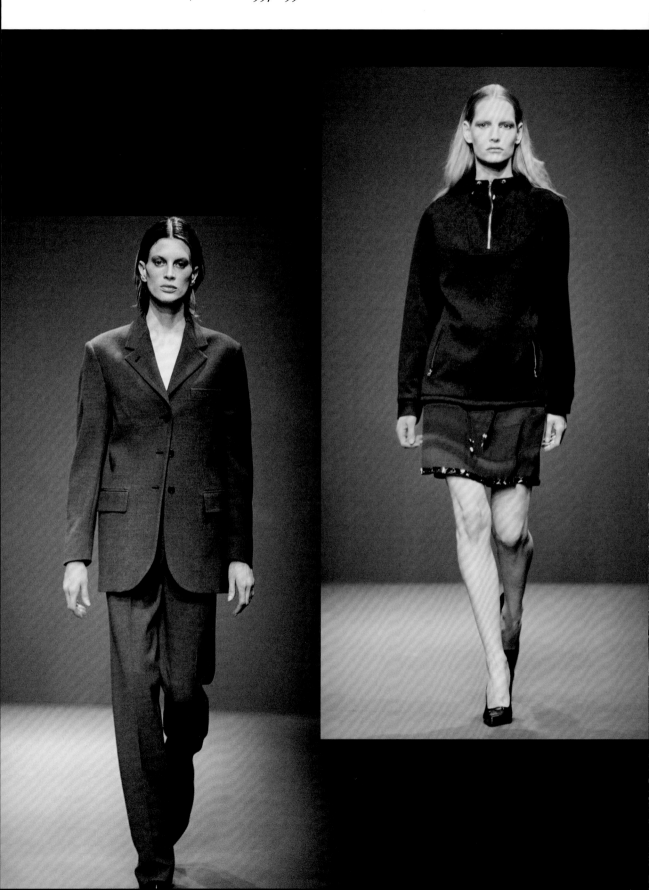

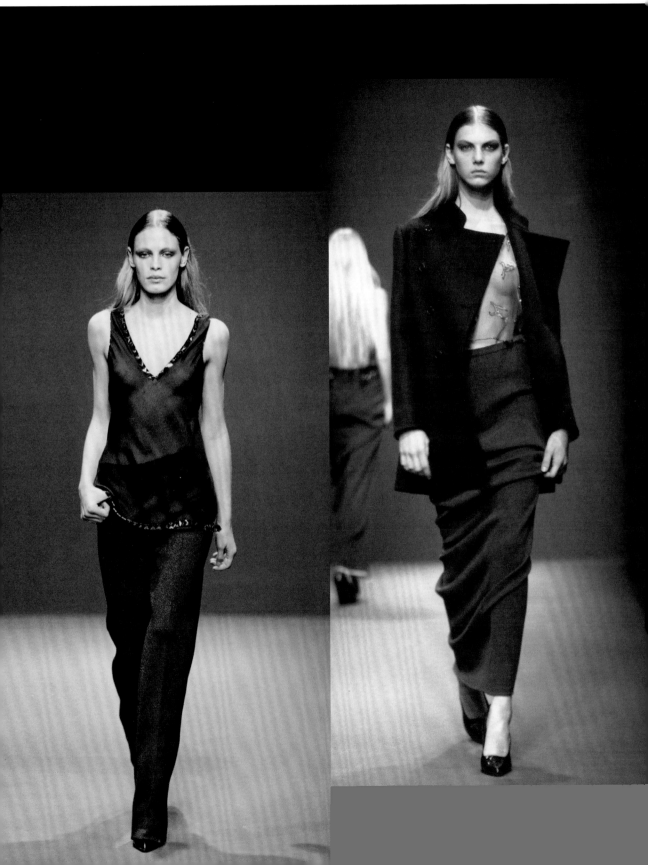

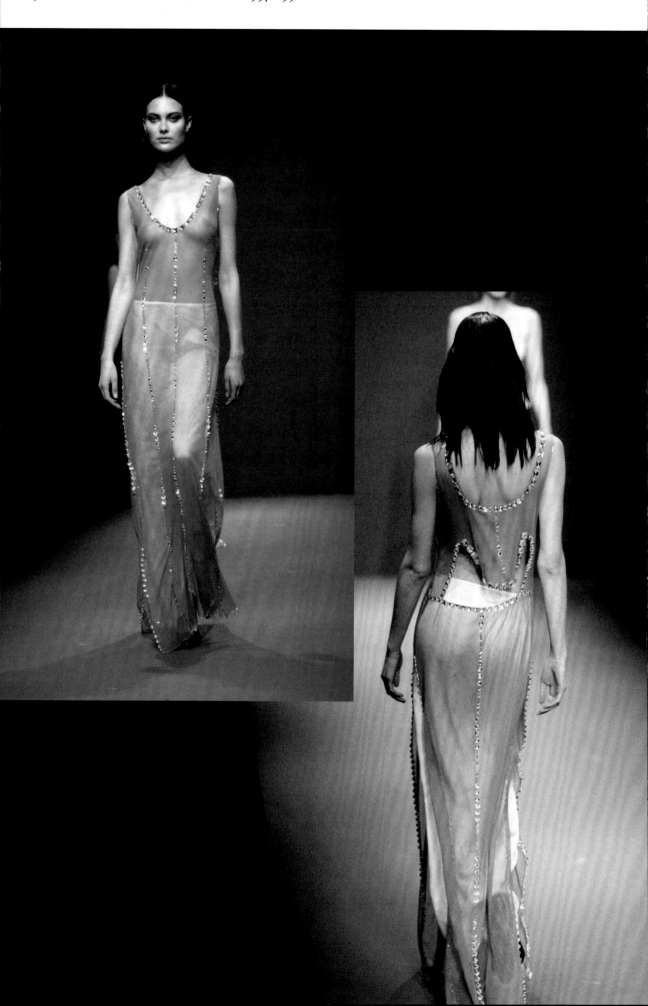

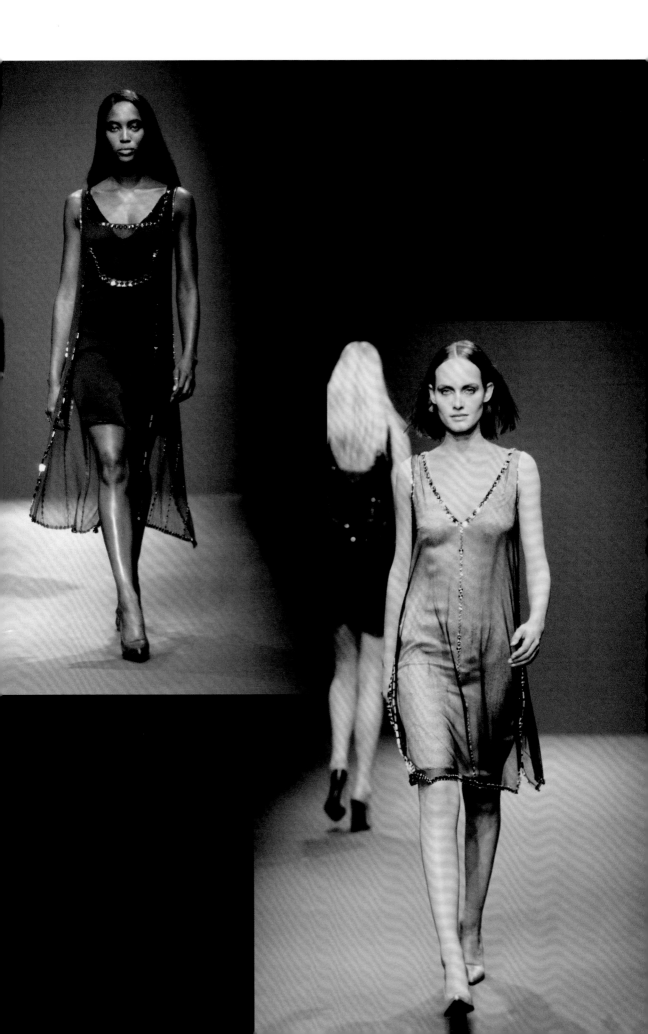

The show notes for Spring/Summer 1998 referred to
'an avant-garde work ethic'. That translated, perhaps,
as an exploration of imperfection, of the touch of
the human hand. This was a collection infused with
a respect for nature, too. Edges were frayed, fabrics
included both hemp and latex, and prints were
homespun, depicting wheat fields and exploded
tartans that looked as if they'd been cooked up
in huge dye pots in an especially well-appointed
old kitchen and under the watch of an unusually
discerning eye.

A by now characteristic childlike naïveté was evident
in an asymmetrically placed hand-painted bloom
here and there, randomly tied ribbons, puckered
pleats, tiny ruffles on shirts that looked as if they had
seen better days, and roughly gathered puffball hems.
These off-kilter details appeared alongside the
perfect simplicity of white cotton shirts – with or
without sleeves – worn with high-waisted Capri
pants. For all its humility, there remained a discreet
sense of Hollywood's Golden Age to this collection,
too, in the form of pale metallic silks panelled or
paired with more rough-hewn hopsack (see p. 181)
and also a gold strapless pencil dress with – a
subversive touch if ever there was one – latex
inserts (p. 180, right).

Sandals, meanwhile, were very much of the Dr Scholl
variety: they went on to sell like the proverbial
hotcakes, prompting a revival of the originals that
inspired them. At this point in time, it's worth noting
that Prada accessories – and shoes, in particular –
were considered so important that close-ups of
designs were projected on screens placed above
either side of the runway as models walked.

In the end, though, this was a show that was
exceptional due to its overall lack of literal reference
to the distant past. At a time when the rest of the
fashion world was steeped in nostalgia, Miuccia Prada
was continuing to travel her own path.

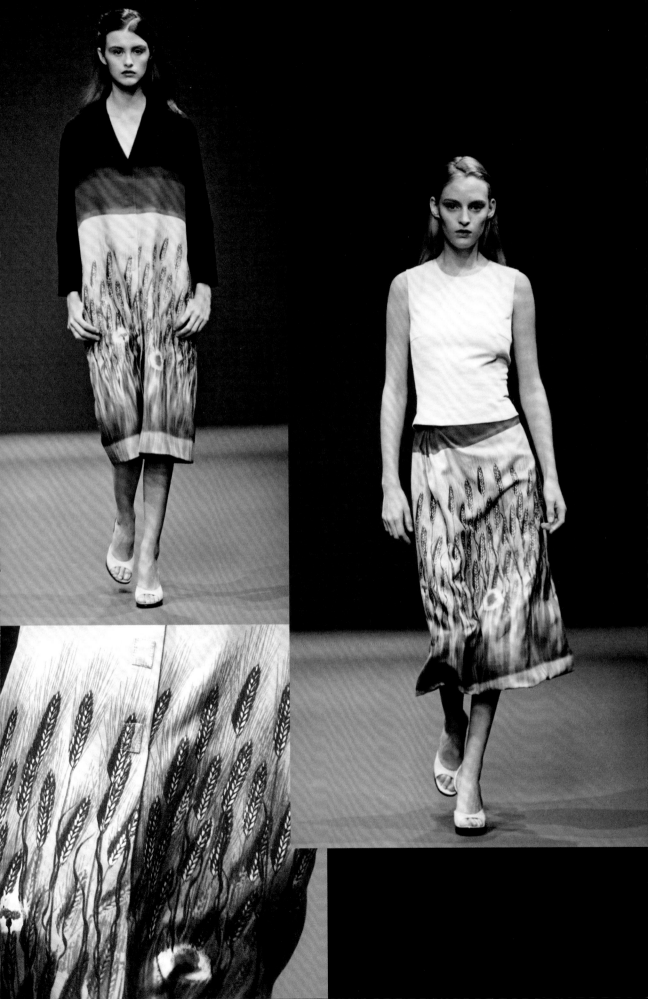

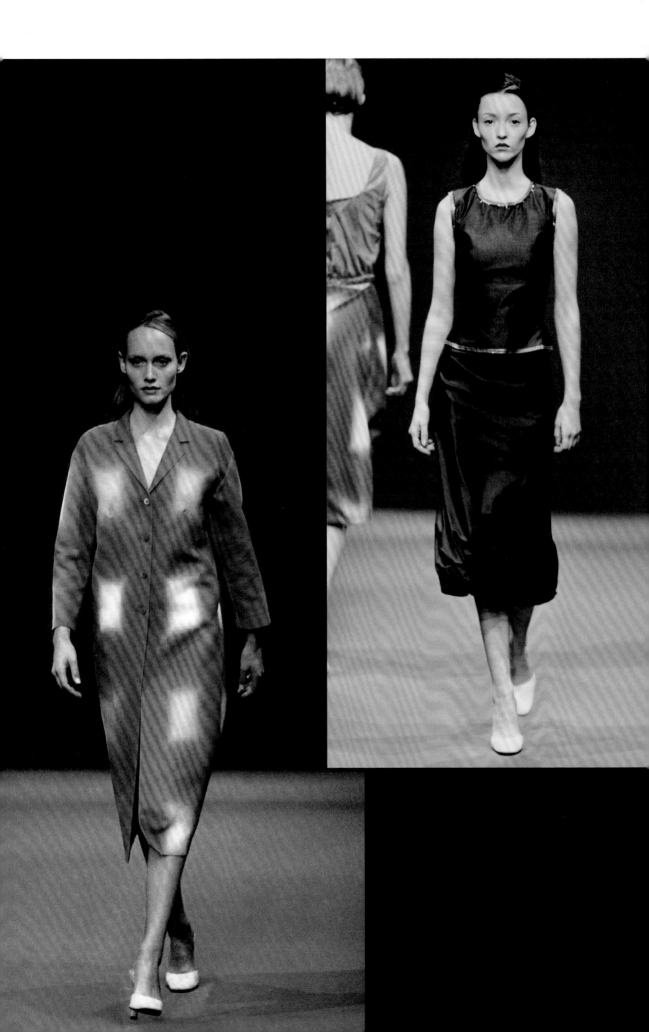

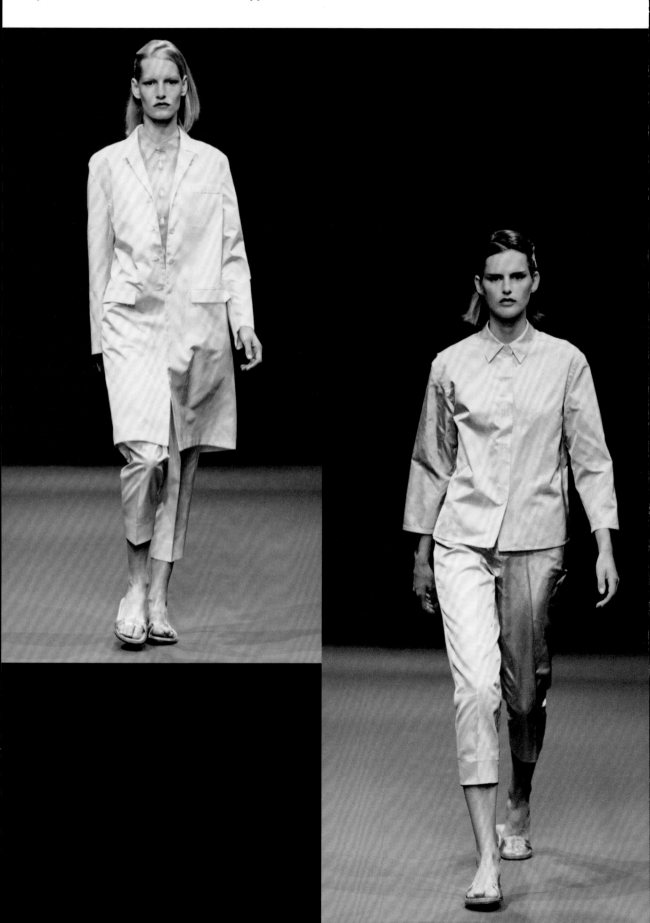

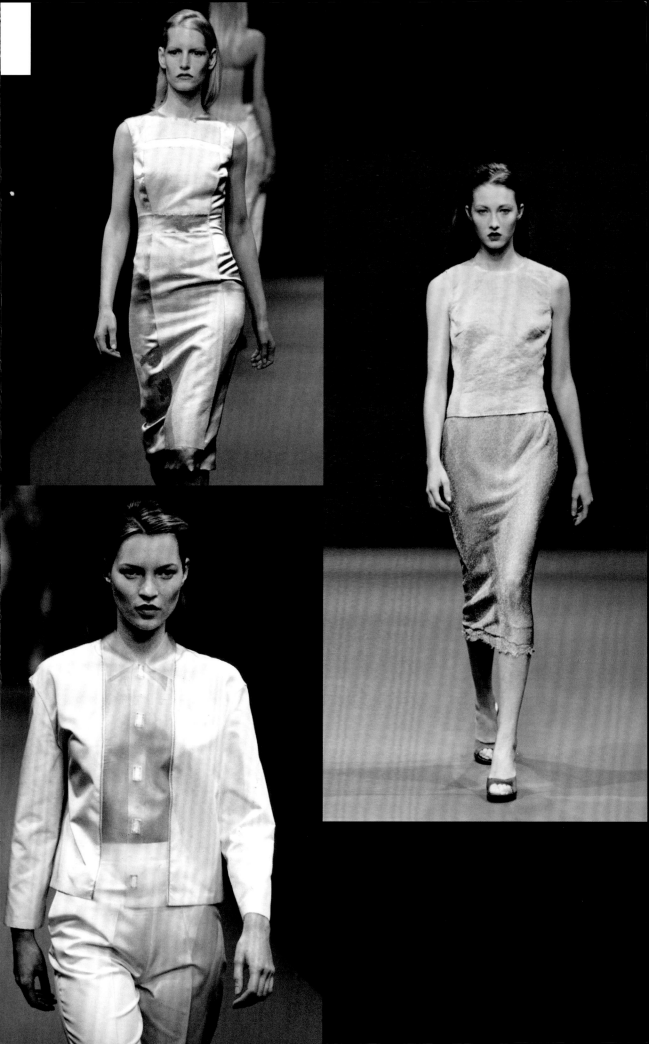

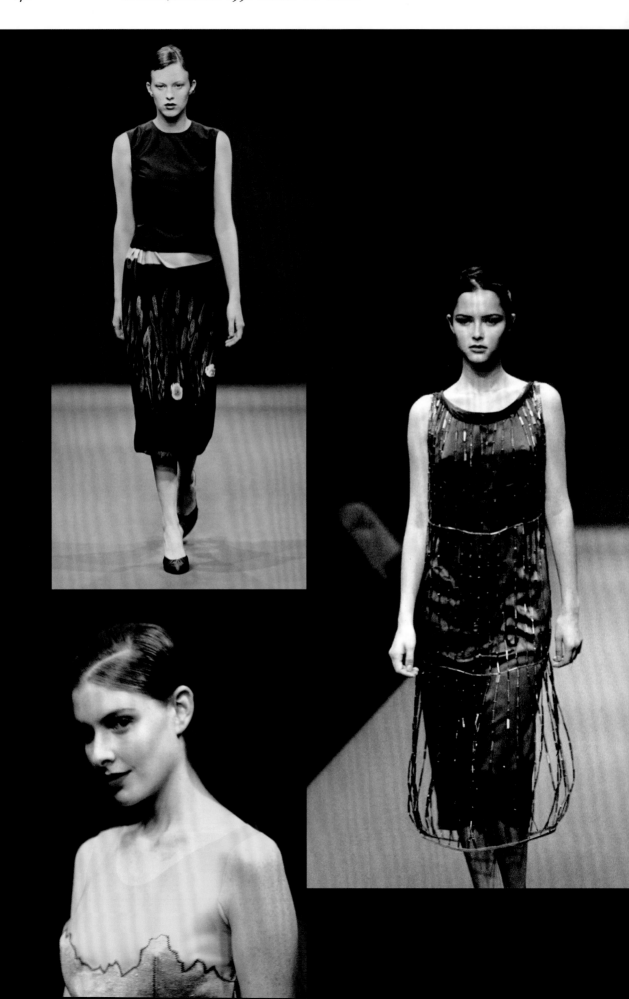

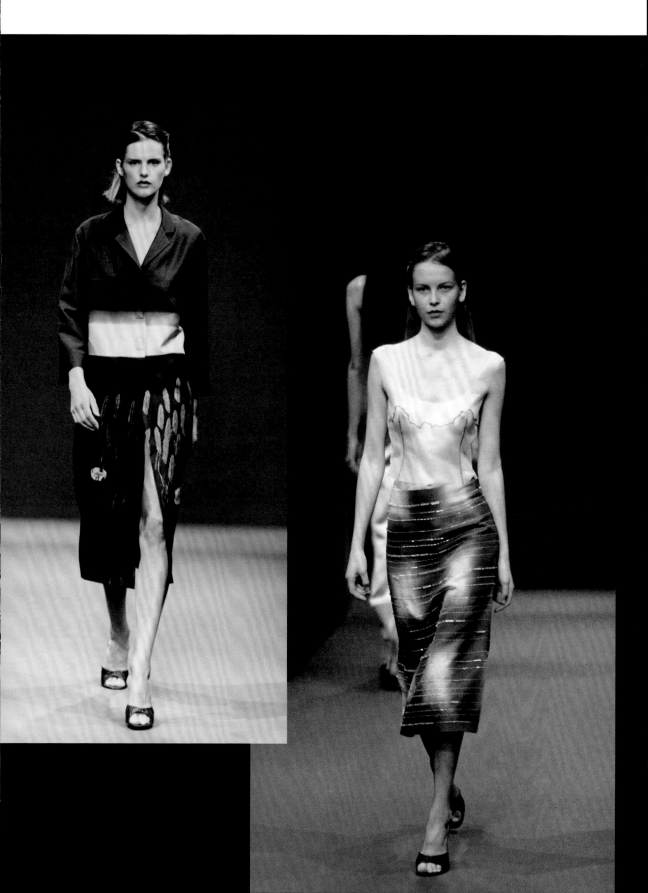

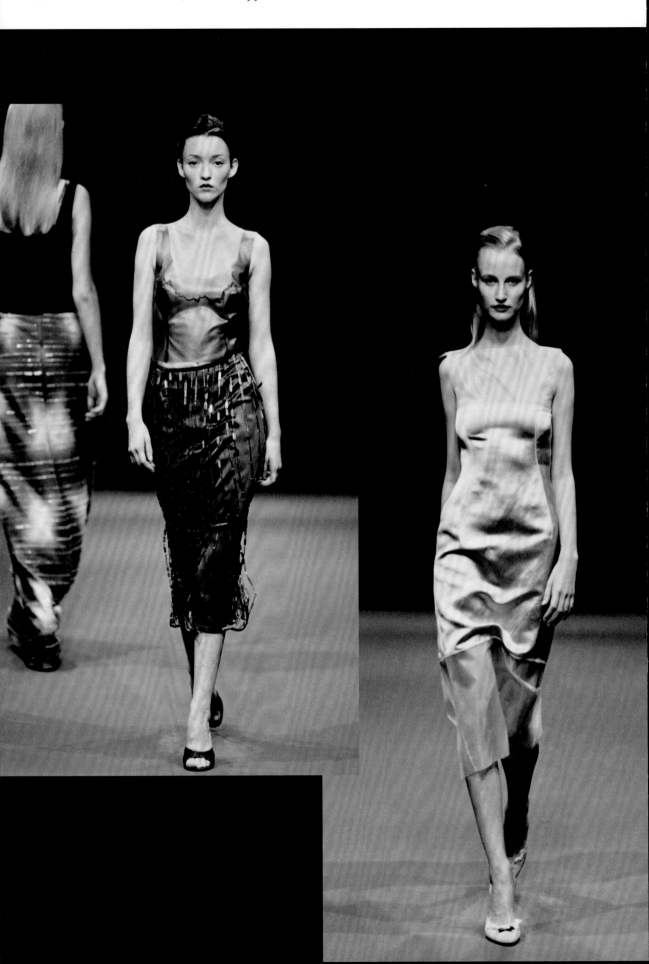

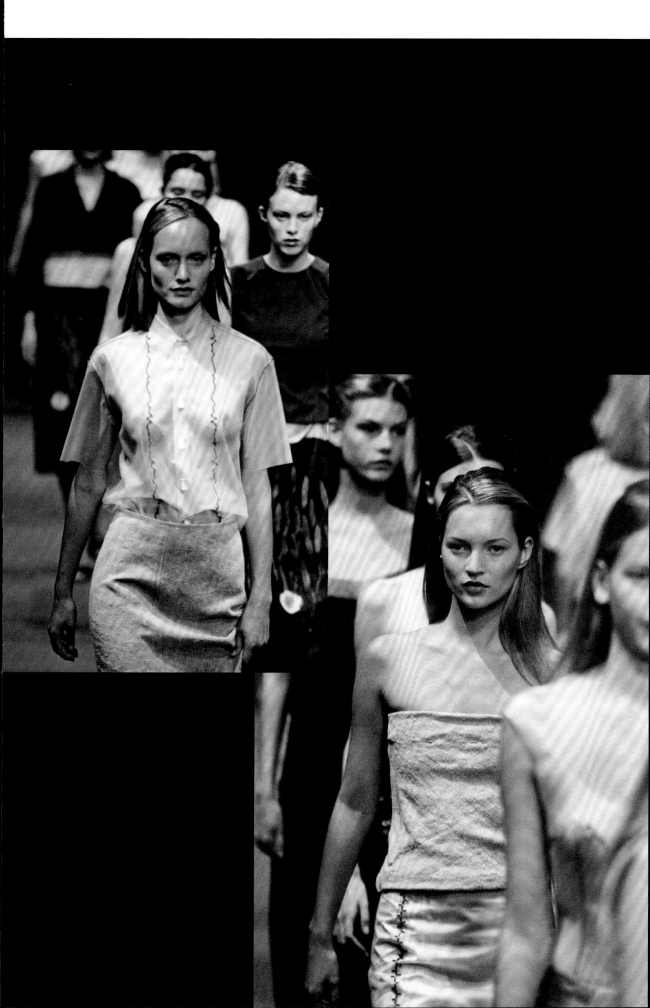

A decade after her first ready-to-wear collection was shown, *Women's Wear Daily* prefaced its review of Miuccia Prada's new collection in this way: 'Risk – a noble mark of greatness. Not those sophomore risks taken merely for amusement value, but the willingness to play it dangerously unsafe in the name of progress. That type of risk is the essence of Miuccia Prada's career. She has built her name, her image, her reputation, on a fervour to challenge the status quo, taking her passion of a revolutionary to her search for the future.'

Prada, for her part, explained in that same publication: 'After the famous minimal period of taking away, when nothing was very traditional, I wanted to start building a new beauty, a new richness. But traditional richness looks old, it looks to the past. I want to build something for now.'

On one level, this collection was clearly indebted to French futurist fashion. The colour palette was black, white and red all over, and the silhouette was short, sharp and boxy. There was even what looked like a Prada spin on the Courrèges go-go boot accessorizing each look; in fact, these turned out to have their own, entirely original, geometrically complex heel (opposite, above left). And such innovative – even truly futuristic – twists occurred throughout. Delicate beading and silk-thread embroideries were replaced by gleaming strips of plastic or metal, mannish Shetland double knits were contrasted with rich silks and astrakhan, wool felts with chiffon, to create an apparently simple wardrobe of A-line coats, shift dresses, boyish tailoring and carwash pleat skirts, which were at times deliberately rumpled and crumpled, and which were, in the end, anything but straightforward. As was her wont, then, Prada was redefining luxury once again.

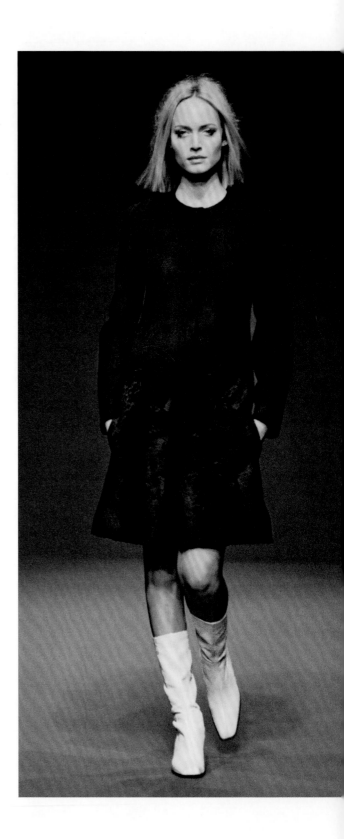

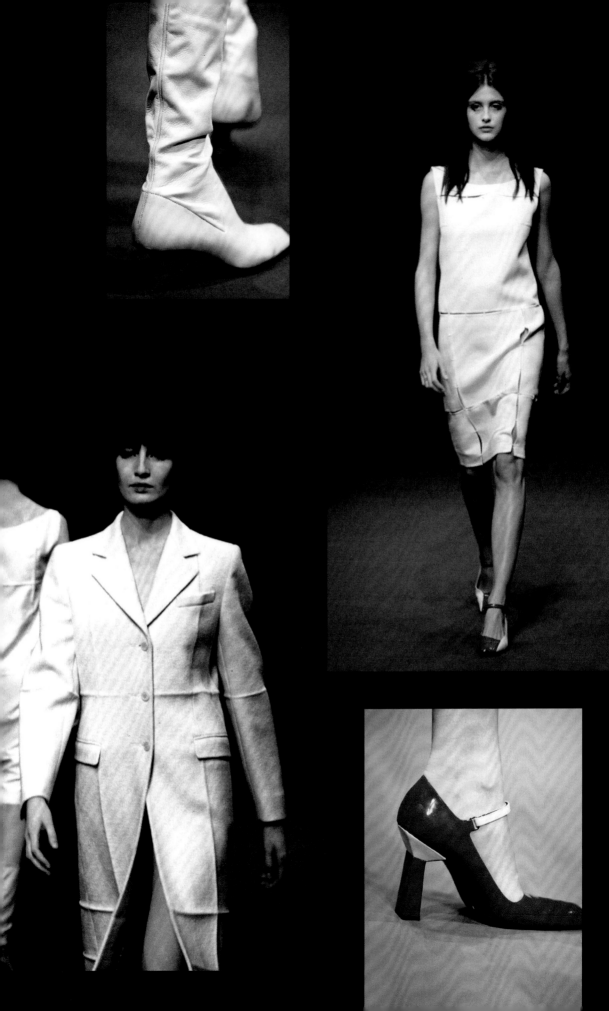

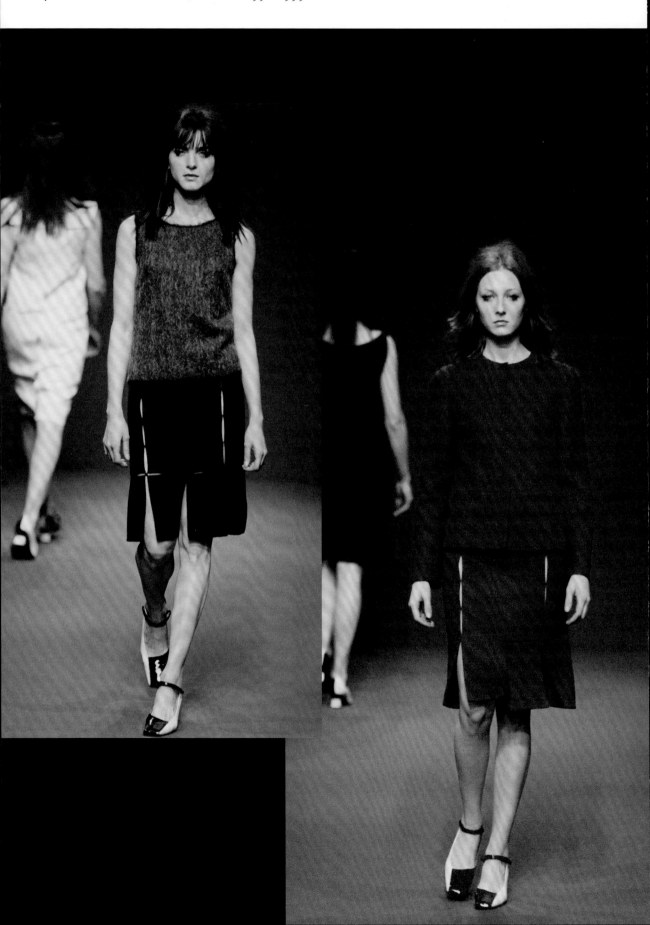

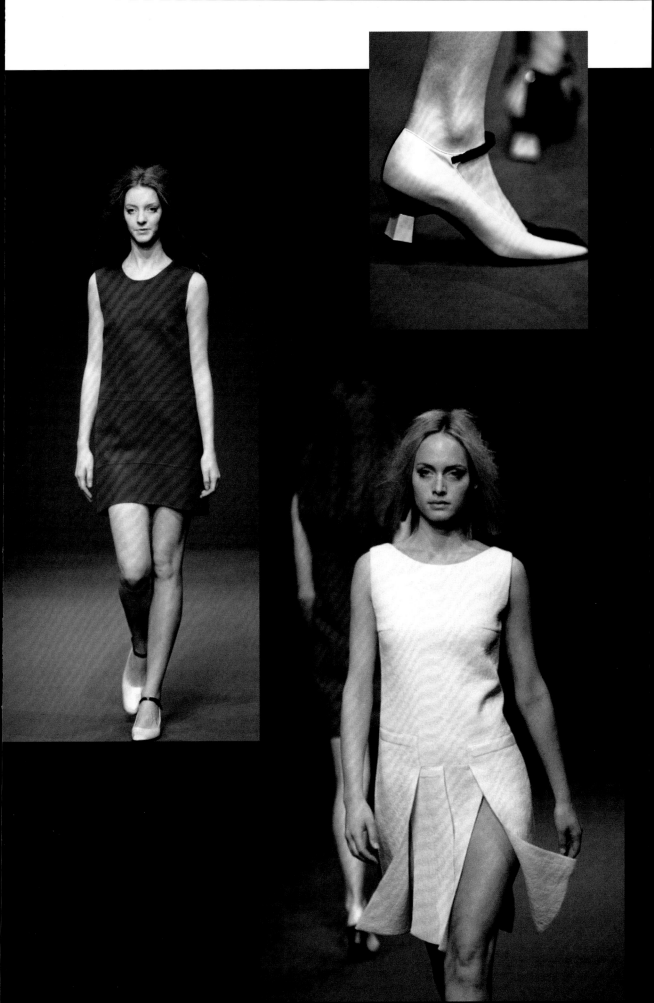

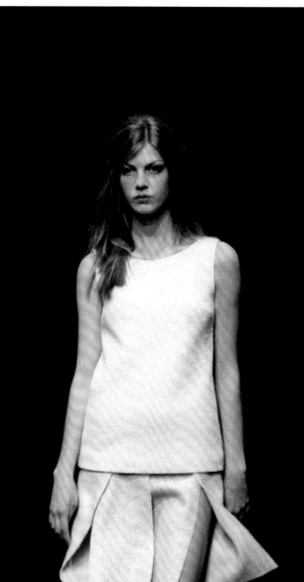

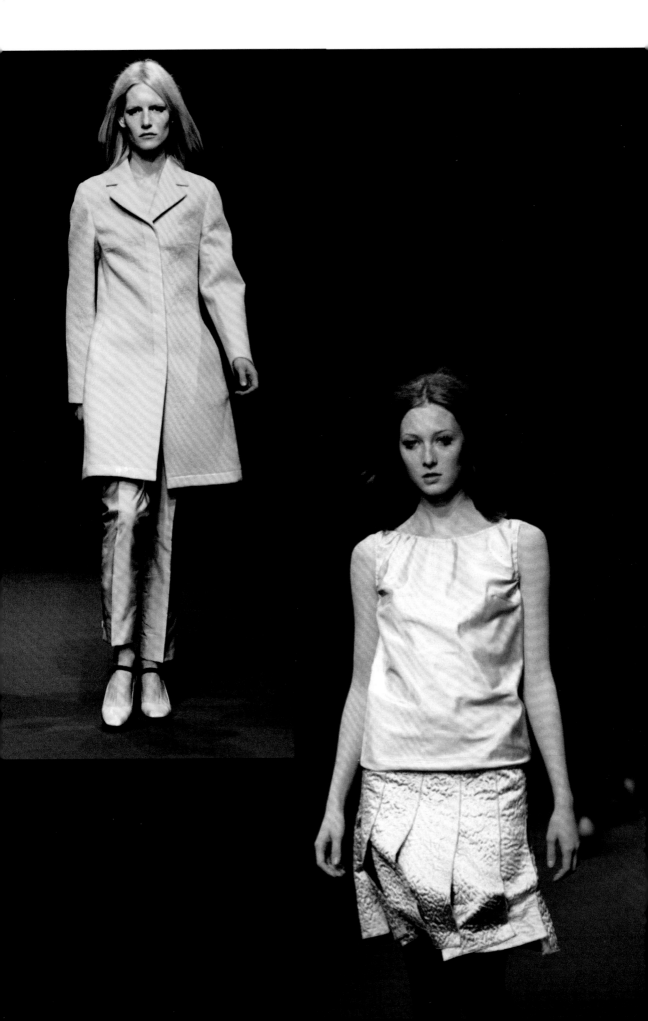

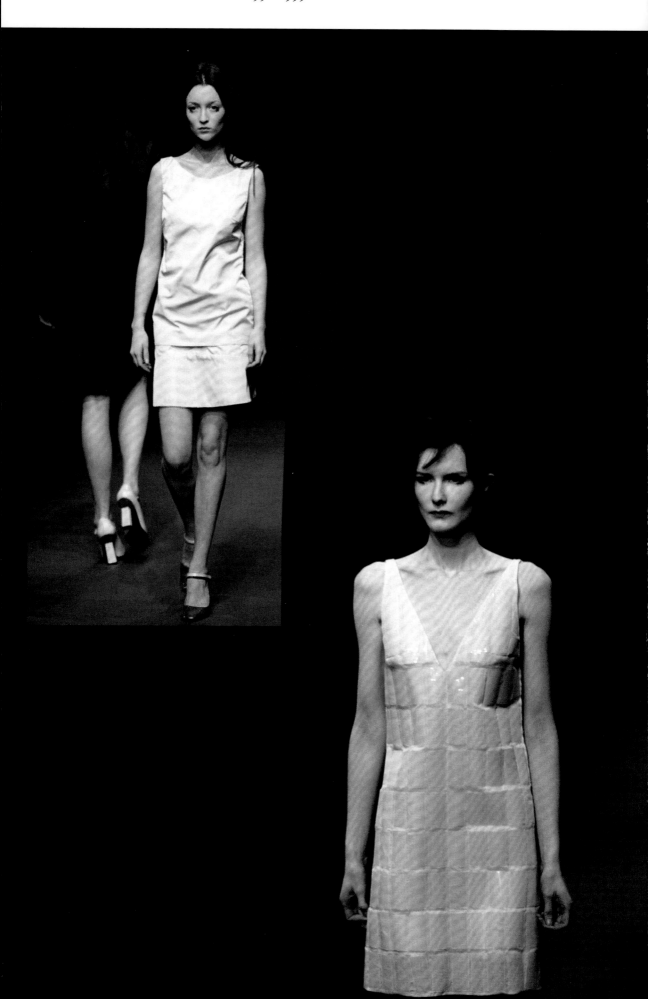

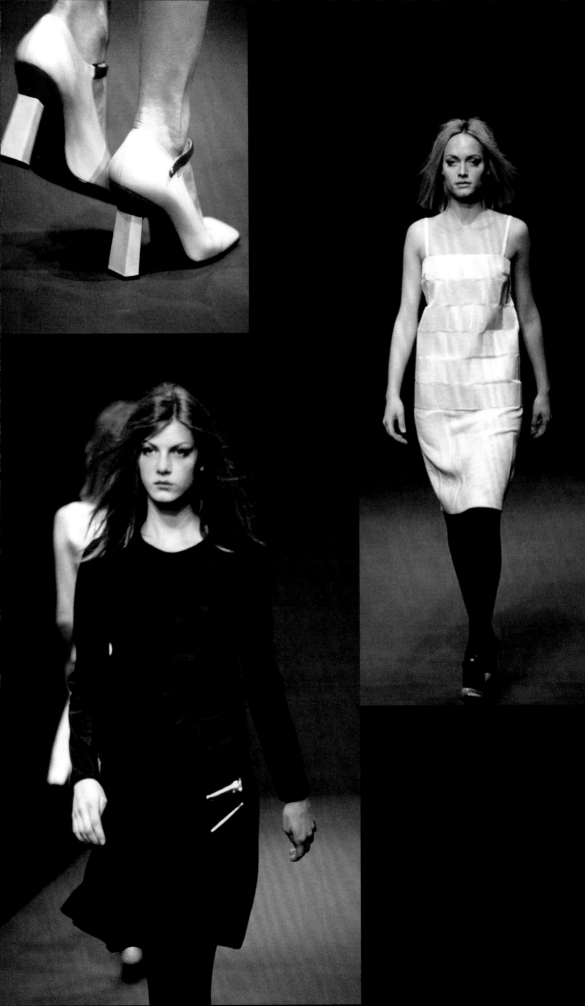

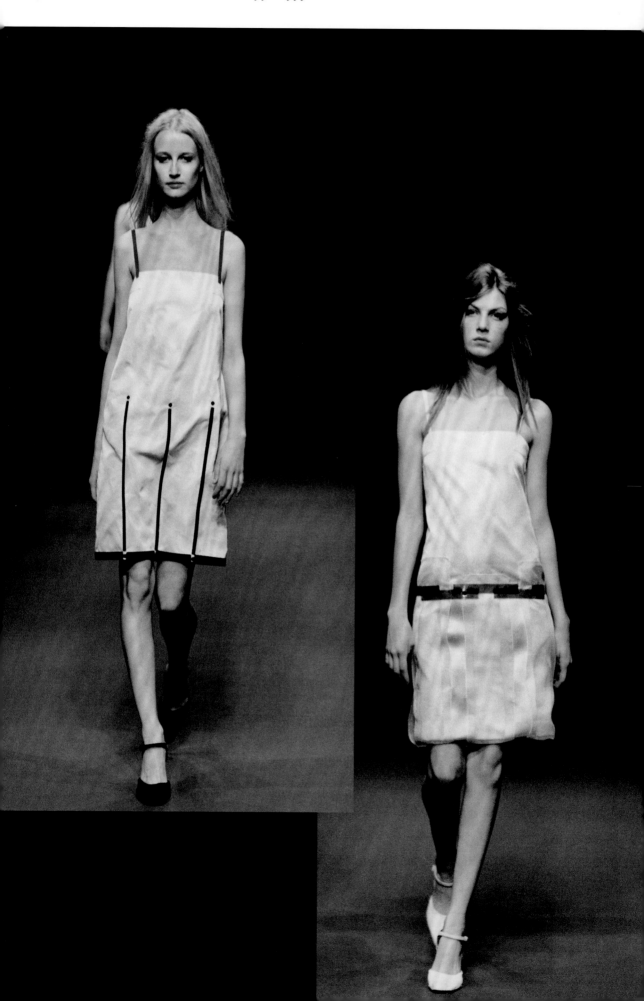

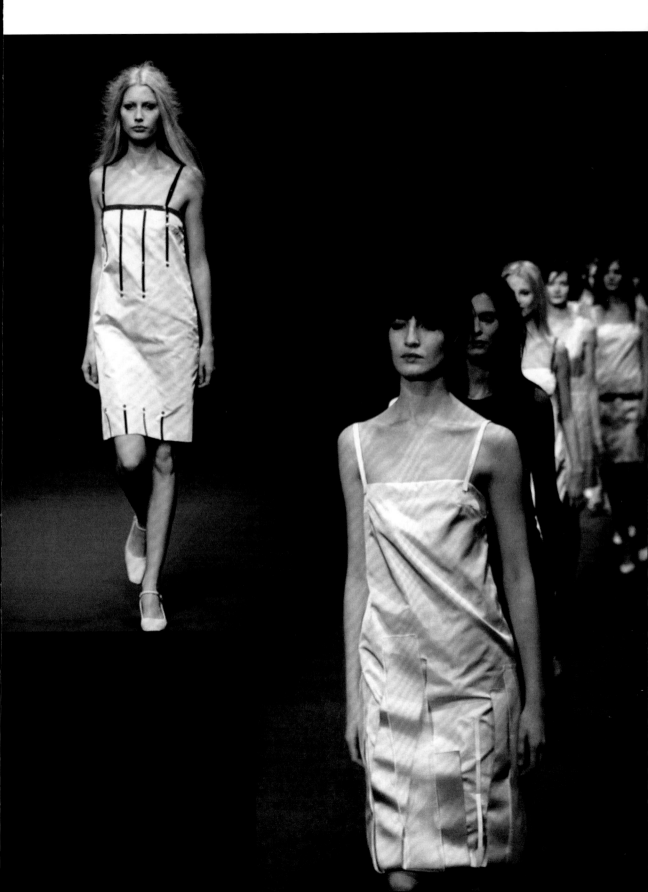

Prada's final spring collection of the millennium
saw the launch of the Prada Linea Rossa women's
collection on the runway, although the line had
been introduced six months earlier, following the
announcement in 1997 of the Prada Challenge 2000.
Spurred on by Patrizio Bertelli's passion for sailing,
this was the Italian entry to the forthcoming
America's Cup, for which Italy's competitors would
be decked out in Prada. The red Linea Rossa logo was
reminiscent of the lettering on the Luna Rossa boat.

There was more to this move than that, however.
Designer sportswear was a new and quickly
expanding commodity across the board, and Prada,
with its luxe-industrial and pioneering heritage,
was well placed to capitalize on that. The clothes
in question looked every bit as desirable as might be
expected: clean shapes in technologically advanced
fabrics, with equally practical shoes and bags – from
pouches to fanny packs.

That was only one half of the story, however. The
Prada paradox here lay in the contrast between
this and the main-line collection with its romantic
full canvas skirts and coats with broad pleated-
ribbon edges, crumpled chiffon dresses, skirts and
knickerbockers in tea-stained shades and more in
coated paper, and richly coloured crocodile skirts
and jackets. More than a few of these designs were
embellished with circular mirror embroideries the
size of small saucers that reflected light as models
walked (see p. 200).

In a bid both to cater to the real and ignite the
fairytale in the modern woman's life, here was
a magnificent display of the functional and the
fantastic rolled into one.

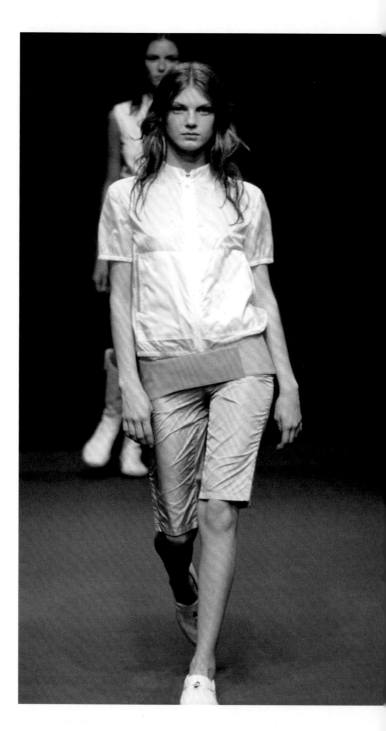

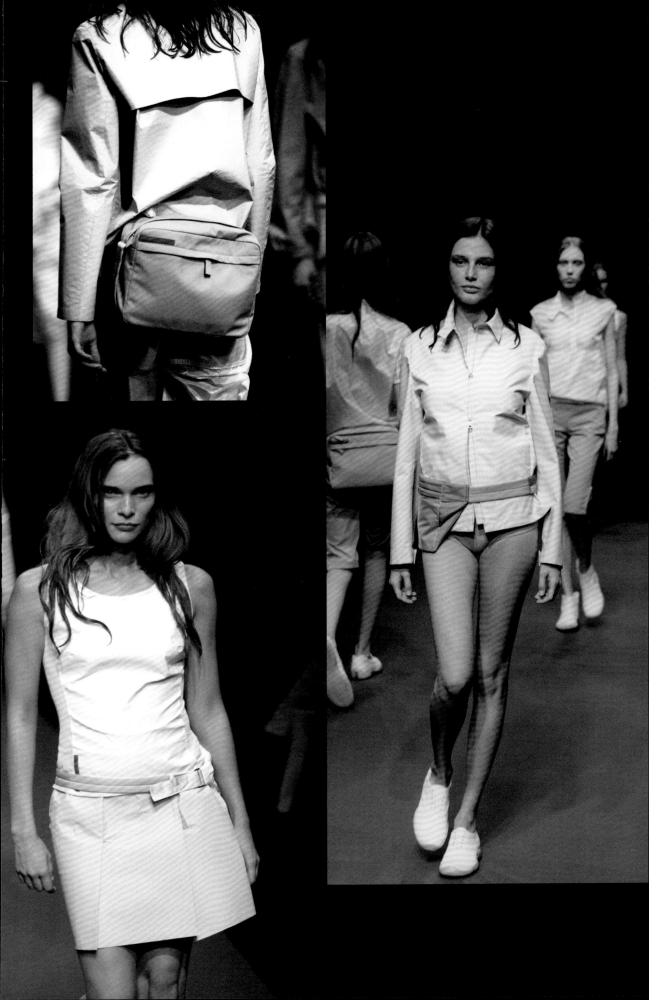

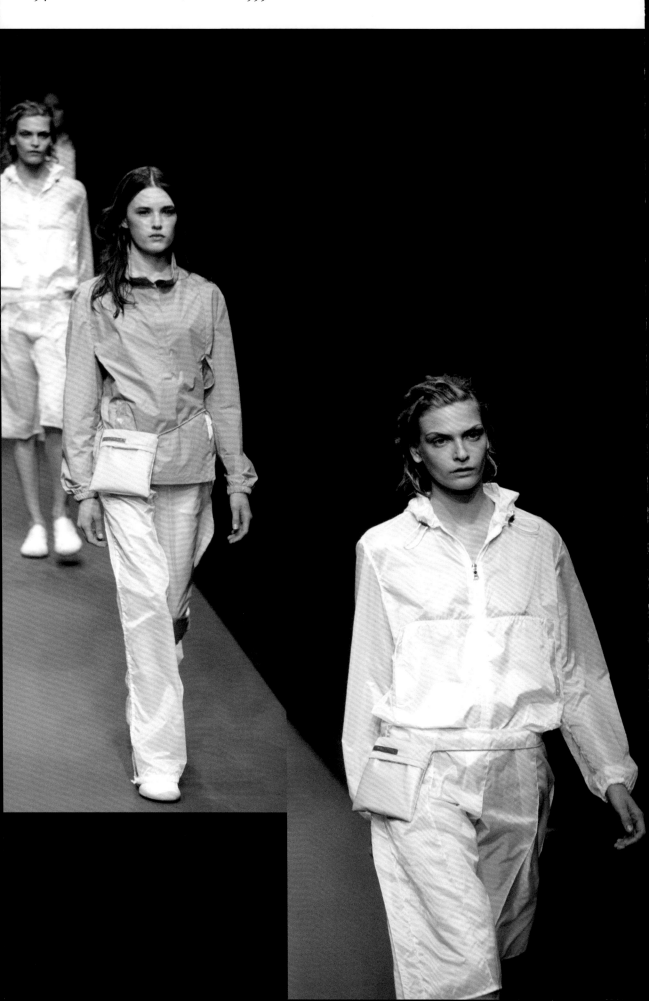

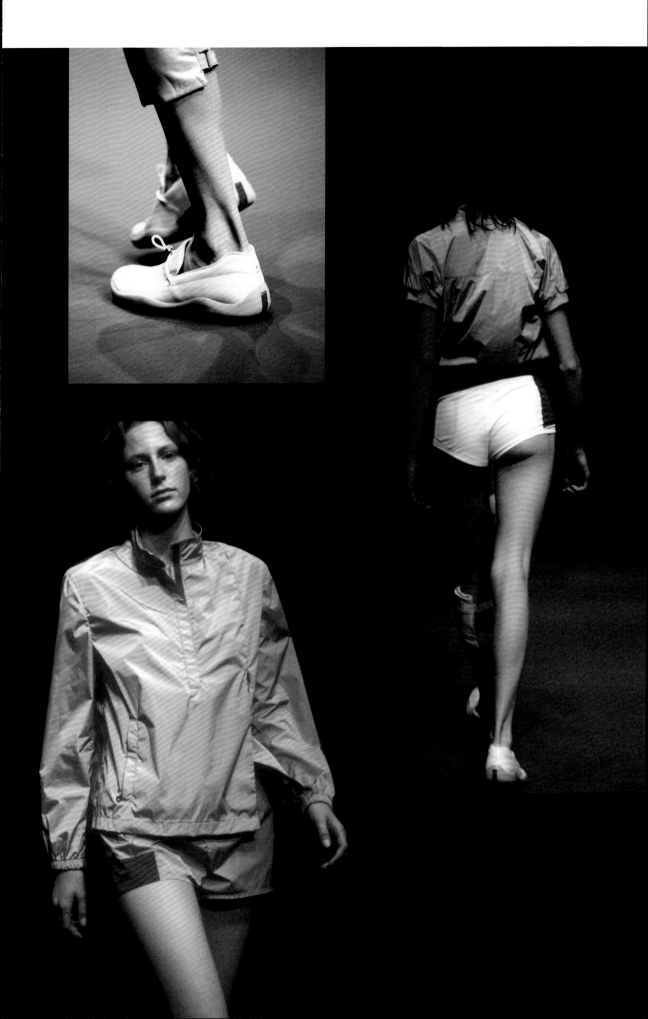

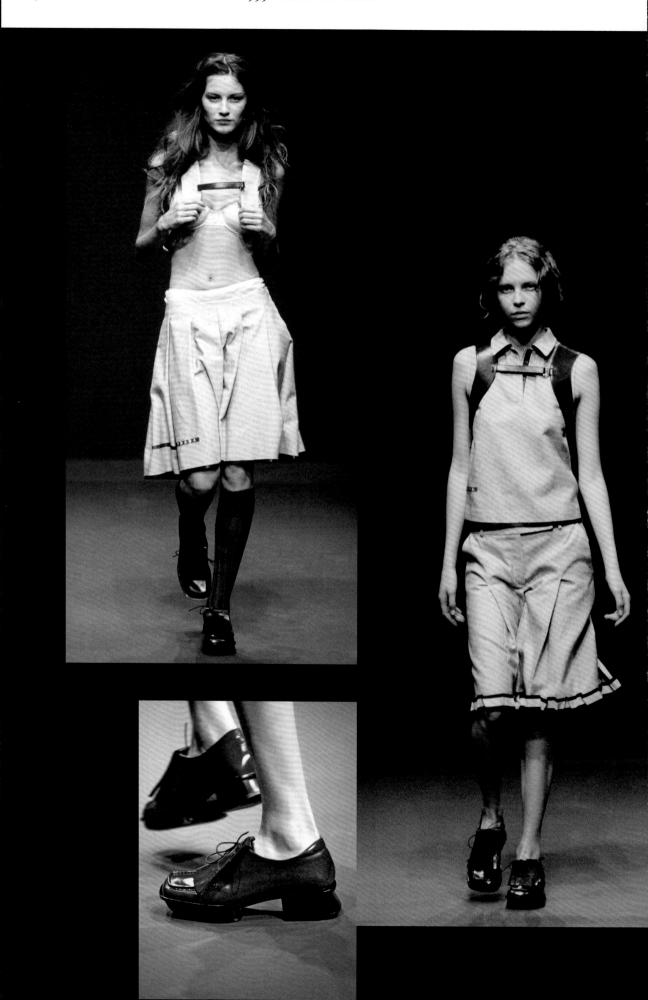

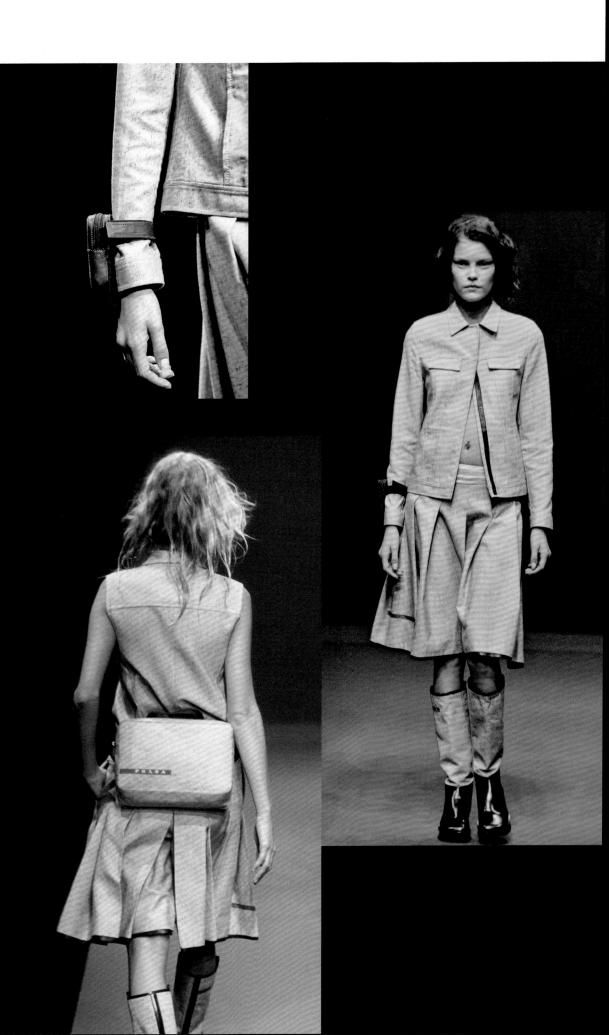

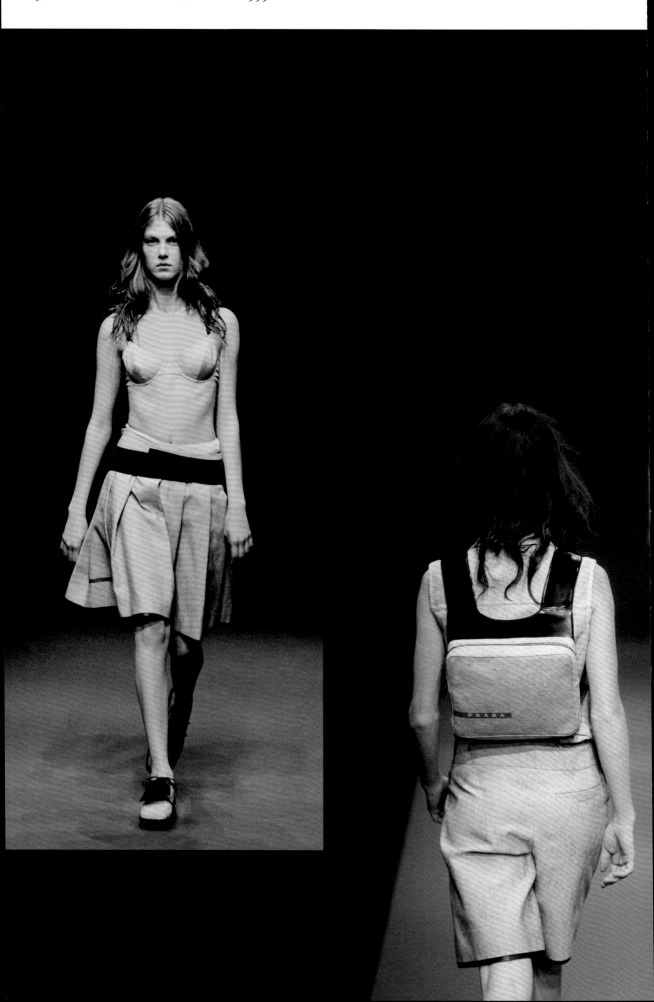

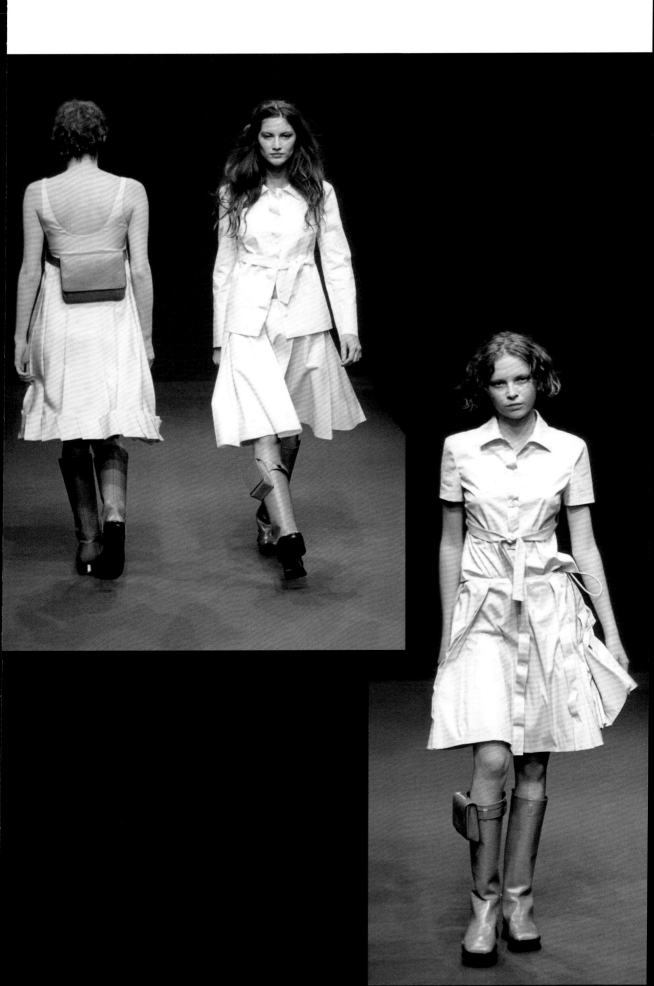

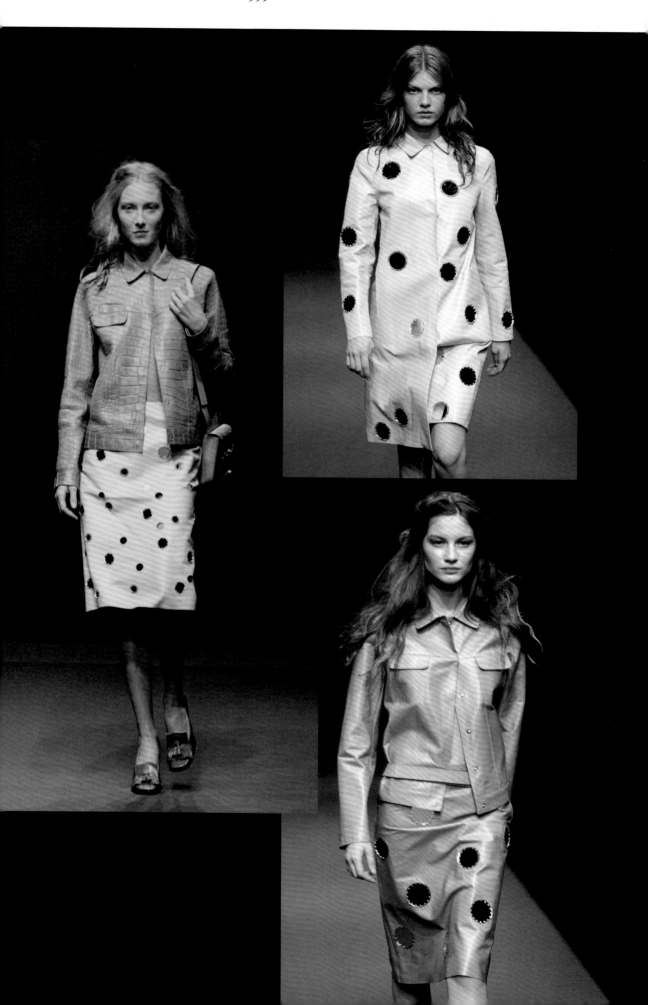

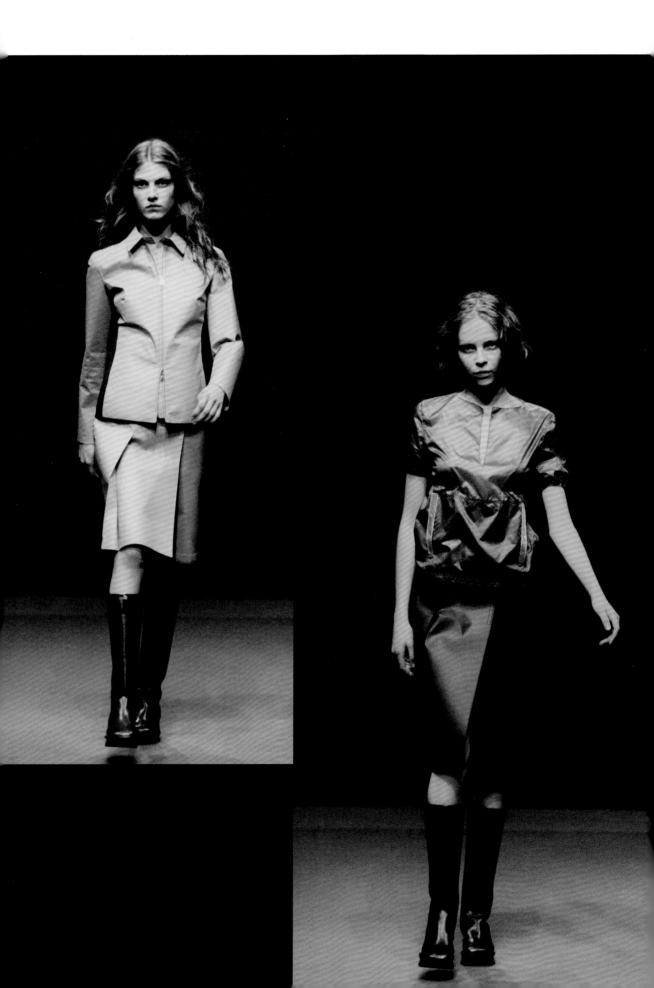

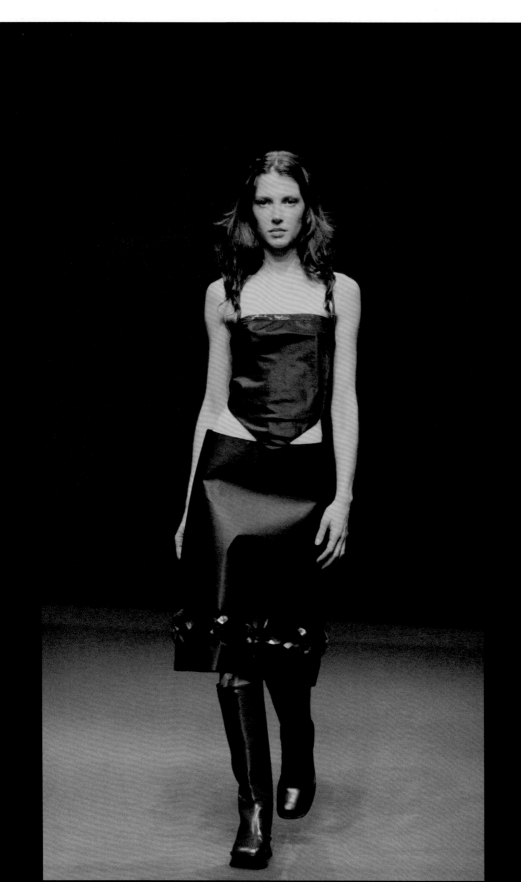

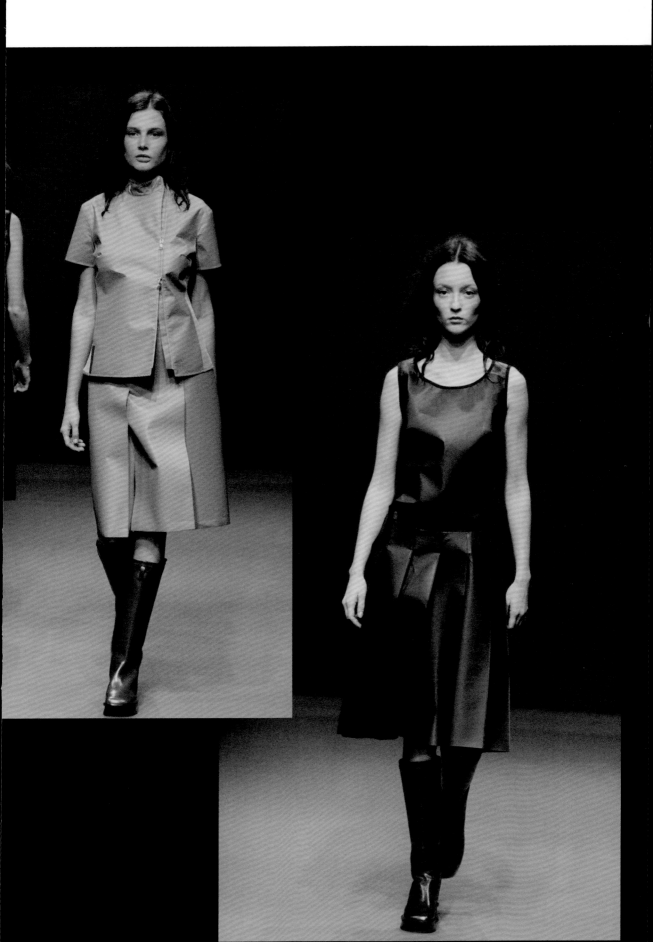

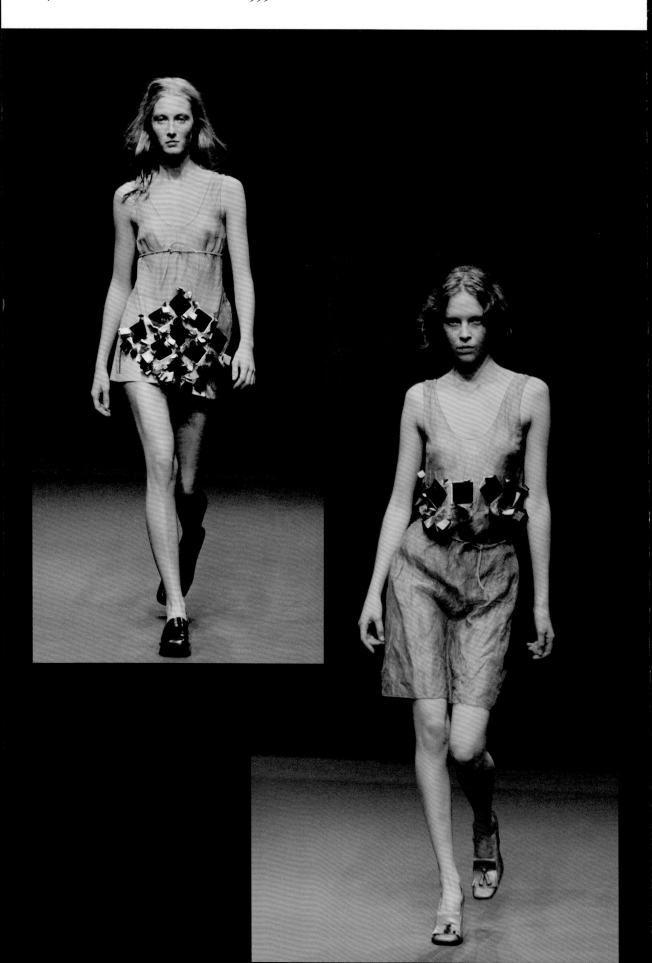

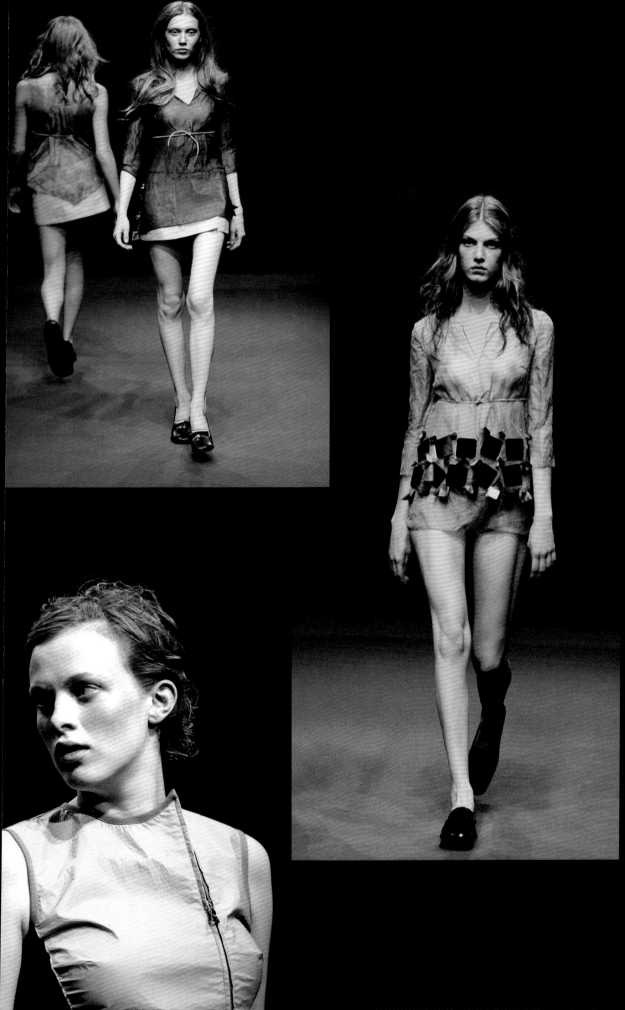

The tension between function and fantasy continued
for the Autumn/Winter 1999–2000 season with
a collection that was quintessential Prada from the
jewelled chiffon coats and jackets with neat pointed
collars, belted at the waist with slim bands of leather
(right and opposite, below left), through the zip-
fronted khaki sweaters and matching track pants
(p. 208), to the strange colouration, square toes and
high sculptural heels of models' boots. A contrast
between an almost pastoral beauty (leaf and petal
embroideries) and an essentially urban and artificial
one (luxurious parkas and gilets in technical fabrics)
was evident also.

As well as offering new silhouettes – a midriff-baring
bib-fronted harness with slim elastic straps, a straight
skirt that fell to the knee and was split up one side
to the thigh, a low-rise boot-cut pant that hit the
floor – Prada's skills as a colourist were here on a
high: vibrant lilac, pink and orange punctuated an
otherwise autumnal palette of emerald, forest and
olive green.

While models came down the runway one minute
in the simple separates Prada was still more widely
known for – short A-line minis and neat little jackets
with barely a fastening to be seen – the next their
appearance was more artsy babes in the wood. A
duffle coat was embroidered with the aforementioned
foliage (p. 213), a sleeveless astrakhan maxi-coat
was the ultimate luxe camouflage (p. 215, right),
and supple suedes and crystal-encrusted wools and
silks were further appliquéd with stylized flowers.

With the new millennium dawning, Miuccia Prada
continued to drive fashion forward. This runway
was more replete with ideas and intelligence, as far
as their realization was concerned, than any other
designer's of the age.

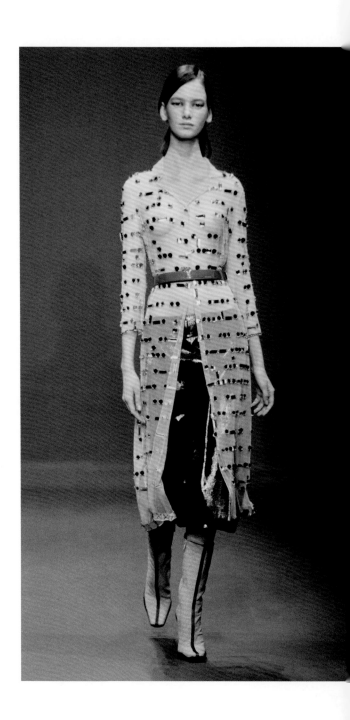

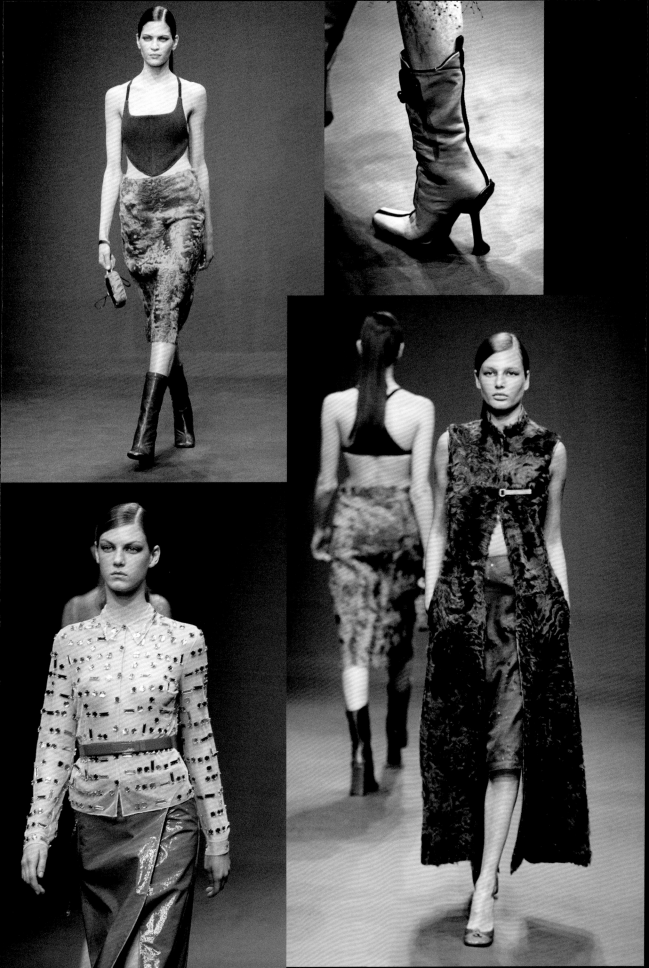

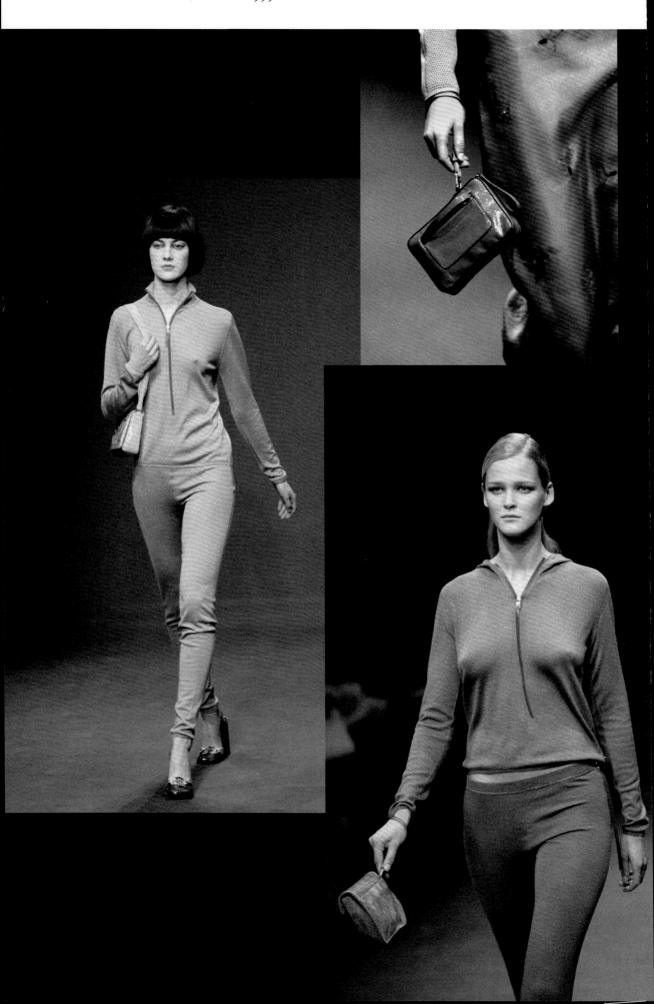

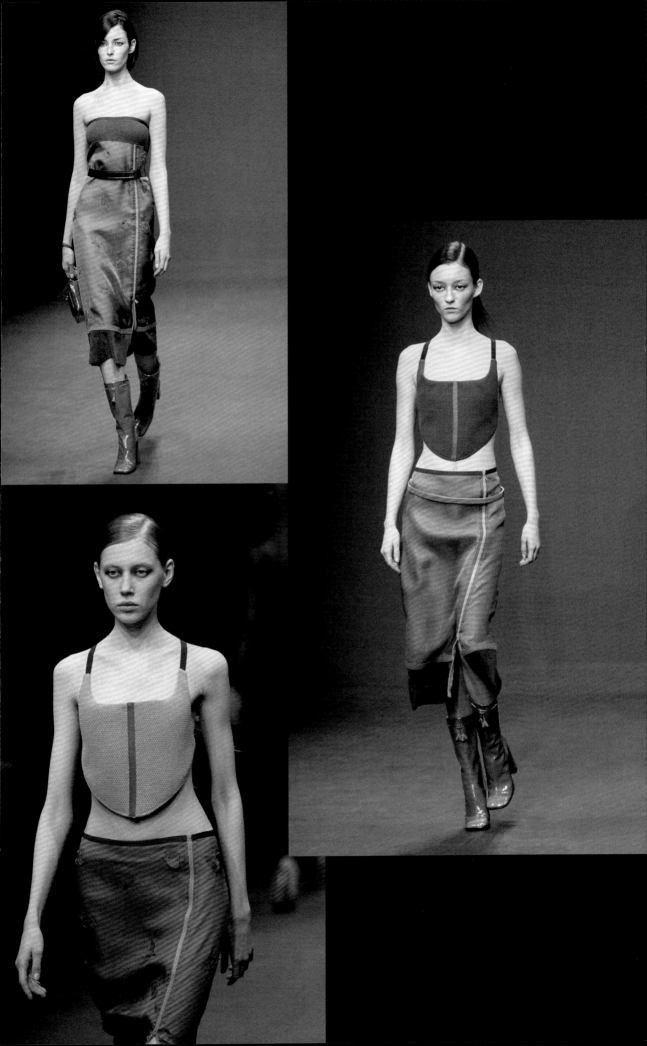

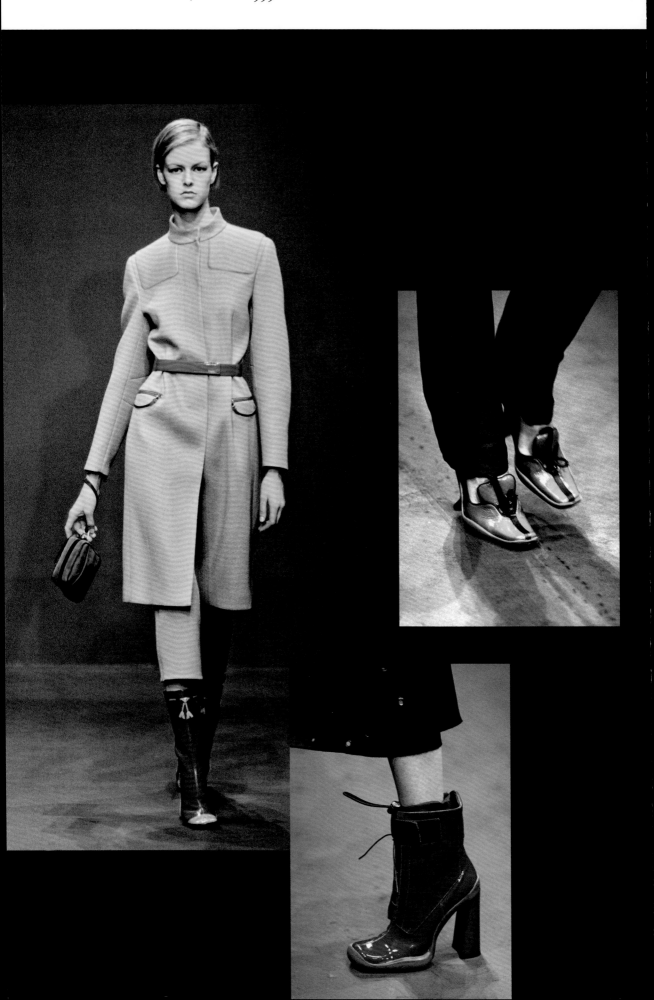

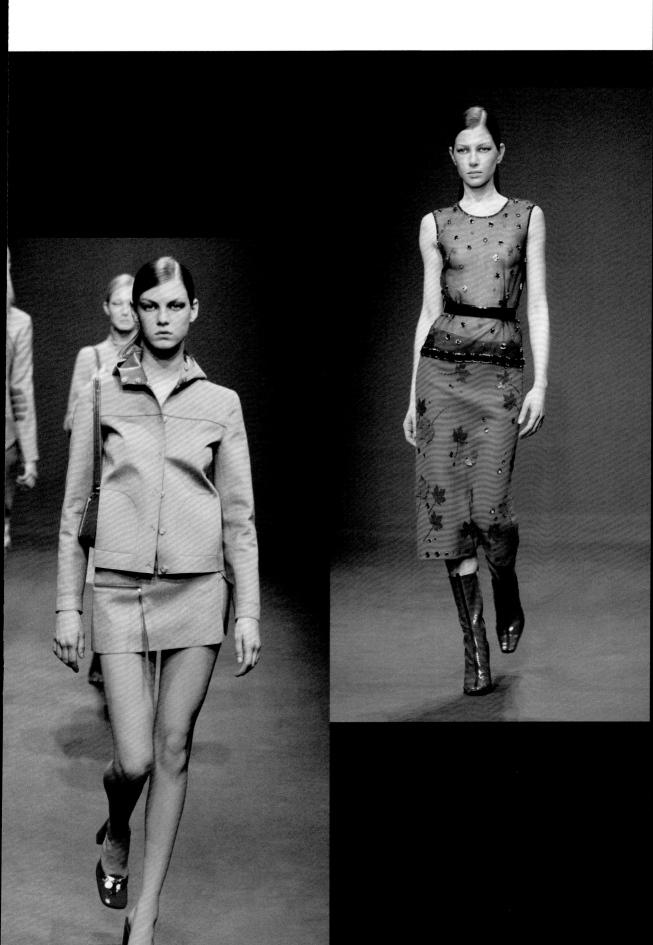

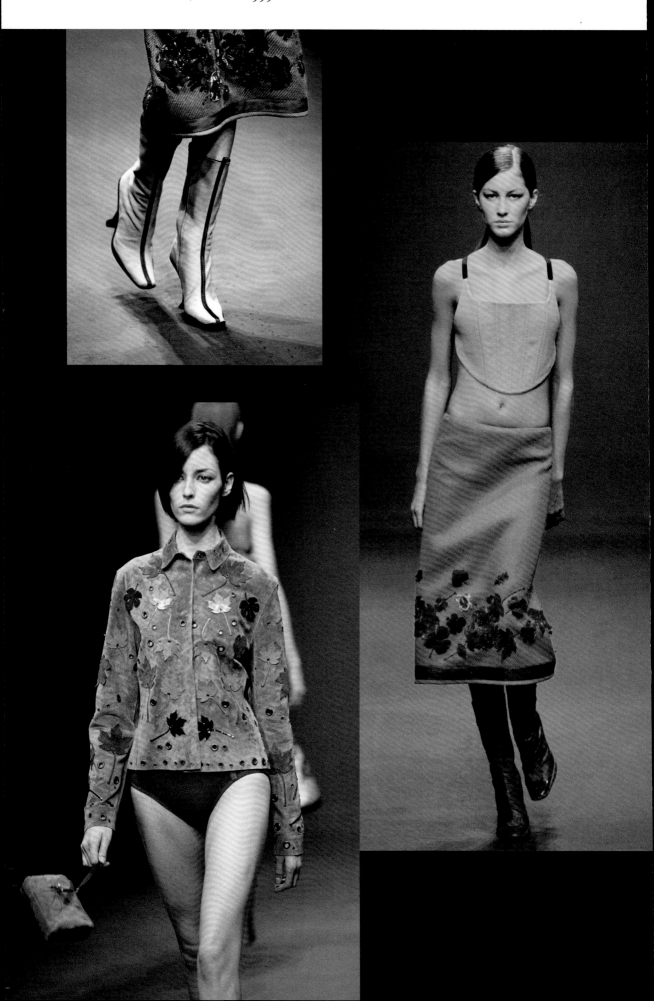

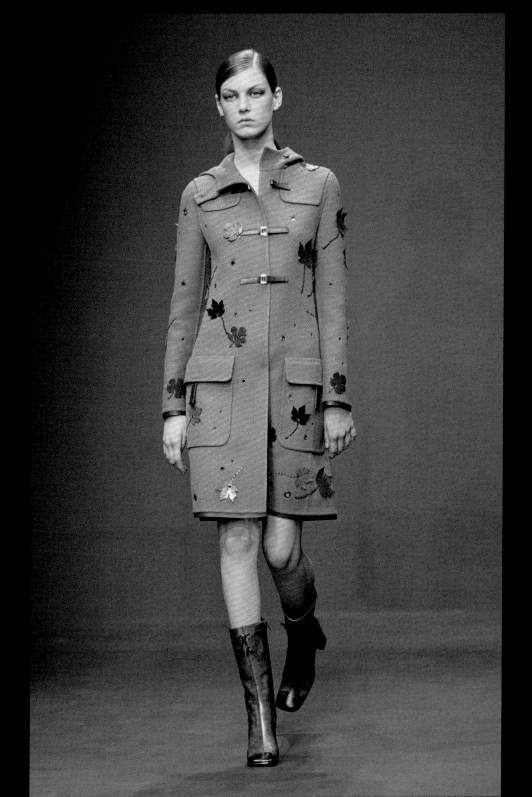

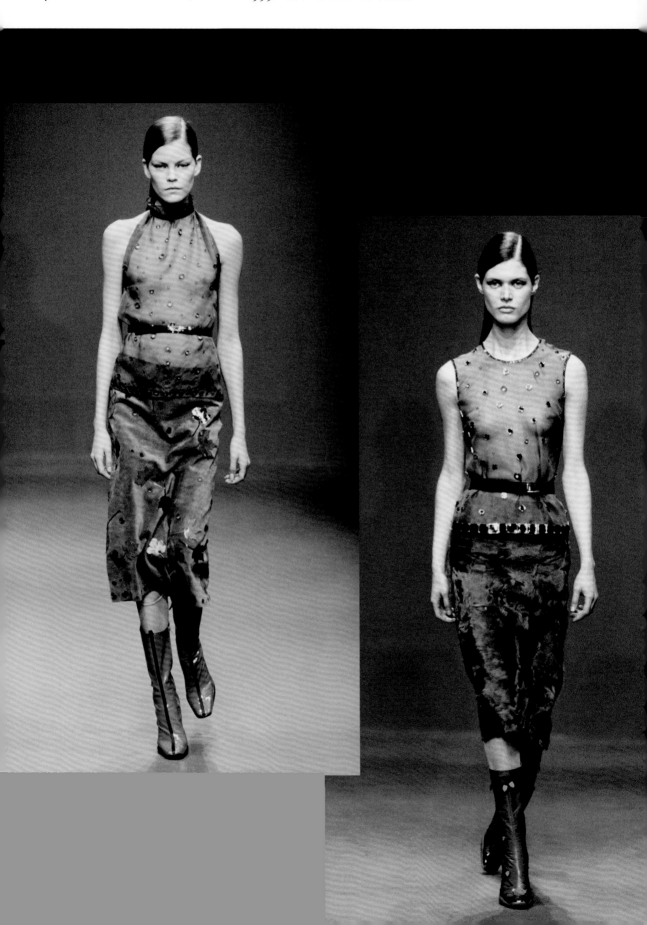

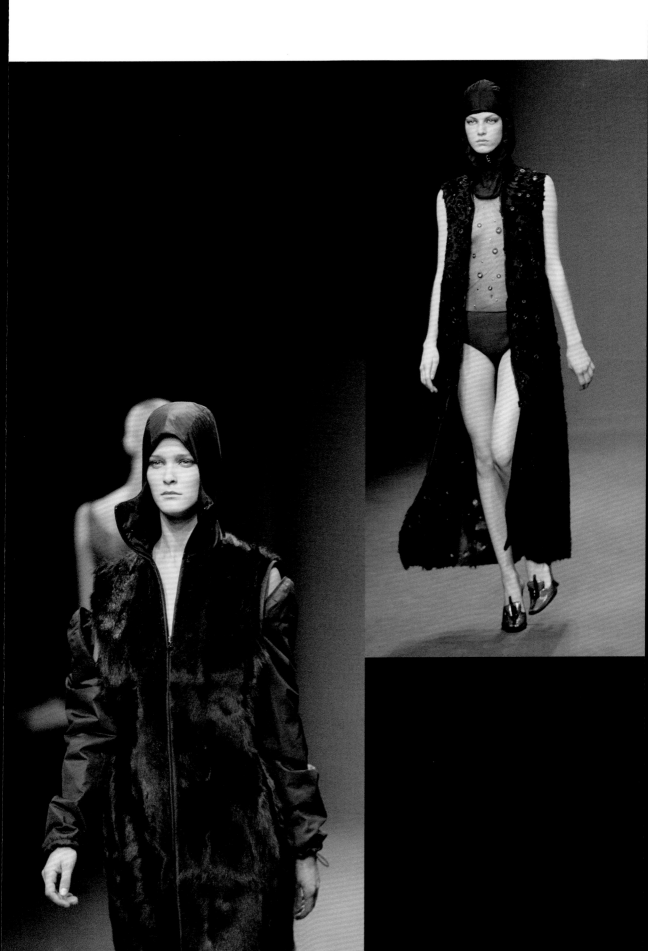

'Sincere chic' read the show notes on this occasion, and not since her Spring/Summer 1996 so-called 'ugly chic' collection (see p. 134) had Miuccia Prada made such waves. If a radical conservatism had been part of her story even in the early days, here the fact that, as a fully signed up member of the Italian Communist Party, she had worn Yves Saint Laurent's Rive Gauche ready-to-wear to feminist rallies in the 1970s rang out loud and clear. 'I was a Communist but being left wing was fashionable then,' she told the *Independent*. 'I was no different from thousands of middle-class kids.'

Backstage, after the show, she told *Women's Wear Daily*, 'This was the only new thing possible. Super chic, very ladylike. In the past I've done so much experimentation but you can only go so far. I didn't want to push myself into being unnatural.'

And, for Miuccia Prada – who grew up surrounded by the best possible taste, but who, in the past, had explored and battled with that as if her existence depended upon it – this was, by contrast, the most natural thing in the world. Pussy-bow blouses, mouth and lipstick prints, little black dresses, tan and lavender ostrich leather suits, skinny sweaters over knee-length pleated chiffon skirts: all nodded to the master of late twentieth-century fashion's vocabulary, and to the wardrobe he created for Catherine Deneuve in the 1967 Luis Buñuel classic *Belle de Jour* in particular. Prada had long been an open admirer of Saint Laurent's work – after all, who in fashion isn't – but few have such a profound understanding of his aesthetic.

Of course, this was more than mere pastiche: proportions were discreetly new (those silk skirts were cut to be worn low-slung on the waist, for example), prints were sketchy or blurred (disorienting, and perhaps not so 'sincere' for that), and all of it was undercut by time-honoured Prada-isms – knitted playshorts and schoolboy Bermudas, lingerie-inspired chiffon dresses and more. Still, in the end, this was a brilliant tribute to the bourgeois French wardrobe, however twisted. With that in mind, fine-gauge knit cardigans were worn over models' shoulders, as were neat leather purses or bi-colour bowling bags; shoes included classic courts.

'I used to wear Saint Laurent all the time,' Prada told *AnOther Magazine* in 2017. 'I always liked the bourgeoisie. I was intrigued by the bourgeoisie. But mainly that was the culture of the Sixties and Seventies. Antonioni, Godard, Buñuel.'

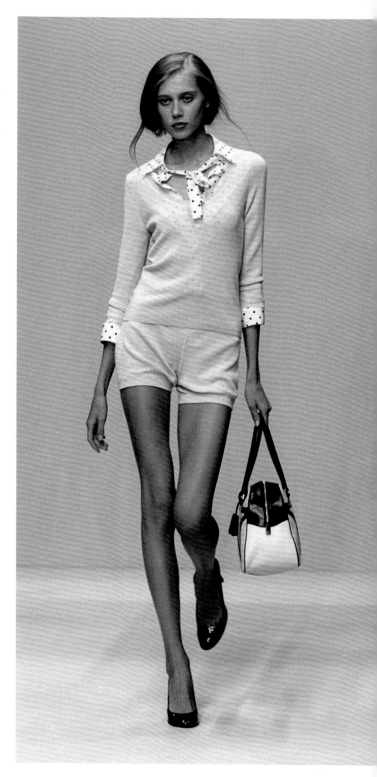

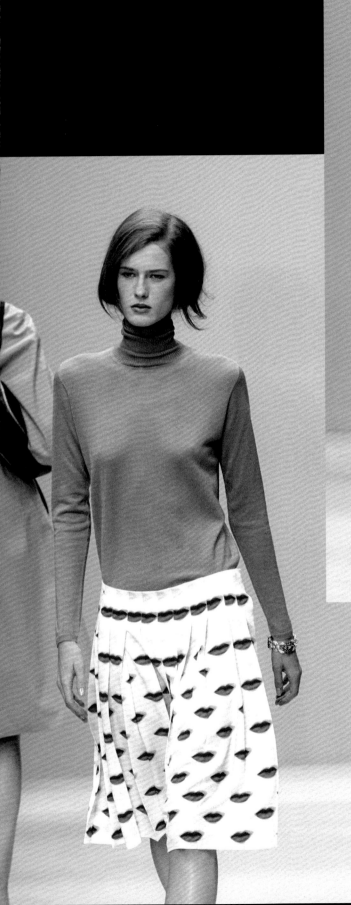
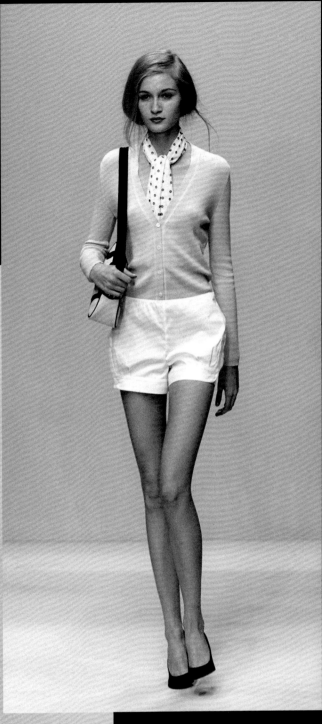

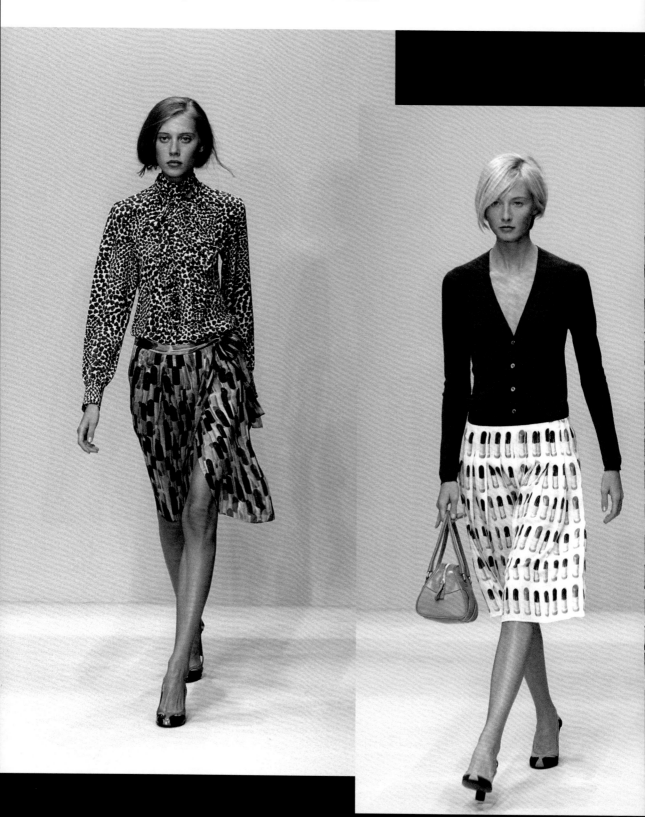

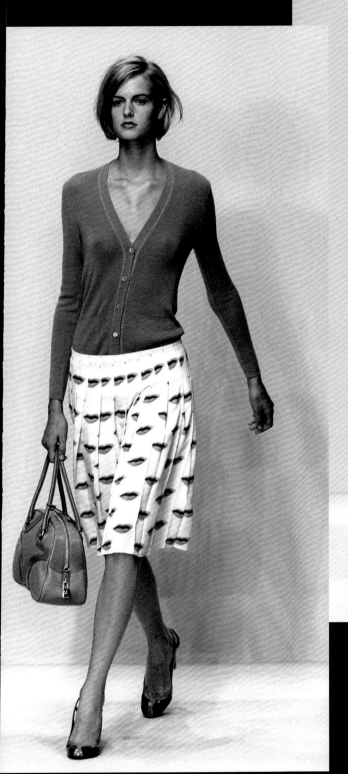
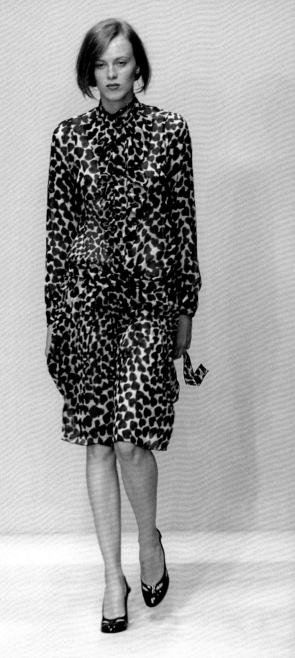

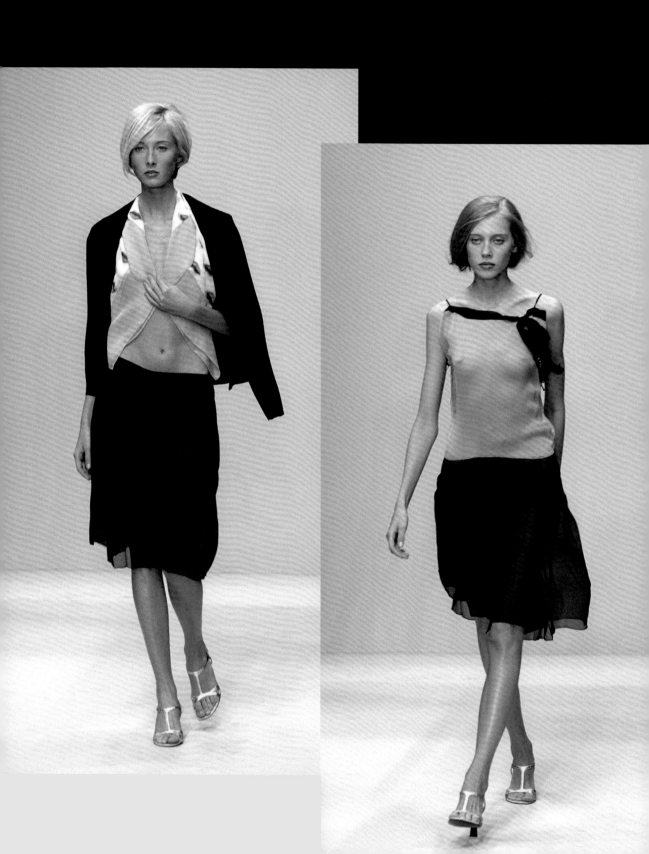

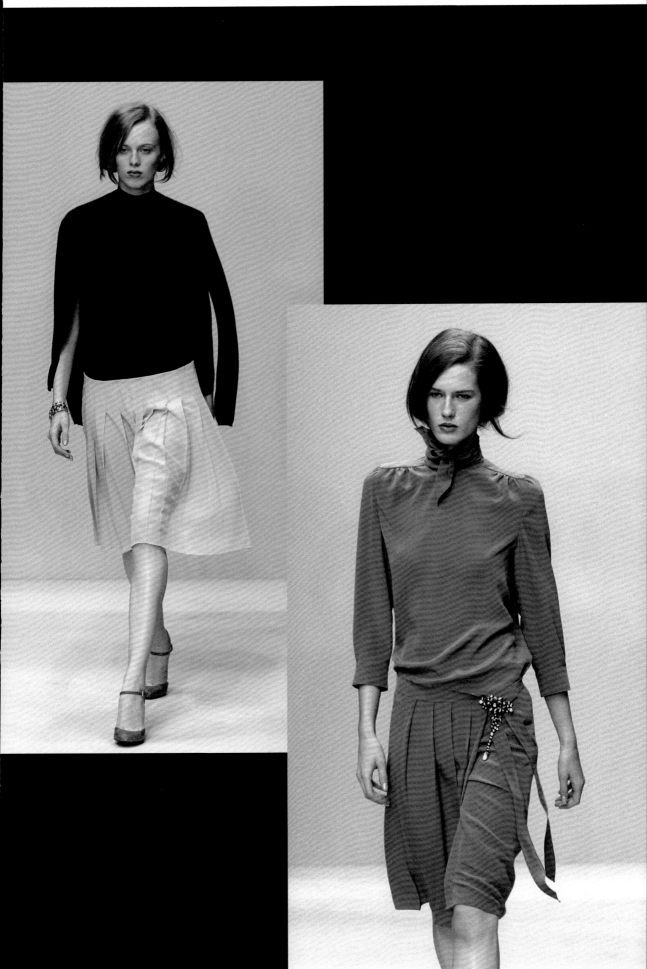

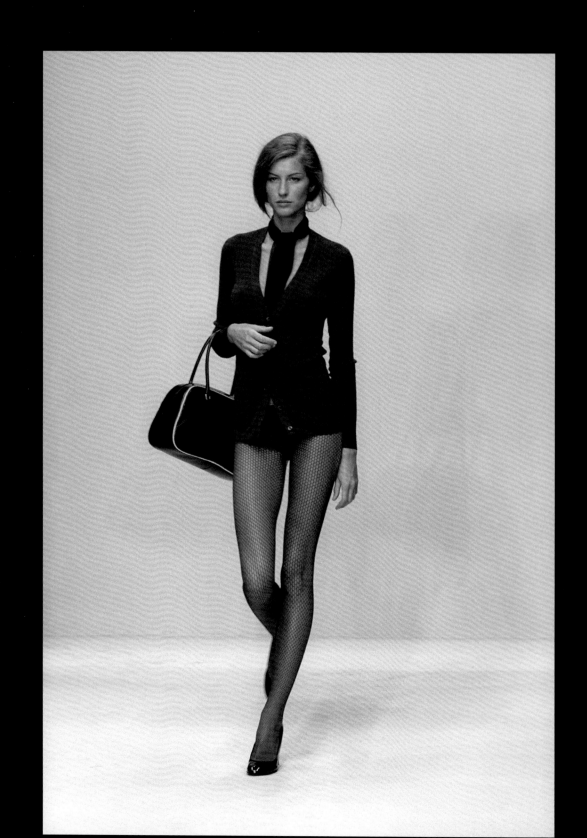

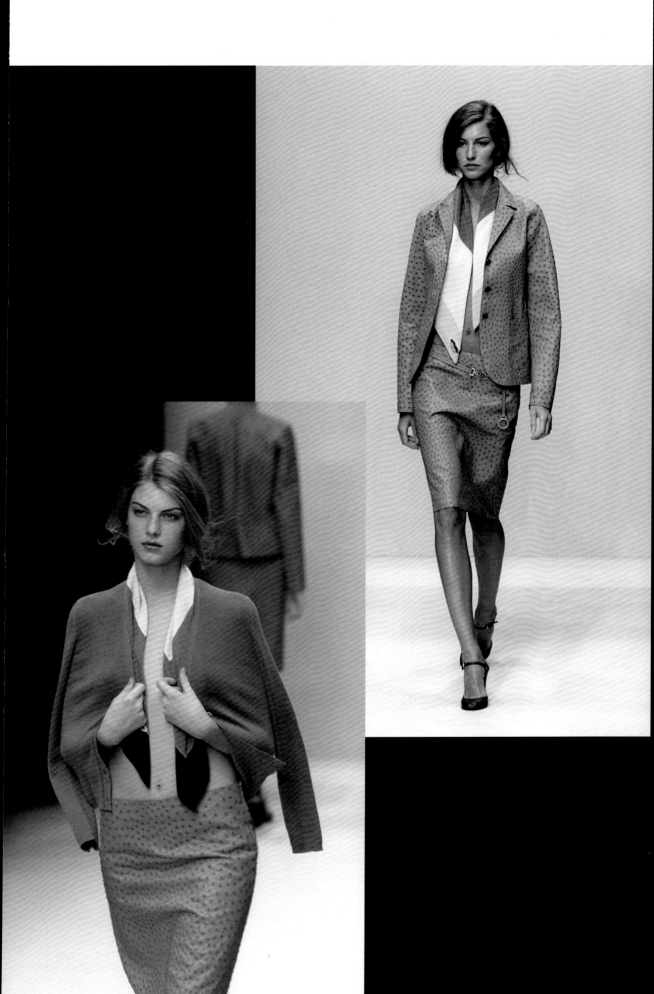

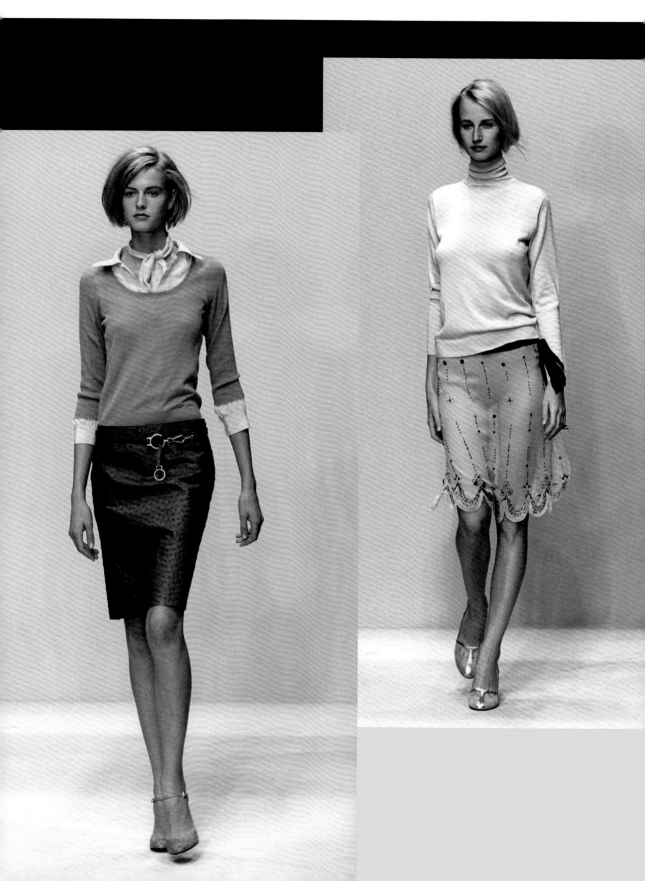

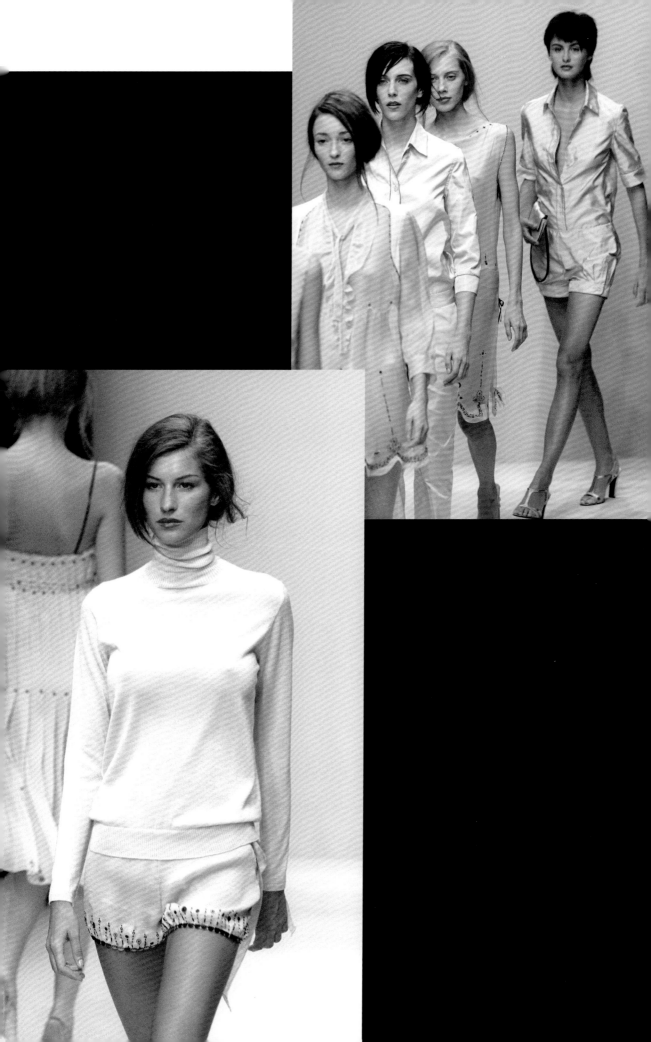

The impact of the Spring/Summer 2000 'sincere chic'
collection (see p. 216) decreed that it was now not just
acceptable but fashionable for a woman to dress like
her mother, or even grandmother – the more ladylike
the better. For Autumn/Winter 2000–2001, Prada, not
insignificantly, and famously like Yves Saint Laurent
before her, seemed to mine the 1940s for inspiration,
offering up an elegantly bohemian collection that
was more haute make-do-and-mend than grande
bourgeoise in flavour. With grosgrain ribbons –
the kind that used to be found on the waistbands of
skirts – tied into little bows for belts, and fur tippets
across the shoulders, the relative formality of Spring/
Summer was here replaced with a celebration of
individuality, a sense that the woman in these clothes
was free to wear them exactly how she wanted to,
free to style herself.

There was a narrowness to the silhouette – to
curvaceous single-breasted jackets and knee-length
pencil skirts – that spoke of the age of austerity and
a utilitarian severity to heavy tweed coats and skirts.
Of course, appearances are deceptive: these clothes
and the workmanship and materials that went into
their creation were anything but poor. This collection
did, however, mark a return to a certain modesty,
a quiet imagined glamour this time reminiscent
of a film noir heroine – a reference that would
make a more blockbuster return later (see p. 480).

For the first season in some time, black was
prominent on the Prada runway, as was tailoring.
Still, that was softened by embroidered chiffon tea
dresses and by an end sequence of liquid sequinned
designs with deep V-necklines in shimmering silver
and brown (pp. 234–35), the hemlines of which were
delicately frayed.

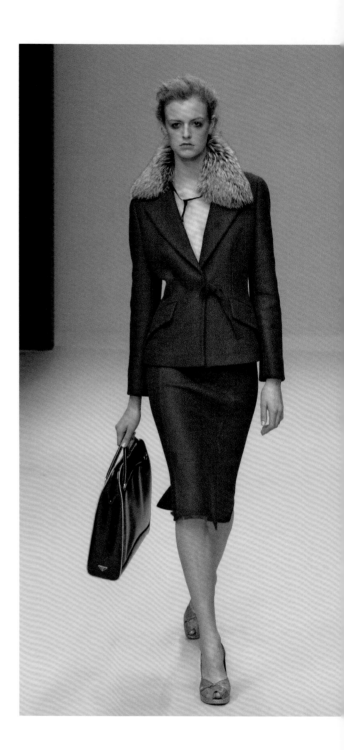

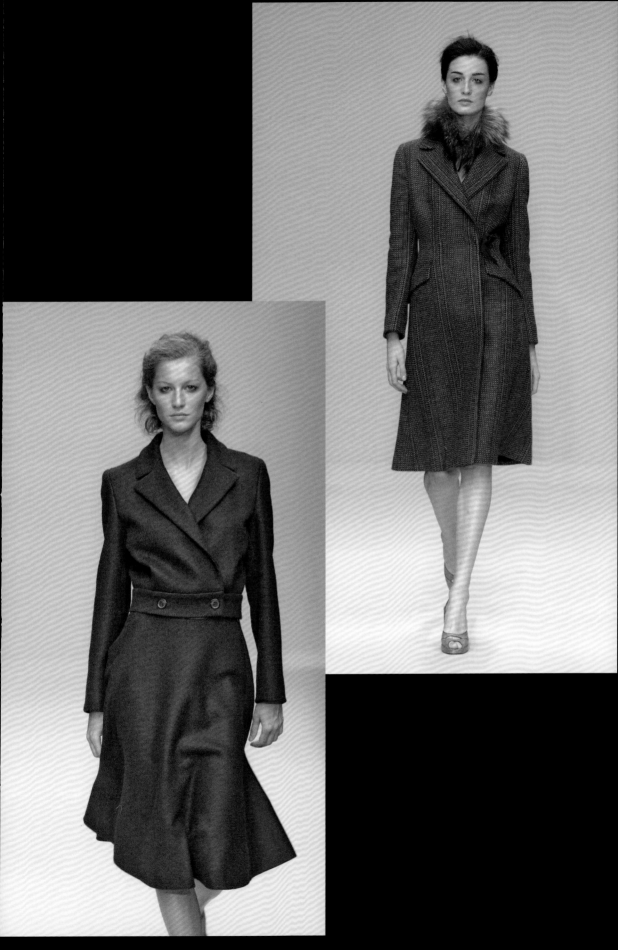

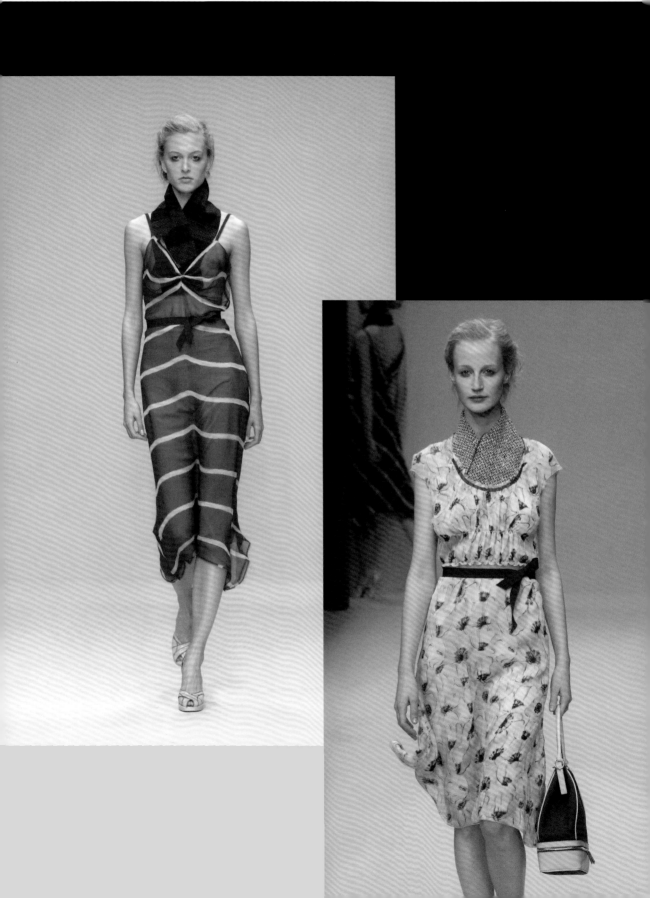

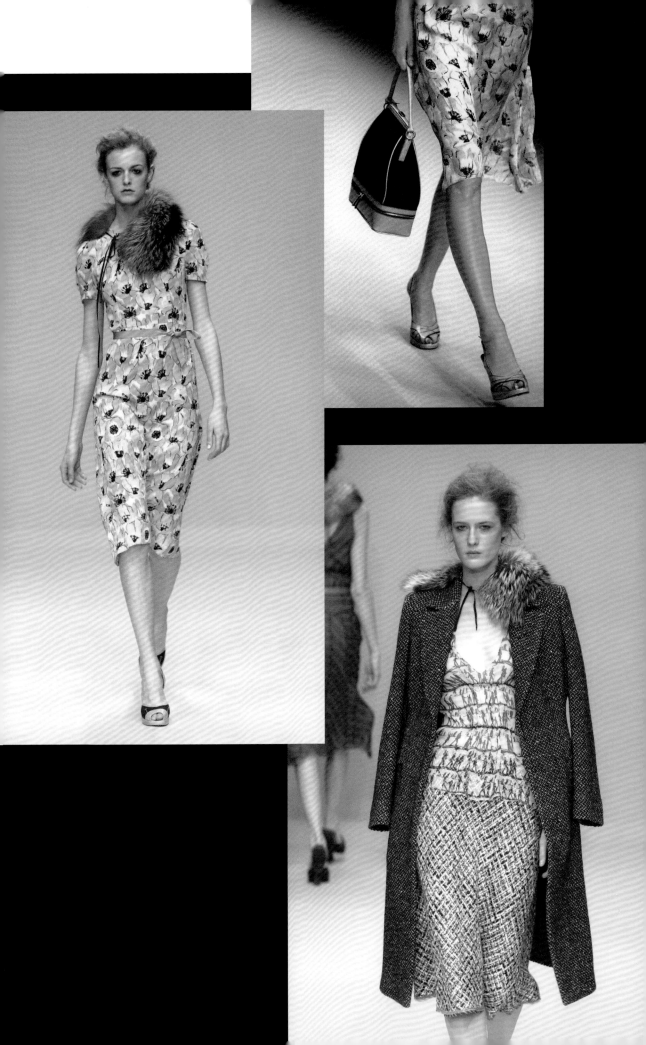

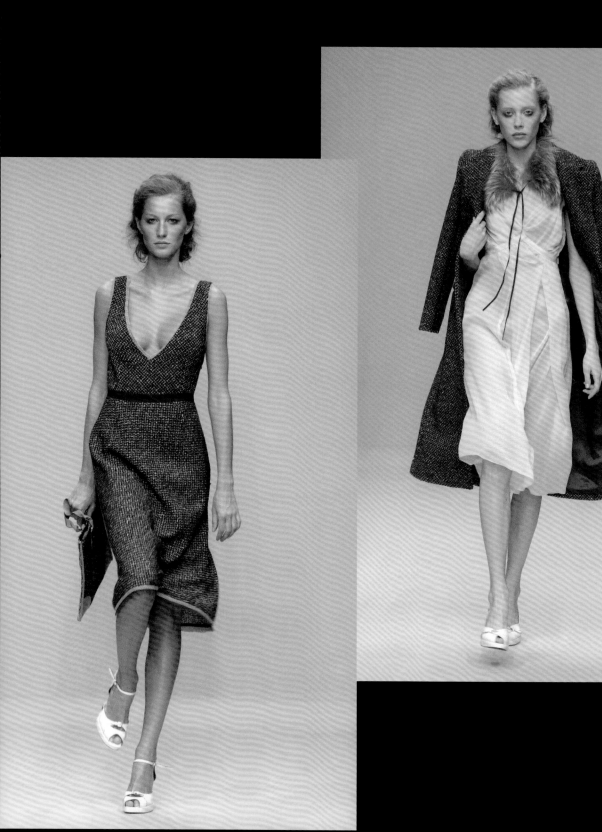

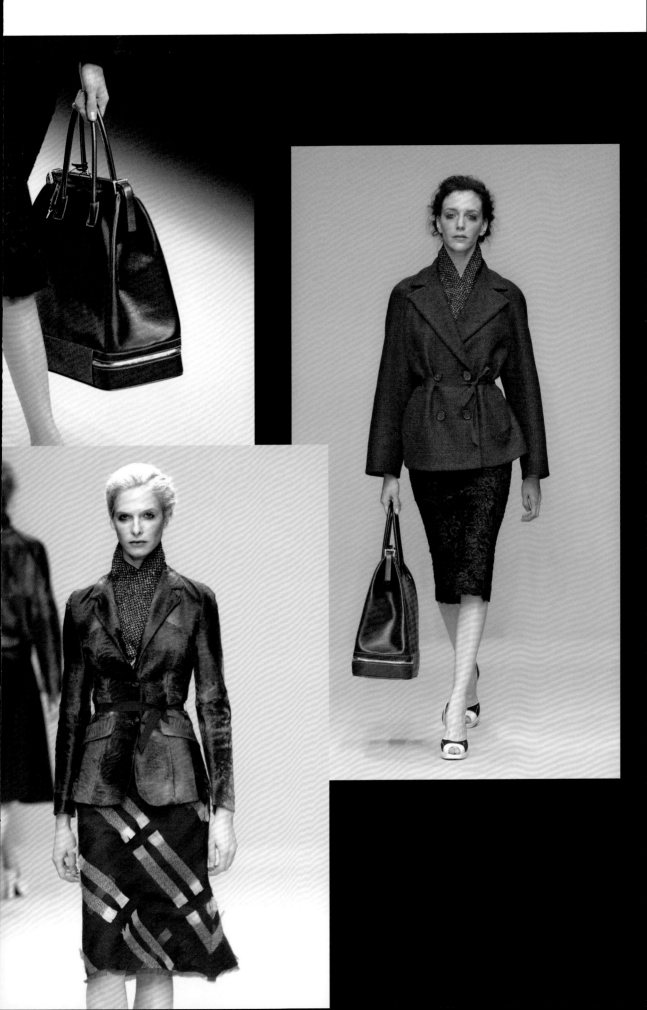

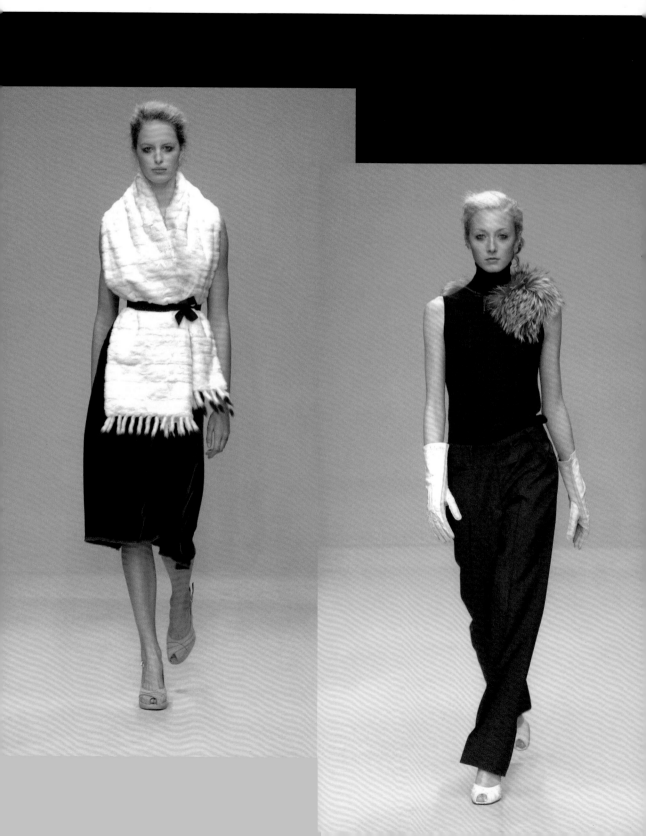

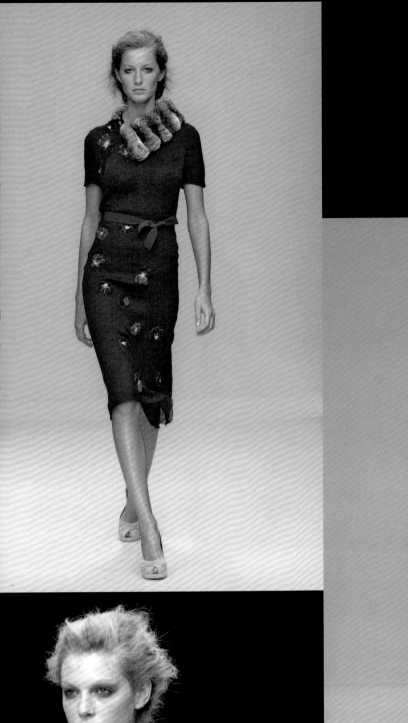
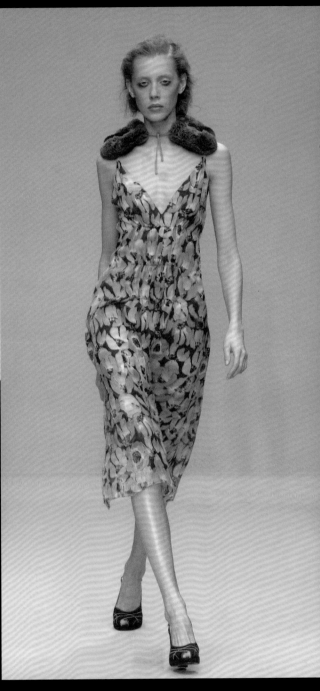
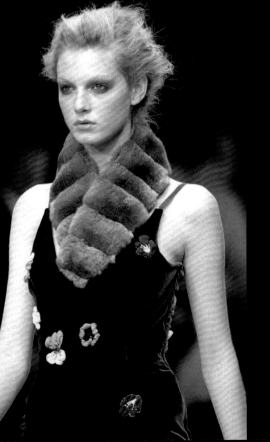

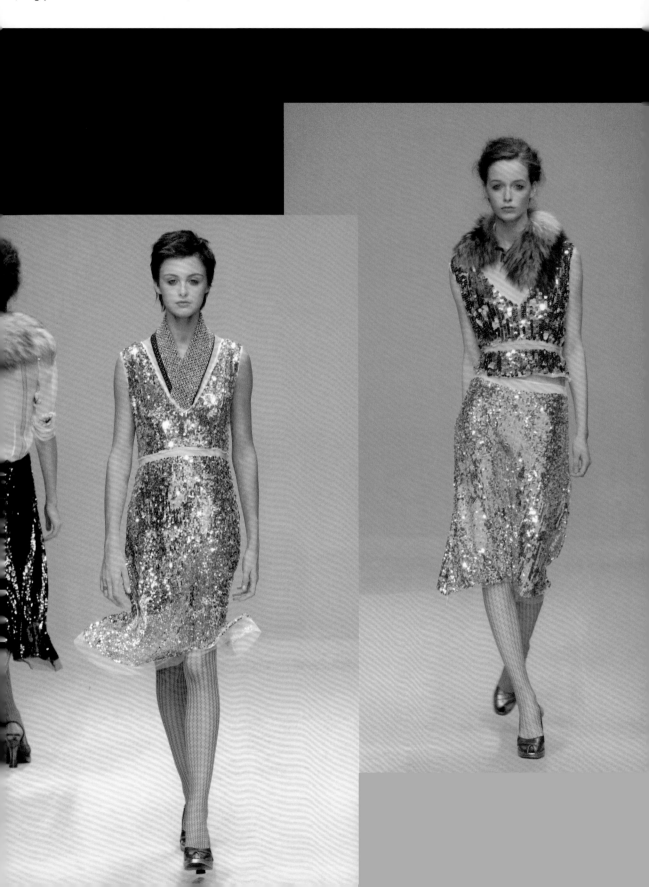

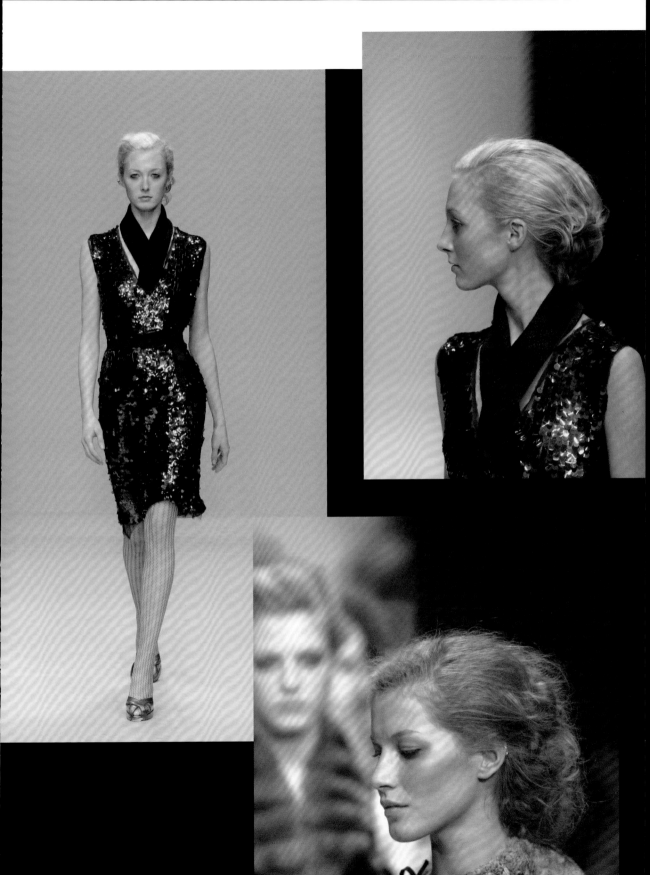

'The moment you start being in love with what you're doing and thinking it's beautiful or rich, then you're in danger,' Miuccia Prada told Cathy Horyn of the *New York Times* before this season's collection was shown. 'You have to always work against what you did before and even against your own taste.'

In this instance, she was referring to the 1980s, not a decade she was espoused to, having consciously kicked back against it when her career as a ready-to-wear designer started. Still, she was looking at it here. It was certainly interesting to see her spin on the type of all-black shirt and full skirt combinations (worn, incidentally, with black wool socks and shoes) that were central to the avant-garde aesthetic of that period.

For all her allegiance to humble fabrications and a look that no one would describe as pretty, the designer was, once again, entering a new phase. 'Ms Prada is ... a person whose moods swing as abruptly as a child's,' Horyn reported. 'Give her too many pretty sequins and she is bawling for dull cloth. After the show, some people read into the clothes a sinister degree of manipulation, as if by proposing something as banal as a polo shirt with a slim jersey skirt and showing only one style of shoe – a black pump with a conical heel – she was jerking everyone's chain. It should come as news to no one in the fashion industry that Miuccia Prada is jerking everyone's chain. But don't look for complex motives. Ms Prada did an about-face because she has always clicked between rich- and poor-looking clothes and because she was bored.'

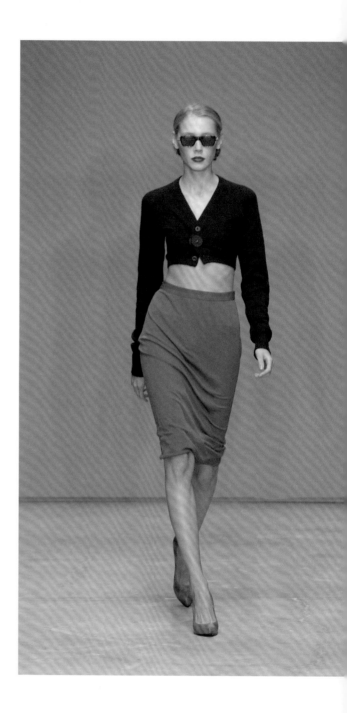

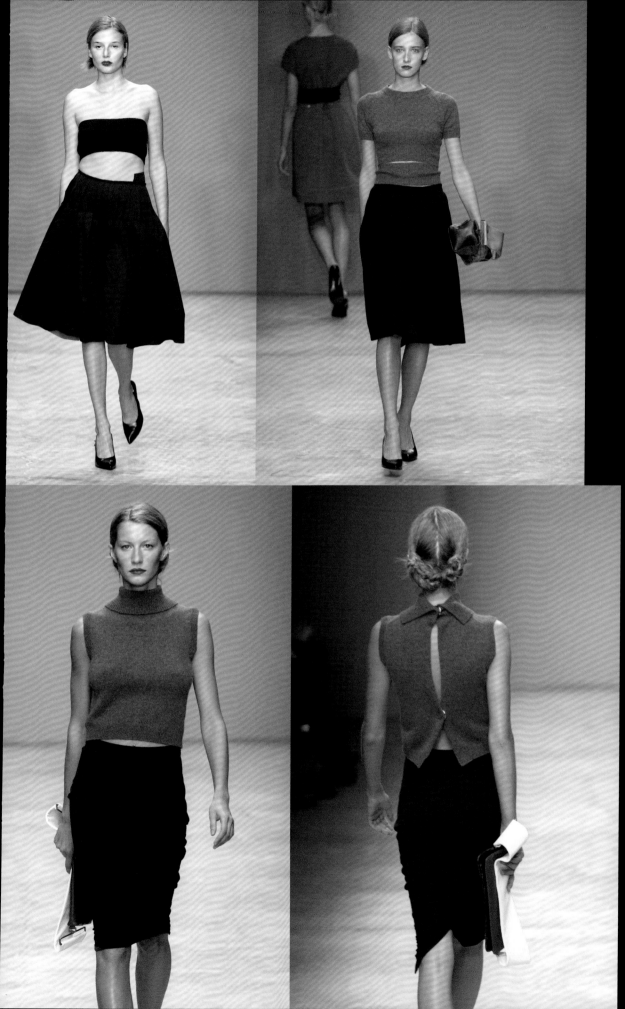

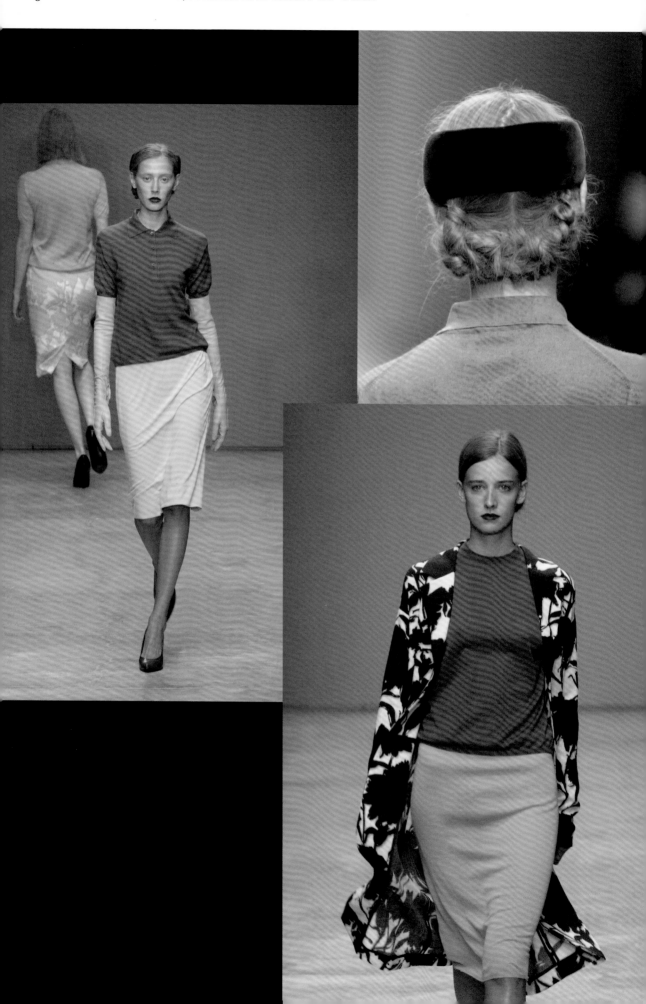

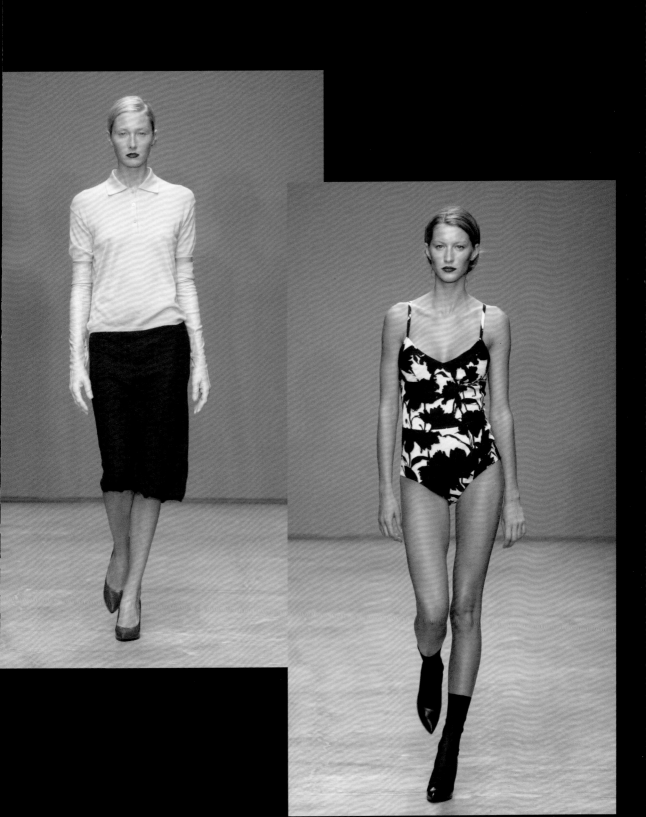

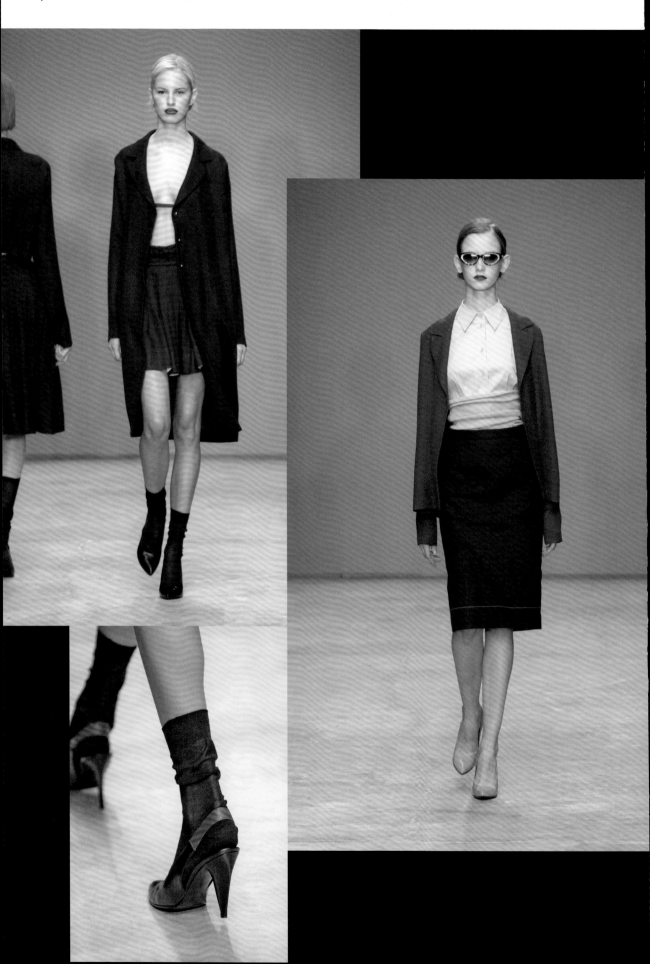

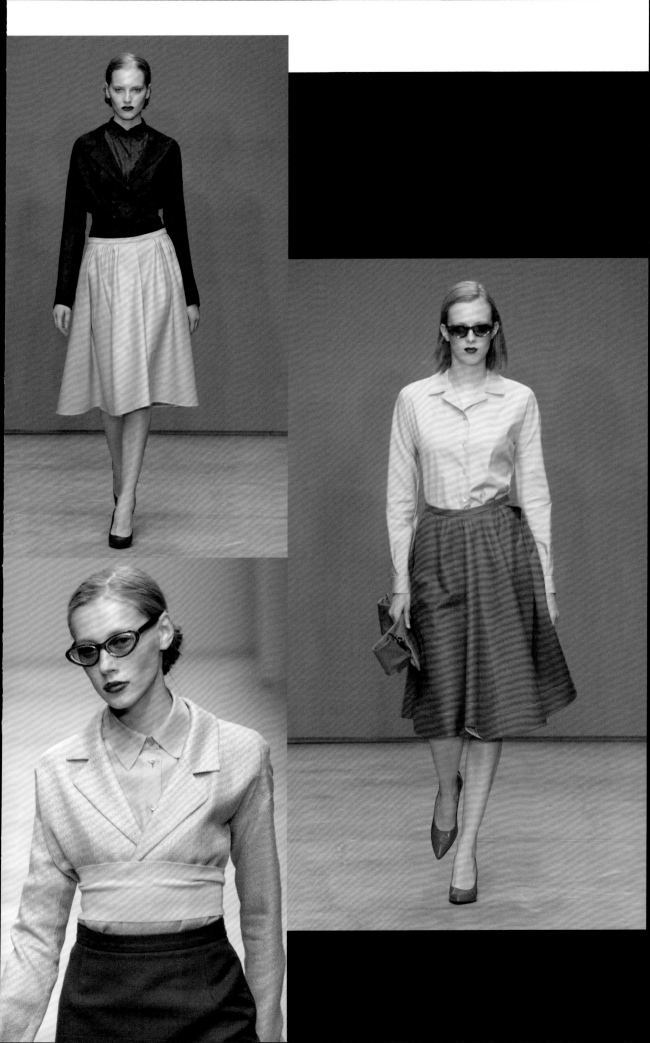

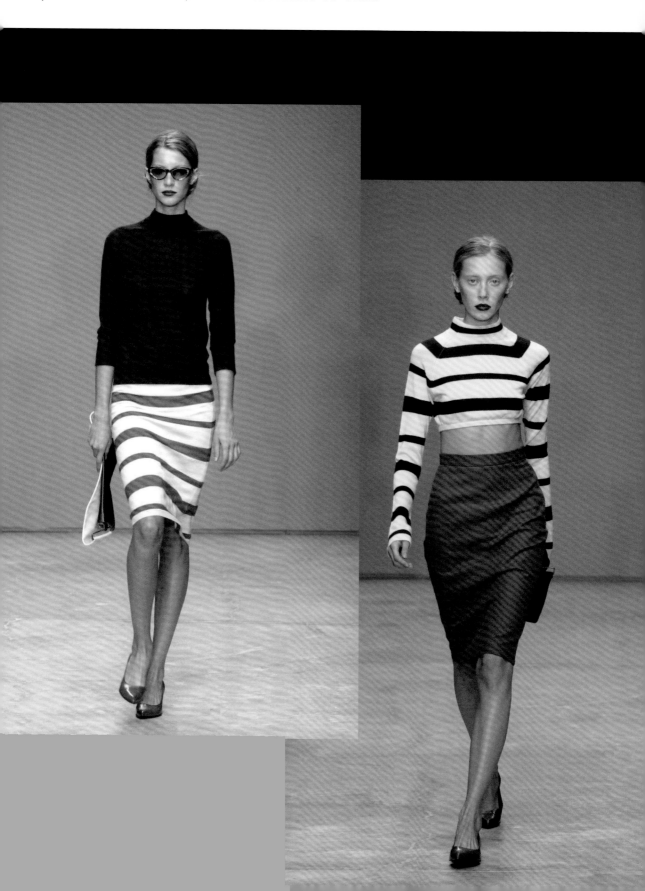

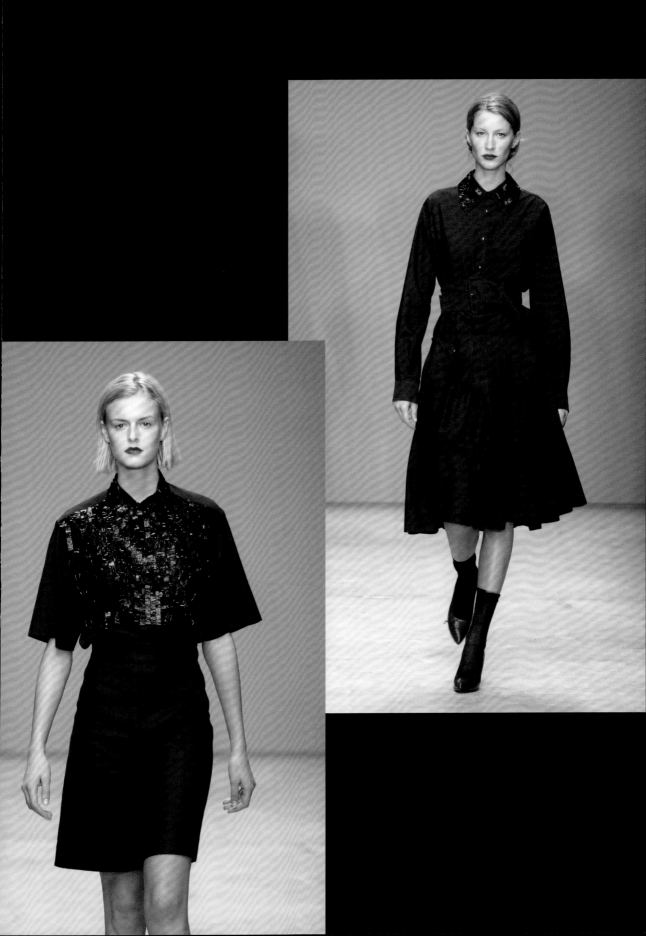

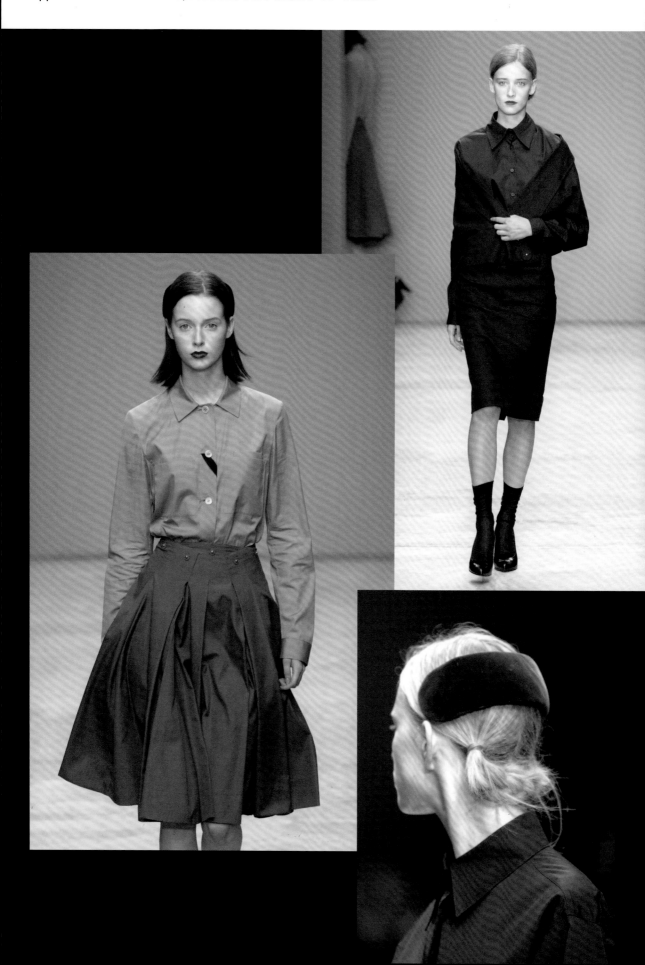

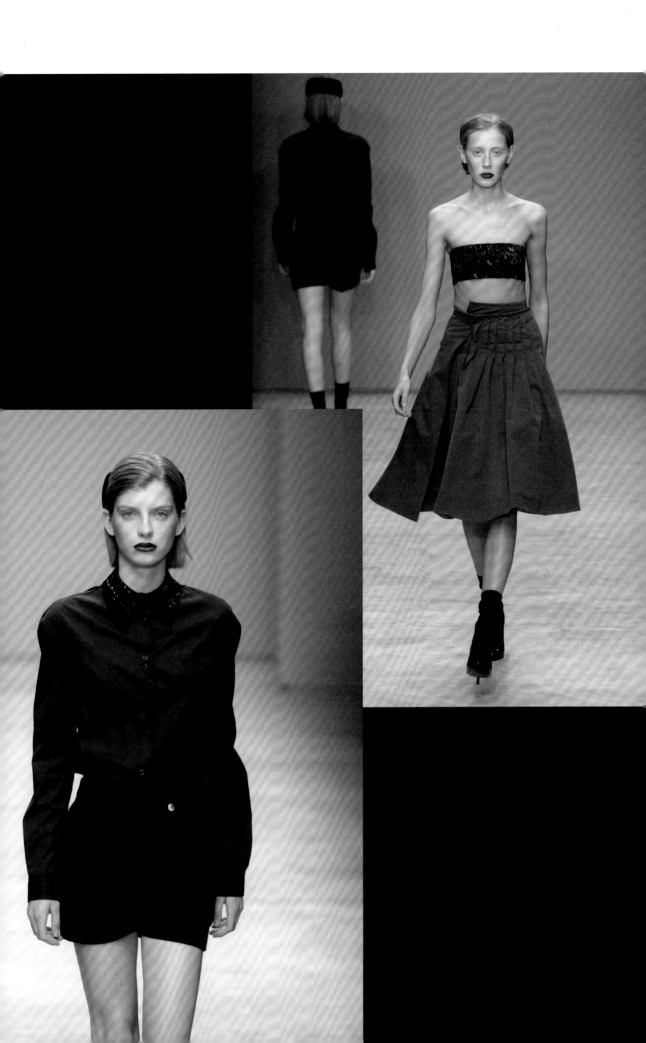

Prada's return to sobriety continued for Autumn/
Winter 2001–2002 with a collection that saw the
designer reinterpreting many of her own signatures
with an elegance and restraint that was, in its own
dignified way, as lovely as any romantic eccentricity.
'I was attracted to a time when fashion was really
avant-garde,' she said in the *New York Times*,
referring to the 1960s, it seemed, and the designs
of Mary Quant and André Courrèges, which had
long been of interest.

At a time when, elsewhere in her business, she was
shifting perspectives – Rem Koolhaas's designs
for Prada's new concept stores were exhibited post-
show, while Miuccia Prada and Patrizio Bertelli were
also establishing themselves as avid collectors of
contemporary art – that decade ticked the boxes
for many of the obsessions that grounded her. These
included an interest in a childlike silhouette – Mary
Quant played on that, too, seen through the lens of
Edwardian children's wear – and a retro-futuristic
optimism and purity which was always Courrèges'
domain in particular.

'The mood went from schoolgirl to sleek ingénue,'
reported *Women's Wear Daily*, 'the former in pleated
skirts and fabulous empire-line dresses, the latter in
stiff boxy jackets and coats and ribbed leggings that
flared over the shoes like spats.' Again, the colour
palette was dominated by black, this time with jolts
of brown, flame, plum and purple. Luxe flourishes –
an extended fur cuff on a slender knit, a felt crash
helmet or fur hat – were all present and correct also,
and so too was many a money-spinning accessory:
granny boots and patent Mary Janes, textured wool
tights and satchels suspended from sturdy straps.

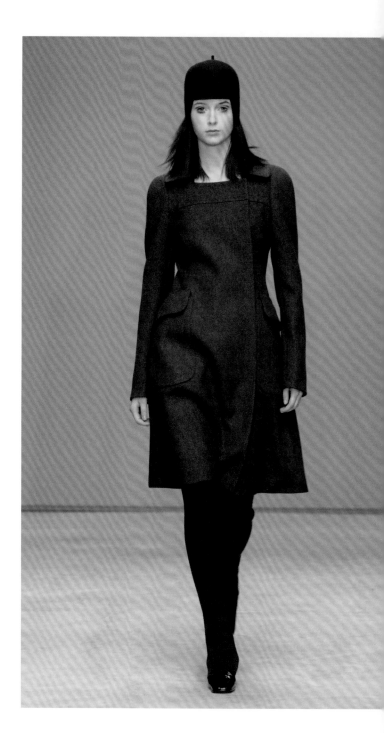

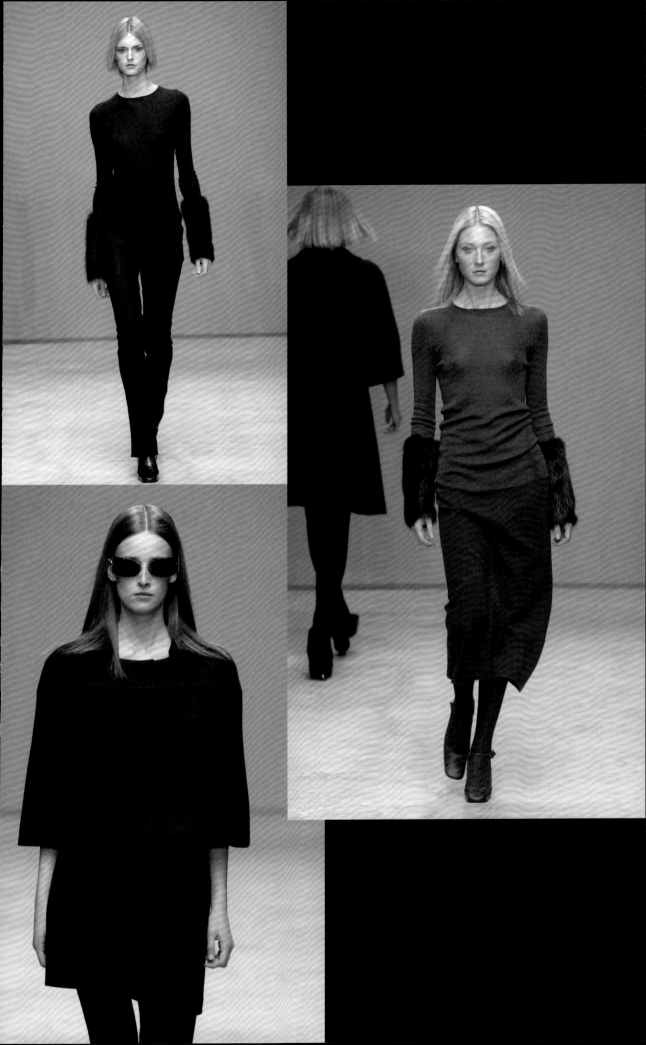

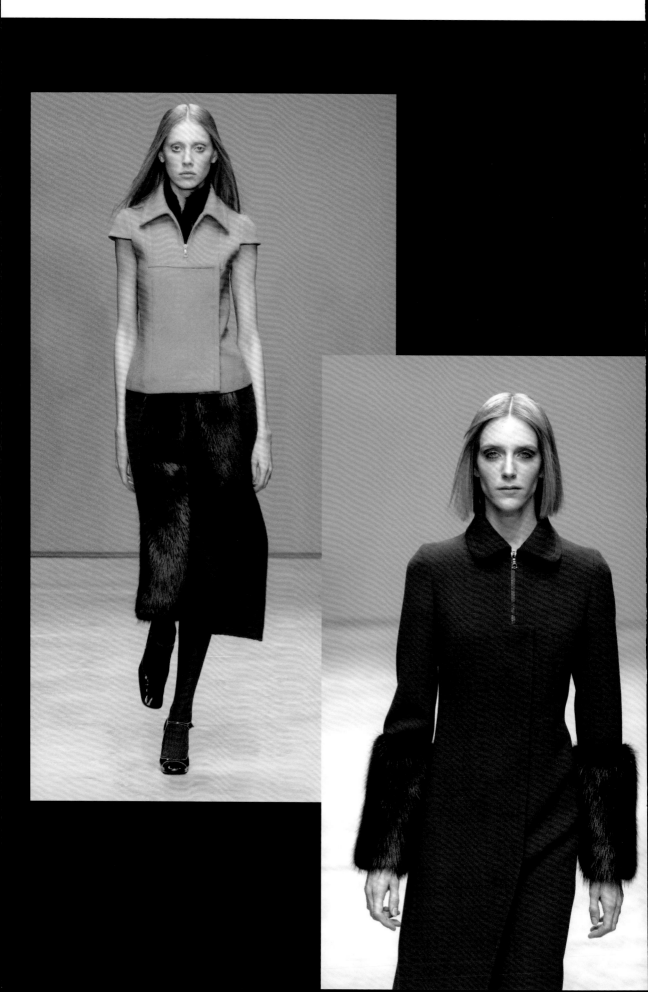

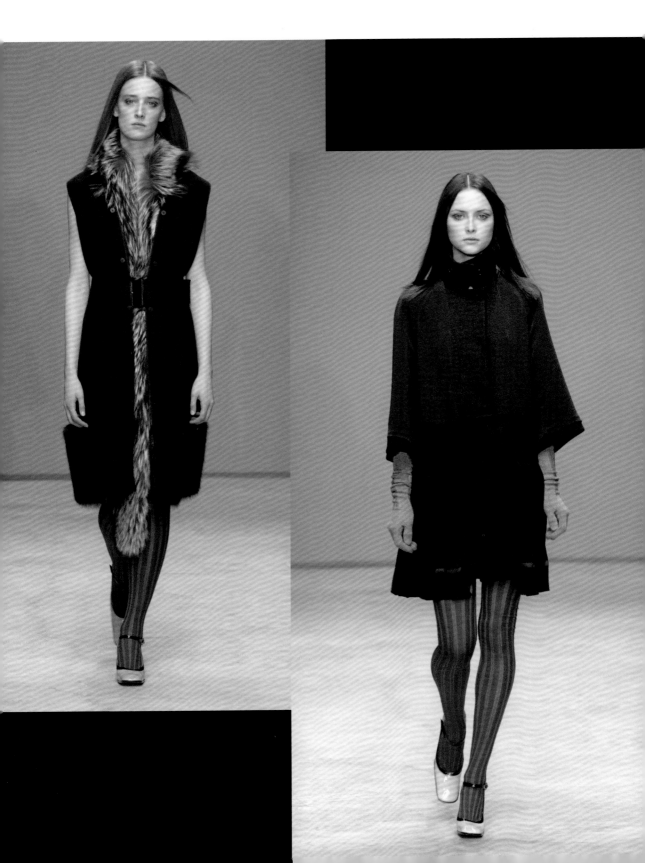

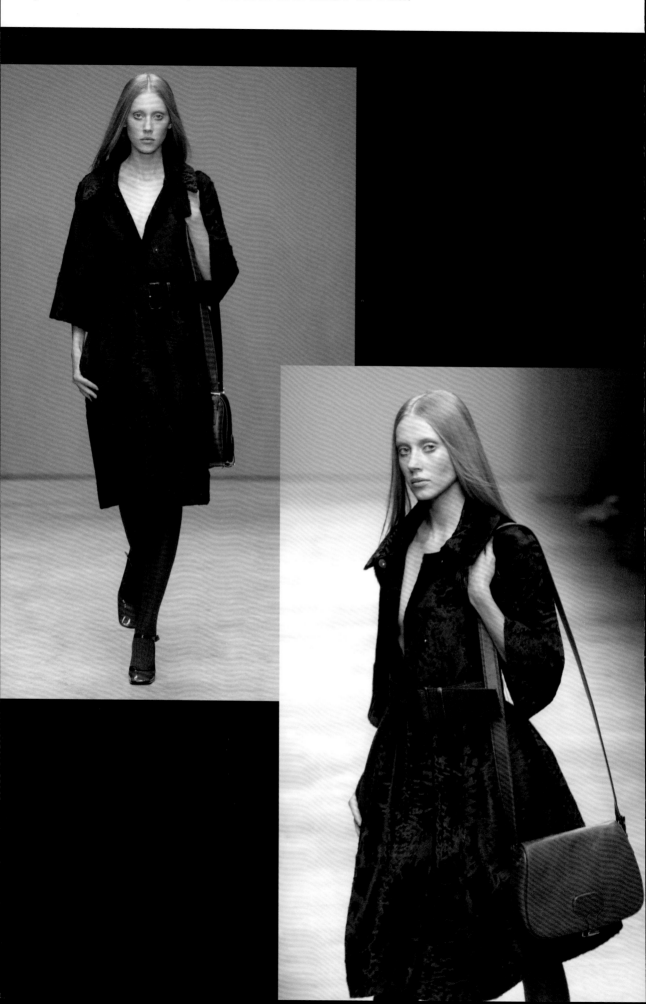

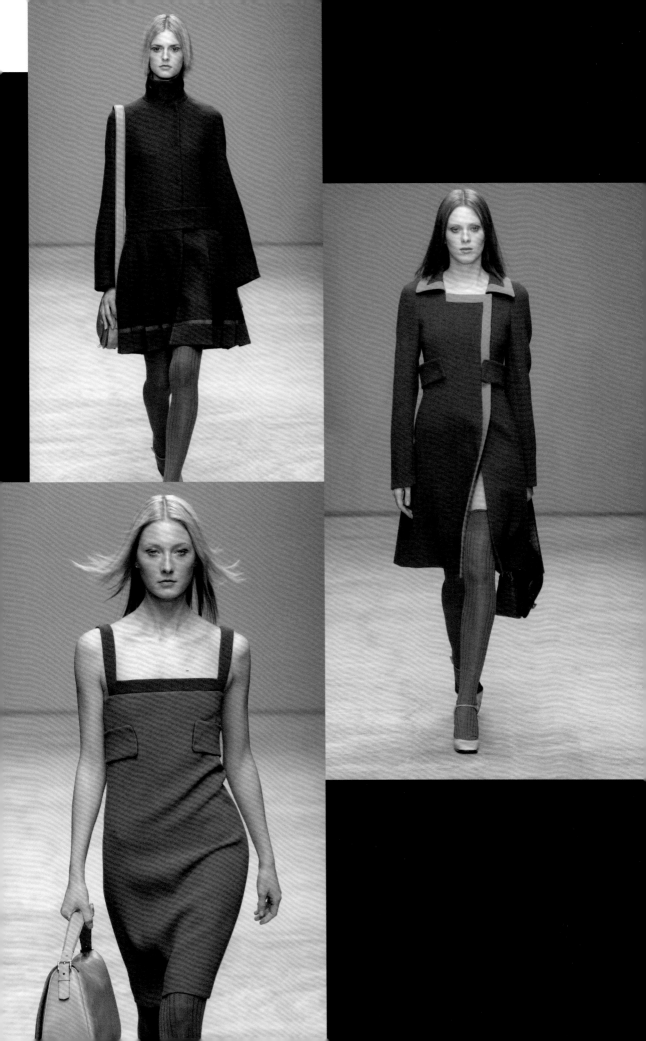

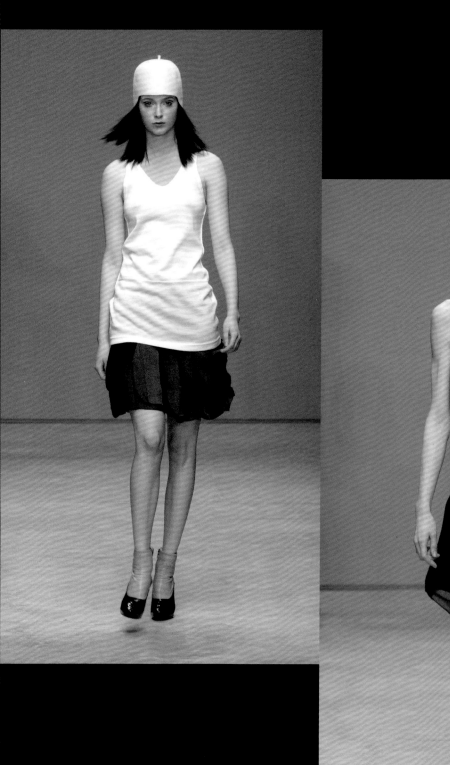

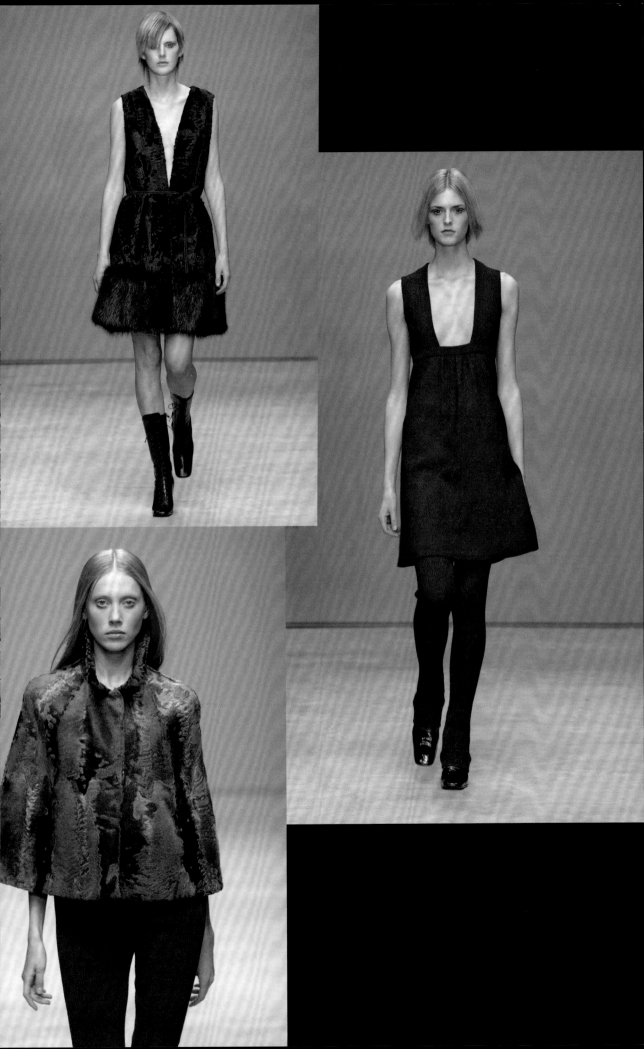

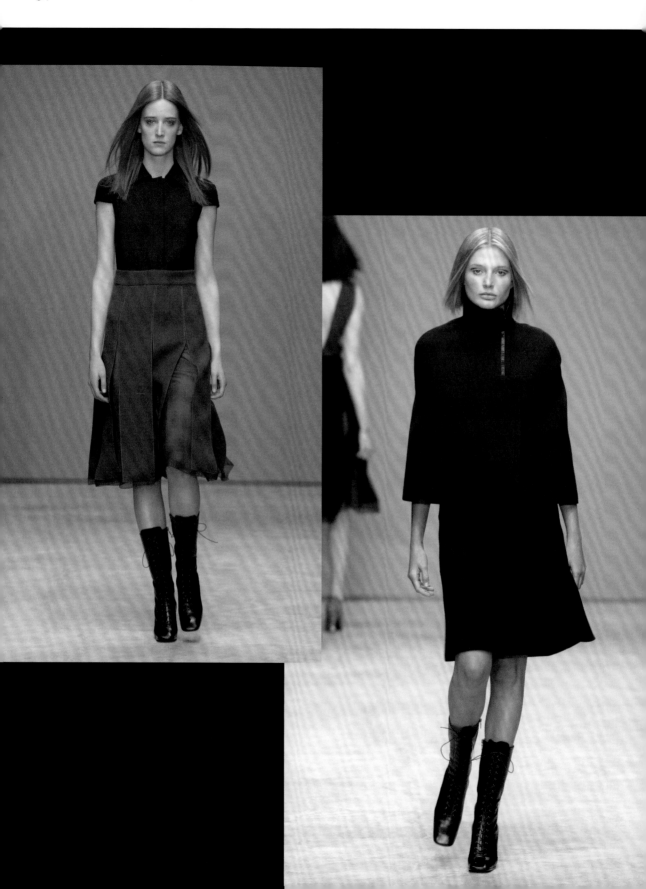

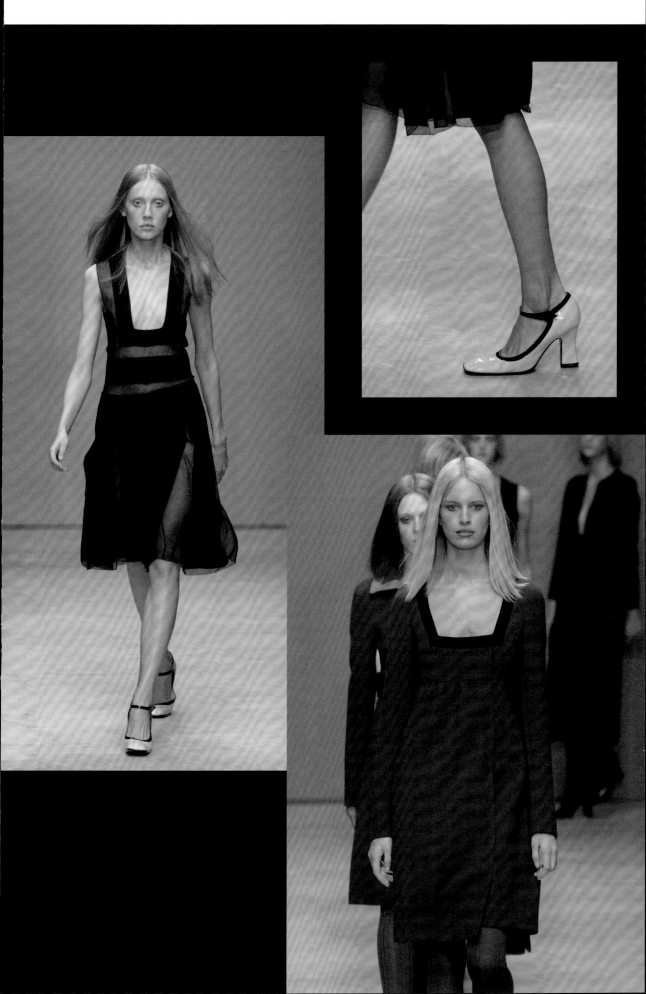

Opposites attracted once more, this time around
in a collection that juxtaposed discretion – skinny
tailoring, knitted tanks and cardigans, contrast-piped
shirts inspired by men's pajama tops, and straight
knee-length skirts – with an especially opulent lamé,
vaguely Eastern in appearance. It was a fabric which
Miuccia Prada told journalists post-show had taken
ten years to develop and which catered to the
universal desire for decoration, for clothing which
she herself has often described as more obviously
'appealing'. 'The collection centres on taking a new
perspective on lamé – deconstructed and restructured
to create a lavish image but without excess,' the
show notes read. 'Rather something beautifully
feminine and discreet. Discovered in French factories,
vintage fabrics originating from the 50's and 60's
are reworked on original machines. The result being
a juxtaposition between gloss and matte, thus dulling
the bold tones of gold whilst still preserving its rich
hues... The mix of small simple pieces ... makes the
lamé wearable and everyday.'

While such apparent paradoxes were part of her
vocabulary, in this instance they often played out
in a single outfit, which was more unusual. If the top
half was understated, the bottom was anything but,
and vice versa. Aforementioned lamé, in the form
of a sleeveless shirt further embellished with a large
ruffle down the front, jarred merrily with black school
shorts (opposite, above); a black V-neck knit was
equally disorienting worn with a lamé skirt, again
with a ruffle (black this time – to match?) down the
front (p. 264, above right).

Although Miuccia Prada has never used the runway
to comment directly on political issues, her work is,
and always has been, political. This Milan season
took place less than a month after the September 11
terrorist attacks, which struck in the middle of the
New York collections. With emotional, cultural and
economic uncertainty at a high, the end sequence
finally gave way to head-to-toe richness and to an
intelligent and dignified perception of ornamental
beauty that even the most minimally minded onlooker
would find uplifting.

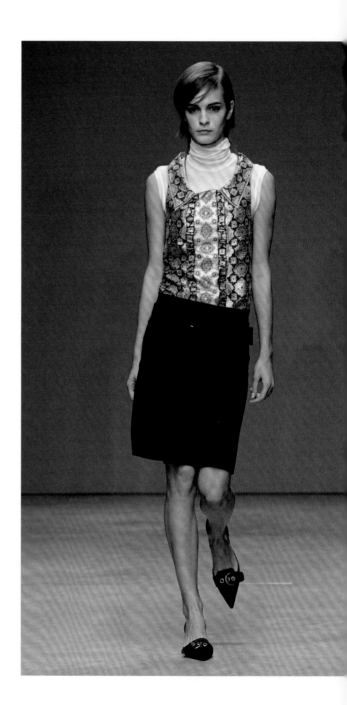

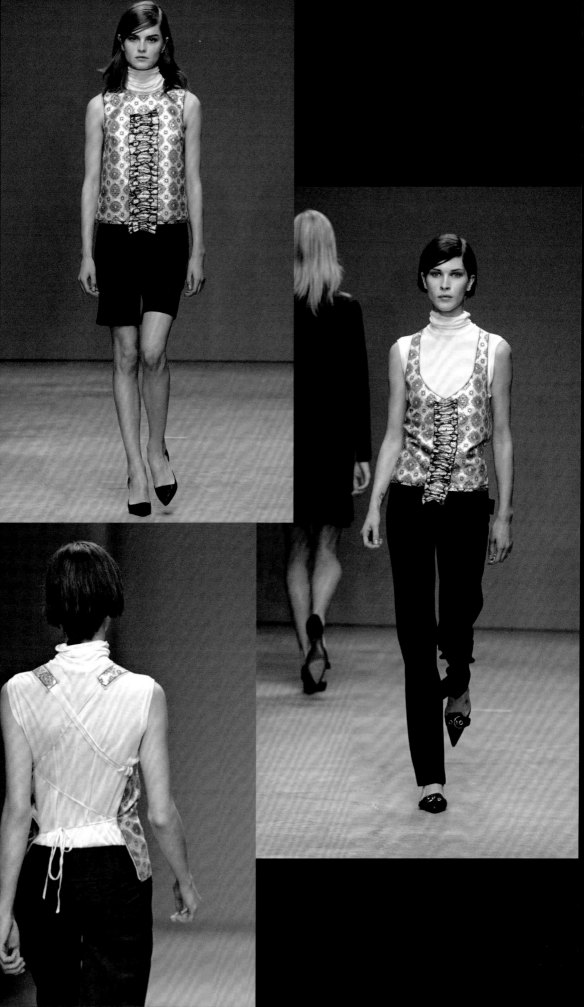

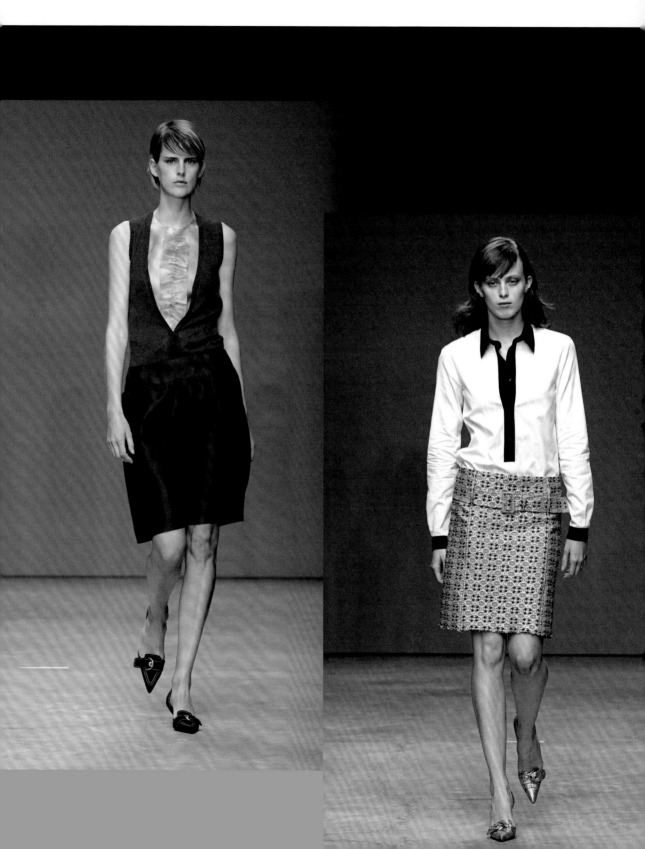

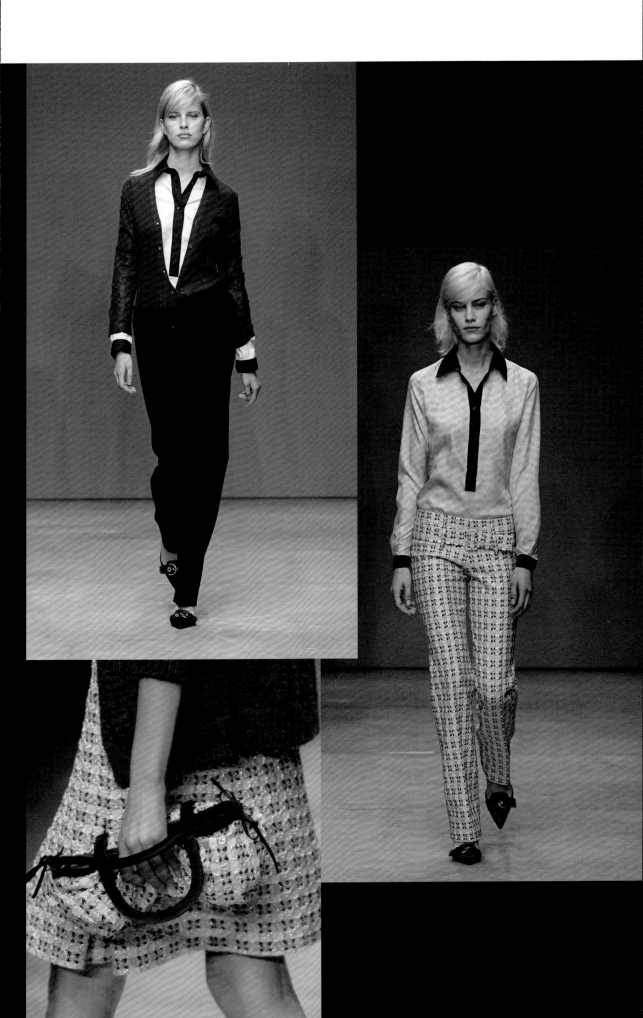

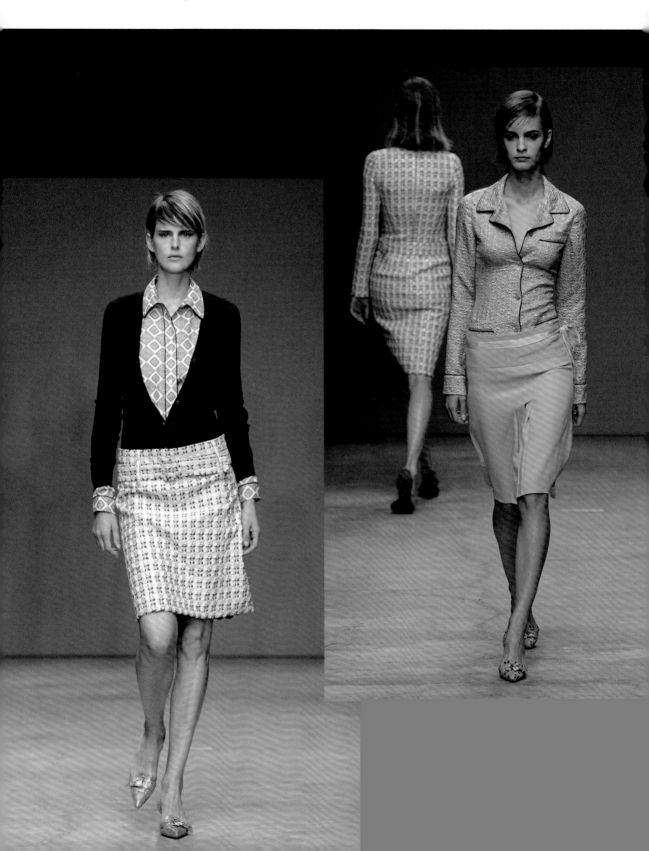

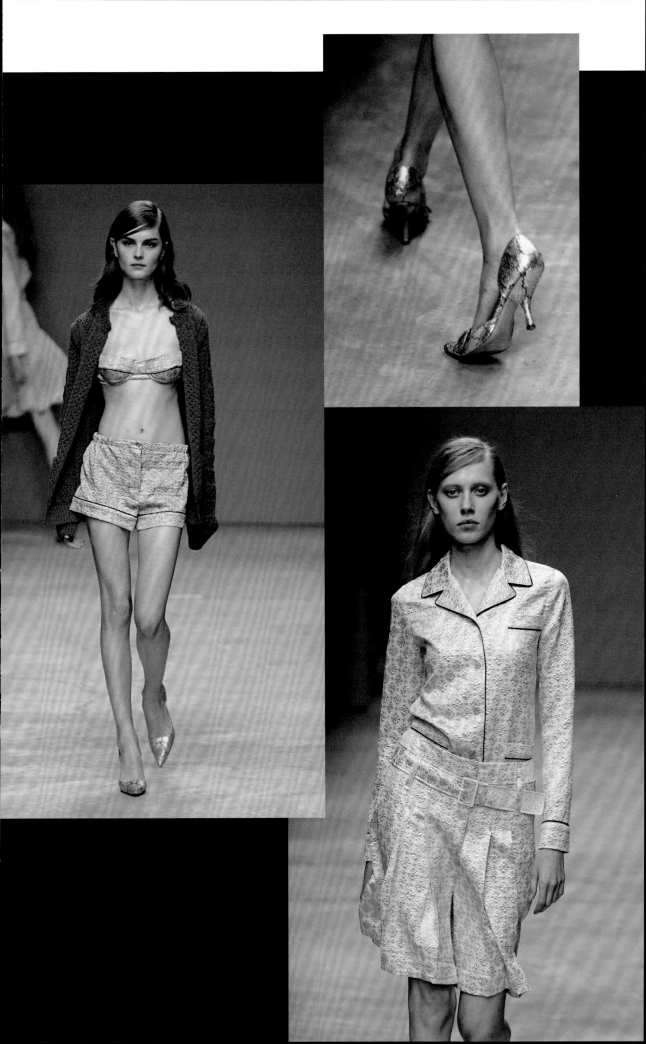

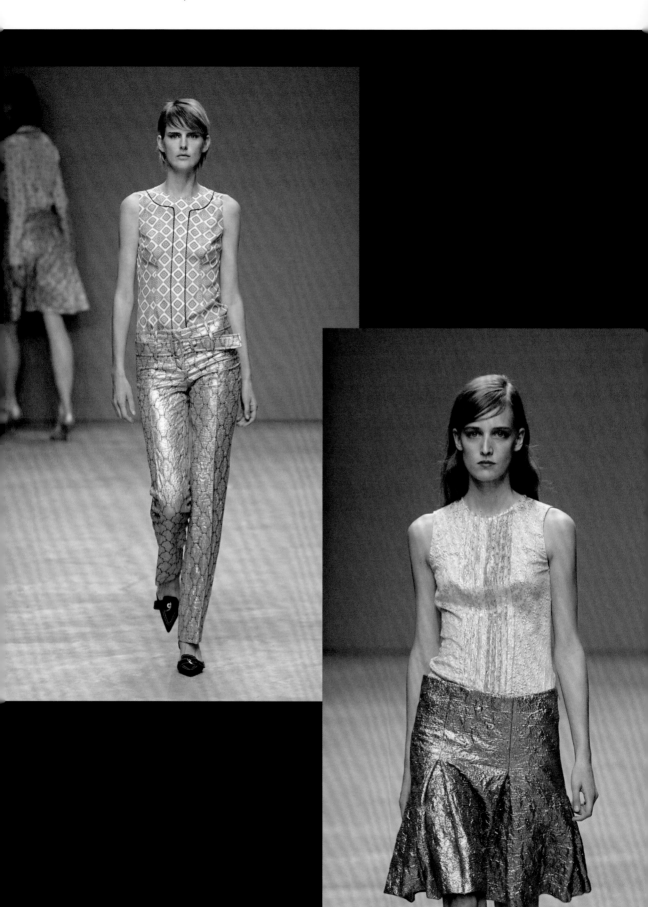

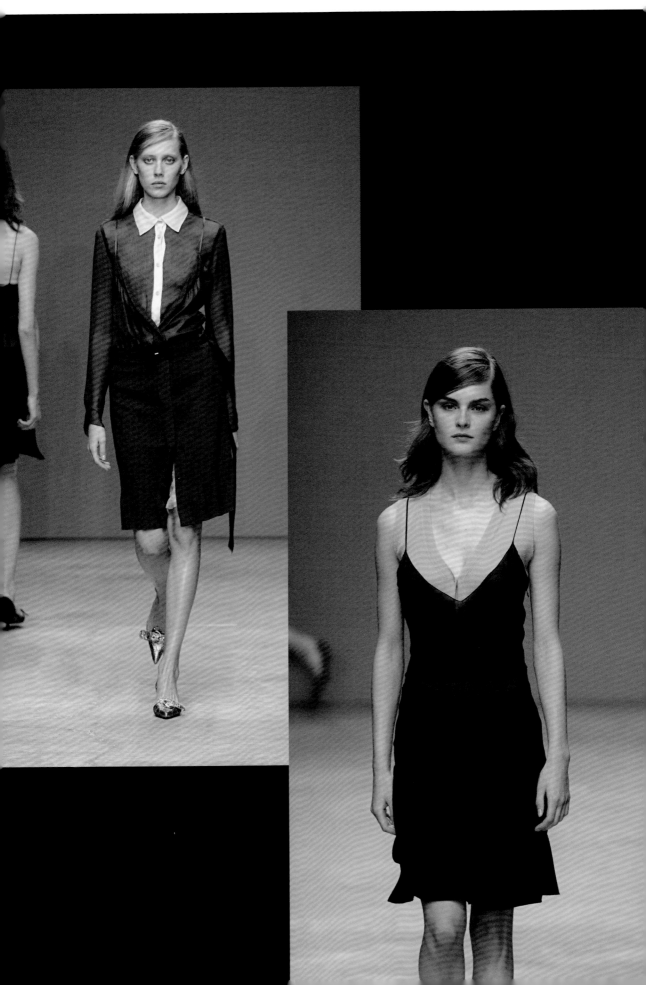

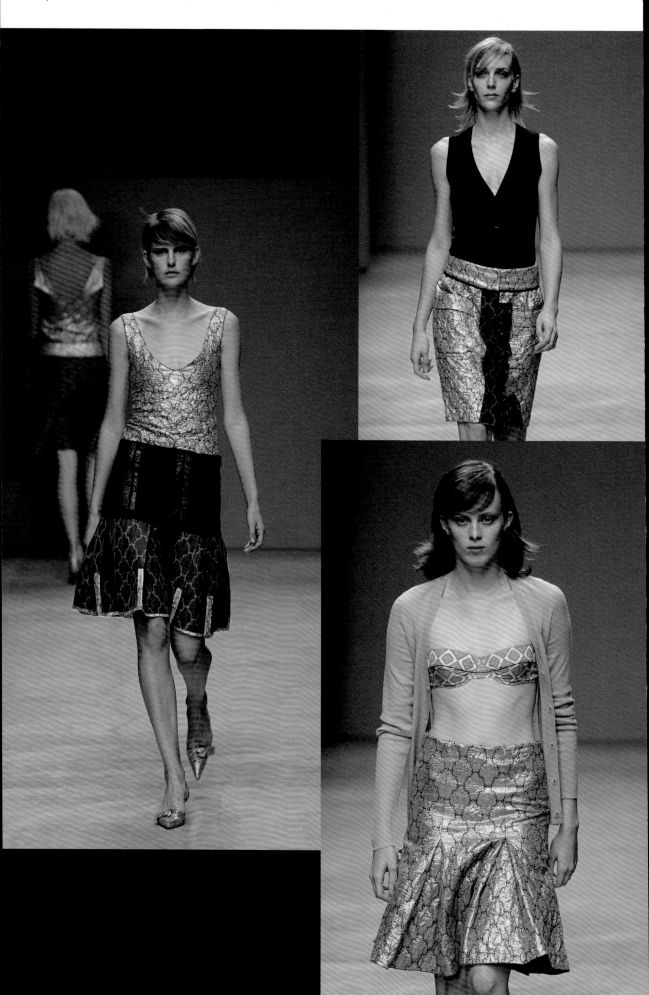

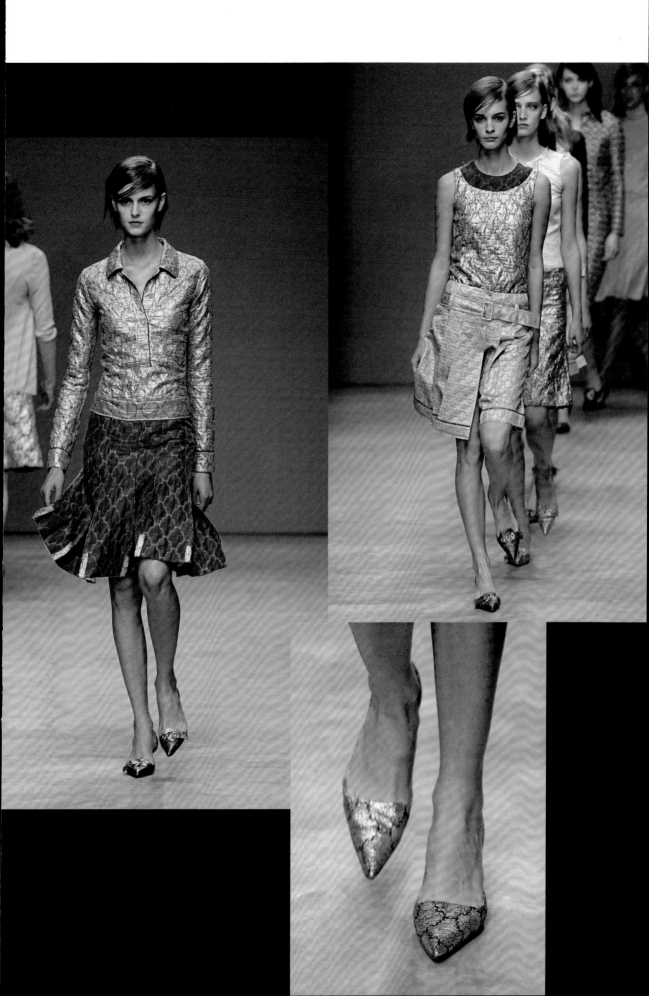

Glamazon Eva Herzigova opened the Prada show
this season in a black nylon and fur bomber jacket
and flirtatious knee-length black skirt, with her
hair pulled into a high ponytail (right). 'I'm tired
of hearing people tell me that I don't do sexy things,'
Miuccia Prada told *Women's Wear Daily*. 'I'm
interested in the obsession with sexiness. I worked
on what people think is sexy... [M]y idea of sexy ...
is personal.' Later she would refer to her look as
'porno chic'.

Many of the clichés that go hand in hand with that
were here in place: embonpoints were bared with only
a shadow of silk tulle keeping modesty intact, tailored
jackets were worn with sheer chiffon blouses and
breasts bared, more fur was teamed with chainmail,
and, on typically playful form, the designer went so
far as to layer transparent PVC coats over at least
some looks decorated with black or orange piping.
Knee-high black leather boots, meanwhile, and quite
possibly the highest heels that had ever appeared on
this runway were about as close to fetishwear as this
designer had come to date.

There were references to the 1980s again in the
volumes (a pencil dress with overblown sleeves,
fit-and-flare skirts, skinny trousers, and a strong,
sharp-tailored shoulder that nodded to Azzedine
Alaïa) and in the fabrics (flashy sequins, silk satins,
that chainmail and PVC), not to mention the styling.
If ever anyone were in doubt that Miuccia Prada has
a sense of humour, meanwhile, she appeared to have
designed a Prada flasher's mac – in stone-coloured
gabardine – worn over an especially risqué lingerie-
inspired metal mesh dress (p. 272, right). Prada
being Prada – and this not really being her idea
of sex appeal, as she herself had said – the latter
was worn over a long-sleeved silk slip.

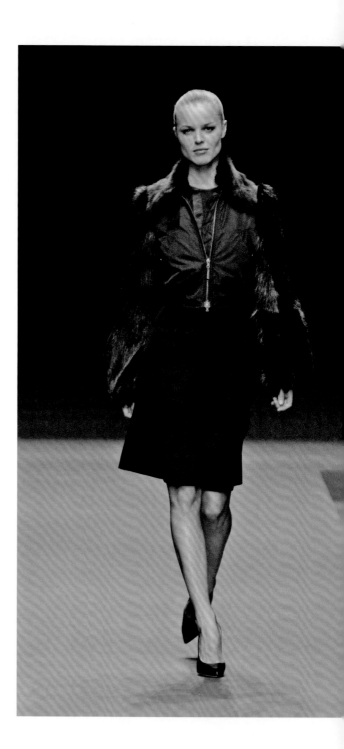

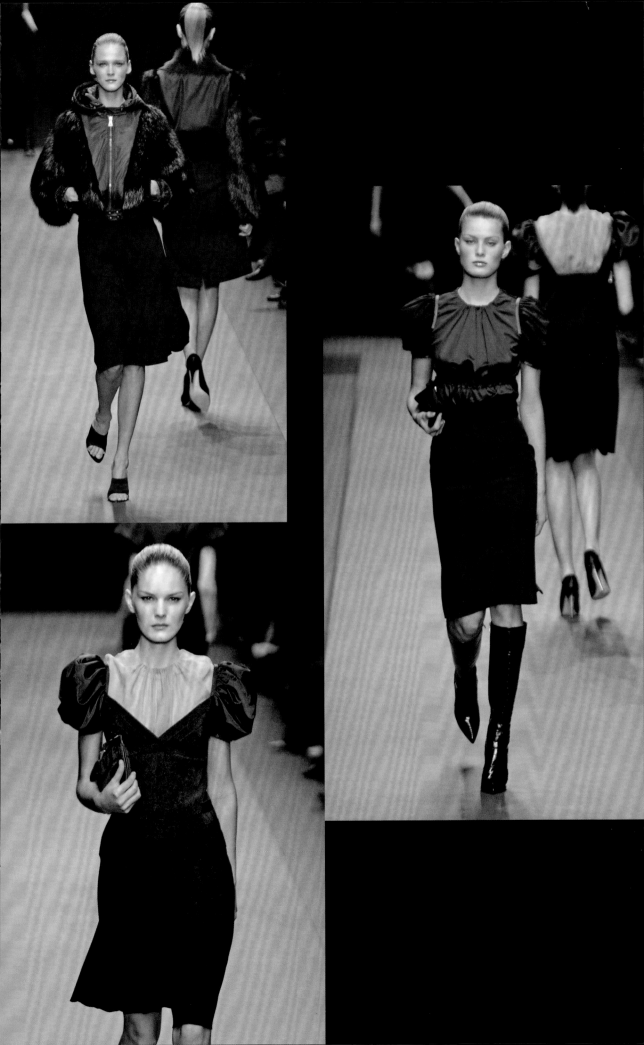

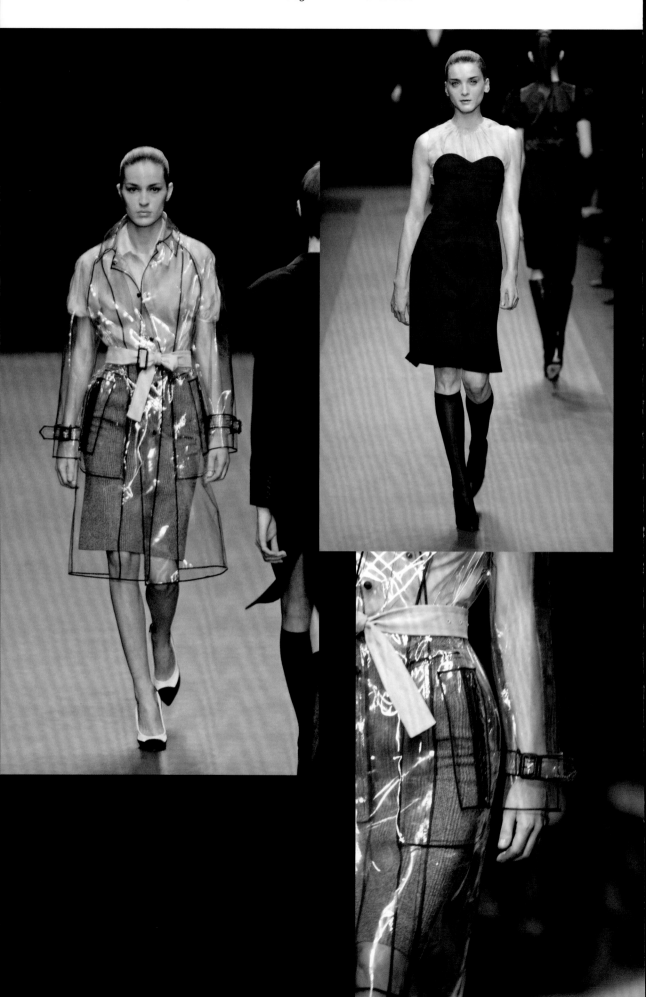

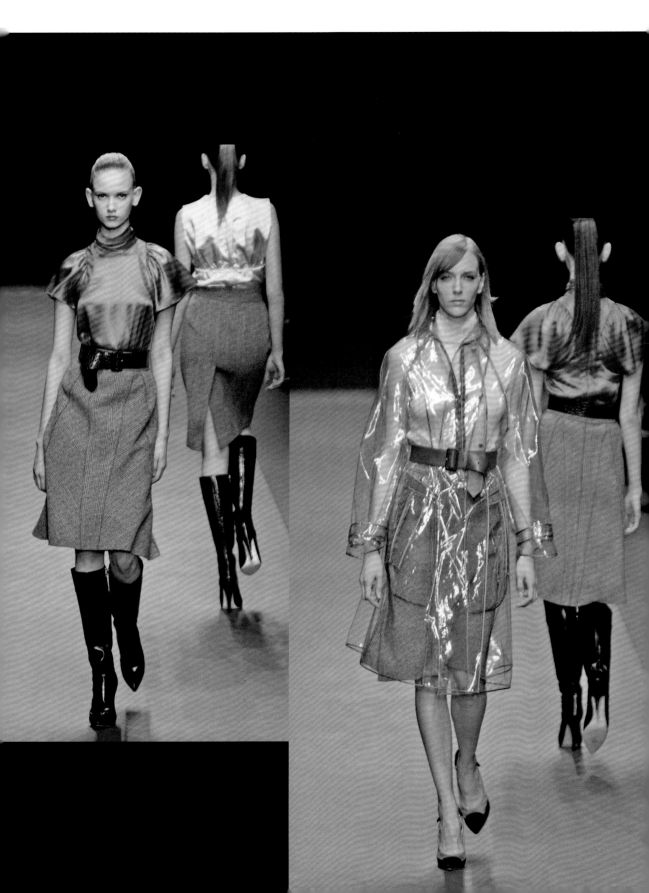

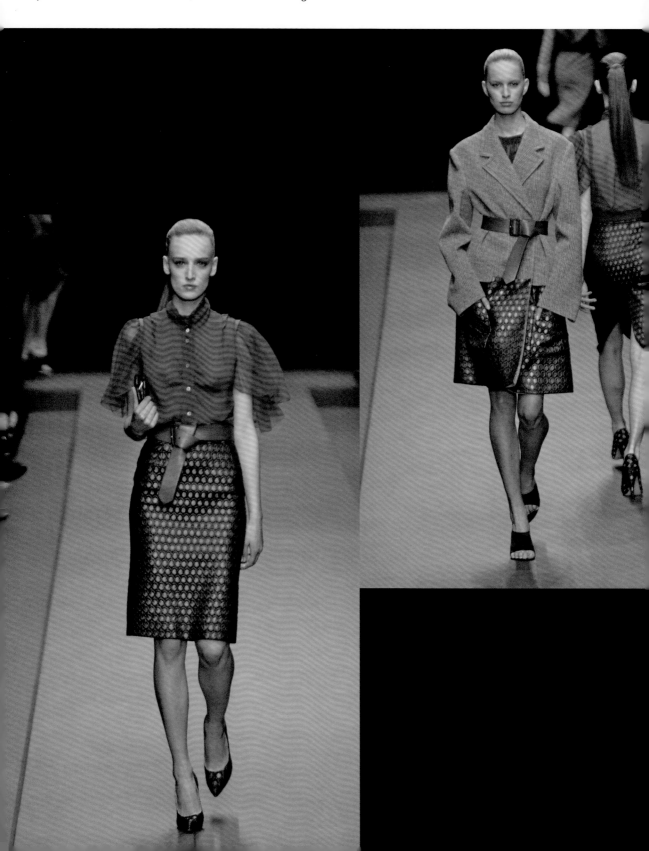

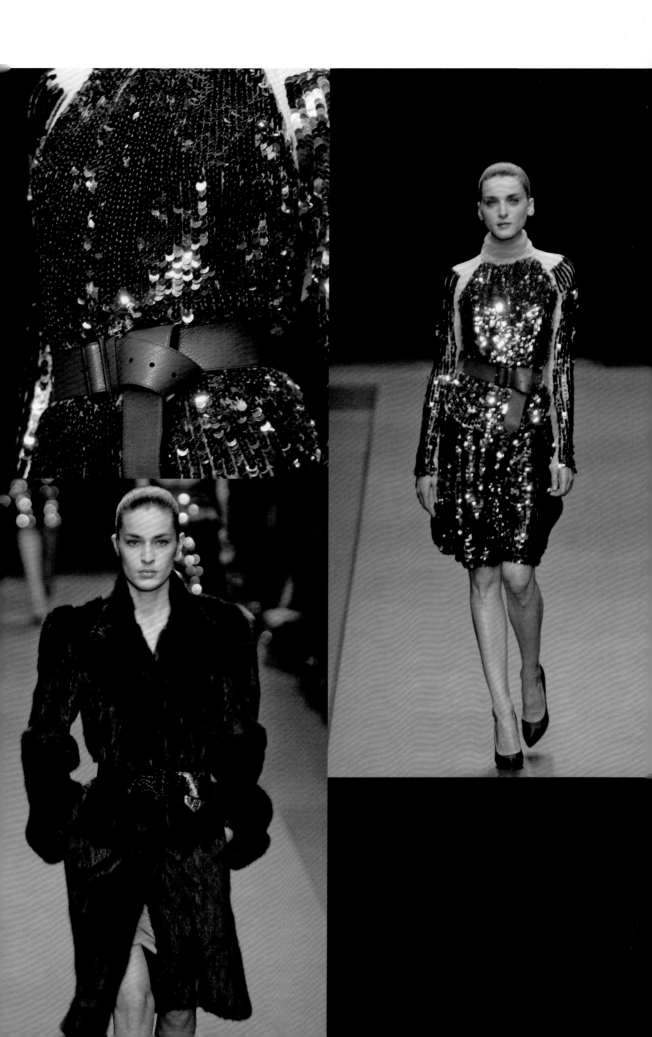

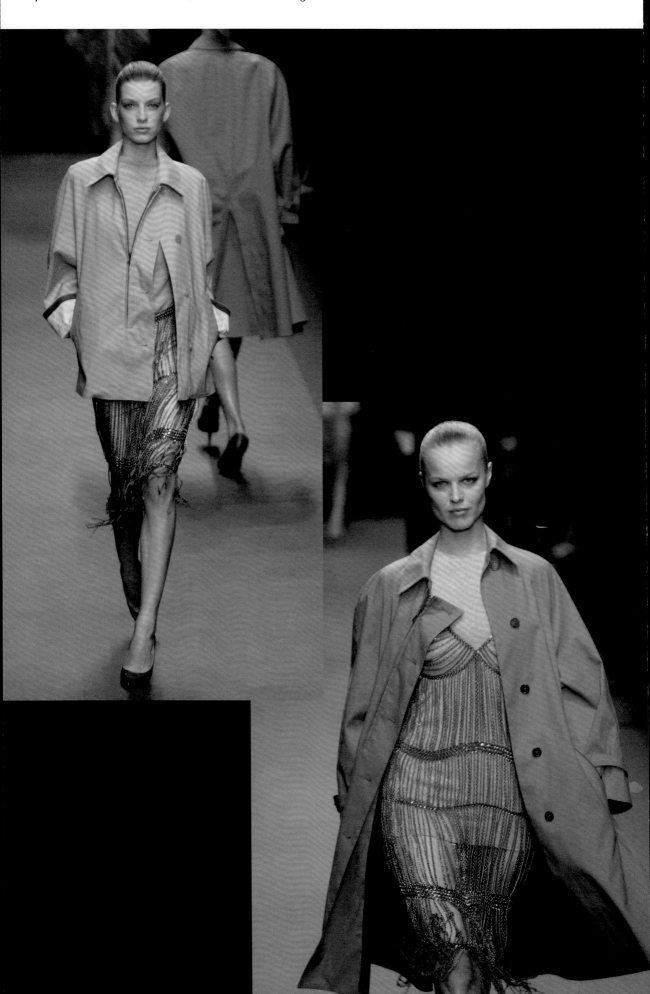

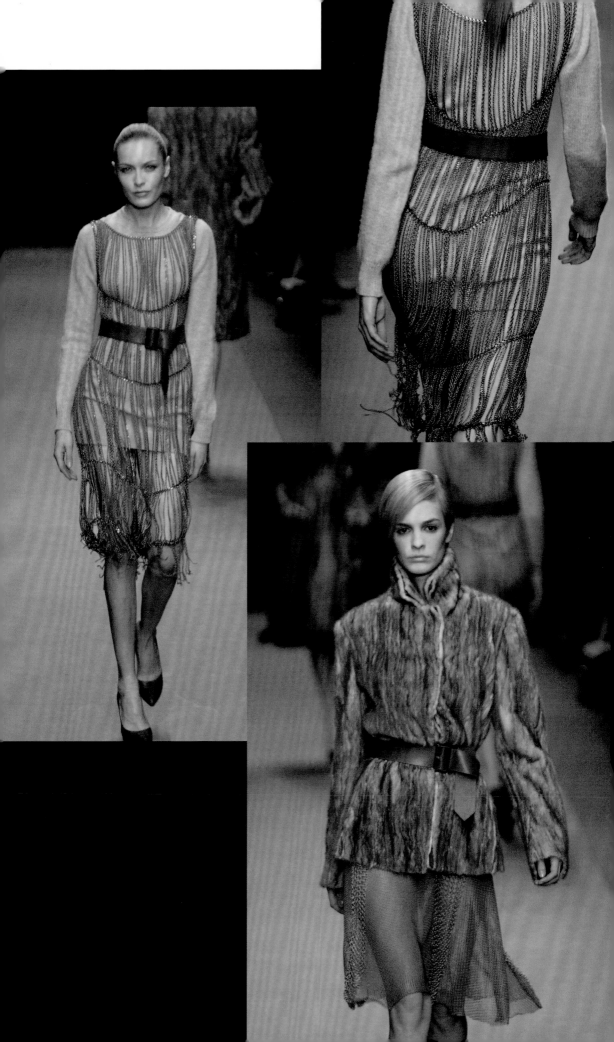

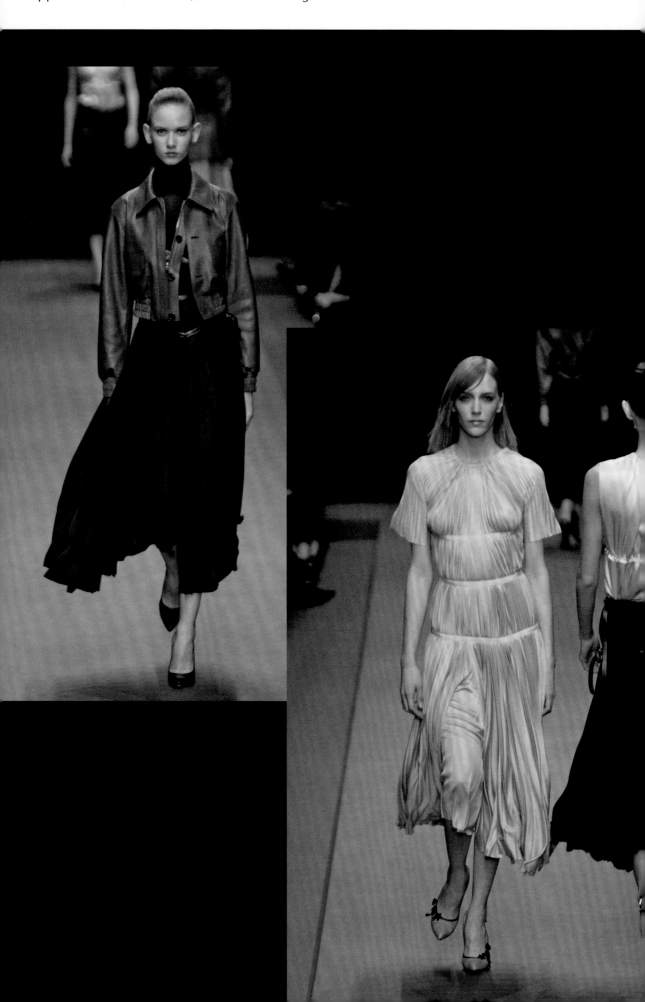

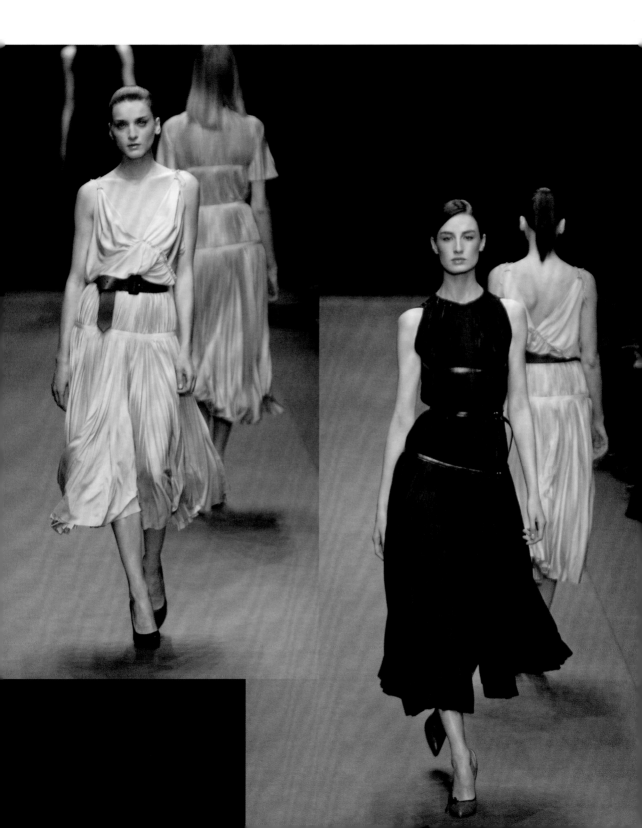

Prada's Spring/Summer 2003 collection was,
in fact, probably much closer to what Miuccia Prada
personally thinks of as sexy than the one that
preceded it, even though its strangeness at times
divided opinion, particularly over the thorny issue
of wearability. That, in itself, is a strange notion.
Both in theory and practice, everything on a runway
is wearable. Whether an individual should opt to
wear it is their choice entirely. Should that ever be the
motivation of the creative brains behind it, though?
Most probably not. Many a wardrobe staple caused
a scandal when it was first shown, after all, including,
most famously, women in trousers.

Colour was of prime importance here. Fuchsia, lime,
flame and orange – shades that seemed almost violent
when they came in pairs – graced a typically short,
sharp silhouette: young, leggy and principally teamed
with a flat sandal-slipper hybrid and bags that –
either scaled up or down, and at times suspended
from a curved metal bar and with utilitarian flap
openings – were a clever play on proportion.

White plastic clusters of beads bloomed across
micro-mini and knee-length skirts, worn with
nothing more obviously feminine than a buttoned-up
white cotton shirt. Elsewhere naïve circles of baubles
– they looked almost like pebbles and stones gathered
on the beach – found their way onto simple shifts.
More were worn in ropes around models' necks,
adorning garments otherwise so plain they were
almost surgical in appearance.

Then there were knitted bra tops and knickers
(presumably designed to be worn on the street, not
the beach), alligator skirts teamed with cheongsam
tops (see p. 282, below right), and a backless, barely
there vest worn with jersey leggings (brown; p. 283,
below right). Finally, shimmering brocade duster
coats layered over knit knickers again, Bermuda
shorts, tunics and skirts lent a marginally more
conventional form of glamour to the look, as did
models' blown-out hair, although, even then, they
wore aviator sunglasses – or were they goggles? –
where otherwise hairbands might be.

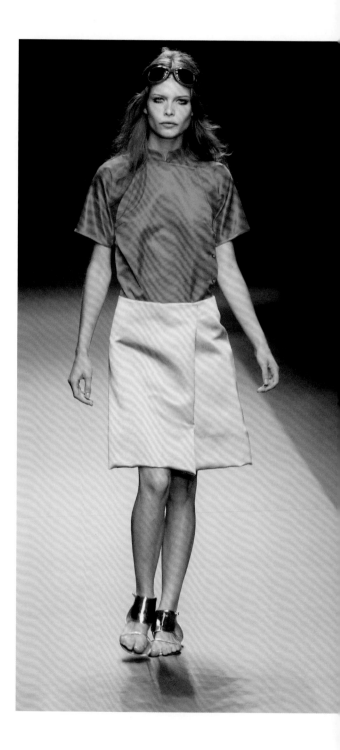

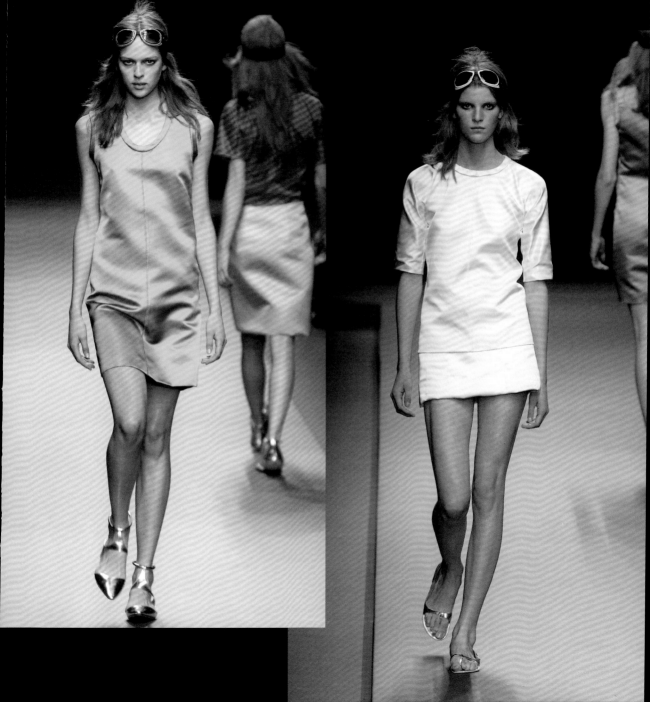

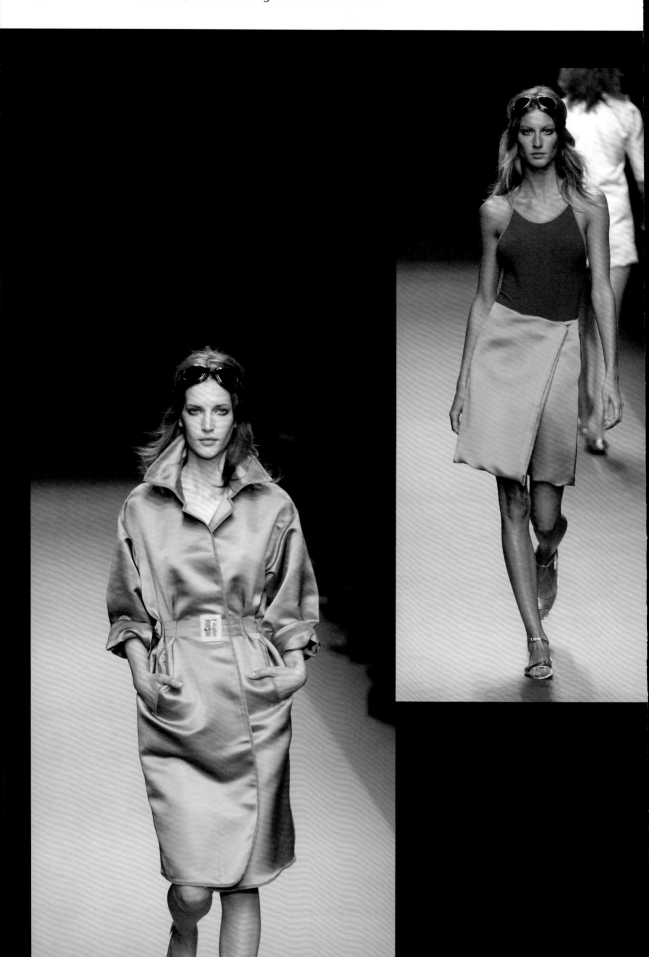

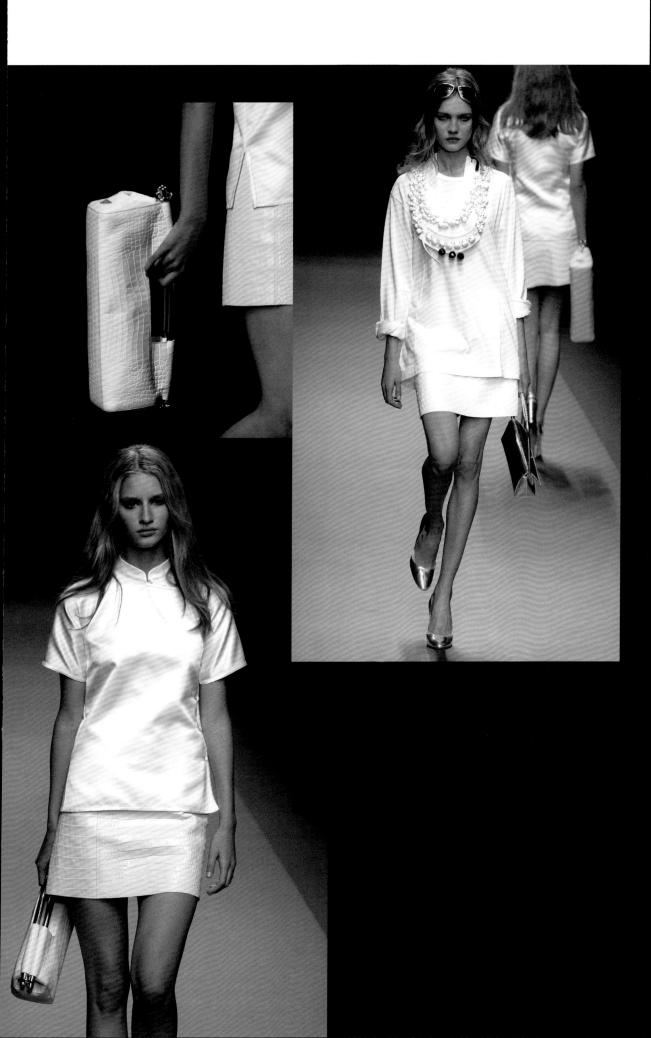

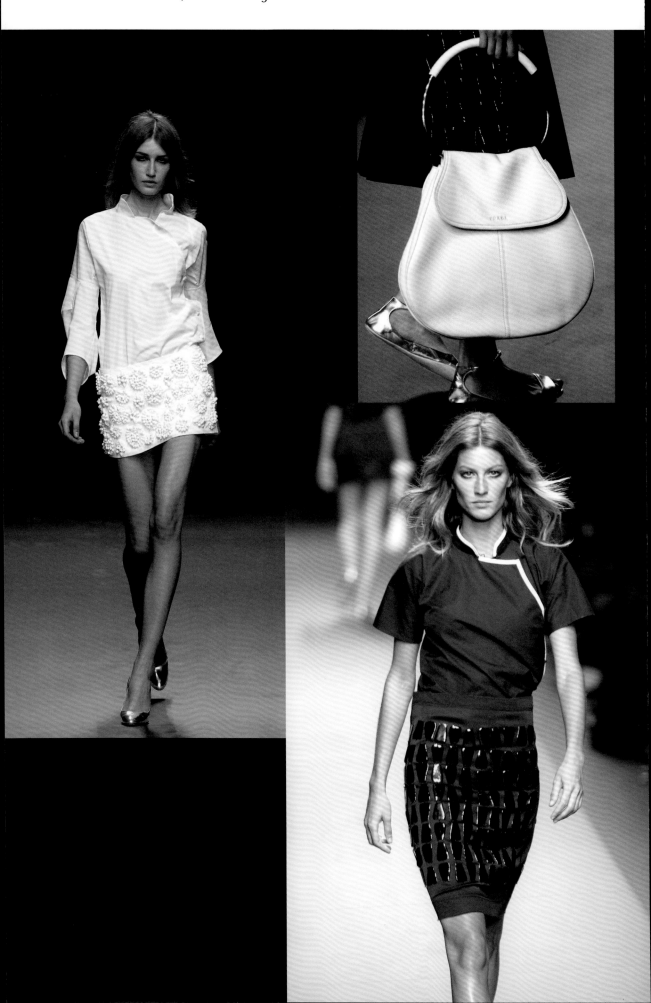

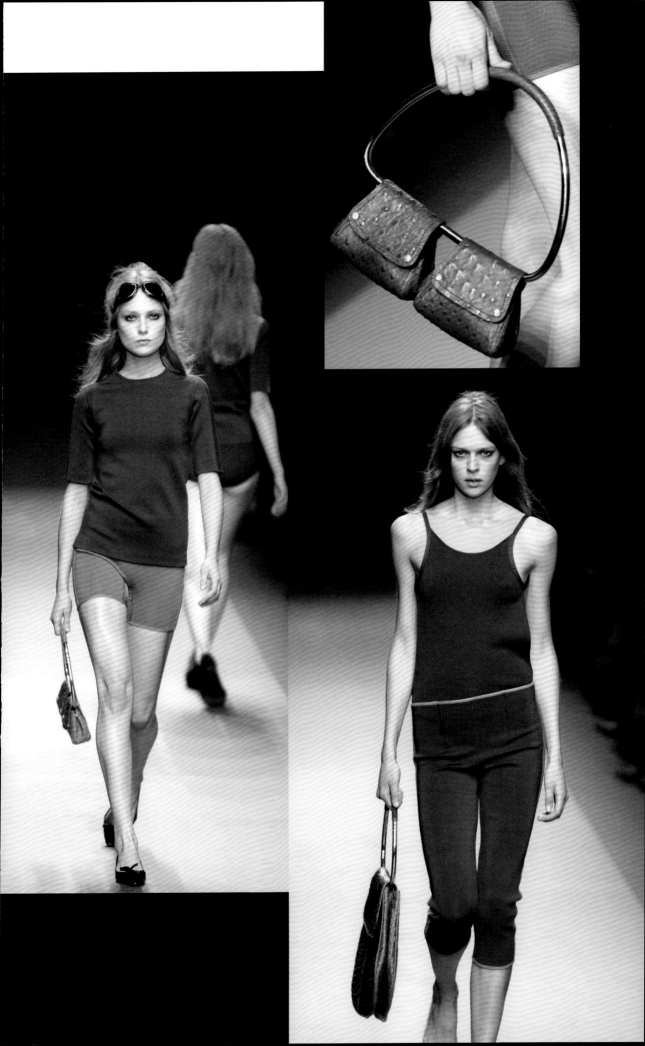

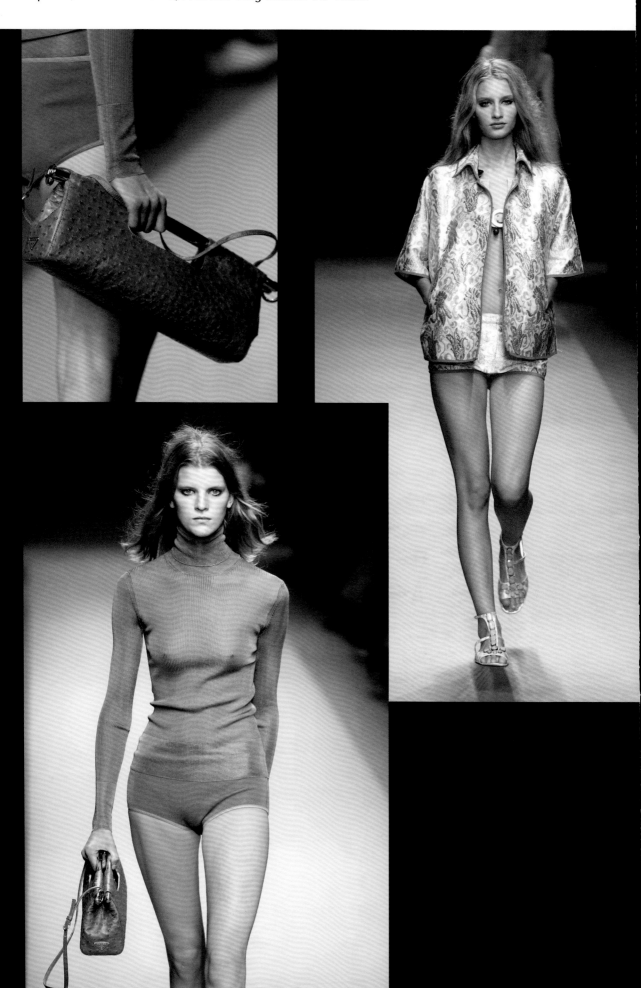

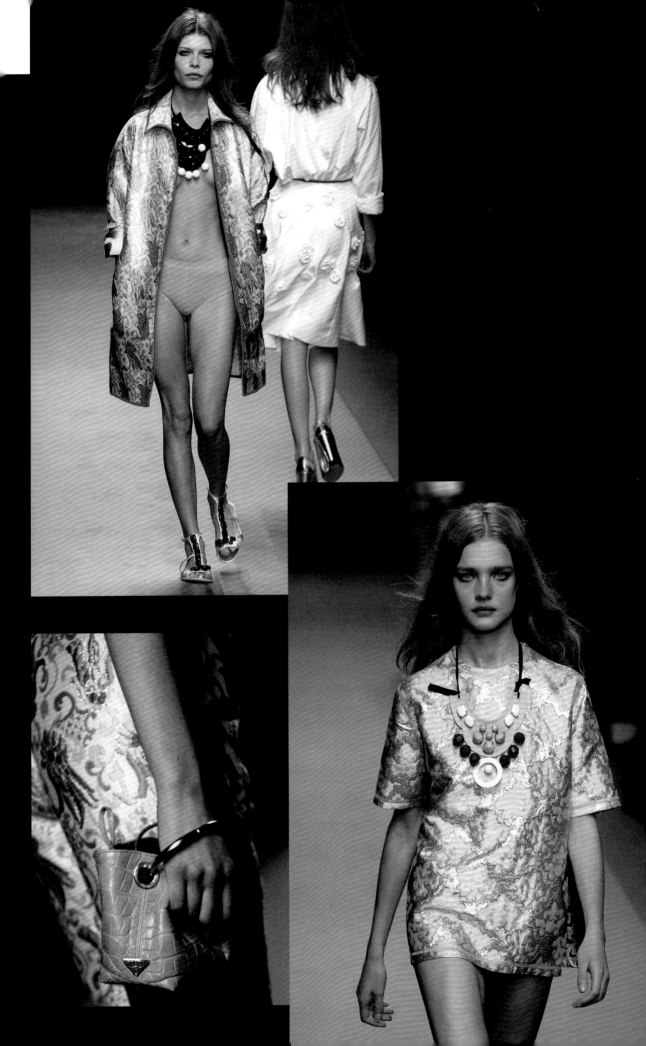

Unlikely juxtapositions were more layered than ever throughout Prada's Autumn/Winter 2003–2004 collection: luxe furs rubbed shoulders with humble lining fabric, exotic skins with what looked like daddy's camel cashmere sweater. What, this old thing? The contrast between masculine and feminine, equally, returned to the foreground, with none of the clichés that, in the hands of lesser talents, that might entail. An Anglophile spirit broke new ground for Prada: mannish tweeds, men's cotton shirting, Argyle knits and glowing William Morris flower prints all featured.

'When the going gets tough, no one can cut an argument for great design with as much substance, conviction and richness of intelligence as Miuccia Prada,' wrote Sarah Mower on Style.com. 'She performed sheer alchemy to create a vision of high chic for hard times.'

Savile Row staples included pinstripes – cut into flat-fronted trousers and pencil skirts – and windowpane check. These were teamed with satin platform-soled sling-backs and worn slightly undone. An alligator coat was thrown over a white cotton shirt (p. 288, above); more of these appeared with their sleeves hacked off. Sweaters were layered over brightly hued designs and under country jackets with bracelet sleeves – the better to show off long leather gloves. As was – and still is – so often the case, the latter went on to become the accessories of the season. The look was all the more remarkable for the fact that madam appeared to have forgotten her skirt. Finally, knee-length floral print dresses and others in plain crumpled silks were embellished with bold fur and fabric neckpieces, the kind that might have been rustled up by a clever young woman sitting by the fireside after dinner at her family home.

'Visually and intellectually, this is a collection that hit the high notes,' Mower continued. 'Post-show, Prada explained her endeavour to be "a desperate search for beauty as we wait for war."' The invasion of Iraq took place less than three weeks after this collection was shown.

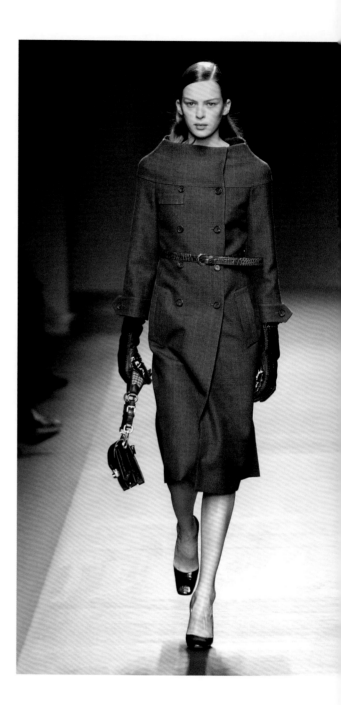

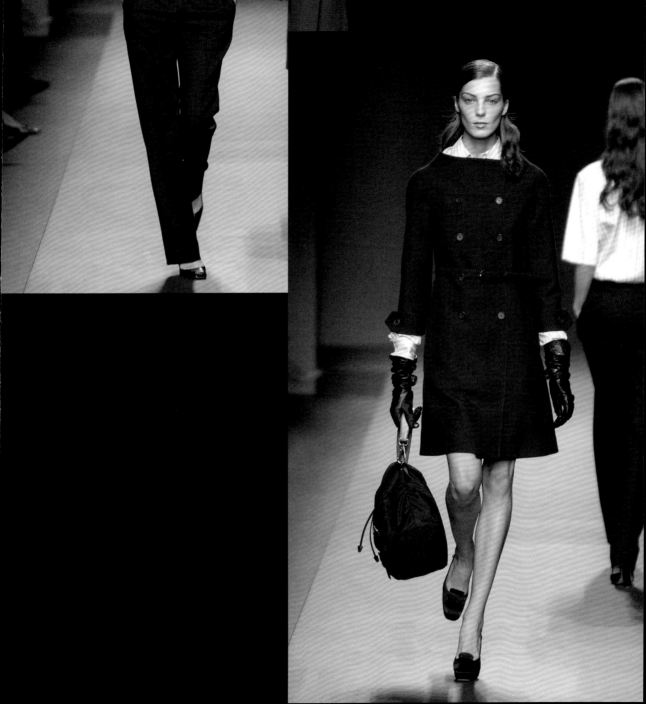

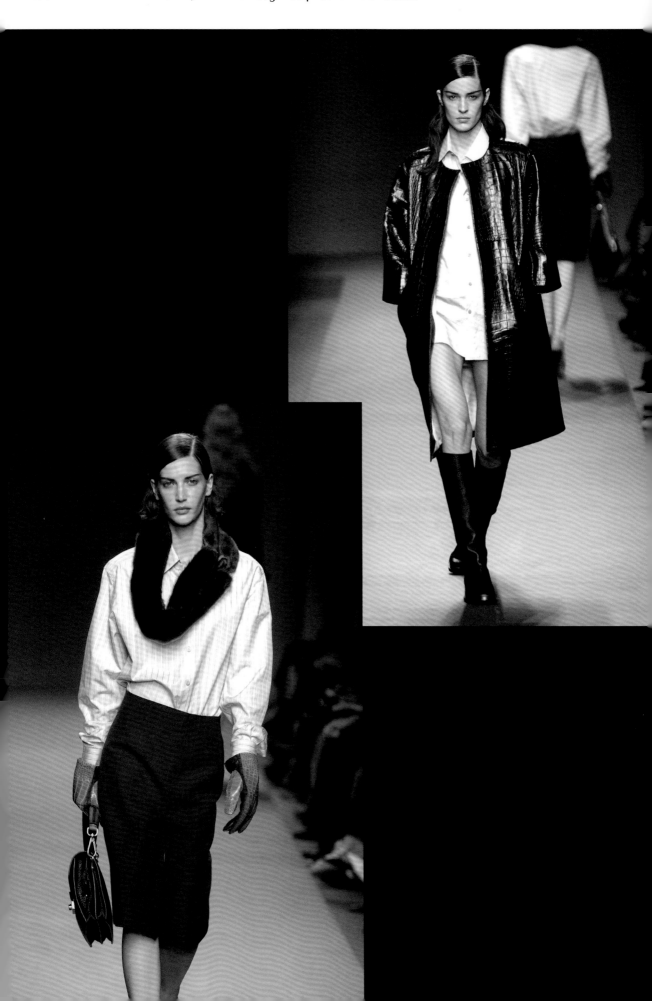

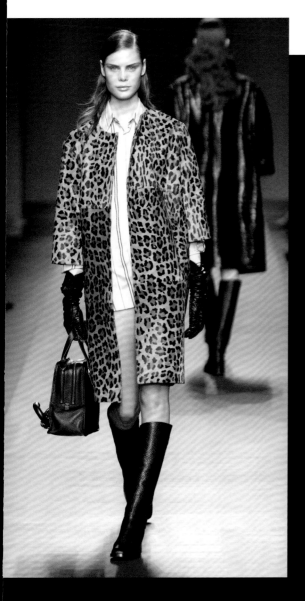

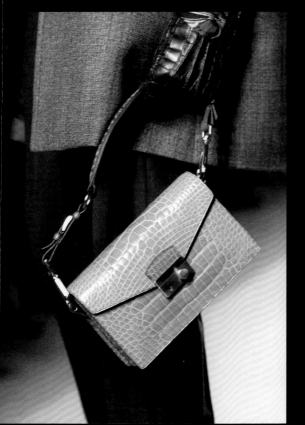

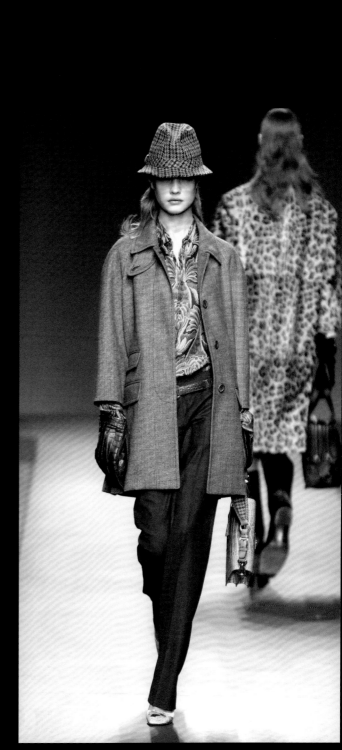

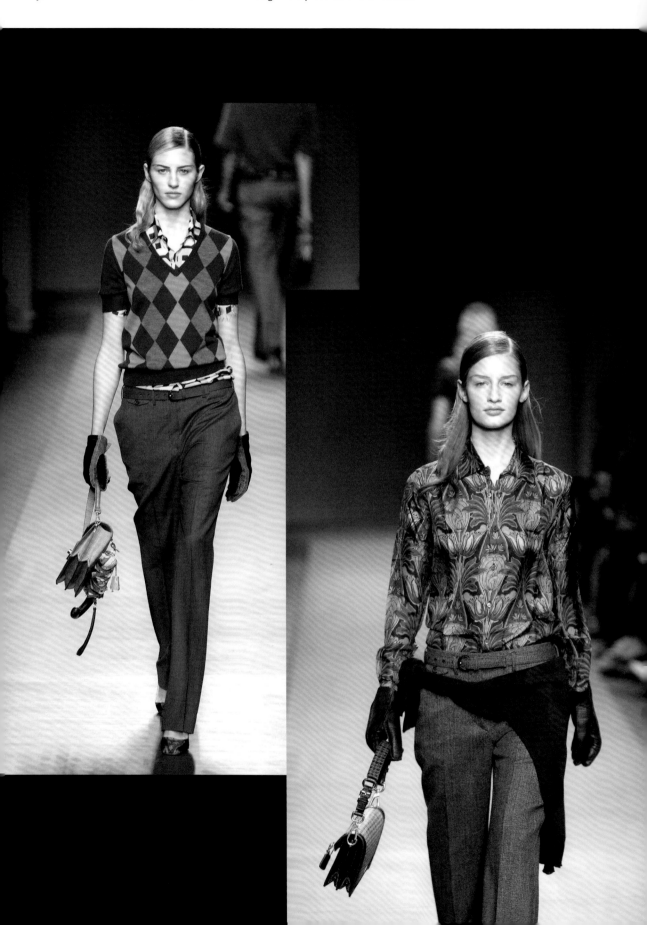

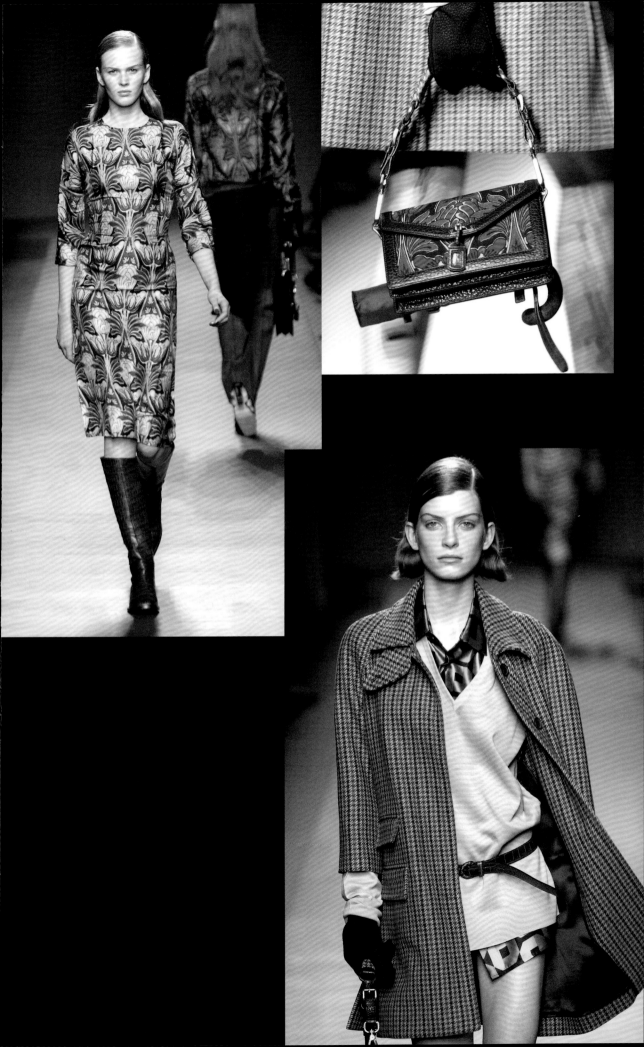

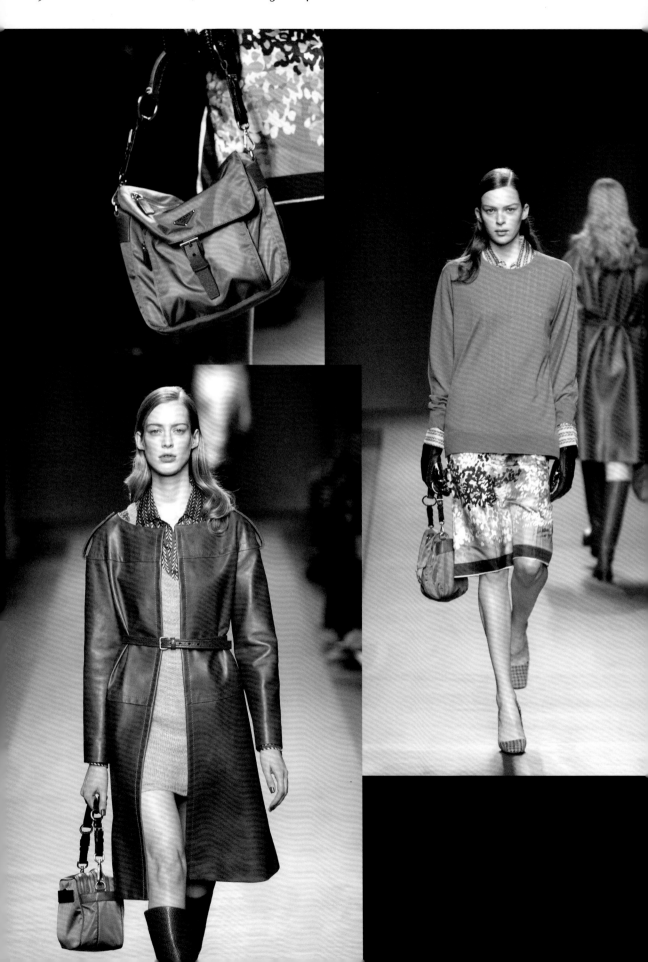

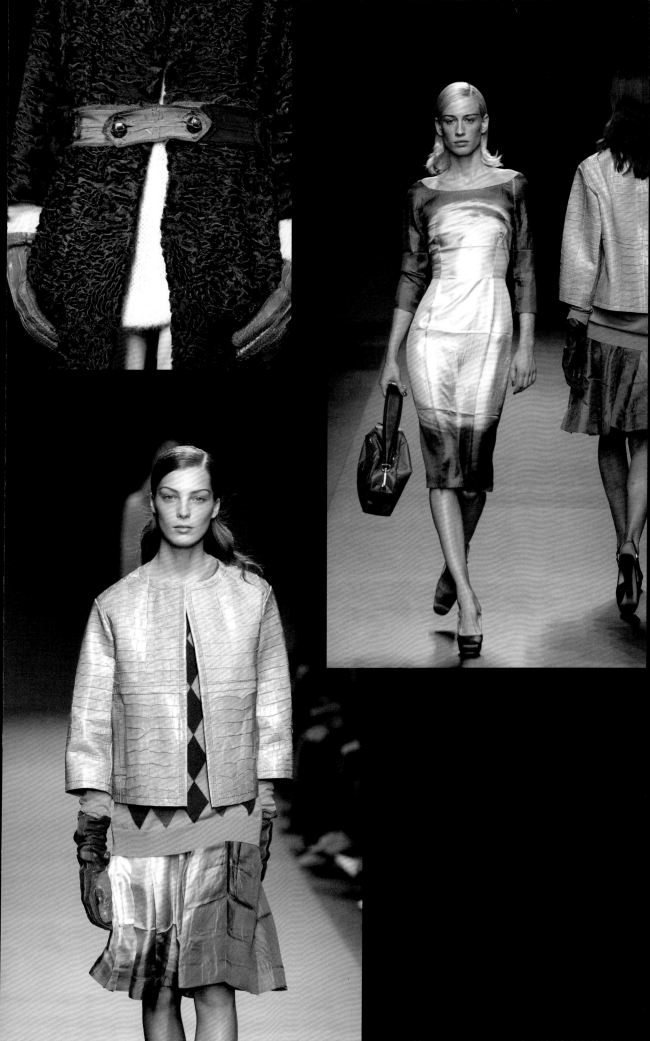

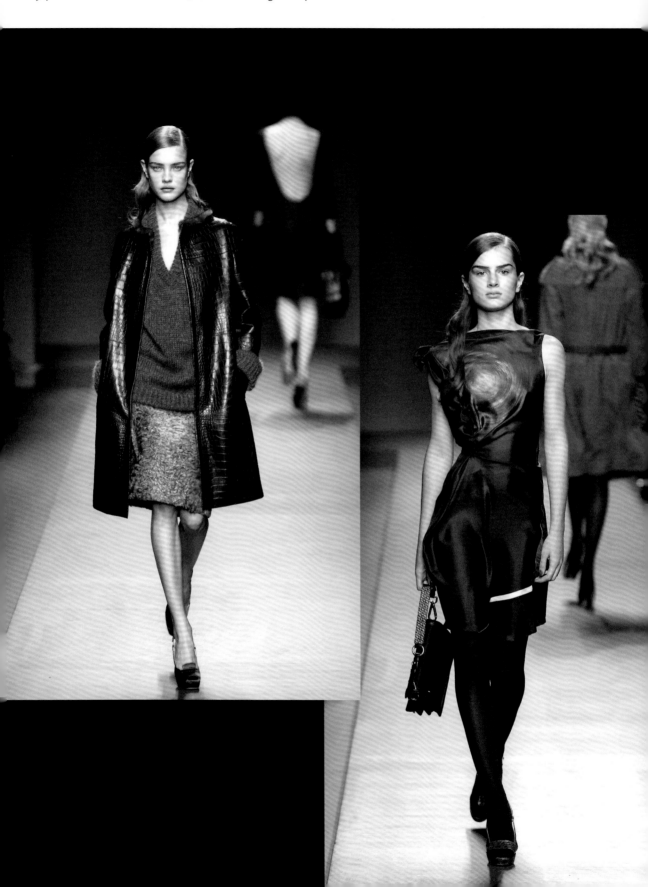

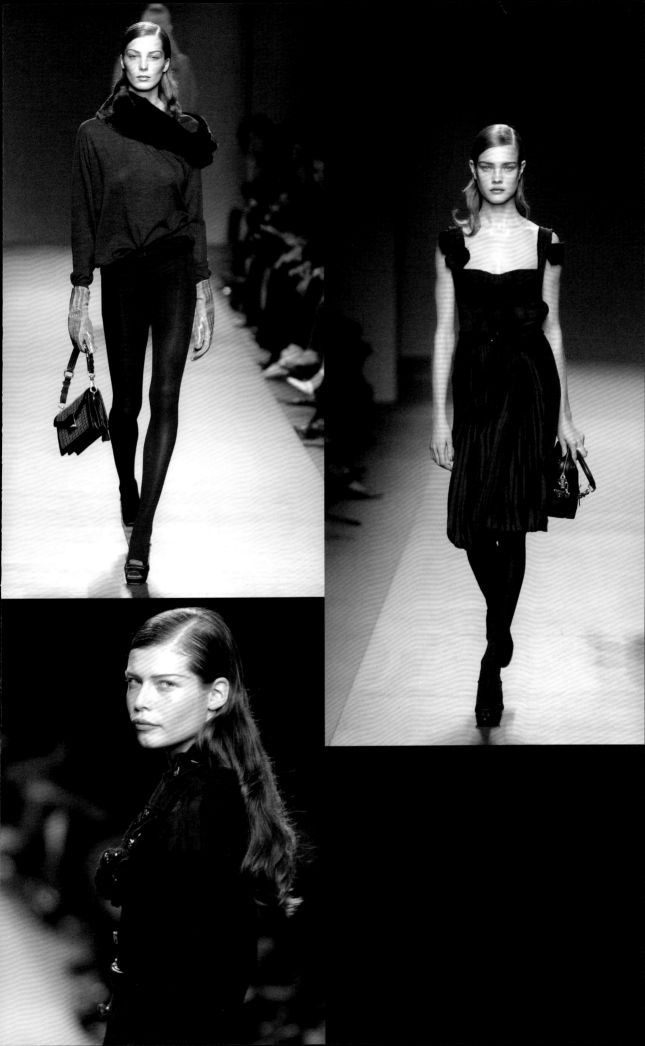

The architect Rem Koolhaas and his OMA/AMO studio clad the walls of the Prada show space with airplanes flying over a Venetian sky this season, imbuing the set with an openly romantic, filmic feel. 'There was a nostalgia for that kind of happiness,' Miuccia Prada told the *Independent* newspaper of the meaning behind the clothes. That explained the dominant 1950s silhouette comprising full knee-length skirts, Capri pants and narrow waists, at times belted with grosgrain ribbon just as they were for Autumn/Winter 2000–2001 (p. 226; fur tippets, also seen in that show for the first time on a Prada runway, made a comeback here too; see p. 303, right). 'I chose the period for its symbolic value,' the designer continued. 'It is a symbol of femininity, of being feminine, pretty, nice, if you like. Of course, we don't want to go back to that but there was something very appealing about being so comfortable, about not having to think much, not having to choose.'

How interesting – and open, in fact – that a woman who had fought so hard for her independence, and been so stratospherically successful, was looking back to a time when there were no such opportunities and life was, in some ways, more straightforward for that. Any escapism didn't stop there as postcard-style etchings of Italian tourist destinations – the Duomo in Prada's home city of Milan, Venice again – appeared printed across white cotton circle skirts. More were dip- and tie-dyed because, Prada said, she was also bringing back craftsmanship 'in a big way'. 'I'm very upset when people say the big companies destroy everything, when they say that they destroy craftsmanship,' she explained. 'We had such fun making this collection, using all sorts of different techniques and tie-dyeing all this gorgeous material in the kitchen sink.'

The end result was more home-grown – more Italianate – than ethnic: imagine Anna Magnani for the twenty-first century. 'I am interested in the criss-crossing of culture but of seeing it in a very European way,' Miuccia Prada concluded.

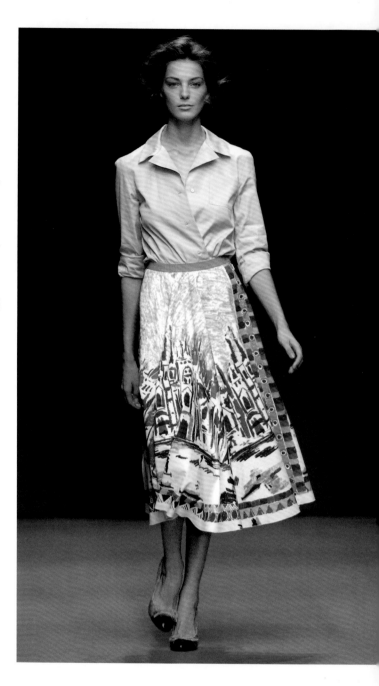

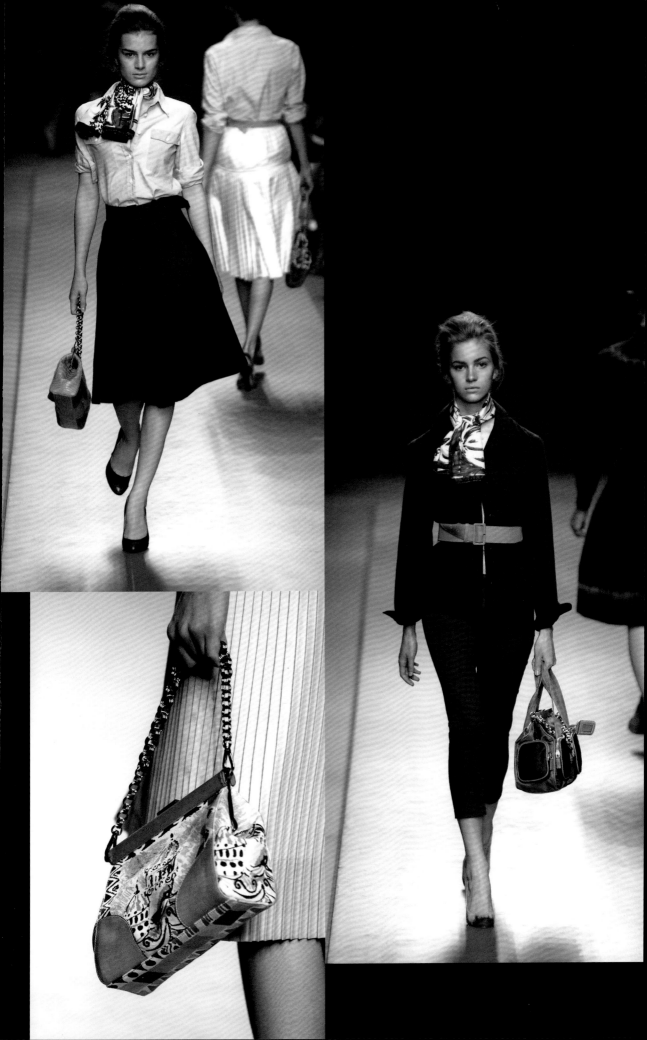

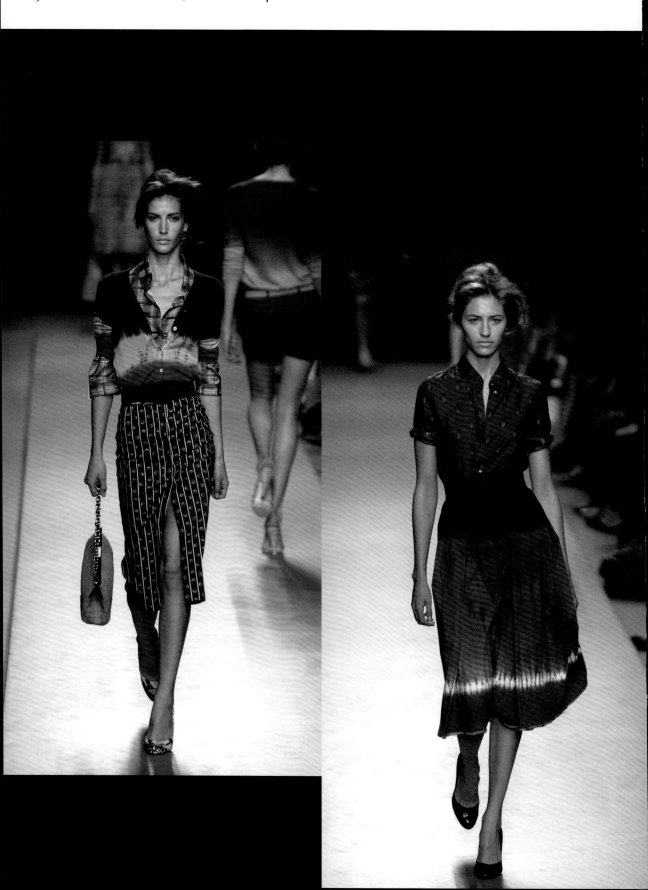

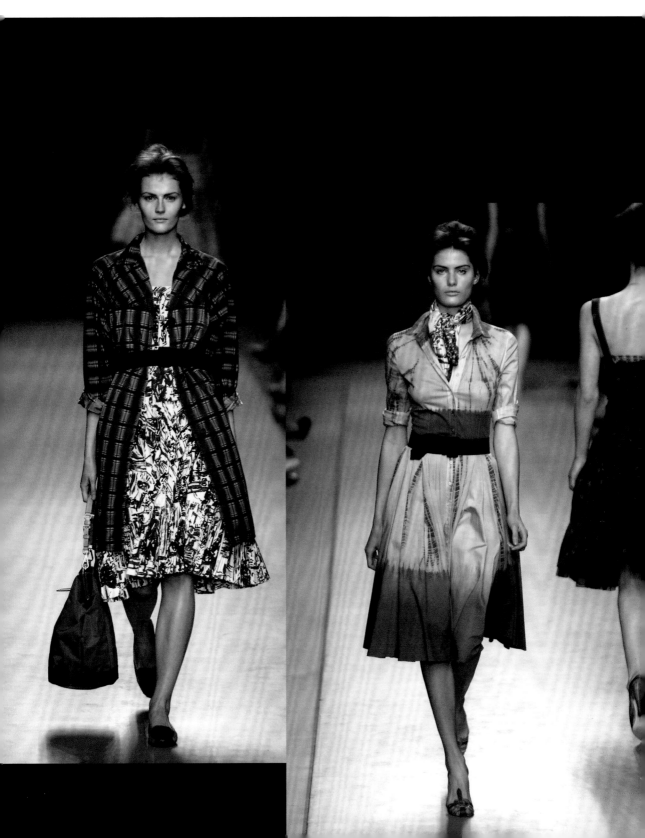

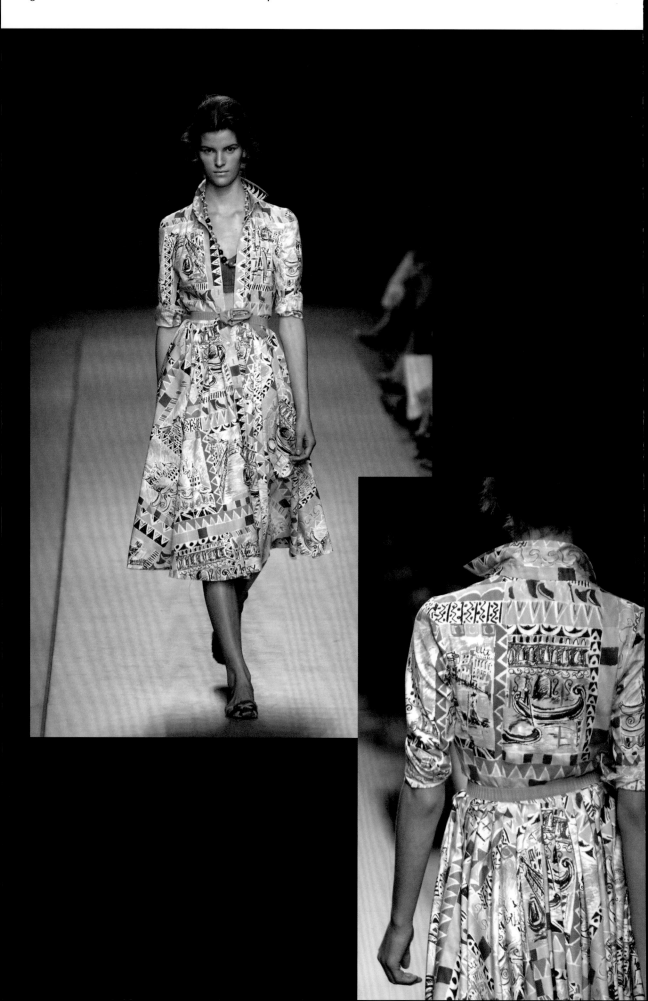

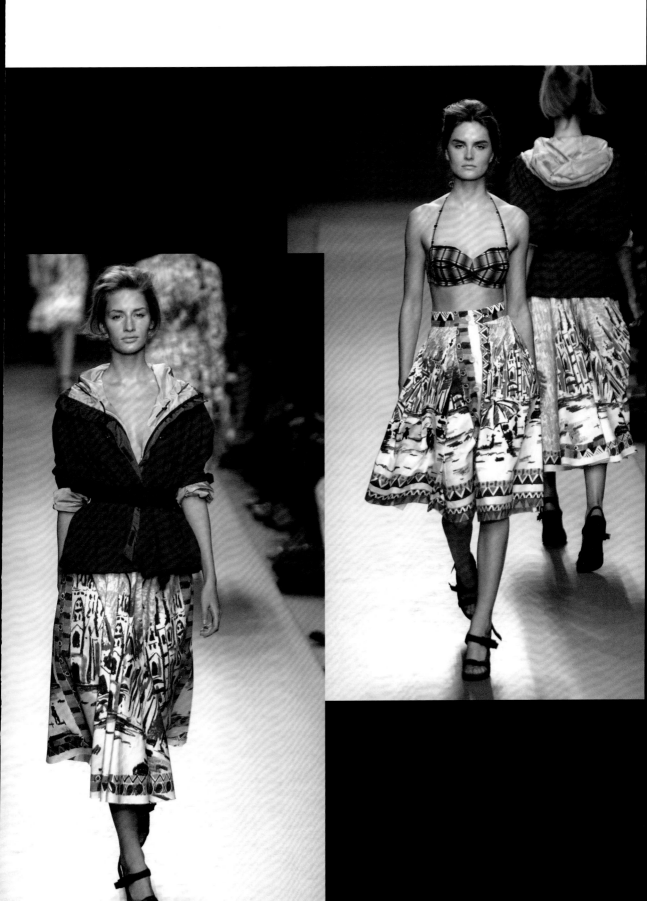

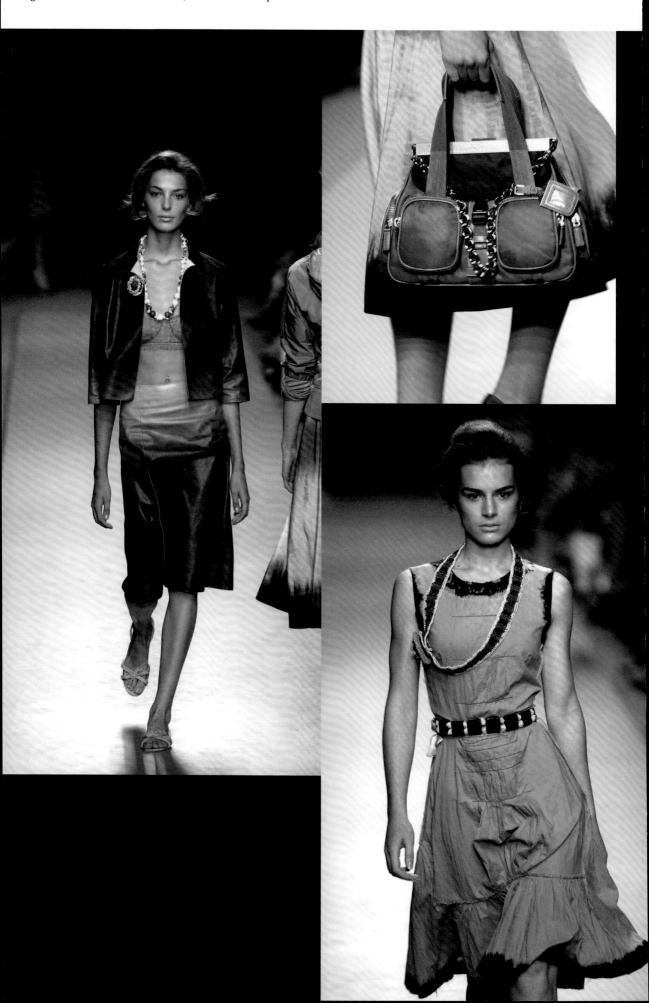

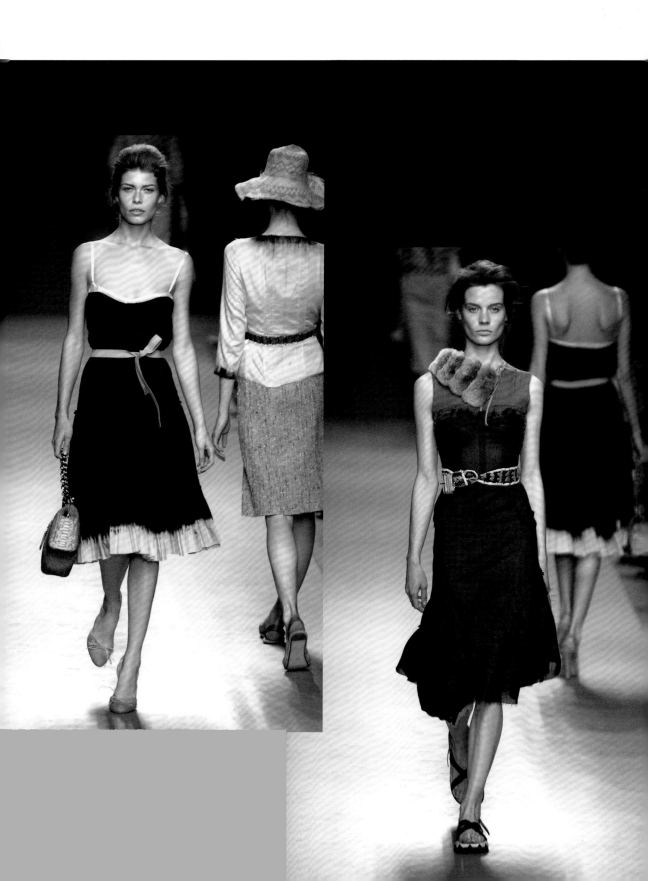

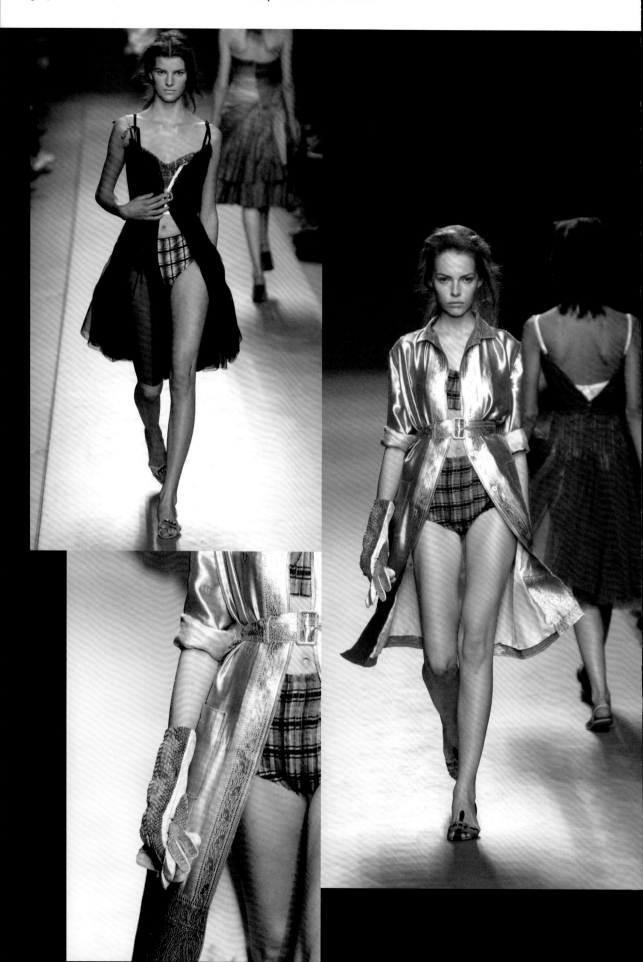

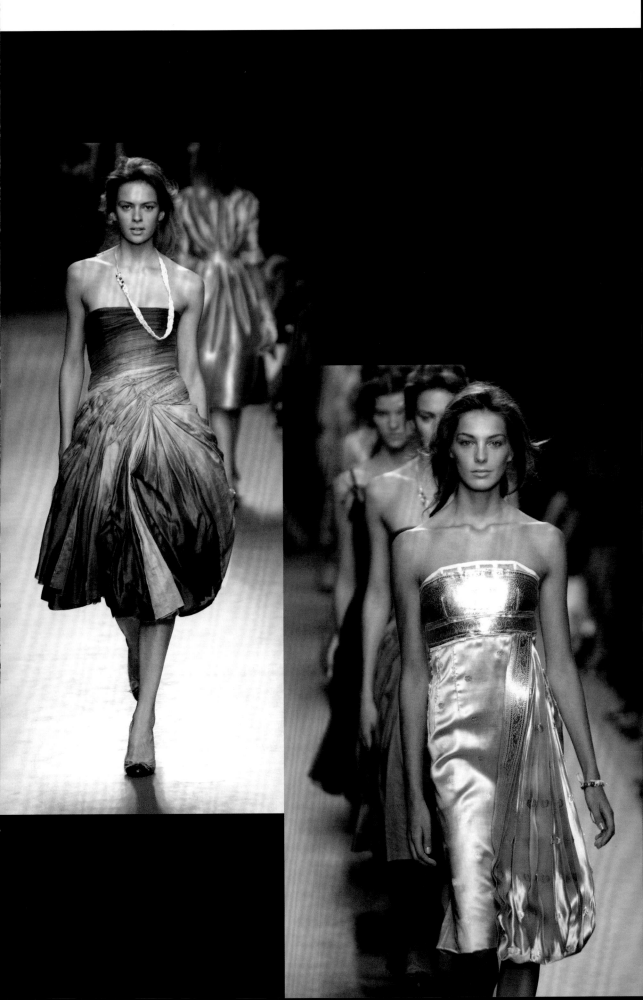

From emotionally charged sepia-tinted picture
postcards and nostalgic local tourism (see p. 296),
Prada moved on to time travel with a show that
seemed to say: copy me if you dare. That applied
to everything from the extraordinary fabrications
to the sheer grandeur of the concept. In her own
words, talking to *Women's Wear Daily*: 'I wanted
to express romanticism and dreams. It's a kind of
extreme romanticism of the future and the past.'

OMA/AMO's murals this time featured the planet
Mars in a pulsating palette principally of orange,
yellow and red. 'It's not that I want to go back. It's
a dream of a world of beauty, of positive things, of
big thinking, not small thinking. I think that, even in
art, everyone has experimented with every aspect of
the trashy side of life by now and there is a need for
something different. It's not necessarily about being
rich or expensive but you don't have to be banal,
dressing and elegance is more complicated than that.
You have to try to elevate the level of dressing in some
way, make it more cultivated, more sophisticated.'

The future part of the story was not this time the
retro-futurism upheld by Courrèges, Rabanne or
Cardin (see pp. 54, 246). Instead, it was suggested
in disorienting holographic prints, more that evoked
moving images, and even a little green-faced alien
robot print on a T-shirt of a sort one might normally
find in an animated game (p. 309, below left). The
historical aspect was inspired by the work of German
artist Caspar David Friedrich: his glowing landscapes
appeared across richly hued silk dresses that were
nothing short of spellbinding (pp. 312, right, and
313, left).

Perhaps taking over where Spring/Summer left
off, decoration – craftsmanship again – was a focus
throughout. Minimalism be gone. Whatever the
silhouette (and it veered between lean and relatively
simple to overblown) or the texture (ranging from
feather-light chiffon to army rib knits), ornamental
touches appeared on almost every garment: crystal
and cross-stitch embroideries, jewelled elbow
patches, glitter and fur trim.

'Waist Down' – a travelling exhibition of 200 Prada
skirts dating from 1988 and conceived in collaboration
with AMO – opened at the Prada Epicenter store
in Tokyo in November 2004. When the show moved
to New York in April 2006, Prada told the *New York
Times*, 'We realized that when you talk about the
design process, people are very interested. So we
started with the skirt because the coat and skirt
are the pieces I like the most. The skirt is a feminine
symbol, and it's also something you wear every day.
It's my T-shirt.'

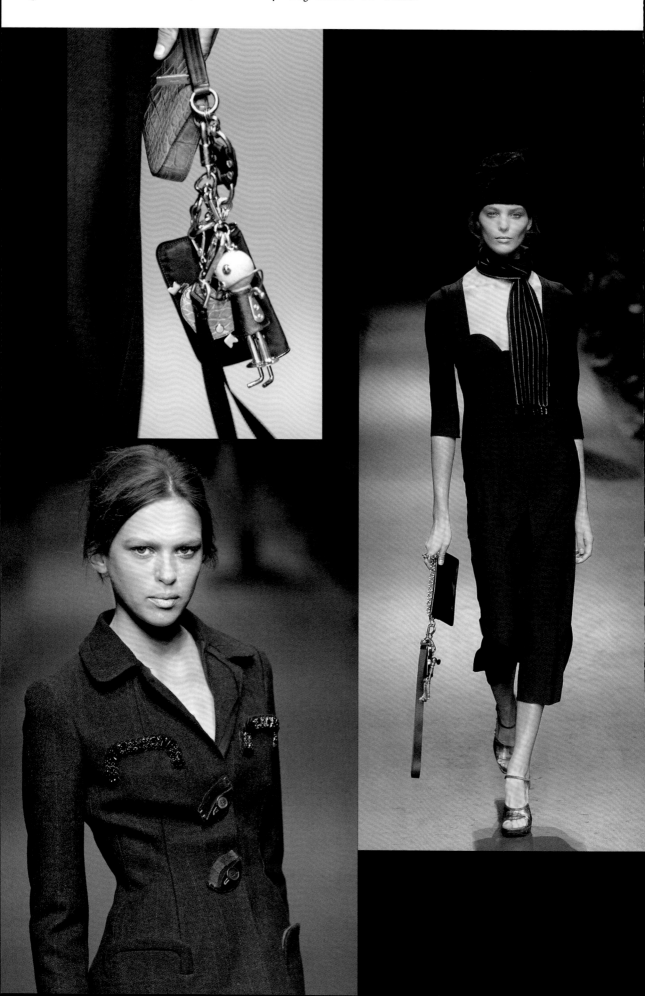

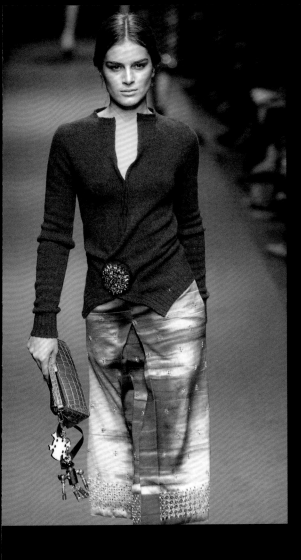
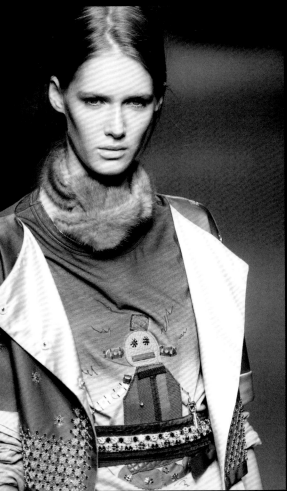
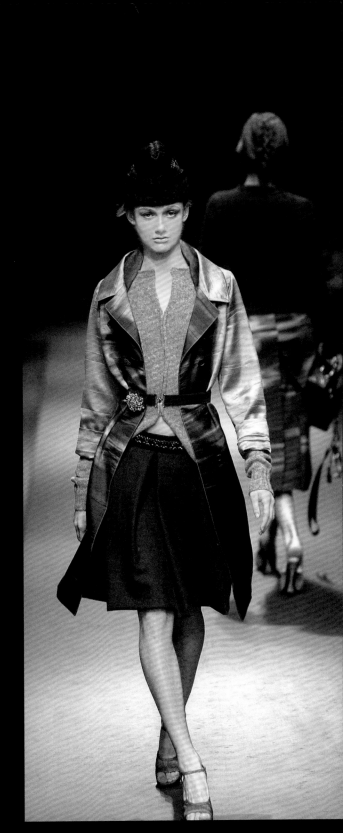

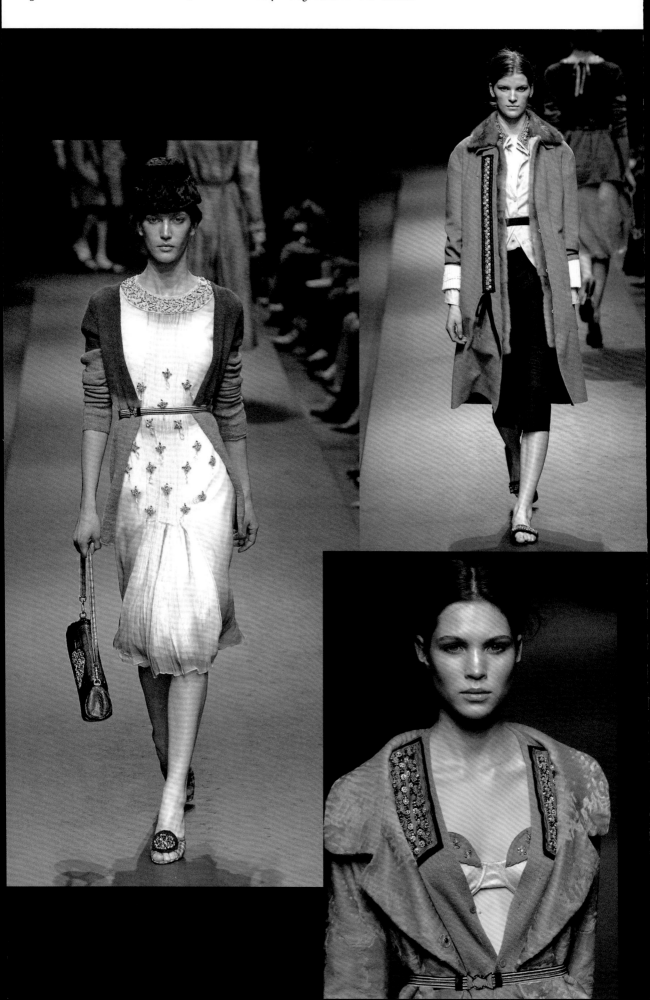

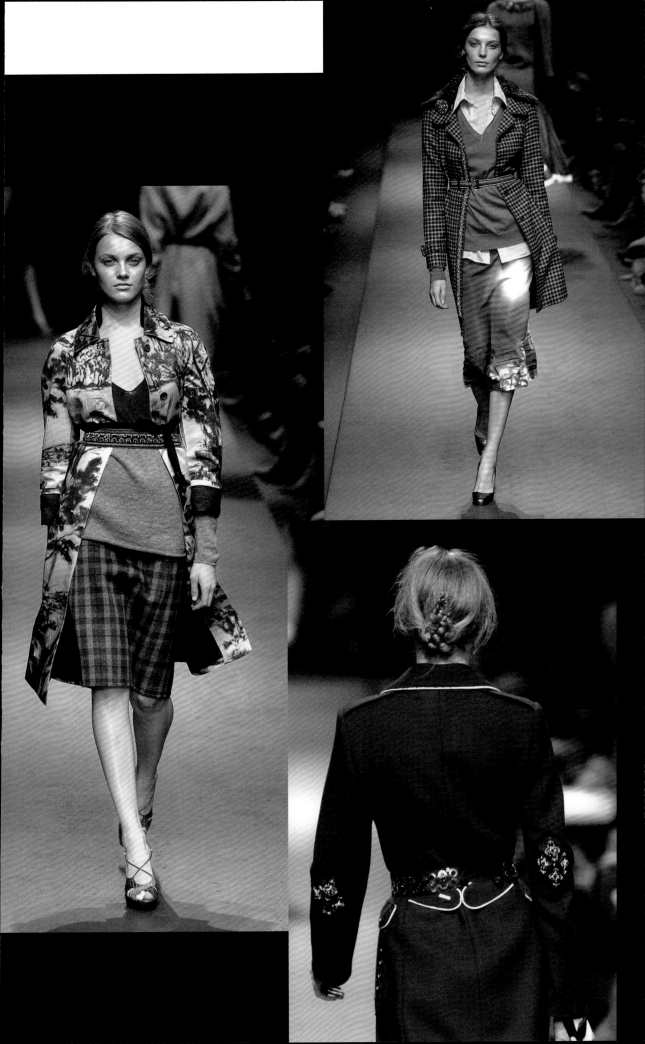

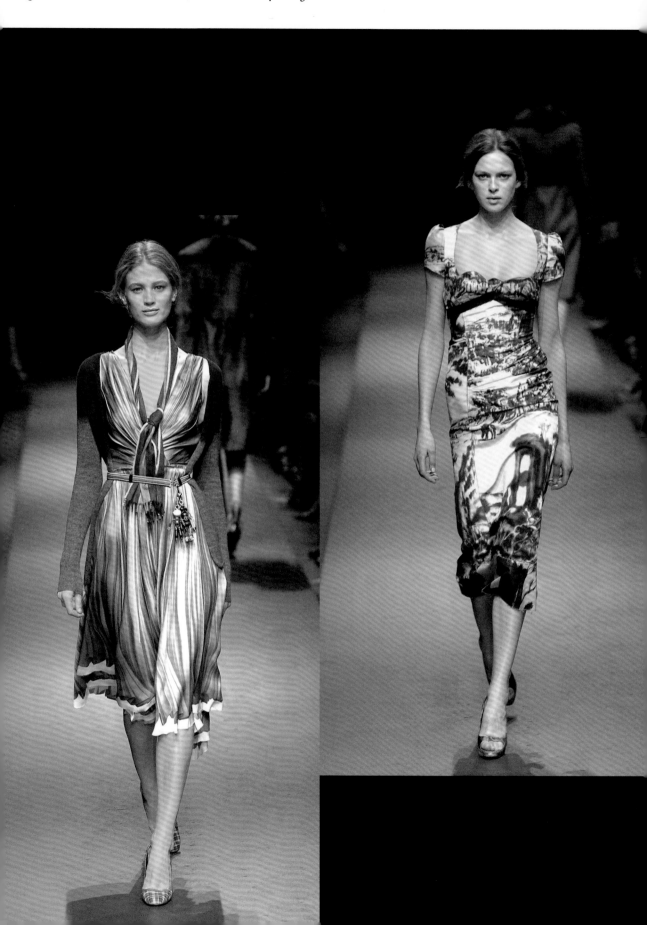

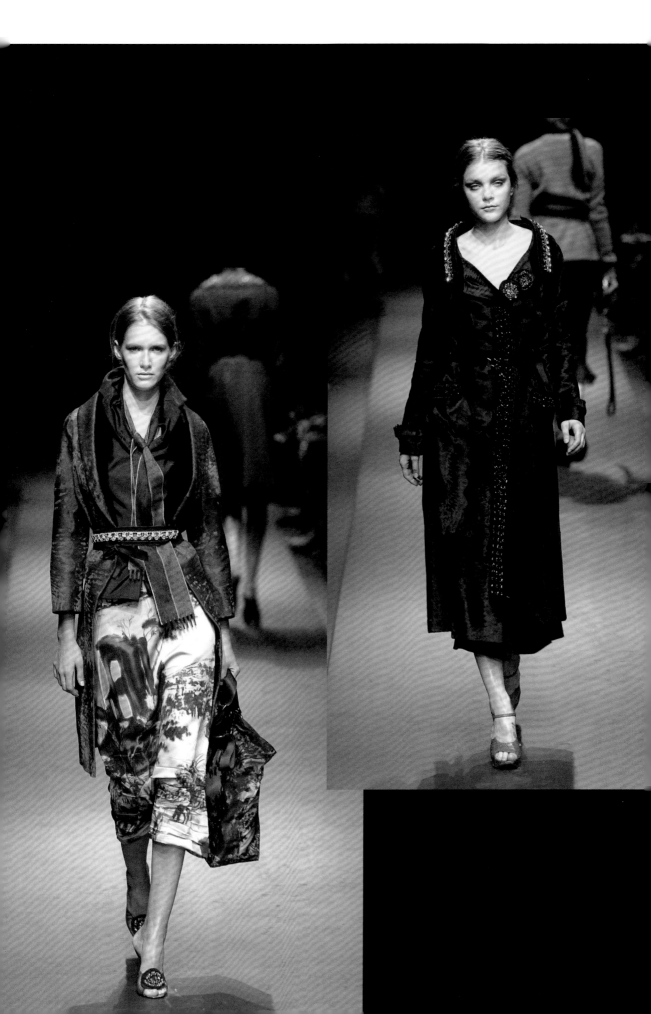

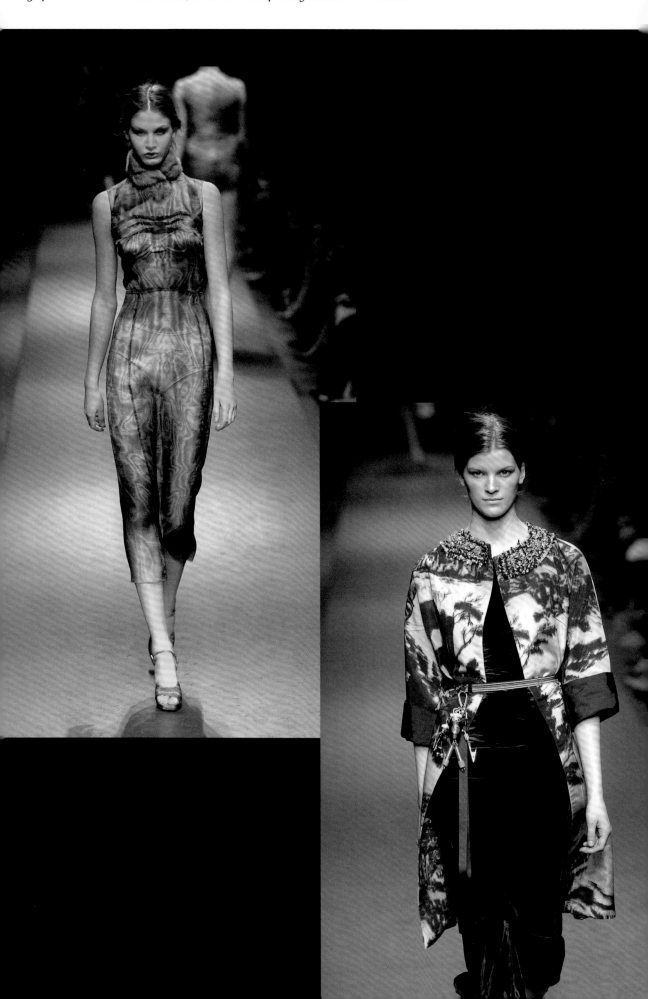

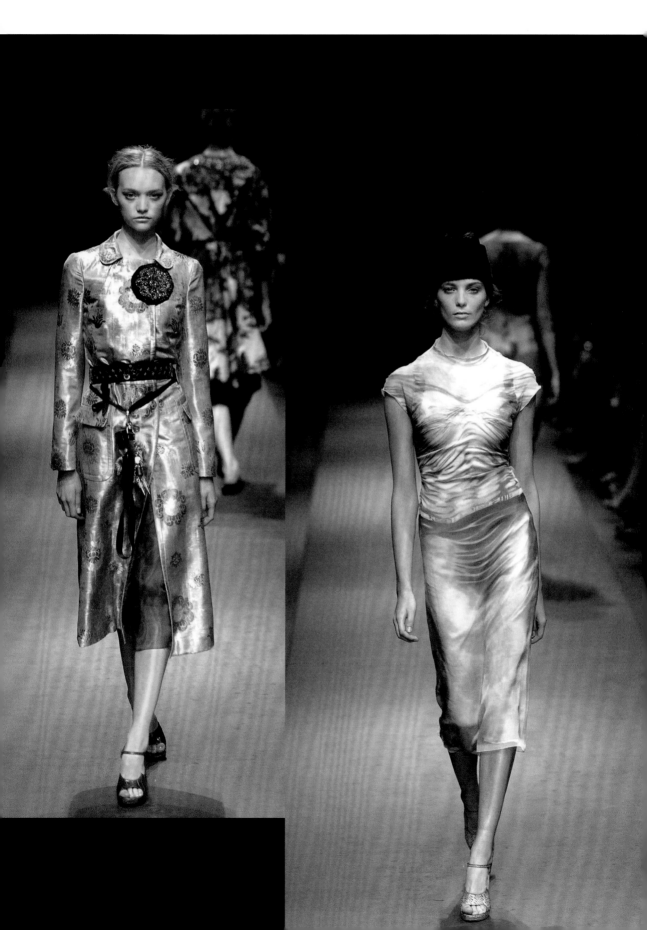

'A vague idea of birds; birds of vanity, like peacocks, parrots, and swans,' Miuccia Prada told Style.com, was the starting point of her Spring/Summer 2005 collection. 'I also wanted to move toward something more young and sporty, tall and narrow.'

The show space was stripped bare and, with a stream of live newsfeeds projected onto the walls, this was indeed younger, fresher and more borrowed from the street in flavour, despite the fact that the rest of the world was still mining the bourgeois aesthetic Prada had initiated.

There were rasta colours – and a reggae soundtrack – across striped knits, polo shirts and skirts that fell to mid-thigh. Also present were suede kilts and tunics, schoolboy shorts and patch-pocketed shirts, cute fit-and-flare dresses, crocheted cloche hats, bucket bags and a mix of preppy penny loafers, sturdy block-heeled sandals in glossed leather and sling-backs in shades of mustard, olive and purple, say.

Perhaps the designer was thinking of birds in the not entirely politically correct 1970s sense of the word, as used to describe girls, given the spirit of that decade had returned to her runway. There were winged creatures also, however. They took flight in the form of a leather parrot nestling next to a sailing ship pinned to a natty jacket (opposite, above left), and were printed and appliquéd large across mini-dresses. Most dazzling were densely embroidered peacock feathers across more skirts and dresses to artfully eccentric effect.

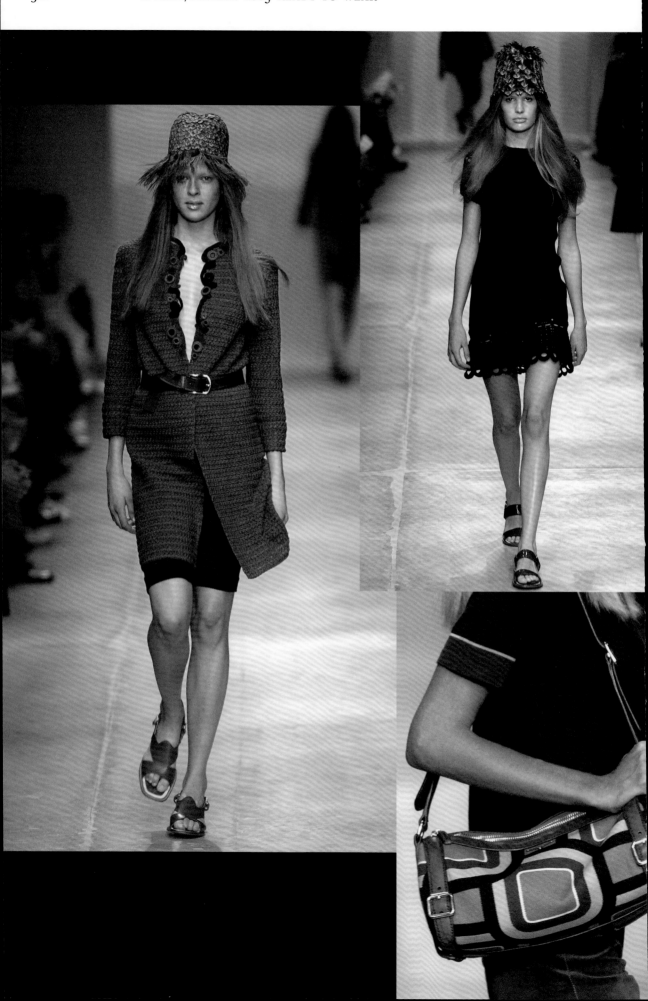

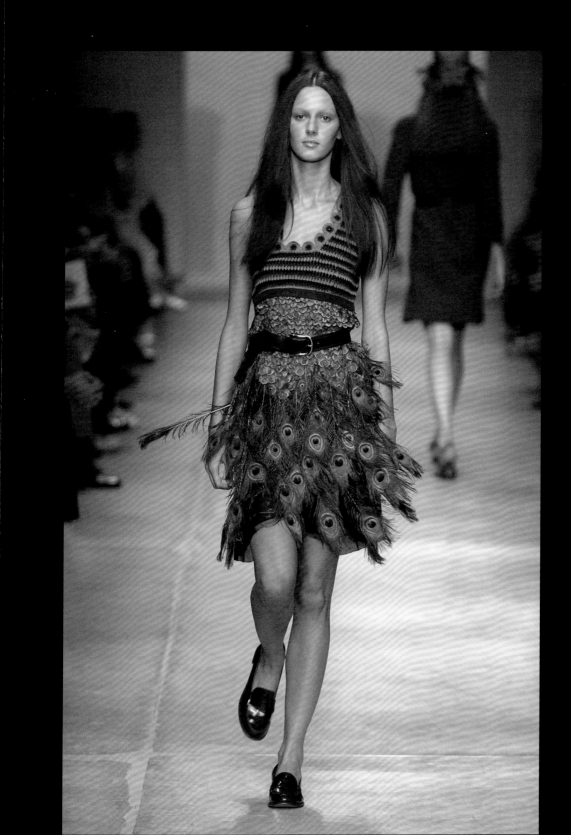

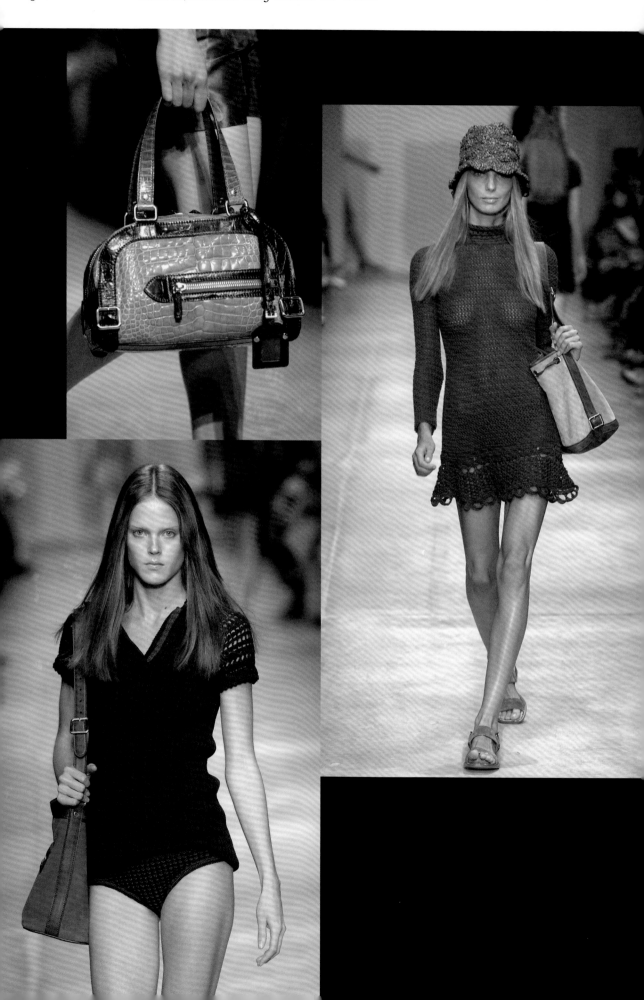

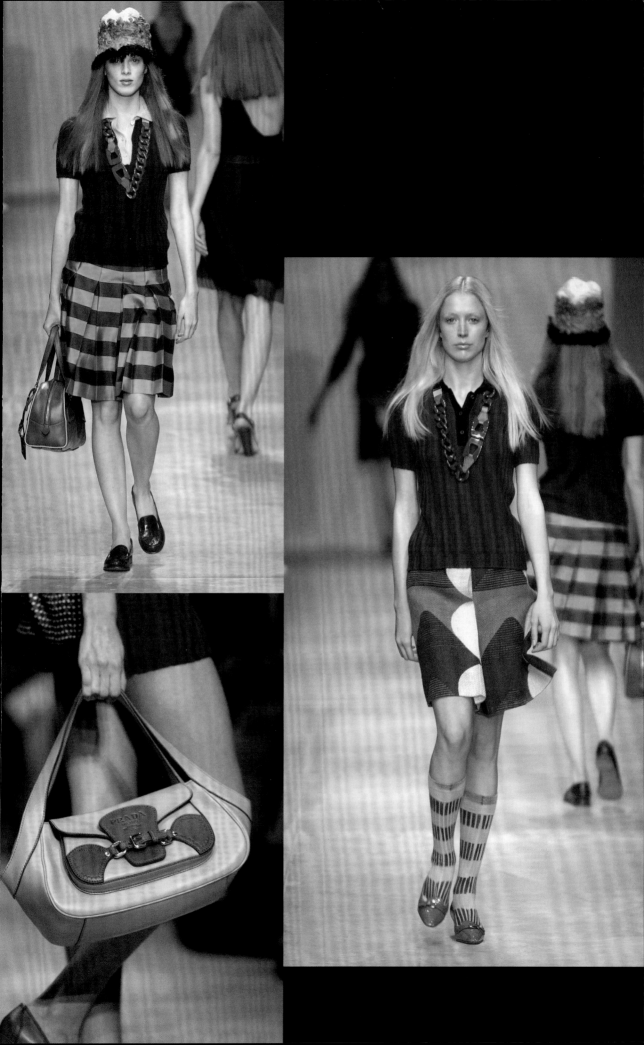

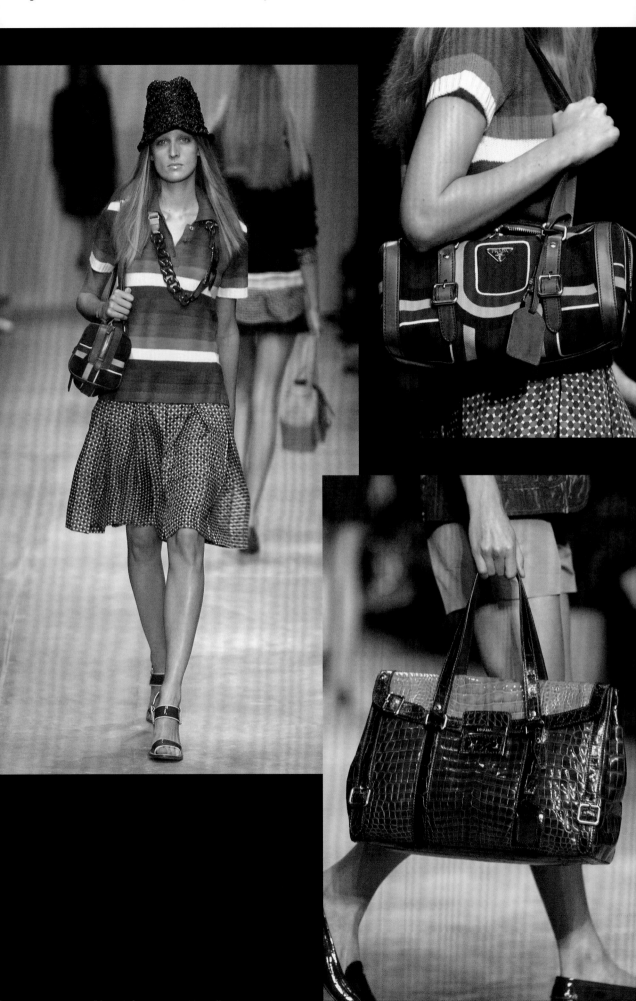

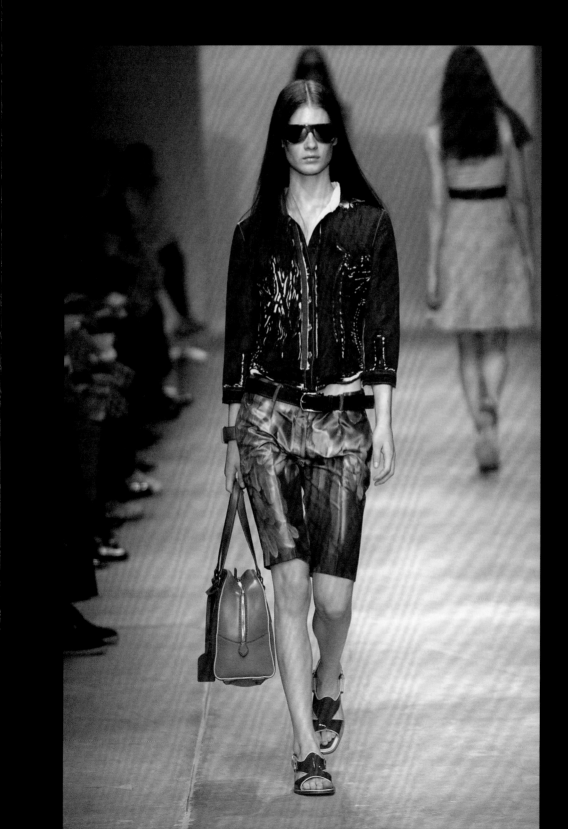

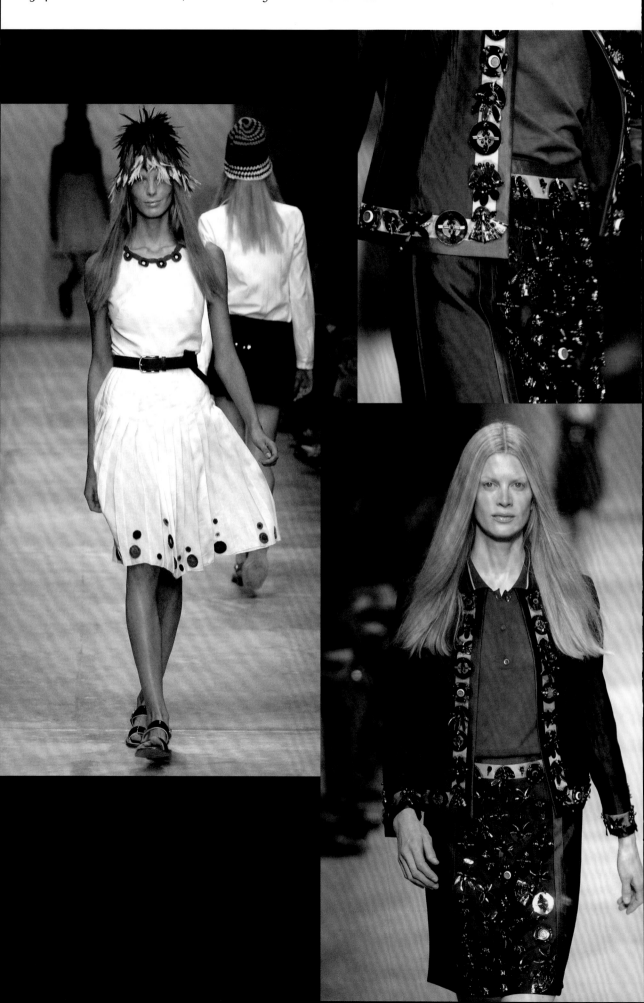

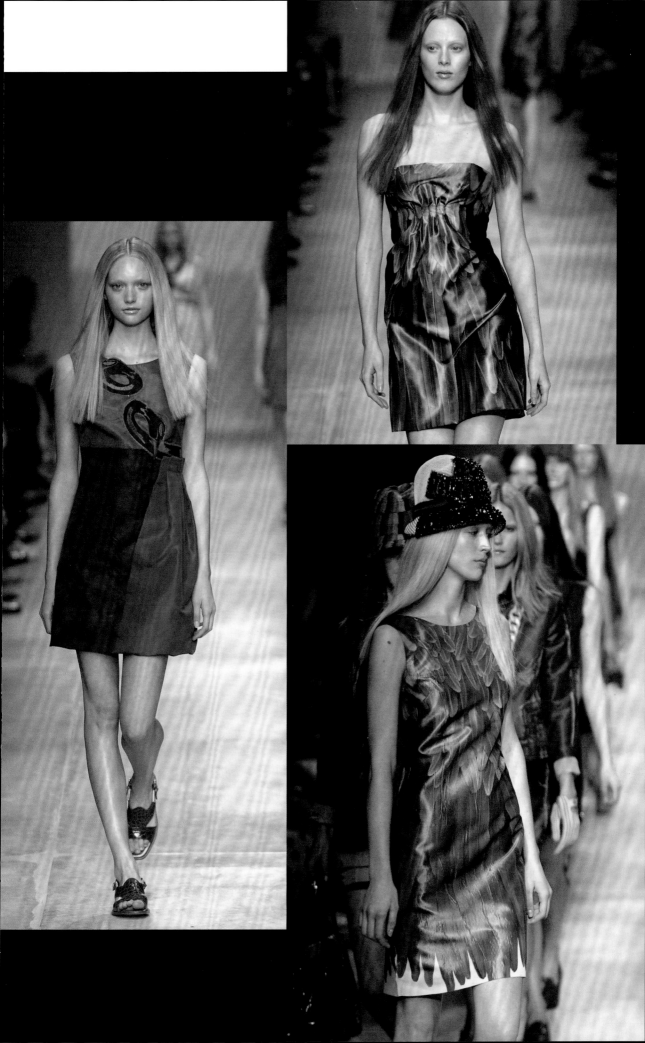

The speed at which Miuccia Prada turned out new
ideas at this point in her career was extraordinary.
There was no other designer in the world who was
more influential or who challenged the fashion
audience so consistently. Having spent the past
few seasons exploring ornamentation, this time
Prada went back to its roots, reinventing Nineties
minimalism for the new millennium with a
stripped-back sophistication that was every
bit as impressive as that which came before it.

'I had an instinct to go back,' Miuccia Prada told
AnOther Magazine. 'To go back not to what I'd
done before but to something more simple. It was
not only about the exterior but also the interior,
a different aspect of femininity. The word dignity
came up and power: dignified, powerful, deep,
clever, beautiful women.'

The opening sequence set the tone. It was all black,
from the thick bands pulling the hair back off
models' faces, stripped of make-up save for a dark
lip or eye, to the clothes: a wool slip dress that fell
to the knee, another with a deep V-neckline, peasant
sleeve and tulip skirt, black platform-soled pumps
and neat black leather bags. Here was all the drama
and internal strength of the film noir heroine. Then
came more tailoring in camel, a shimmer of bronze
sequins on a nude chiffon dress (p. 329, right), a veil
of black lace on a black A-line coat and another
printed with red roses (p. 332, left), that flower being
the most romantic of them all. More roses appeared
on dresses and stamped in red and blue on purses.

'For years I didn't want to declare any of my
feelings,' Prada continued, of this gesture in
particular. 'I was always involved emotionally,
but with minimalism you can hide everything.
Those roses were a symptom of me opening up.
Those red roses – that was being brave.'

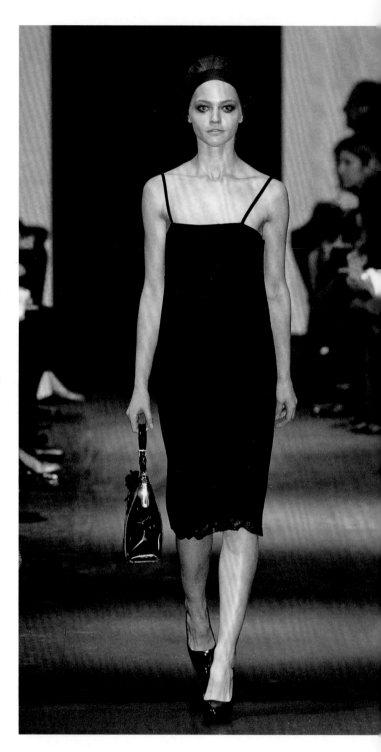

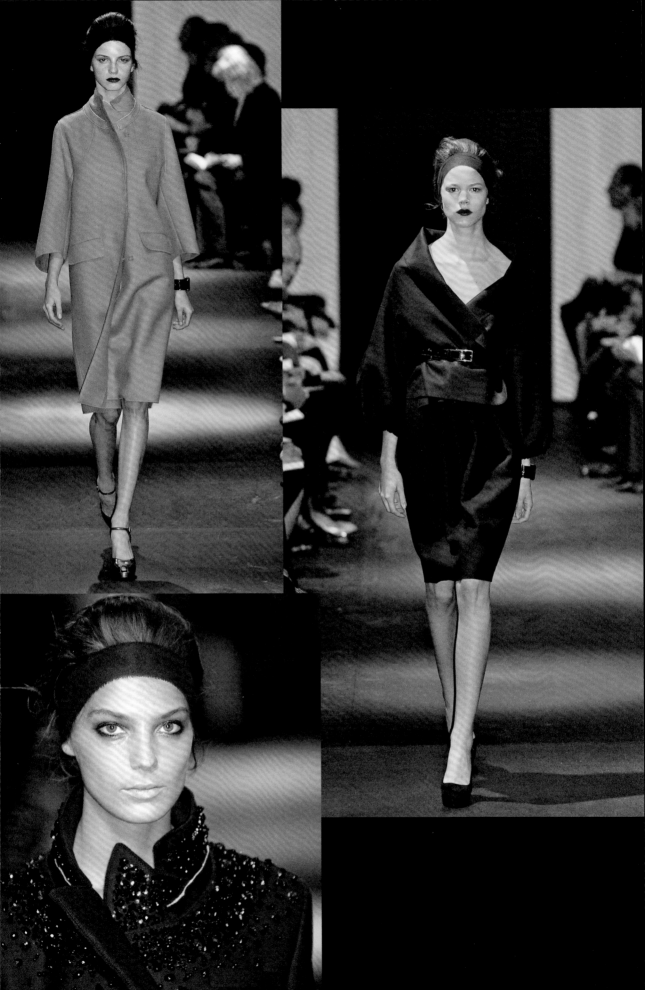

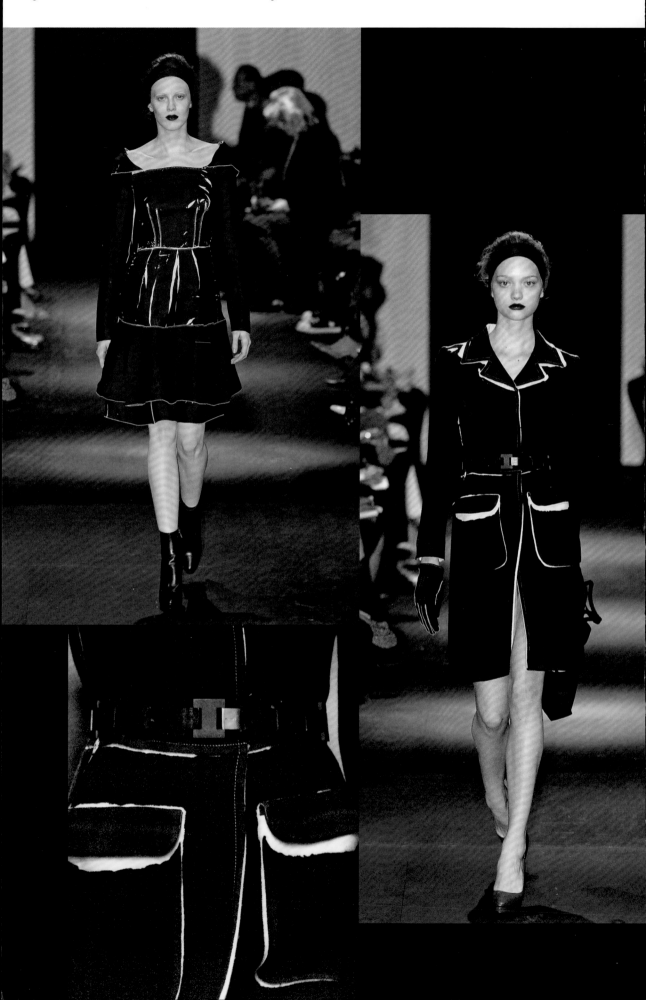

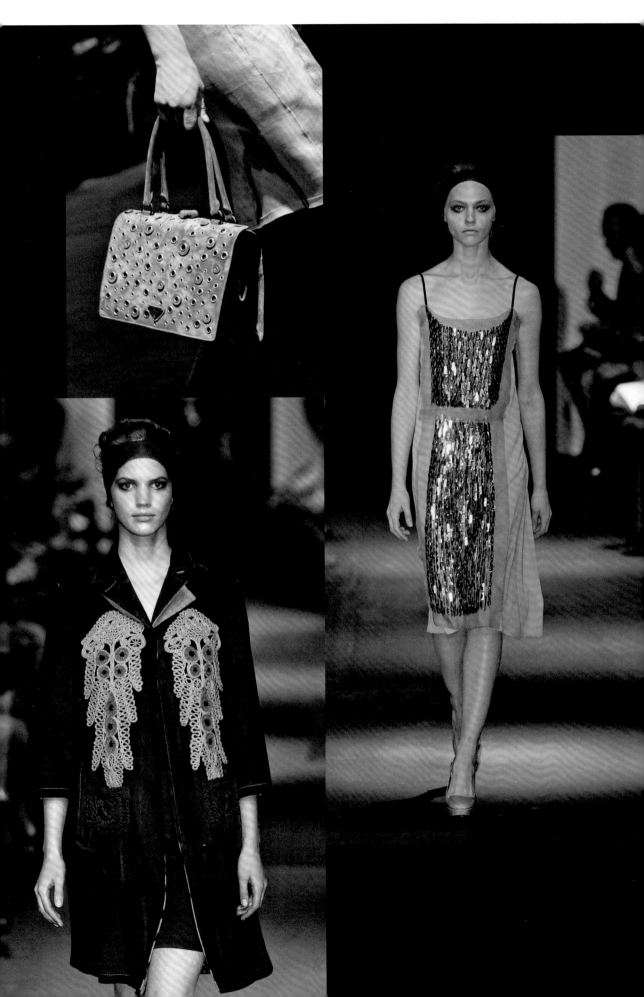

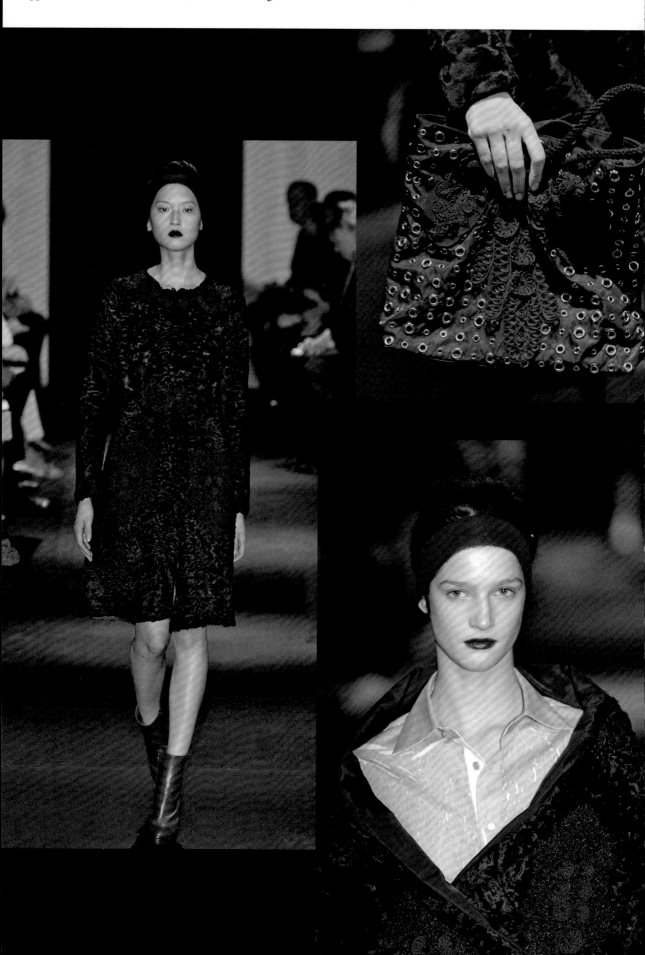

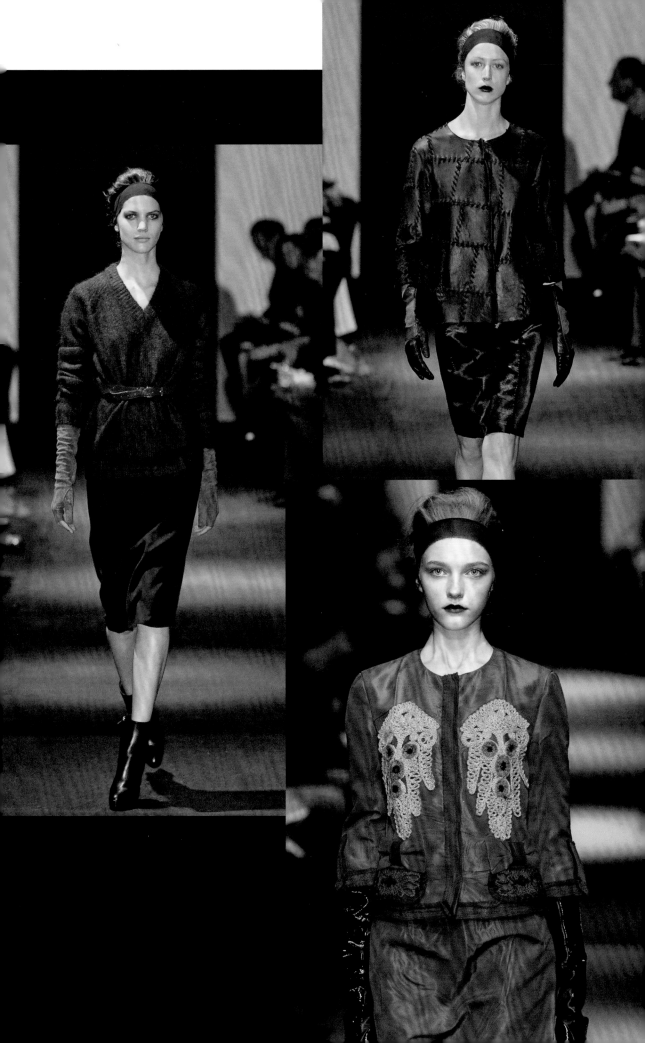

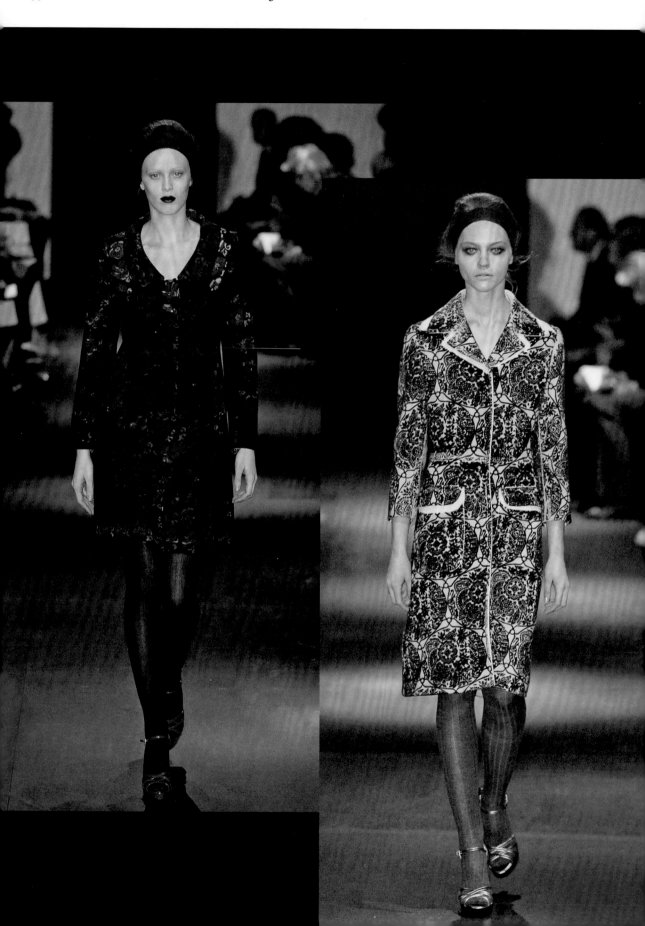

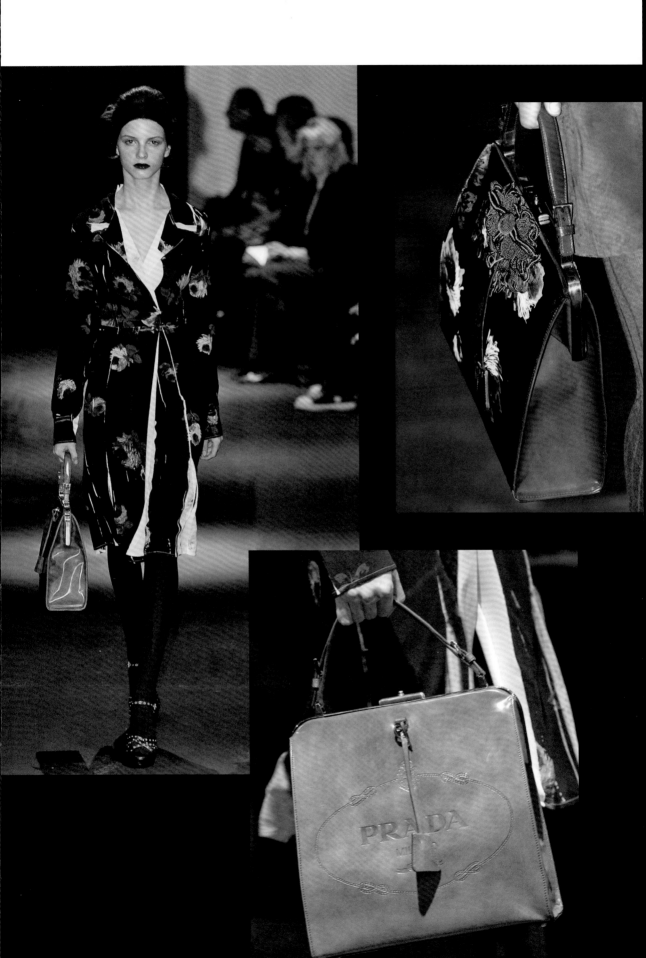

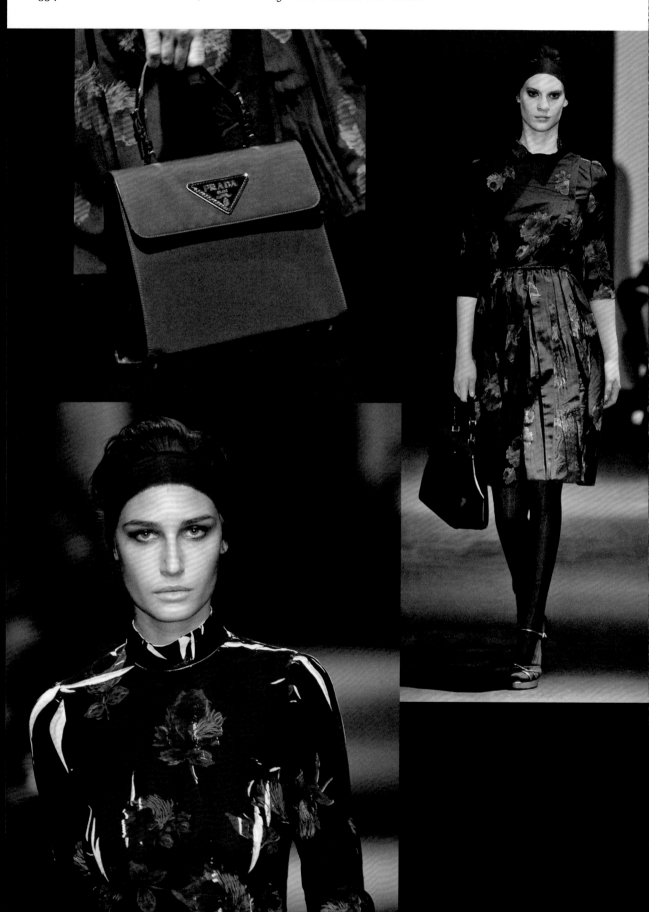

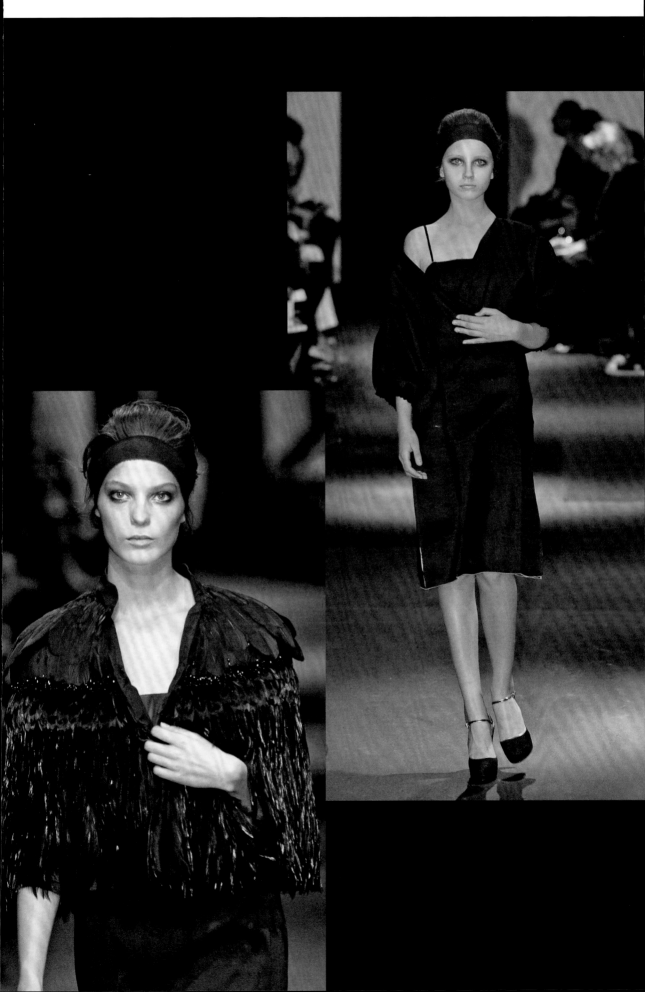

'I still think the idea of a new minimalism is relevant but, of course, you can't do anything simple any more,' said Miuccia Prada in *AnOther Magazine*. By this point, the designer was veritably mobbed post-show by journalists who hung upon her every word. That is not surprising. She is more interested in verbalizing concepts than many of her profession, who not unreasonably find it easier to express their feelings in cloth. 'I'm interested in whitewashing, in over-dyeing, in florals that are cancelled out somehow,' she continued. 'Last season I described the collection as dignified (see p. 326). This season it is more nostalgic. I like the idea of a dress in which you can forget yourself, so you can dream your dreams without being worried about how you are physically.'

If the predominantly pale colour palette and silhouette that honoured the space between the body and the clothes in this collection appeared at first sight to be naïve, there was a complexity to the texture of fabrics, to faux pleats and embellishment – a shower of golden embroidery here and more that was indeed actually whitewashed there. Remarkably, while surface decoration is normally just that, in this instance it gave garments their structure and depth – an effect amplified by a mirrored floor and walls that reflected looks from every angle.

This was, in some ways, Prada at its most introspective, even profound. There was still a playfulness to be seen, however, predominantly in accessories. These included Space Age visors, mottled over-the-knee socks and shoes that were, even by this designer's standards, far out: peep-toed granny boots with hot pink patent leather uppers and a high spike heel, caged wedges and more in gleaming metallic snakeskin. Finally, Prada trolley dollies made their debut on the catwalk: at least some models wheeled cases as they walked.

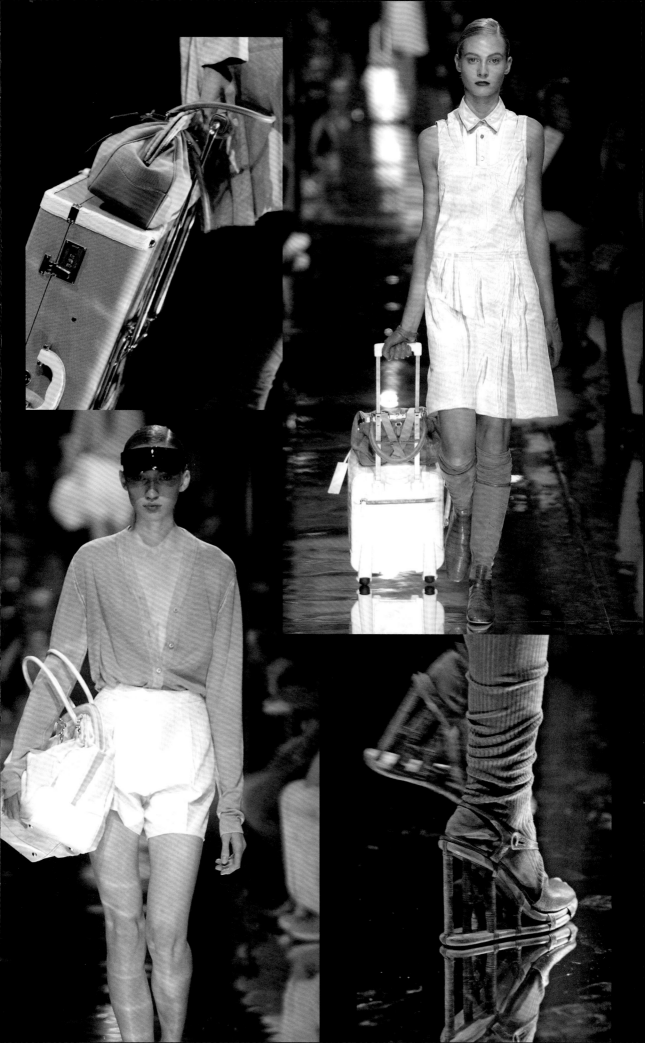

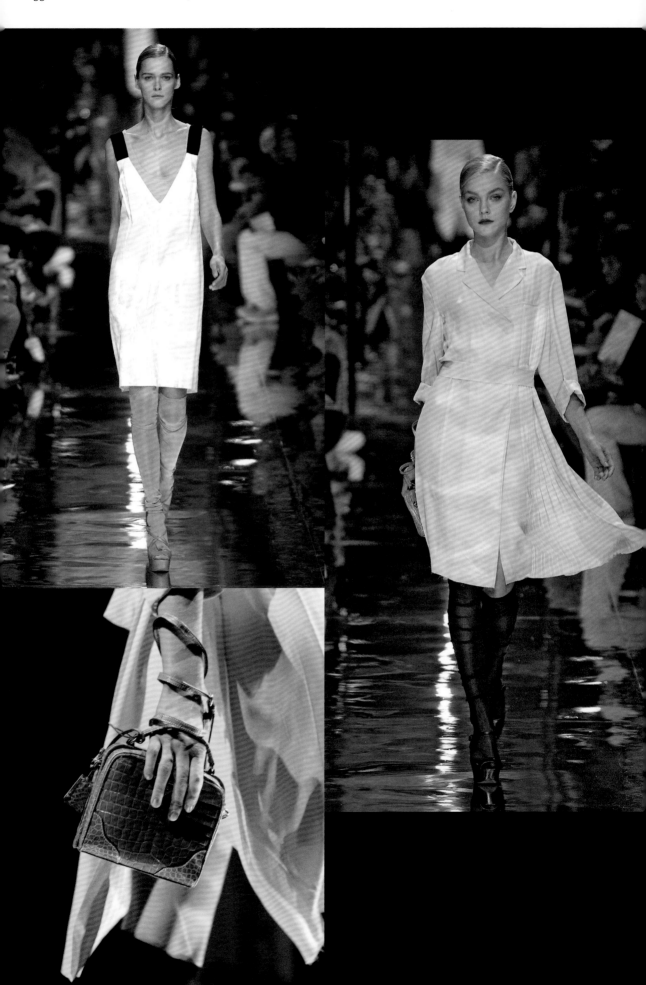

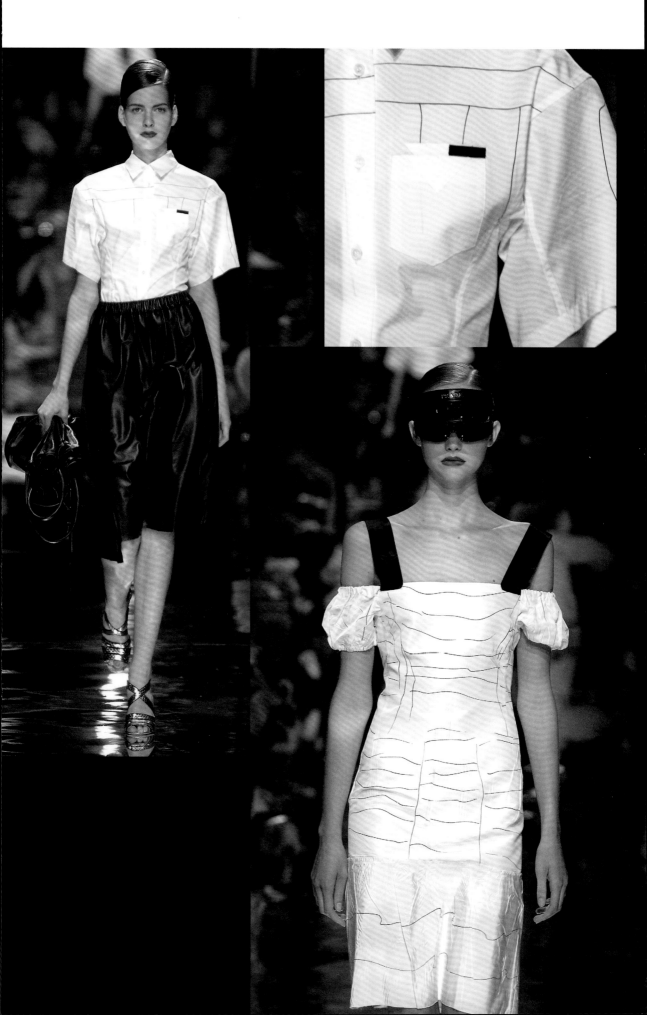

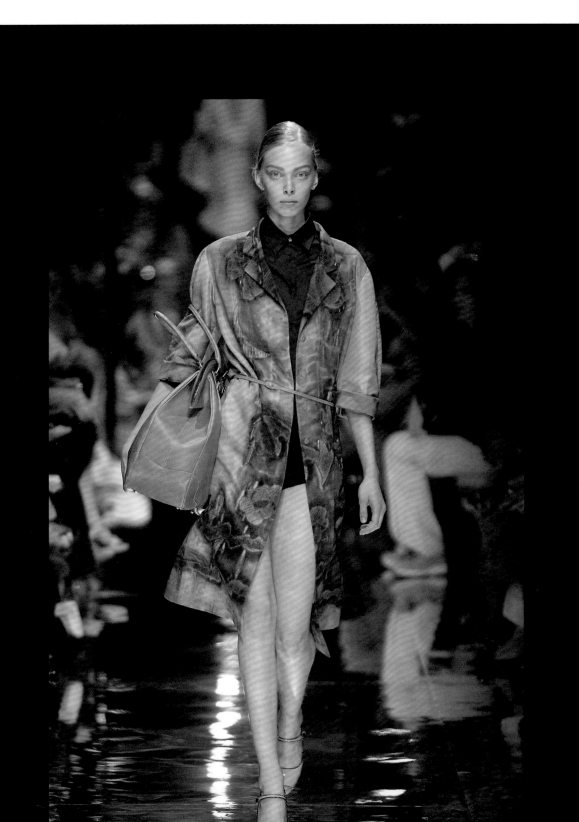

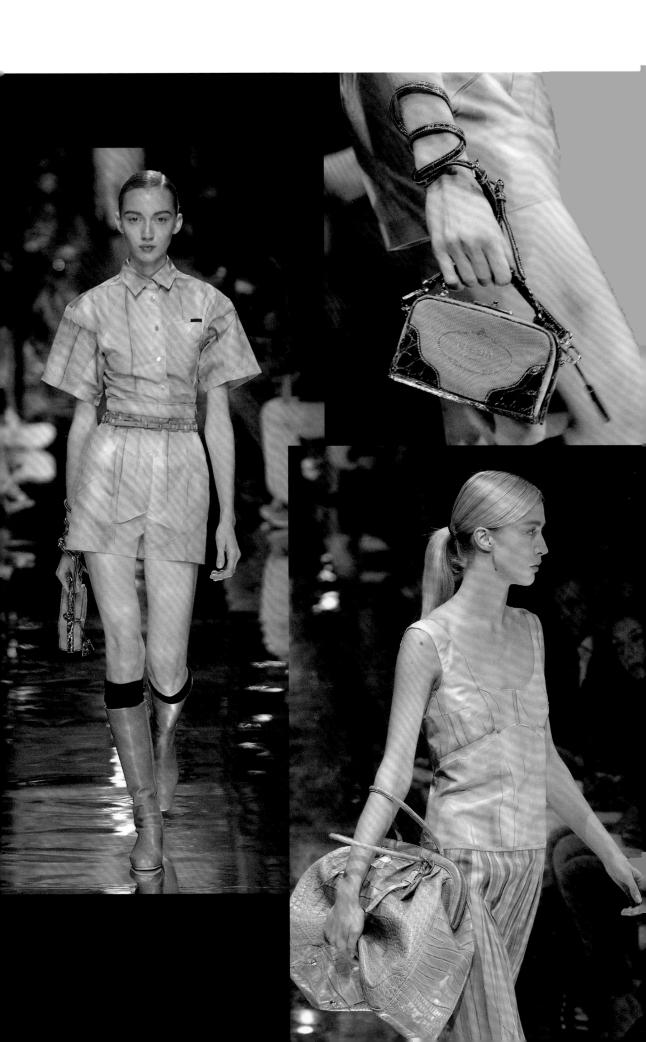

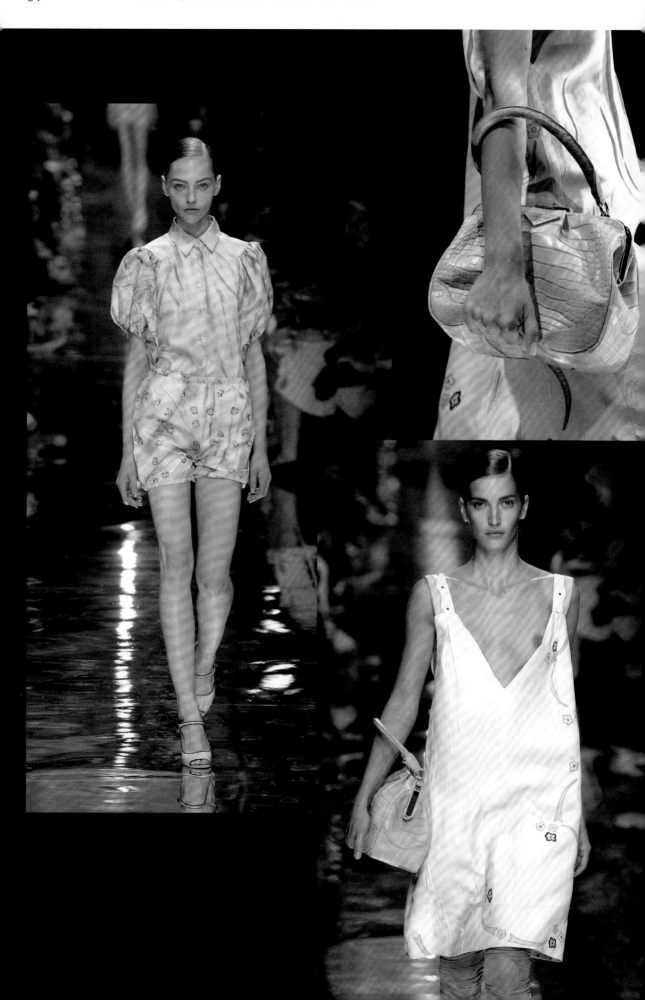

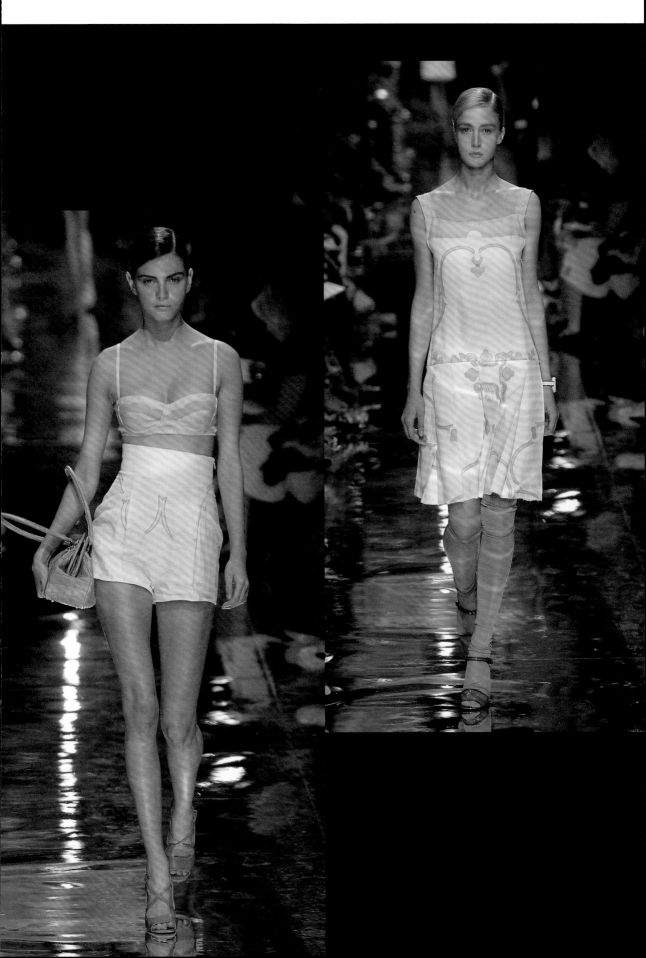

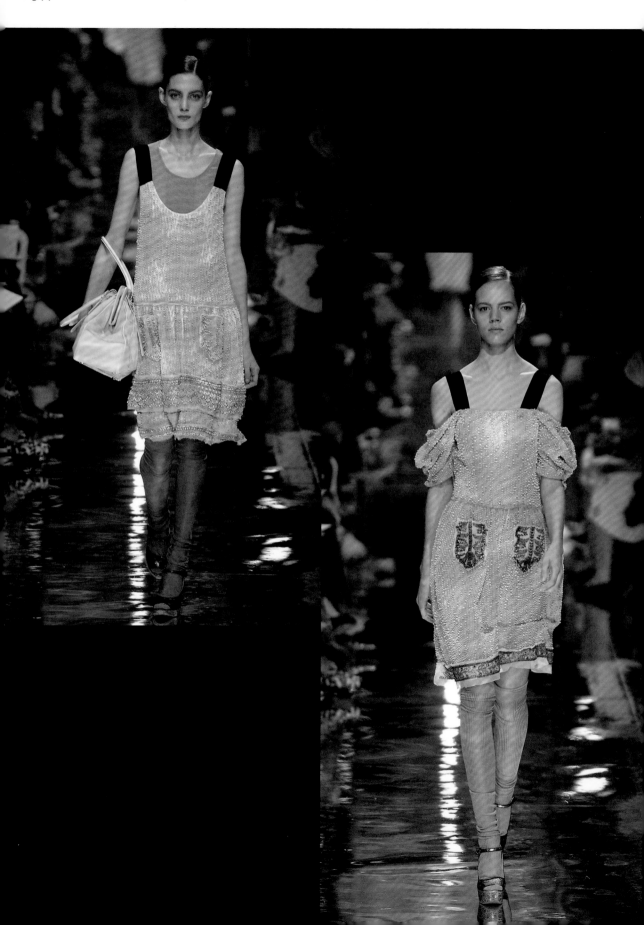

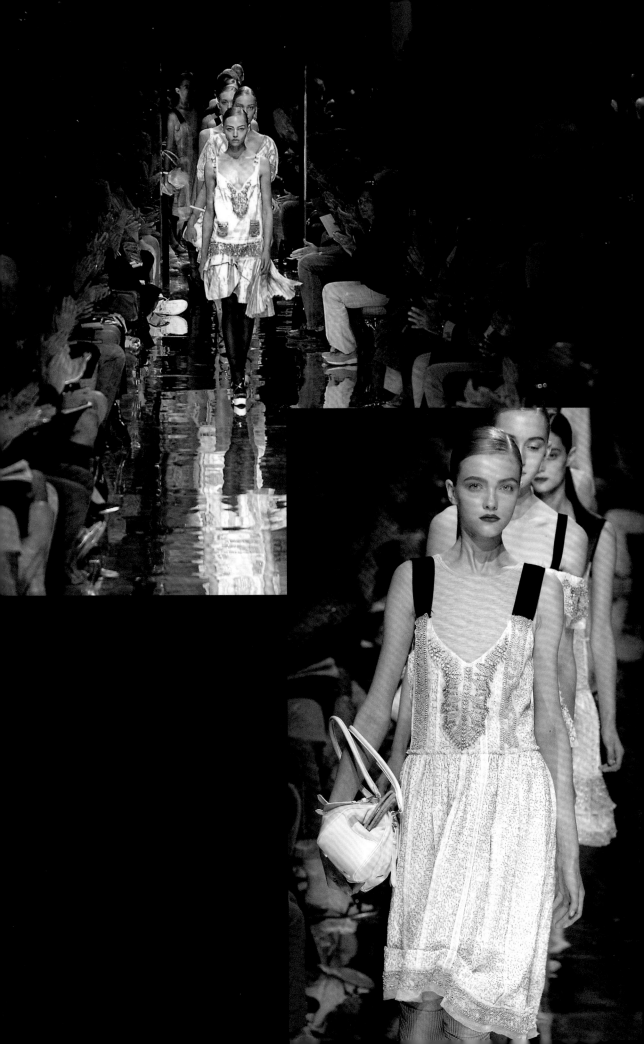

'Christian Dior defined Cristóbal Balenciaga, the ultimate designer's designer, as "the master of us all",' wrote Suzy Menkes in the *International Herald Tribune* in February 2006. 'Miuccia Prada ... can rightly be described as "the mistress of us all". No other creator has the same ability to distil the essence of what is modern, sampling the cultural heritage, anchoring shifting society and making it all seem relevant.' Praise indeed.

'Until 10 years ago', Prada told that paper, 'it was about changing a bourgeois vision of beauty – then 10 years defining a new beauty. Now the world is so complicated and loud, unless you scream no one listens.'

At least some of the screaming in this collection – which was fierce in the extreme – was seen from behind: an entire animal attached to the back of a parka is unlikely to be worn by a shrinking violet, after all (p. 348, left). Front on, neither is a leopard-print coat with bristling fur sleeves (p. 352).

To a certain extent Prada was looking back at her own archive: the heavy knits in muted colours, the nylon, the bra and corset detail that seemed like it might possibly itch, and the belted tunic, again decorated – for want of a better word – with rough patches of more fur. Some of the models carried briefcases and notebooks under their arms. The message? We should all study. Take this collection apart, meanwhile, and find raincoats, bomber jackets, skirts in lining silks, buttoned-up shirts, many of Miuccia Prada's staples, although her take on luxe utility had rarely looked so wild. As Prada's power as a designer became increasingly heavyweight, so did her point of view more broadly.

'I wanted to move away from the idea of retro prettiness', she told the *Independent,* 'and back to a sense of power, dignity and intelligence. I think the past has great value, but not the idea of retro niceness. At the same time I was interested in a very animal woman, in using the animal as a symbol of strength. No, she's not nice, this woman. She's the opposite of nice. That doesn't mean that she's not exciting, though.'

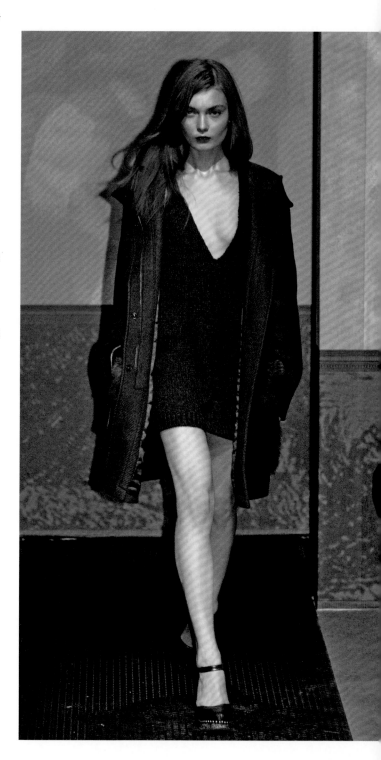

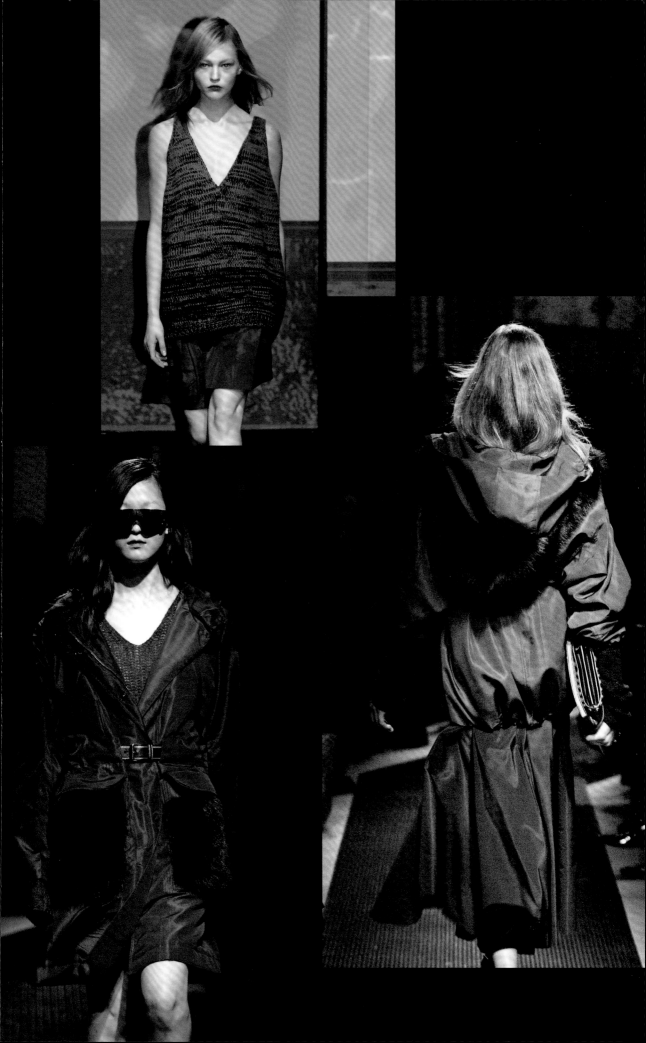

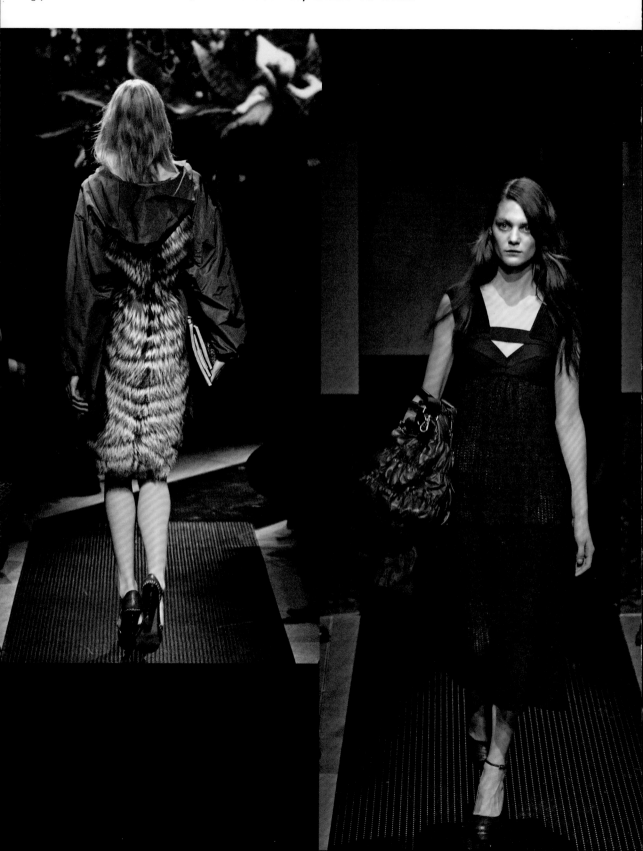

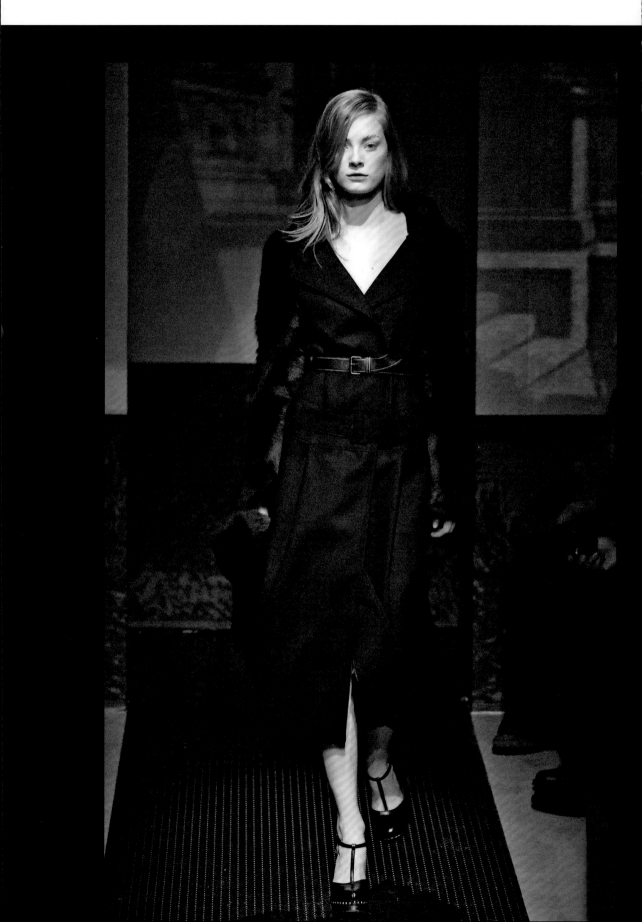

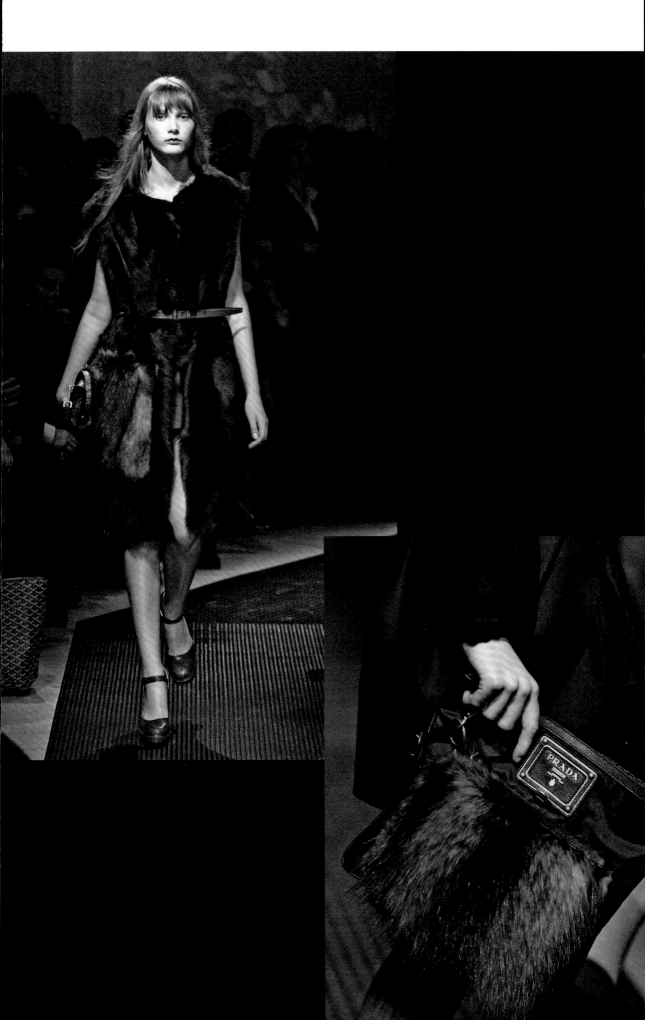

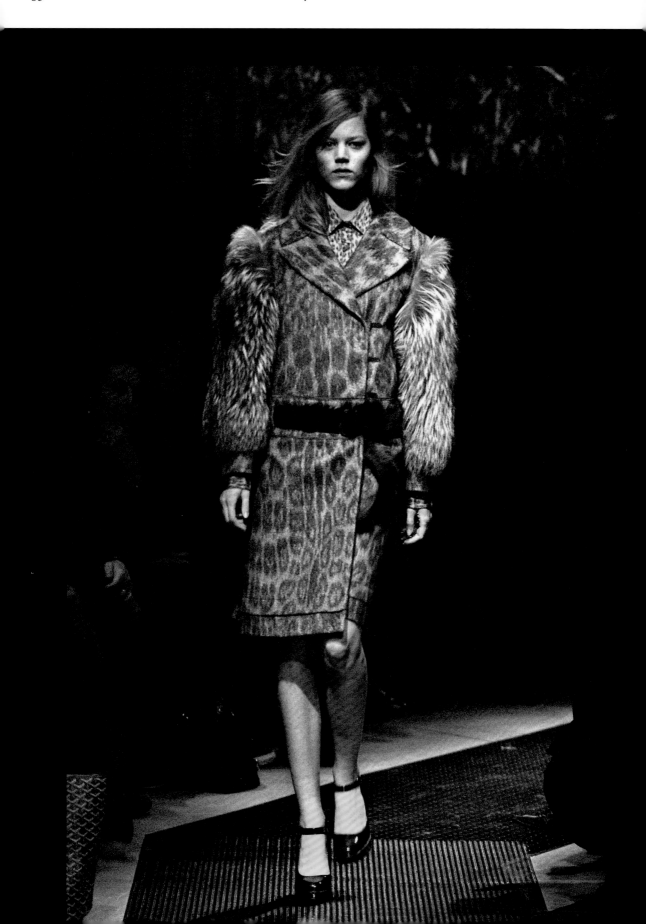

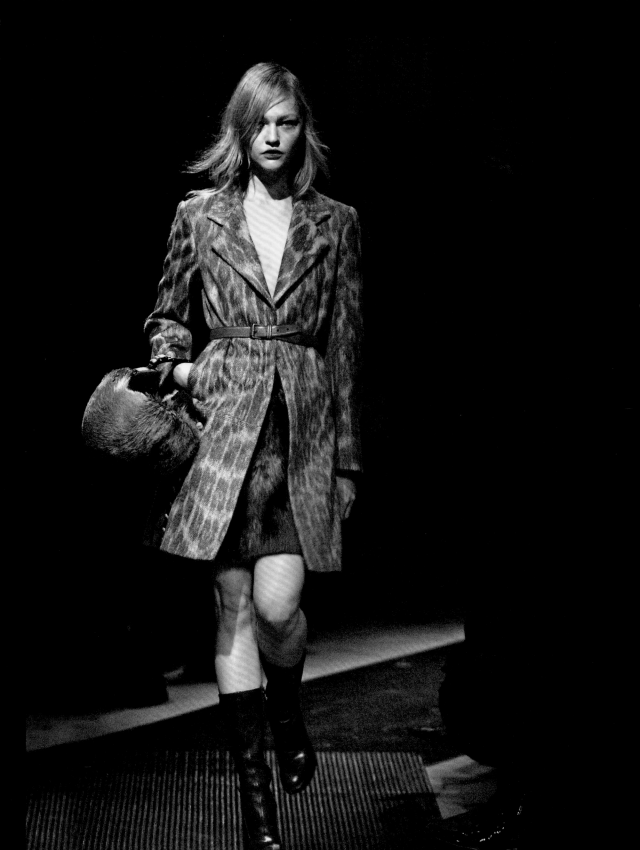

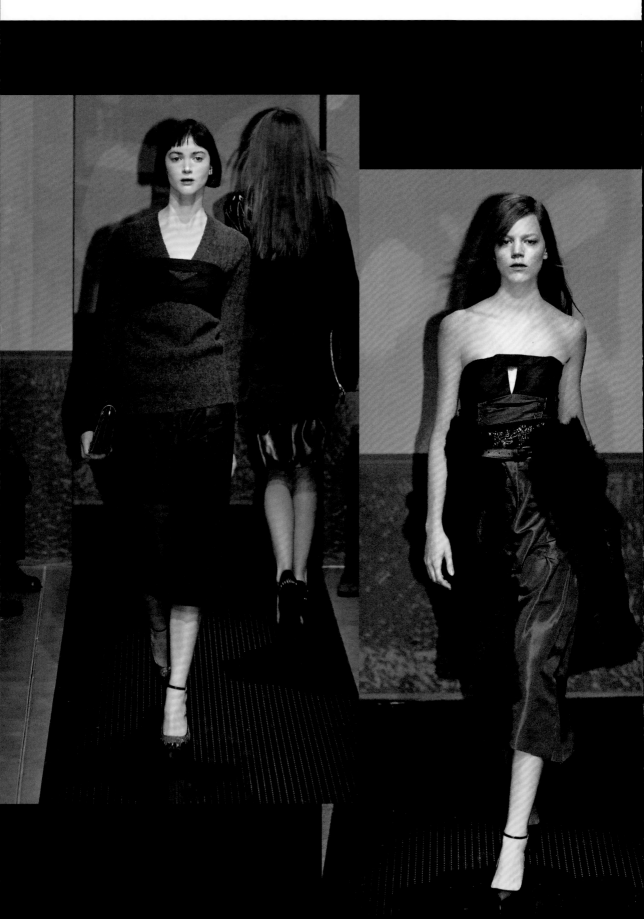

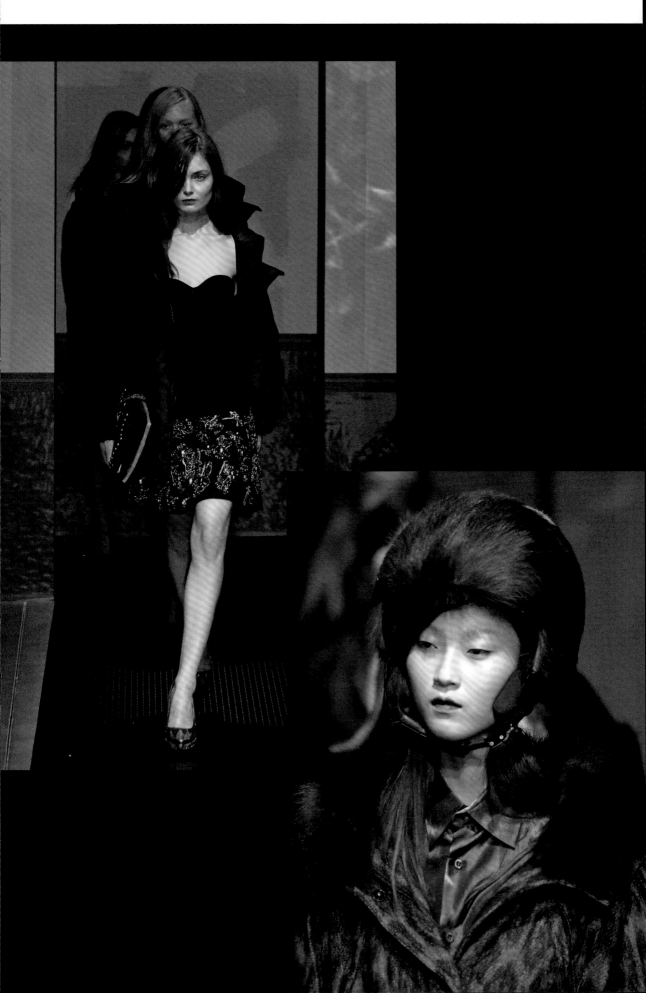

The effortless migration of decoration across continents and history was the story for Spring/Summer 2007. Few designers have explored ethnicity in fashion with the intelligence and integrity that Miuccia Prada has. This was fused with an exploration of quintessentially feminine iconography. The silhouette decreed that a focus on a strong, sharp shoulder demanded a long, lean and slender line from the waist down: either narrow trousers or muscular legs bared. The jewel colours, the satins and the paillettes were indebted to celluloid glamour and – once again – Yves Saint Laurent. Turbans, though, are associated with both women and men, in India and in Africa, as well as with Hollywood in the 1940s. 'What fascinates me is having to deal with the whole world,' Prada told *AnOther Magazine*. 'I was thinking about fashion, of course, but also about women in general at this time and about empowering women. This was an allusion to typical symbols of femininity.'

In a witty play on proportion, the backpacks in this collection were bigger than the clothes: utilitarian, strangely futuristic; the woman here is a pioneering traveller. Also, seen from behind, tunics were split up the back, like hospital gowns – surgical. 'The original reference for the print [see p. 359, below right] was African,' Prada went on to explain, 'but by changing the colour to violet it looked turn-of-the-century European.' Finally, the by now famous bottle-top skirts and dresses hail from this season (pp. 362–63): they jingled and jangled when models walked.

For all the talk of embellishment, this was a Prada season that also upheld the spirit of minimalism: 'but not in the sense of minimalism in the Nineties. That was the point of the colour. Those colours – yellow, acid-green, turquoise – were as far away from the white and beige associated with Nineties minimalism as possible,' the designer concluded.

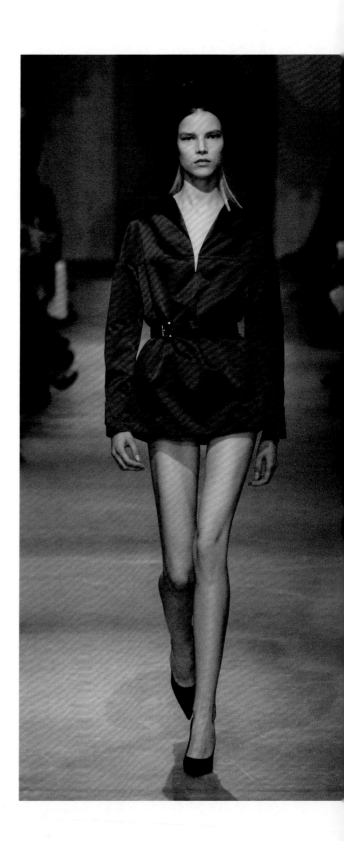

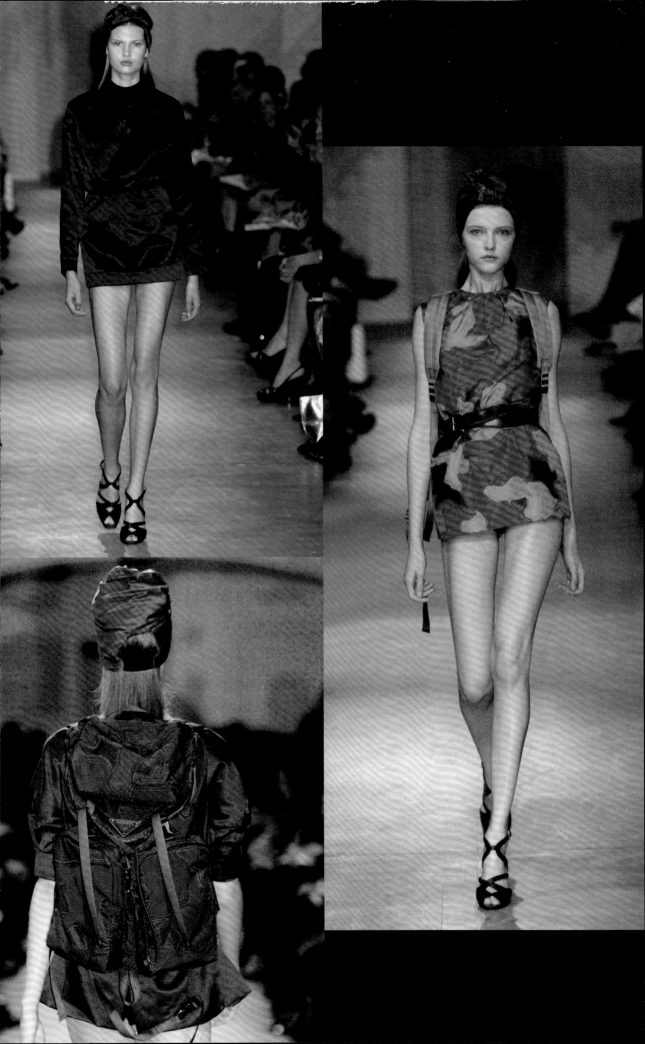

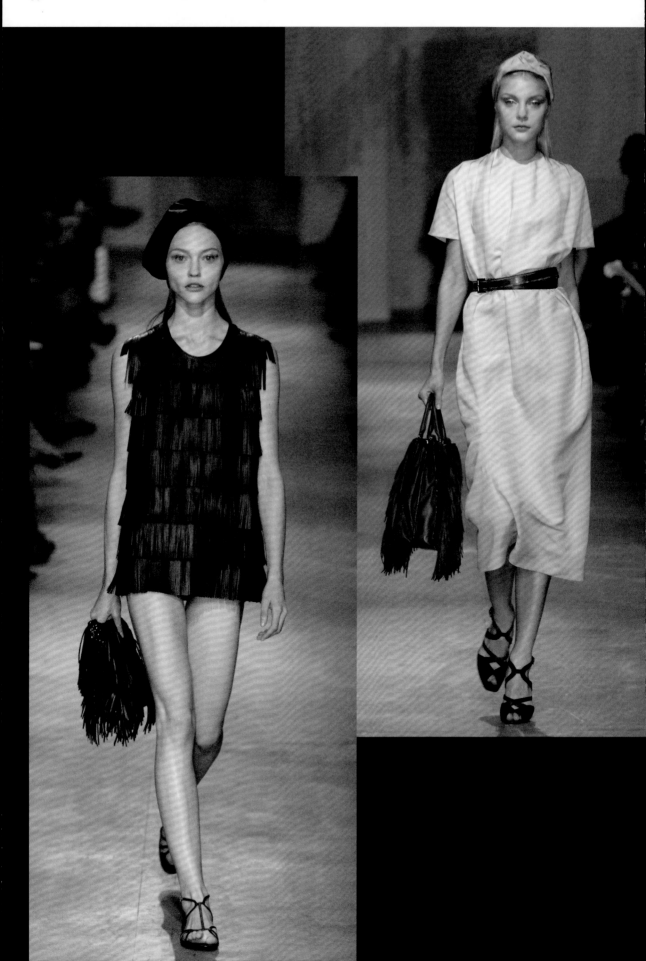

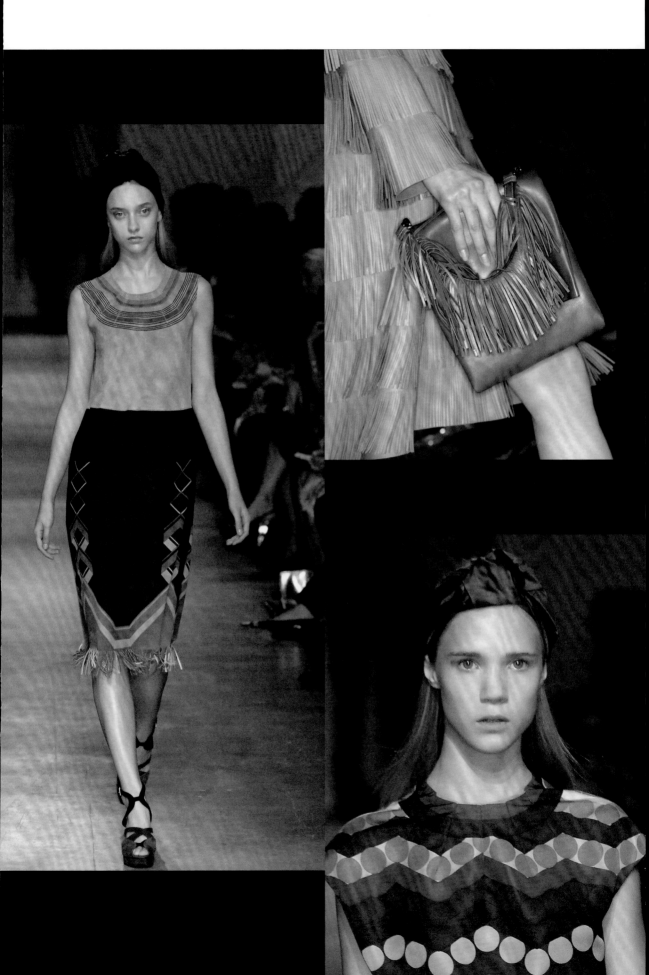

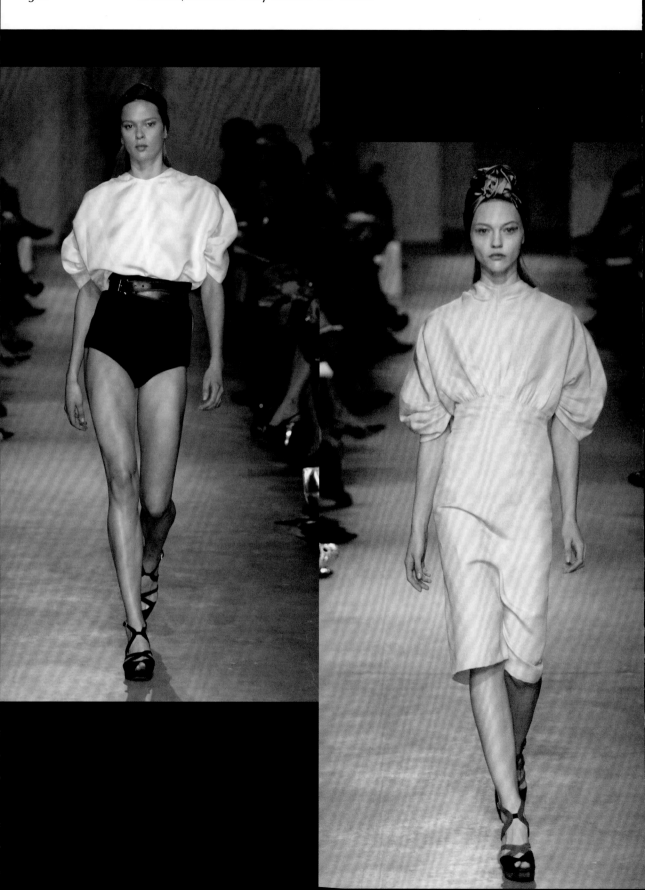

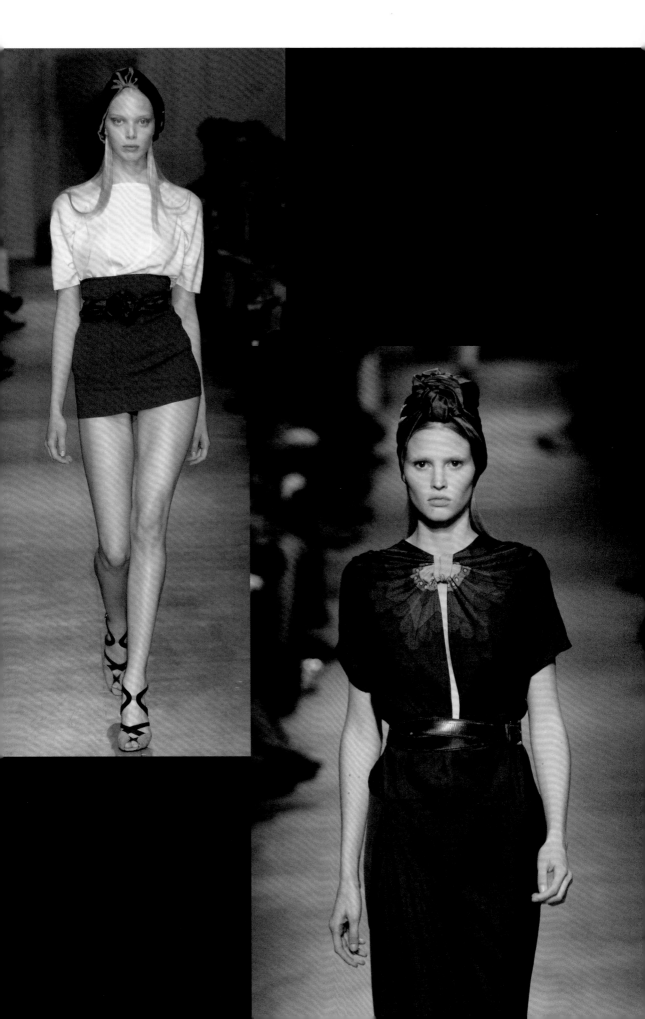

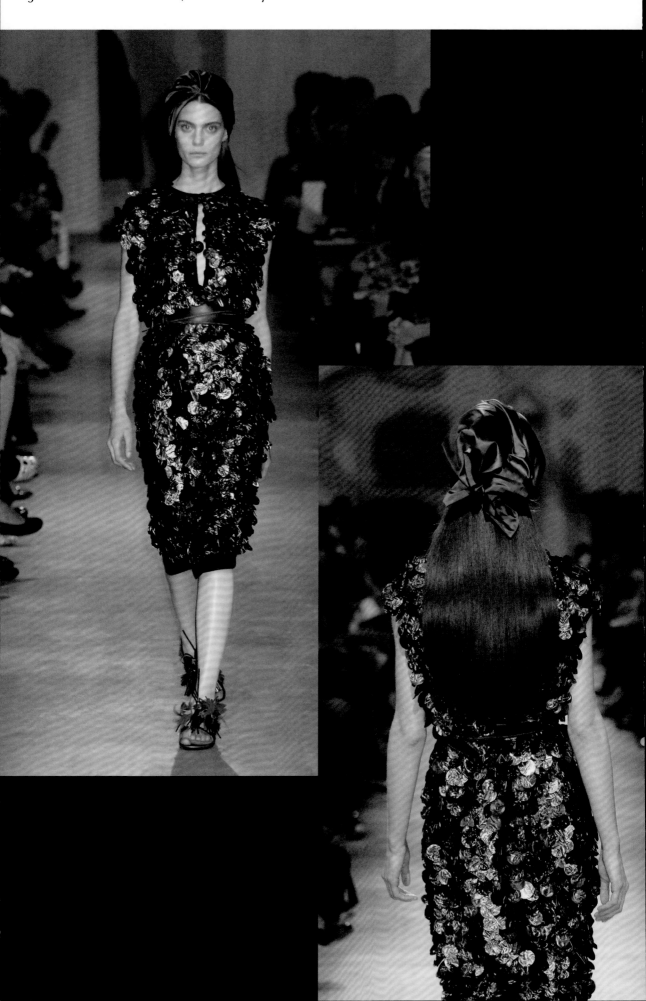

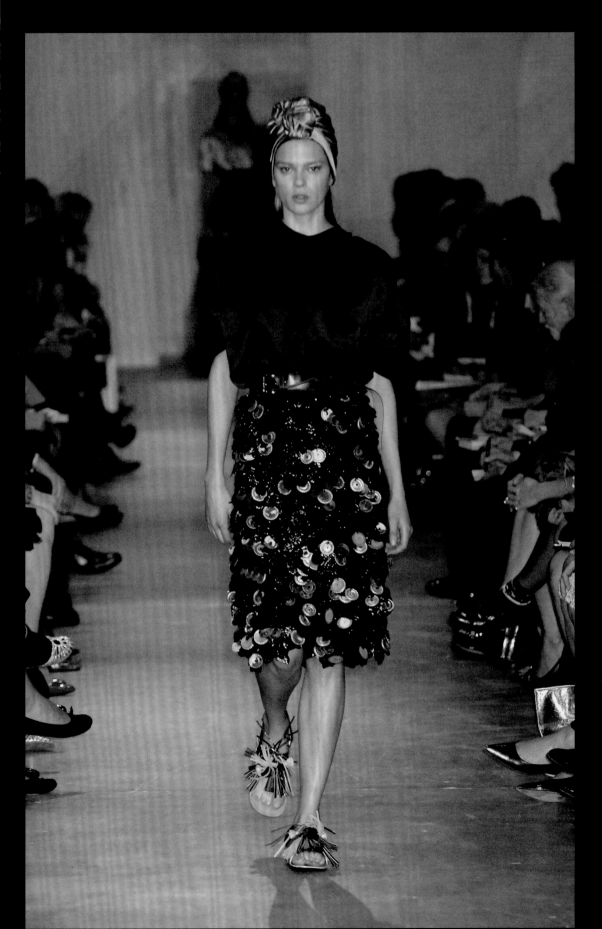

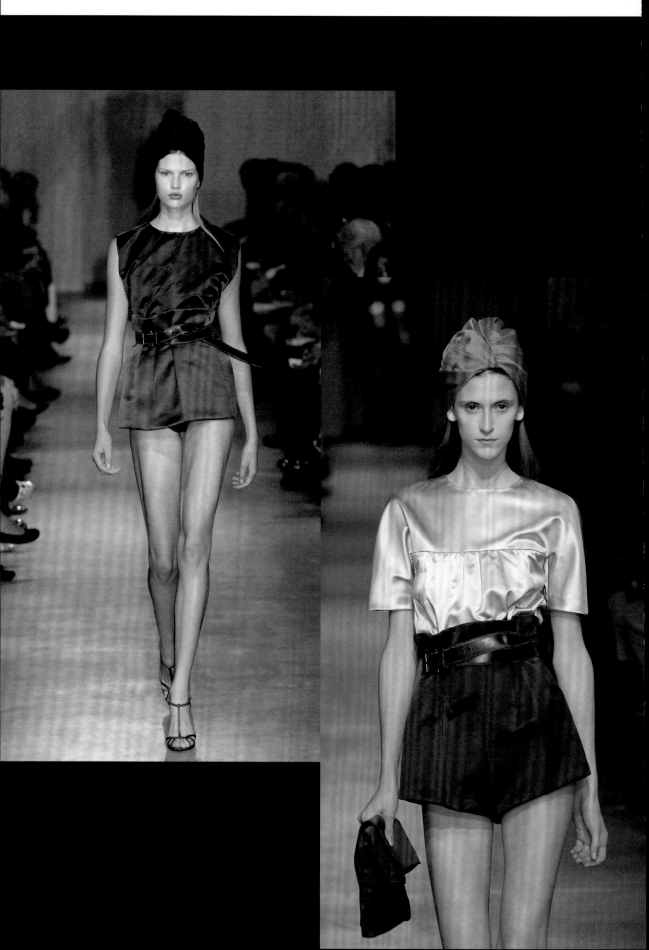

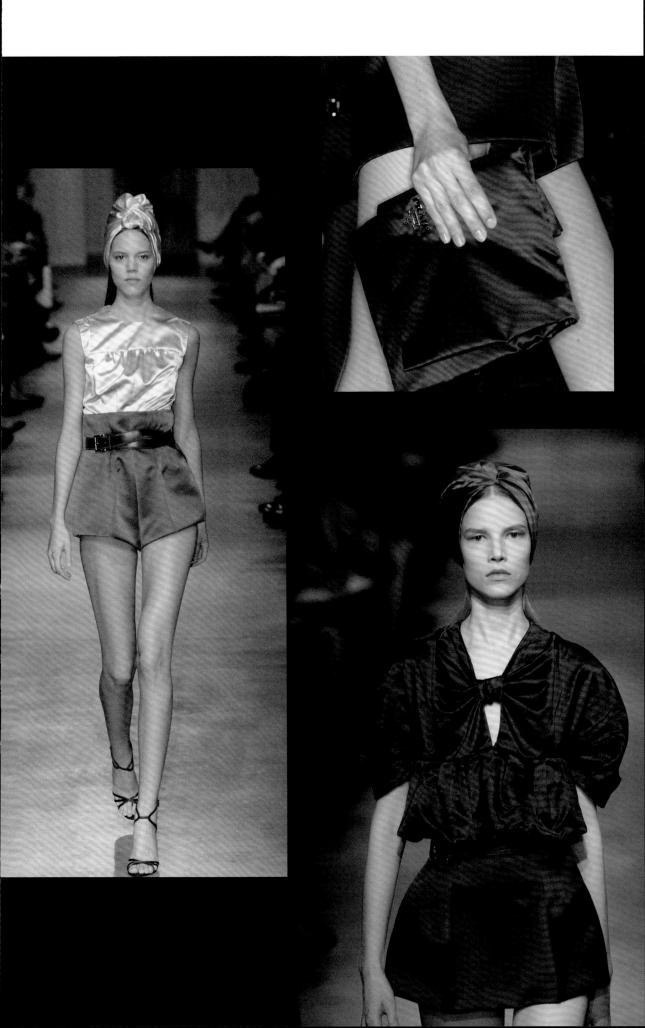

Although there is a consistent awareness of fashion history – and of culture more broadly – in Prada's collections, at this point its expression was deliberately disorienting and difficult to pin down, resulting in a look that was contemporary to the point of avant-garde. This is how the designer herself described her work, speaking to *AnOther Magazine*: 'I have been trying to work without any point of reference, with no pre-conceived idea beyond what looks new and modern to the eye. It's much more difficult like that because you are forced to empty your mind and judge everything purely visually.' That is not easy, for sure, and, for that, and the radical shifts in aesthetic, season after season, the rest of the fashion world was running to keep up with her.

Fabrication here – and the strange juxtapositions of fabrics, to be precise – was extraordinary. It was difficult to see where the tufty alpaca, crushed pleats and fringed sequins stopped and started, so immaculate was the transition between three such apparently jarring elements. Steven Meisel, who had taken over as photographer of Prada's print campaign by this point, captured both this and the equally unpredictable colour palette beautifully, making it appear almost hyper-real. 'There was this whole idea of mutation,' is how the designer put it, 'where a certain fabric or colour actually became something else.' This extended to the shoe, which became a sock, and to the sock, which took on the colour of a skirt.

More broadly – in at least some cases literally – here was an exploration of the concept of clothing being flattering in the conventional sense of the word: much of this collection certainly was not that. 'In the end, if you just want to look thin and sexy – to wear a narrow, sexy dress – then you end up with clothes that are boring,' Prada continued. 'There is no possibility for invention. You can do super tight jackets, but I don't like them, or you go for something that is soft but the fabrics are light and, again, there is nothing you can do that is particularly interesting with that. There is more to fashion than just being appealing. Of course, I am always aware of the importance of that and ultimately make sure the clothes work on that level. But it's much more exciting to have something interesting to look at and to wear and to experience your body in a different way.'

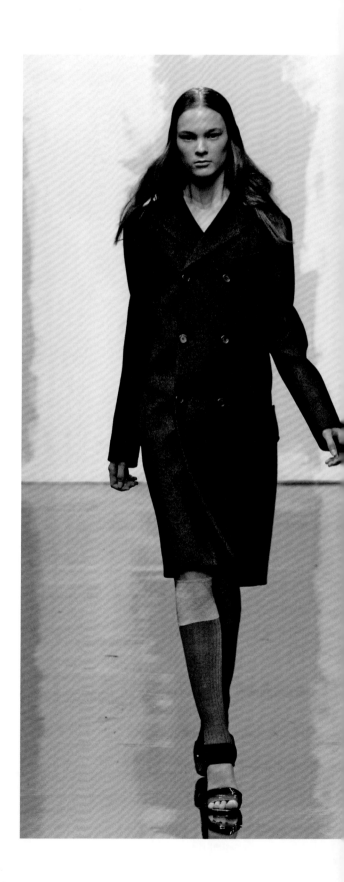

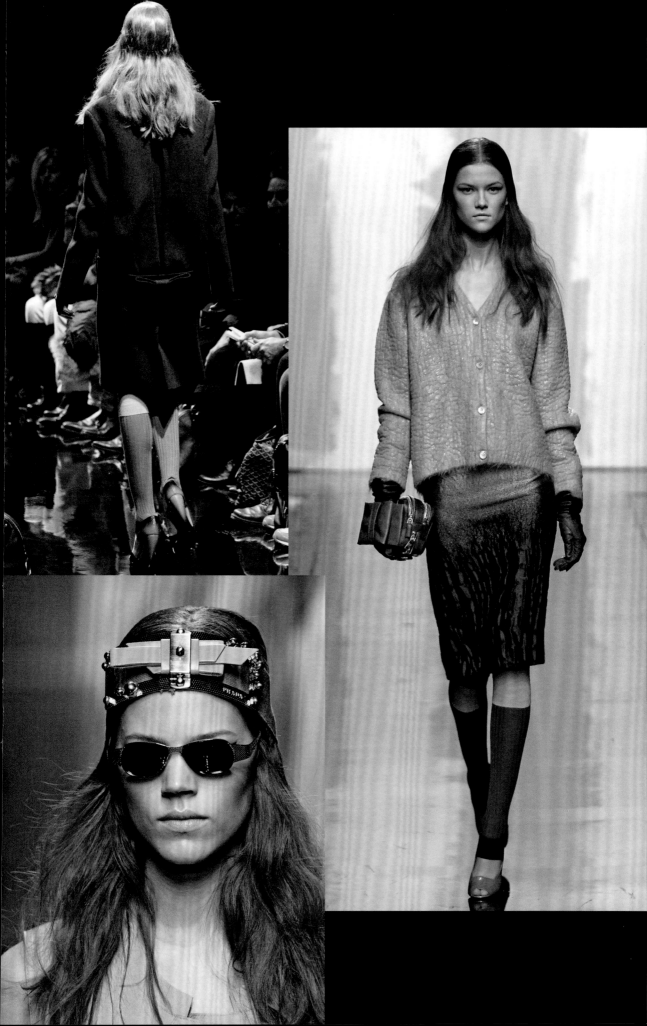

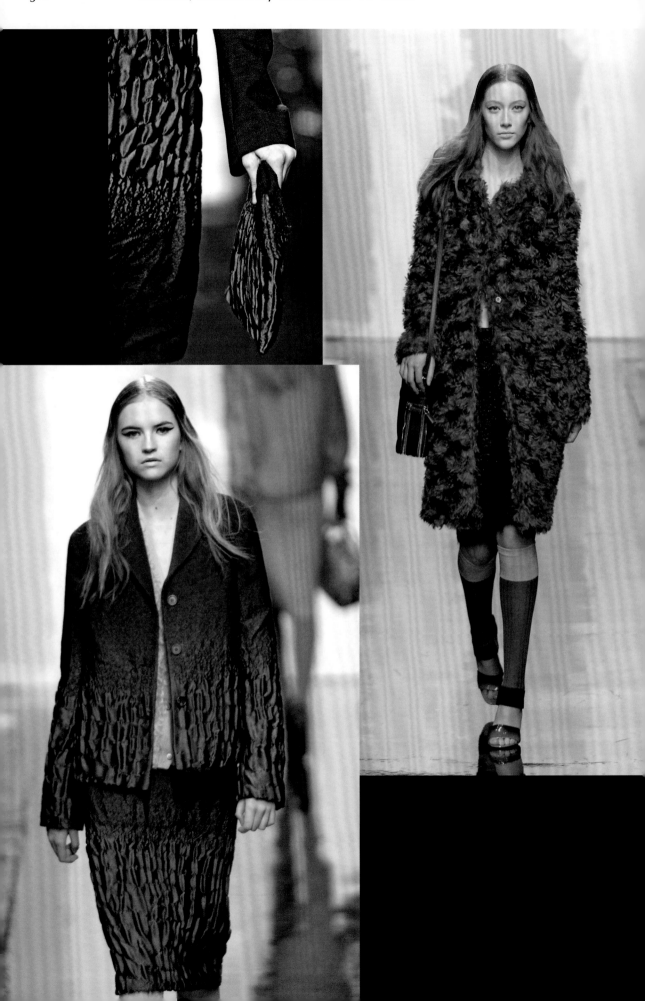

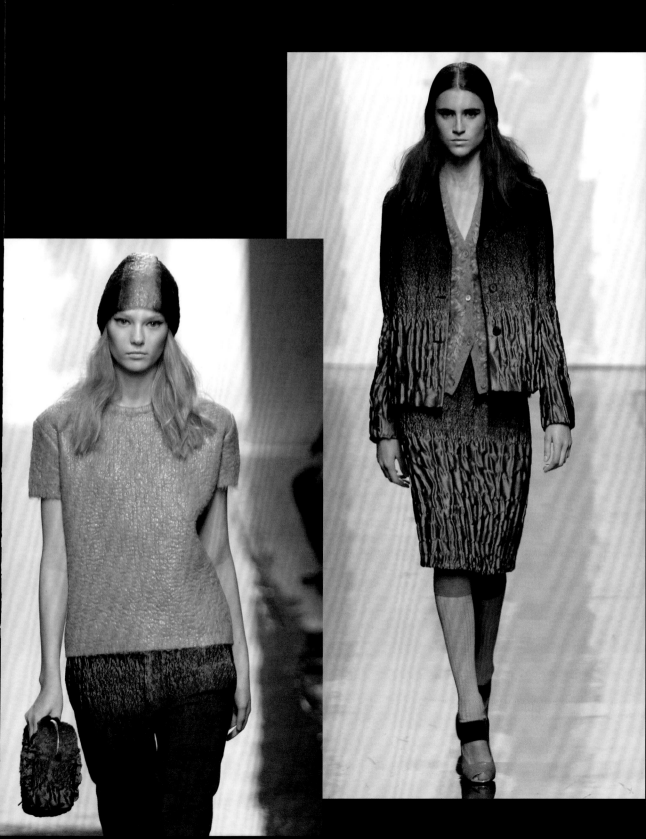

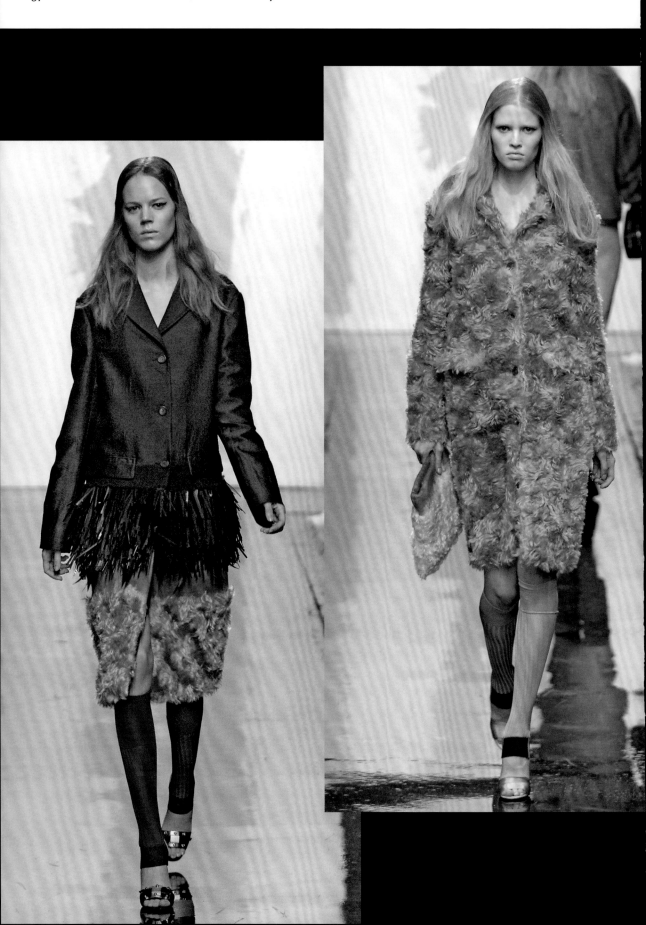

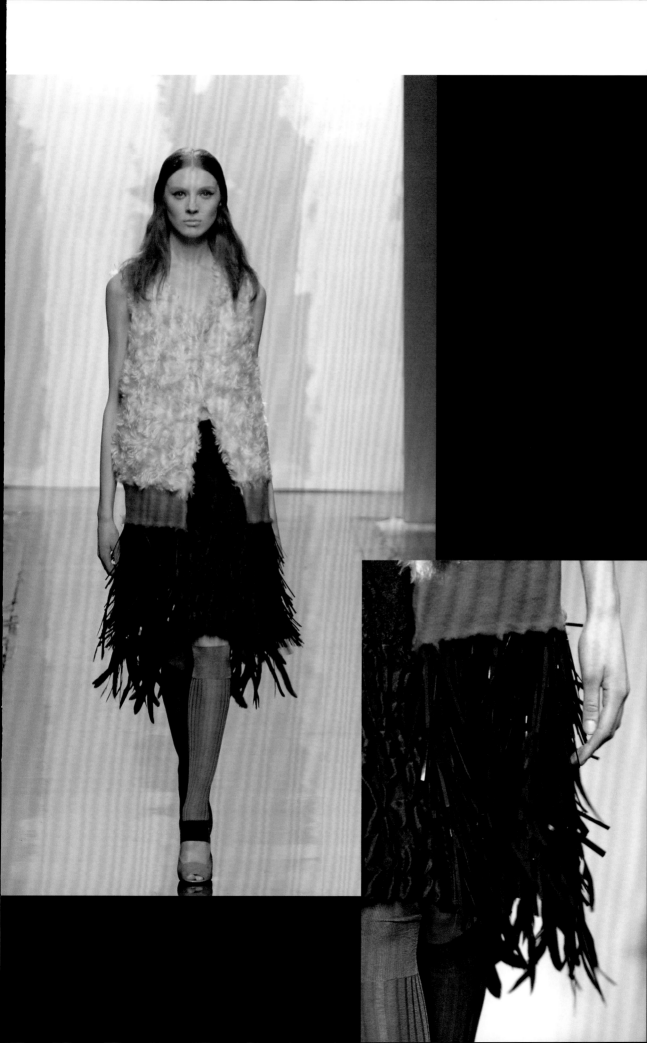

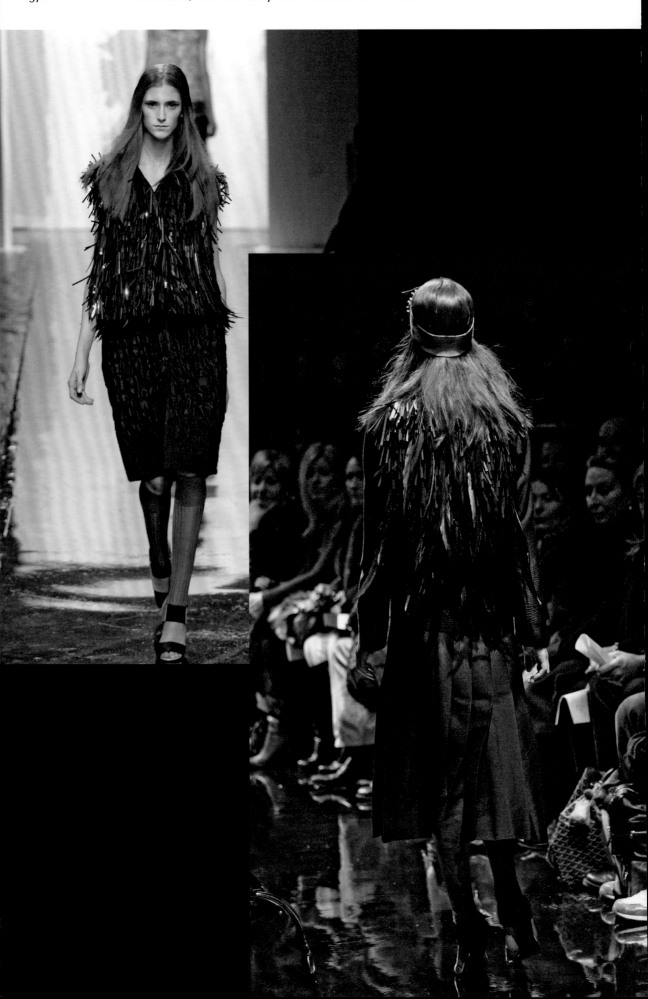

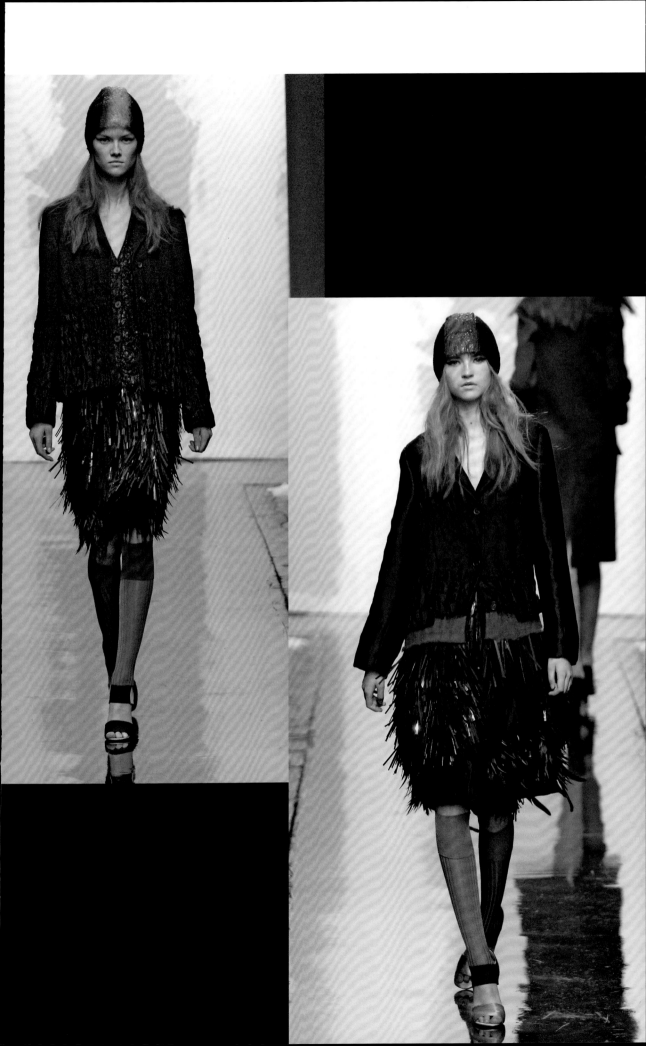

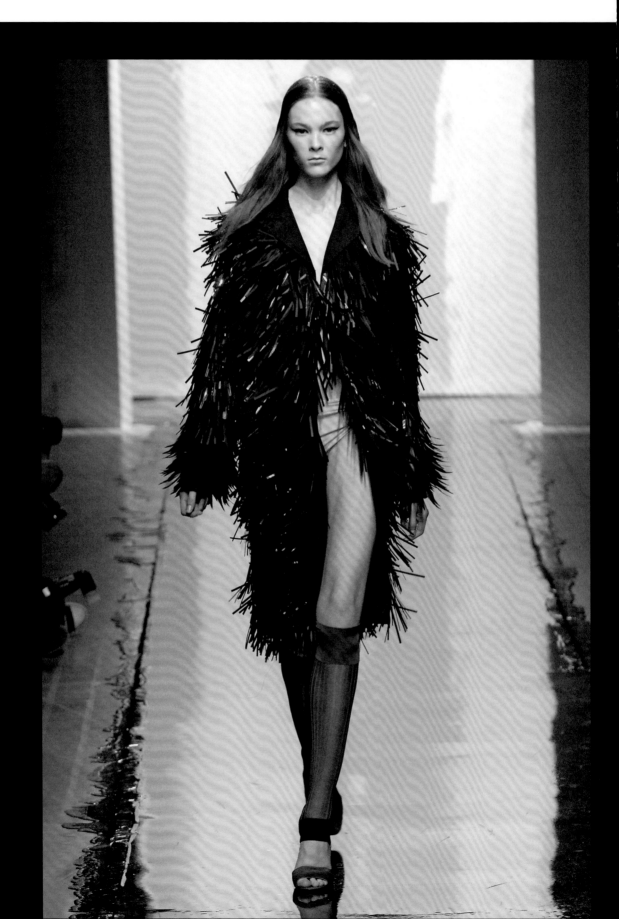

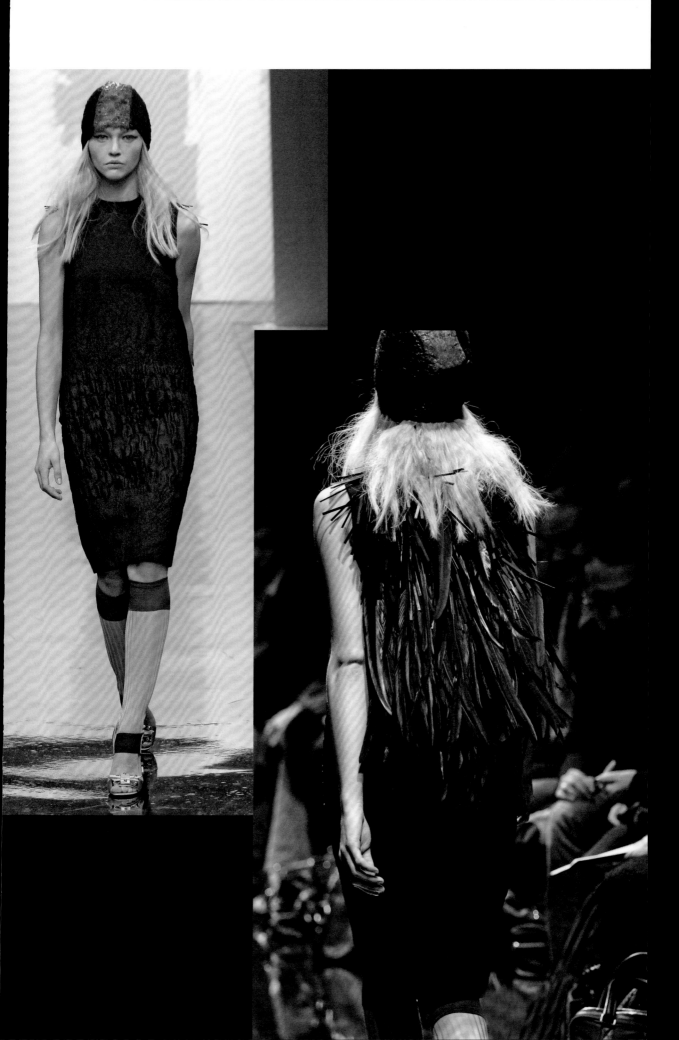

This collection might arguably be described as
Miuccia Prada's take on unbridled fantasy – not
to mention deep-rooted eroticism and a look into
the female subconscious that begged for Freudian
interpretation as much as, if not more than, it did
fashion criticism. 'Fantasy,' the designer told the
International Herald Tribune. 'The only thing for
a fast-moving world.'

Fairies, flowers and foliate curlicues covered the
show space, a vaguely eerie environment out of
which models, wearing designs featuring similarly
enchanted designs, appeared almost to grow like
otherworldly blooms. There was a debt to the proudly
decorative and unashamedly voluptuous Art Nouveau
style here and to Aubrey Beardsley, Liberty and
Hieronymus Bosch, offset by more graphic, richly
coloured checks and stripes. In a similar vein, for
every powder-puff-light, bouncing prom skirt in
equally powdery shades there was a forest-green
knitted vest and pair of long, lean trousers that
whispered of Barbara Hulanicki's Biba in its heyday.

The illustrative element of the show marked the
start of a typically ambitious project that saw
Miuccia Prada conceiving a dreamscape environment
that extended across backdrop and clothes in
collaboration with AMO again (see p. 306), Michael
Rock and Sung Joong Kim of 2x4, and featuring the
work of James Jean, a young, Los Angeles-based
artist. The marginally disturbing look that unified
the whole and ensured that it was anything but sugar
sweet was extended into an animation, *Trembled
Blossoms*, based on these designs and directed by
James Lima, which was screened for the first time
during the New York collections the same season.

As far as the fashion itself was concerned, the
exquisitely ornamental shoes in this show, which
sprang from the same references, were among
the most complex in this designer's history – and
the most written about and analysed of the season.

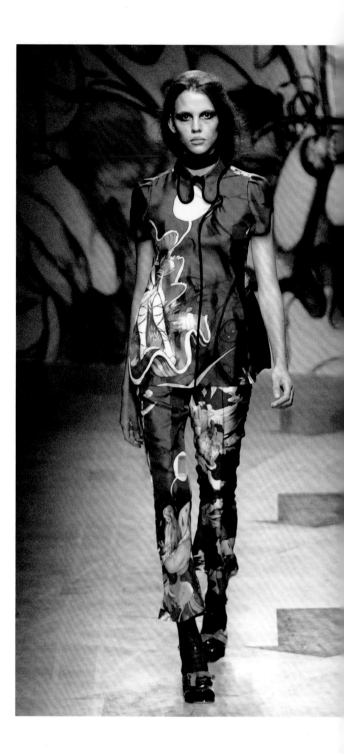

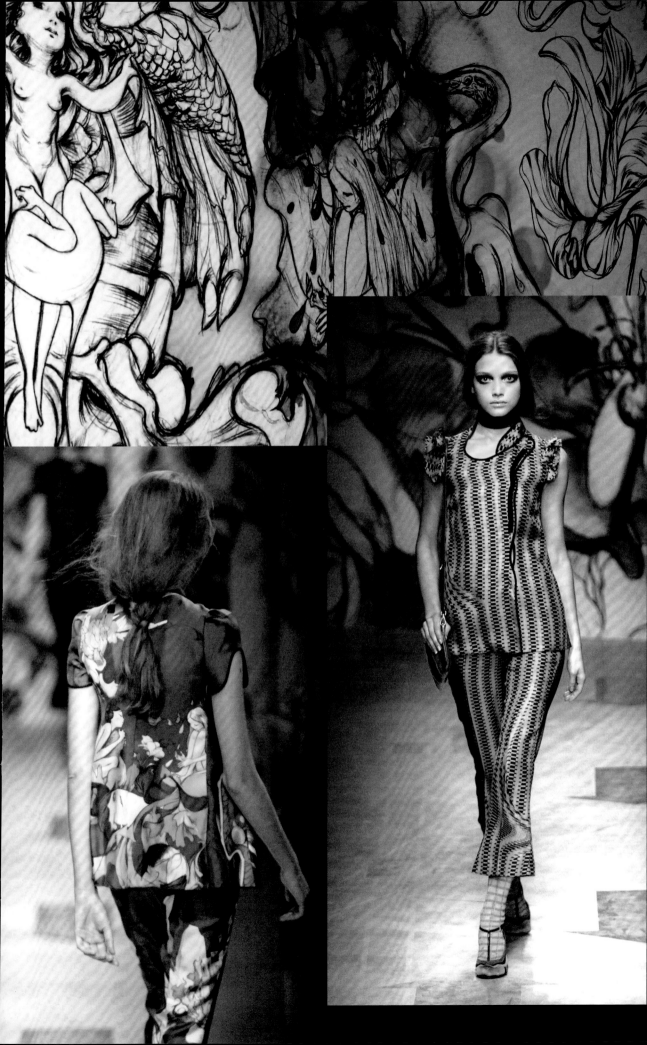

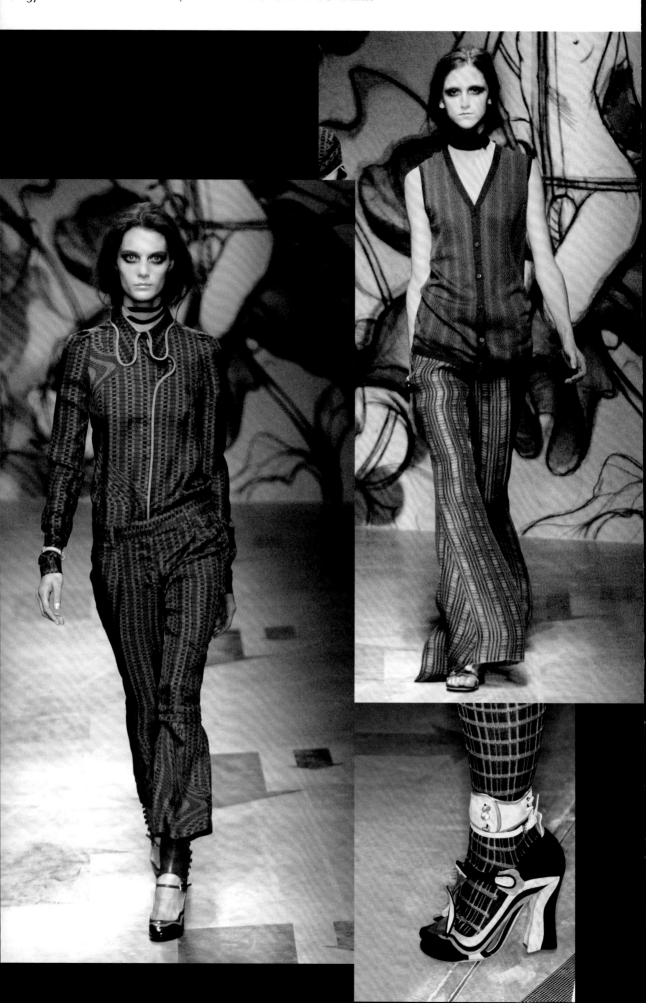

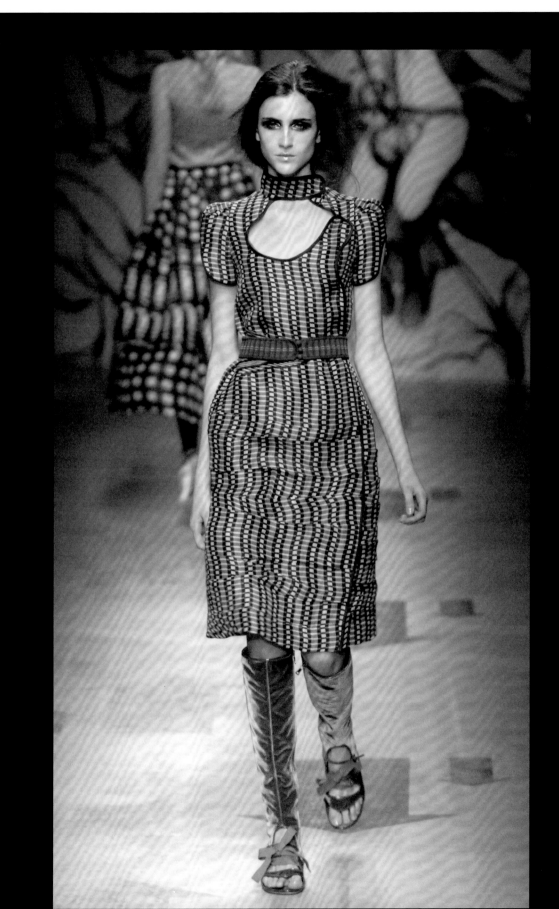

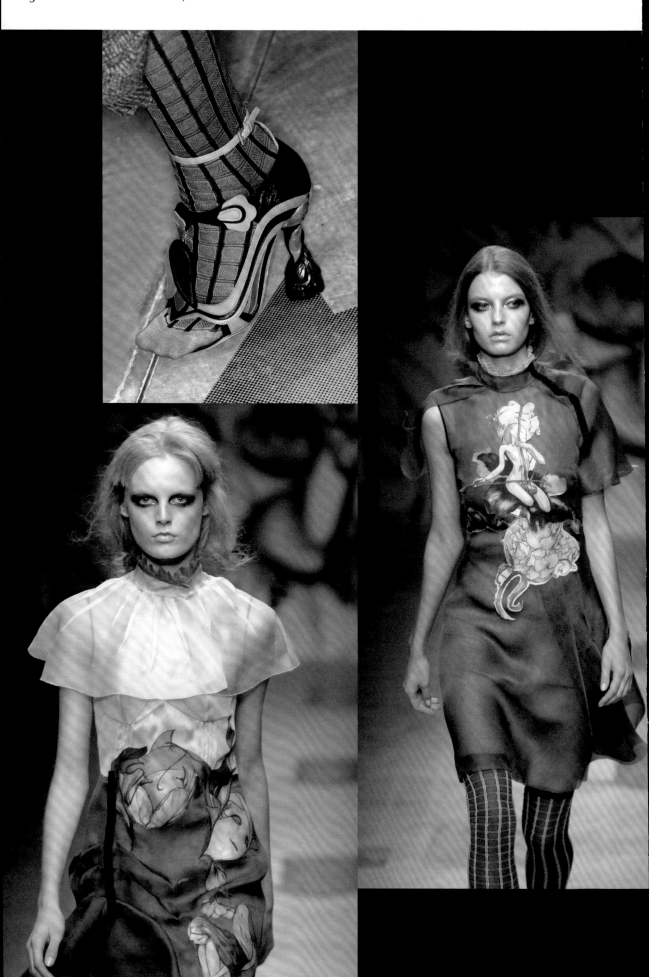

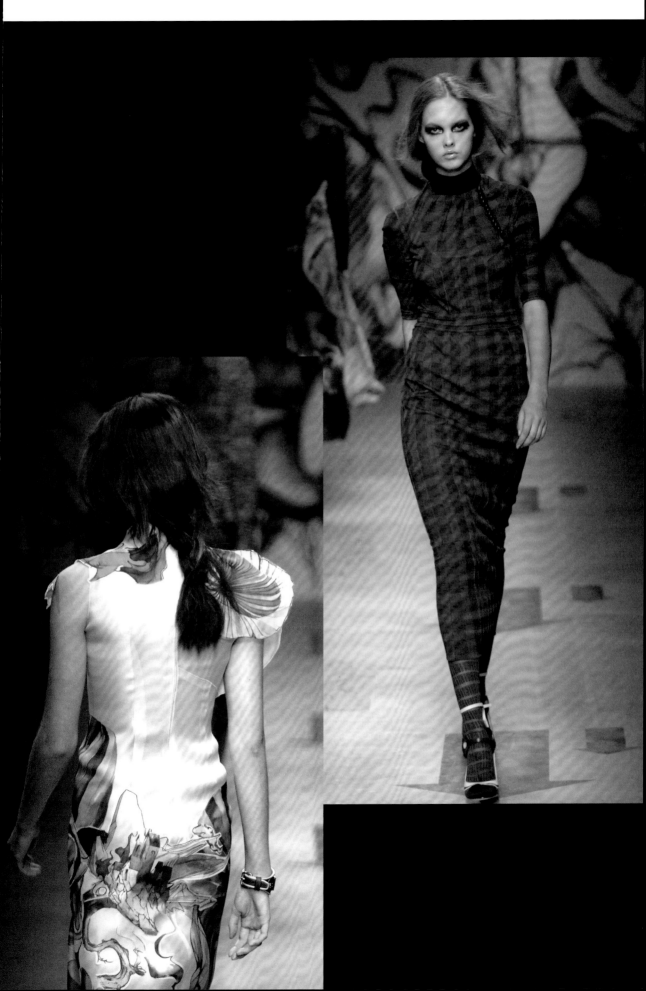

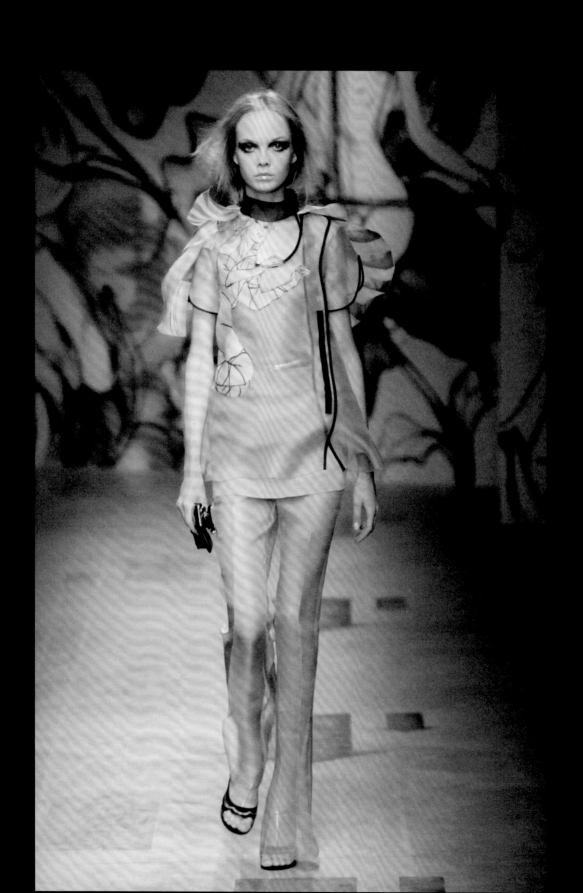

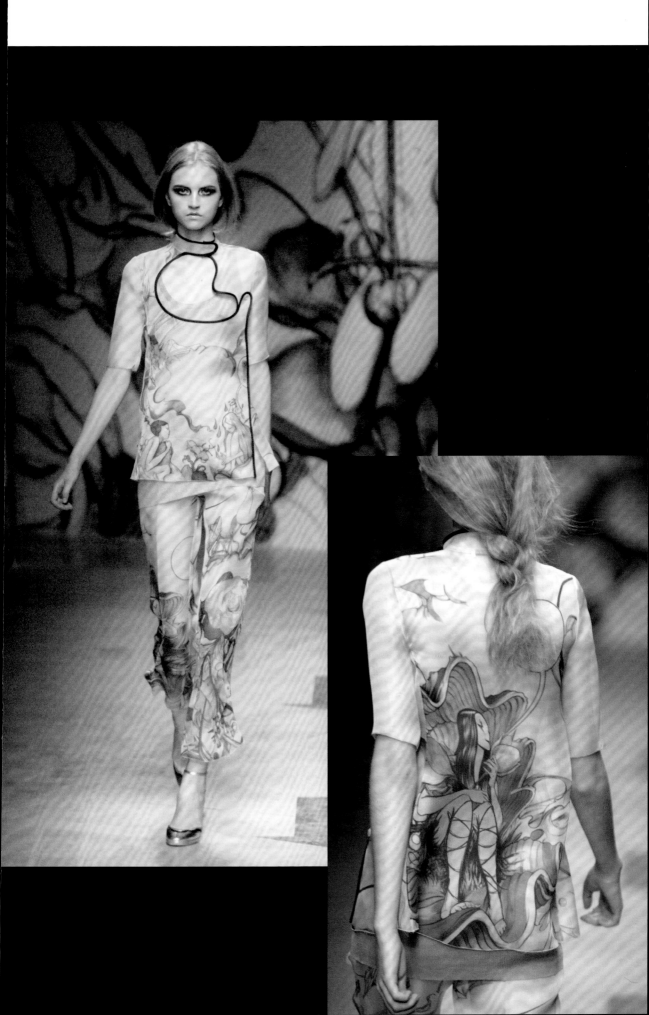

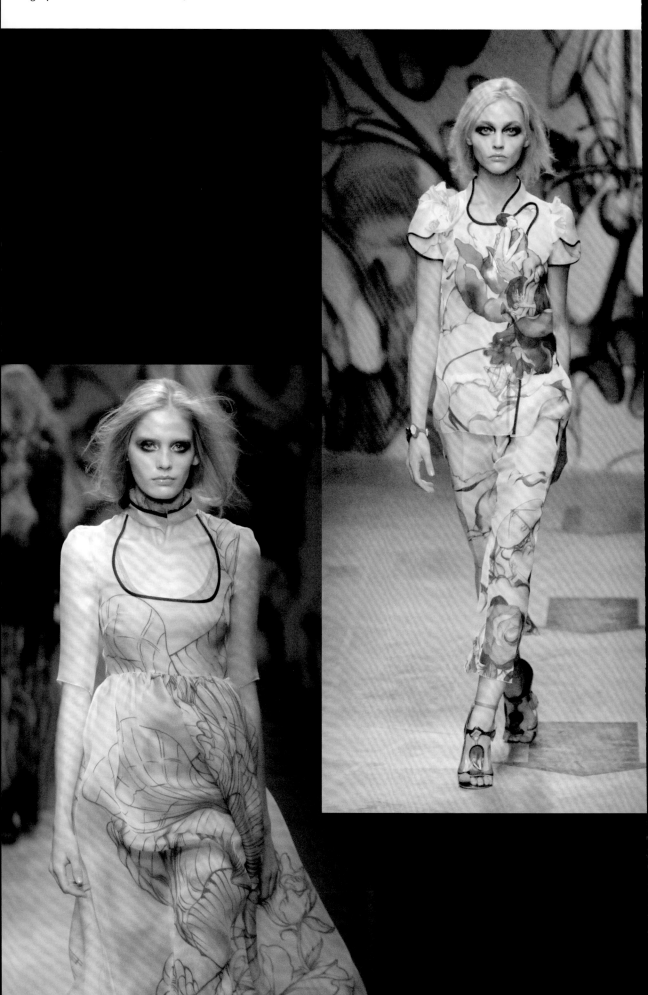

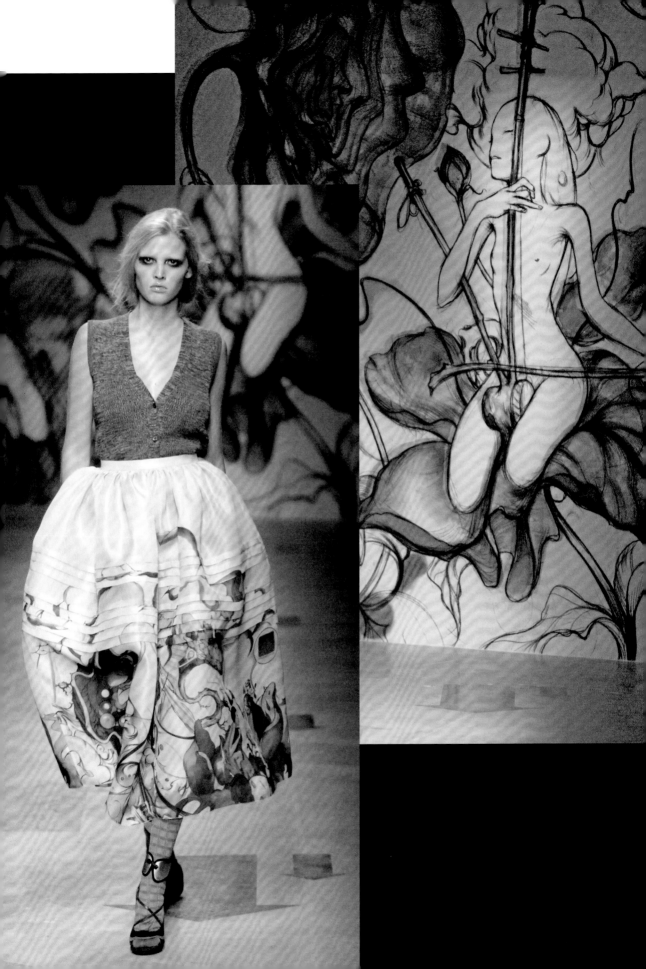

'You have to go all the way. A little touch of lace becomes pretty,' Miuccia Prada told the *New York Times* of this collection, which looked at this most evocative of fabrics in a typically layered manner. Lace, after all, is part of a woman's life – and a Catholic woman's life, in particular – from her christening, confirmation and wedding gowns to black lace widow's weeds. No other material is so romantic, therefore, or indeed emotionally charged, and that applies to both any symbolic meaning and the fact that delicate lace upholds the value of the touch of the human hand (again, predominantly the female hand).

The silhouette was slender – a peplum here, a frill at the shoulder there only adding to a distinct, 1940s, filmic feel. The hemline was modest, falling to below the knee. Black lace dominated but was thrown off-kilter by touches of that same material in lingerie beige, sky blue and flame. Not insignificantly, white lace was conspicuous by its absence: this was a collection focused more on experience than innocence, it seemed. In some instances, with that in mind, the body beneath the clothes was exposed; more often than not, though, there was a more discreet, self-possessed and womanly sexuality at play. Necklines were high to the point of clerical, and buttoned-up cotton shirts were gathered to the body with bra-strap details: the contrast between the austere and the erotic was most evident here.

That this was a show about women at their most essential – and indeed powerful – was clear from start to finish. Classic bags and sculptural sandals and pumps were either covered in more lace or sprouted ruffled leather to mimic the ornamental nature of that material.

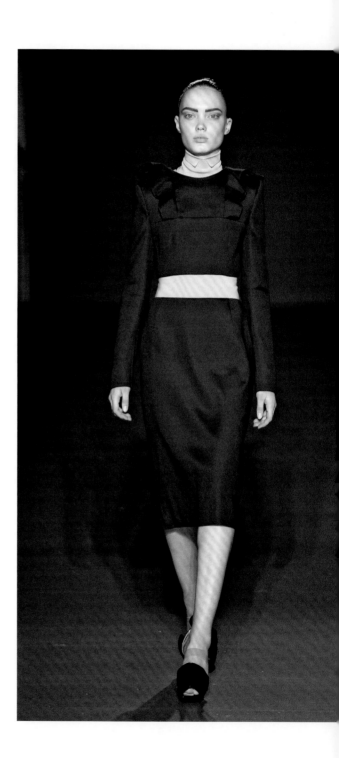

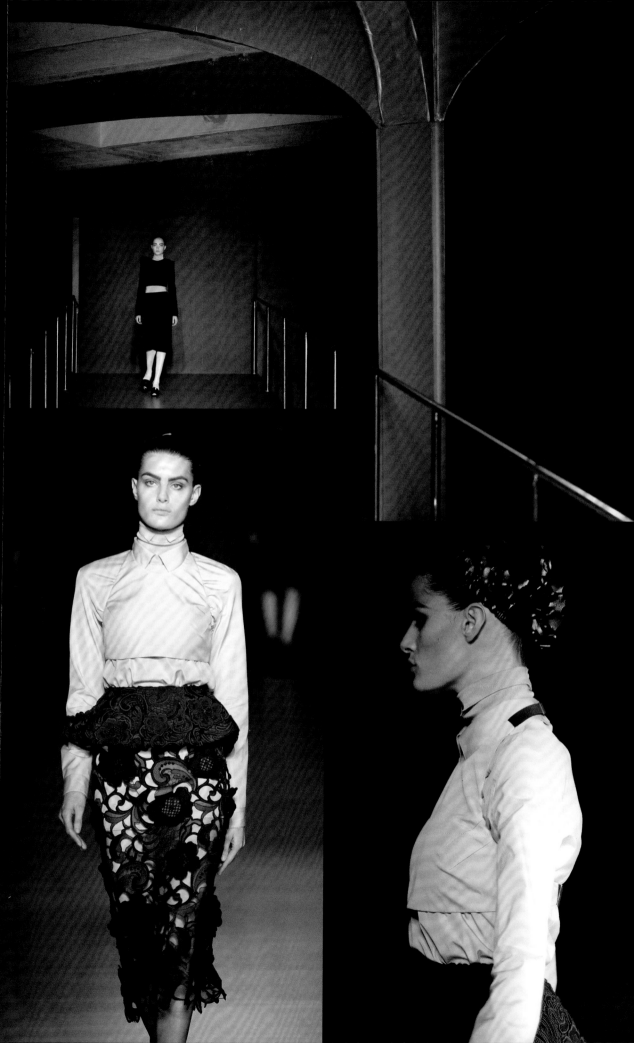

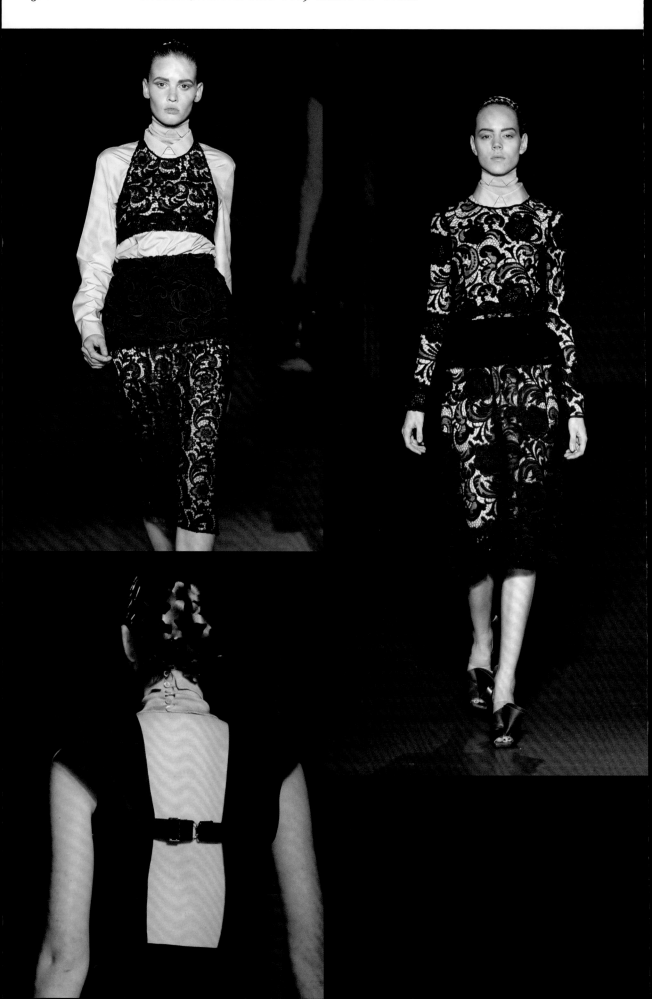

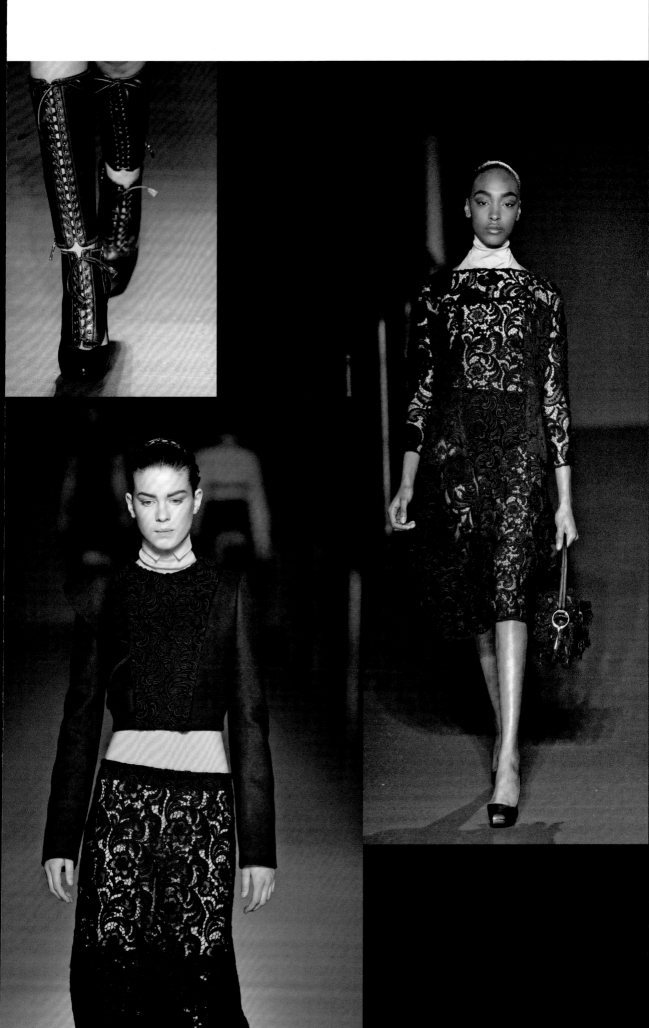

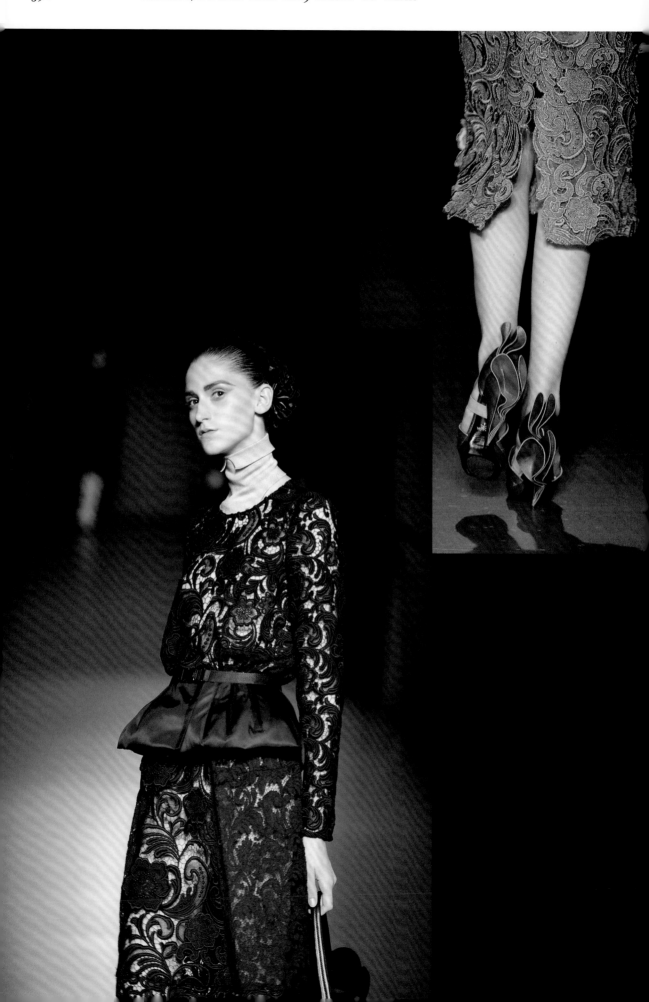

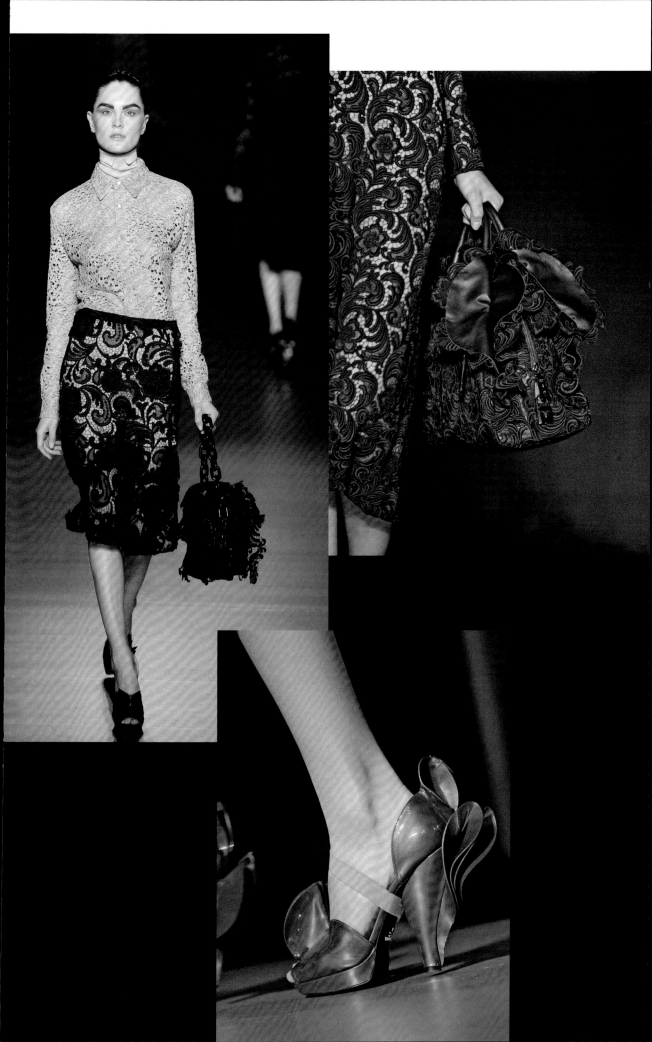

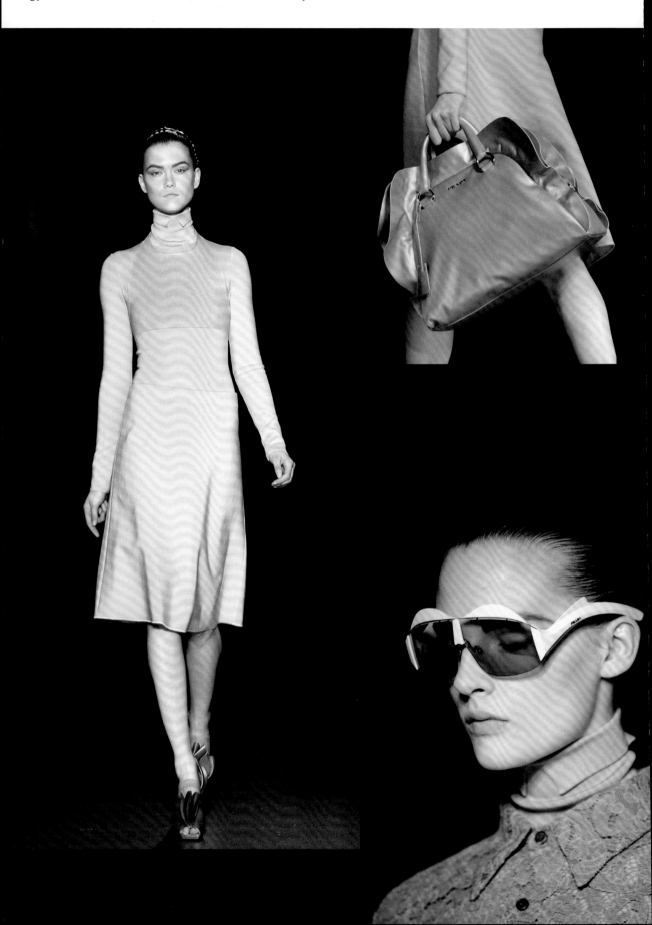

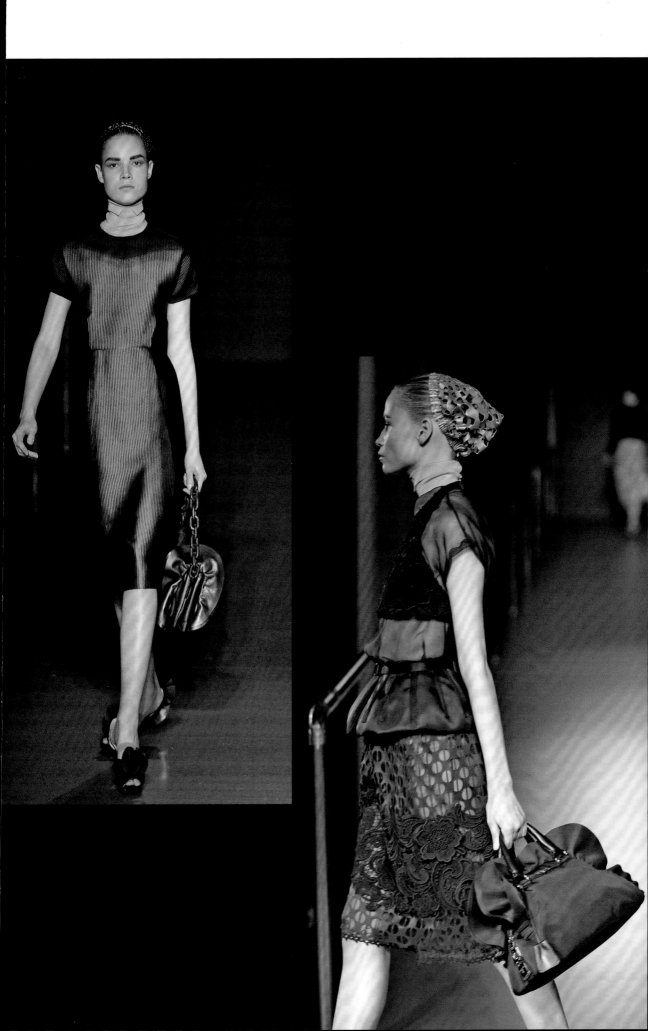

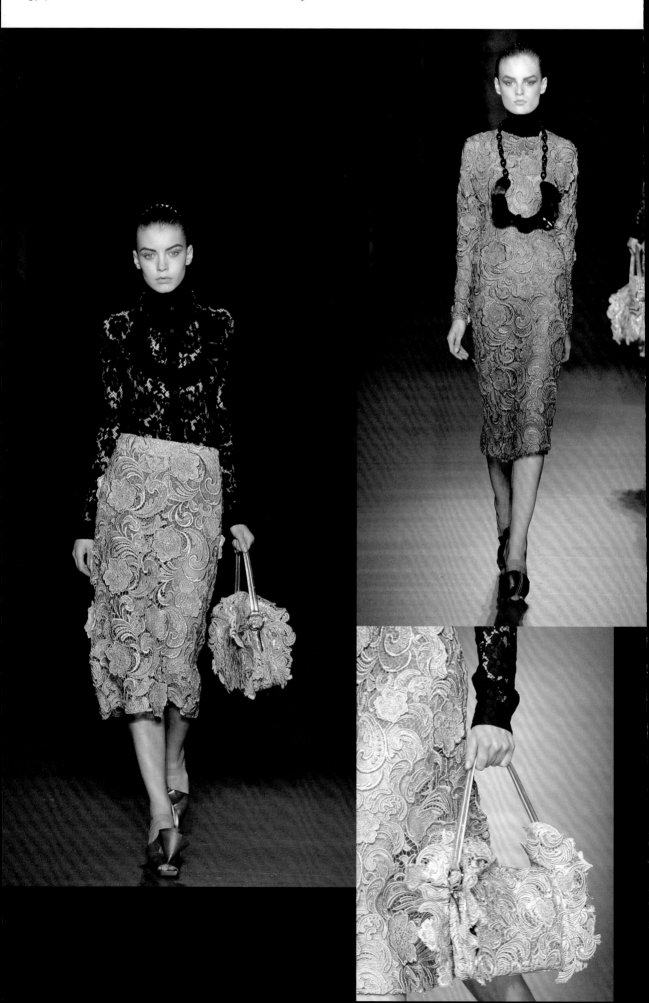

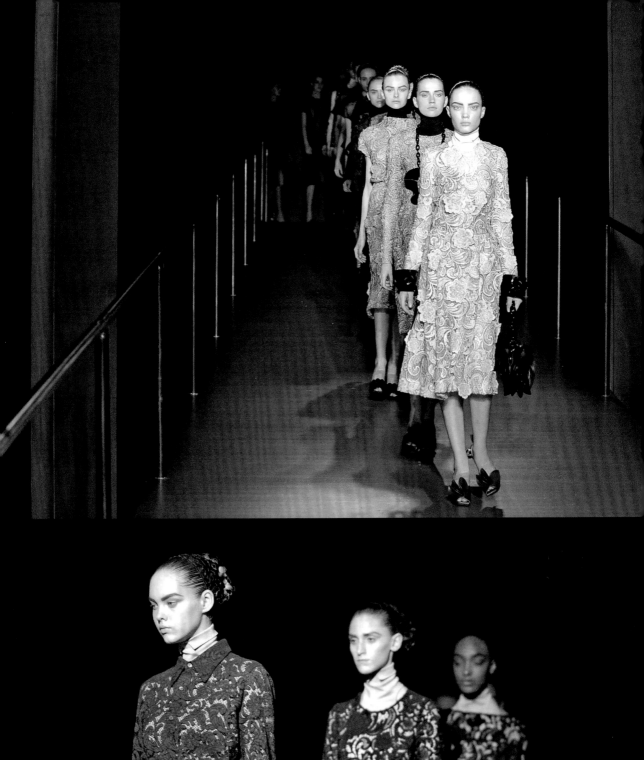
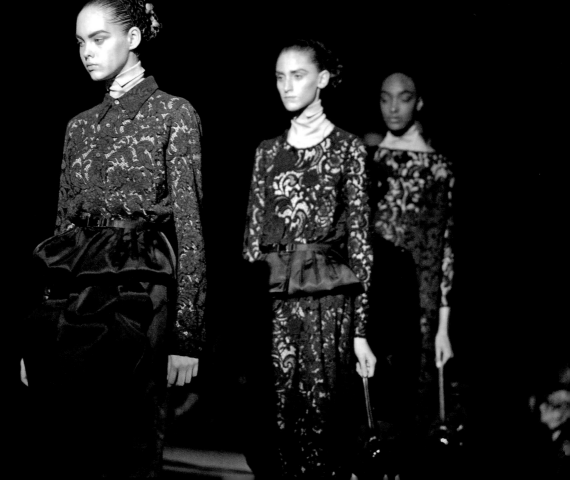

From the haute, even sirenesque form of glamour
expressed in the Autumn/Winter 2008–2009 lace
show (p. 386), Miuccia Prada changed gear once
again, telling *Women's Wear Daily* in a preview of
this collection: 'The idea was to move away from all
the fussy, couture-derived fashion that I think has
become too heavy and over-exploited.' Here, then,
a more raw, unravelled and unashamedly wanton
beauty came to the fore.

Again, a narrow silhouette dominated and, again,
the hemline of form-fitting designs fell to below the
knee, but the look was undone – *déshabillé*. A blouse
was cut away, leaving nothing but sleeve details and
a bra, embonpoint exposed (right); a ruffled skirt
was split thigh-high to reveal childlike puffed panties
beneath (p. 400, left). Ribbons and bows fluttered
at the throats of jackets and at the edges of skirts.
They seemed part Marie Antoinette, part parachute:
the bucolic and the utilitarian rolled into one.

Fabric, in this instance, was distinctive for the fact
that black, brown, blush and white cotton was shot
through with metal thread holding crumples and
rumples in place. This looked all the more distinctive
in python print, spliced with broad stripes (p. 402),
or stamped with a naïve repeat fish motif, and in an
end sequence in shimmering gold (p. 405).

Elevated, predominantly wooden, platform-soled
sandals finished with more fluttering ribbon, edging
uppers or wrapped around models' ankles, caused
quite a stir. However, the press – and the liberal press,
in particular – were enamoured with an obviously
strong and highly controlled view of womanhood,
one defined, let's not forget, by Miuccia Prada.
This, though, was suggestive of a more scandalous
and wilfully provocative muse. She, too, was soon to
be replaced by a tougher heroine. Less than a month
after this collection was shown, on 29 September,
the American stock market crashed.

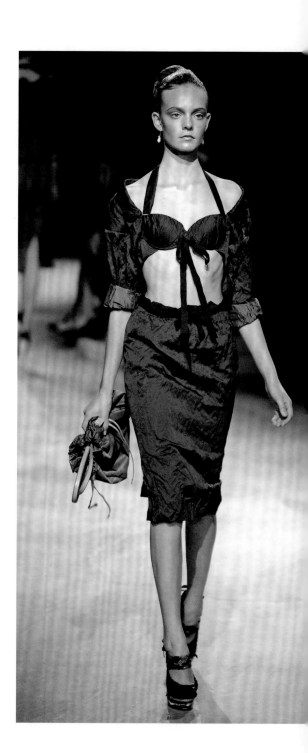

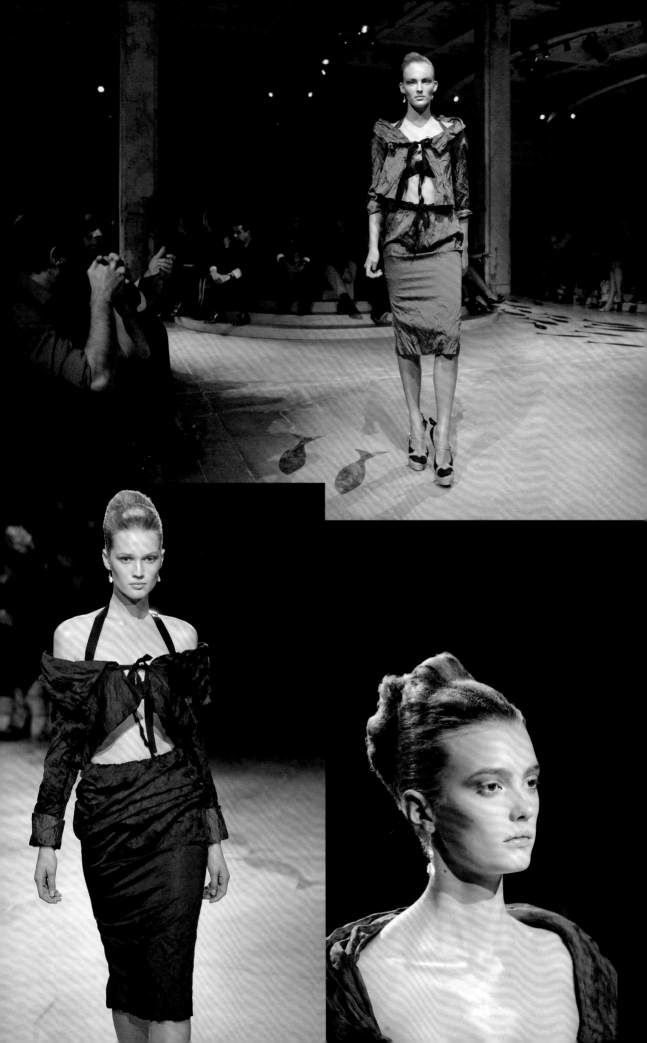

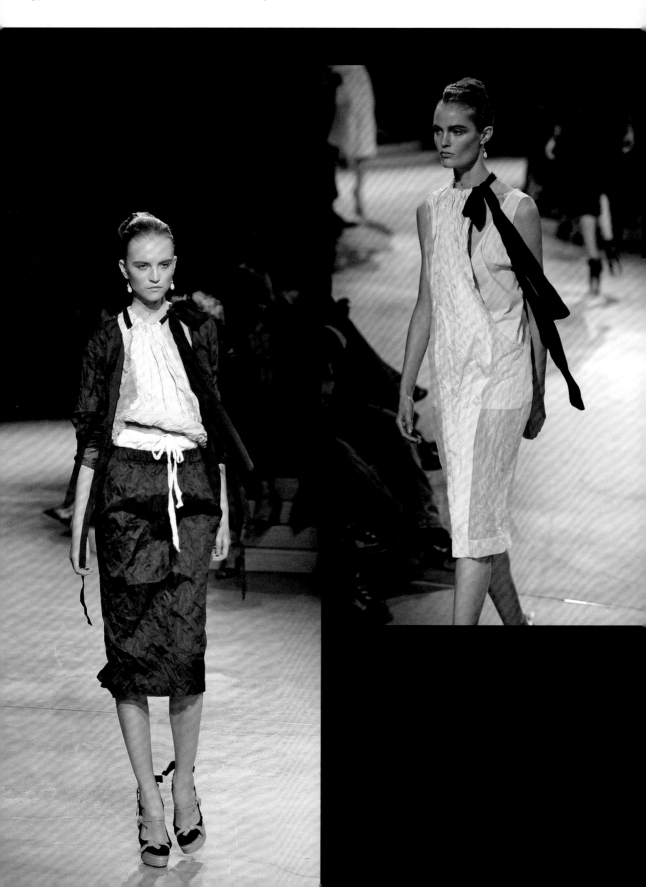

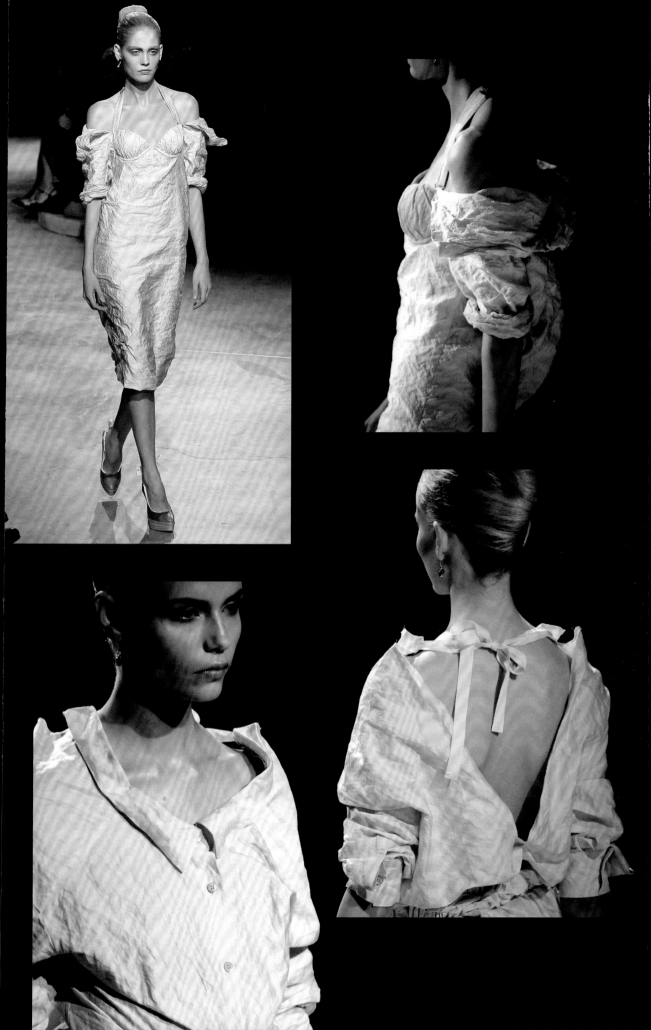

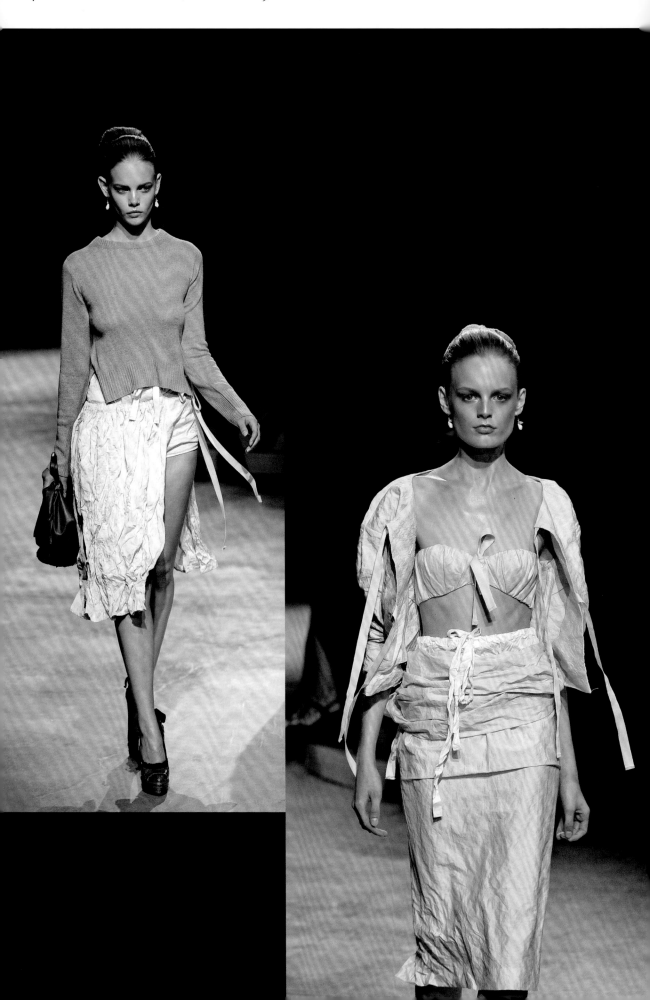

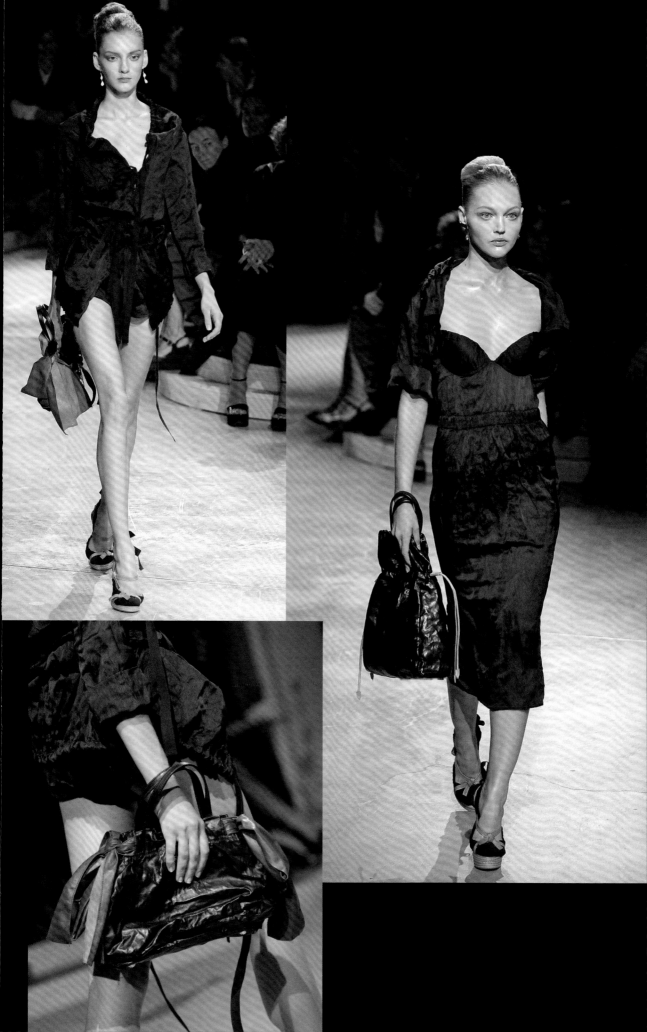

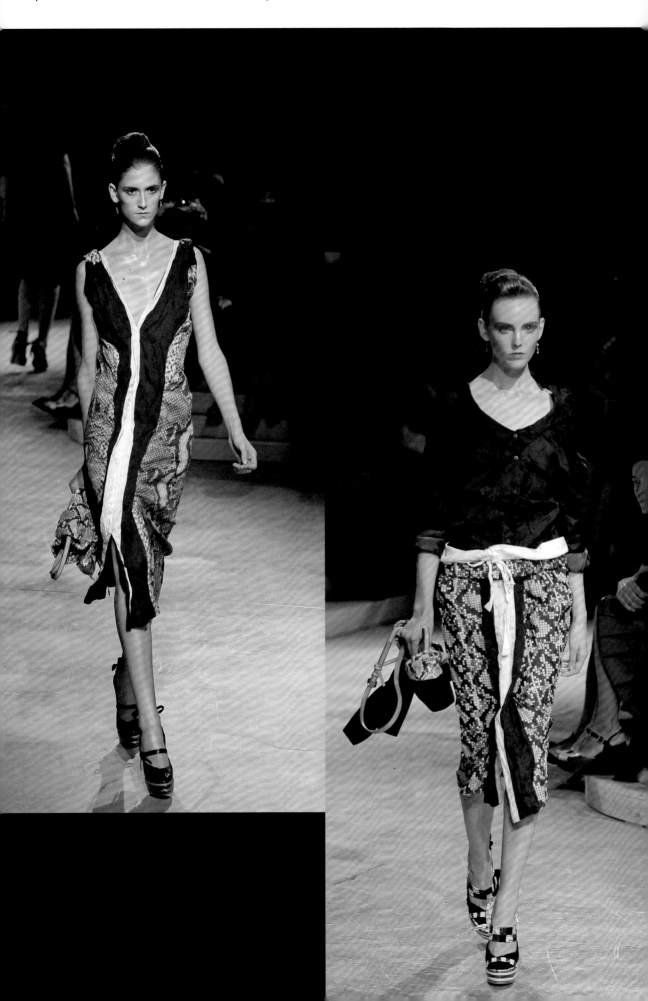

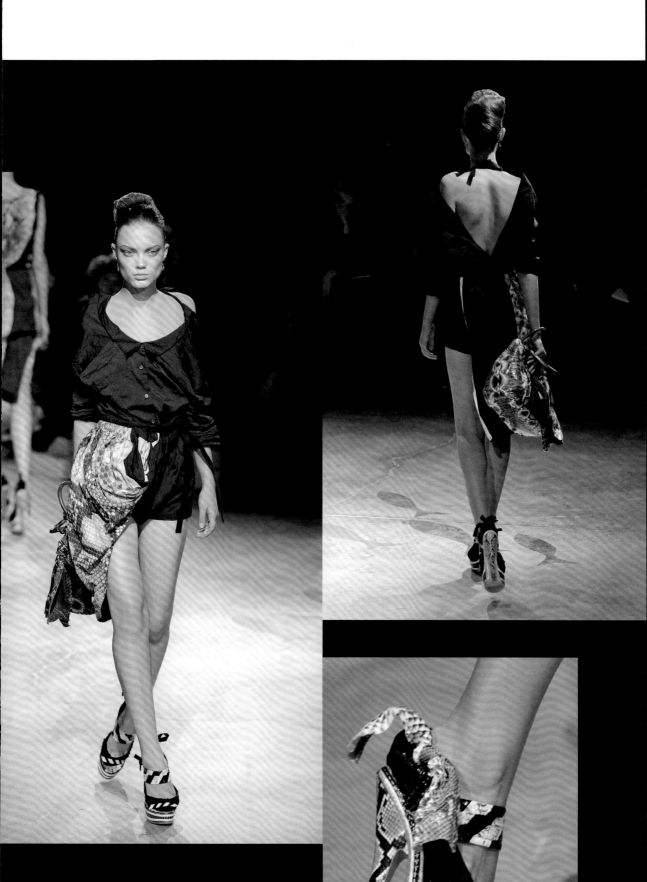

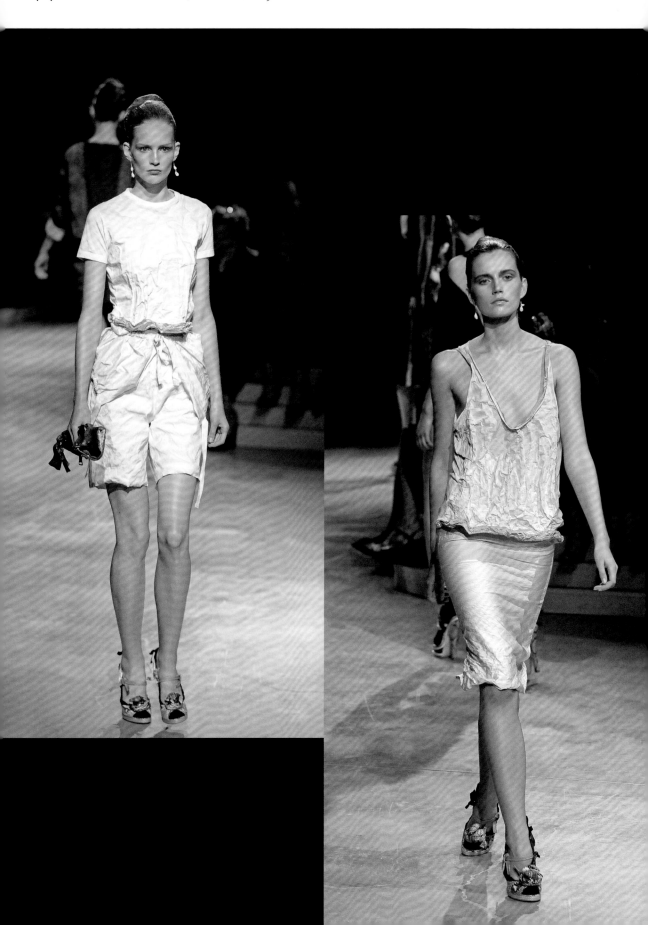

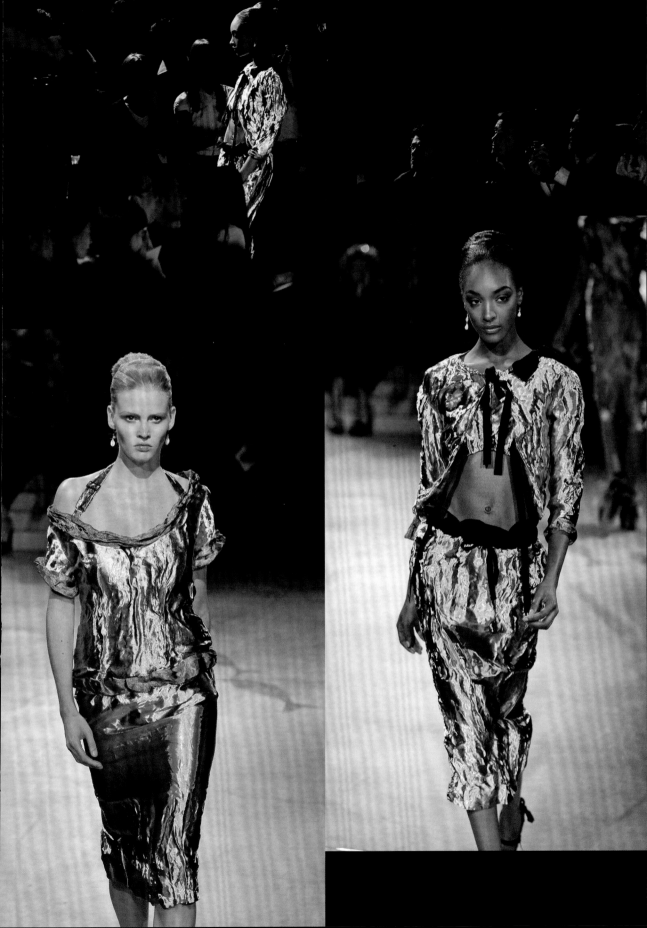

'Fashion is not dead but the world has slowed down and sobered up,' wrote Cathy Horyn in the *New York Times* in February 2009. 'Between last September and the start of the fall 2009 collections, on February 5, merchants saw business fall dramatically as consumers shifted from spending to saving in the path of the recession... Fashion houses, anticipating reduced orders, cut out the theatrics as they sought to appeal to a relatively new demand in luxury fashion: value.'

As always, Miuccia Prada responded to the prevailing climate with razor-sharp clarity and a collection which proved, if ever that were needed, that her sensitivity and powers of reactivity were second to none. There was a rough-hewn, almost rustic quality here that looked, once again, at the 1940s, at an haute Land Girl if you will, and saw any more frivolous fashion concerns give way to serious and pragmatic ones; that saw any frills, furbelows and vertiginous ornamental footwear (see p. 403) give way to heavy wools in sludge colours and waders. Yes, waders. The woman here was formidable over and above flirtatious, wearing thick rib-knitted cardigans in autumnal shades and bright red over tweedy micro-shorts made all the more confrontational given the aforementioned oversized leather thigh-high boots.

'Those who know of Ms Prada's fondness for rural life – and the tension it has long given her fashion – understand only too well the incredible allure of these clothes, their richness and plainness', Horyn continued. 'She also, in a dozen small ways, expressed key trends: the return of the coatdress, the use of asymmetry and the new cut of sleeveless dresses, so that the shoulders of a velvet and tweed dress extend slightly over the arms.'

Meanwhile, in November 2009, the first major Prada monograph was published by the company. 'Careful observation of and curiosity about the world, society and culture are the core of Prada's creativity and modernity,' read the foreword. 'This pursuit has pushed Prada beyond the physical limitations of boutiques and showrooms, provoked an interaction with different and seemingly distant worlds, and introduced a new way to create a natural, almost fashionless fashion.'

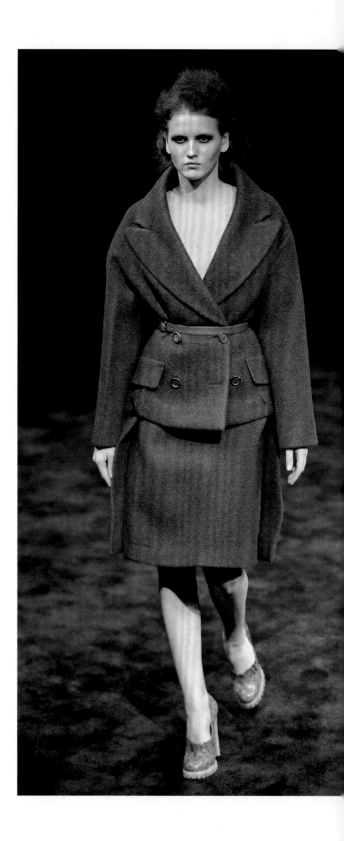

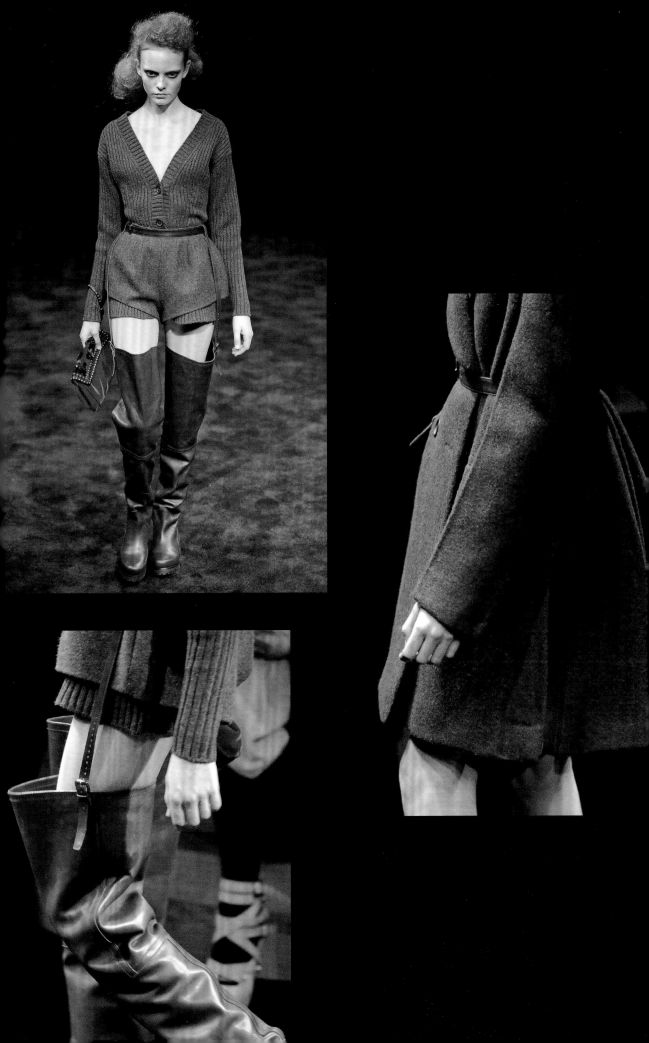

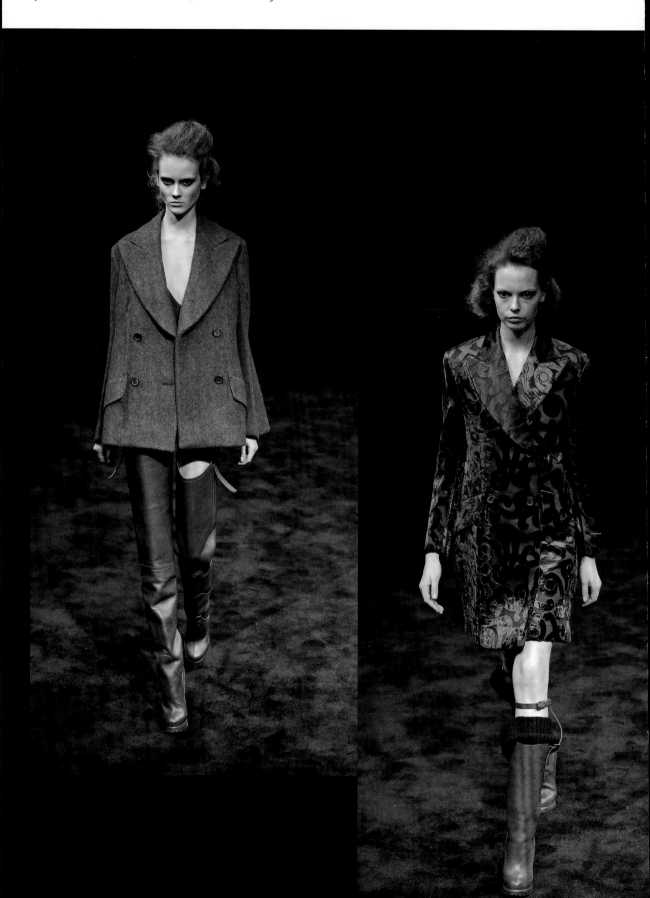

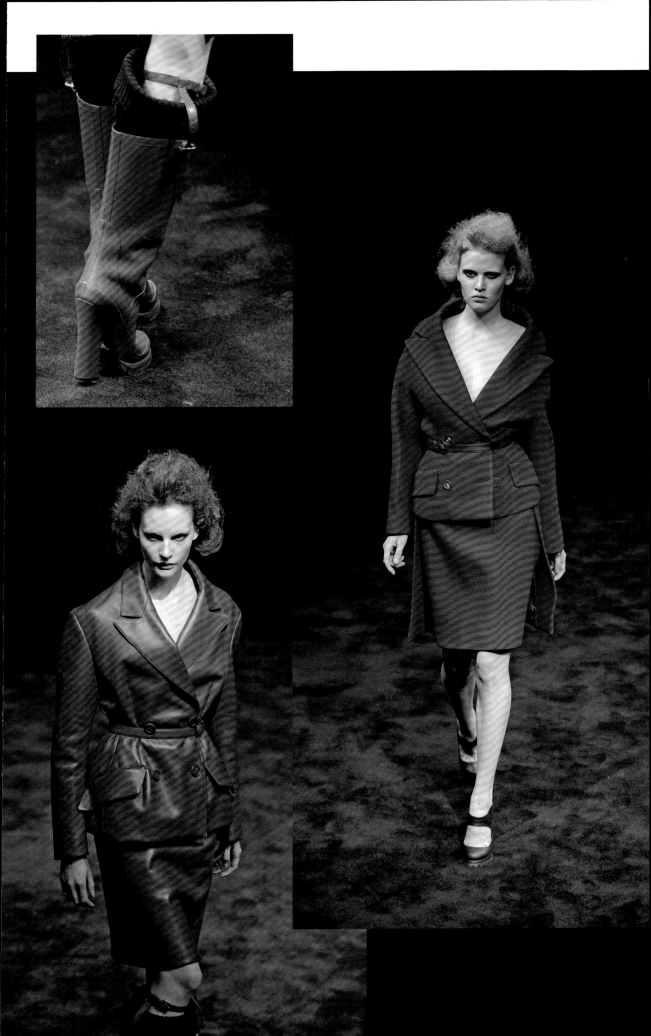

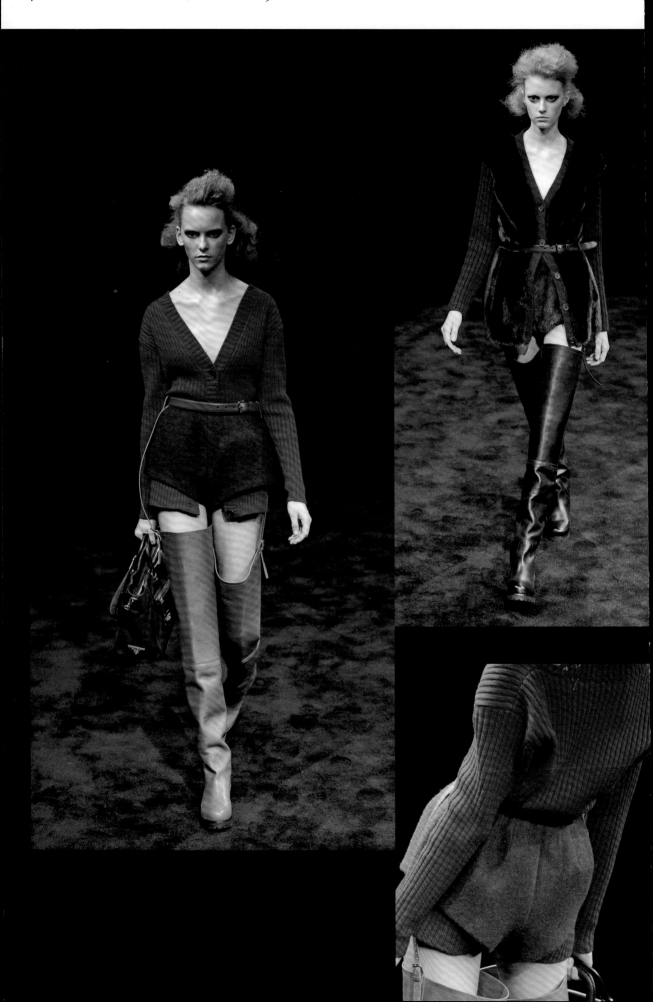

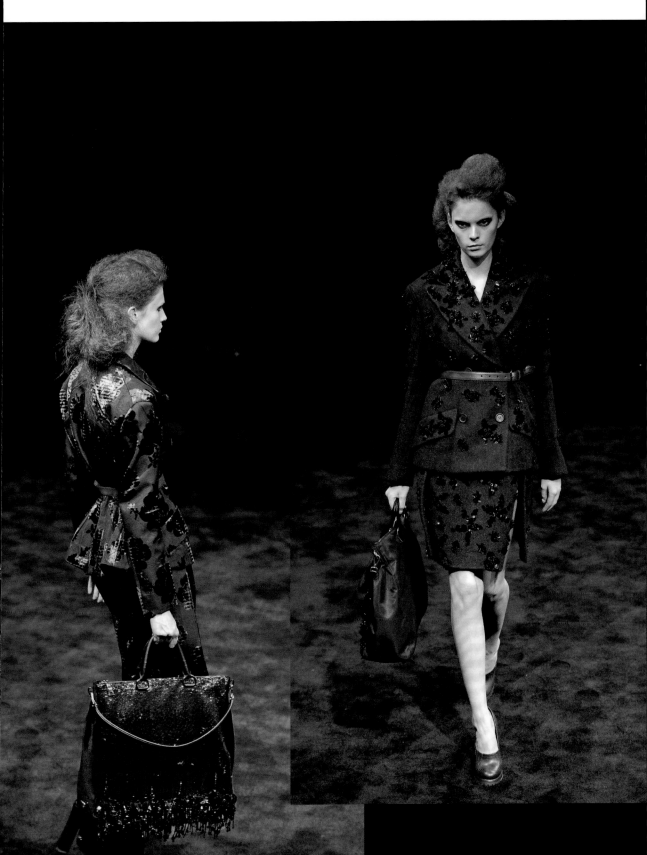

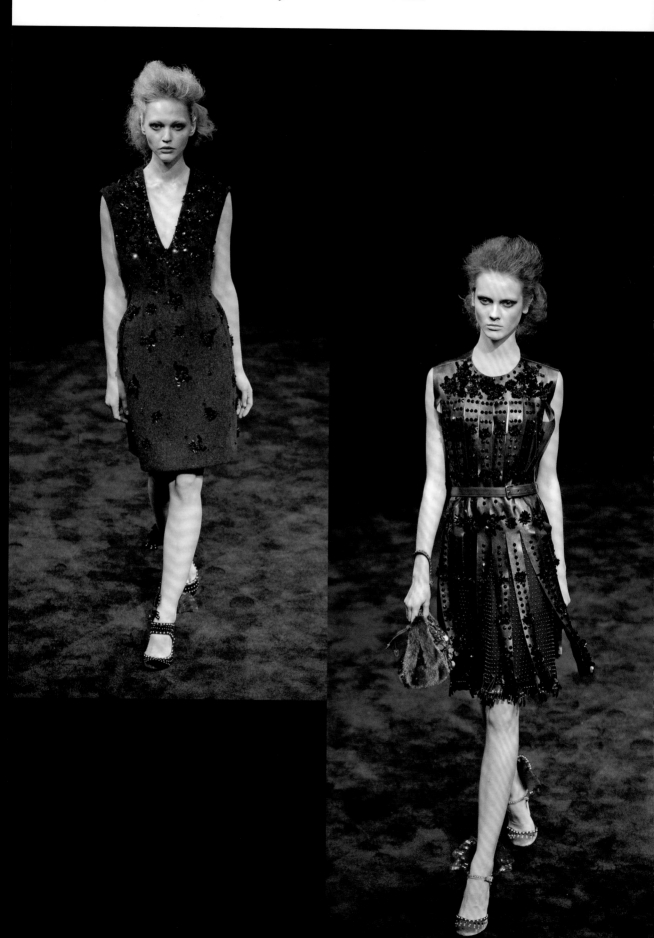

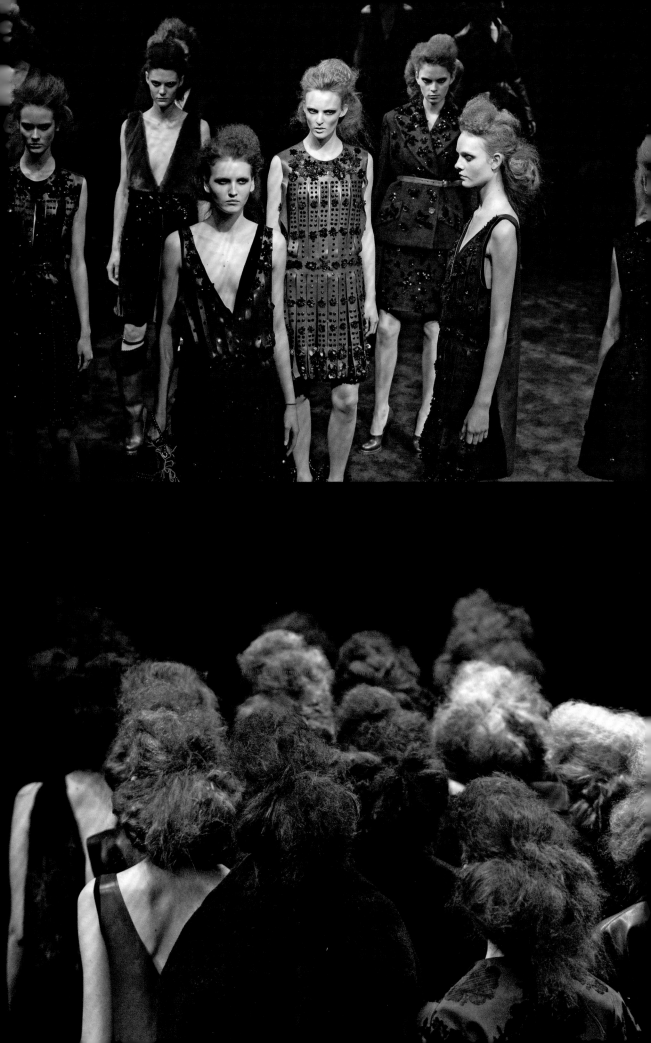

Against a backdrop of a checkerboard runway
and projections of huge chandeliers, doorways,
beaches and picture postcards, as first seen in Prada's
Spring/Summer 2004 collection (p. 296), this was
a lighter and more youthful view of femininity, but
one still underpinned by many of Miuccia Prada's
favourite things.

Positioned somewhere between fantasy and reality,
the hems of masculine shirts extended below those
of silk panties in nothing more girlish than gunmetal
silks (opposite, below left), while crystal prints and
embroideries appeared across mini-shift dresses,
A-line coats and vests. The simplest cotton separates
were veiled with cages of more crystal, and Bermuda
shorts, at times teamed with matching cropped
jackets, were boyish and button cute. Hemlines
throughout were high and colour restricted to black,
white and grey, save for the odd appearance of a
seaside print glowing with chemical pinks and blues.

'Beach and antiquity – high and low – it is all the
same,' Miuccia Prada told the *International Herald
Tribune* after the show. 'It is supposed to be an ironic
take – sometimes nostalgic, a contemporary take on
antiquity for those who don't understand the beauty
of the past.'

Her words went at least some way towards explaining
the strange, childlike beauty of models in barely there
clothing accessorized with transparent bags with
crystal clasps and chandelier shoes. In the end, this
collection was as clean, clear and sparkling as the
one before it had been sturdy; the woman as blithe,
optimistic and free-spirited as her immediate
predecessor had been serious. The overall effect was
of a palate cleanser, a fresh start, paving the way for
things to come.

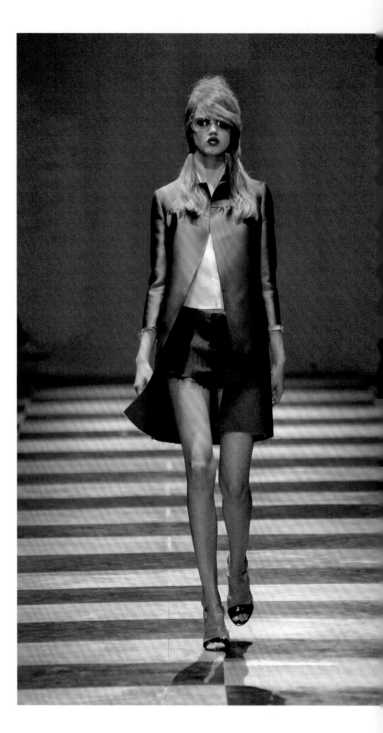

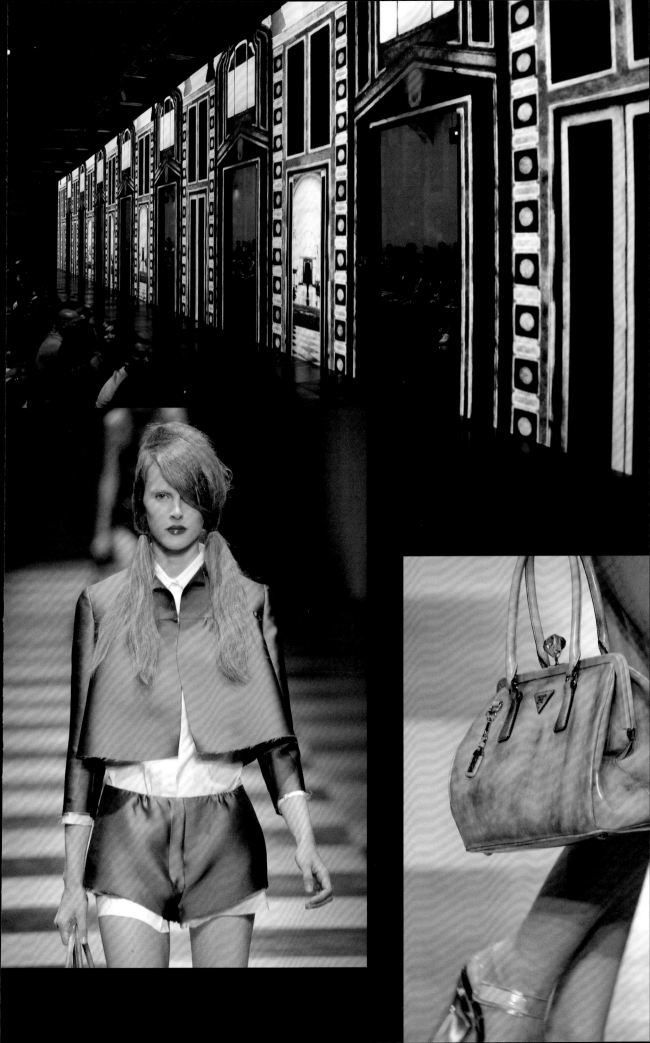

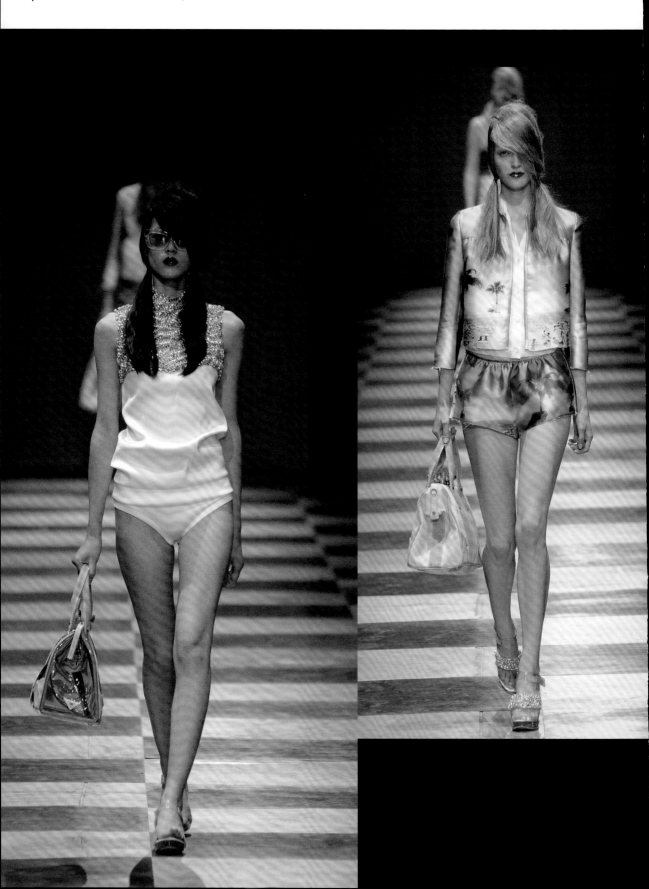

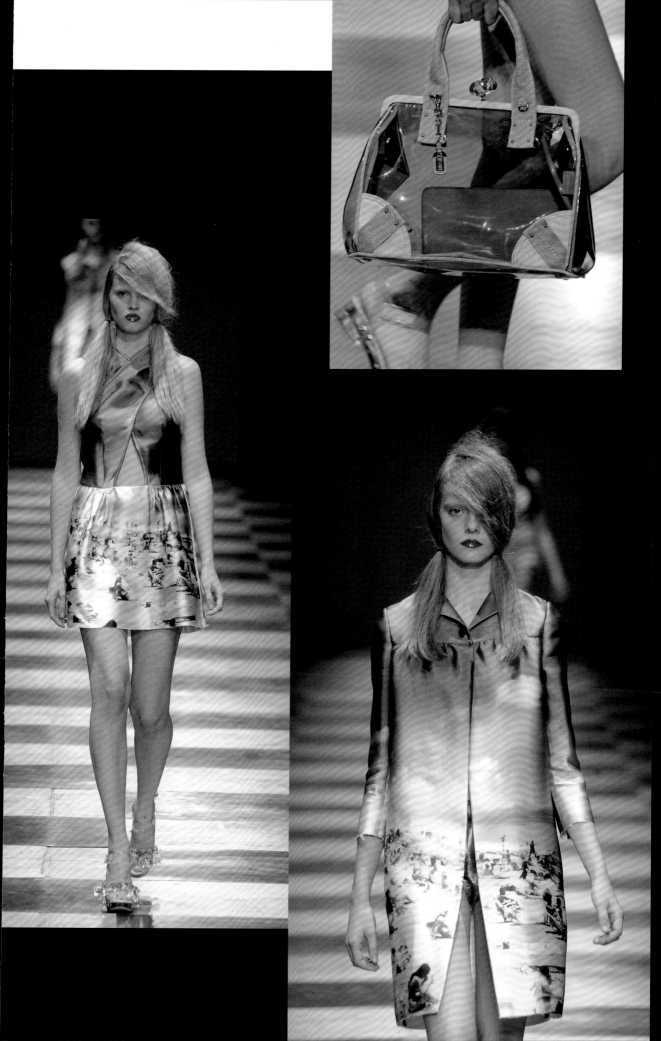

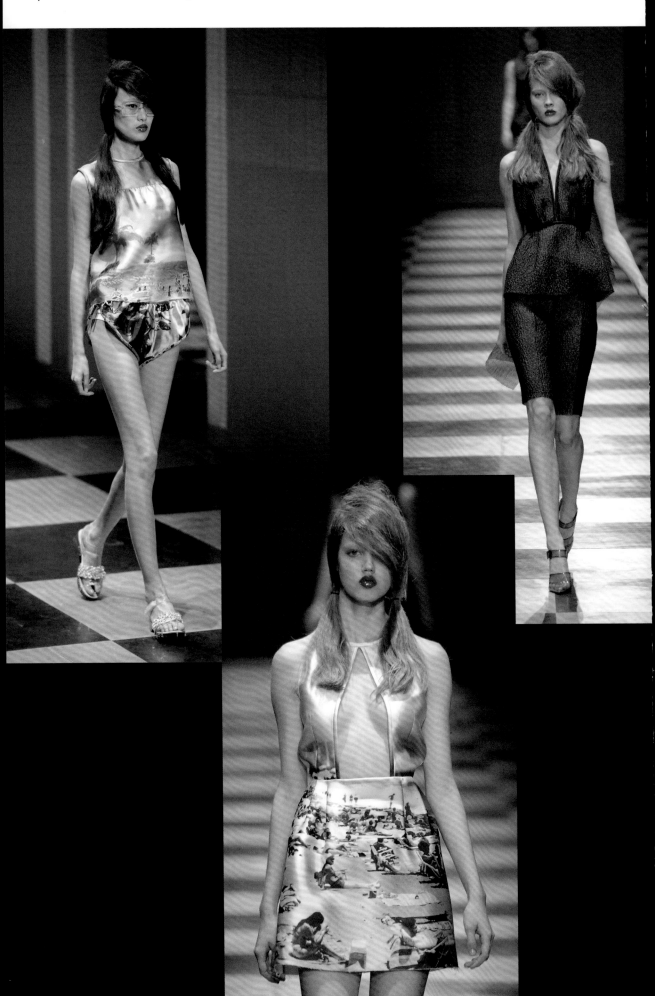

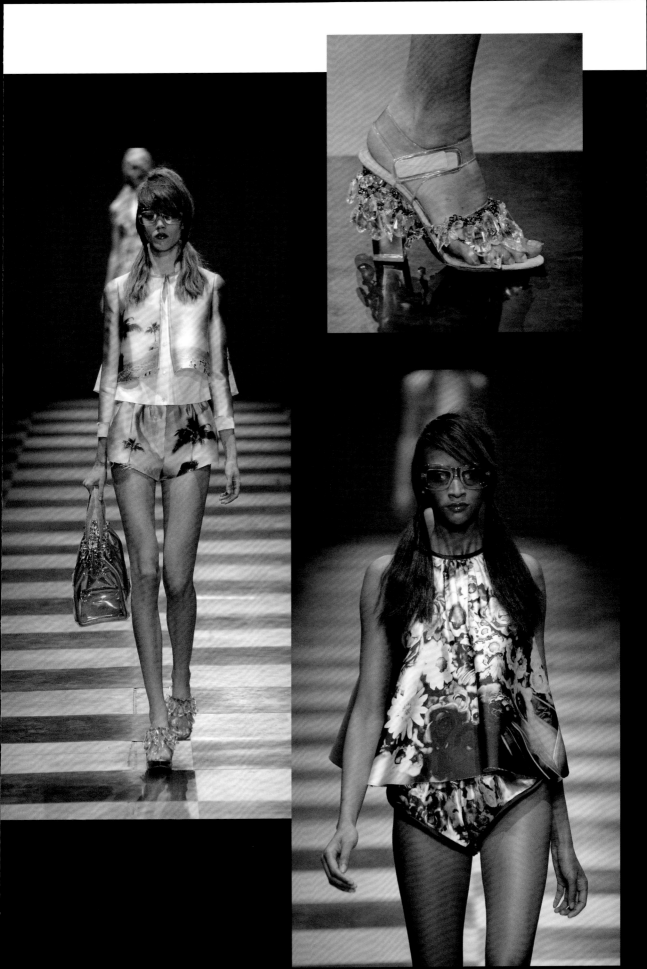

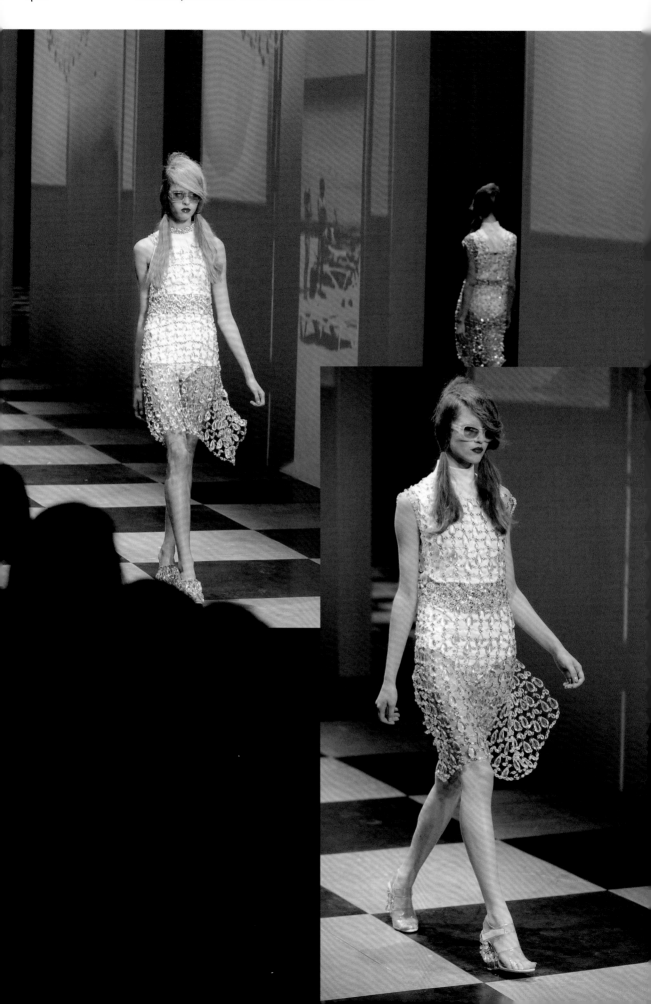

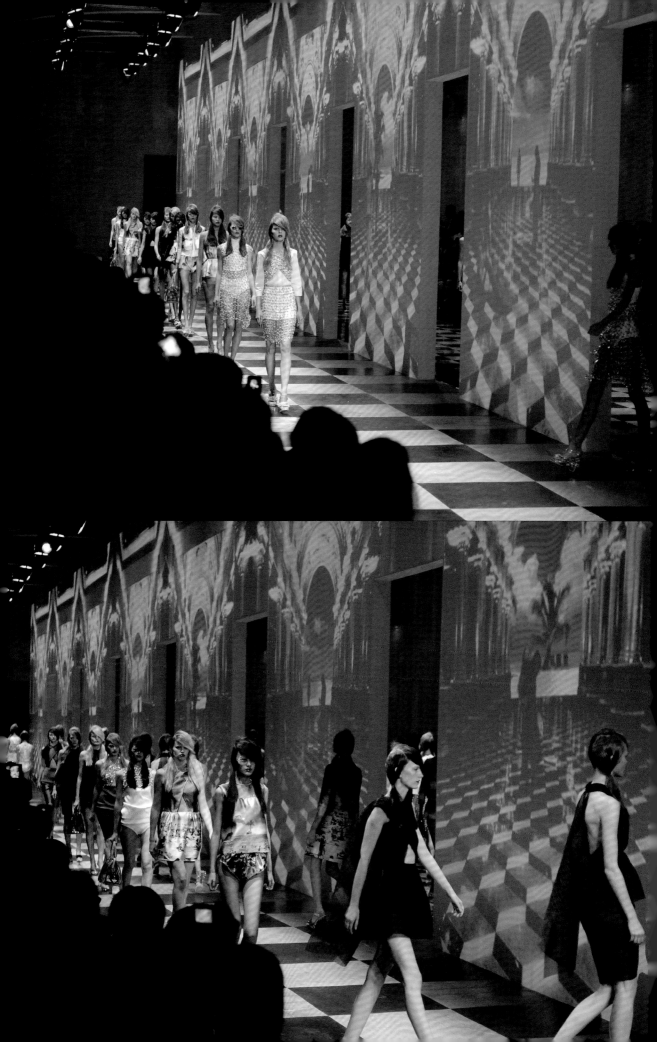

'It's normal clothes,' Miuccia Prada told Style.com
backstage after this show, although such things are
relative. 'Classics,' the designer continued. 'Revisiting
things I did in the Nineties.'

This was also among the most deliberately womanly
shows this designer had come up with for some
time. The clue was in the casting. Doutzen Kroes,
Lara Stone and Miranda Kerr were comparatively
curvaceous – for want of a better word – and full of
personality, with none of the blank-faced, bored and
beautiful appearance that, for the most part, found
favour at this point in time. The clothes themselves
only emphasized that fact. The focus was on the bust,
on sweetheart necklines embellished with balconette
ruffles, on cable-knit fitted sweaters belted at the
waist, on a raised waistline and on pointed bra details.
The look was bourgeois, for sure, but exaggerated,
humorous even: imagine a super-charged, sexy
secretary. Some models even sported cat-eye glasses.
The projections on the walls said it all: 'Brush your
hair 100 times per night', read one piece of advice
that appeared to have come straight out of a 1960s
beauty parlour or, perhaps, finishing school.

The classics included the prevalence of a silhouette
indebted to the Fifties and Sixties: A-line skirts
that fell to the knee, Capri pants and vests, peacoats
in leather and tweed, cashmere and more leather
trimmed with fur, at times natural, at times dyed in
colours brighter than nature ever intended and every
shade of brown. The peek-a-boo eroticism that first
emerged way back when was here, too: dresses were
cutaway to reveal the torso but in the most delicate
manner. There was nothing minimal about this
collection, as little black dresses traced with jet
beading and coats densely embroidered with more
of the same went to prove.

So far, so not Nineties, when Prada's clothes were
largely clean-lined. The prints, however, were revived
directly from that period, referencing Prada's duo
of ground-shifting 1996 collections famously dubbed
'ugly chic' (pp. 134, 144). They were recoloured to even
darker, sludgier, kitchen-sink shades for this
reiteration – the old once again made new.

Prints included, this was quintessential Prada right
down to pointed patent pumps tied with neat little
bows, with a curved stiletto heel paired with nothing
more obviously appealing than hefty knitted socks
finished with more ruffles. That mix of the appealing
and the disingenuous, the unexpected, reads as pure
Prada.

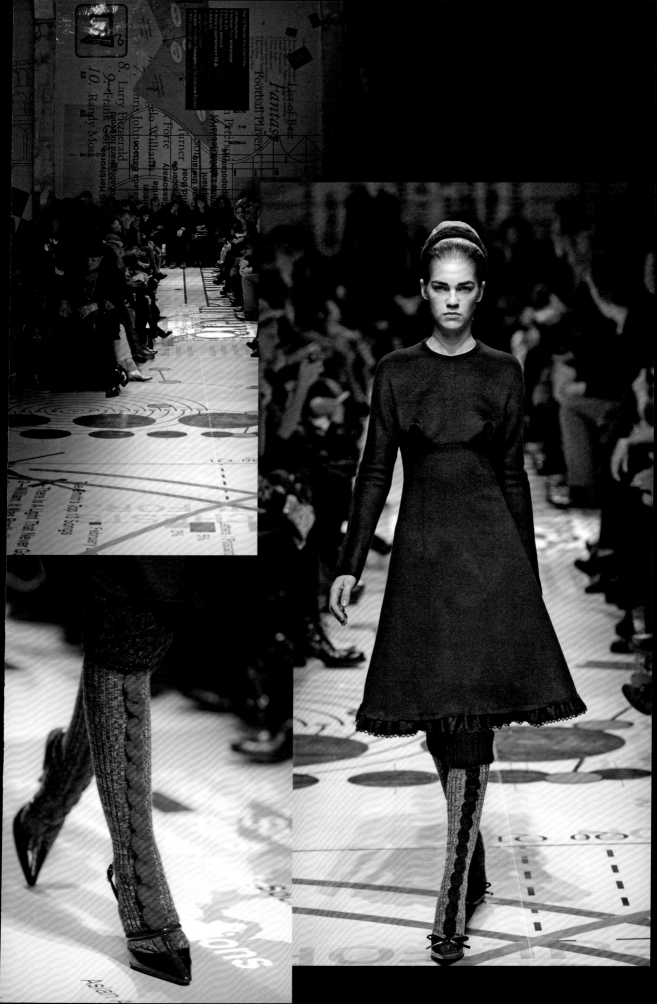

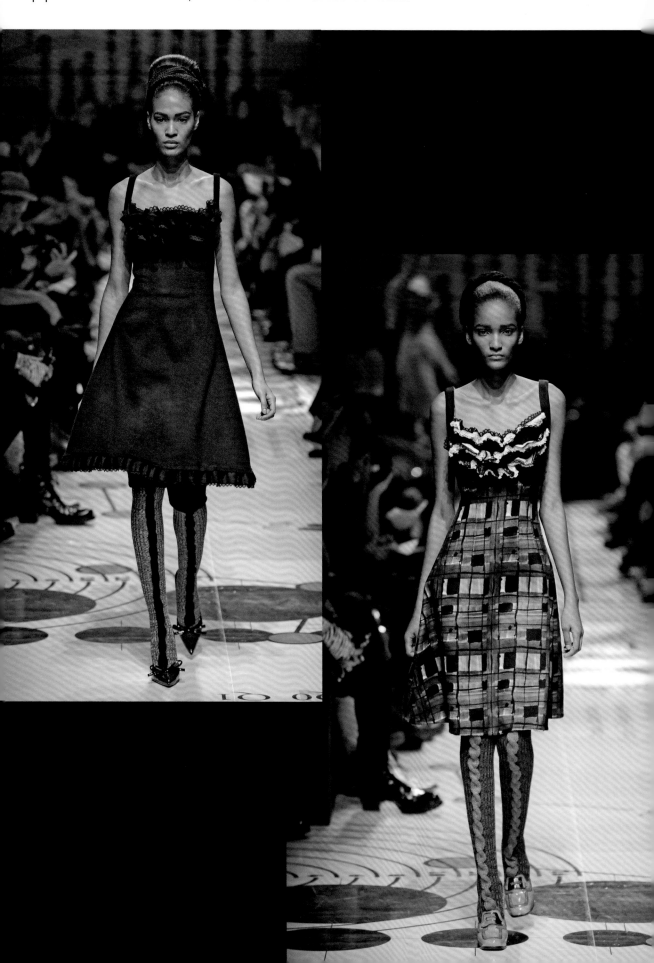

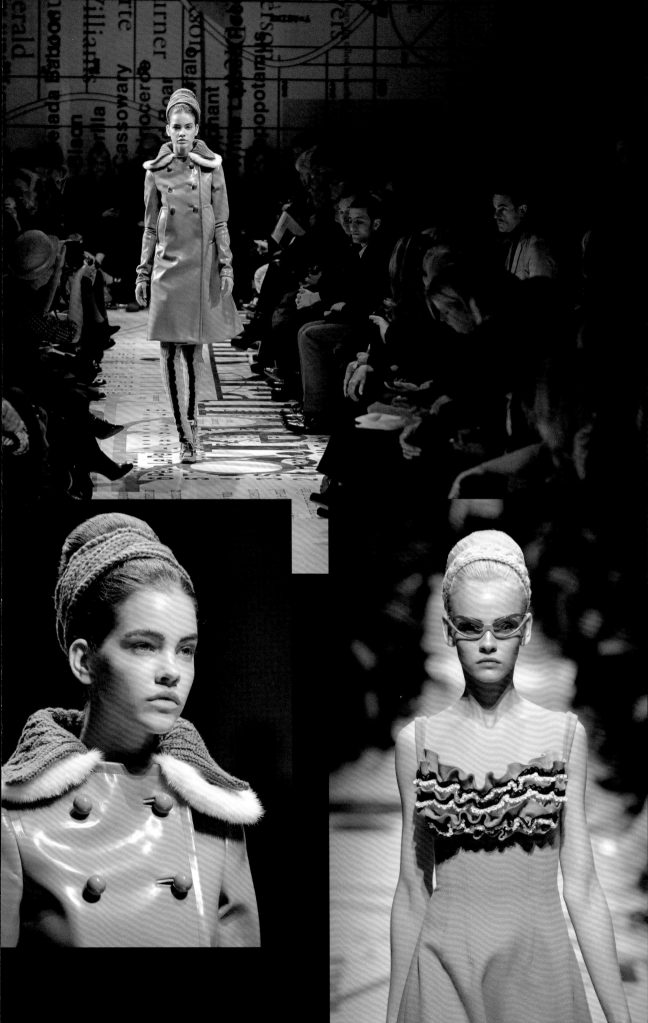

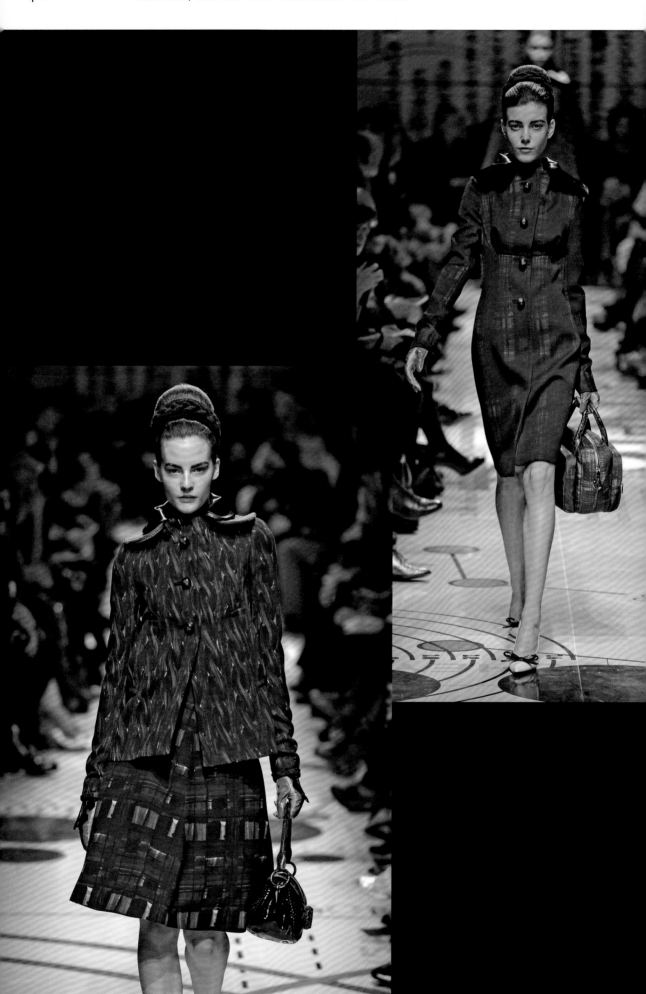

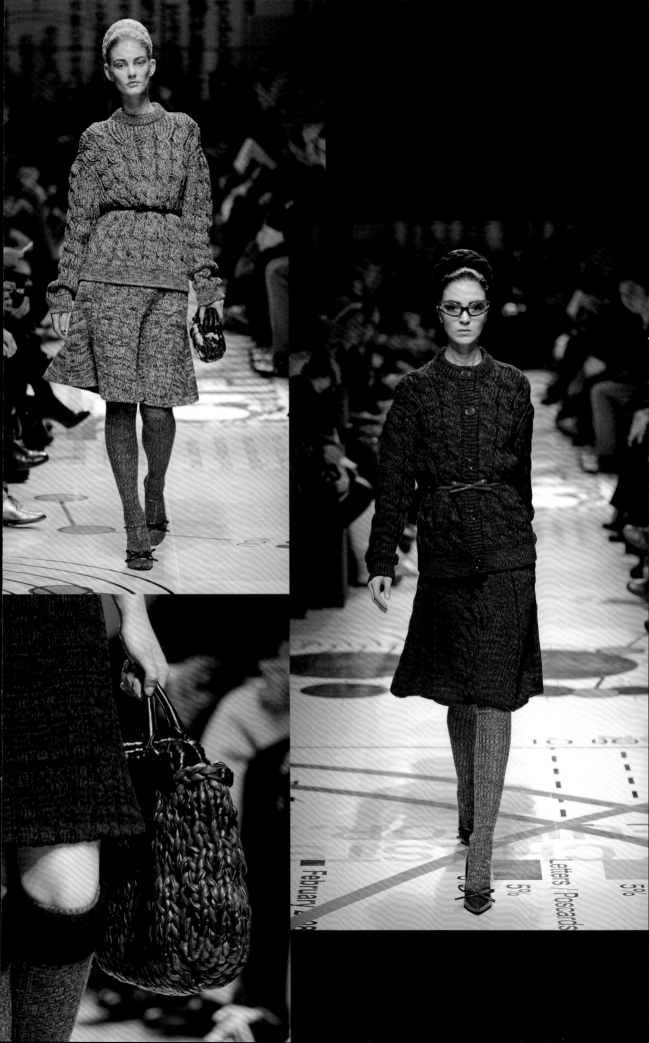

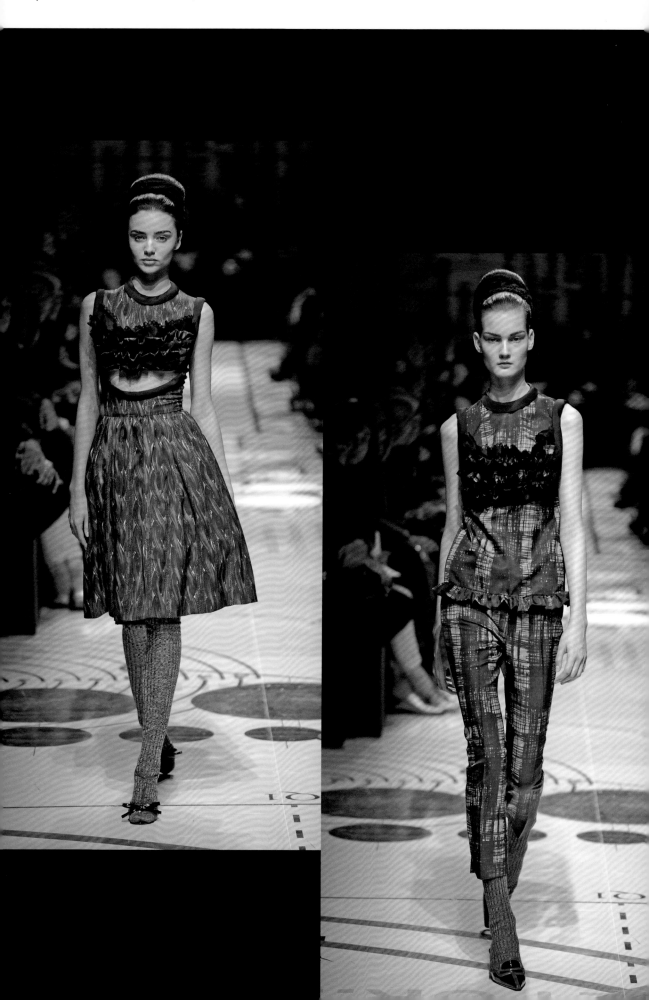

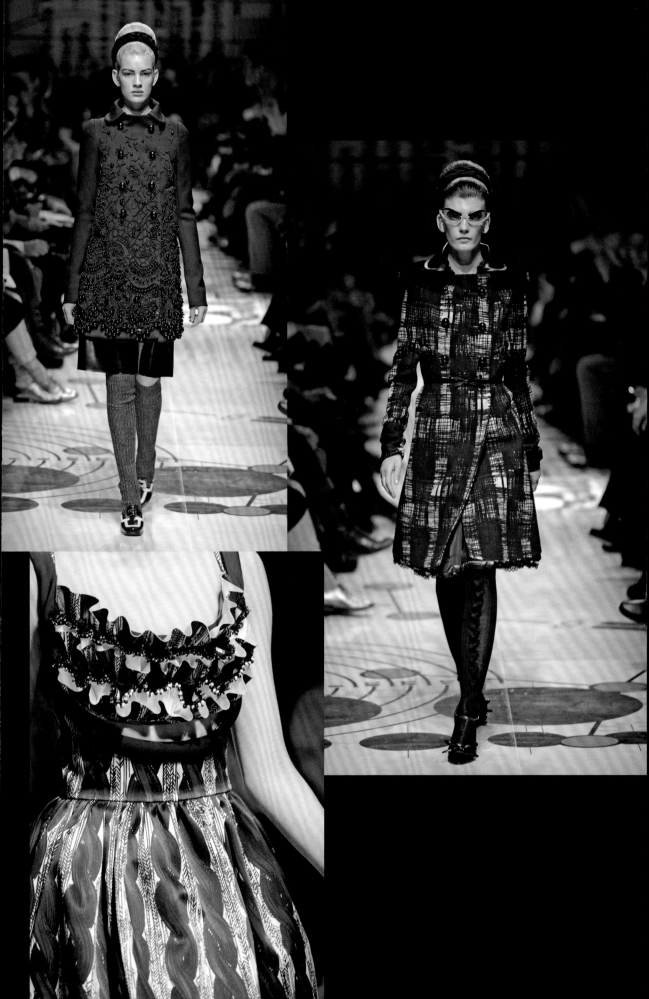

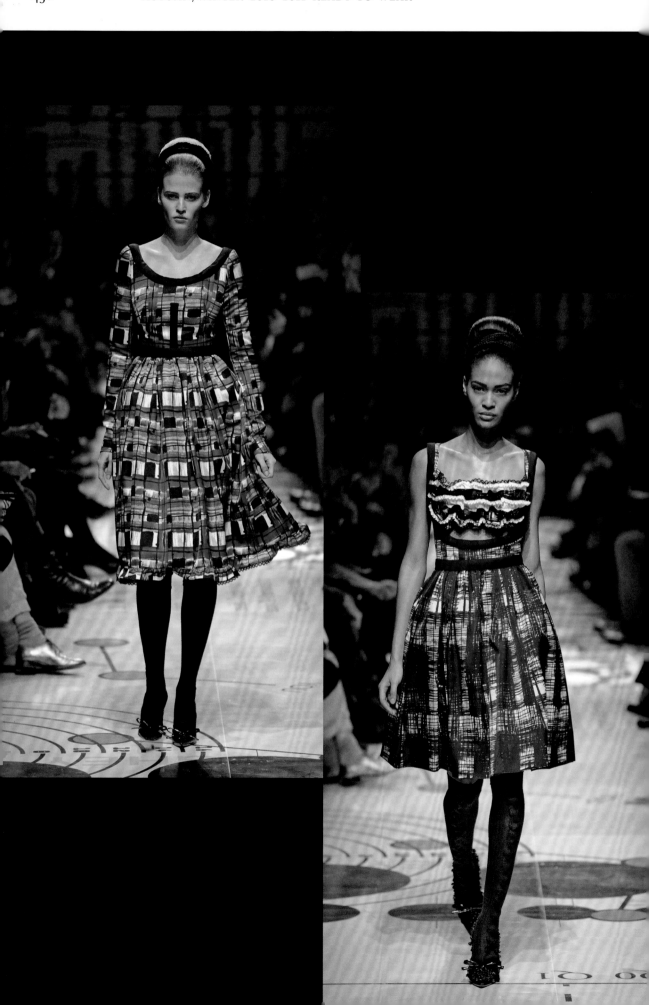

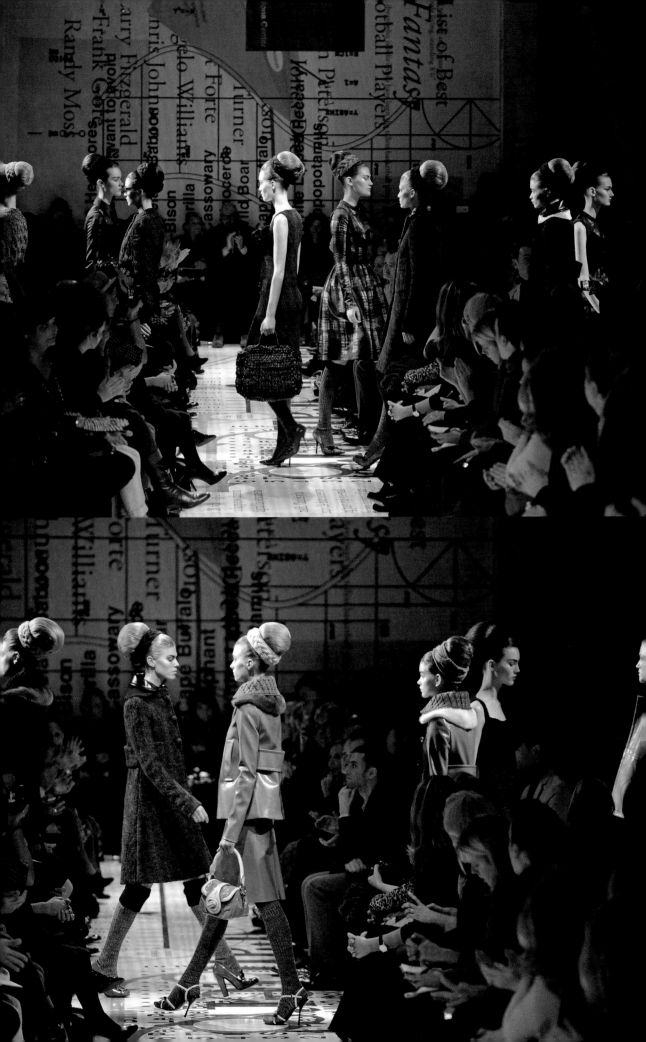

The simplest clothes in shades of cerise, tangerine, cobalt blue and forest green against graphic white and black came out on a dazzling silver mesh runway this season, when Miuccia Prada decreed that oversized tunics resembling surgical scrubs, square-cut aloha shirts, single-breasted skirt suits with a broad curved sleeve and zip-fronted bombers teamed with fit-and-flare skirts might look all the more brilliant when worn with oversized fox fur stoles in an even brighter, striped palette.

From the furs, said stripes migrated across clothes – and the platform soles of soon-to-be bestselling sandals and mannish brogues – and then came monkeys prancing across lush jungle greenery and even juicy bunches of bananas. The designer famously took her bow beaming in a pair of plastic earrings featuring that same dangling fruit – earrings which she has been known to still wear to this day.

A beachy feel came through in those prints again, and in Mexican embroideries across the front of a white sun dress (p. 440, right), and in huge sun hats (more stripes) tied around the neck with black grosgrain ribbon. There were shades of Josephine Baker also here, emphasized by the models' slick, pin-curled hair – just the lightest touch of history in case anyone might forget where they were and the deep understanding of culture that entailed.

Bar the furs and jangling plastic beads at hems, the clothes in this collection were entirely made from cotton – sensible, hardy, humble. Practically, cotton also takes dye well, allowing for the zinging colours in question. Ultimately, though, for its unadulterated plainness this collection was extraordinarily bold: an immaculately executed fashion statement that couldn't have been more confident, clear or right for its time. What could make for a better image in an age when bloggers were often treated with more respect than even the most seasoned critics, and when a single picture beamed all across the world in a matter of seconds spoke a thousand words.

With that in mind: 'I'm interested in a wider world,' the designer told the *New York Times*. 'You have to face it, embrace it and like it.' In December 2010, Prada's importance as not just a designer but a patron of the arts was recognized when, at Tate Britain in London, she presented the artist Susan Philipsz with the coveted Turner Prize.

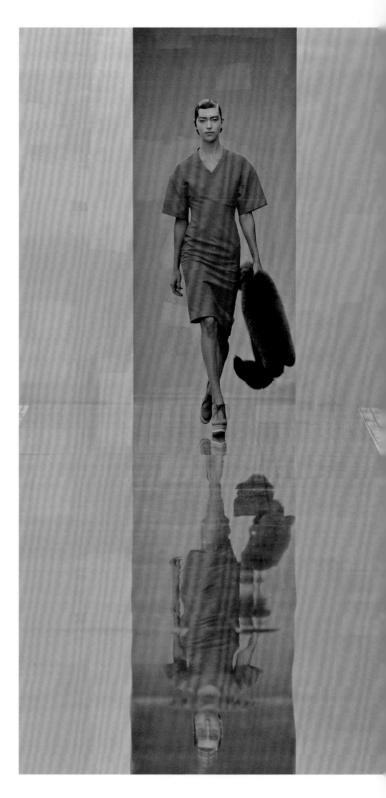

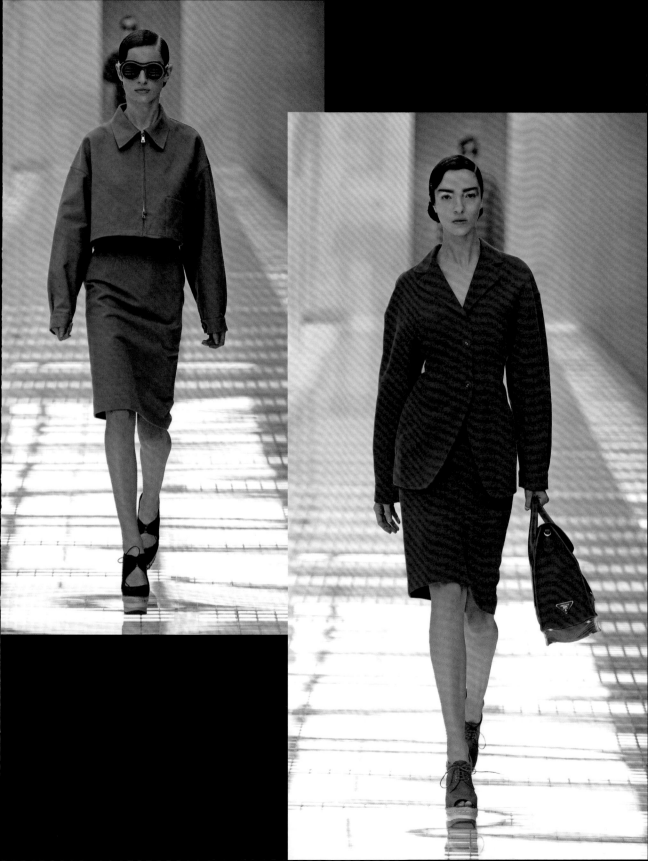

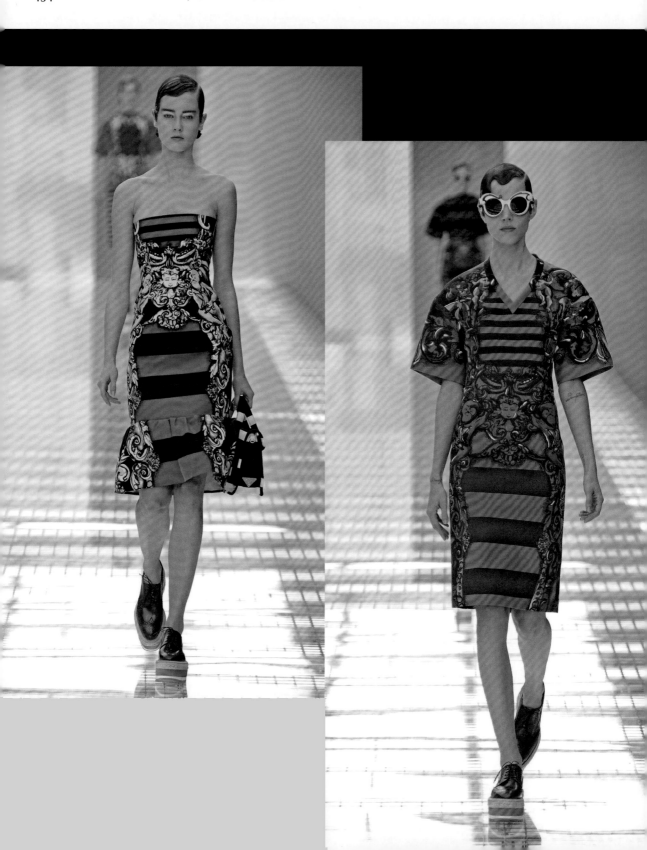

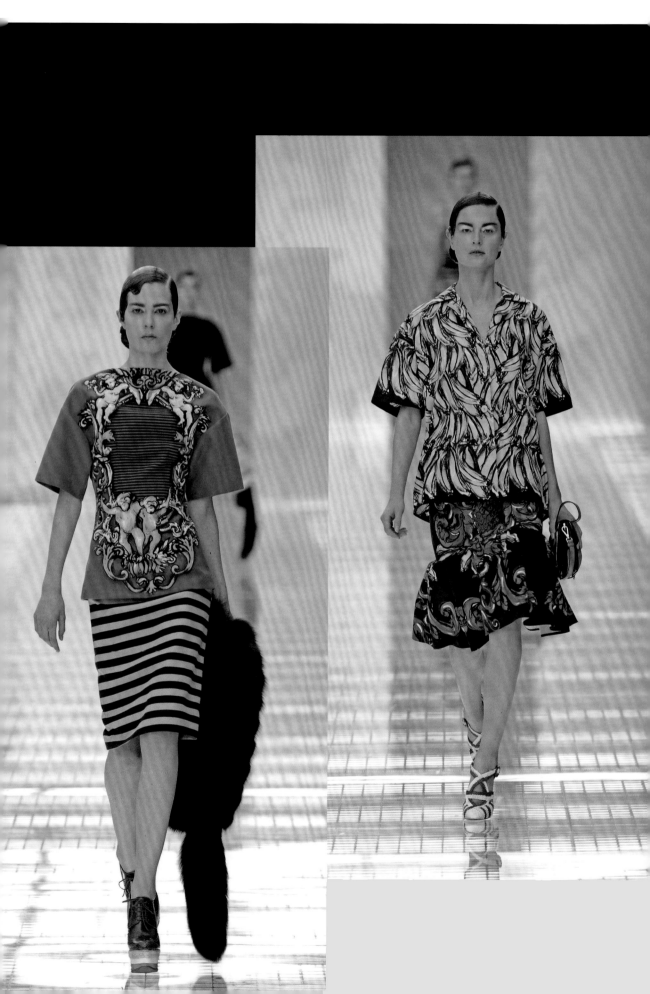

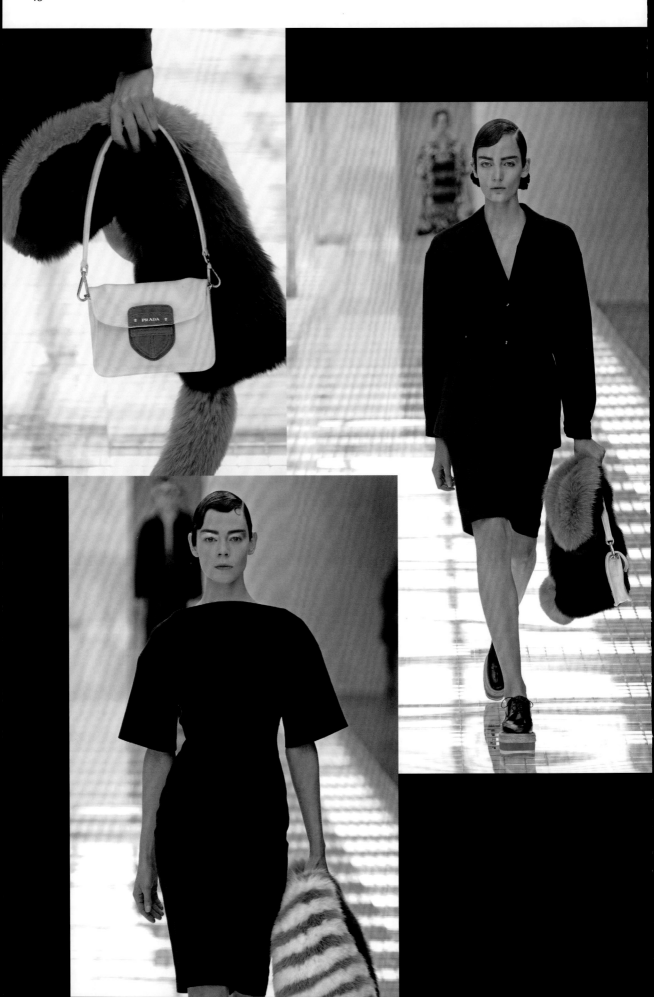

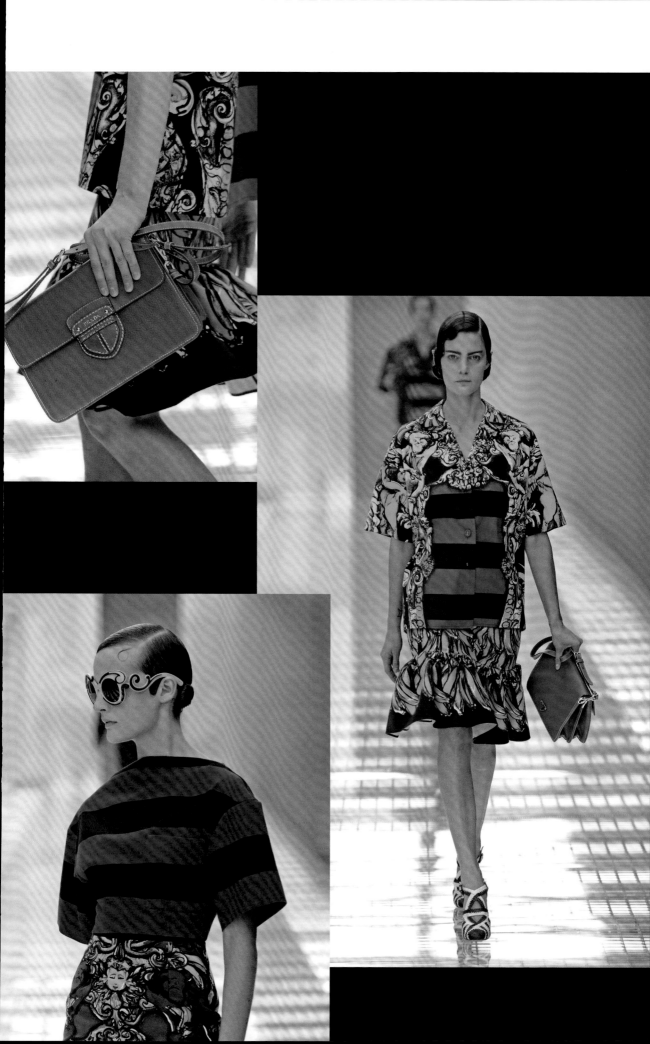

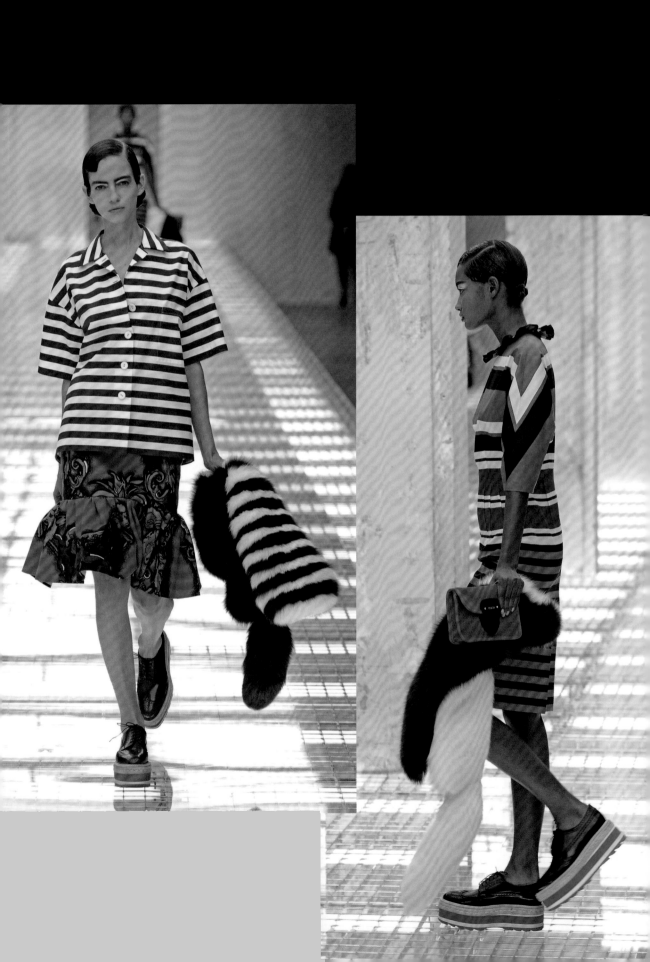

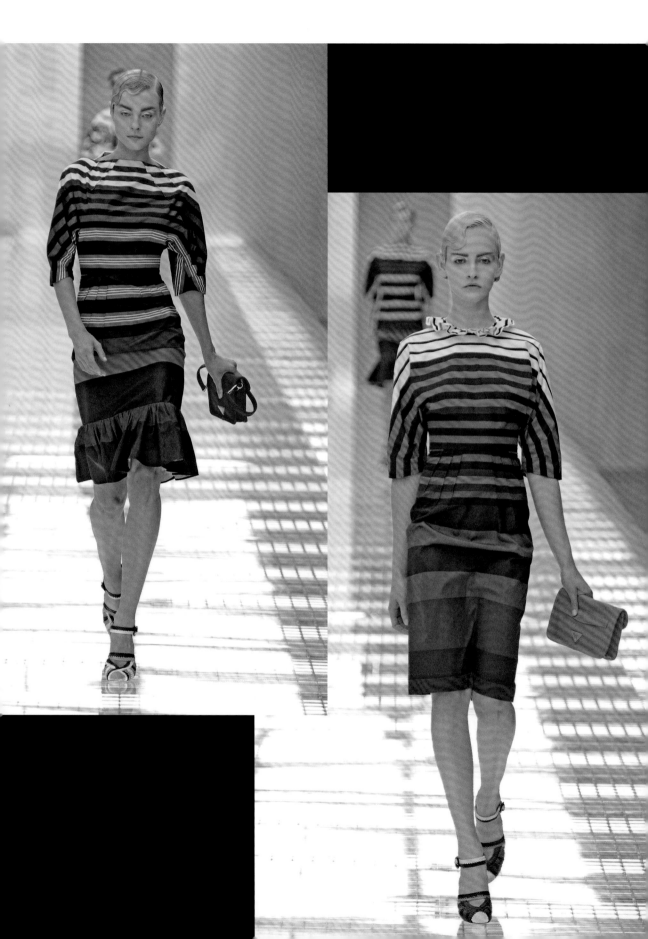

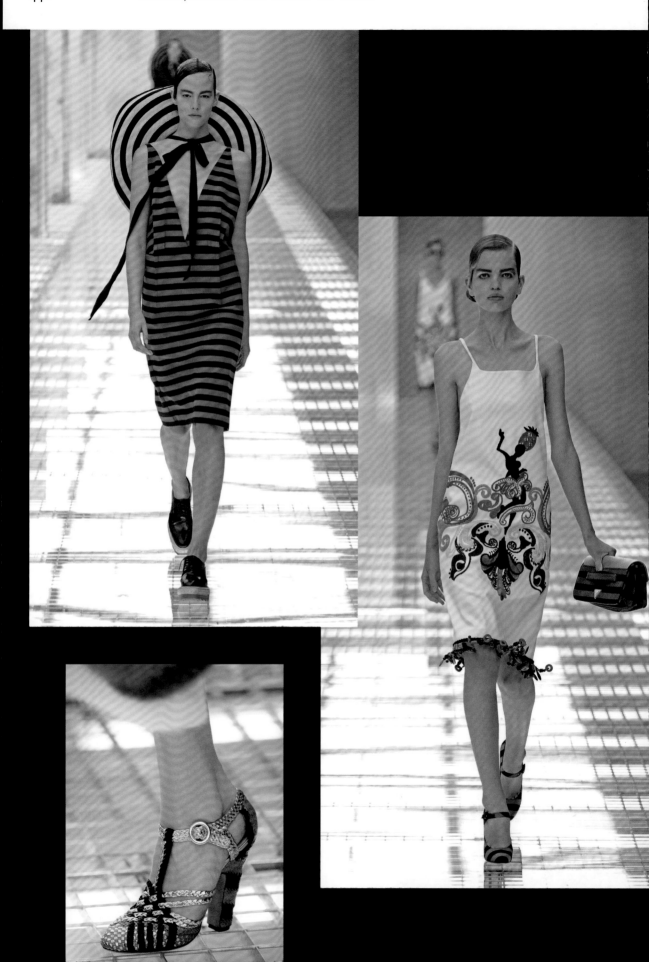

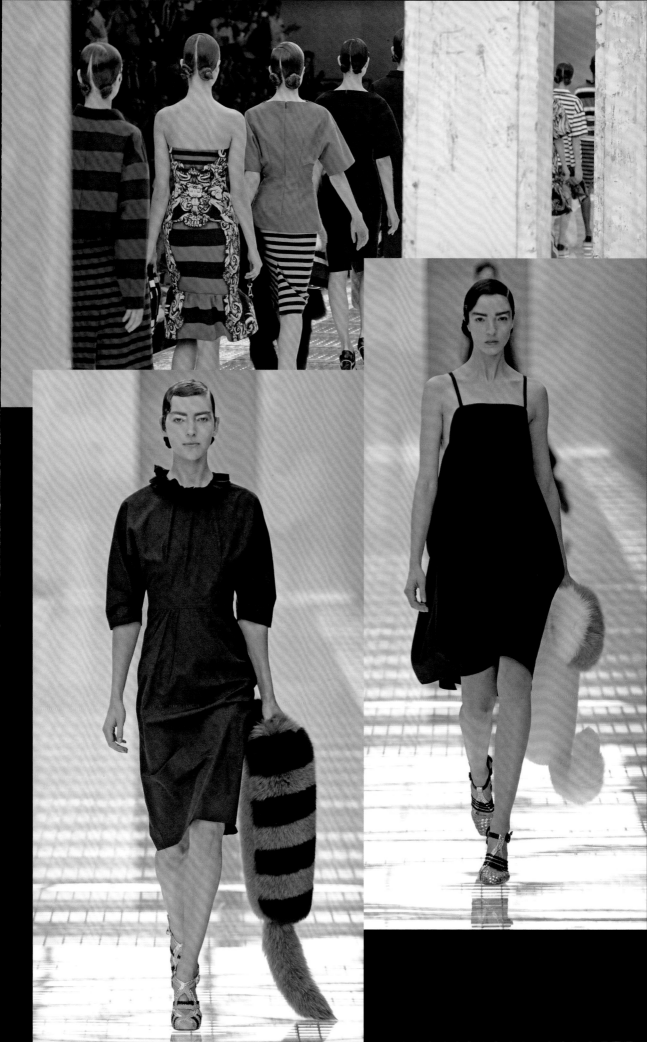

No one would ever accuse Miuccia Prada of being
backwards in coming forwards with the seasonal
soundbite. And so at a preview of this collection,
as reported by *Women's Wear Daily*, she said her
intention was to make 'glamorous and sexy materials
more innocent and fresh. The collection is not exactly
childlike but more ingénue… It's fun, with a cartoon
effect. Women should look more innocent, rather
than making girls look like women.'

Anyone present at her Autumn/Winter 2010–2011
collection, shown just one year before and prized
for its womanly power (see p. 422), might suggest
such a radical shift was mind-bending. And so it is.
Prada's constant analysis not only of fashion but also
of culture and, above all, femininity – and, specifically,
femininity of all ages – is pivotal. Whichever way
one chooses to look at it, without her brilliantly
provocative musings, not to mention her ability
to constantly embrace change, the world would
be a far less interesting place to be.

The materials in question here were python, sequins
and fur, all present and correct but largely subverted.
As well as elegant snakeskin coats and boots there
were aviator caps worn with Biggles-style goggles;
sequins were predominantly plastic; and fur was
often of the teddy bear variety, in unlikely shades
and coated in more plastic.

There was certainly a girlish feel to dresses and
coatdresses with oversized buttons and Peter Pan
collars, and to multicoloured checked and striped
designs that fell to mid-thigh and sported a dropped
waist: school uniform has rarely looked so chic.
Then came feather-light organza skirt suits in baby
pale shades, all the better worn with ruby red velvet
slippers and thick tan socks that wrinkled around
the ankles. Or how about a Sixties-line shift covered
in fish scales (faux) (p. 451, right)? All in all, the
collection was equal parts beautiful and bizarre –
just as its creator surely intended.

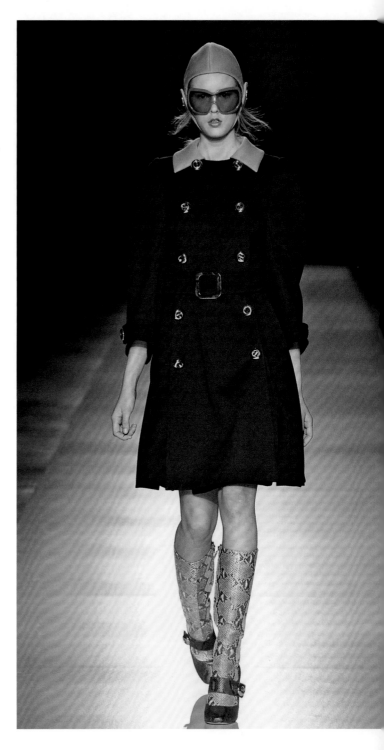

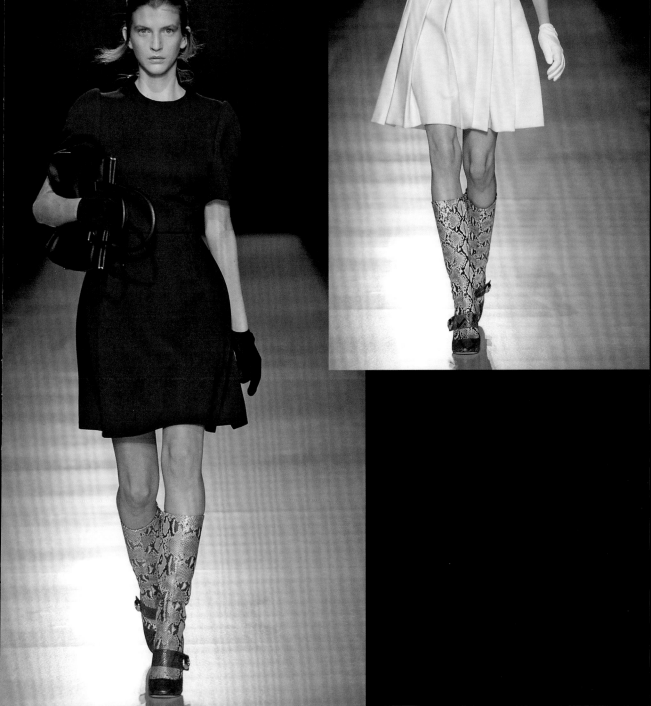

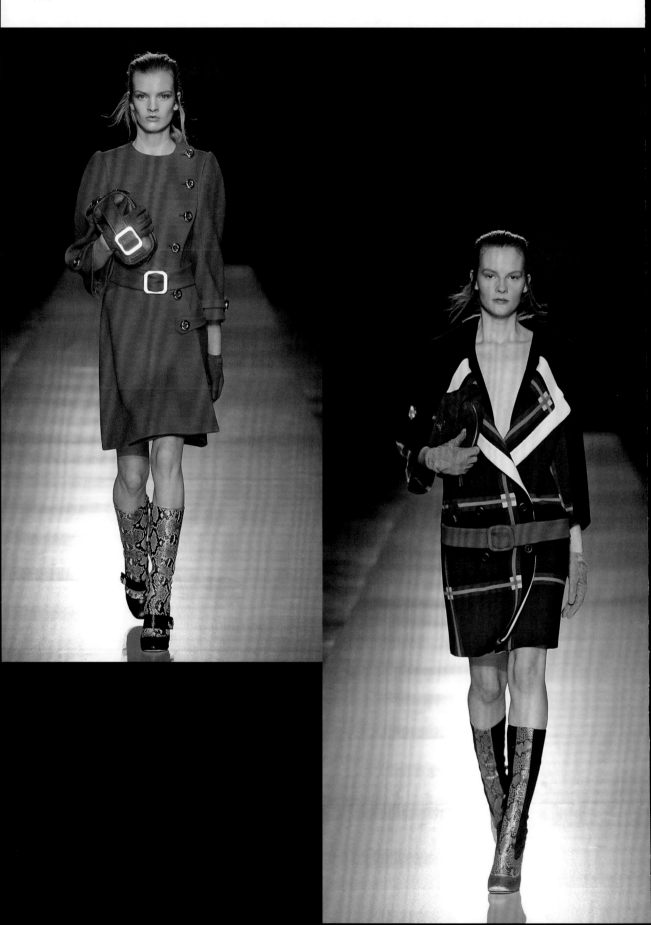

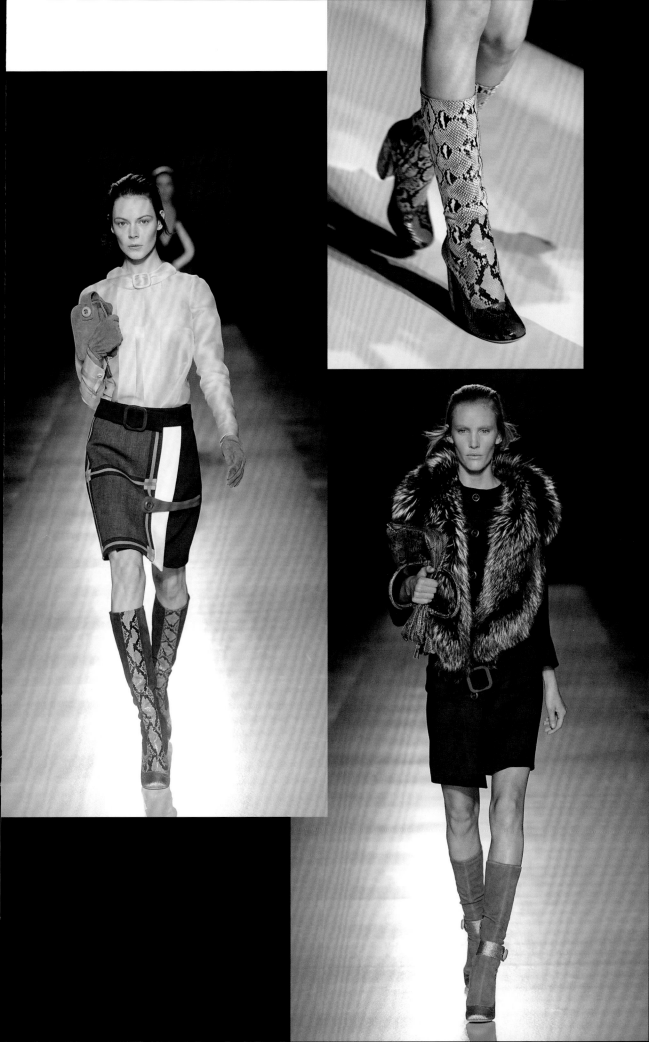

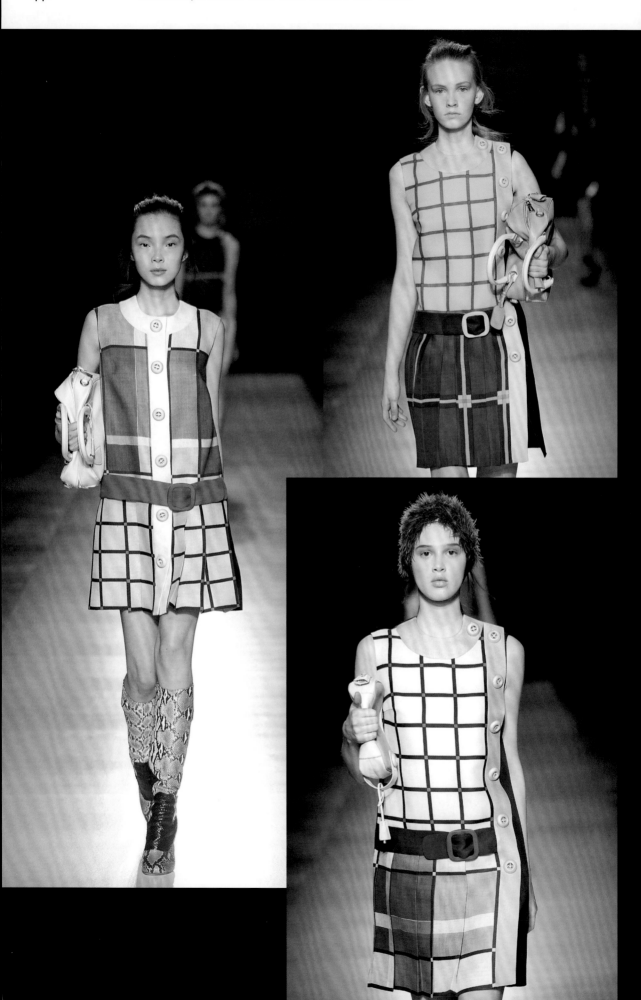

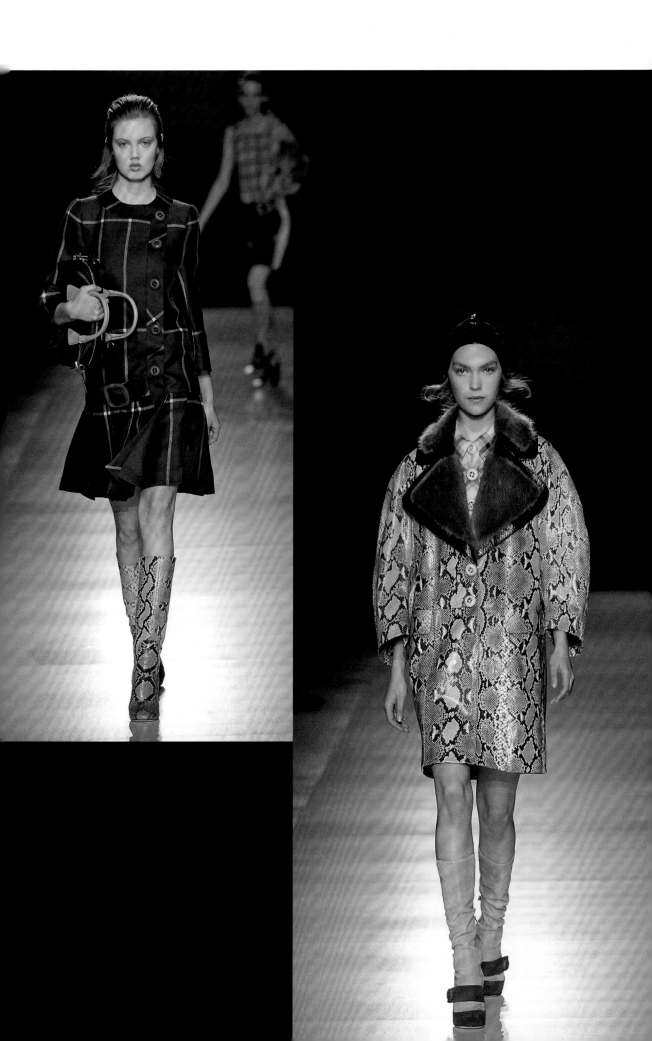

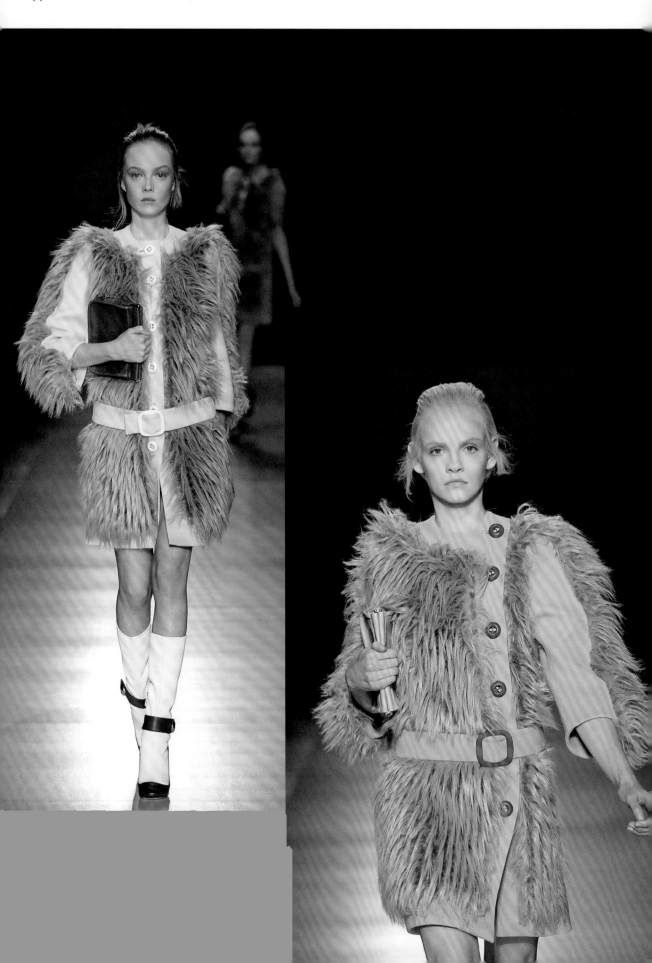

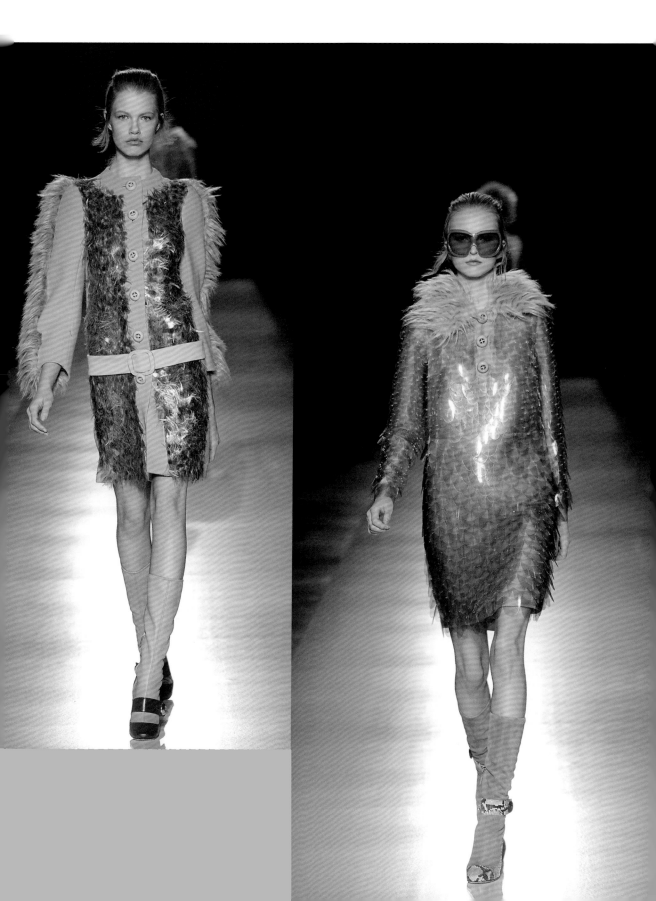

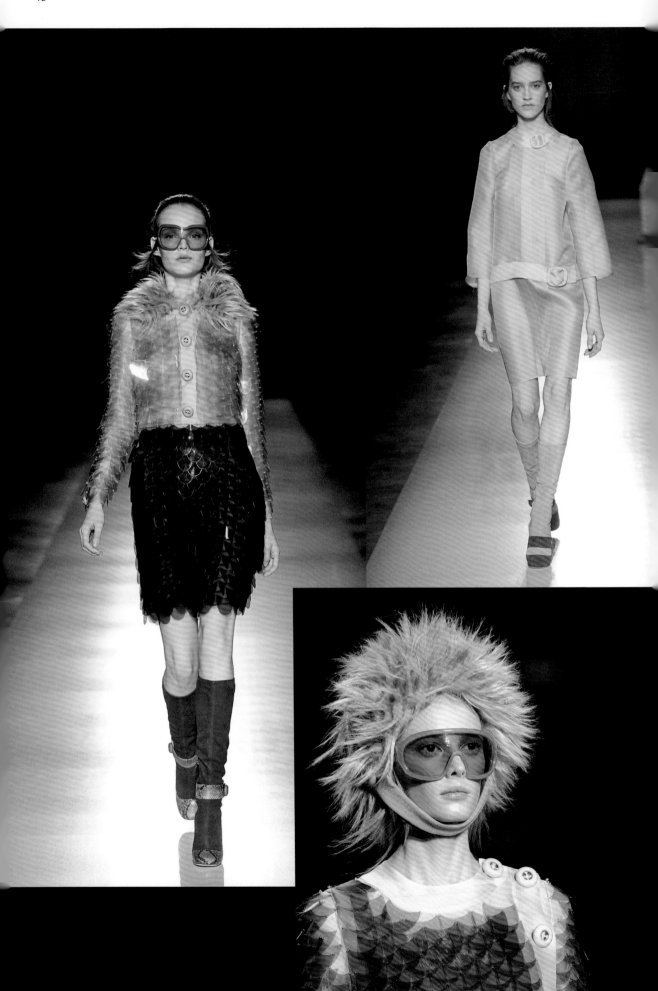

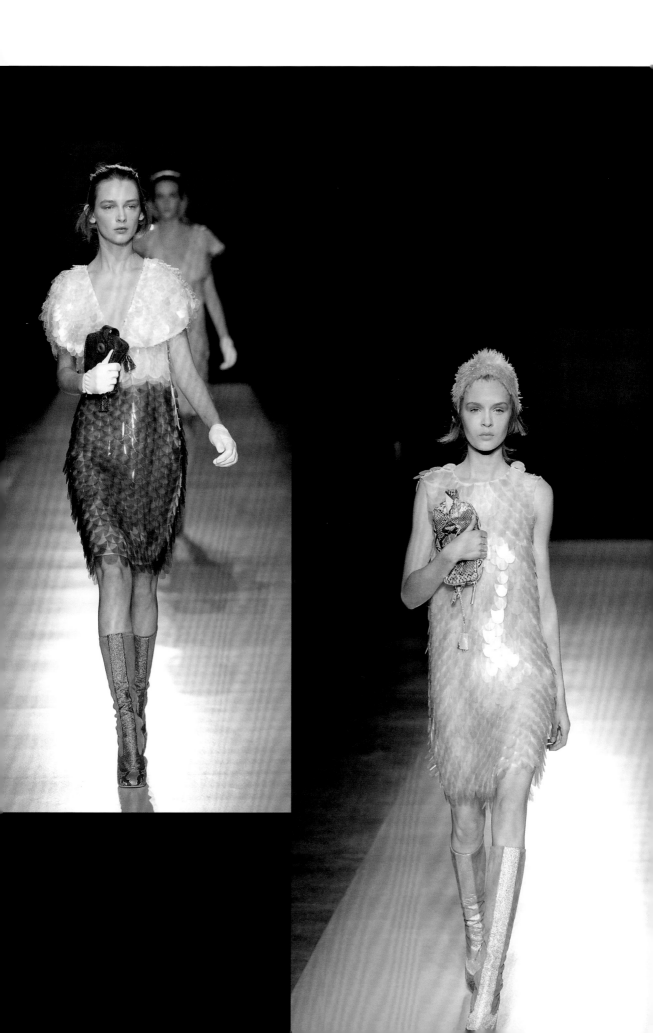

By this point, the anticipation building up to a Prada
show was so intense that those in attendance looked
for clues everywhere, from the canapés and cocktails
served as they entered the show space – which were
indeed often signifiers of things to come – to the set.
In this instance, a bank of Styrofoam sports cars gave
the game away.

The clothes were, predominantly, ultra-feminine,
and in a fondant bright colour palette that was
almost cloying: the feminine cliché often analysed
by this designer was more present than ever here.
Fifties-style circle skirts with elasticated waists,
pencil skirts, blouses and more looked all the prettier
for the models' doll-like make-up and softly curled
angel hair: for the first time, Prada also accessorized
the show with parures of faceted crystal jewelry in
boiled-sweet shades, with drop earrings and rose-
shaped necklaces. Miuccia Prada collects vintage
jewelry: these reflected that passion.

The effect of all this was certainly toughened by coats
that were more masculine, with a broad dropped
shoulder worthy of a mechanic's overalls. Even these,
though, were embellished with films of dense floral
lace, rhinestone embroideries, or prints of Fifties cars
– referred to by men, incidentally, by the feminine
pronoun: 'she'. Elsewhere, those cartoonish engine
prints leapt to real life on stiletto-heeled sandals with
miniature tail-lights, bursting into leather flames
from behind. Both hinted at the danger lurking just
beneath the surface of a woman who, at first glance,
was as pretty as the proverbial picture.

'We have a thing in Italy about women and cars,'
Prada told the *Independent*, and, if this collection
was anything to go by, she herself was no exception.
'Sweetness is a taboo in fashion,' she continued, 'and
I wanted to combine sweetness, which is possibly the
greatest feminine quality, with cars.' And that she did.

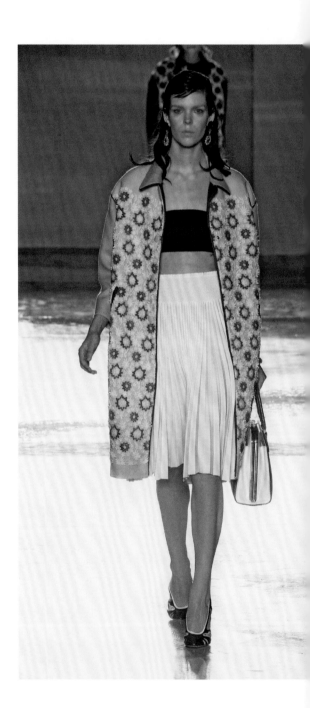

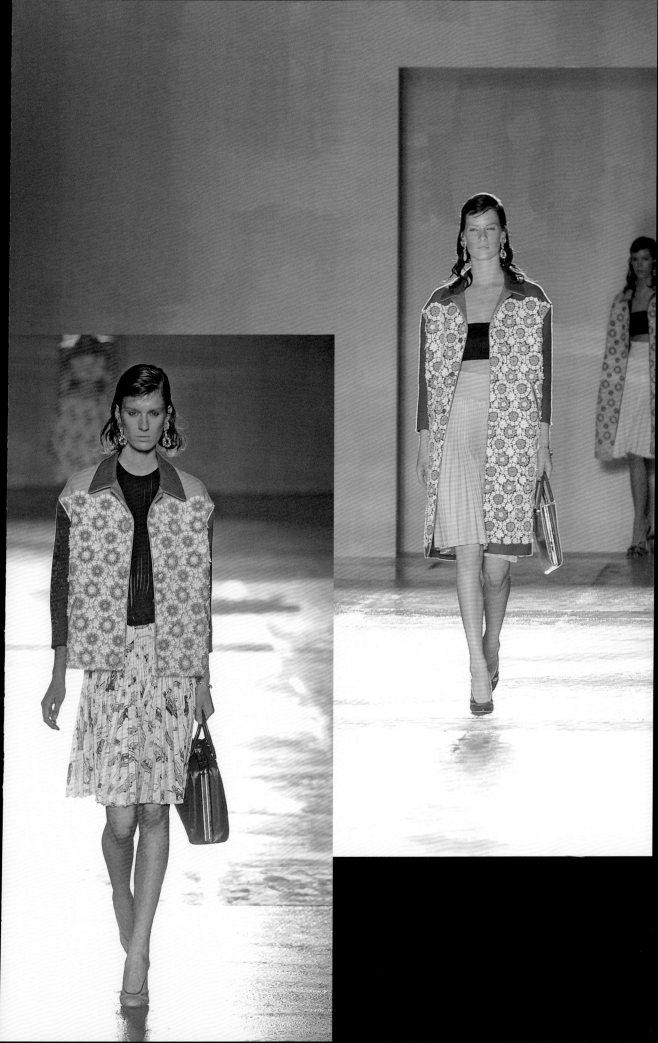

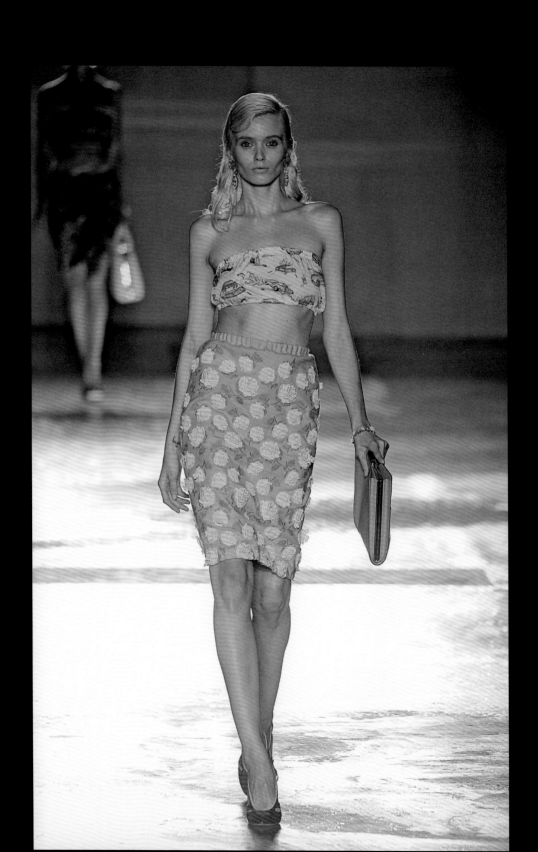

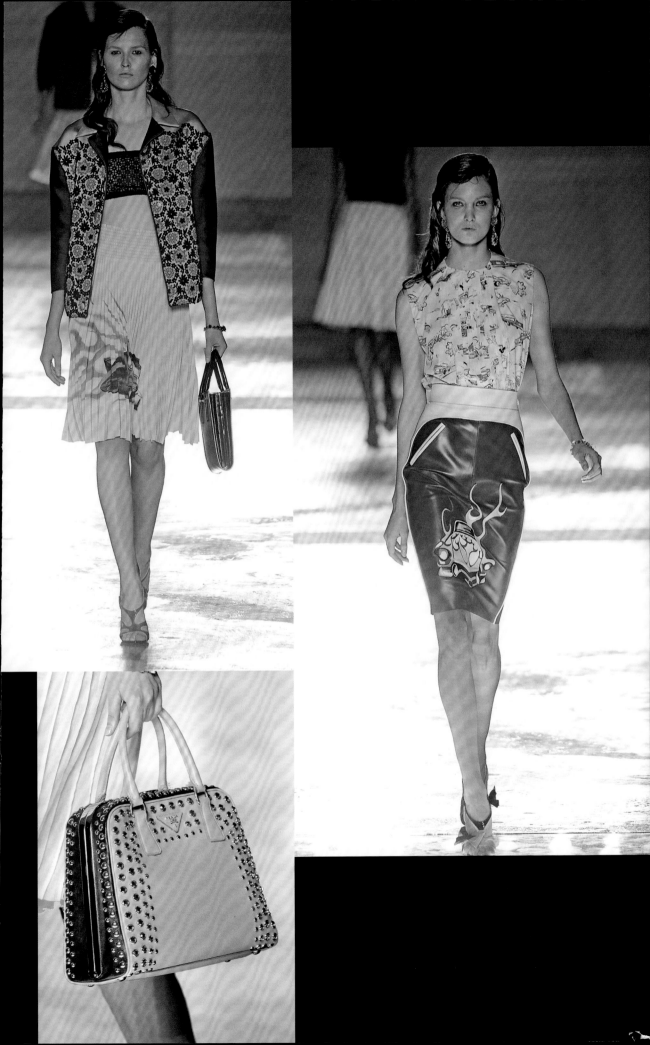

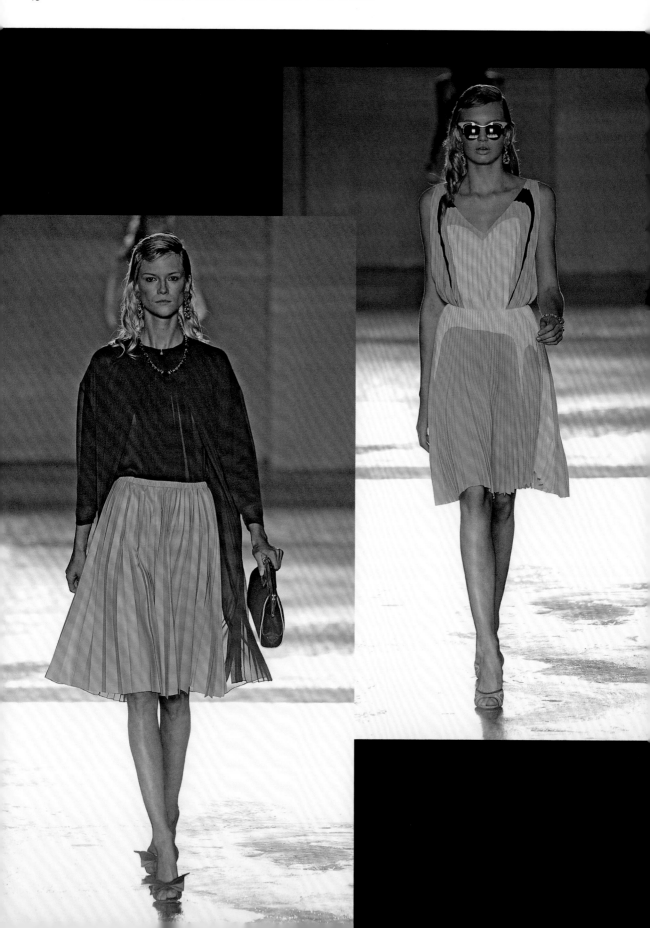

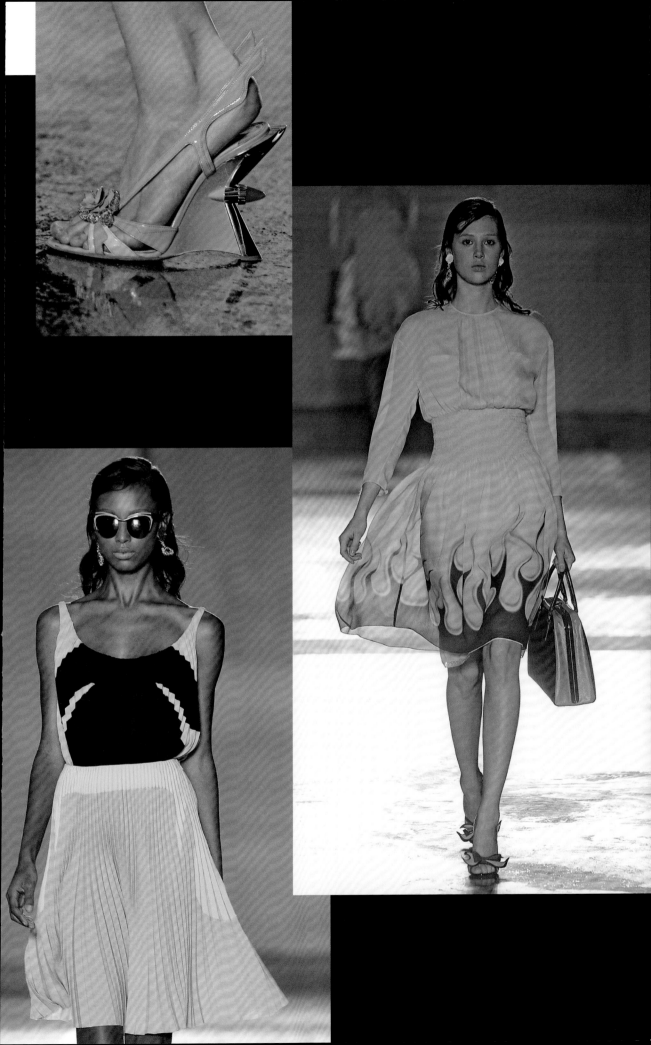

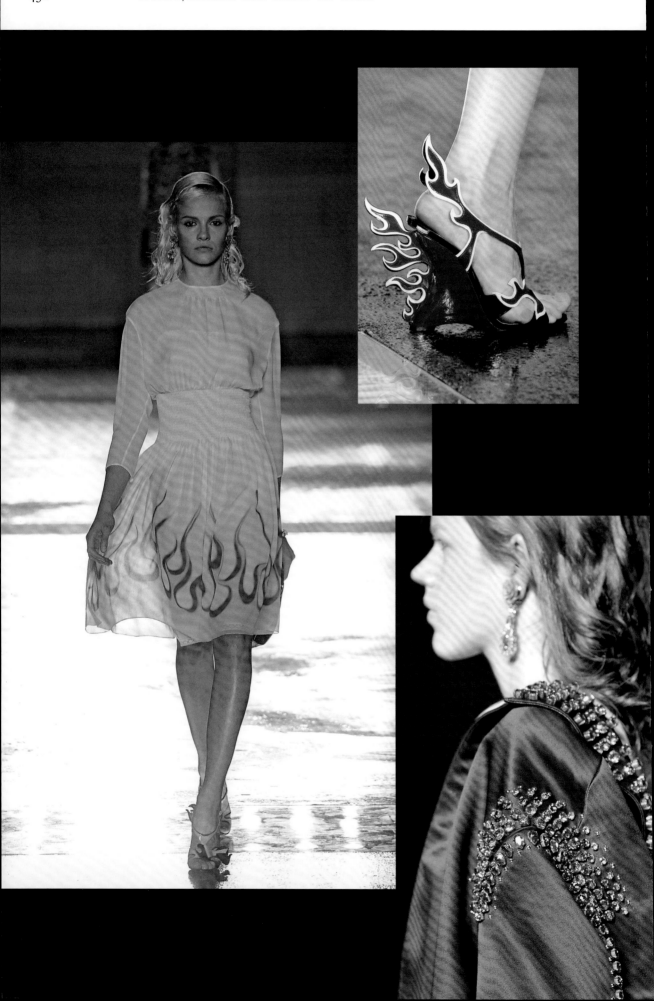

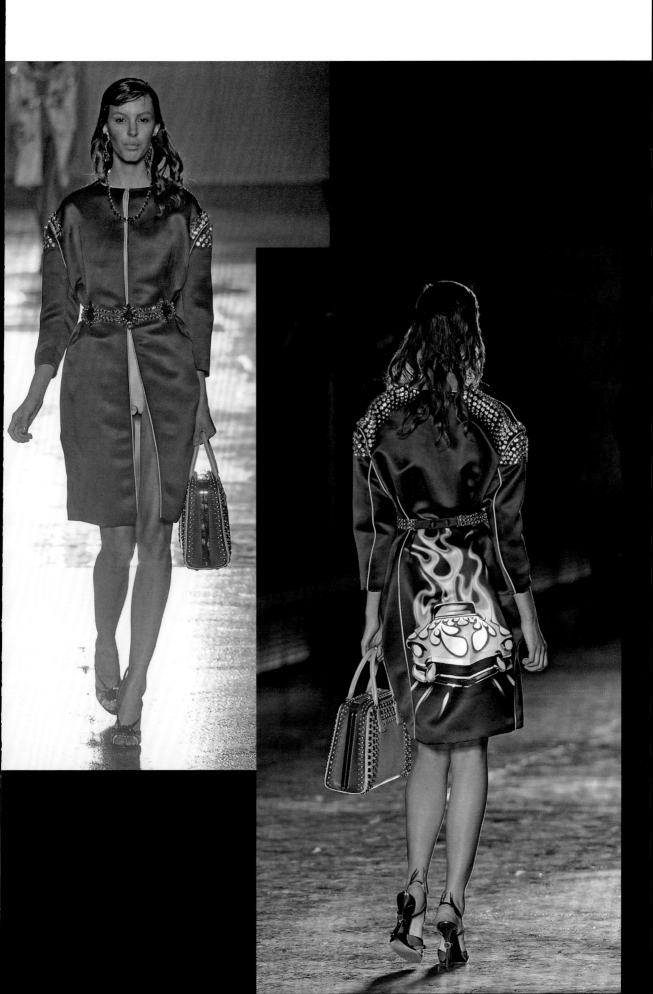

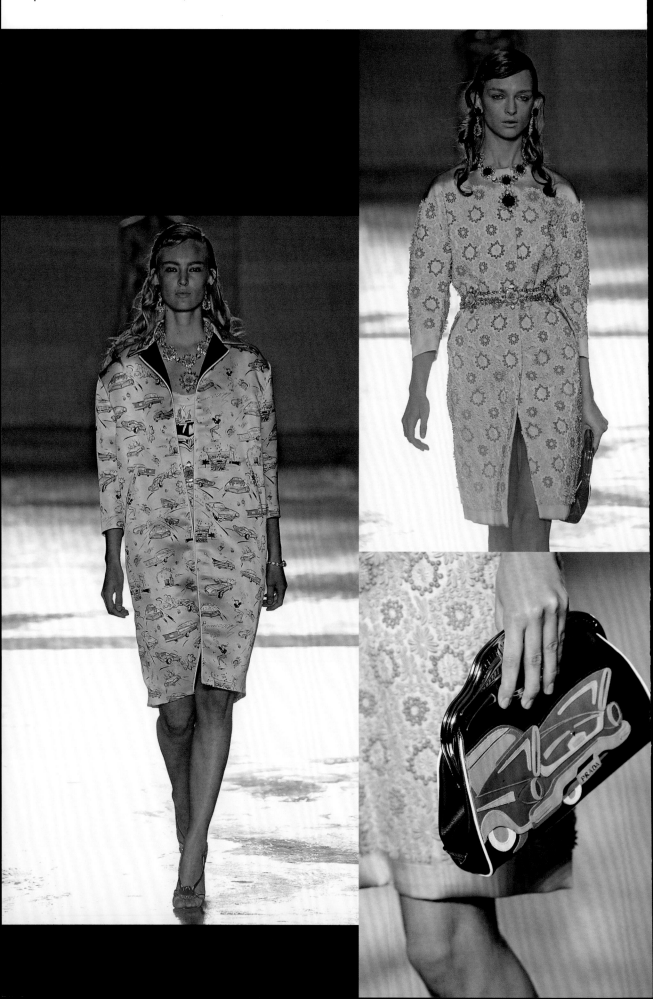

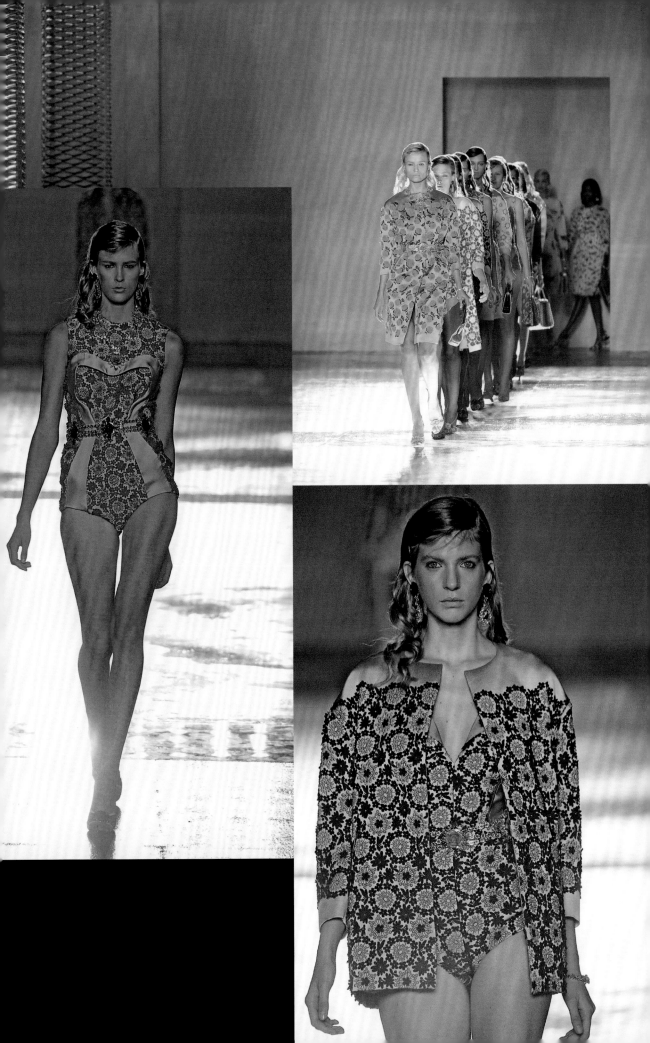

In May 2012, 'Schiaparelli and Prada: Impossible Conversations' opened at the Metropolitan Museum of Art in New York. The exhibition was named after Mexican artist Miguel Covarrubias' column 'Impossible Interviews' in *Vanity Fair* magazine in the 1930s. Of course, both fashion designers were born in Italy and were unusually culturally aware, facilitating artist collaborations and extending their creativity way beyond the fashion show arena. Above all, though, here were two inveterate risk-takers, constantly questioning broadly understood notions of beauty, and thereby changing the way women see themselves and express that through dress.

'At a luncheon preview on Friday for the Met exhibition,' wrote Cathy Horyn in the *New York Times* in February, 'the curator Andrew Bolton observed something quite true about Ms Prada. You have to be fairly sophisticated to grasp what she does each season, he said. And if you don't, you can feel a bit stupid. She challenges everyone, knowing or innocent. After her fall collection here [in Milan], on Thursday, reactions online confirmed that view, with comments on the order of "I wouldn't be caught dead in that."'

Again, this was to some extent a reprise of the mid-Nineties 'ugly chic' collections (see pp. 134, 144), which, we now know, evoked a similar response from at least some. There were echoes of these in the geometric prints and jacquards here. The sludge colours of that period were thrown aside, however, in favour of more conventionally lovely, saturated shades and fabrics lighter and easier on the body, as anyone who has actually worn the original incarnation, which was proudly acrylic and as stiff as a board, will be quick to testify. Also in line with the designer's pursuit of the appealing, jewelled embroideries edged elegantly elongated garments, lightening the proceedings still further.

It's hard to say whether critics' – as opposed to the aforementioned less immersed onlookers' – unanimously favourable reaction to the show was a result of their by now being more familiar with Prada's vocabulary. Suffice it to say that the models' appearances were formidable, for sure, but most of those in attendance would be more than happy to look as 'ugly' as they did.

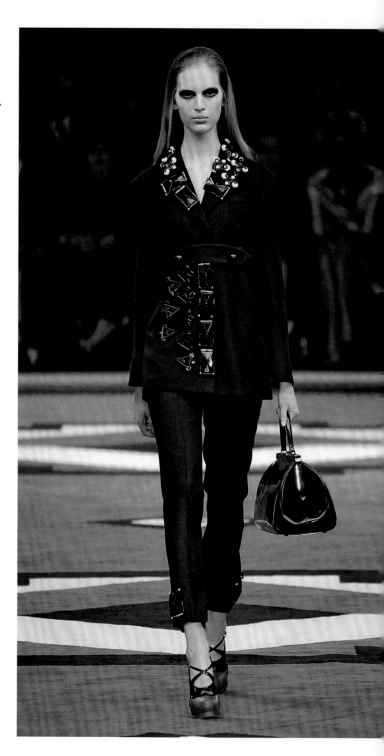

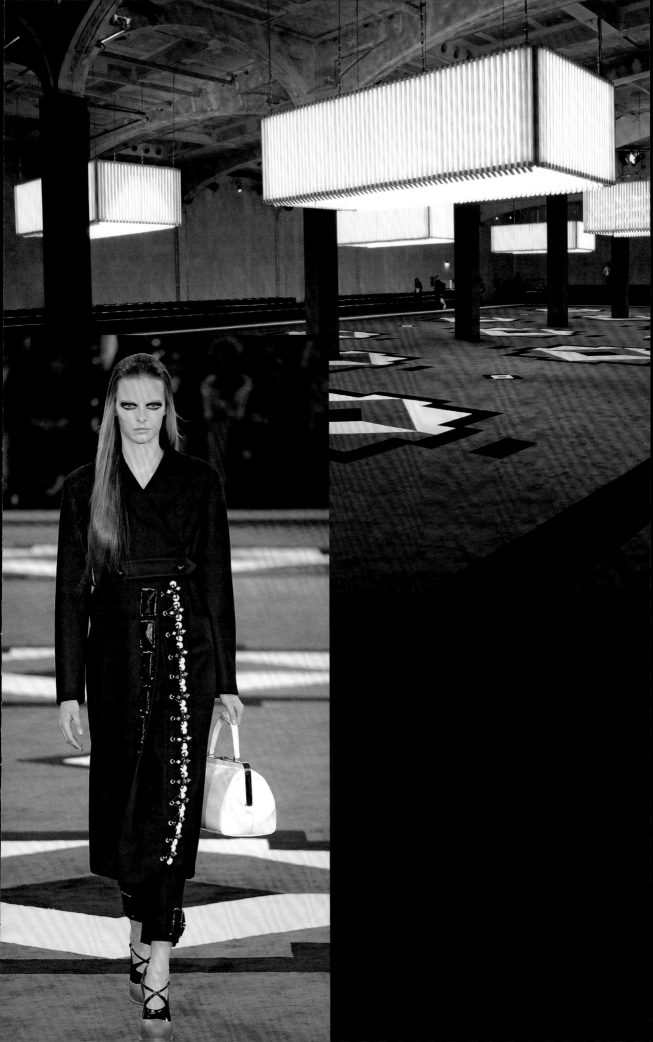

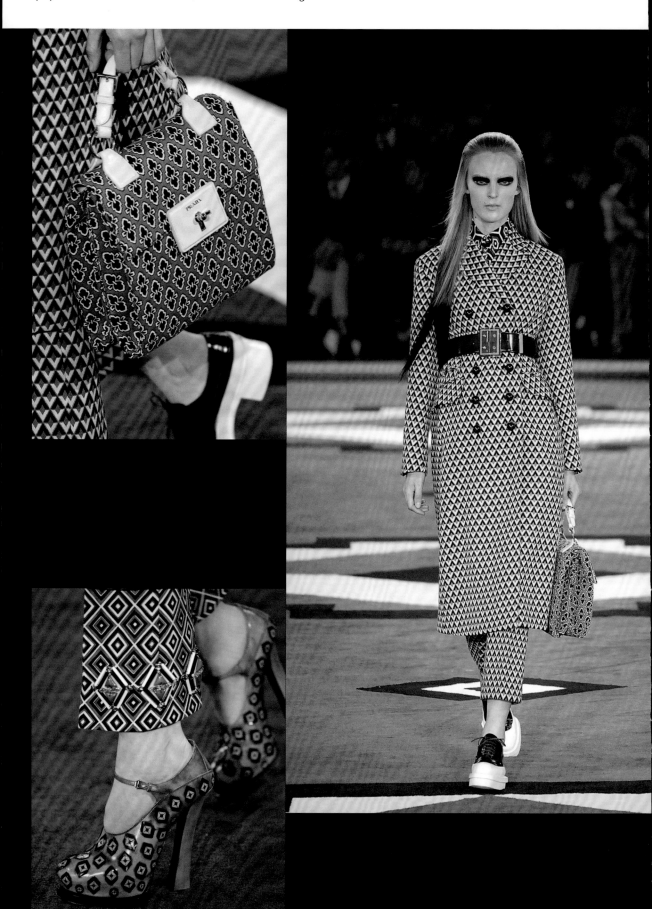

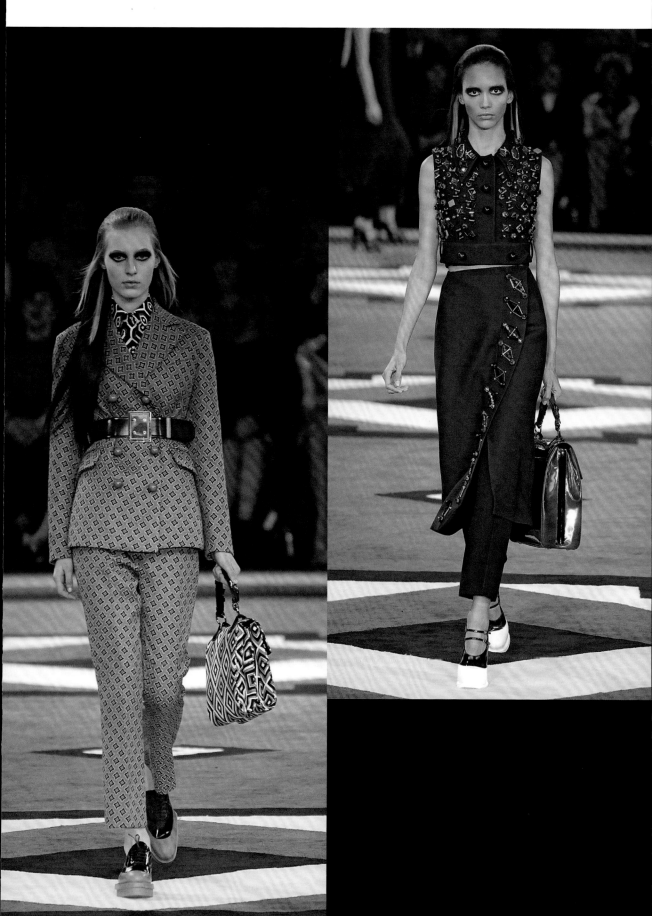

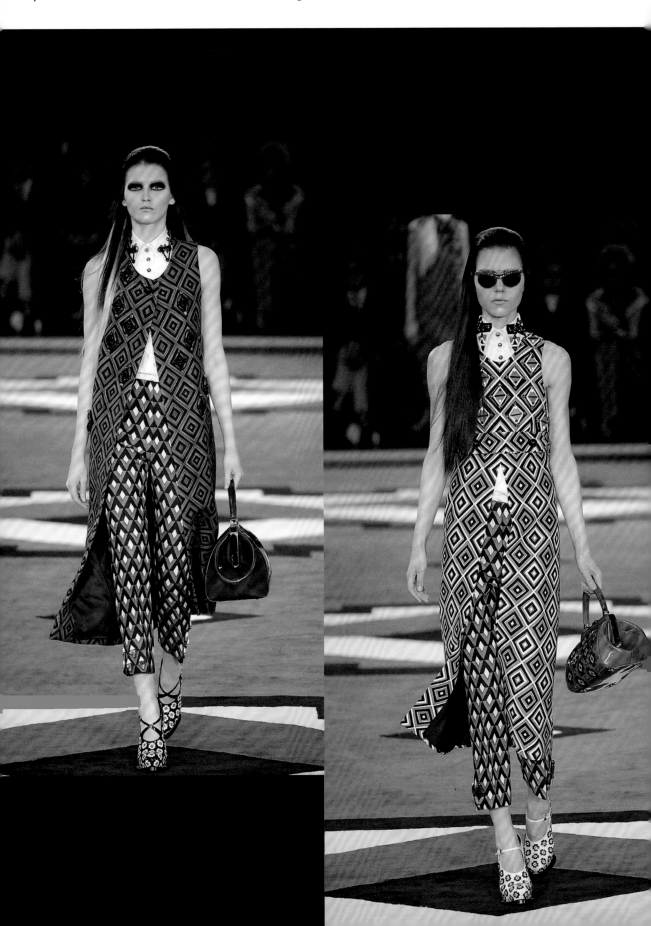

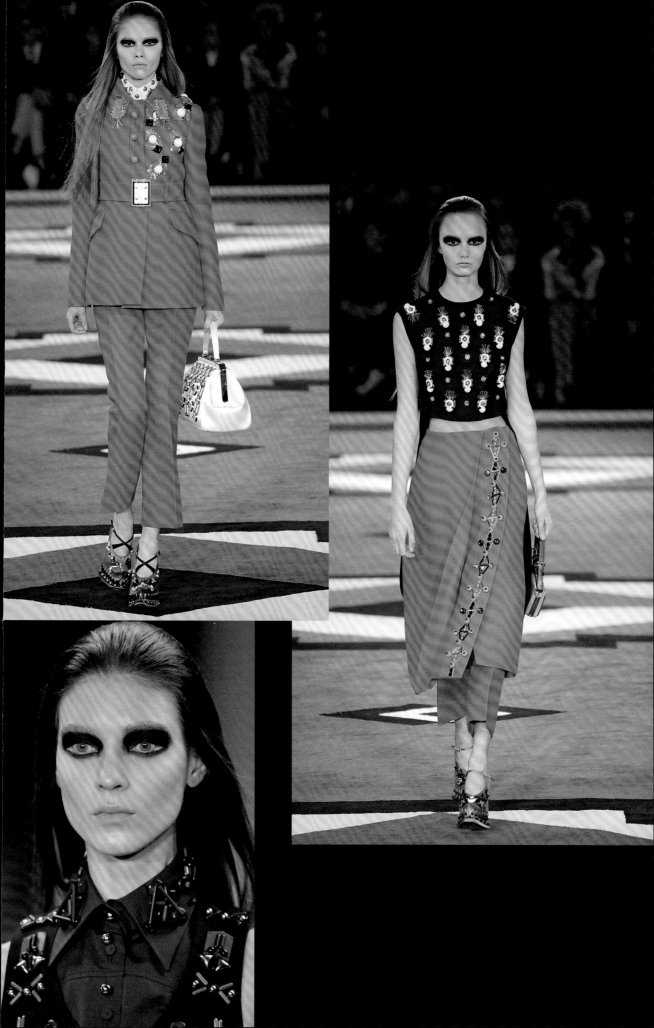

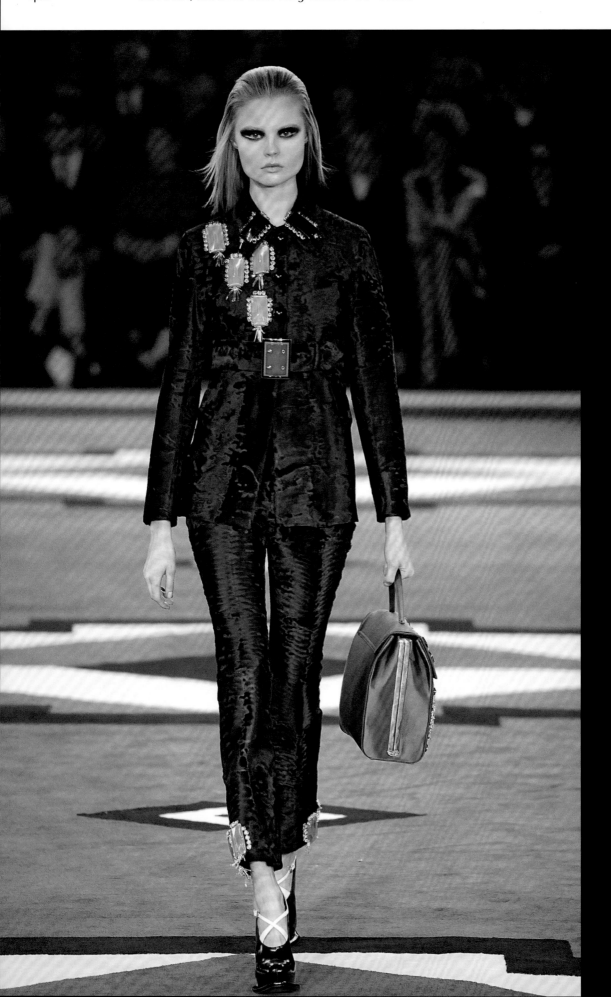

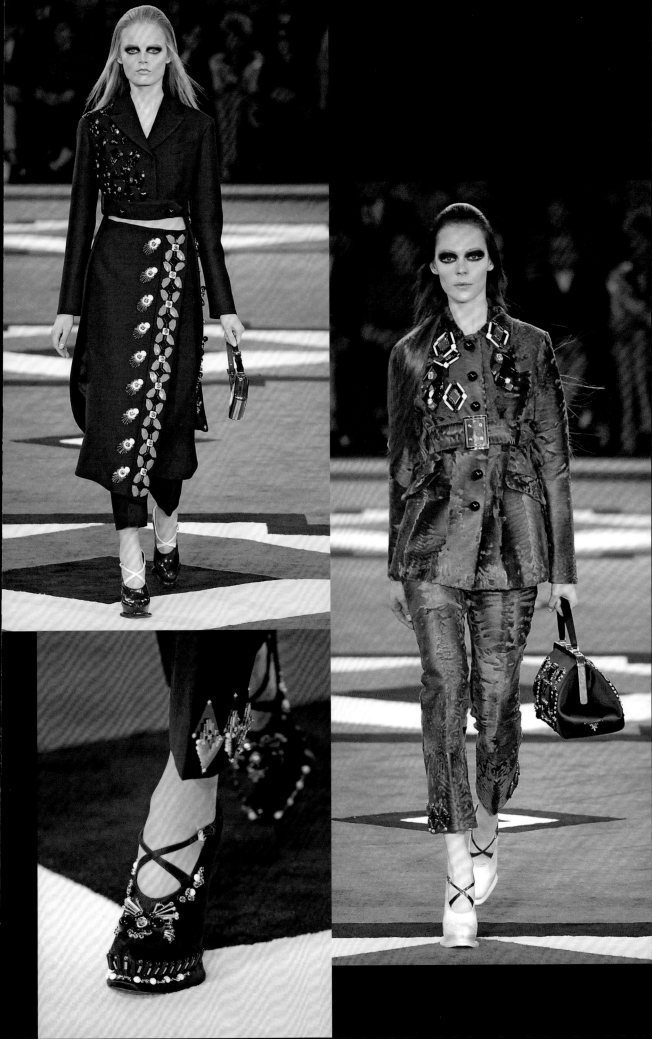

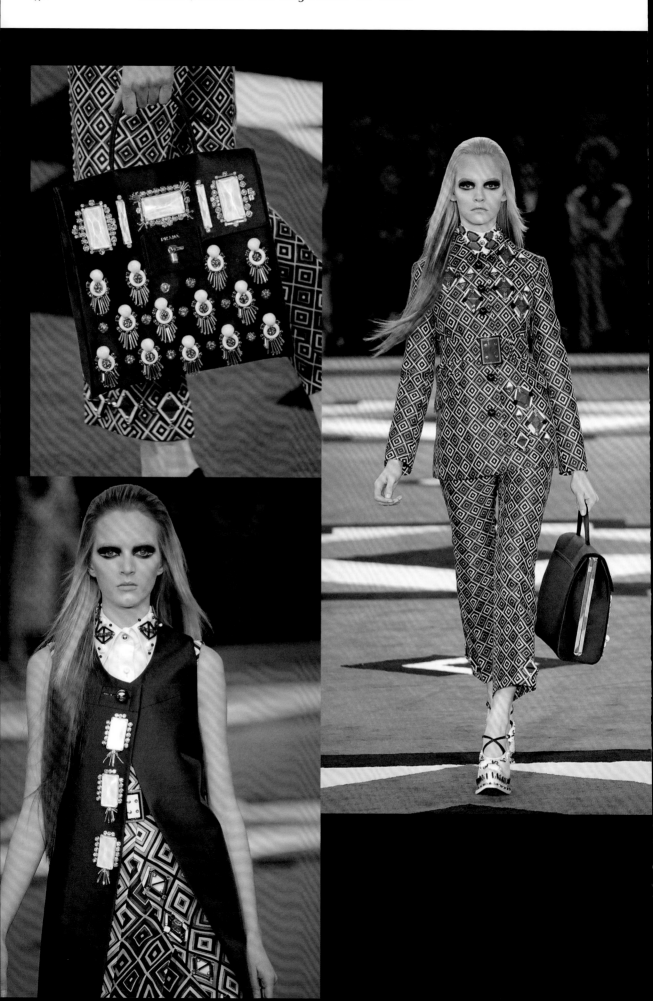

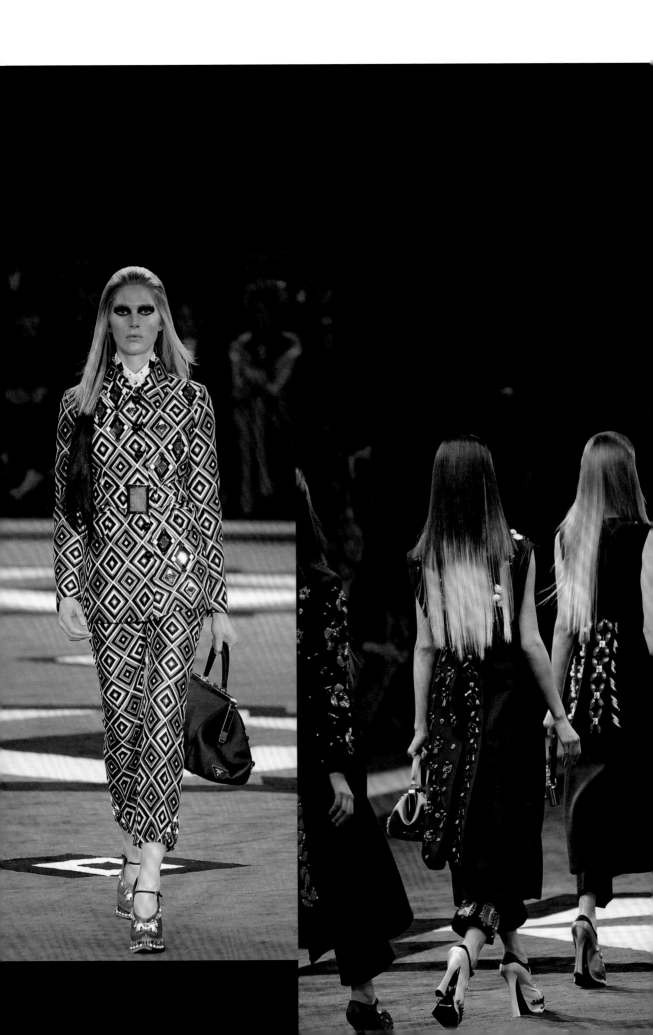

Following her Autumn/Winter 2005–2006 collection
(p. 326), Miuccia Prada had explained that the roses
included therein were a symptom of 'me opening up'.
They were 'brave', she said. Here, once again, she
expressed her feelings – and warmth – by working
with florals, this time stylized in the extreme, painted,
printed, embroidered and strategically placed across
the most streamlined of garments to graphic and
modern effect. And if anything, these looked bolder
still, and, again, a million miles away from her show
the previous season (p. 462).

The colour palette of garments emphasized the
rigour involved here: it was black, white, red, blush
and green throughout. Fabric, too, was restricted to
haute couture silks. Even the set – brutally modern
and monochrome – was as clean and clear in intent as
it is possible to imagine. Miuccia Prada is not the only
designer to work with self-imposed limitations to
such powerful effect. It is not often that she does so,
however, which only served to make the end result
more remarkable.

As far as silhouette and embellishment were
concerned, this was a clever fusion of Japanese
kimono dressing and ornamentation with the boxy
1960s line that this designer understands so well.

'Very sensual, deeply feminine,' Prada told the
International Herald Tribune backstage. 'It's about
feelings. There are two opposites – rectangular
shapes, with folds, very geometric; with the flower
as a symbol, of poetry, sentiment, community – those
things that are always struggles in the life of women.'

'The show played out to the mournful voice of
Megumi Satsu, singing in French in the early 1980s
about love and about suicide. The sound, like
Prada's vision, seemed like a hymn to deep feeling
and womanly grace,' Suzy Menkes, writing in that
same publication, concluded.

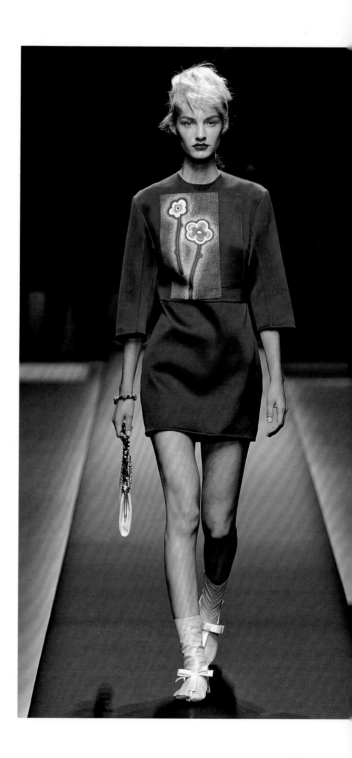

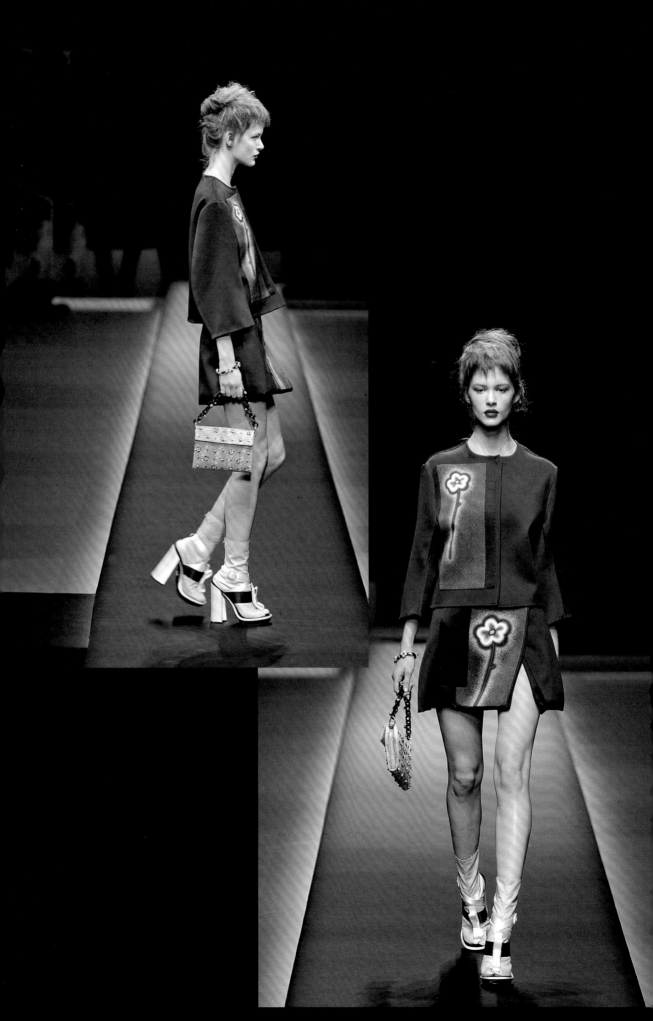

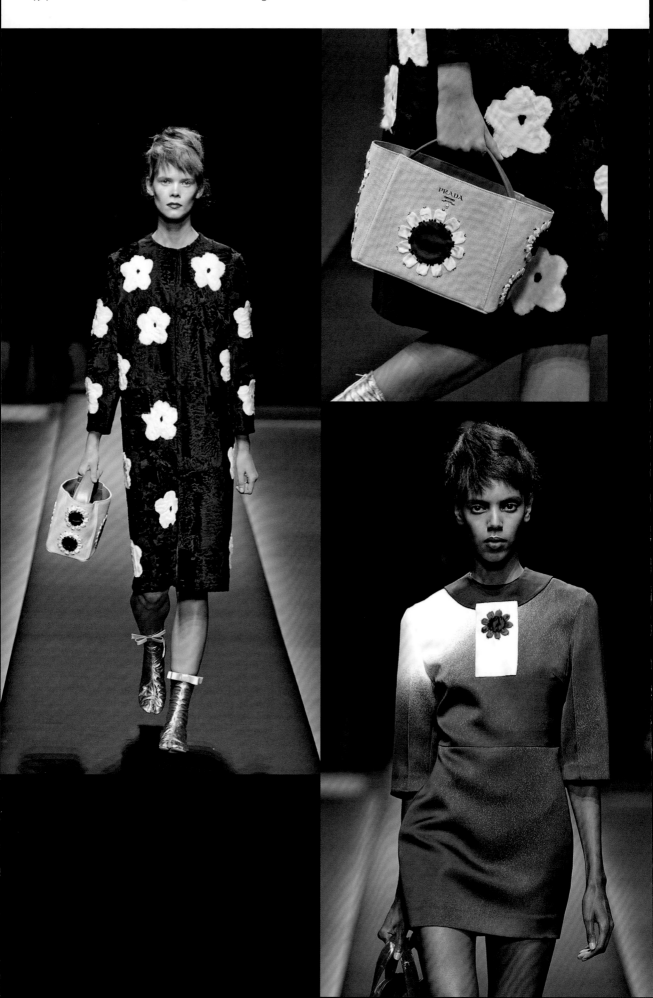

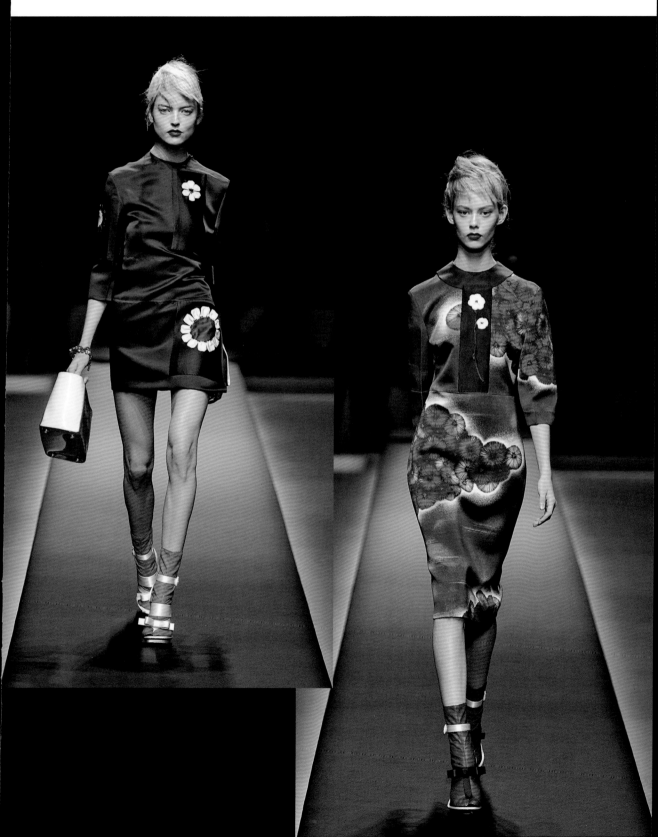

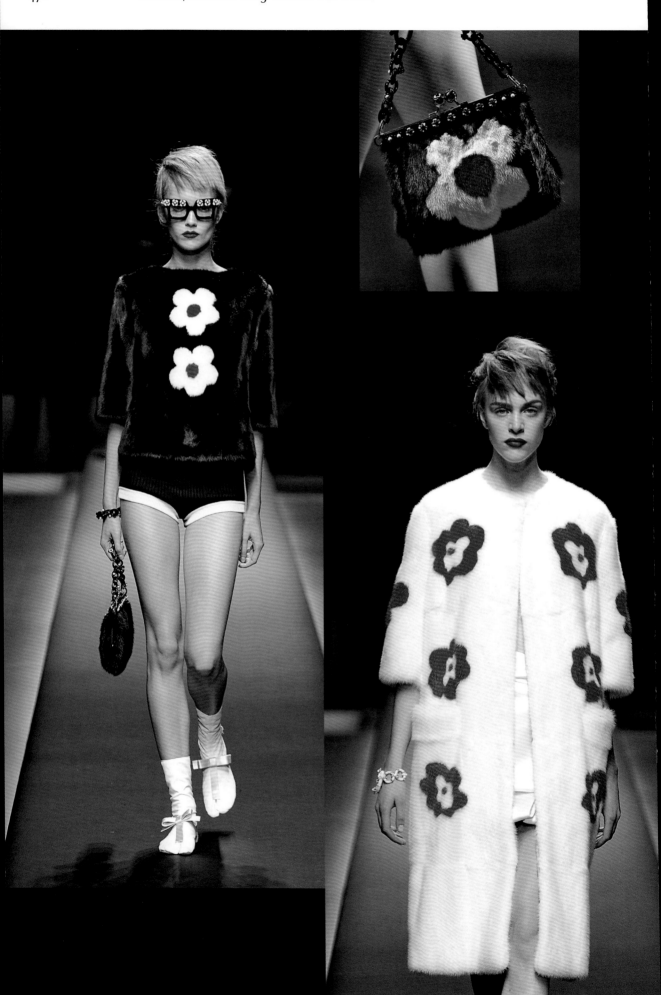

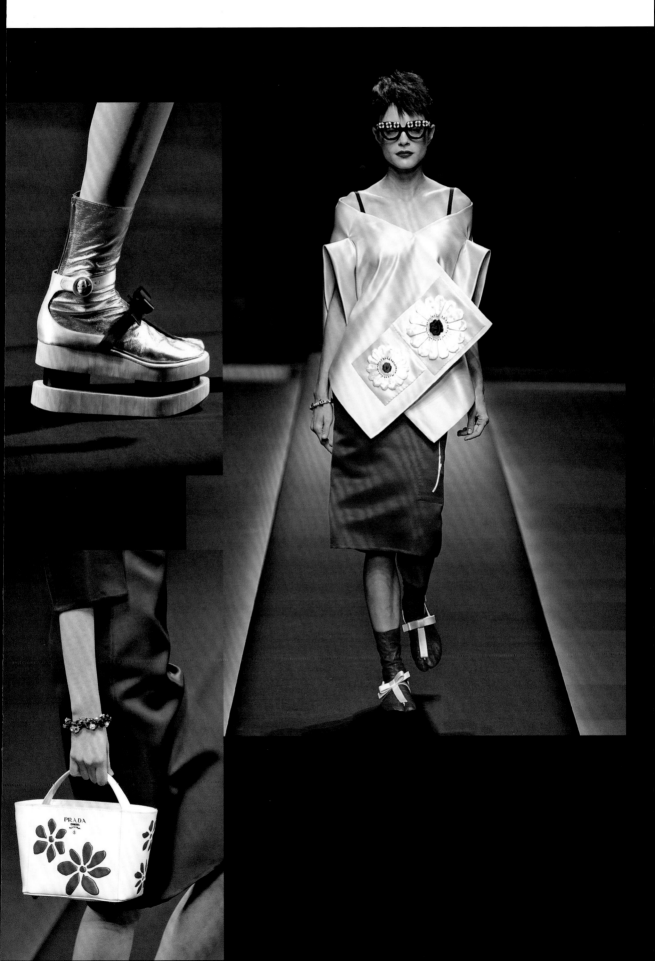

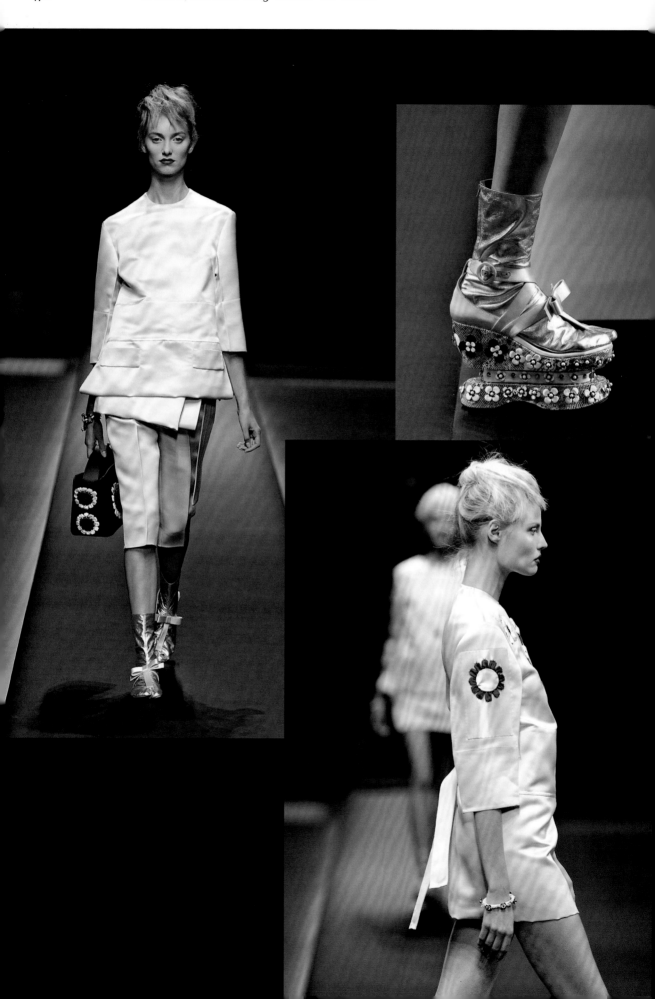

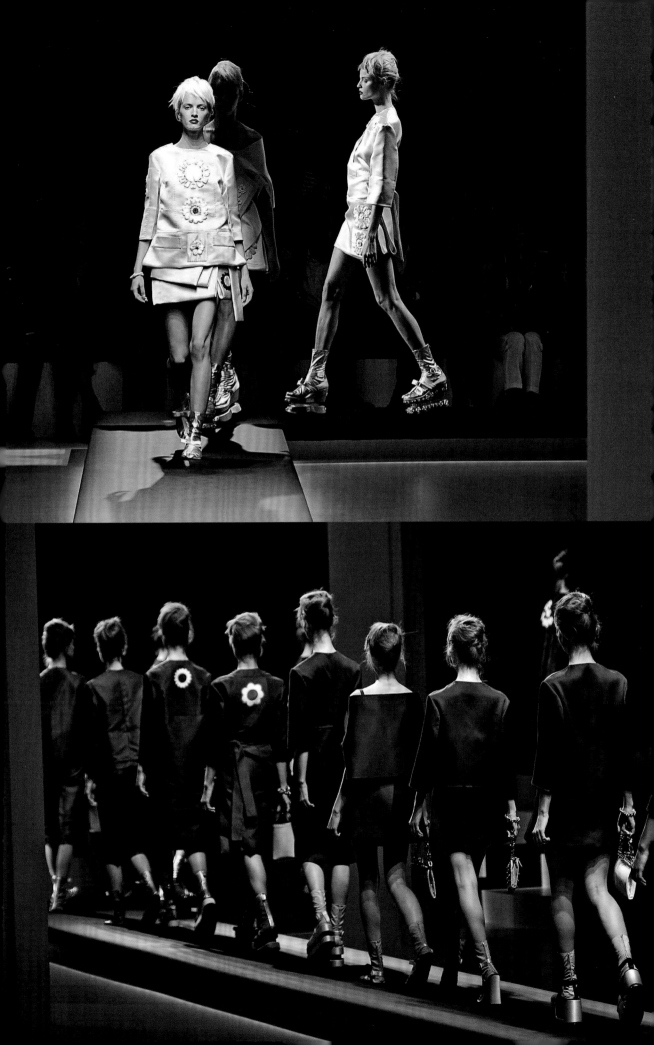

More perhaps than any other, this collection upheld
Miuccia Prada's passion for film and for the film noir
heroine. An actual film projecting images of swooping
flocks of birds, silhouettes of mid-twentieth-century
sirens and a black cat cemented that mindset and
paved the way for many more of the designer's
favourite things to come. Among these were the
fusion of fabrics rich and poor (opulent furs trimming
coarse wool tweeds, sequinned and embroidered
silks over grey ribbed knits included), rustic colours
and heavy sandals with uppers crafted in materials
as diverse as polished brown leather, tooled metallic
silver leather and gingham, worn with coordinating
classic Prada bowling bags. Even models, including
Kirsten Owen, Liisa Winkler and Esther de Jong,
former Prada stalwarts who had been absent for some
time, expressed the designer's emotional involvement
and a nostalgia for times past.

It was 'stories of women and life – who cares about
clothes?' the designer told Style.com, which, given
her profession, was quite a statement. 'Normal',
she added, 'was not the right thing to do. Through
cloth, you can really make movies. I'm obsessed
with impossibilities. Romanticism is forbidden.
It's not modern.'

As so often was the case, although this might have
been the prevailing mood, Prada proved it wrong.
This was a deeply romantic show, from the curvy
dresses falling off the shoulder to reveal the models'
delicate forms to their pretty red lips and tousled
wet-look hair. The line of the clothes travelled back
to the bourgeois 1950s: those dresses, duster coats in
gingham again or more narrow in crocodile, and full
circle skirts.

'It's a lot of things I really like,' Prada confirmed.
And judging by the rapturous ovation at the end of
this show it was a lot of things other people really
like, too.

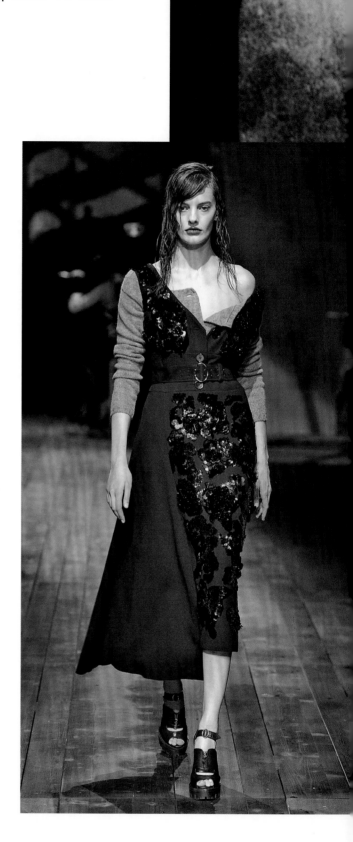

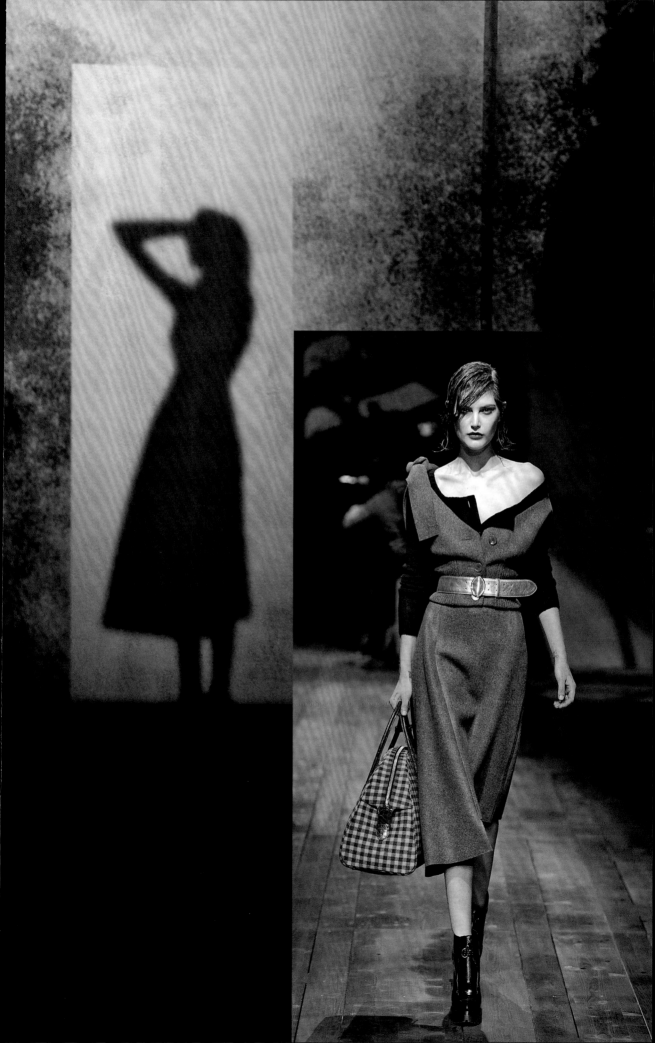

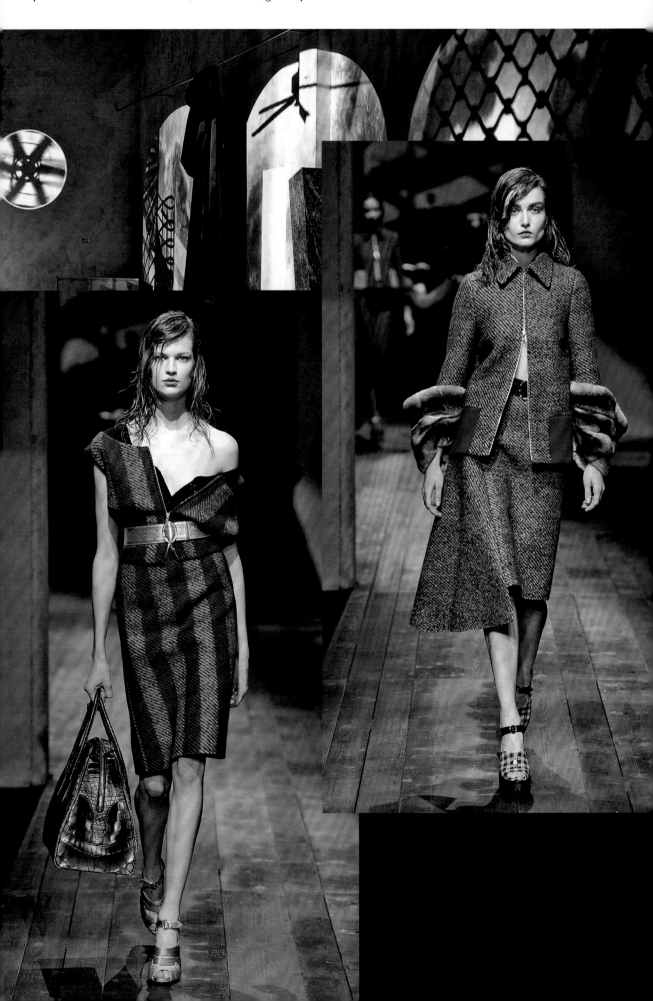

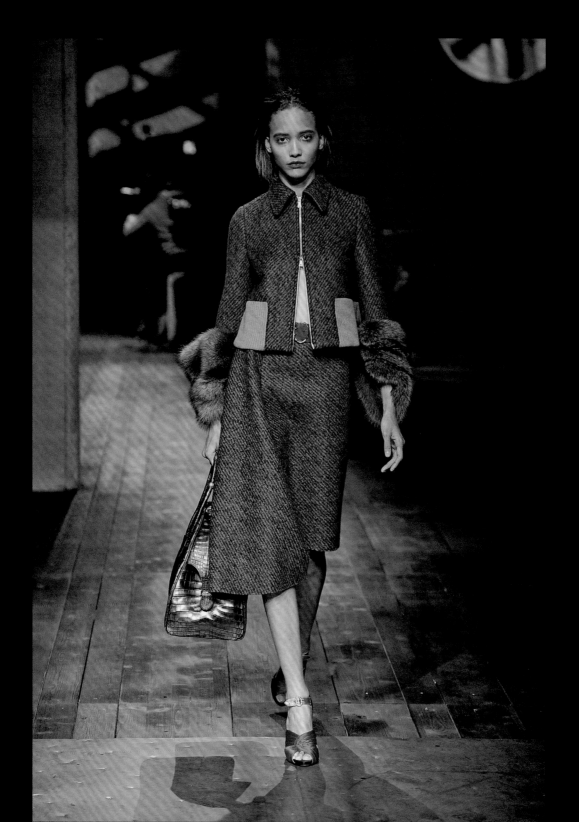

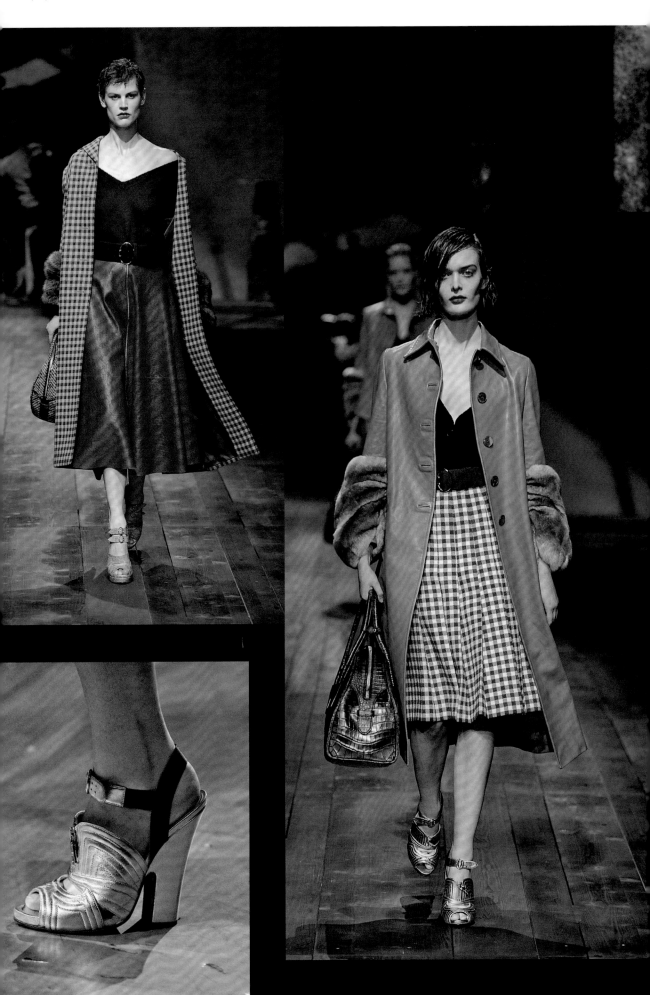

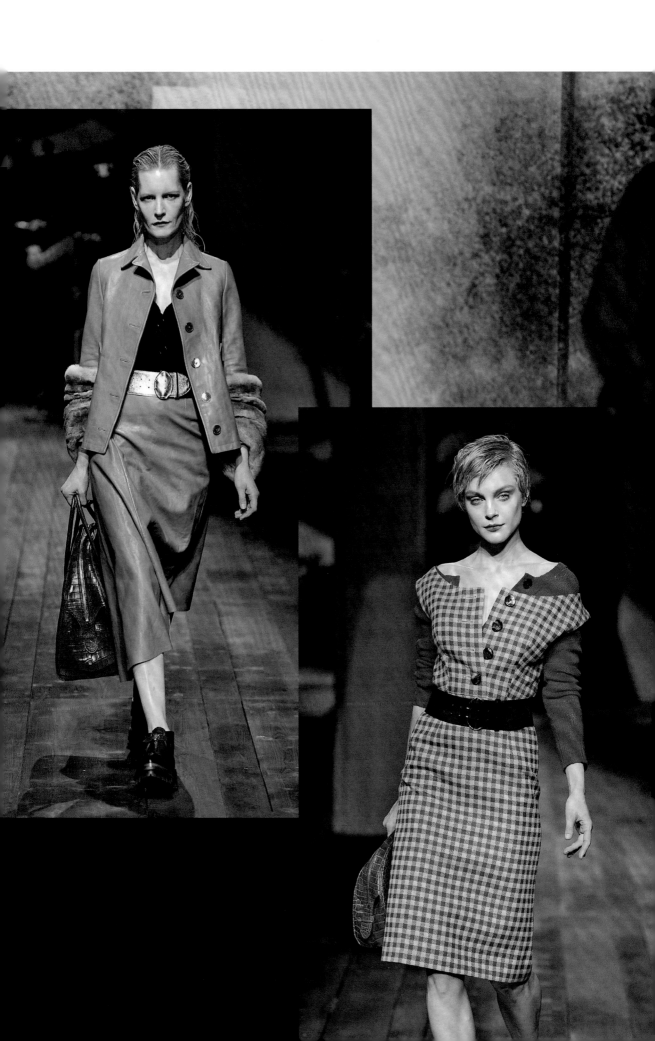

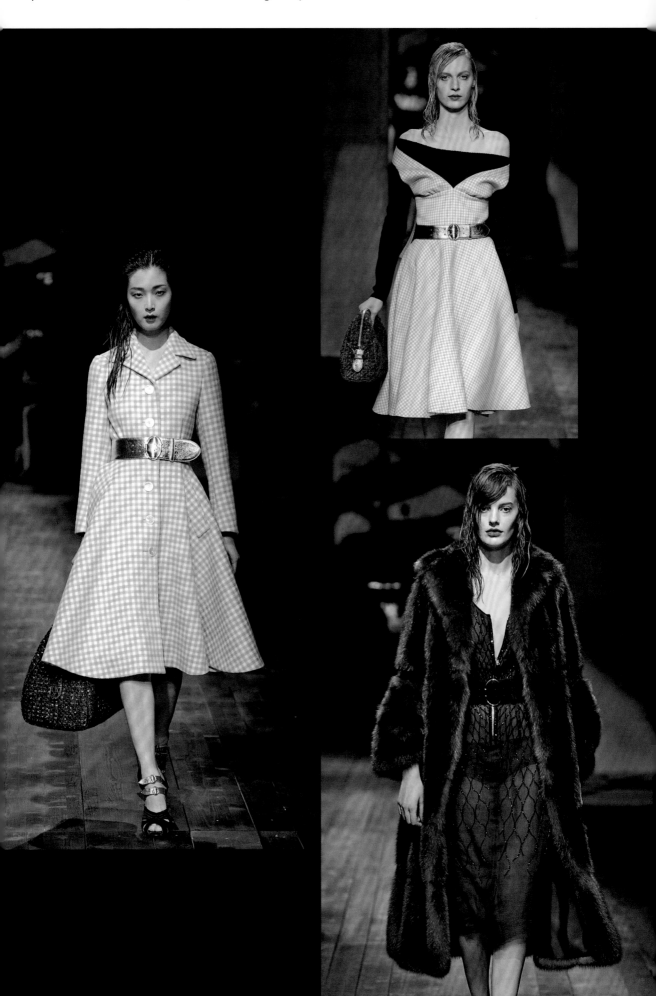

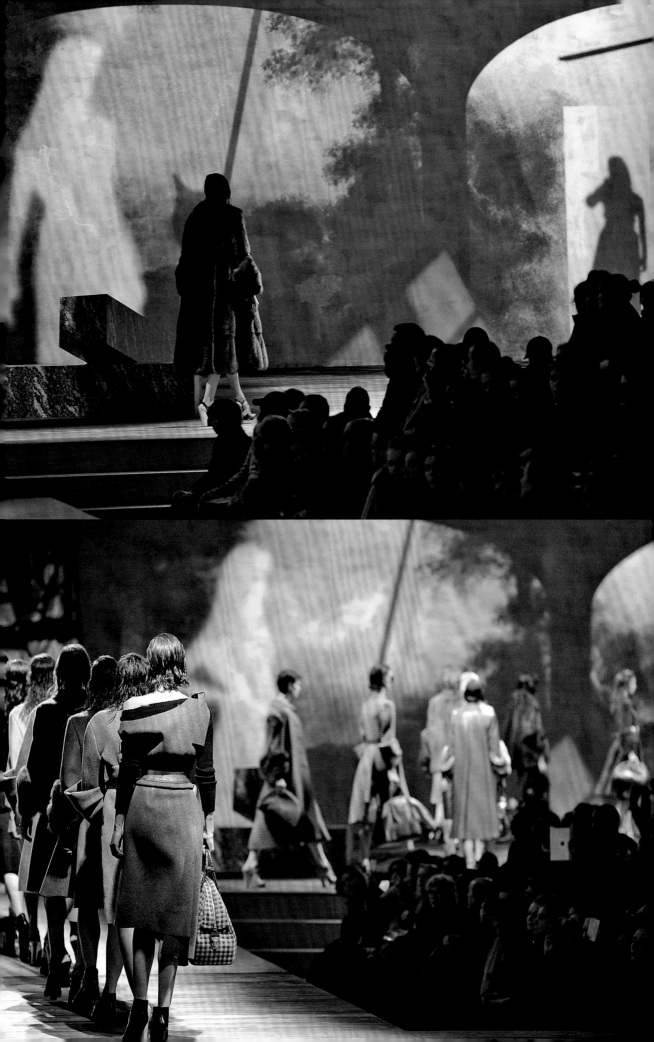

For Spring/Summer 2014, Miuccia Prada and
Rem Koolhaas's AMO studio invited muralists
Miles 'El Mac' MacGregor, Mesa, Gabriel Specter
and Stinkfish, and illustrators Jeanne Detallante
and Pierre Mornet, to create a backdrop around the
subjects of 'femininity, representation, power and
multiplicity' on the walls of the show space. These
artworks ranged in spirit from the tender to the stern
and from the naïvely cartoonish to the plain fierce.
As the accompanying catalogue put it: 'Each painting
depicts a different image of femininity. The women
on the walls represent the multiplicity of guises that
women assume in the course of a day, a lifetime.'

What did the designer herself do with this concept?
The clothes upheld the utilitarian uniform shapes
and colours with which she made her name in the
Nineties, now fused with sportswear detailing in
bright primaries: sleeves and necklines were edged
with striped rib-knit that matched the footless rugby
socks each model wore, the better to show off their
rubber splay-heeled sandals or cutaway trainers.

Knife-pleat schoolgirl skirts, shift dresses with
oversized patch pockets and neat little coats with cute
round buttons were also signature Prada, a fact only
emphasized by a colour palette of navy and khaki or
a typically strange mix of mustard and lilac, turquoise
and tangerine.

If the roots of all the above lie predominantly
in minimalism, the jewel-coloured paillettes that
made their way across surfaces undermined that.
The asymmetrically placed ornamentation that had
characterized Prada's work for some time featured,
and the artwork eventually migrated across clothing:
the designer took details from said murals and
printed and embroidered them onto wools, silks,
furs and even bags.

Finally, if ever there were any doubt that this was
a heartfelt celebration of femininity in all its guises,
it came in the form of bras – cut in contrasting
colours into the bodices of dresses or heavily
embellished and sparkling in the lights. These were
worn throughout over and not under the clothes.

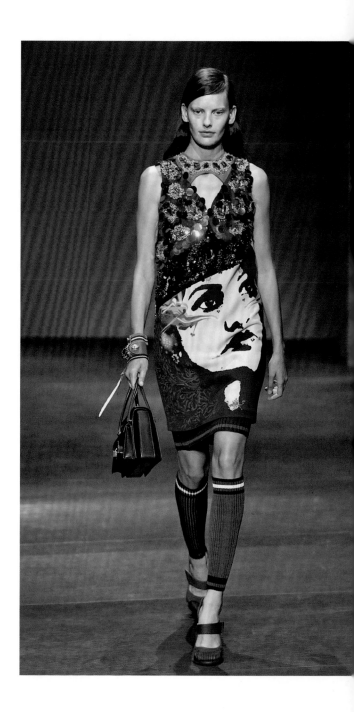

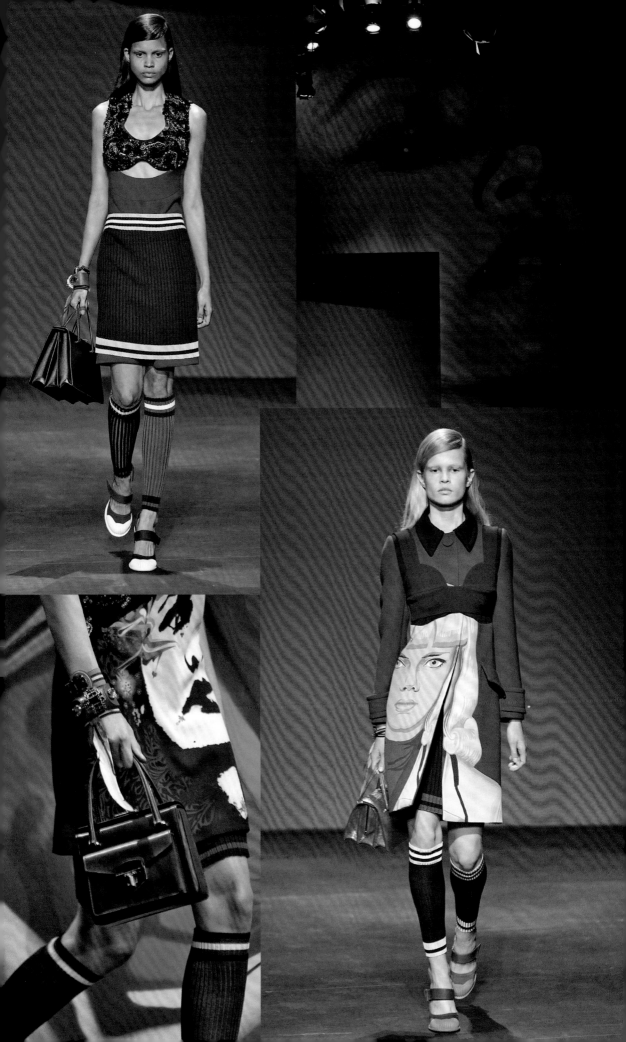

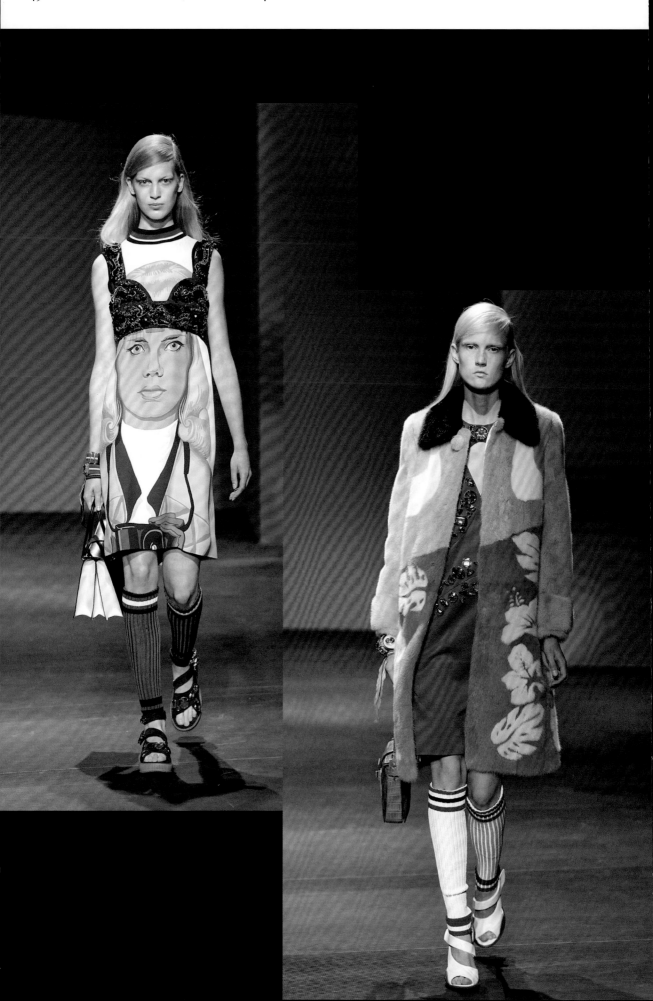

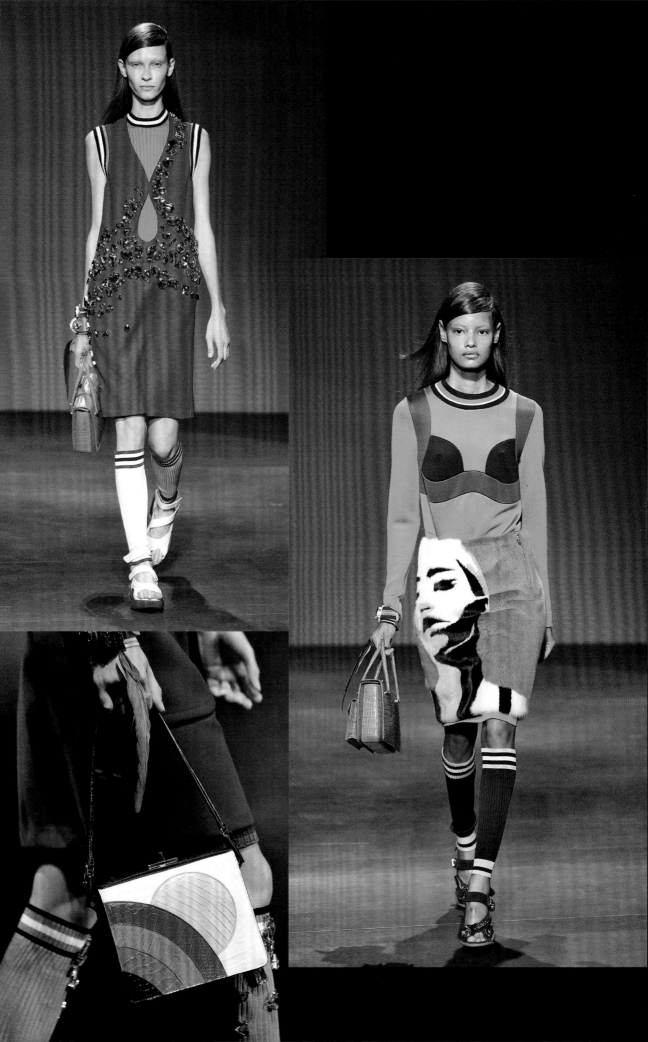

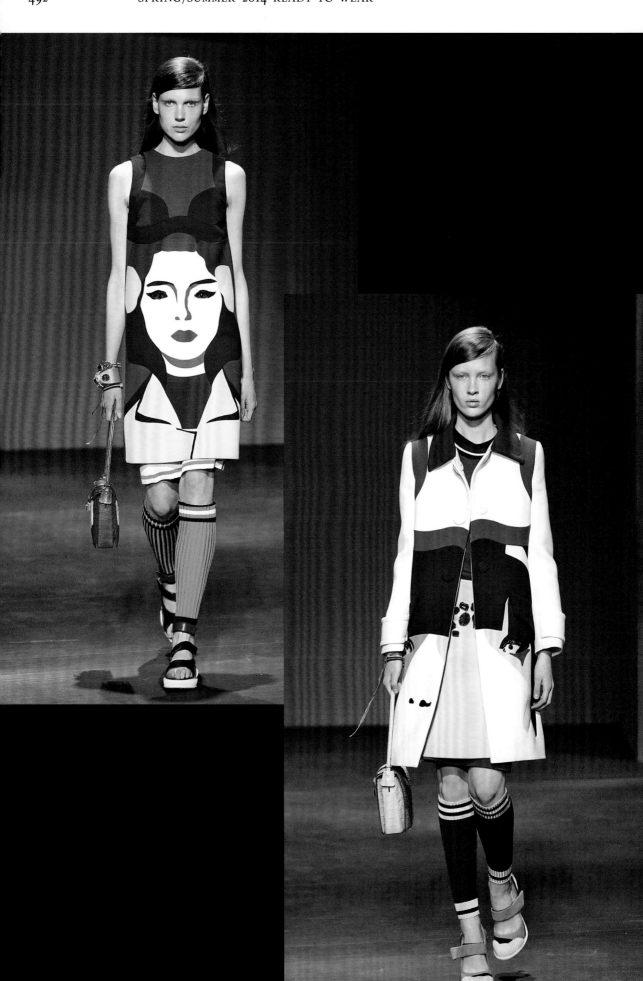

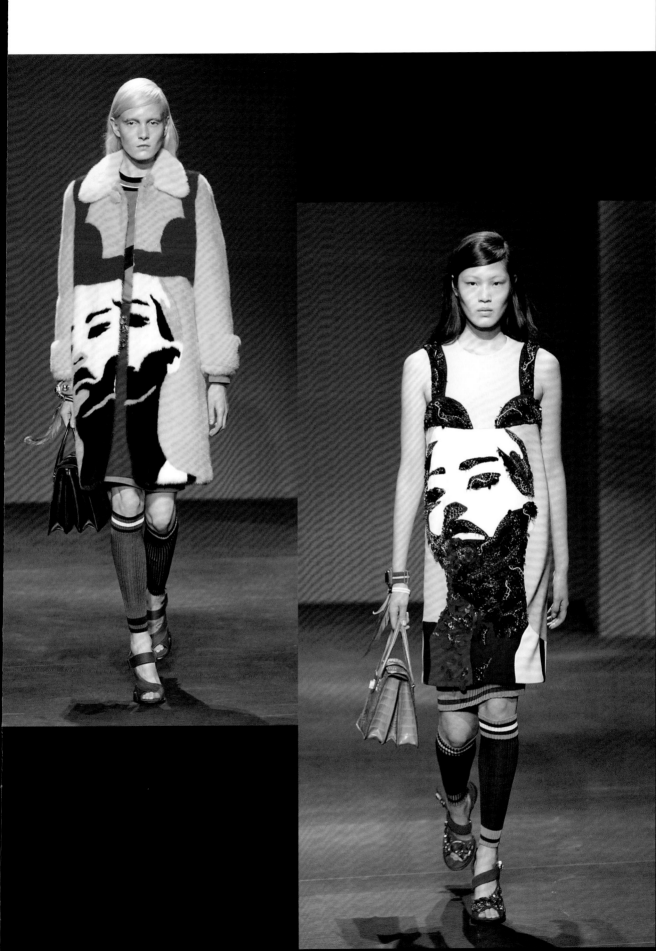

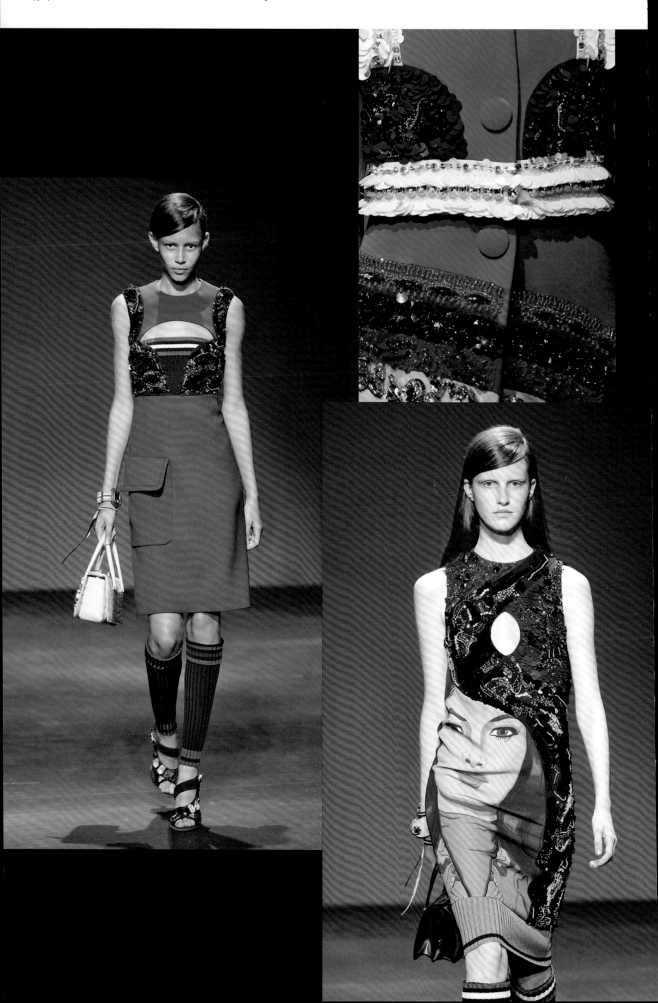

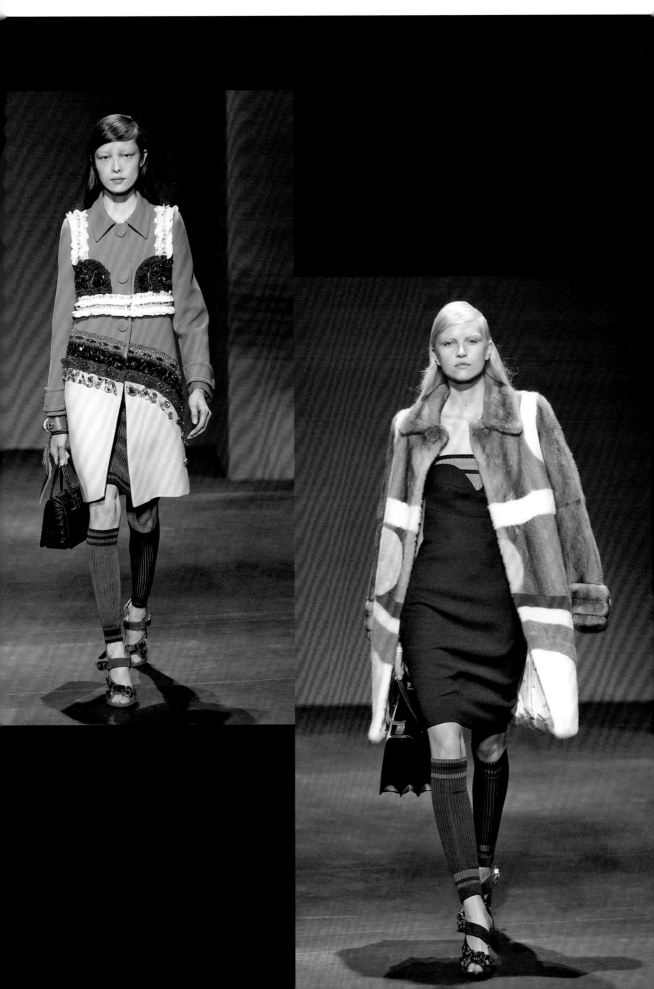

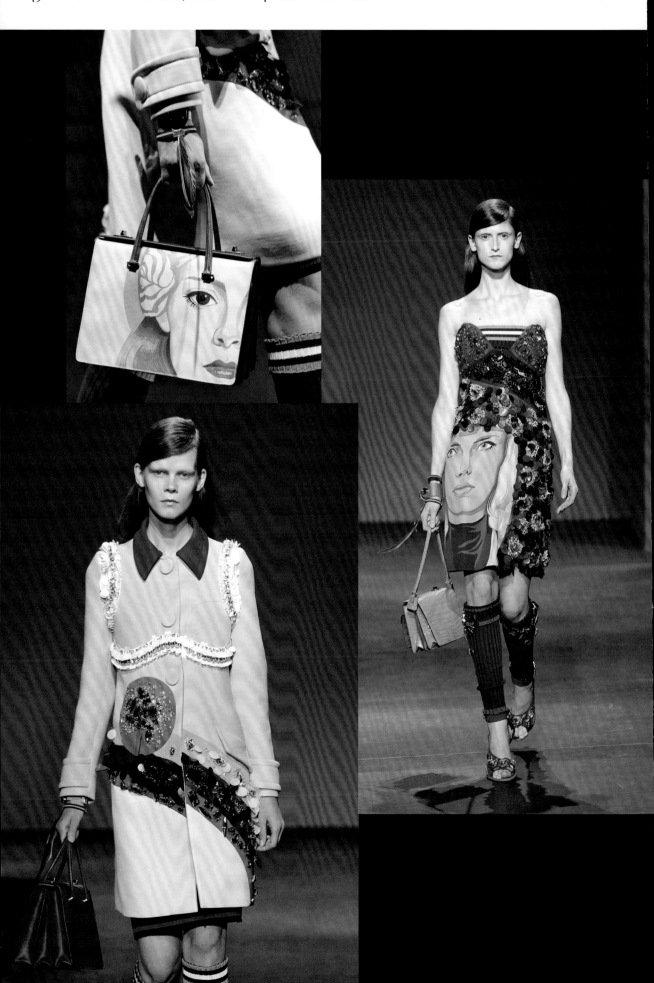

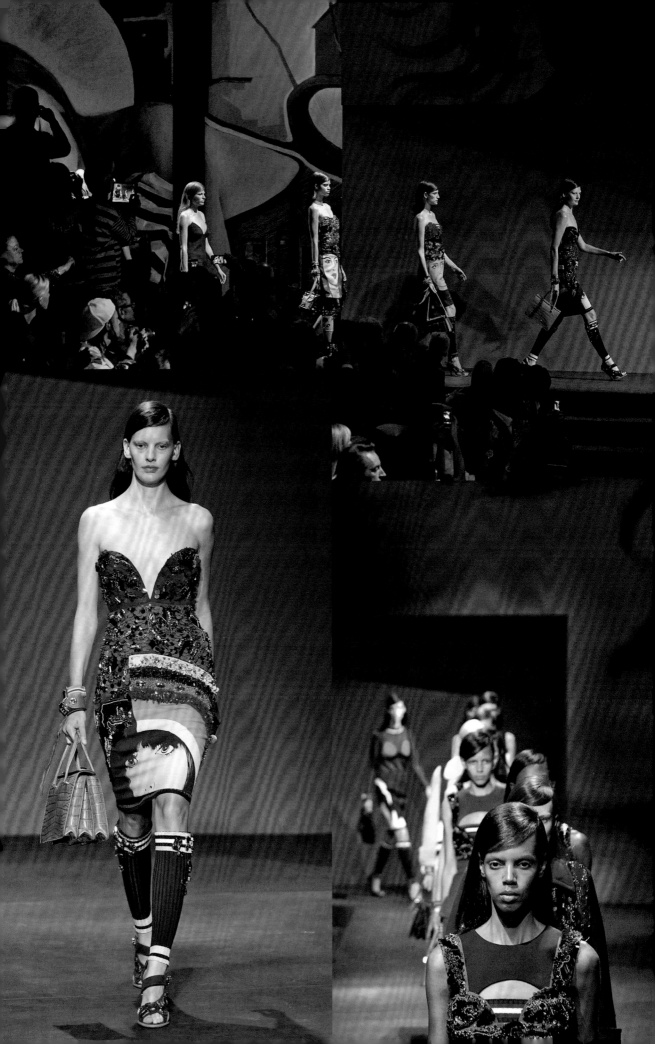

Miuccia Prada looked at German avant-garde culture for this collection. The soundtrack featured music by Kurt Weill, recorded and performed live by Barbara Sukowa, who played the eponymous chanteuse-prostitute in Rainer Werner Fassbinder's 1981 masterpiece, *Lola*. Her appearance wowed even the most hard-nosed fashion commentator, not to mention cementing Prada's stature as not only an immensely powerful fashion designer but also an impassioned arbiter of culture more broadly. Sukowa and the musicians accompanying her were positioned in a strategically placed pit. Models walked above them on an industrial grey concrete runway, punctuated by scaffolding.

The saturated colour and juxtaposition of tough outerwear with the type of seductive sheer shifts that a woman of Lola's profession might wear hinted loosely at that great director's work, as did the references to cross-dressing: a broad-shouldered blazer or double-breasted coat especially distinctive for strips of shearling outlining pockets and seams, a slender silk scarf that might double up as a necktie. There were shades of constructivism to the prints that were also vaguely reminiscent of Prada's own graphic designs.

'I really went bold,' the designer told *Women's Wear Daily*, and that was certainly the case. 'It's about humanity, it's about people's feelings, emotion. I wanted to transmit that kind of humanity and that kind of thinking.'

Perhaps the most significant thing about this show, though, was the apparently effortless mix of high concept with clever, covetable clothing: oversized V-neck knits with and without sleeves came in red, brown, grey and mustard and with broad chevron stripes in a contrasting hue; leather car coats and more in silk jacquards and wool were trimmed and lined in more shearling dyed in bright shades. High ankle-strapped wedge-heeled sandals echoed the mechanical mood of the set; bags were flat, tucked elegantly under the arm.

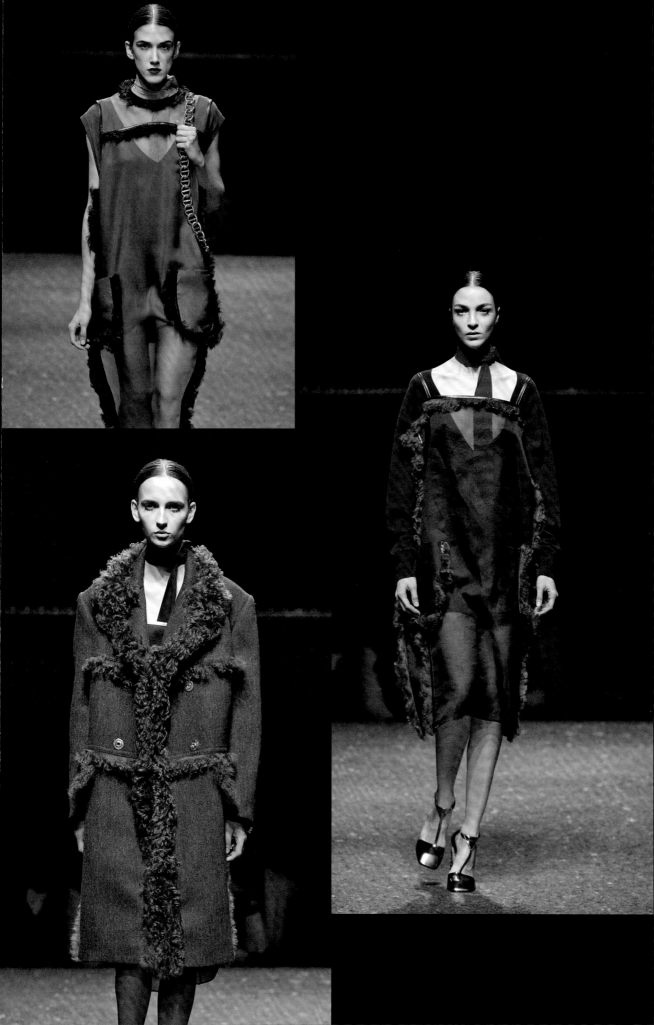

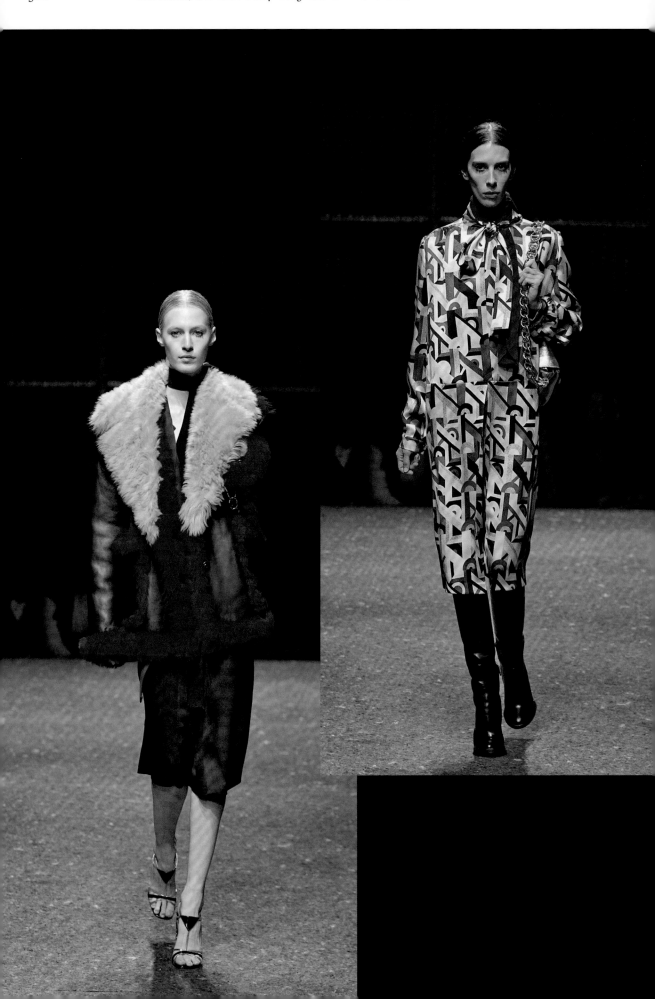

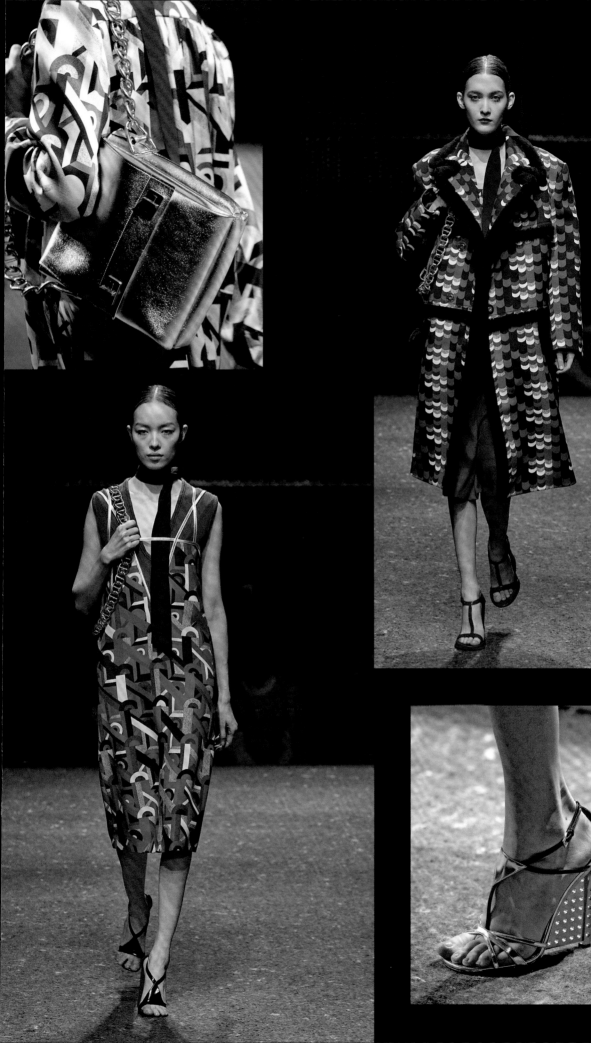

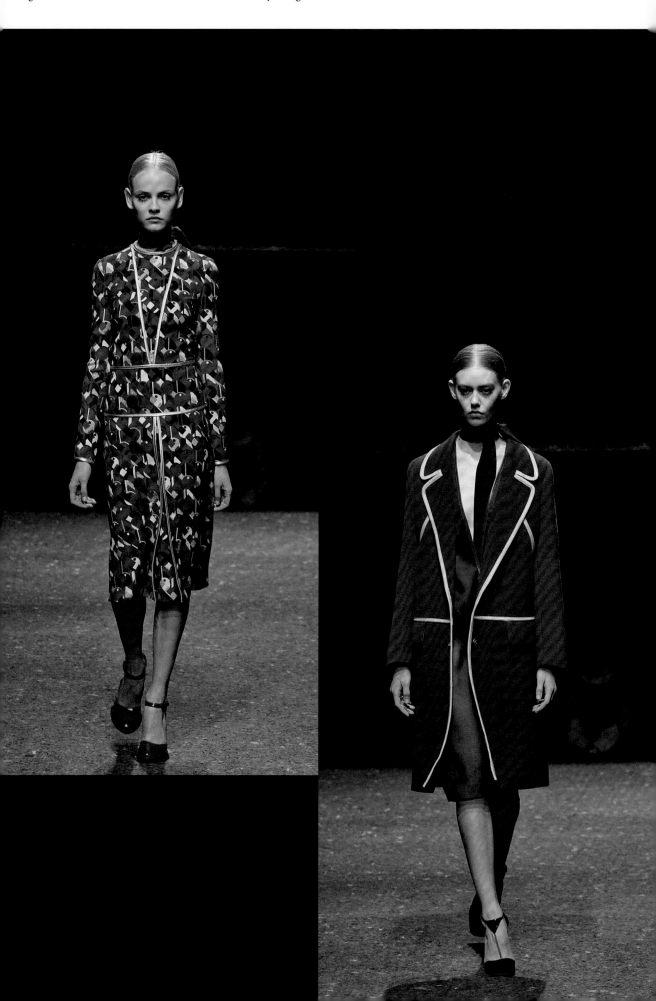

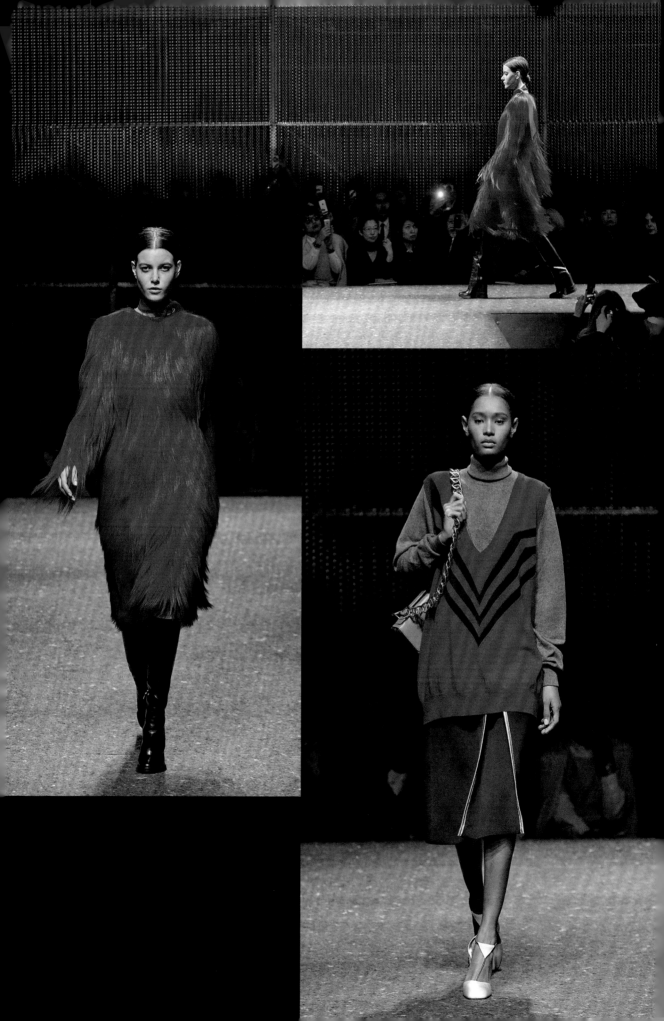

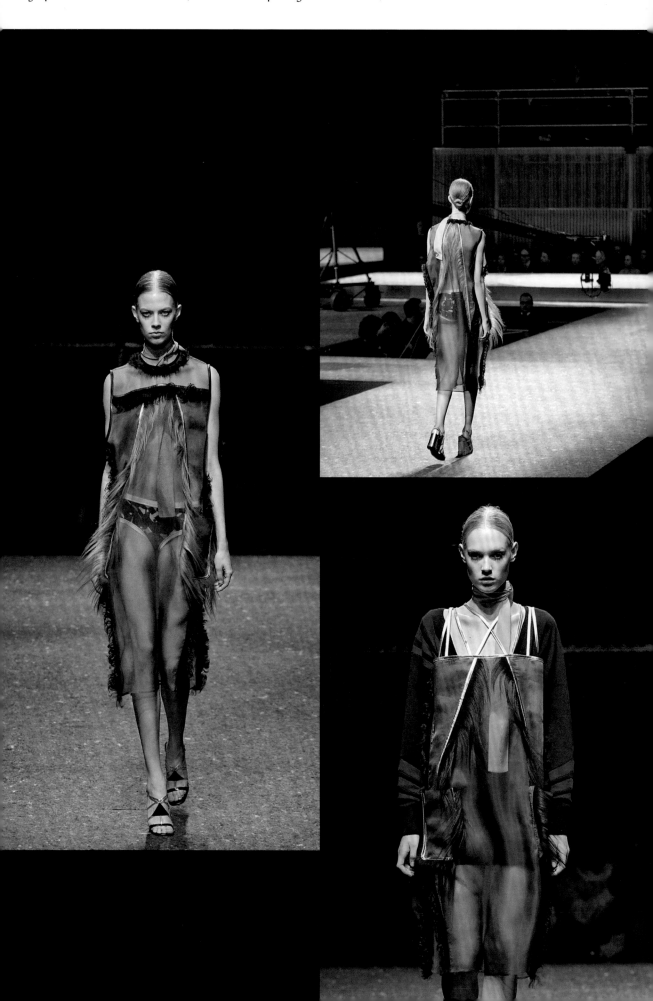

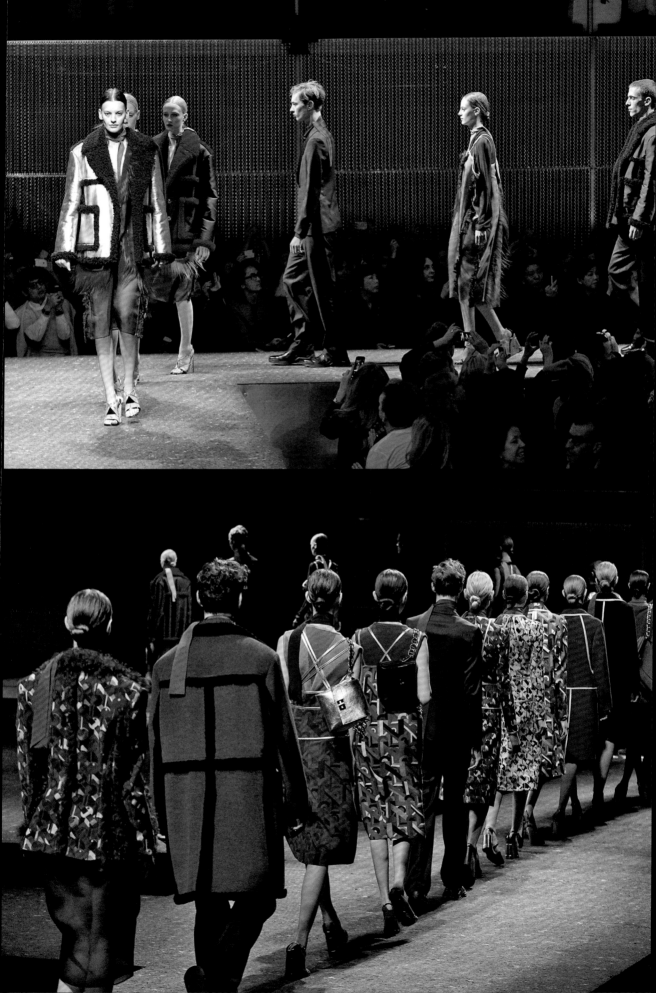

The catwalk was piled high with undulating dunes
of lavender sand for Spring/Summer 2015. This
was not about seasonal holiday dressing, however:
it was so dark in the Prada show space that guests
were shown to their seats by staff carrying torches.

When the lights came up, and as the first models
walked out, carrying neat little purses that were
in direct contrast to their rustic elevated clogs,
it was immediately clear that Miuccia Prada was
focusing on the bourgeois staples she had always
known and loved – and been known and loved for –
and undermining them.

Here were neat, belted coatdresses, A-line coats
with bracelet sleeves, knee-length skirts worn with
fitted sweaters. However, 'seams [were] marked out
for sewing, roughly picked out in topstitching, held
together by leather and the occasional strip of
brocade,' wrote Tim Blanks on Style.com. 'Hems
trailed threads; stuffing burst from pockets. Clothes
that might have been rich in a former life were now
beautiful fragments. There was a definite tug between
rich and poor, not just in the collaging of gilded
fabrics and humbler stuff, but in the way one neckline
was threaded with diamonds, another defined by plain
dark contrast stitching.'

It was almost as if a wealthy young woman had taken
flight from her family home, gathering her most
precious possessions together before so doing, and
had then, over time, been forced to lovingly mend
them to ensure she had clothes to wear to protect
herself from an intrinsically – and increasingly –
hostile environment.

Prada told Style.com that she wanted to 'revive
the beauty of incredible fabrics', and with those
brocades she did just that. But said beauty was
an 'impossibility', she continued, using that word
once more (see p. 480).

'At Prada, even the canapés served before the show
act as clues to the essence of each new collection,'
Blanks observed, 'and here they included a square
of chocolate on dry bread, which could pass as a
poor man's candy bar.'

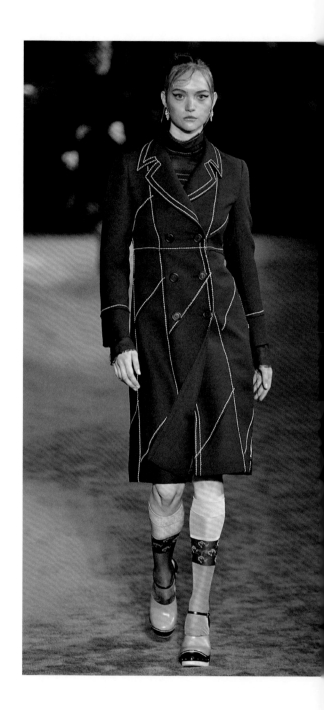

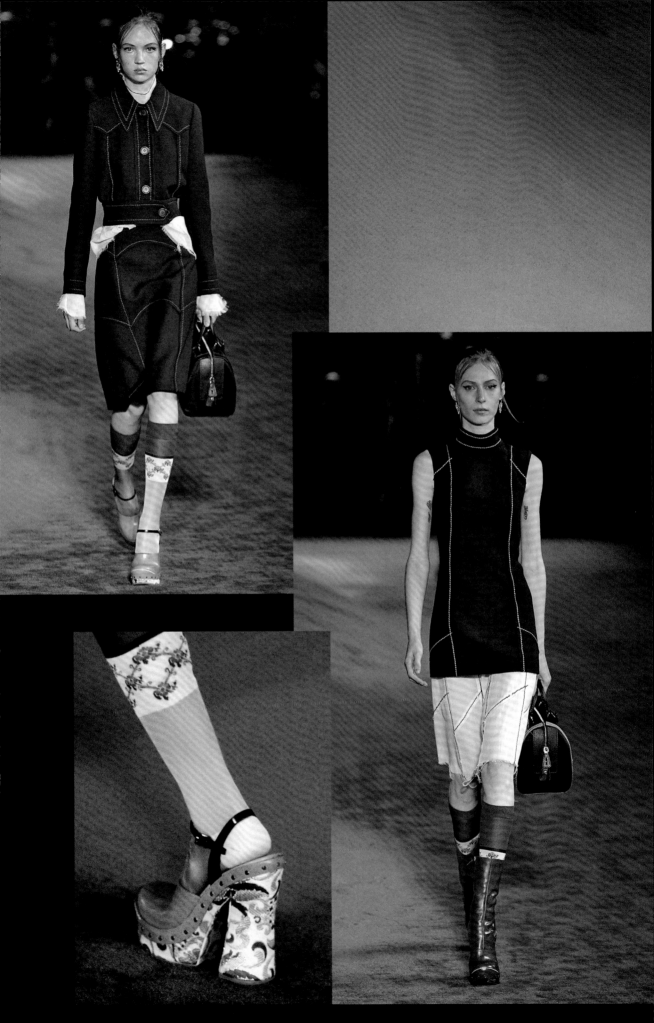

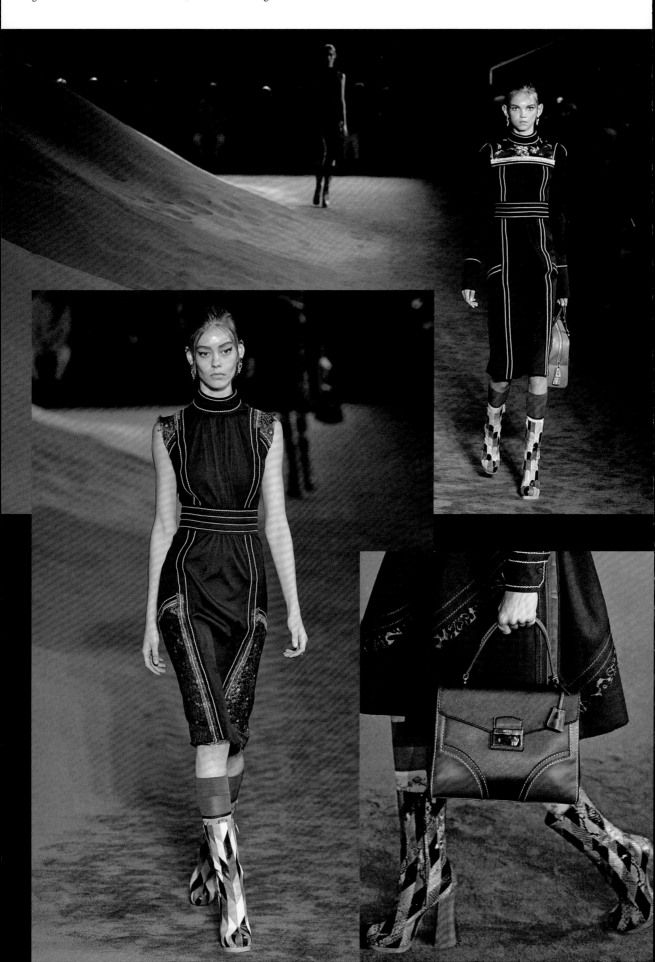

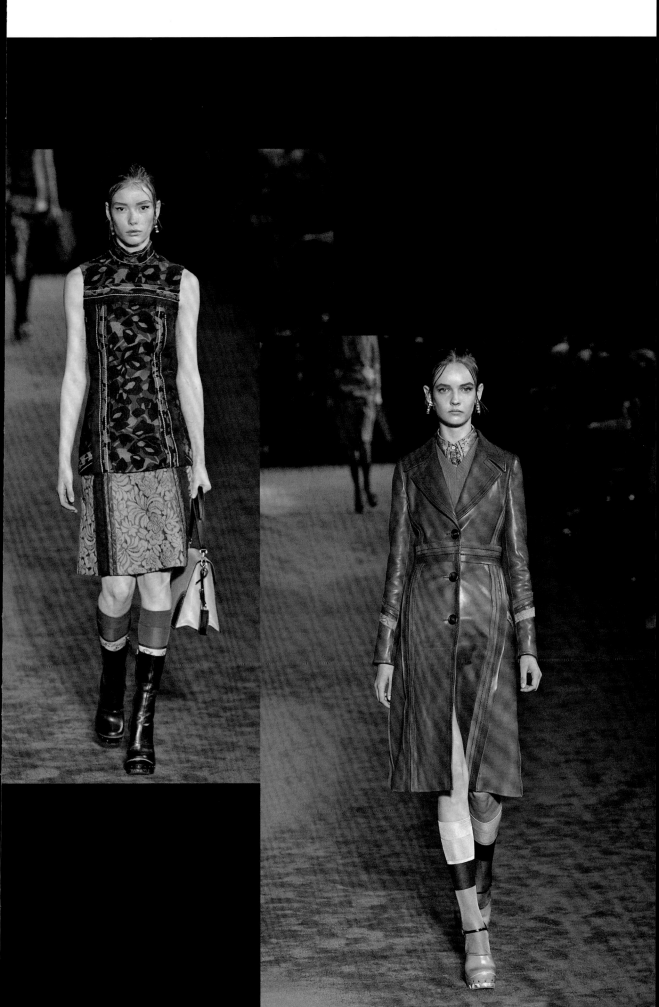

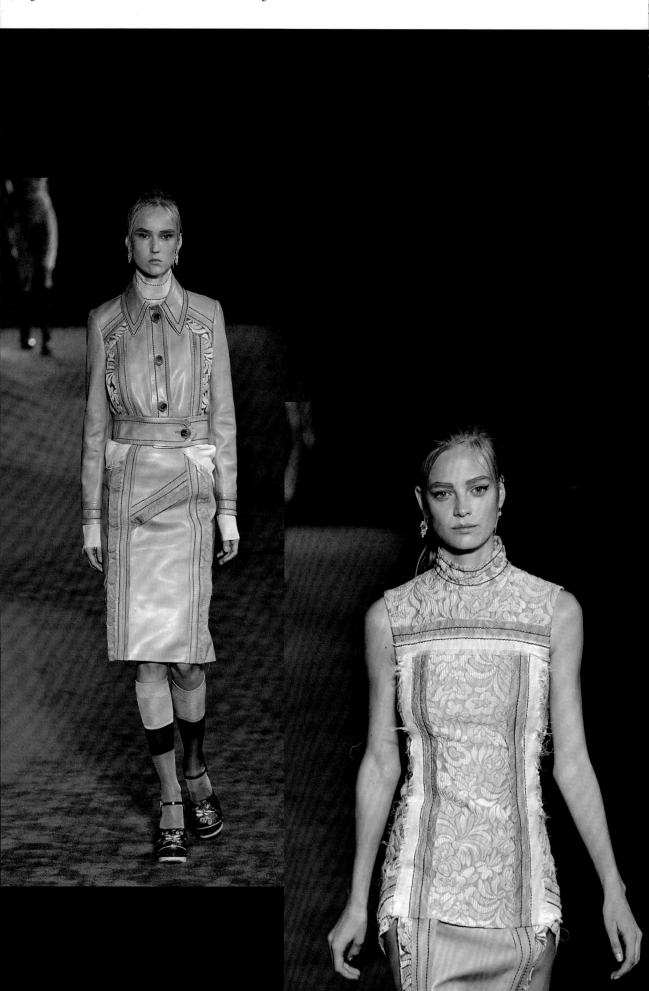

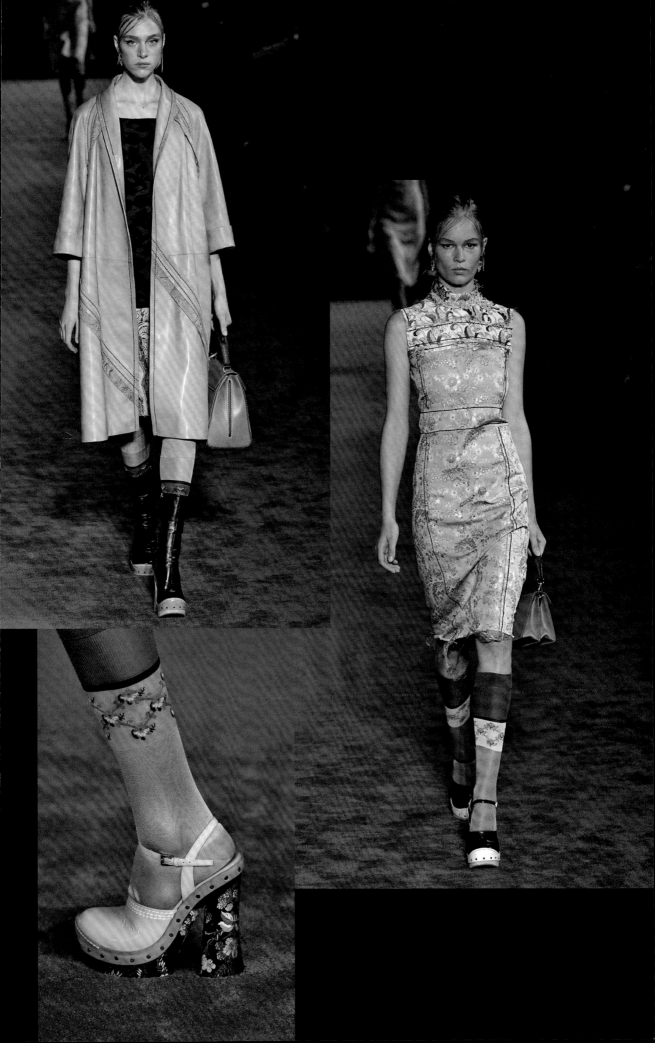

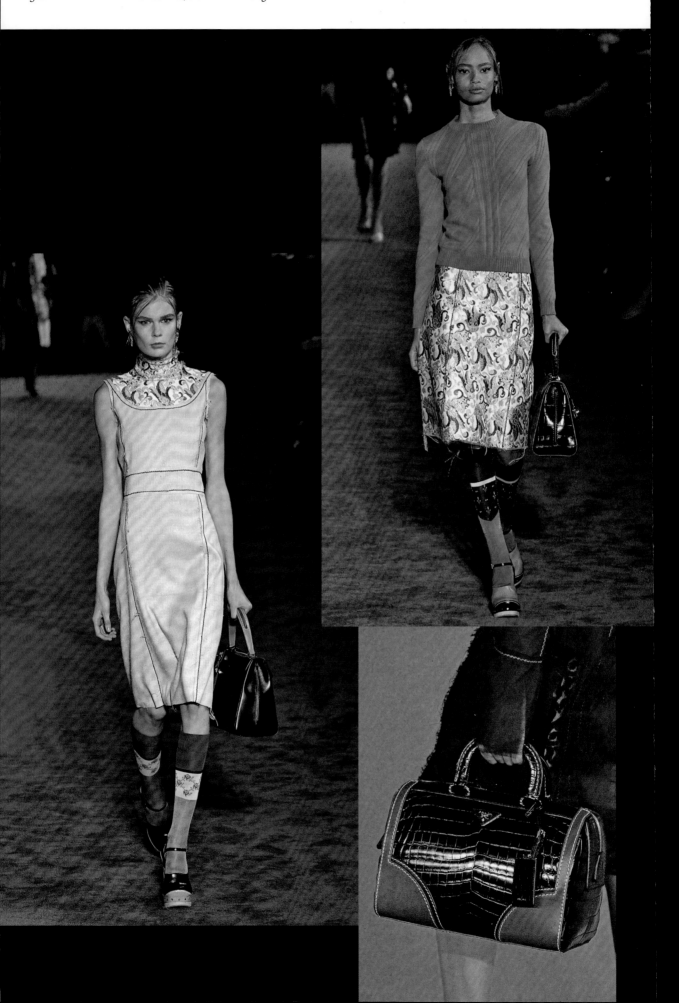

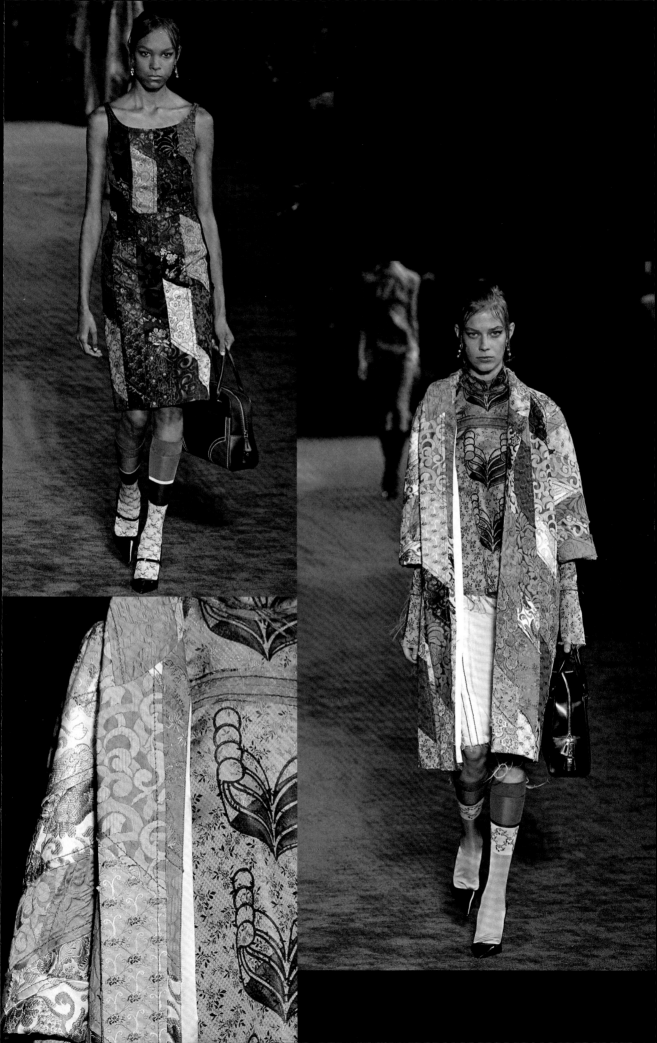

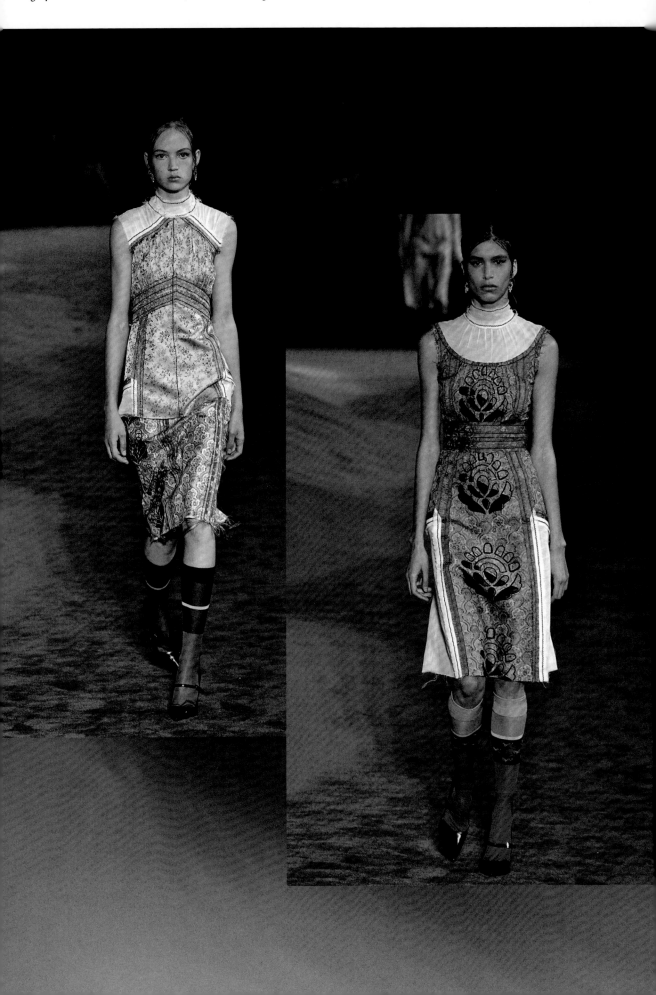

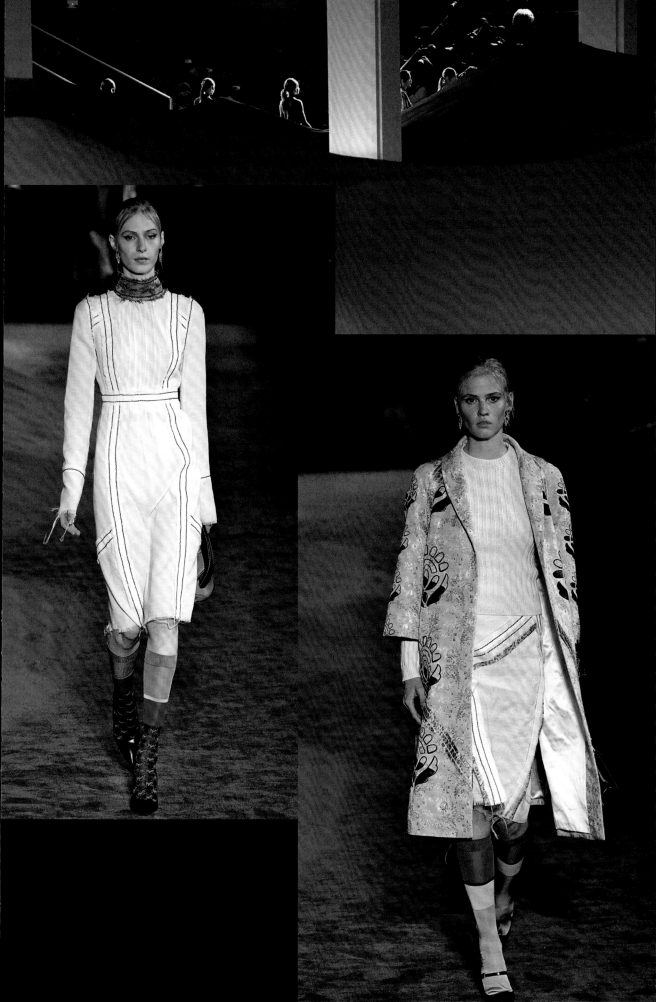

In place of the vast open set that had come to be
expected at Prada, guests this time filed through a
series of interconnecting, salon-style spaces coloured
sugar pink, mint green, apricot and primrose. If the
intimacy of the mise en scène spoke of days gone
by, that was offset by perforated silver metal panels
suspended from the ceiling and more – perfectly
square, oval, circular – placed on the floor that
were modern-industrial in flavour.

The clothes were a similarly effortless fusion of
the timelessly elegant and the innovative. They were
also a little too picture perfect for comfort. 'What is
real and what is fake?' the designer wondered in the
New York Times. 'What does the confusion of the
two mean for our understanding of beauty?'

Tailoring in what looked like scuba fabric – it was,
in fact, a technical double-faced jersey – was neat
and cut close to the body: a buttoned-up jacket with
pointed lapels was worn with trousers, which kicked
at the knee and were cropped at the ankle. Coats in
herringbone tweed were similarly demure. References
to mid-twentieth-century French couture came thick
and fast, in the shape of swing-backs and balloon
skirts and dresses.

If much of the above would not have seemed out
of place at a debutantes' ball – or cocktail party at
least – the look was endlessly twisted. The colour
palette was more jarring than ever: teal green,
chartreuse, raspberry and plum; grey, camel, poppy
red and flame. Equally bizarre was fabrication – that
spongy weave; real ostrich alongside a molecule print
and ornamentation; rectangular strips of fur where
epaulettes might be; jewelled flowers scattered
asymmetrically across the surfaces of clothing,
and larger, stranger blooms crafted in plastic.
Even models' up-dos were pulled to one side: askew.

Finally, leather sock boots with chunky rubber soles
in surgical shades were so awkward they doubtless
made even the woman who designed them proud.

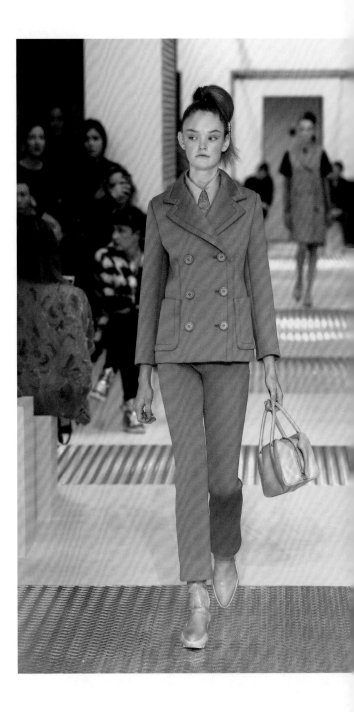

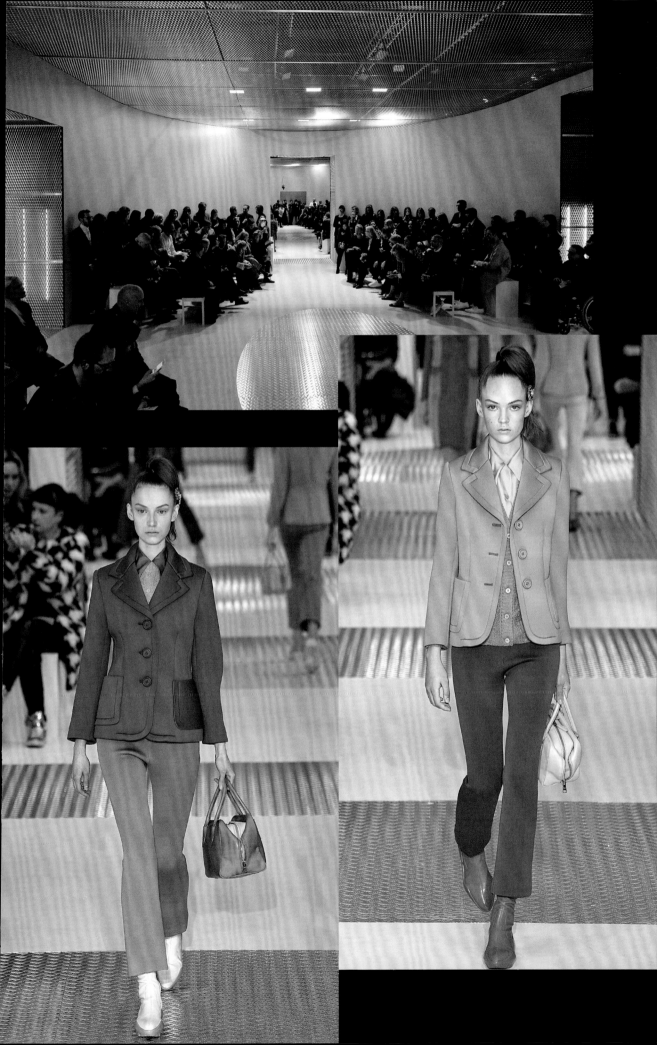

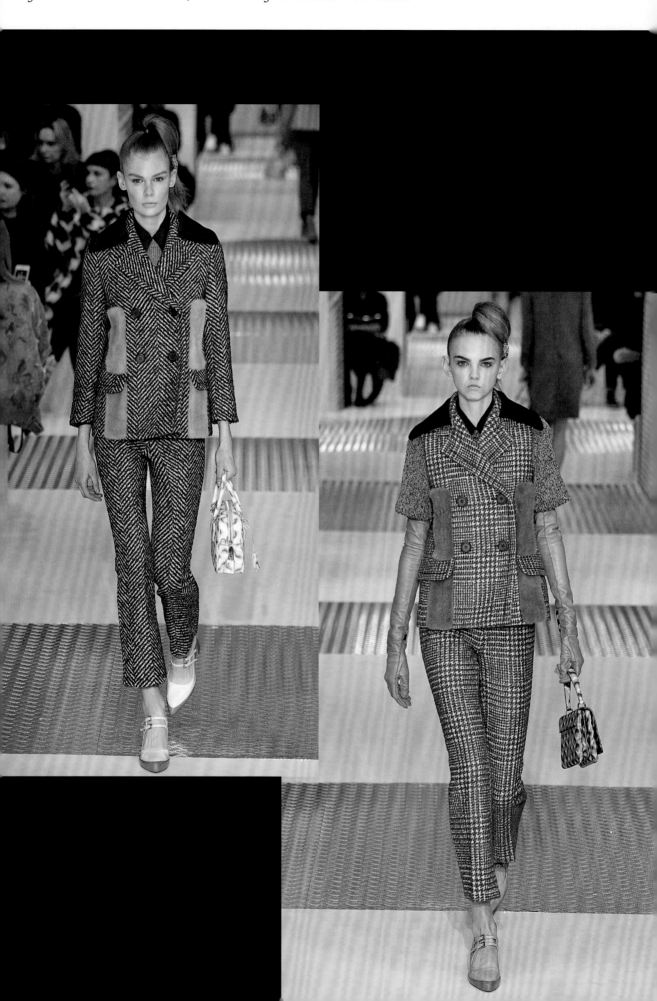

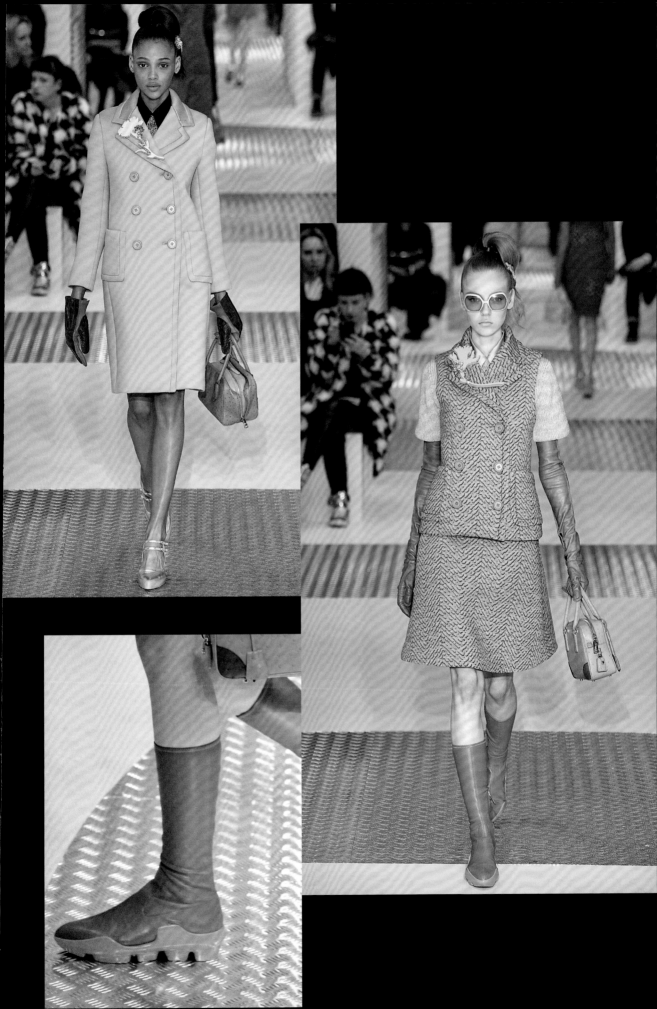

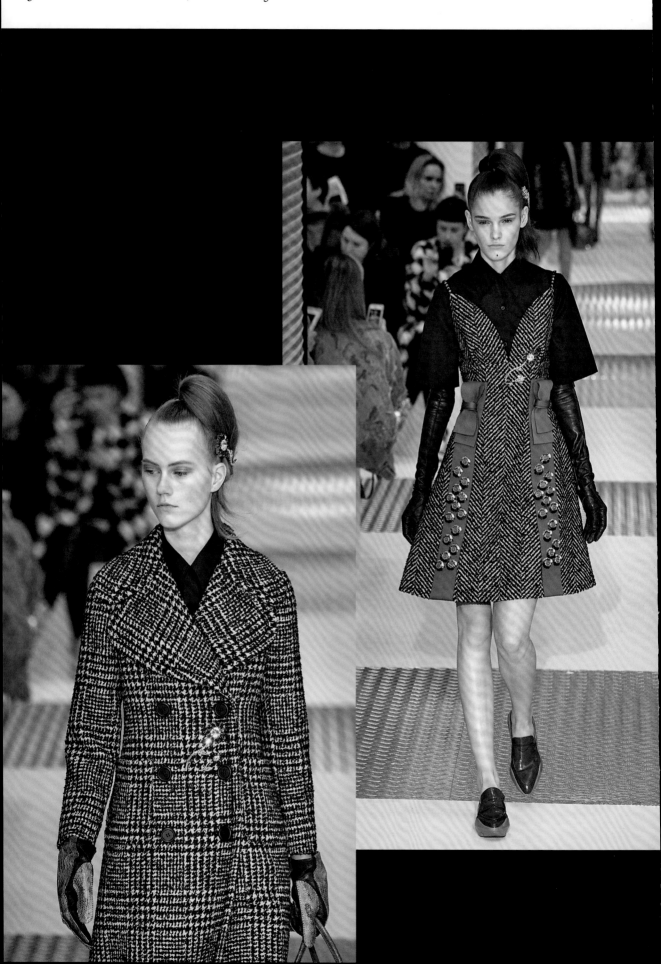

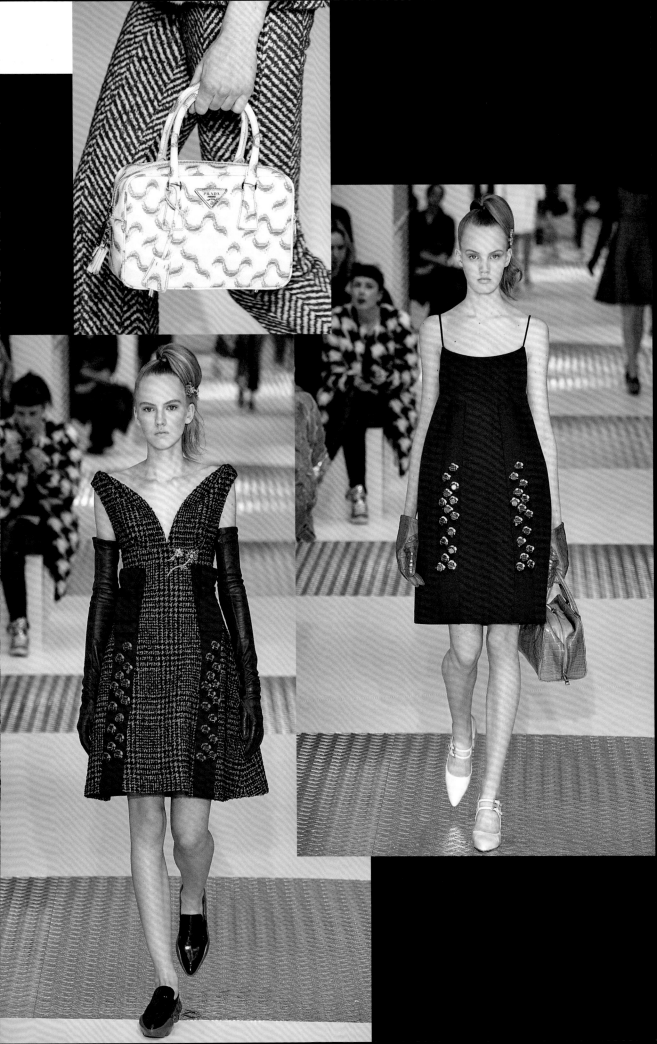

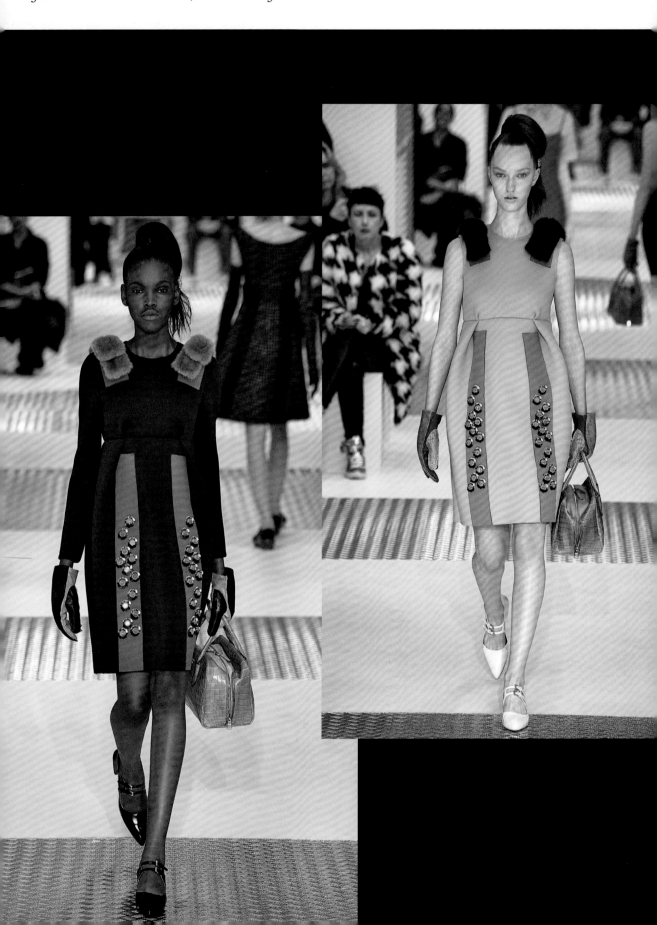

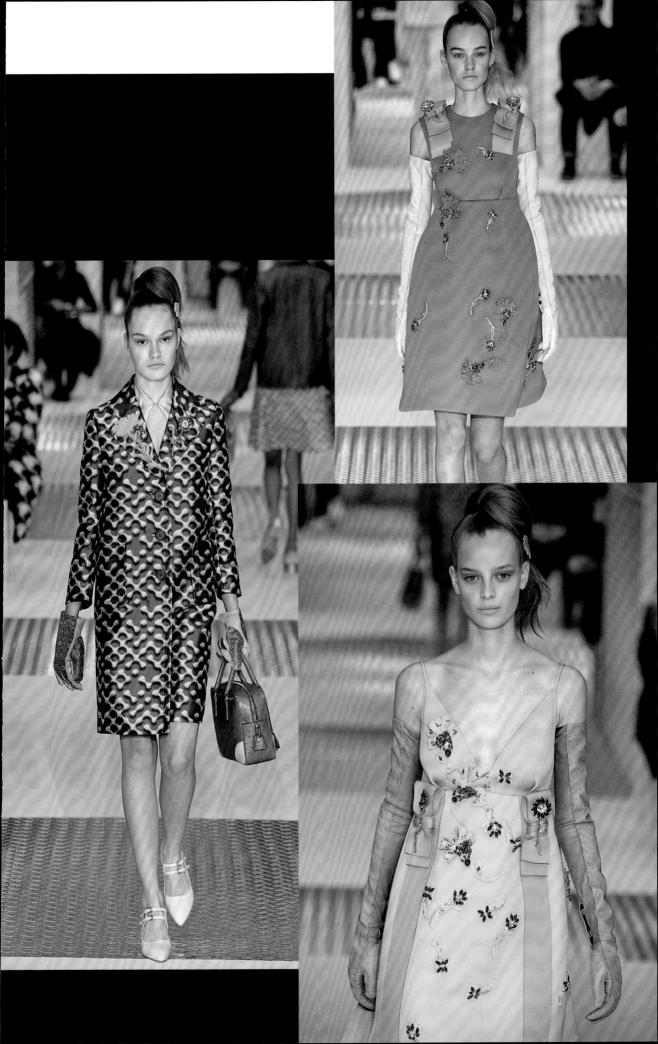

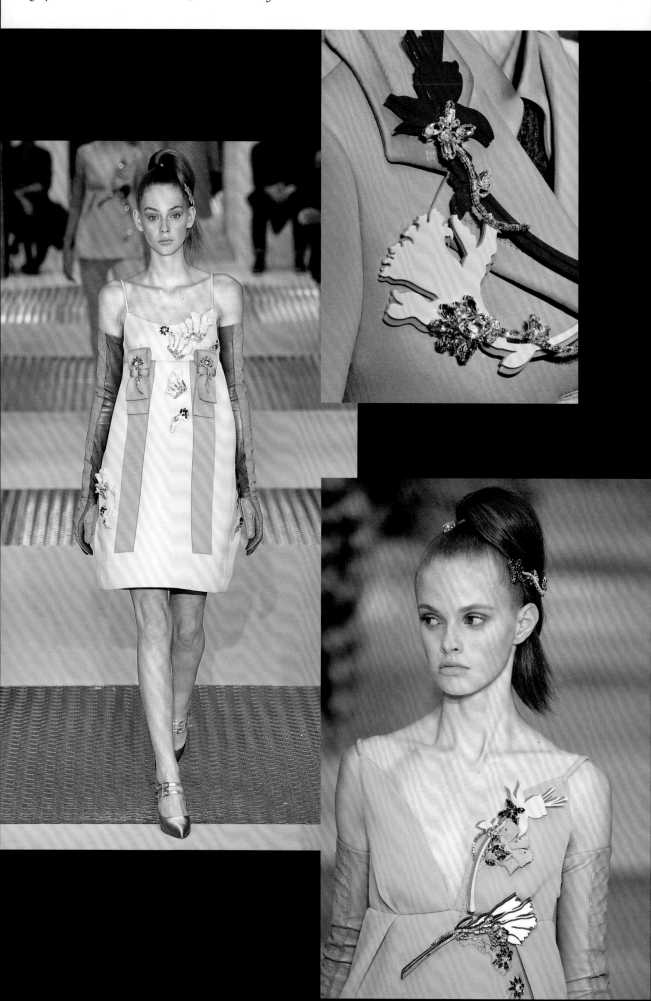

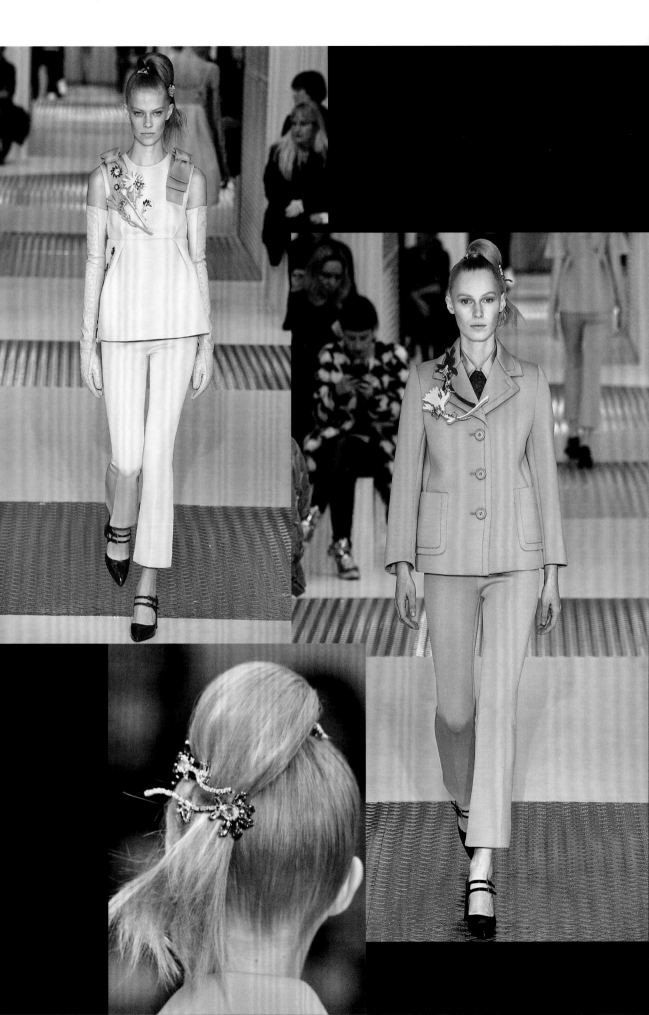

The backdrop and opening sequence of this show might not unreasonably have been described as dour. Corrugated plastic cylinders and oblongs edged with battered metal were suspended from an inky black ceiling and over a concrete floor. First out came leather skirt suits in sludgy colours: the jackets were full with a wide dropped half-belt when seen from behind, the skirts were straight. So far, so frumpy. However, disco ball earrings, patent leather shoes in candy colours finished with silver pom-poms and gleaming brass ankle straps, not to mention the models' burnished gold lips, were a sign of more dressed-up things to come.

The woman here clearly loved embellishment and even frivolity, but the way she put that together was always inventive. With that in mind, sheer organdy dresses were worn over tweedy skirts in murky shades. More tweed was overlaid with a messy cobweb of oversized paillettes that looked like their wearer might have made them over drinks at home before going out on the tiles.

As the show progressed, the character at the centre of this story became increasingly abandoned – drunk on the glitz of it all, perhaps – in oversized Twenties-line silk dresses with a low waist printed with stripes in Courrèges red, in chiffon separates over big knickers and chunky knit tanks in clashing brights and, most especially, in a final sequence of sequinned opera coats scattered with flowers. These were worn over woolly sweaters tucked into pencil skirts of striped bronze, gold and silver python and suede.

Vintage references were ubiquitous this season. Only few of Miuccia Prada's profession have ever grasped the cultural context of fashion from decades past so firmly or been able to reinvent it to both modern and desirable effect.

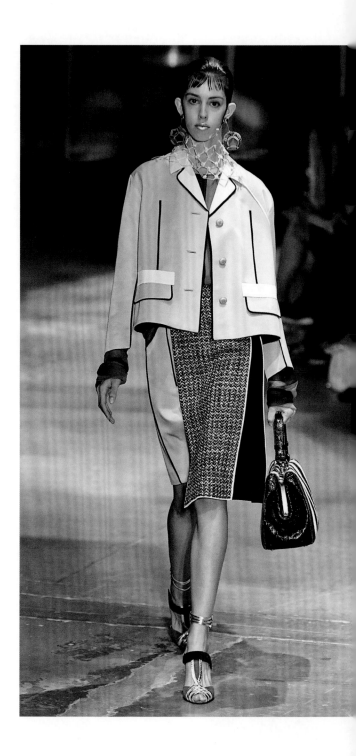

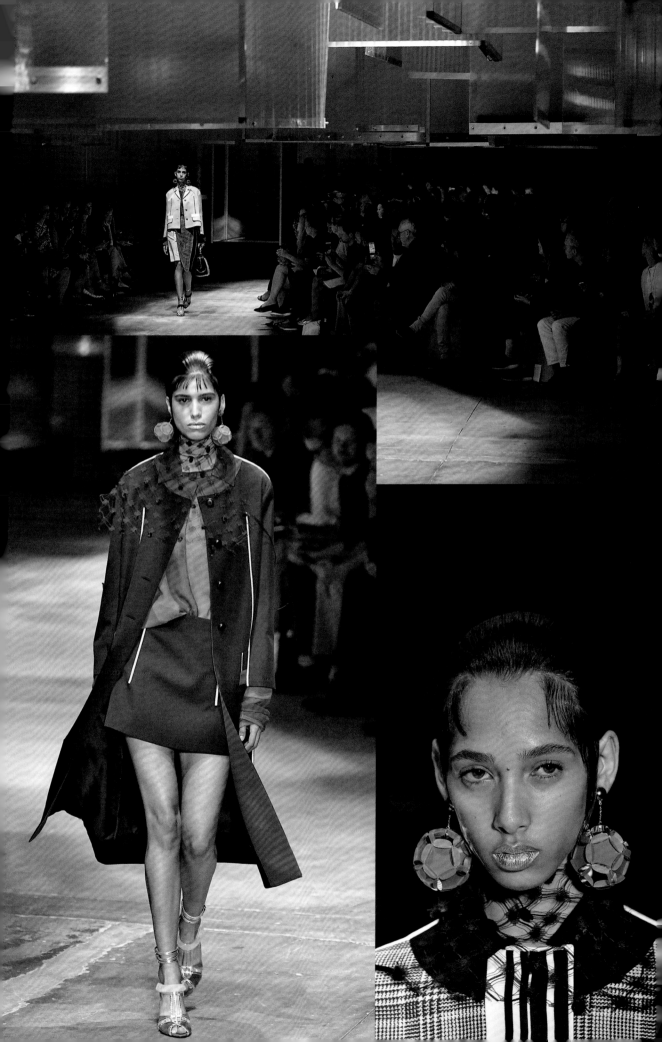

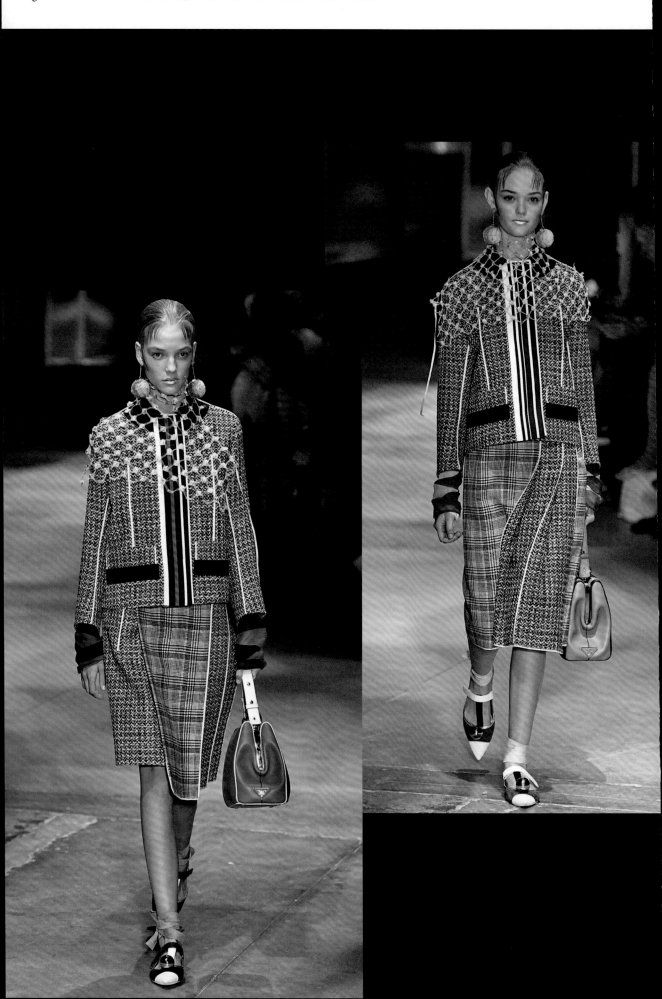

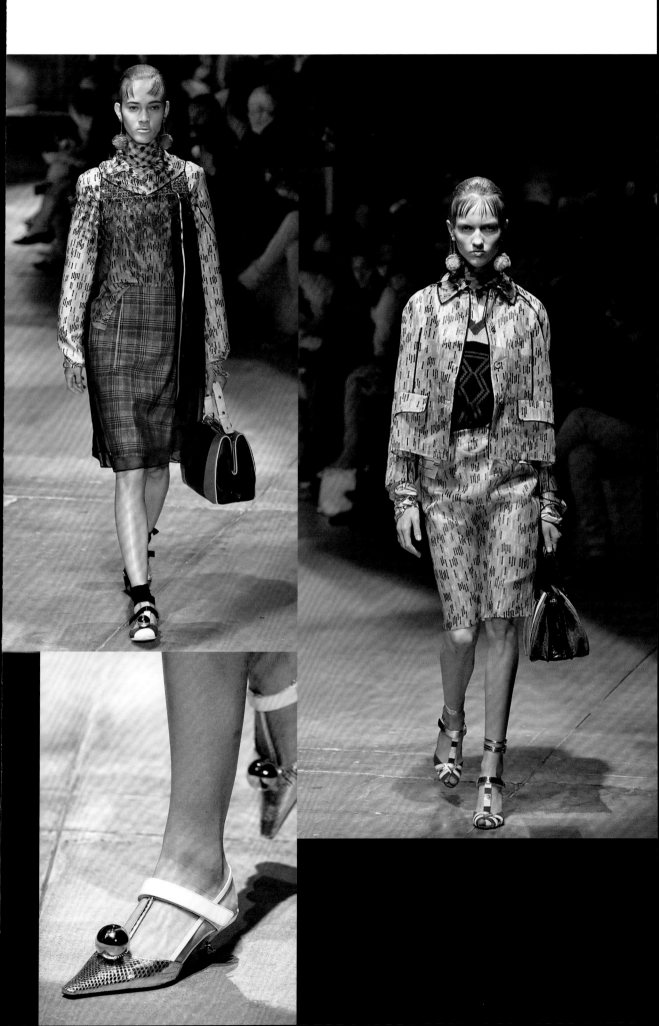

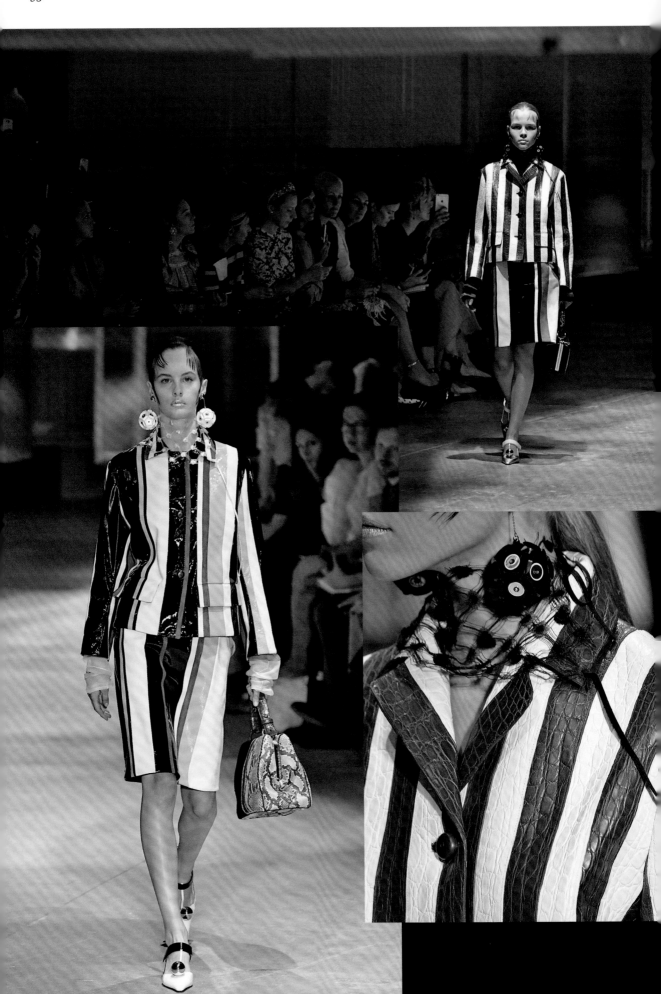

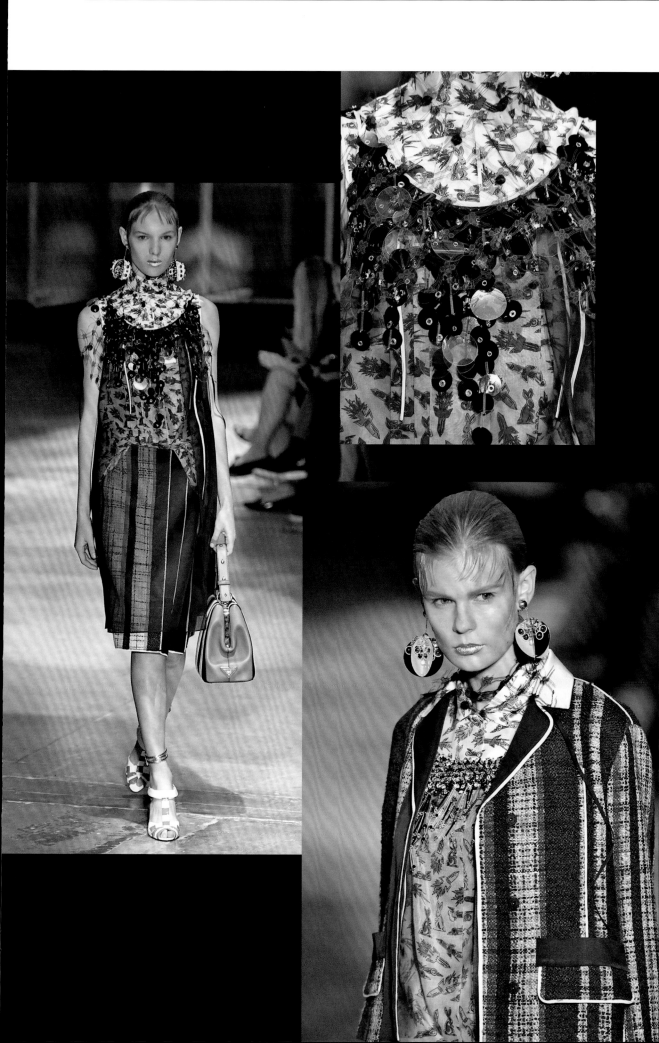

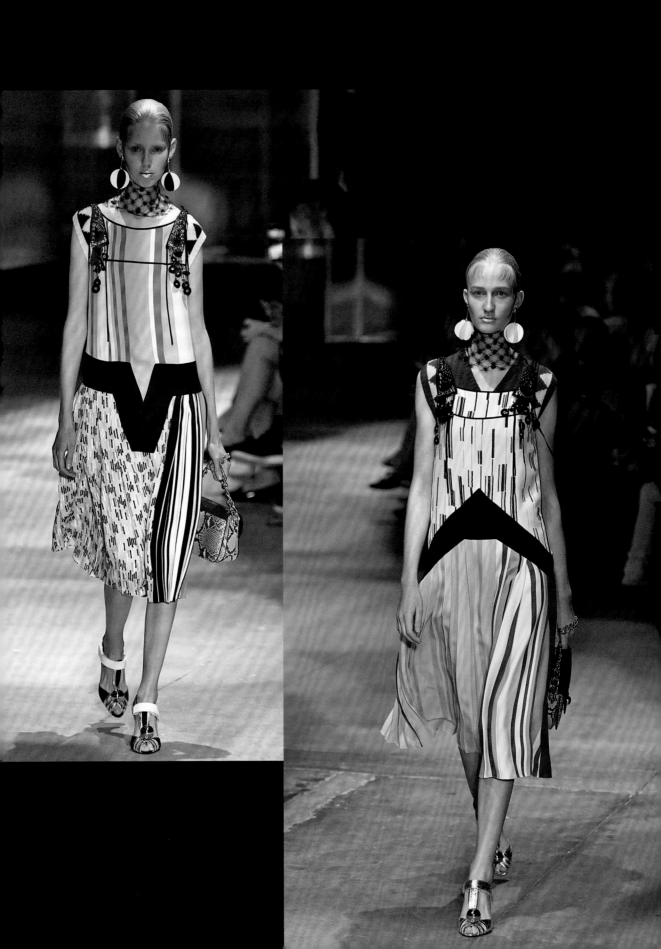

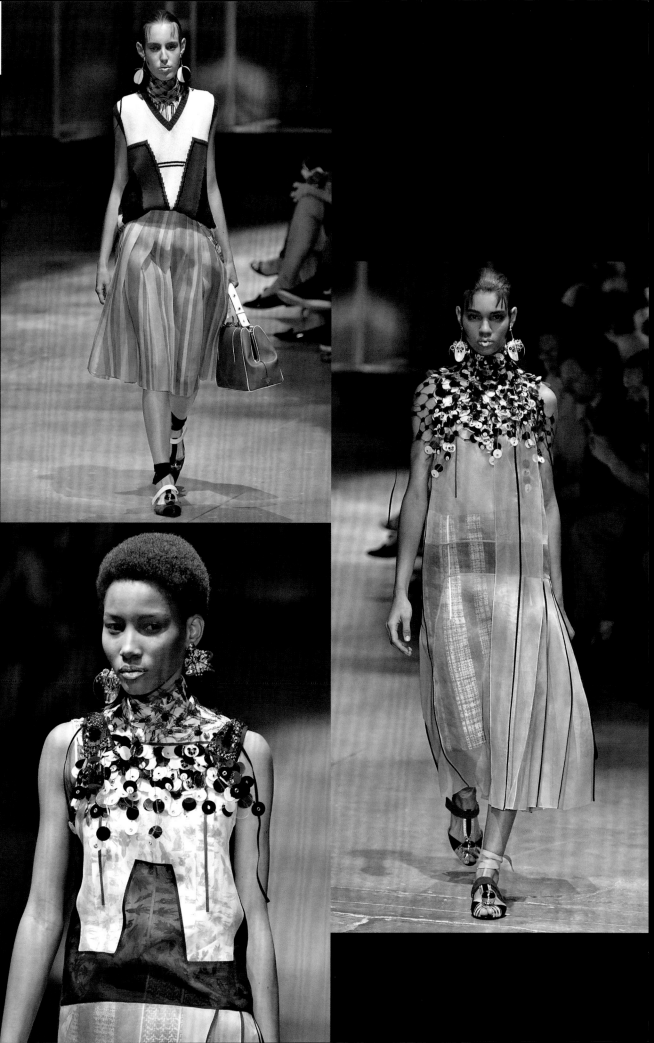

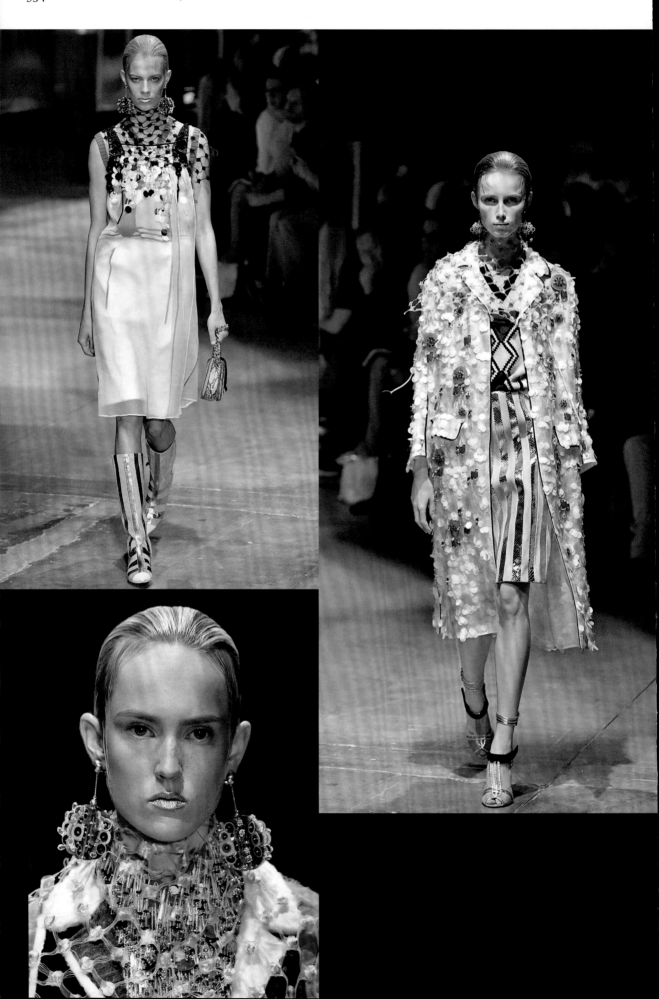

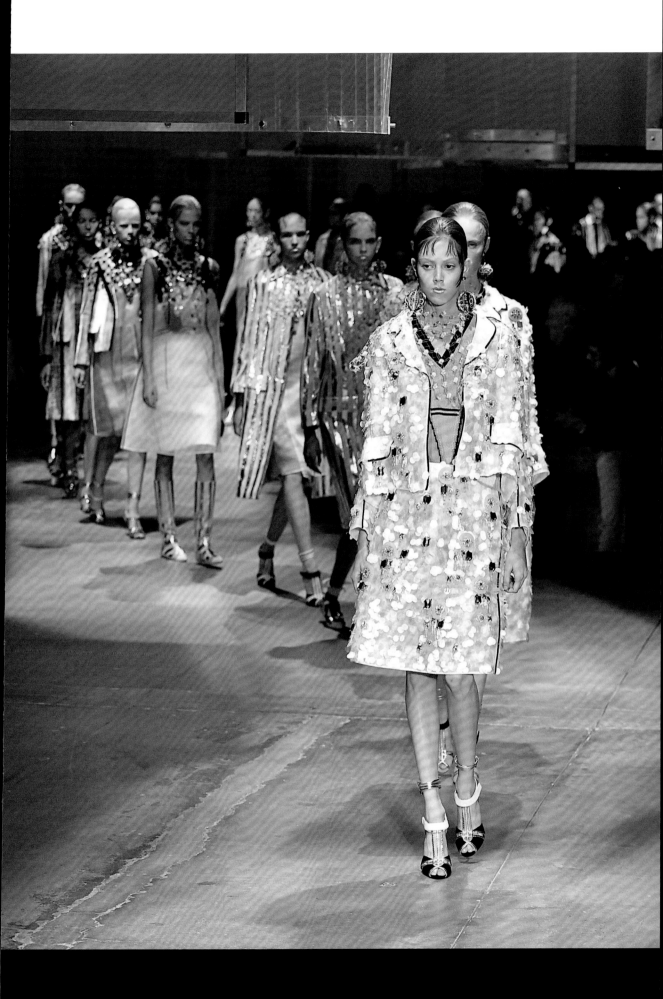

'It was about the history of women,' Miuccia Prada told AnOthermag.com on this occasion. 'Women have more facets [than men]. We are so much more complex. We are lovers, mothers, workers. We have to be beautiful,' she continued, going on to describe the characters that walked her plywood runway as 'vagabonds', roaming through different phases of life and referencing the French Revolution, the Italian Renaissance, the 1940s and the designer's favourite 1950s silhouette.

Frédéric Sanchez's soundtrack – he had been working with Prada in this capacity since the 1990s and does so to this day – was a mix of PJ Harvey, Nico, Edith Piaf. 'I find Edith Piaf so beautiful – heartbreaking,' Prada said.

The artist Christophe Chemin collaborated on the prints, based on the names of the twelve months of the Revolutionary calendar used by the republican French government for twelve years, from late 1793 to 1805, and designed to negate religious and royalist connotations. These were all feminine and focused on weather patterns; among them were Germinal, Floréal, Messidor, Thermidor, Fructidor. The words themselves appeared large across heavy satins and alongside ripened fruit, embracing lovers and the serenely open face of what looked like a Madonna from an Old Master painting: the archetypal matriarch.

The signature mix of the high and the low was here. Magnificent gold brocades had washed white denim collars and were cinched at the waist with laced corsetry in that same fabric. Patchworked knits in autumnal shades had sumptuous fur backs. Boxy jackets, made hourglass with more denim corsetry, in navy and olive with utilitarian patch pockets, were worn over heavy satin circle skirts. Such sturdy looks were contrasted with more obviously feminine organza dresses embroidered in a palette of spun sugar, primrose and apple green. The sailor hats that topped several exits were inspired by a design Prada had seen someone wearing that summer, she said. 'I like them. And they're romantic.' The romance of travel to far-flung climes needs no explaining.

More accessories were similarly tender in intent. Tiny diaries were worn around models' necks. 'Apart from letters, I've never written a word,' their creator laughed. Bags were finished with multiple brass rings, encouraging the attachment of precious trinkets. Wedge heels were encrusted with curlicues and anchors of gold (p. 543, below left), while heavy walking boots were trimmed with fur.

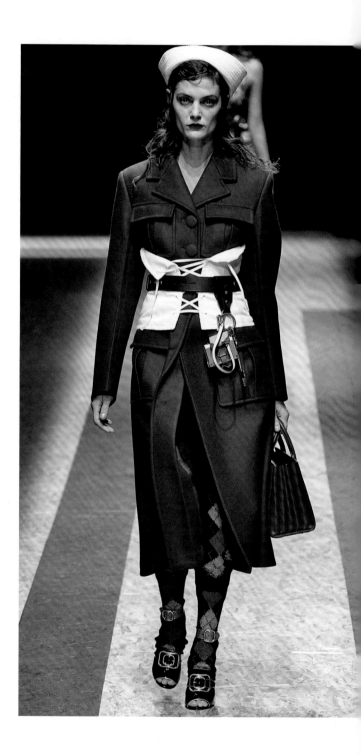

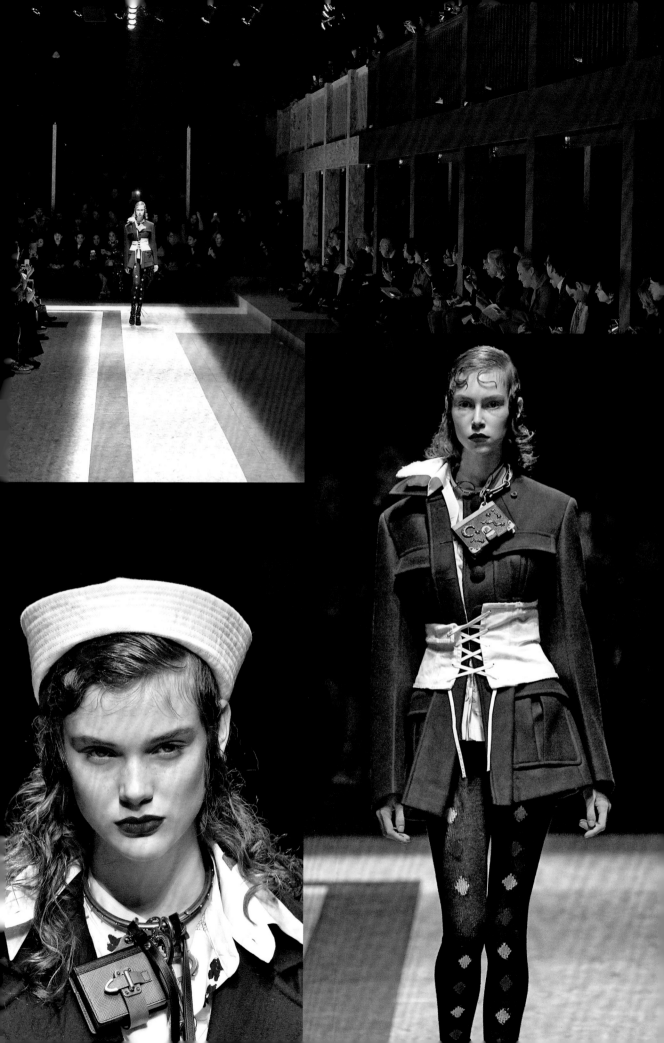

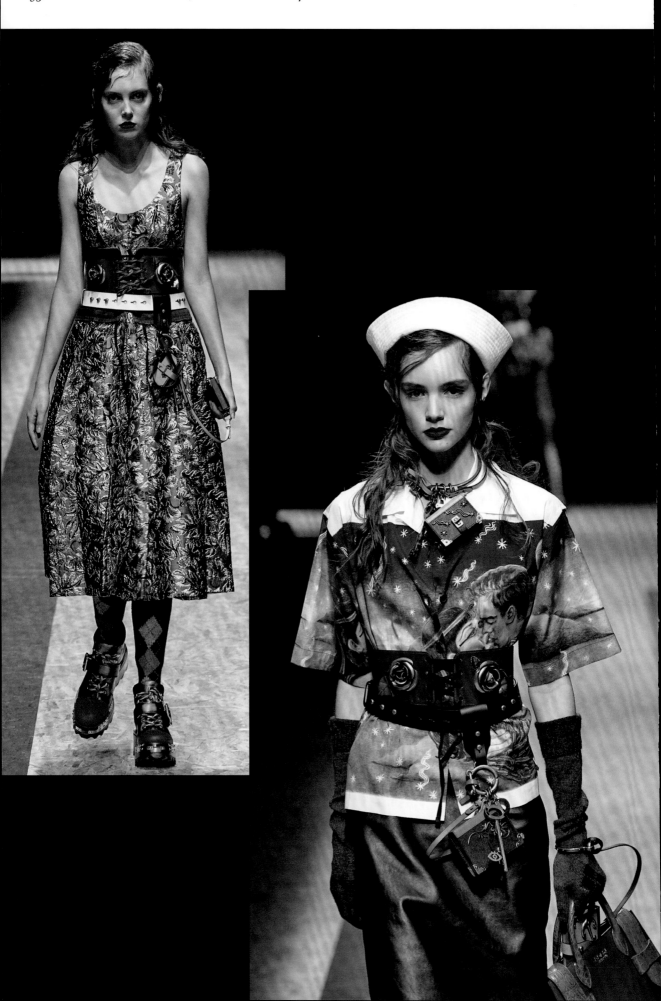

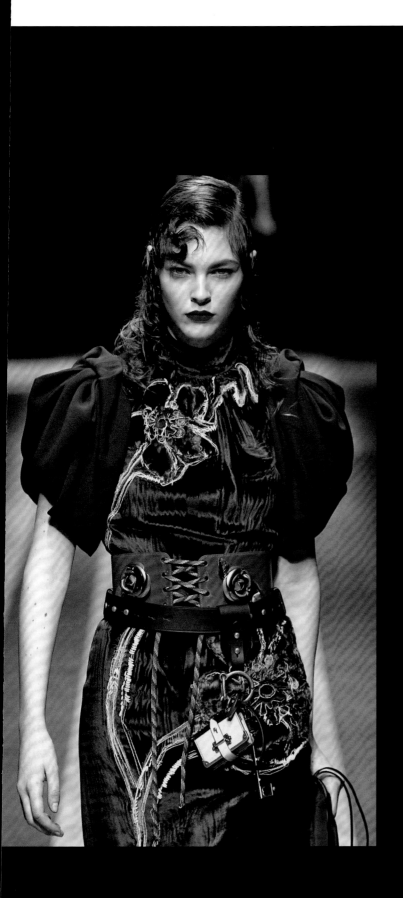

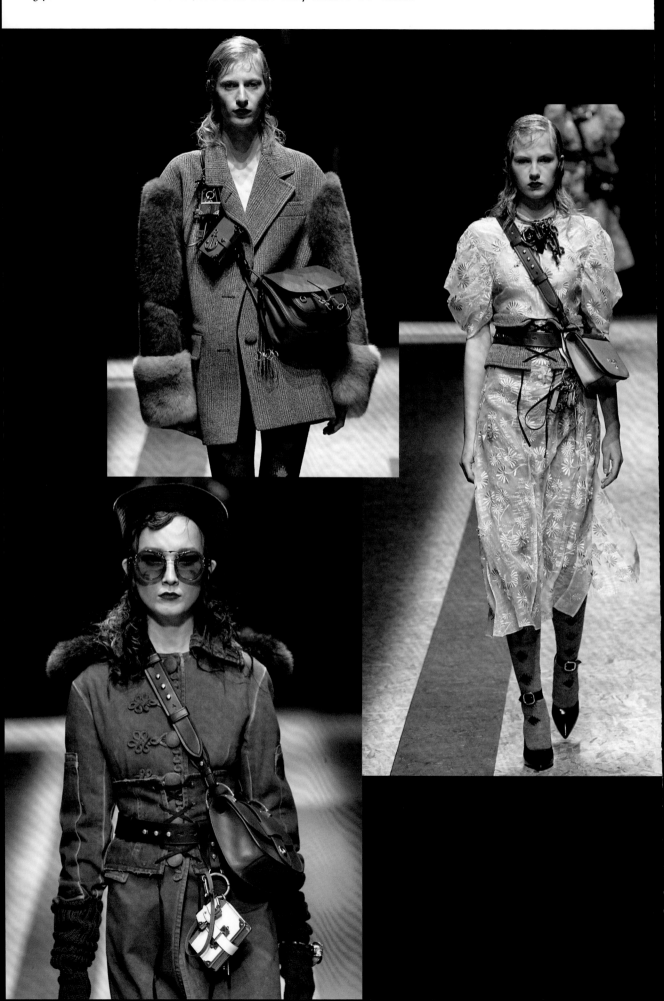

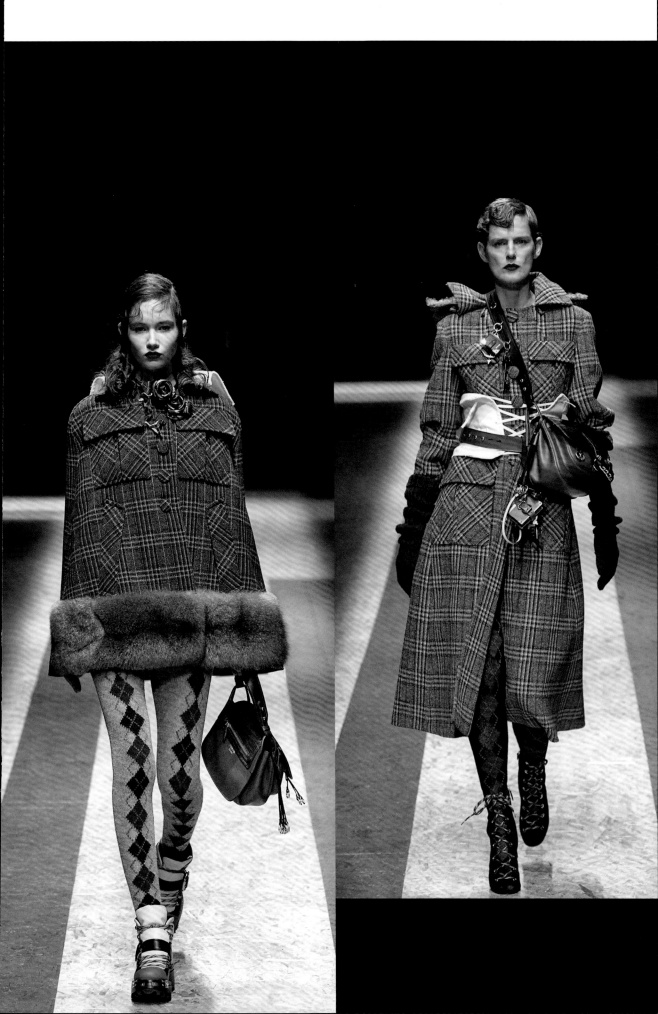

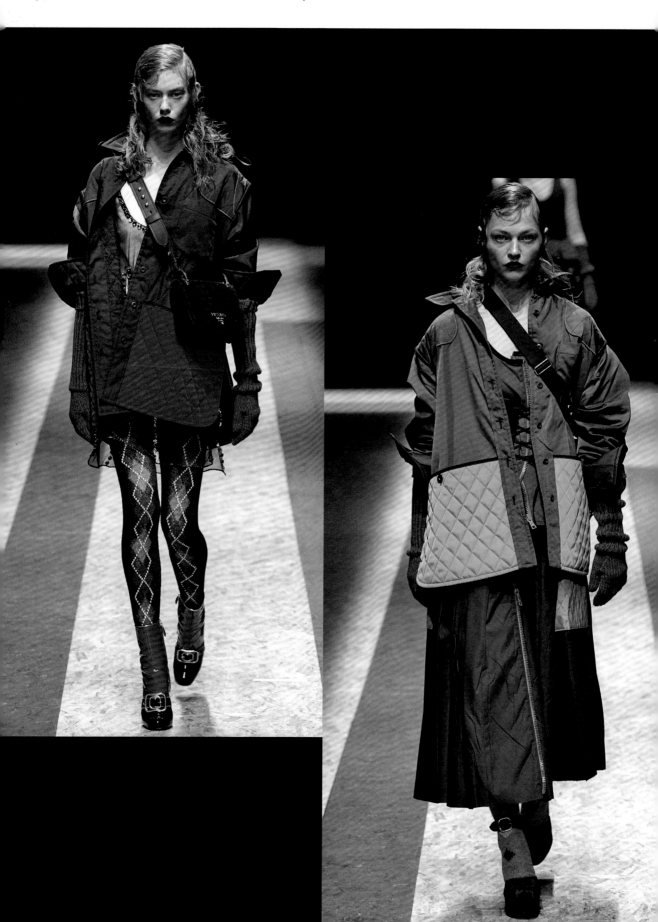

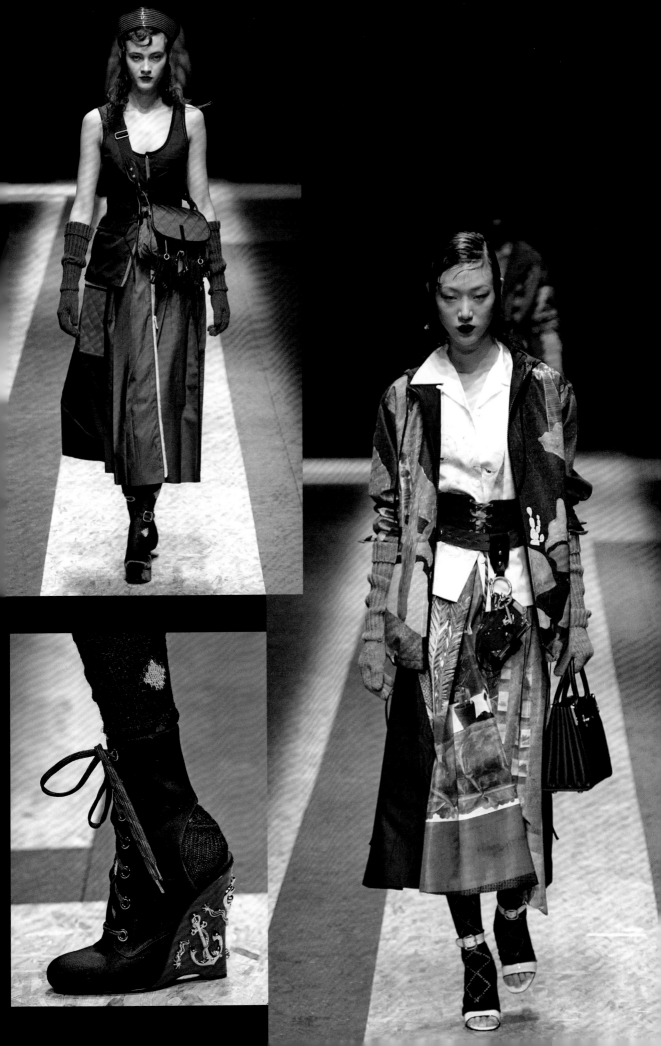

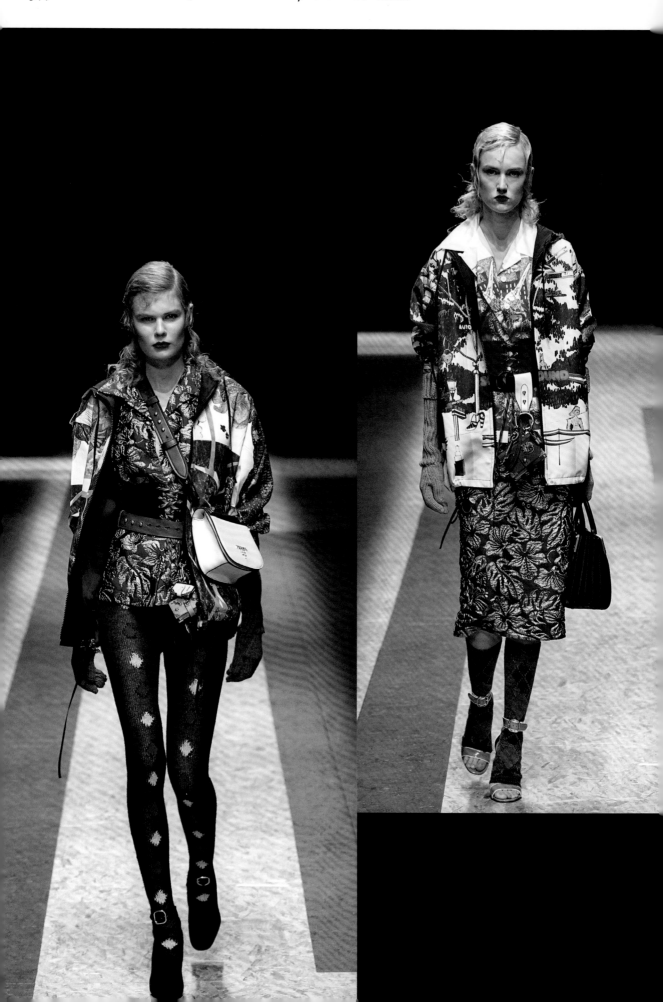

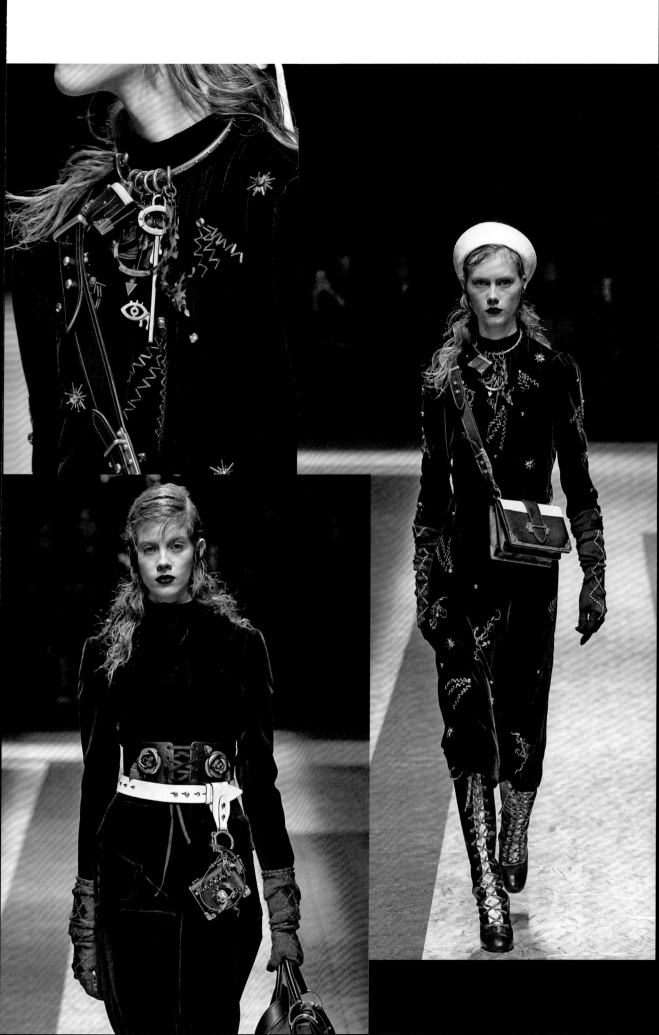

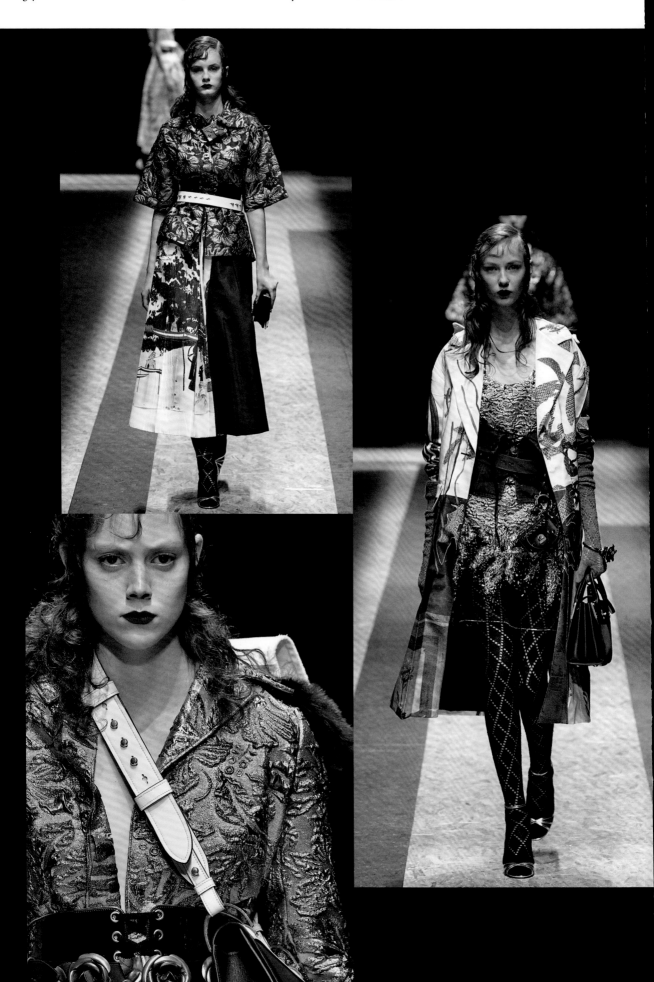

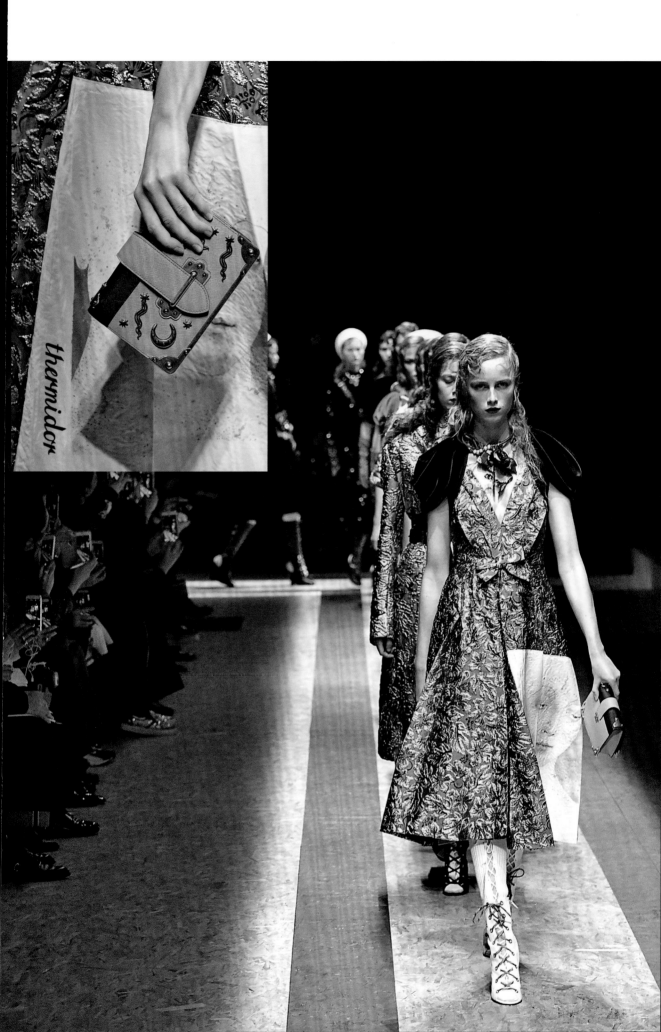

thermidor

This season, once again, Miuccia Prada looked at the tropes that had become integral to her vocabulary and reinvented them. The title of her and director David O. Russell's collaborative short film, spliced and shown on huge screens across an industrial runway, said it all: 'Past Forward'. Models walked on a raised, metal catwalk in front of it.

The opening look was in black Techno stretch fabric: a tank and knee-length skirt belted with pink and red rubber. Perfectly minimal. Then came prints, the originals from the mid-1990s were once again recoloured – turquoise, mustard, shades of blue from duck egg to navy, pink and, of course, brown mixed with naïve daisies, checks and stripes. The fabrics were light – contemporary – and the silhouette streamlined: shirts buttoned up to the throat, straight skirts, patch-pocketed jackets worn with more rubber belts in shades that were typically jarring. Bags were predominantly hugged to the body like precious cargo: friends.

Always aware of the complexity of women's lives, Miuccia Prada largely eschews conventional expressions of sexuality in women's clothing. Still, there was nothing demure about the tiny shorts that more than whispered of mid-twentieth-century pin-up style. They were dynamic, however, over and above pandering to the male gaze. In a similar vein, bra tops were worn over masculine shirting and skirts were split to the thigh but deliberately skewed, fastened with nothing more obviously alluring than Velcro.

The clichés of the woman's wardrobe were all present and correct, too: the colour pink, the aforementioned lingerie details, lace, embroideries, florals, silk chiffon and marabou sprouting everywhere, from bra tops again to sturdy sandals. Maybe more than ever before, Prada juxtaposed these with unlikely fabrications and shapes. There was nothing aggressive about the designer's treatment of these staples of the couture atelier. Instead, this was a sweet, even gentle, and ultimately optimistic understanding of a love of decoration, one which acknowledged the need for fashion to embrace a certain whimsy and frivolity without ever seeming undignified.

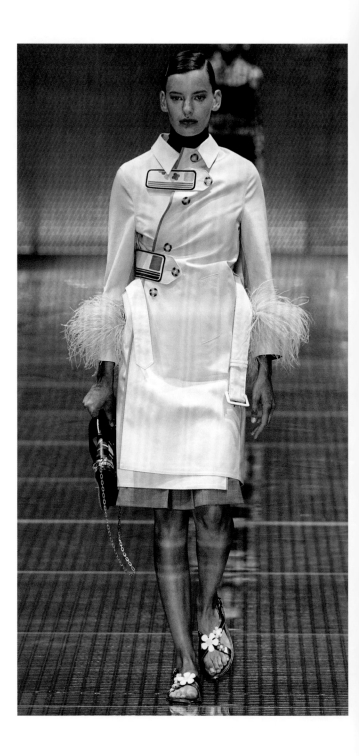

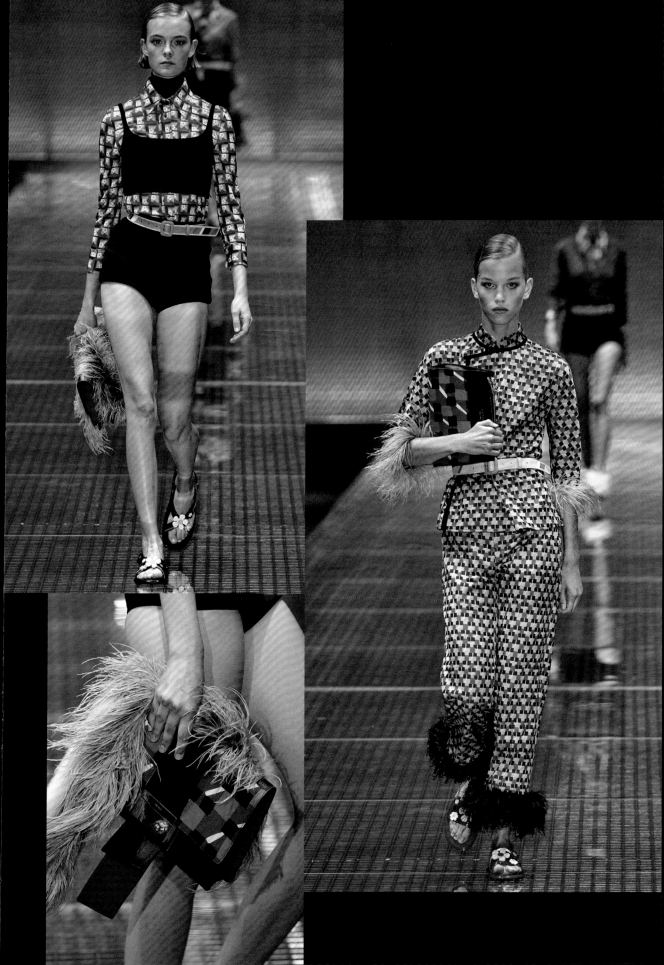

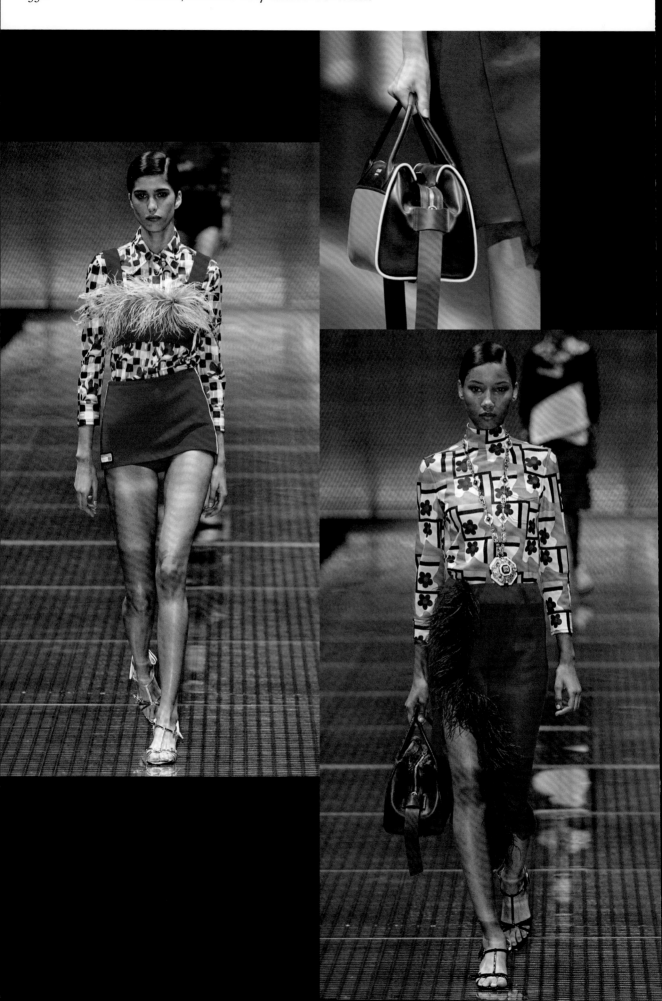

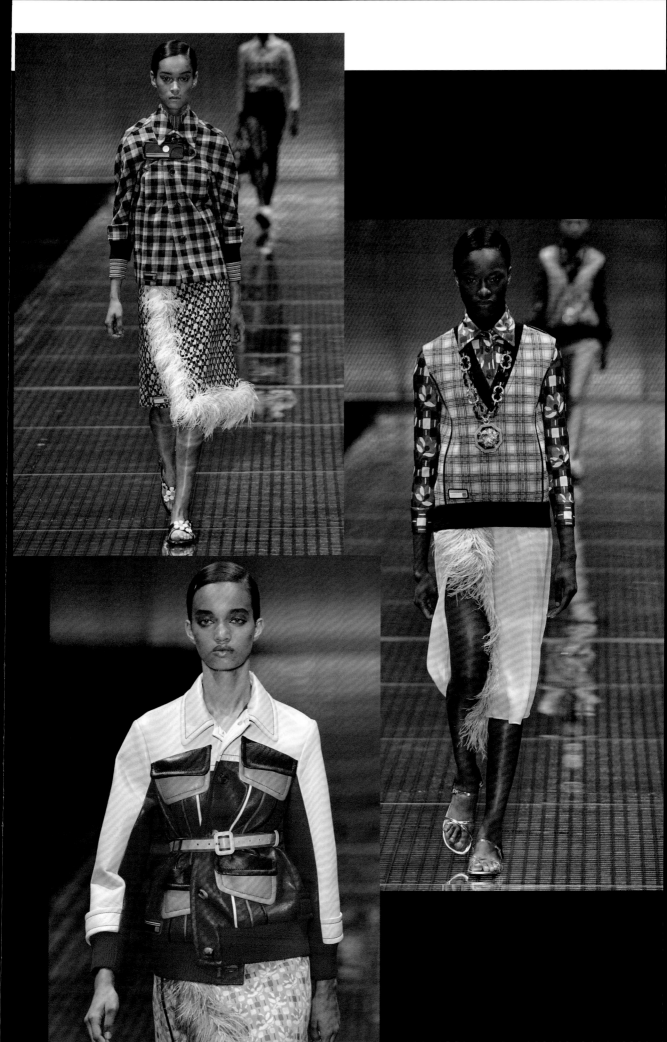

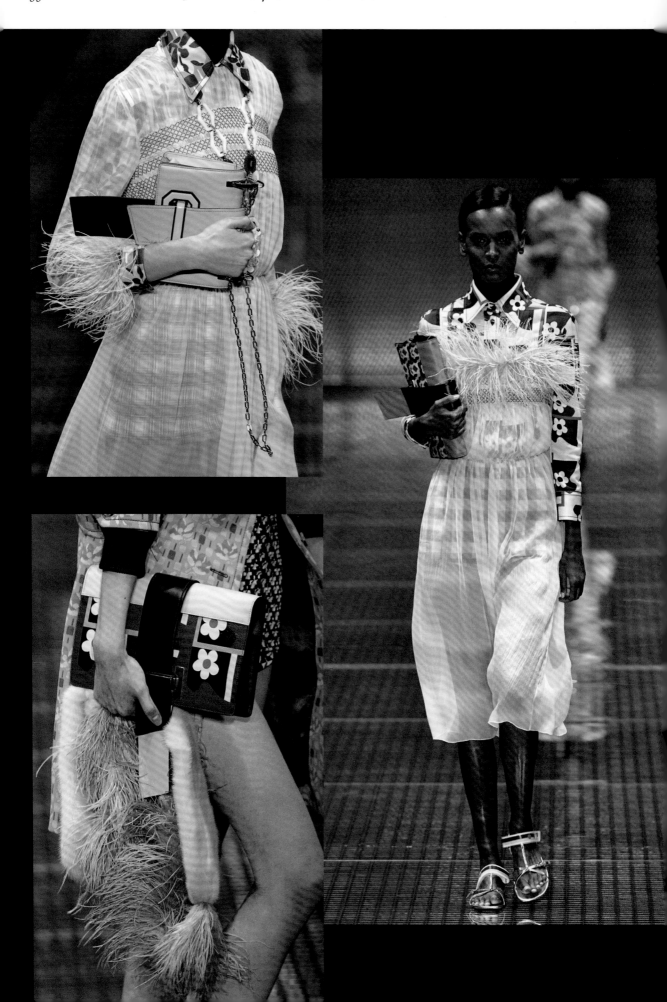

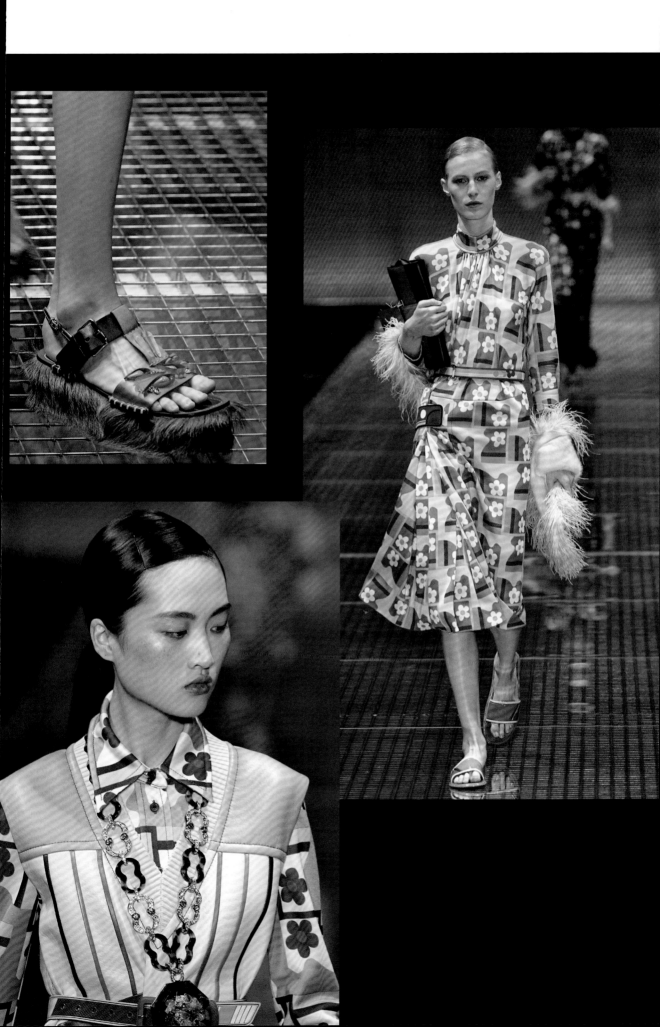

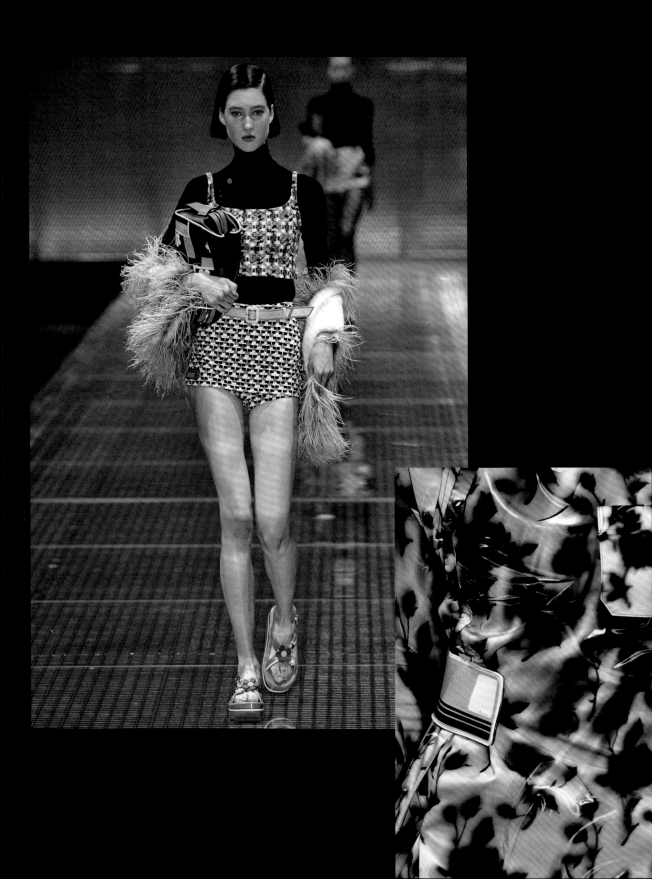

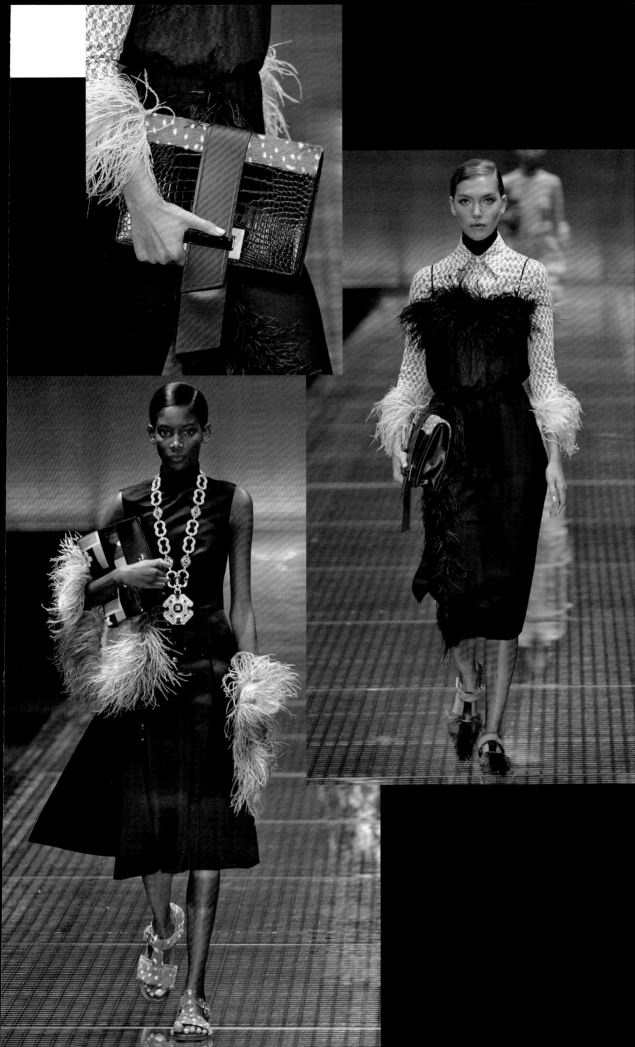

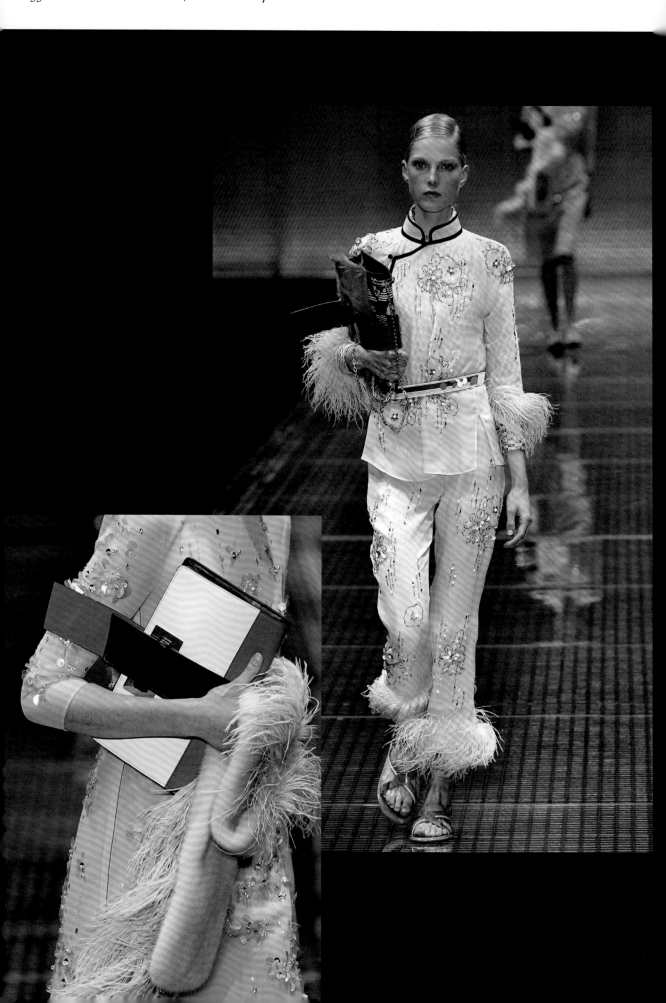

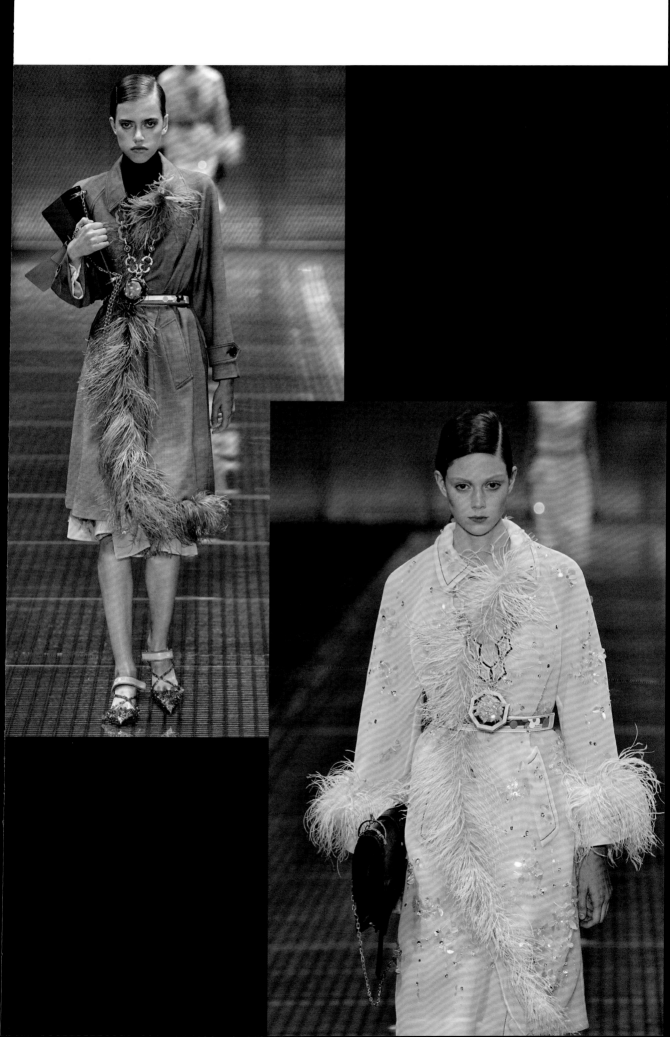

'Fashion is about the everyday and the everyday is the political stage of our freedoms,' read one of many posters covering the walls of the Prada set this season. 'We have decided to look at the role women have had in the shaping of modern society,' read the show notes.

At least some guests took their seats on beds made up with vinyl sheets printed with powder-blue blooms or covered in fluffy faux fur. Artworks were cut out and placed on walls in a manner reminiscent of a rebellious teenage girl's bedroom. The pin-ups, in particular, drew on the art of Robert E. McGinnis, responsible for posters for films including *Breakfast at Tiffany's*, *Barbarella*, *Diamonds Are Forever* and any other Bond classic one might care to mention, and *The Incredibles*. His femmes fatales later appeared on the clothes (pp. 562–63).

'We were doing this set with manifestos that we carefully studied with OMA and Rem Koolhaas because they had to embrace what's happening in the world and to go back to a more sensitive atmosphere,' Miuccia Prada told AnOthermag.com. 'But without being too political because I never want to be too directly political in my job.' Still, this was an exuberant world where women ruled. 'You look at this and you see these women who are beautiful but they are also killers,' she continued with a smile.

Again the 1970s – coinciding, of course, with the second wave of feminism – were mined for inspiration. Apparently contradictory fabrics and colours dominated: rainbow-bright marabou and homey knits, full-length silk charmeuse gowns and thigh-high biker boots. Turquoise blue, mustard yellow, plum and chocolate brown all appeared. Crochet-knit, piece- and patch-working, marabou and more also referenced that decade. 'Do we really still use the same instruments of seduction as we used 50 years ago?' Prada wondered. 'So the problem of women, wanting to appeal, wanting to be beautiful, but how, if you are intelligent, do you do that? It's the usual argument but an argument that was never really properly discussed and which we probably should discuss again.'

The sight of Lindsey Wixson in a cherry red dress with a kick at the hem (p. 560, right) harked back to Prada's own Autumn/Winter 1992–1993 collection (see p. 82, left). 'I was fixated with any hairy material and with the knits, a symbol of women at home but of feminism also,' she said. Chunky knits did appear homespun, and furry panels on dresses and coats were also prime examples of that.

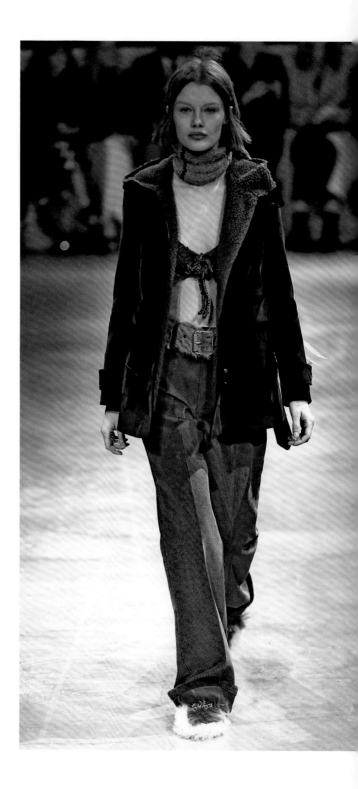

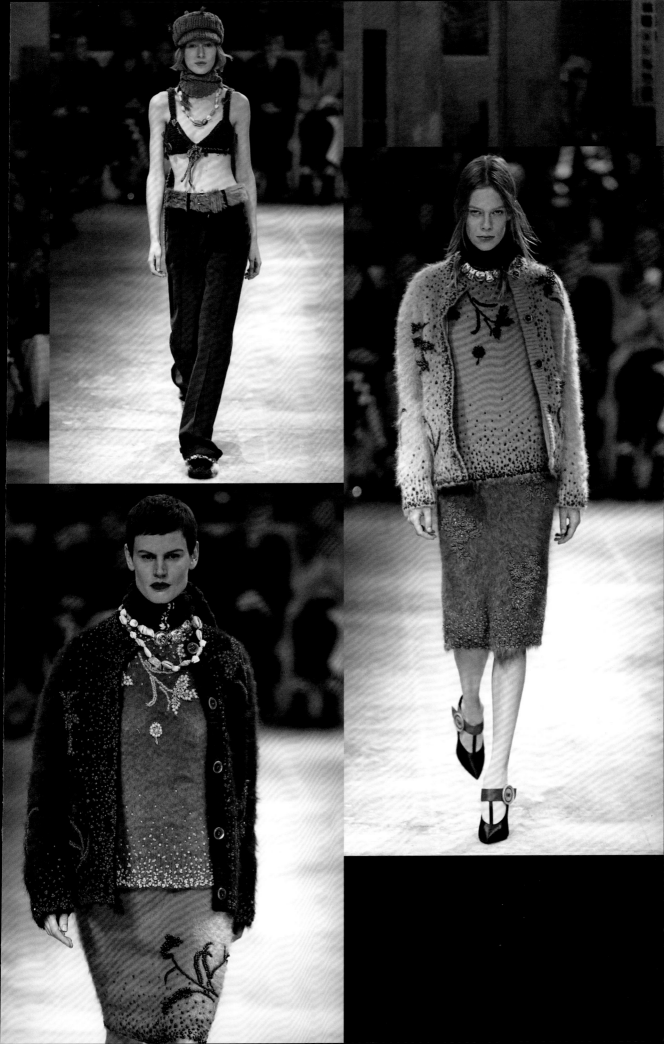

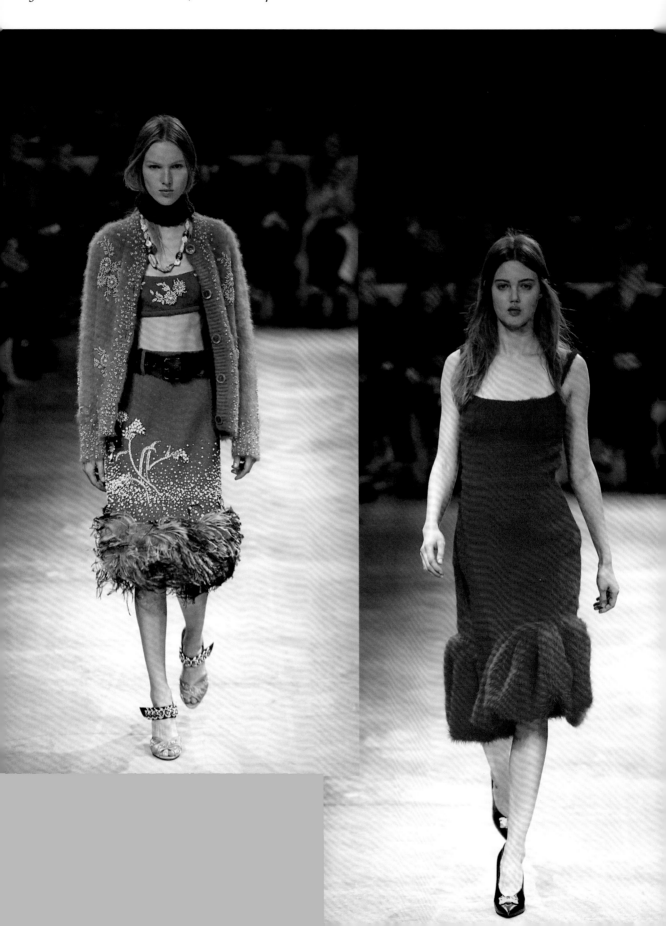

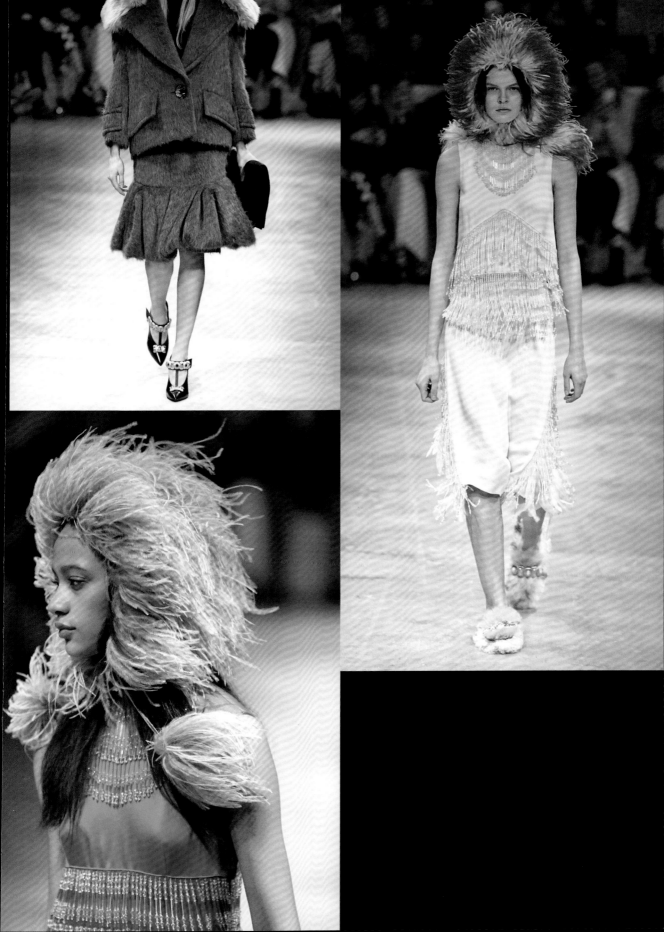

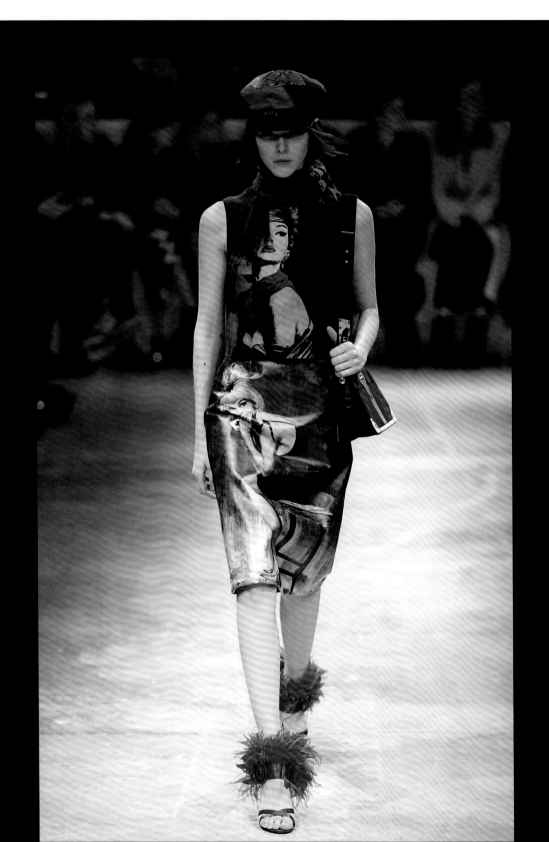

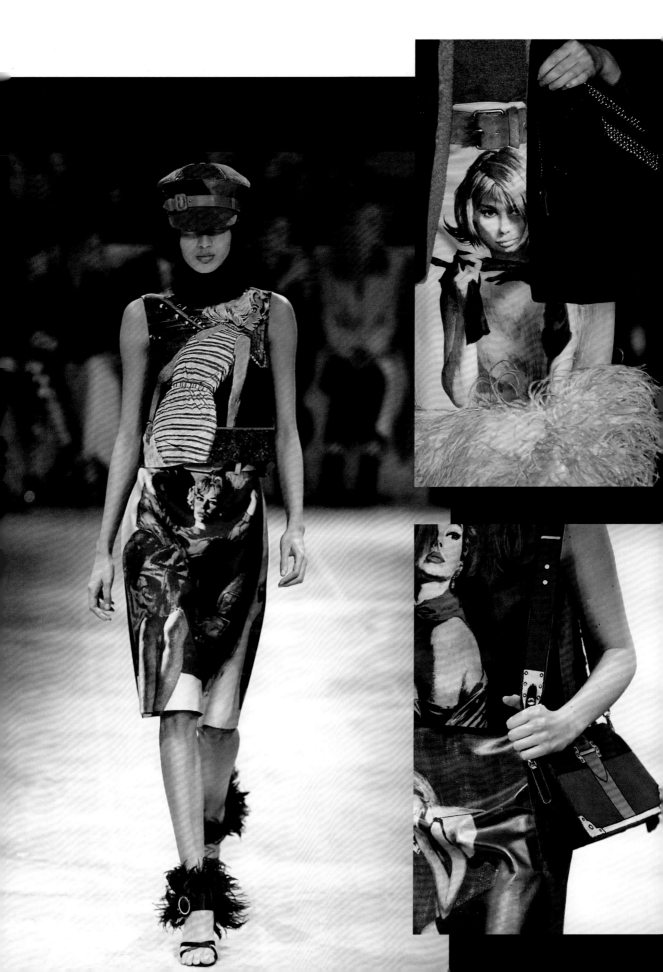

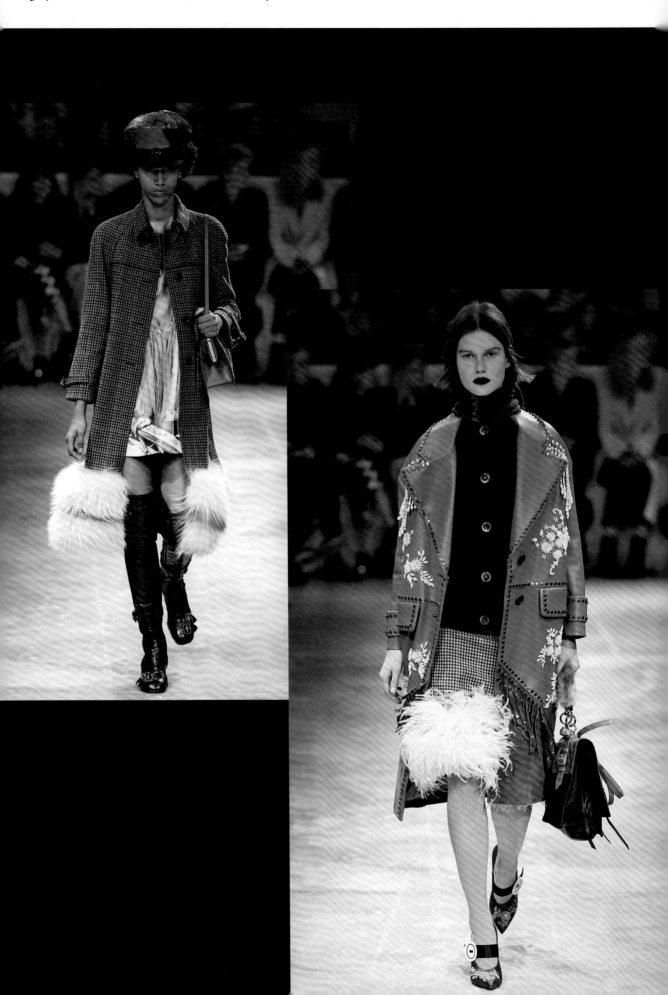

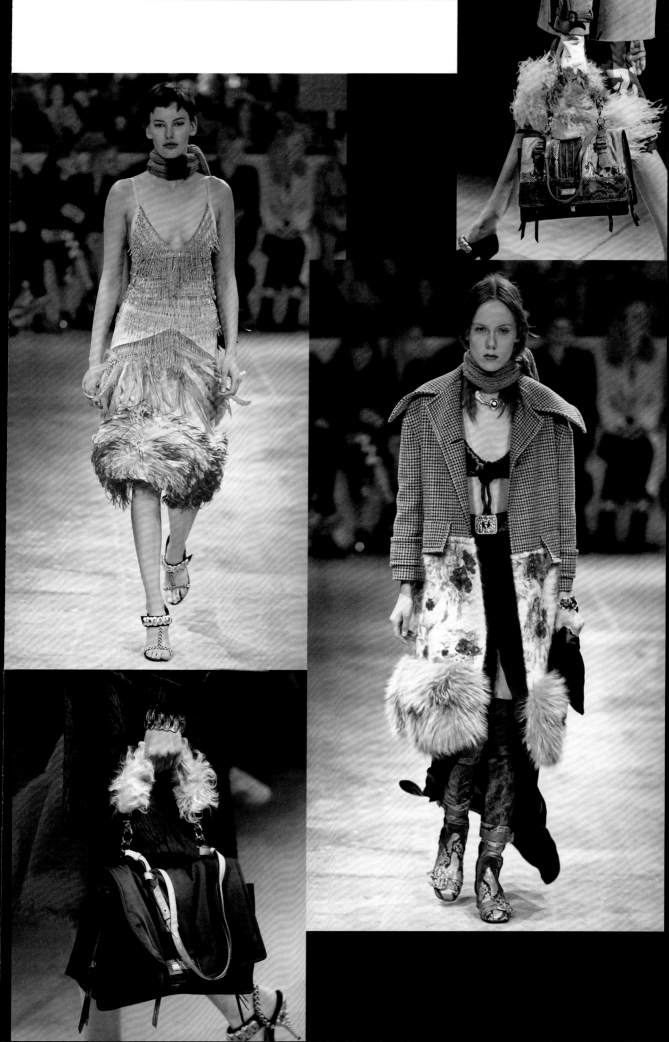

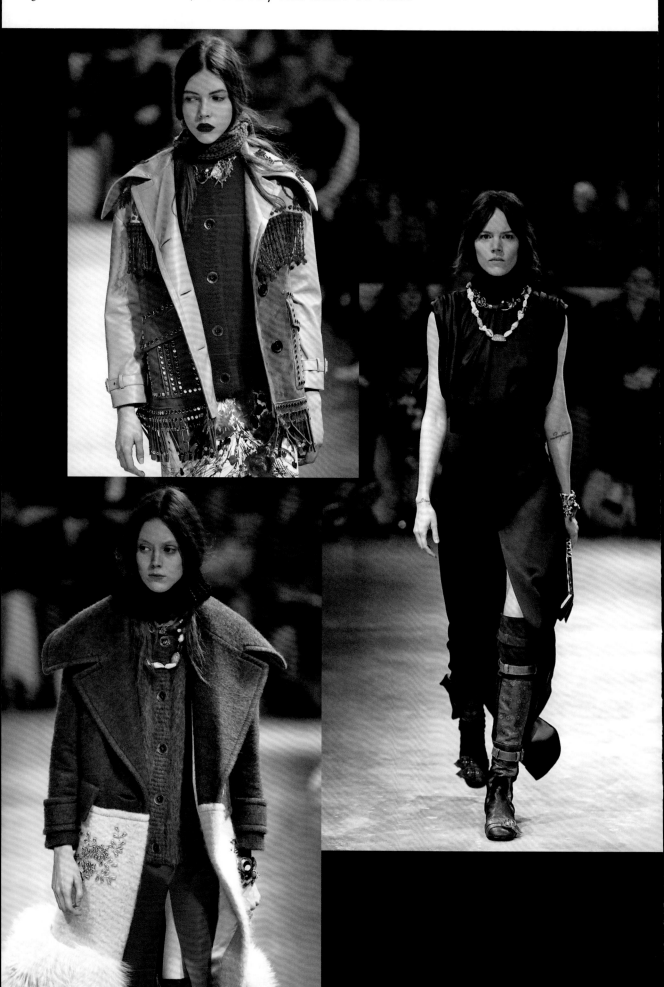

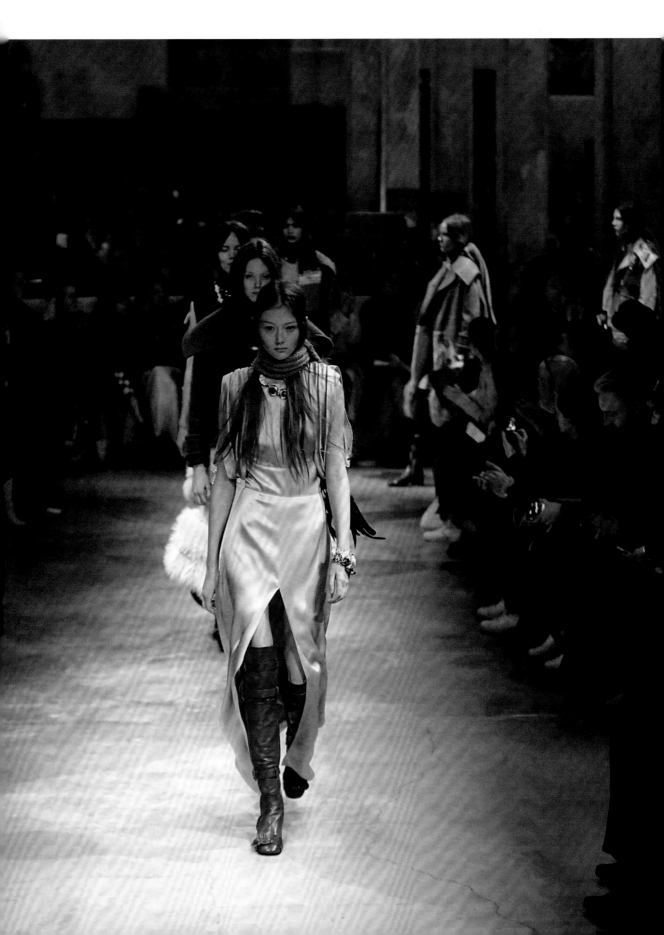

Although Prada had been presenting a small Cruise (or Resort) collection during her menswear shows for some time, this was the first stand-alone collection dedicated to that season. Perhaps ironically, given that Cruise is traditionally aimed at leisurely travel and winter sun, it was unveiled in the company's original home, or at least far above it, in the eaves of the mid-nineteenth-century shopping mall, Galleria Vittorio Emanuele II (the Fratelli Prada store had been opened at ground level there by Miuccia's grandfather, Mario, in 1913). Known as the Osservatorio, given its glass and iron dome, the two upper storeys are now owned by Fondazione Prada and exhibitions exploring 'expressions' of contemporary photography are staged there.

'I never wanted to write "cruise",' the designer told Style.com, on typically contrary form. 'For me a show is a show. They said it was better to understand so I said okay.' She went on to describe the collection itself as 'modernist'.

The location was not the only thing that saw Prada going back to its roots. Black Pocono nylon – not the famous black nylon backpack with which Miuccia Prada launched her career and which had been formally re-introduced in 2015, but now in the form of clothes – was first out. There were sporty separates: zip-fronted bombers and trackpants, slip dresses, shorts and miniskirts, all finished with utilitarian Velcro patches. James Jean, the artist responsible for the fantastical illustrations in the Spring/Summer 2008 collection (p. 376) made a comeback, too. This time lilies and rabbits took the place of eroticized fairies leaping across bags and then more clothes.

As the medium dictates, this was a compact and accessible affair: sheer rectilinear tunics in metal organza were worn over visible underwear; more were ruffled at the hem or neckline, and bra details – frilled and more sporty – loomed large. Not that there was anything conventionally sexualized about the look. Instead, feather head-dresses were teamed with chunky trainers or pumps with heels reminiscent of an upturned Eiffel Tower.

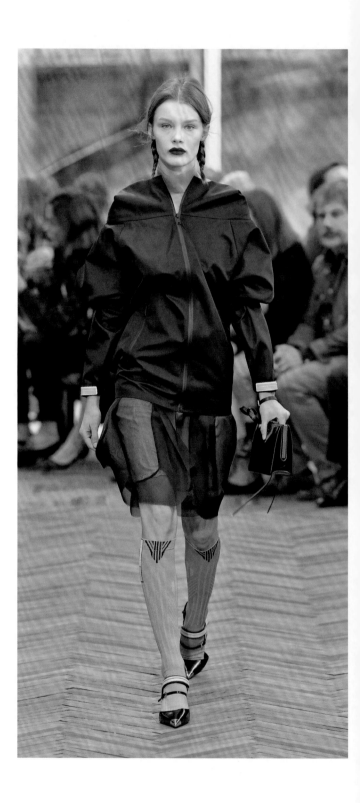

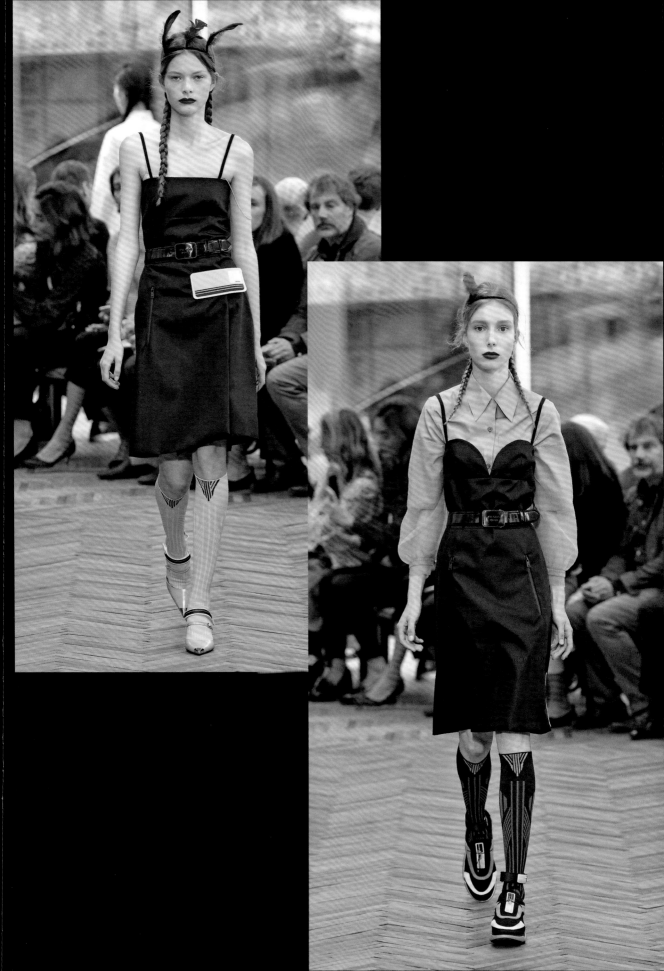

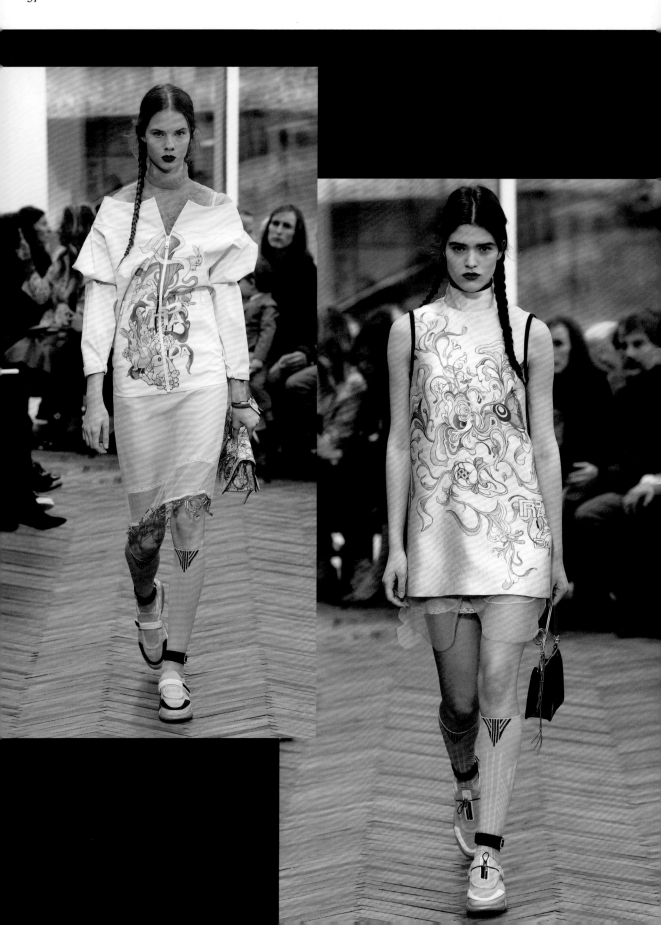

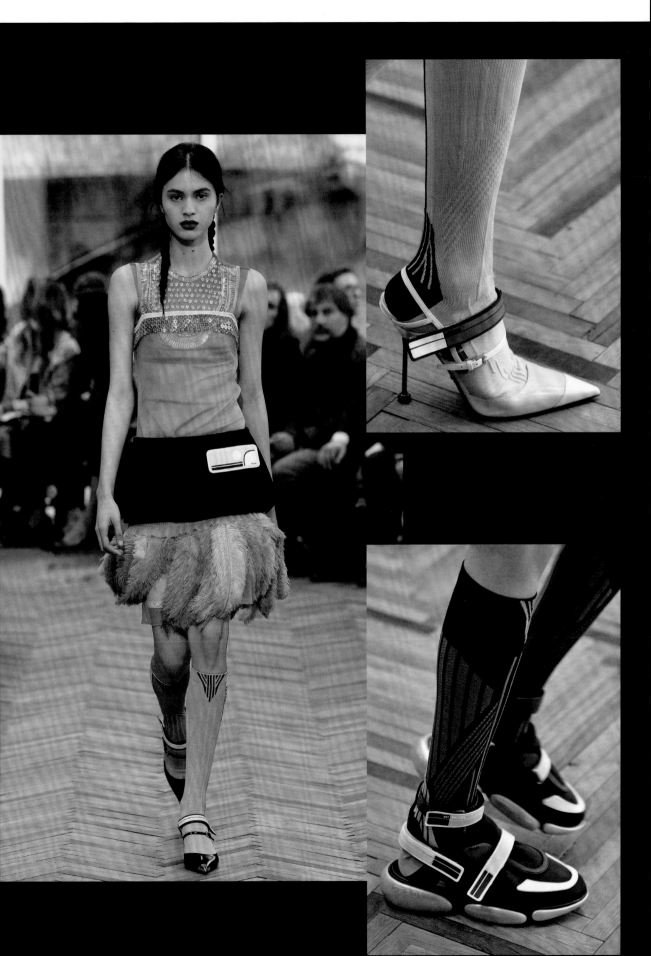

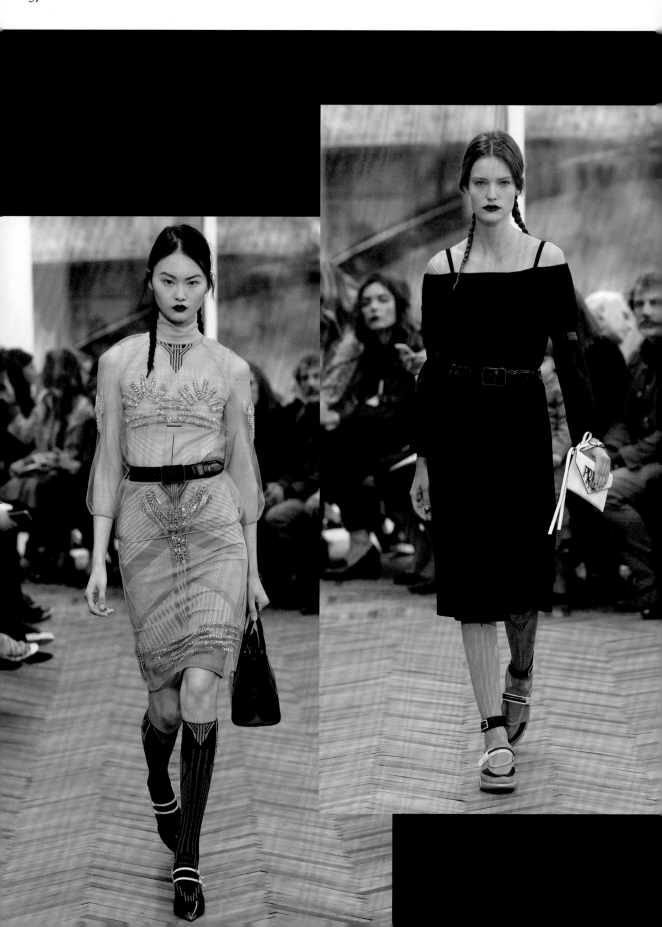

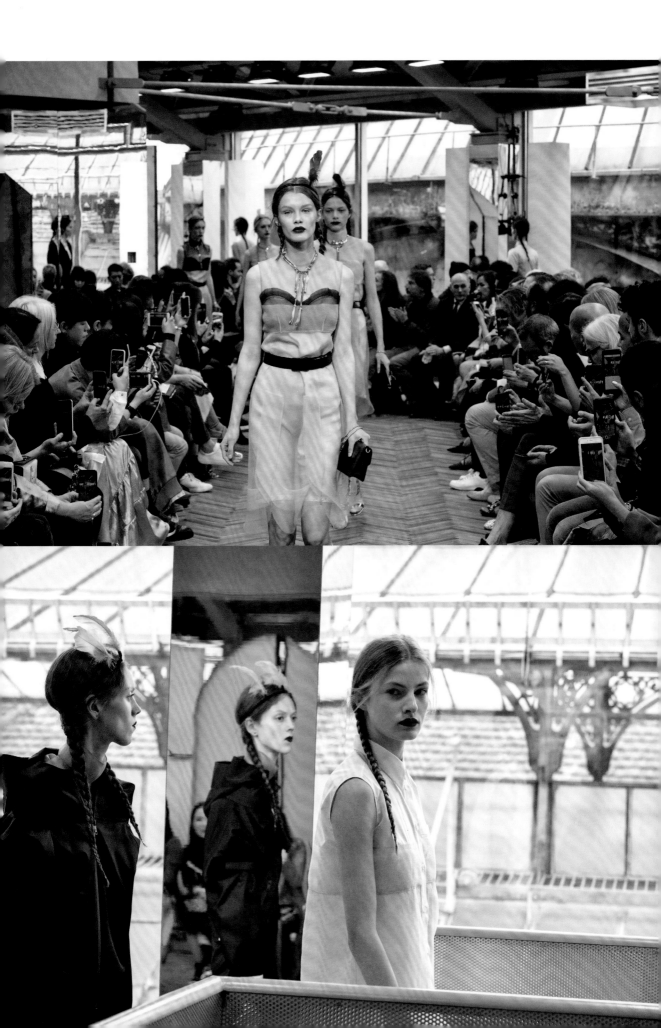

The backdrop this season comprised comic-strip images of women, drawn by women – 'more Angela Davis than Wonder Woman', Miuccia Prada told AnOthermag.com. The designer's research team gathered together the work of female artists from the 1930s to the present day, and Prada edited them down to just eight contemporary names – Brigid Elva, Joëlle Jones, Stellar Leuna, Giuliana Maldini, Natsume Ono, Emma Ríos, Trina Robbins and Fiona Staples – and additionally pulled from the archive of Tarpé Mills. 'I chose the ones that fit my ideas of what a young, combative, militant woman should be. I wanted multiple personalities and to see the human side, the simple side, the underestimated side of women. I chose women who were real, more normal, maybe not beautiful, not superheroes,' the designer elaborated.

There was a youthfulness to this collection that suggested rites of passage and an exploration of gender identity. The masculinity of striped schoolboy shorts and knitted tank tops in violent shades of green, lemon and flame and crawling with insects was undercut by a pink and gold brocade bustier wrapped around a shirt, say (opposite, right), or that same rich, rosy fabric flouncing at the hem of an animal and graphic print dress with a neat white collar. In place of the previous seasons' feathers came heavy metal studs, across accessories and masculine leather jackets and coats. Further embellishment included messy clusters of brightly coloured stones and paillettes and cut-out, pieced and patched illustrations of women.

Prints comprised more comic strips and a warped herringbone design. In a world where digital technology dominates, at Prada garments were screen-printed flat in their entirety, meaning that any creasing resulted in negative space, a disruption that was deliberately difficult to read. A large part of the collection, Prada explained, was designed in the first place in white: 'On the white canvas we printed my ideas, the clothes were a canvas for thought,' she said.

On models' feet were flat studded sandals, neoprene rubber-soled slippers in sporty primary shades or printed kitten-heeled courts sprouting polka-dotted silk or blue-and-white-striped cotton bows and more shiny stones, many of them worn with knee-high socks first seen in the Cruise 2018 collection (pp. 568–72). Round models' necks were enamelled crucifixes, bananas and baubles, from spooky to sweet.

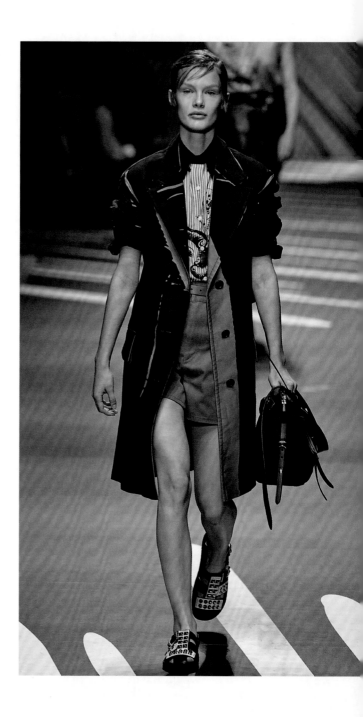

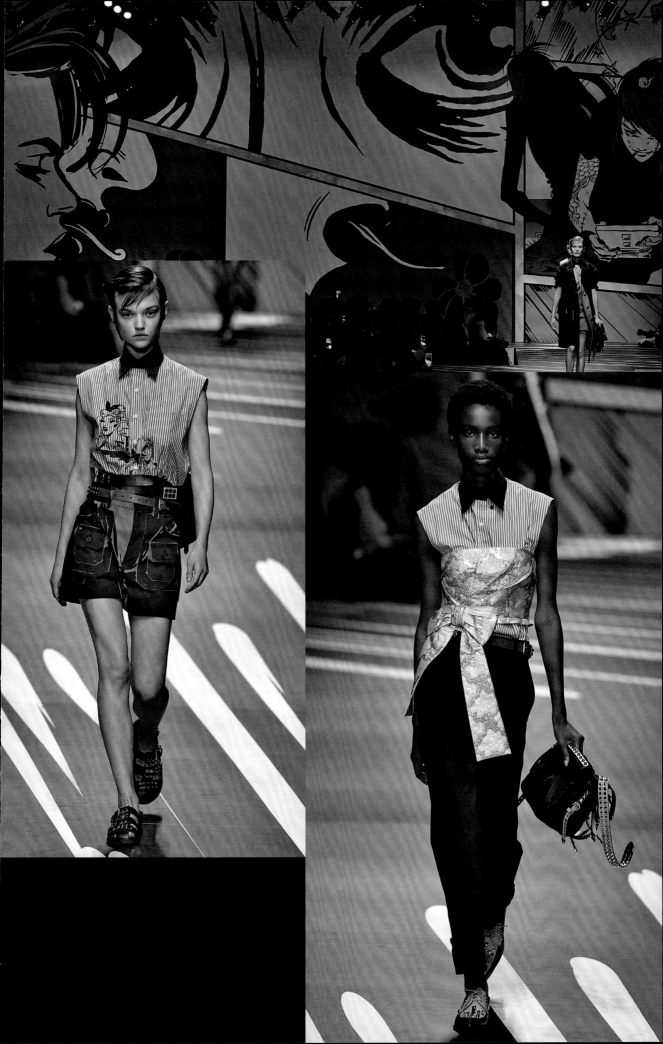

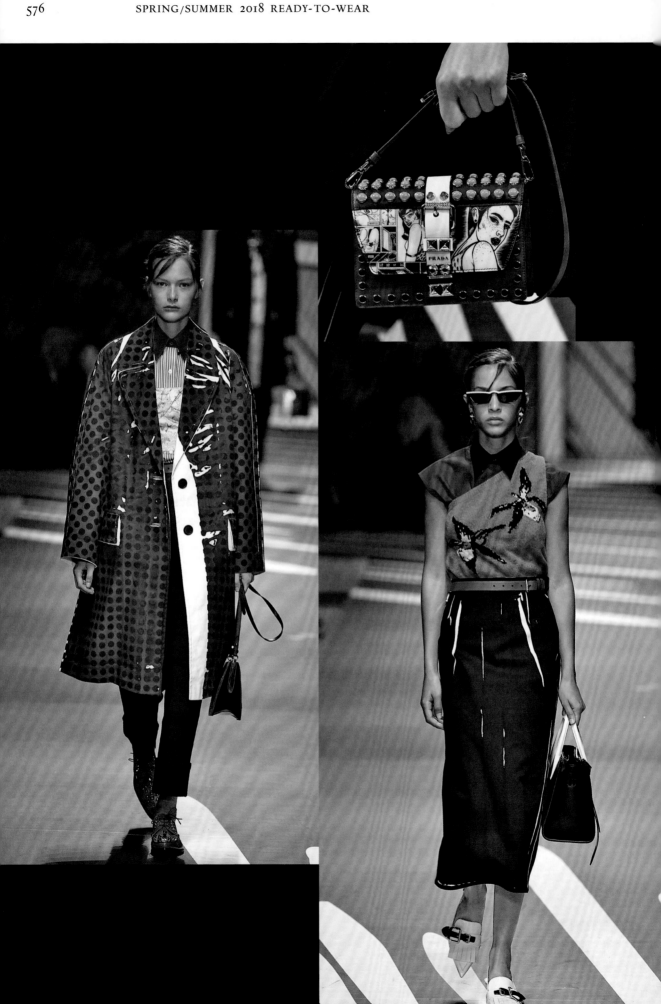

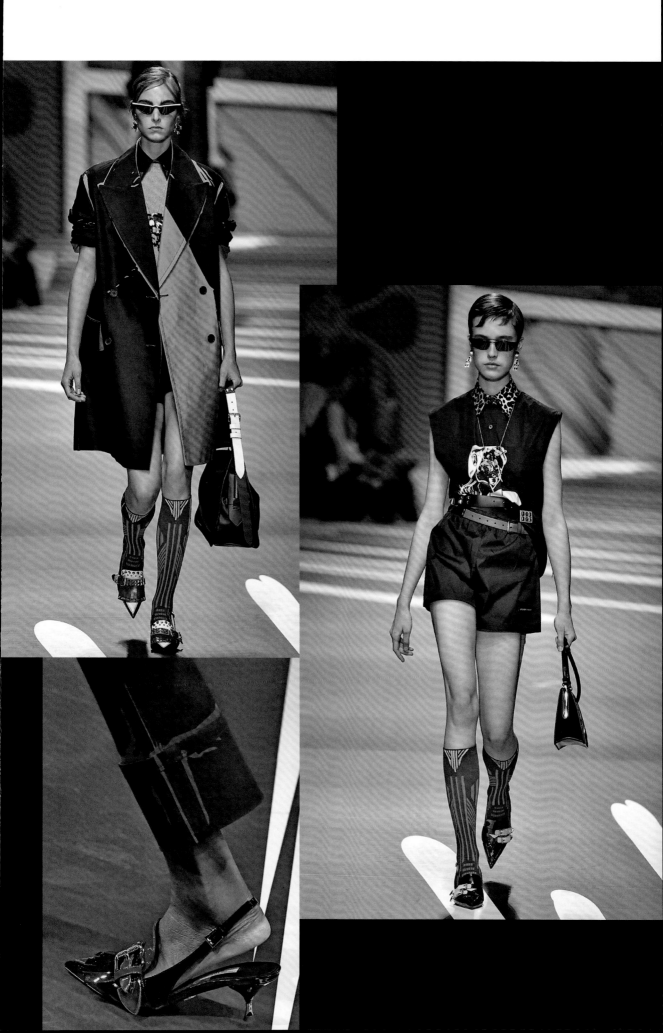

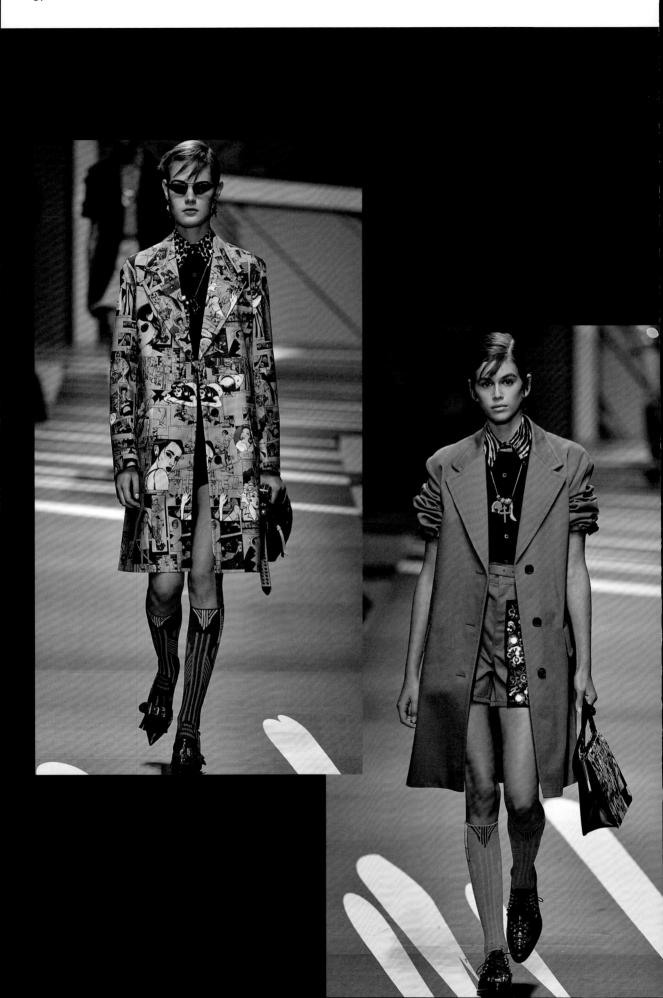

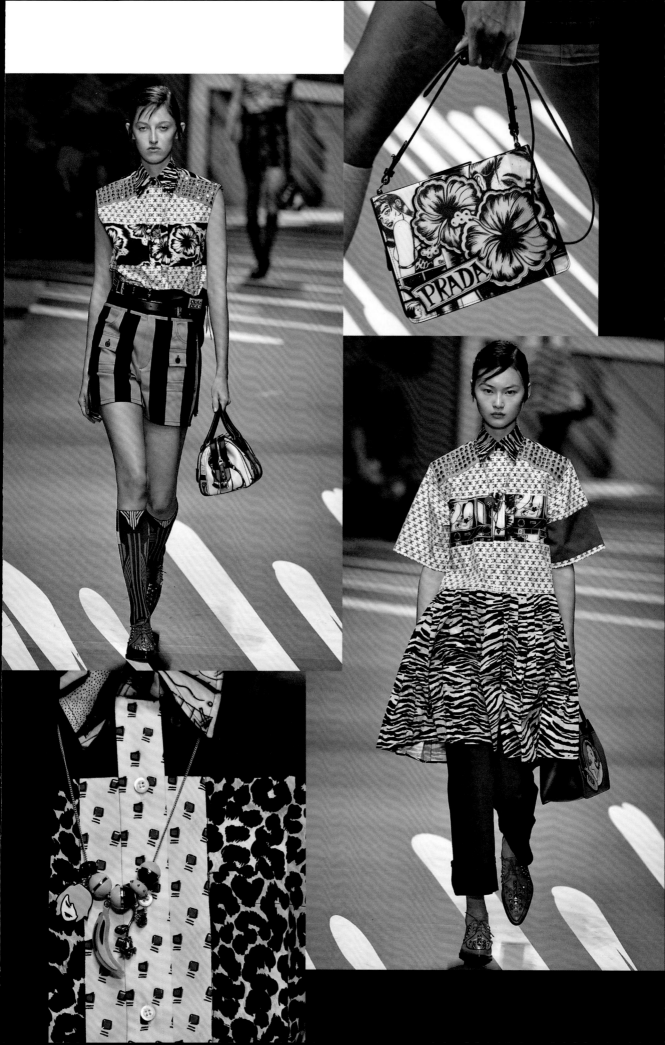

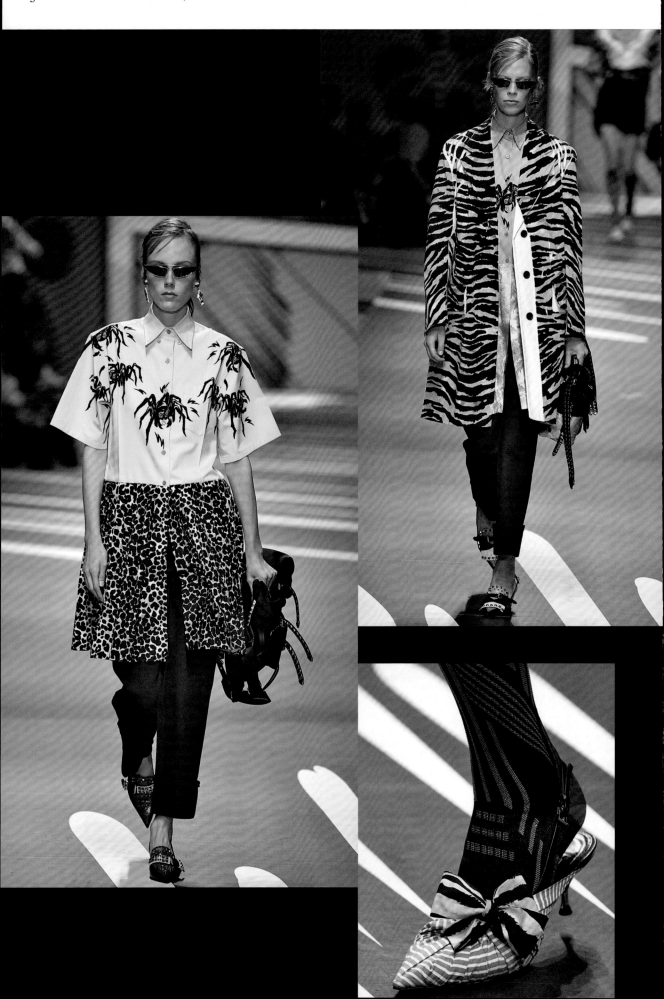

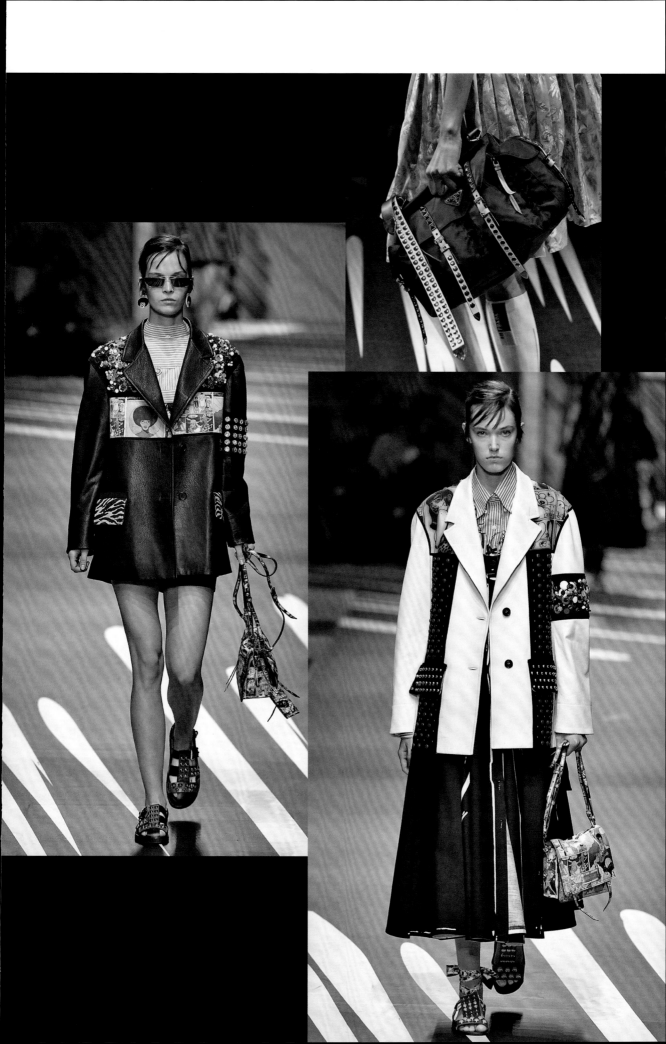

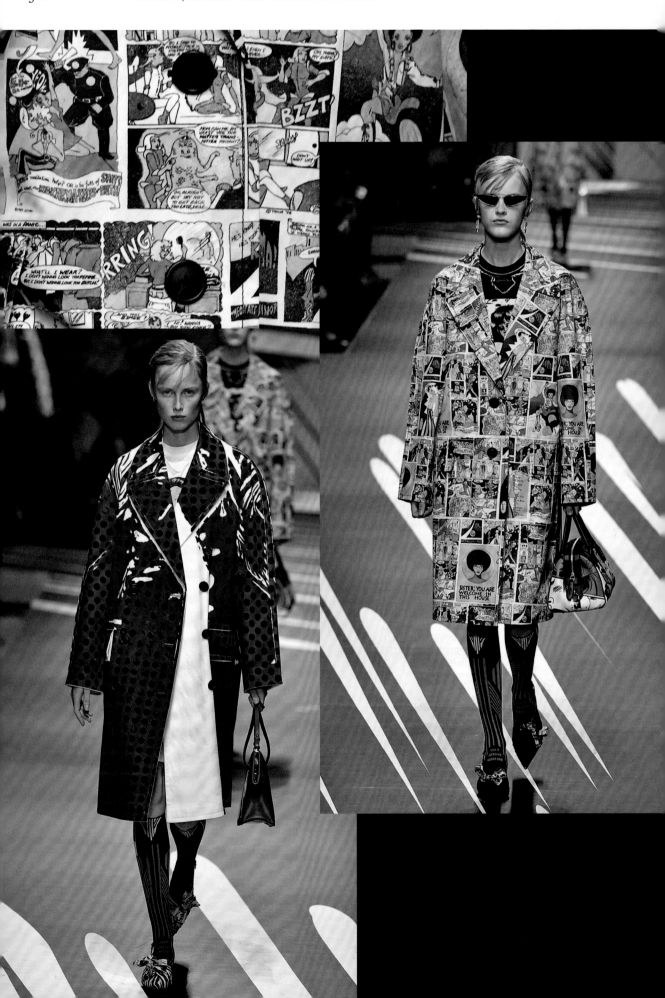

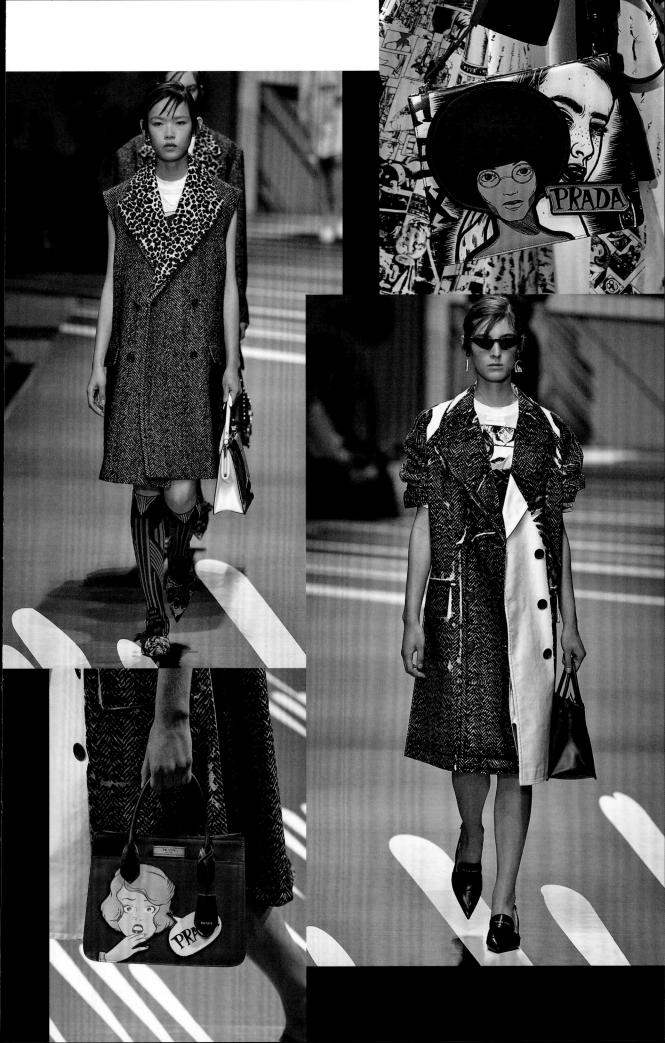

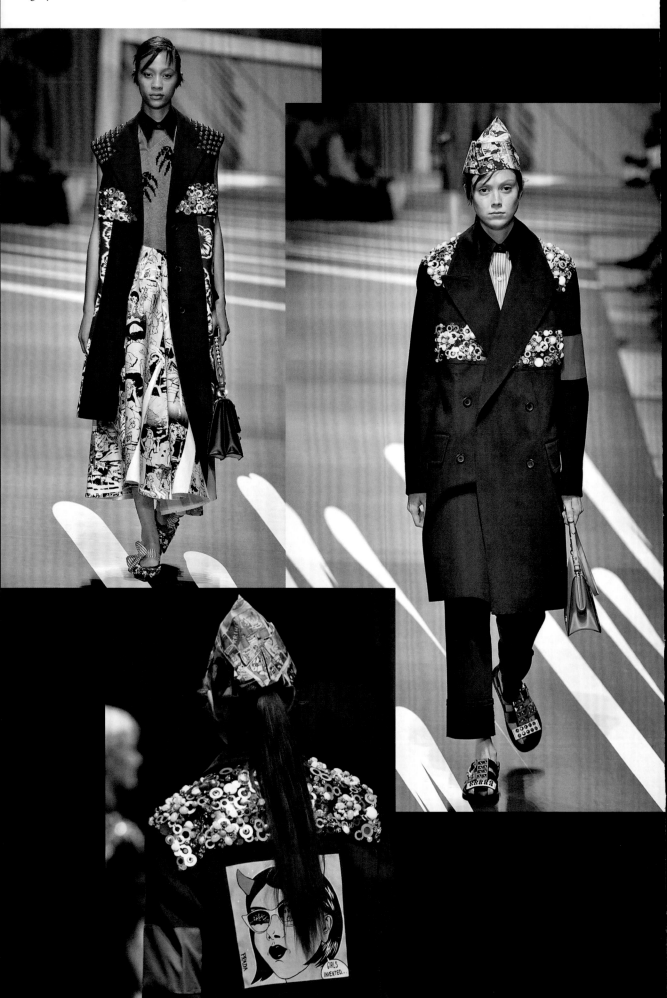

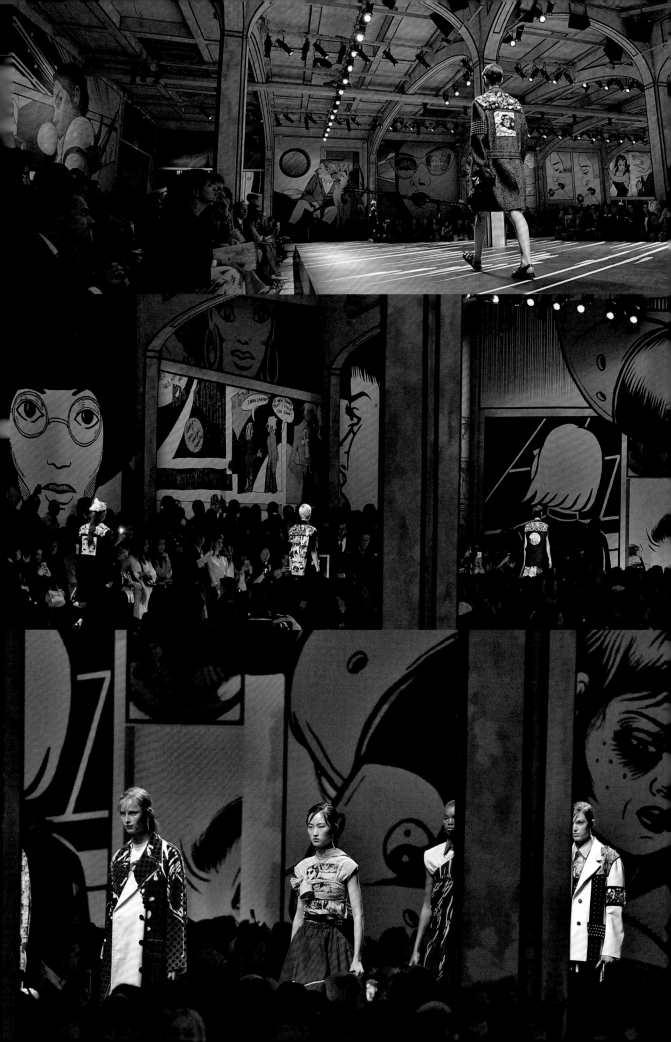

'If ever a designer were made for the #MeToo moment, however, it would seemingly be Miuccia Prada, a woman who has spent her career exploring the shifting, often uncomfortable, balance between femininity and force', wrote Vanessa Friedman in the *New York Times* after this show. It was certainly a prime example of that.

Presented on different storeys of the recently opened Rem Koolhaas-designed tower in Milan, an extension of the Fondazione Prada, the new collection was sent out onto a disorienting black mirrored runway against a backdrop of floor-to-ceiling windows and a dark sky cityscape lit up by neon Prada signs: a bunch of bananas, a monkey, a spider, a dinosaur, a flaming-heeled shoe.

Once again the story was built upon extreme paradox: strength and vulnerability, masculinity and femininity, the utilitarian and the decorative. The list goes on. Oversized padded outerwear in fluoro shades was layered over and under tulle, sometimes plain, sometimes embroidered with jewels and stylized flowers. Rubber rain-boots had high block heels and drawstring nylon tops; pleather coats dwarfed the models wearing them and had faux fur cuffs. Huge Fair Isle-style knits were worn over tweedy knee-length skirts and under even huger plaid jackets, their colours and cuffs edged with more nylon. Warped.

As the show drew to a close the outerwear returned, this time paired with rectilinear plastic sequinned shift dresses in violent pink, orange and lime. In cloche hats or with giant bows tied in their hair, models looked as fabulous as they did fierce. Prada wanted 'any woman to be able to walk on the street late at night and be super sexy without being afraid,' she said. 'The whole point of my job is trying to understand how women can be powerful but also feminine, and be believed and stay respected when everyone assumes those things mean you don't care about clothes.'

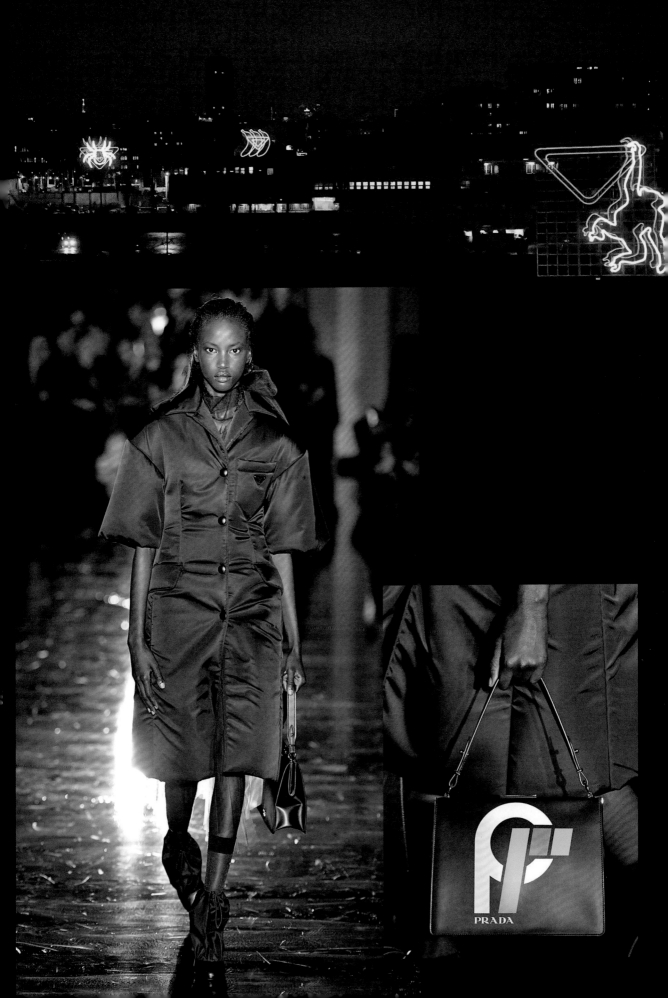

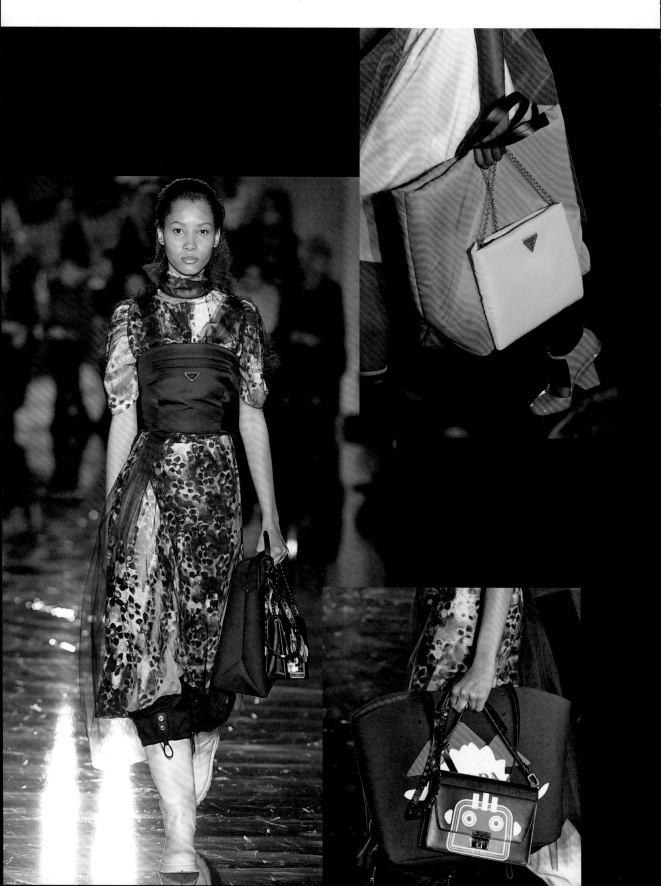

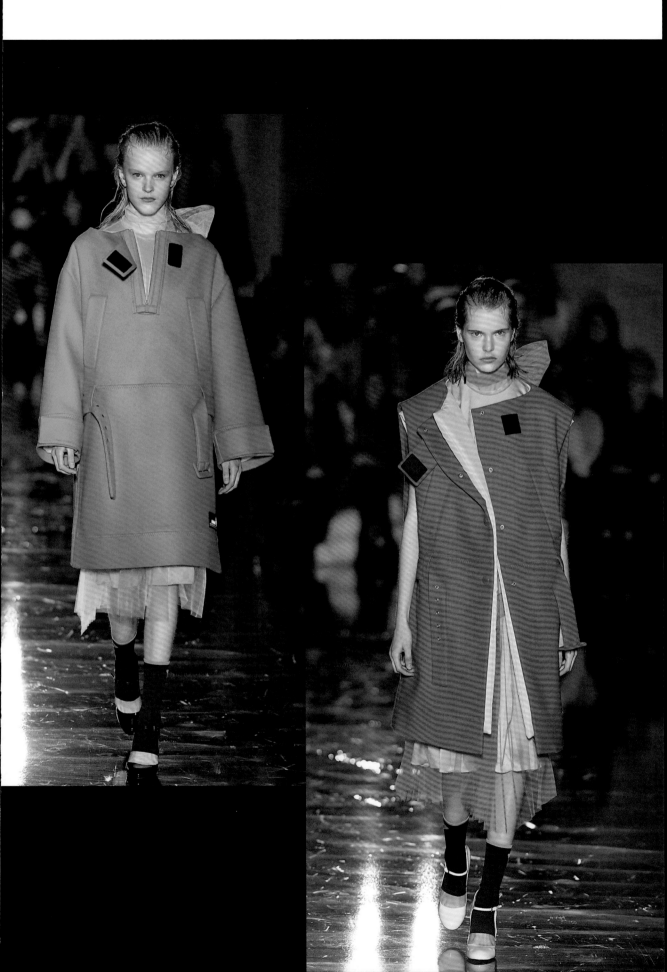

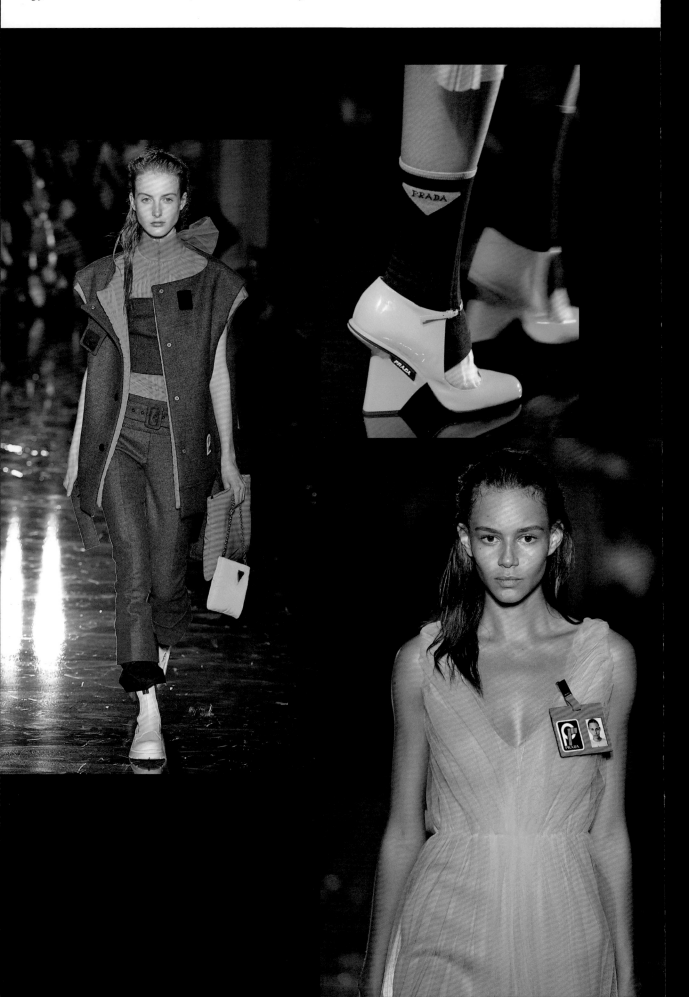

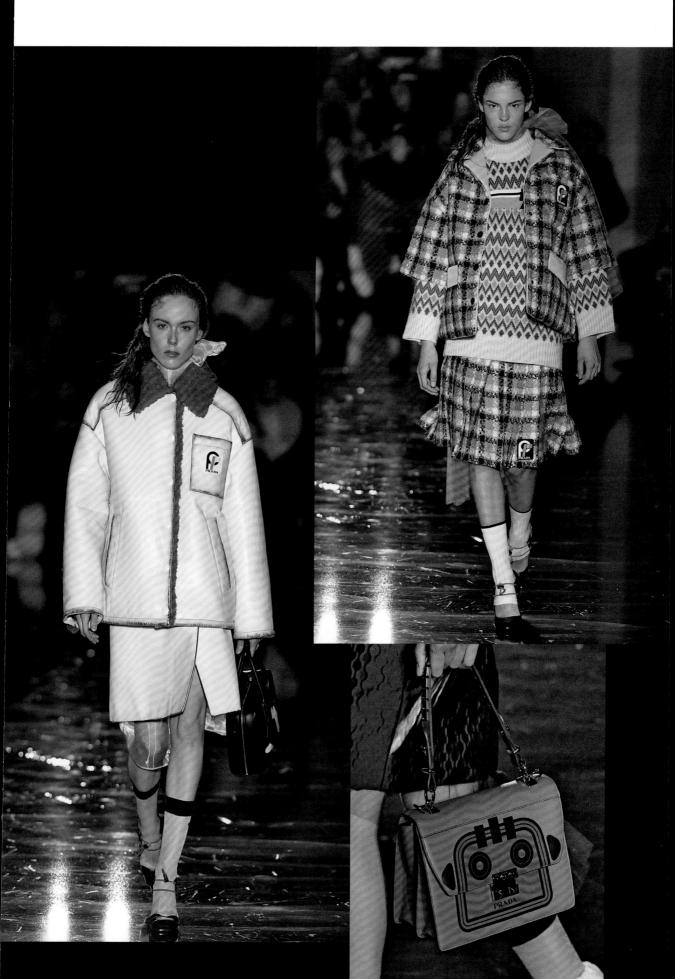

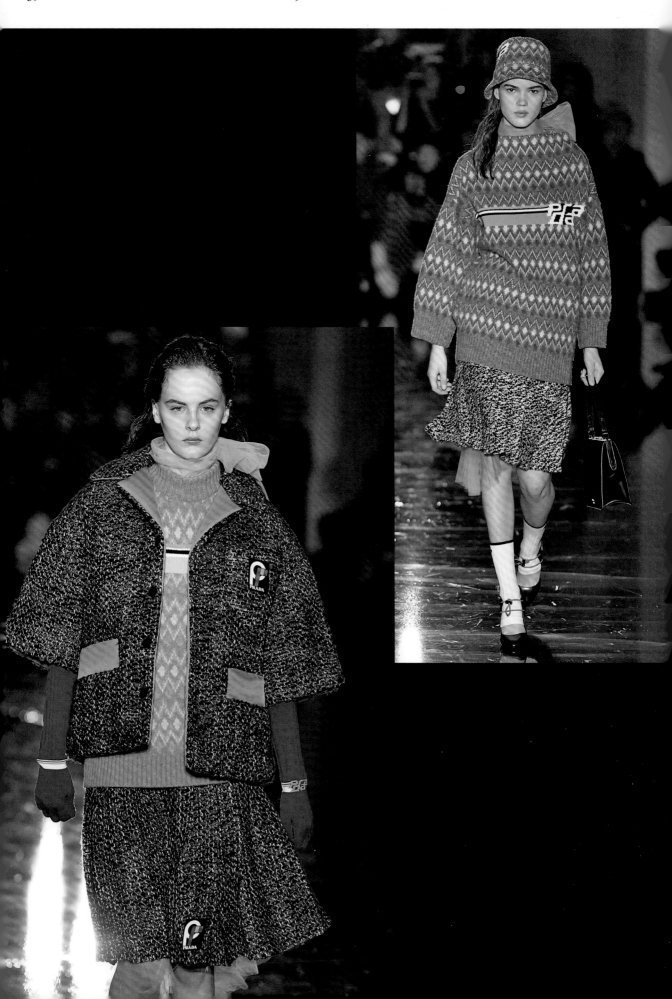

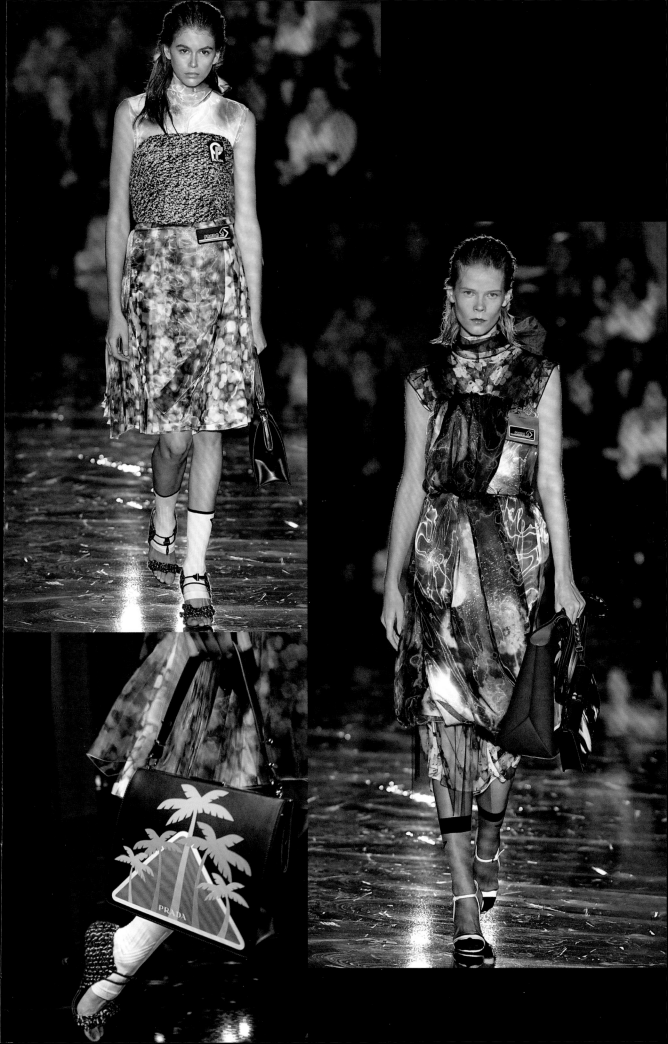

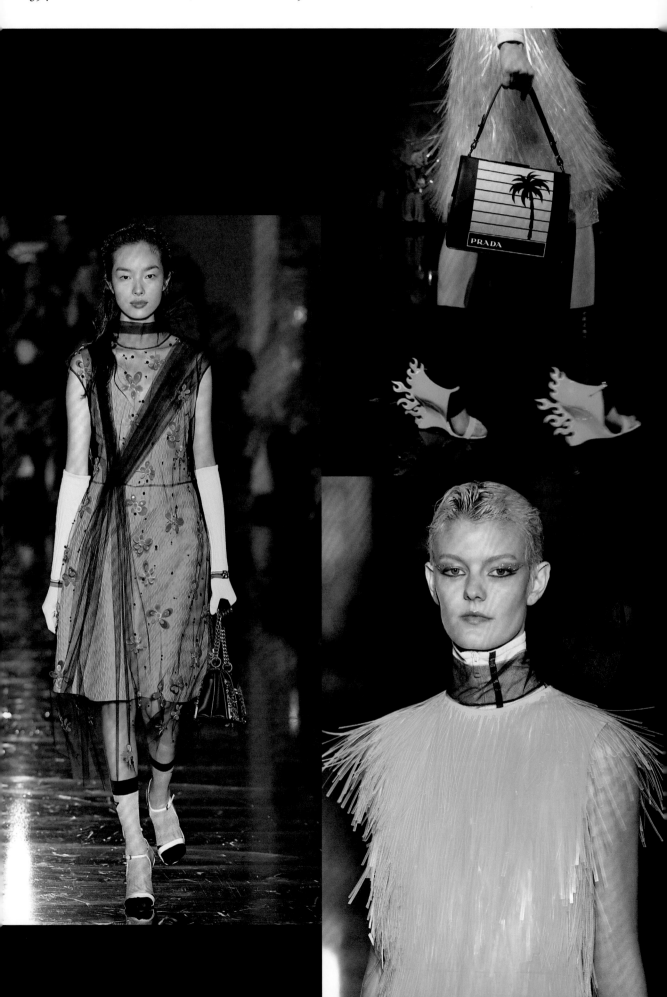

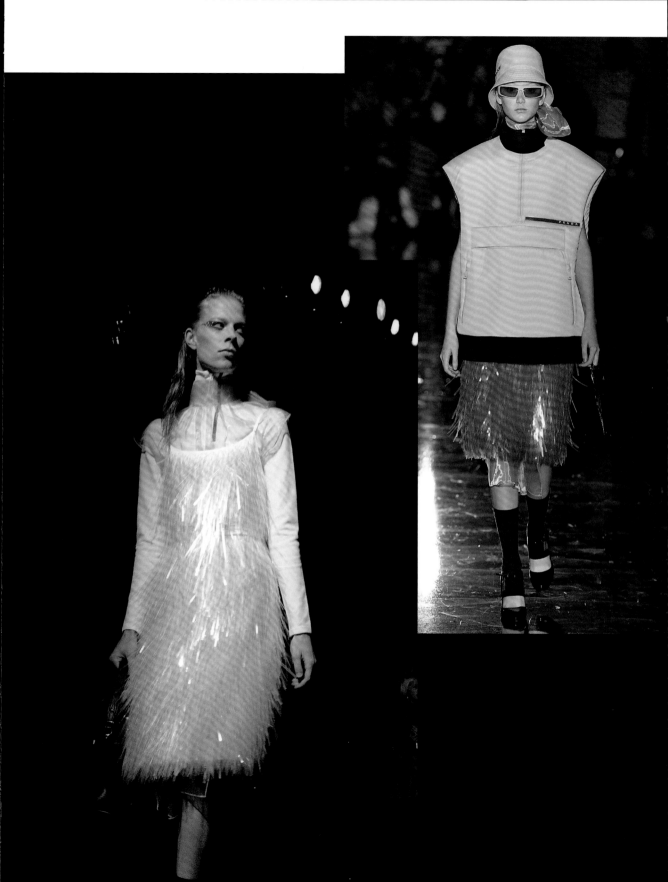

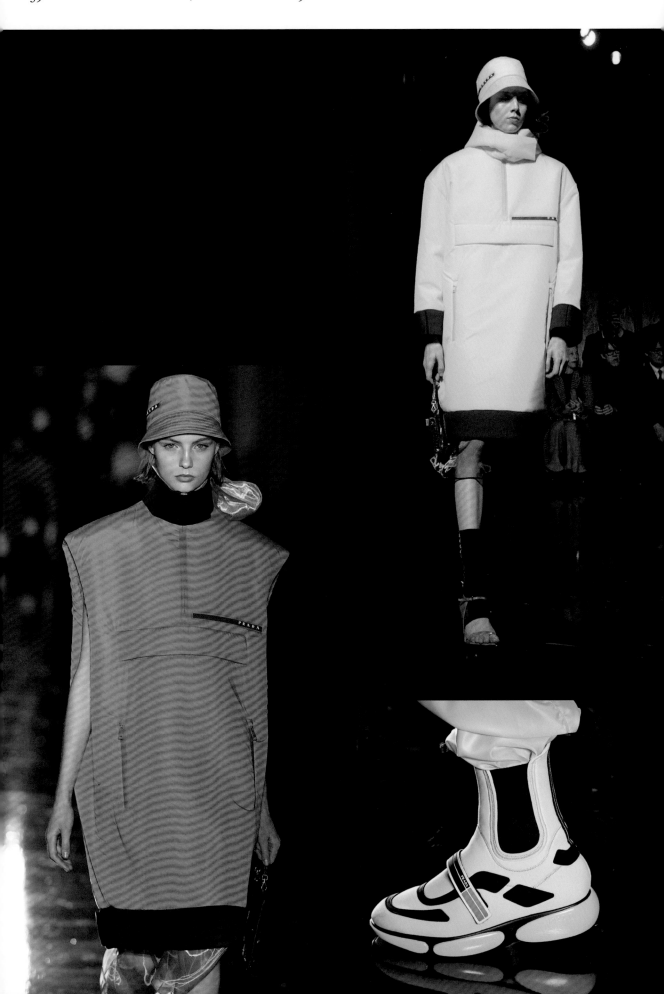

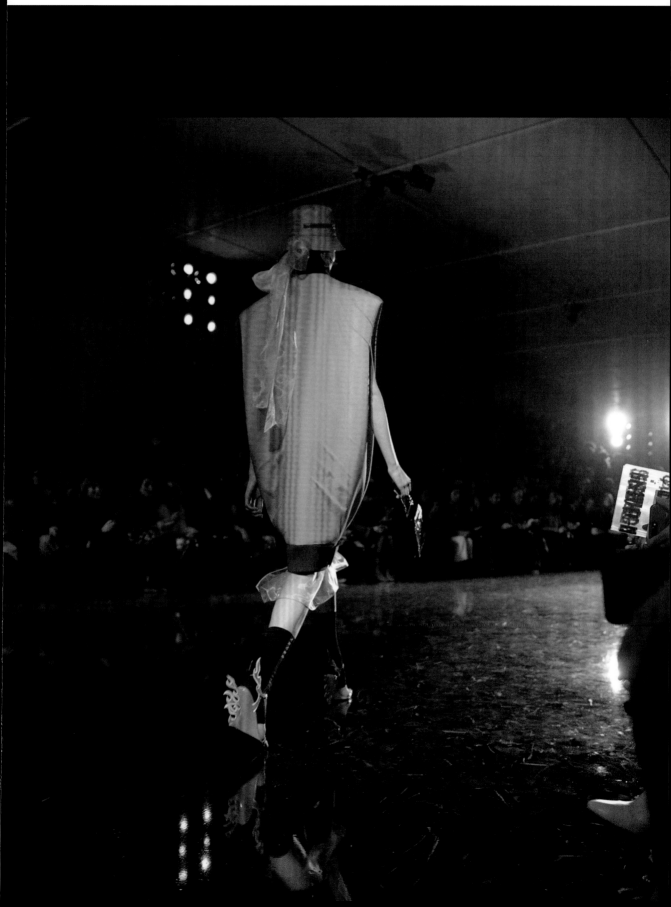

If Cruise collections are today big business, that message was communicated directly in Prada's second stand-alone presentation for this particular season. Not only was it the first Prada show to be staged outside of Milan (the company had reshown collections in countries other than Italy in the past, but never debuted them), it was also presented in Prada's corporate Herzog & de Meuron-designed New York City offices, which, though nothing if not impressive, are grounded very much in reality – and in business, neatly enough. Only serving to amplify any impact, the presentation was also live-streamed on Times Square.

Backstage afterwards the designer told AnOthermag.com that she wanted to 'stay away from big drama'. There was certainly a clarity to the message here and a straightforwardness to the clothes themselves – such things being relative, of course. They were always the focus. The silhouette was slender and – with the exception of the odd low-slung over-the-knee skirt – elongated throughout. That is a look associated with the Nineties, the period during which this fashion super-power truly began to make her mark and which she carries with her to this day. References to that decade – and indeed to Prada's own archive – didn't stop there. They were very much in evidence in bizarrely coloured geometric prints: in places these were over-embroidered to typically disorienting effect. Again, blink and you might miss such a detail, but it was central to the discourse.

'I want this to feel real, without losing fantasy,' Miuccia Prada continued, however. There was certainly an earthly beauty to snake-hipped leggy trousers, skirts and overcoats, and any richness – shimmering florals and brocades – was often undercut by more sporty optic white designs, as in T- and polo shirts with primary colour-blocked short sleeves and collars. Oversized brocade deerstalker hats – once again, how Nineties – were the single horizontal feature that balanced the otherwise rail-thin line. They were also the most frivolous flourish, and even then would be guaranteed to keep ears warm of a frosty Manhattan evening.

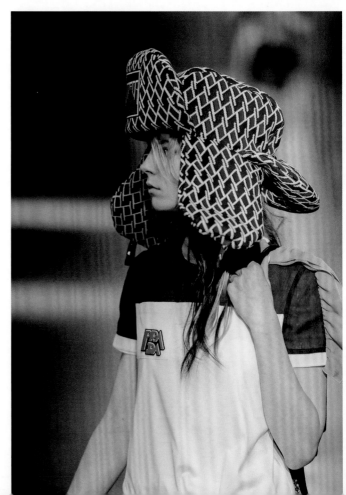

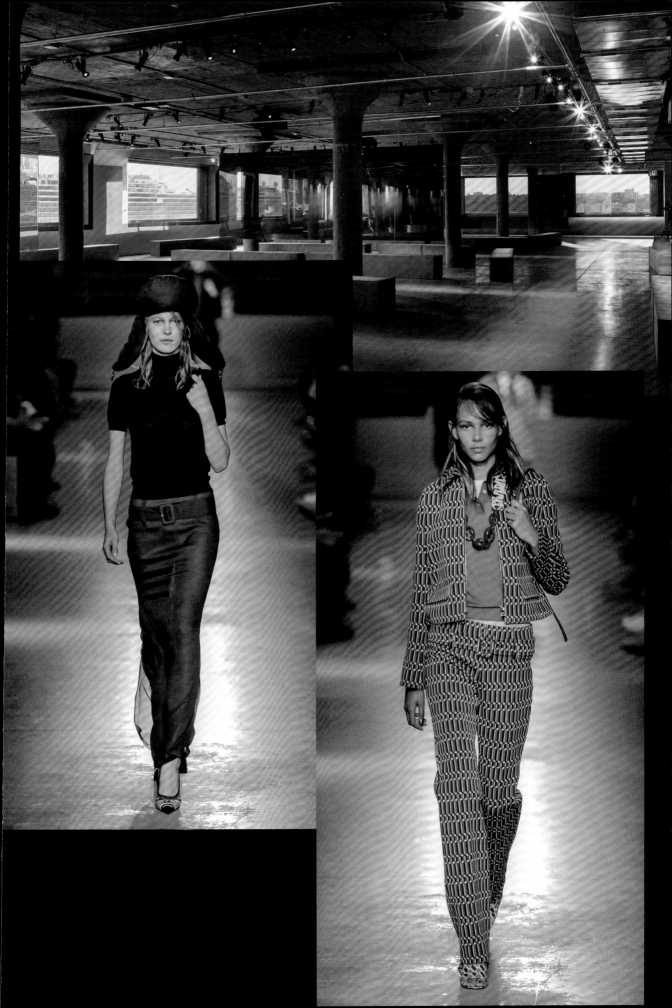

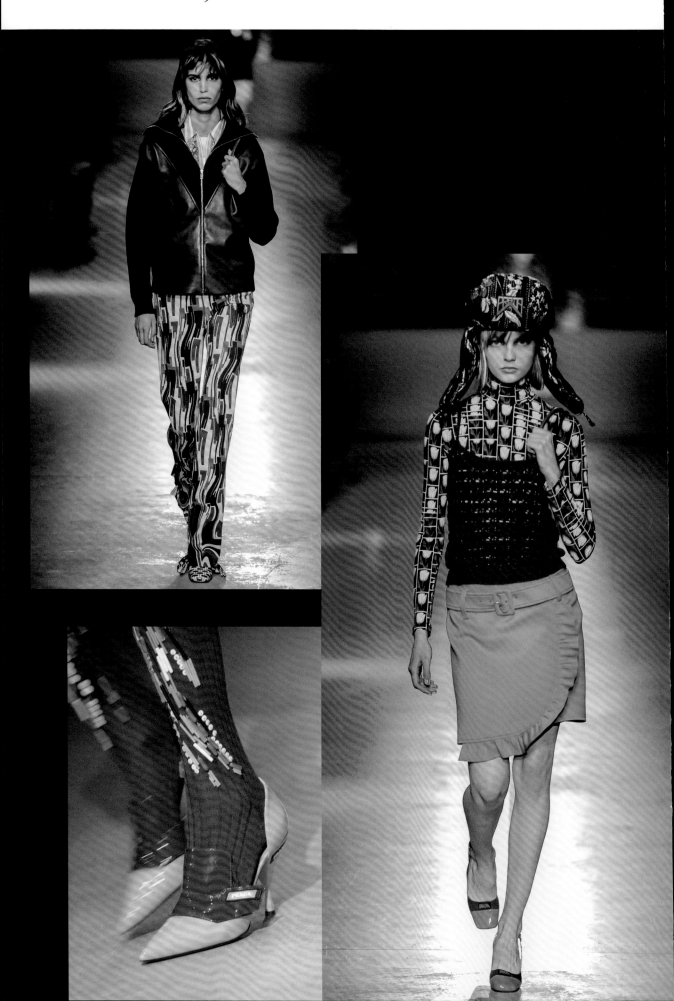

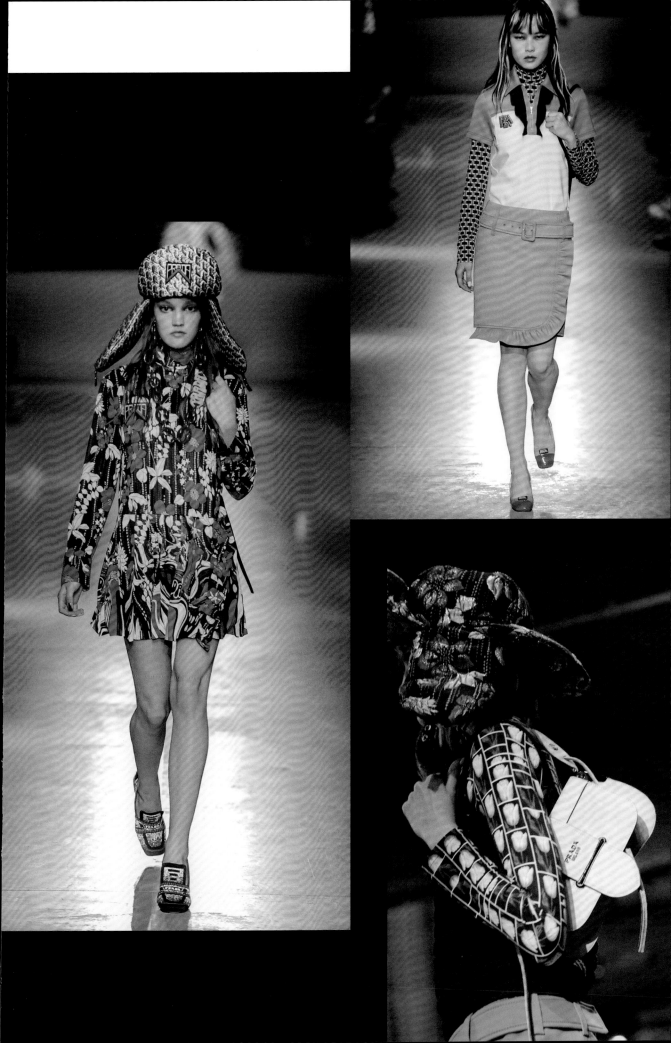

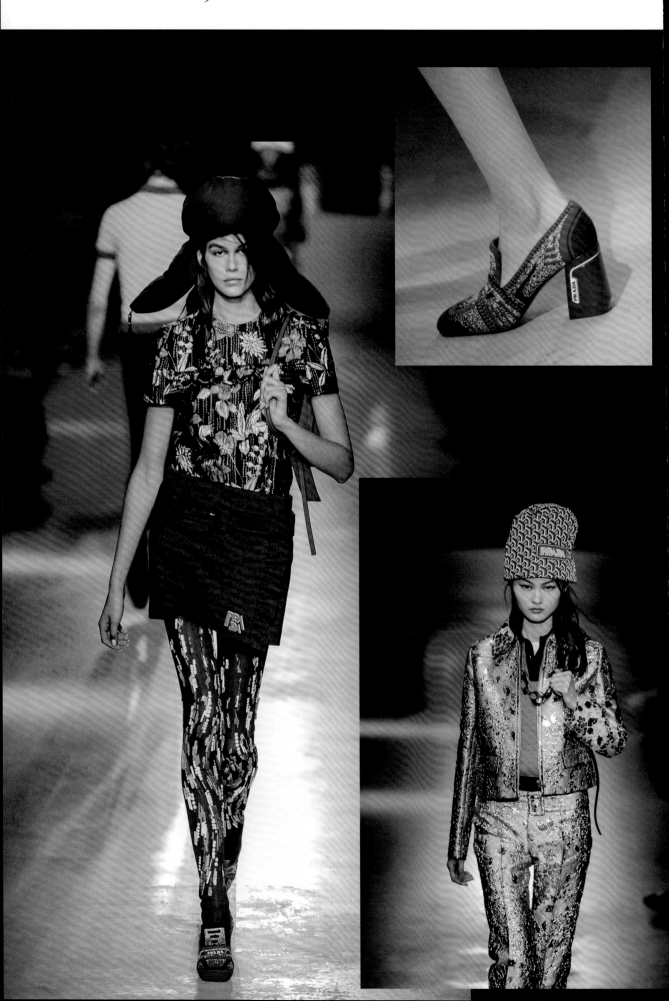

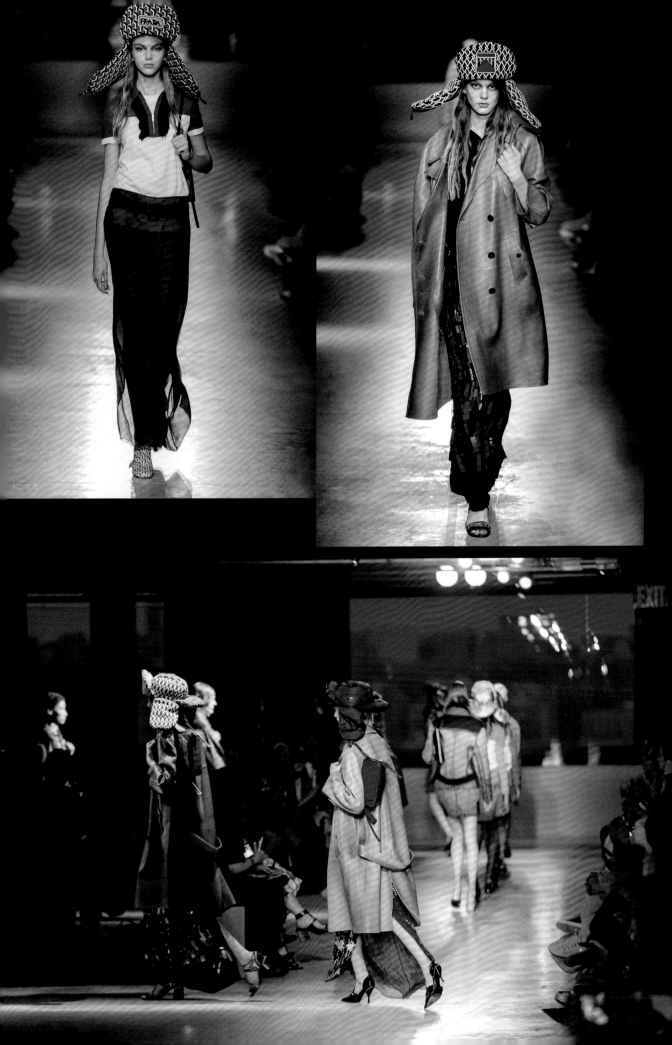

Marking her thirtieth year showing ready-to-wear
– this collection was staged in Milan in September
2018 – on this occasion, perhaps more than ever,
Miuccia Prada created a collection comprising many
of her favourite things. Prada-isms. They are instantly
recognizable by now – the sure sign of the success
of a fashion label if ever there was one. Like the
designer herself, then, the woman who wears Prada
loves schoolboy shorts – preferably brown and, in
this instance, with a sheen never normally associated
with that less than obviously glamorous colour. She
also favours pink, though: a satin skirt (knee-length,
of course) or trapeze-line top, trimmed with another
signature – a neatly tied oversized bow. Graphic
prints – on princess coats, skirts, cycling shorts
and the cutest hats – are part of this time-honoured
vocabulary. So too is surgical white, and knitwear
worn with buttoned-up shirts. Any strictness was
subverted by peek-a-boo cutouts: discreetly erotic,
never obvious. Also very Prada.

Lingerie details (bodysuits plunging almost to the
navel, fastened to the torso with sporty black and
white bands), artsy tie-dyes and florals, glittering
paillettes, girlish plumped-up Alice bands, knee-high
socks stamped with the Prada triangular logo, and
Mary Jane or warped wedge-heeled shoes are all
similarly beloved by this designer and her customer
alike. 'I wanted to break the rules of the classic,' Prada
told Vogue Runway post show, 'to discuss a wish for
freedom and liberation and fantasy and, on the other
side, the extreme conservatism that is coming – the
duality out there.'

Presented in the Deposito, the latest space at the
Fondazione to open ('we wanted to introduce life to
the Fondazione, because sometimes art isn't enough'),
on a concrete catwalk wrapped in plastic and with
guests seated on inflatable (wobbly) Verner Panton
cubes, it almost goes without saying that very
duality has proved not merely pivotal but well-nigh
unavoidable throughout this designer's long and
spectacular career.

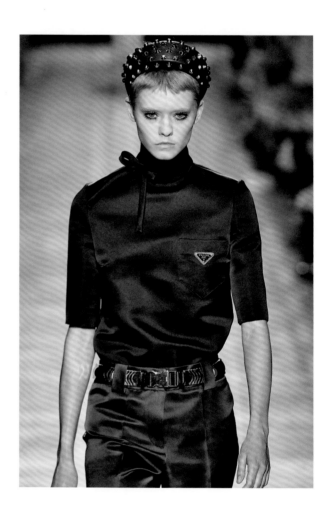

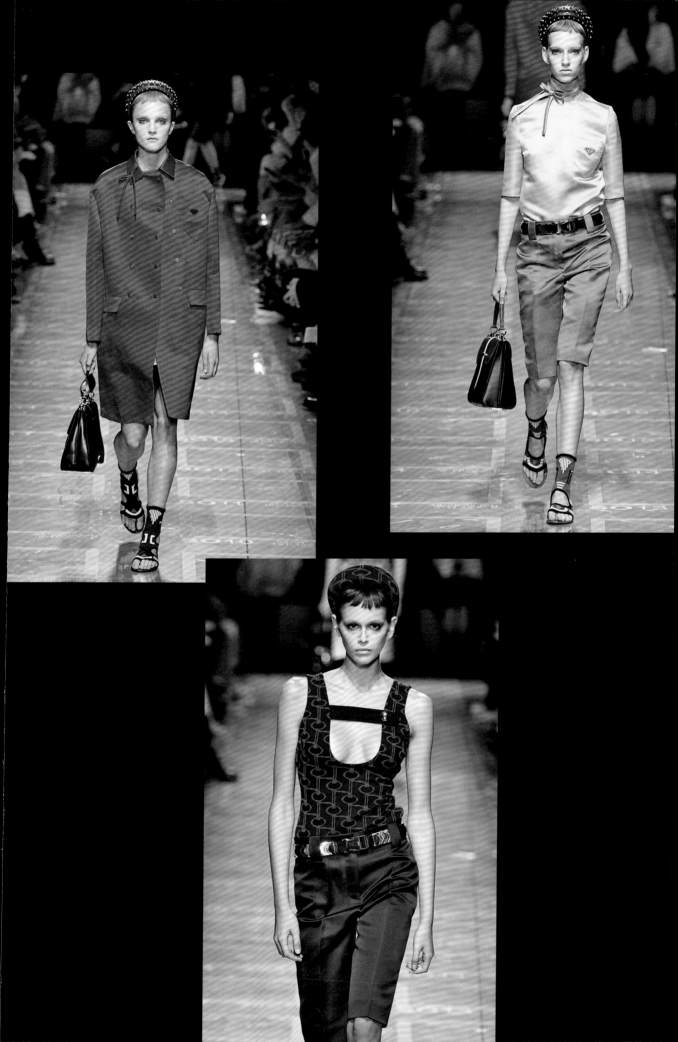

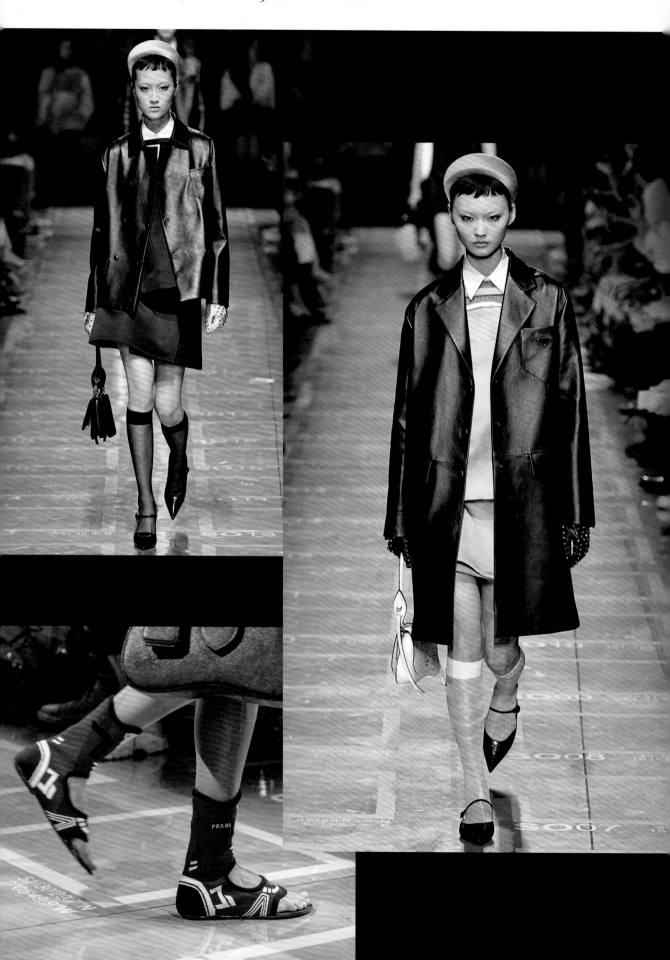

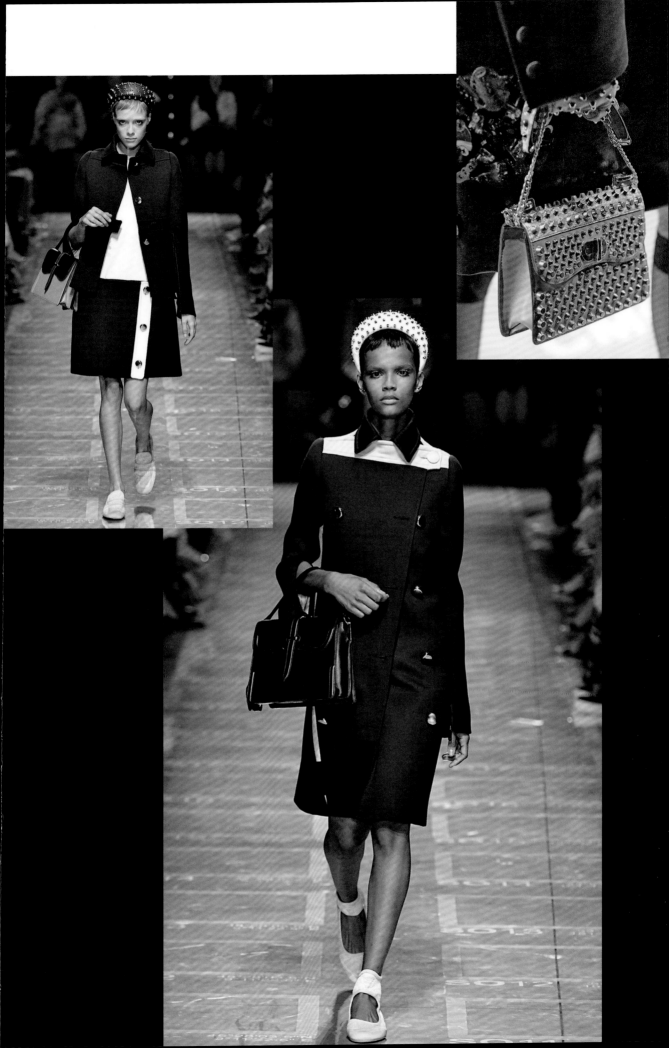

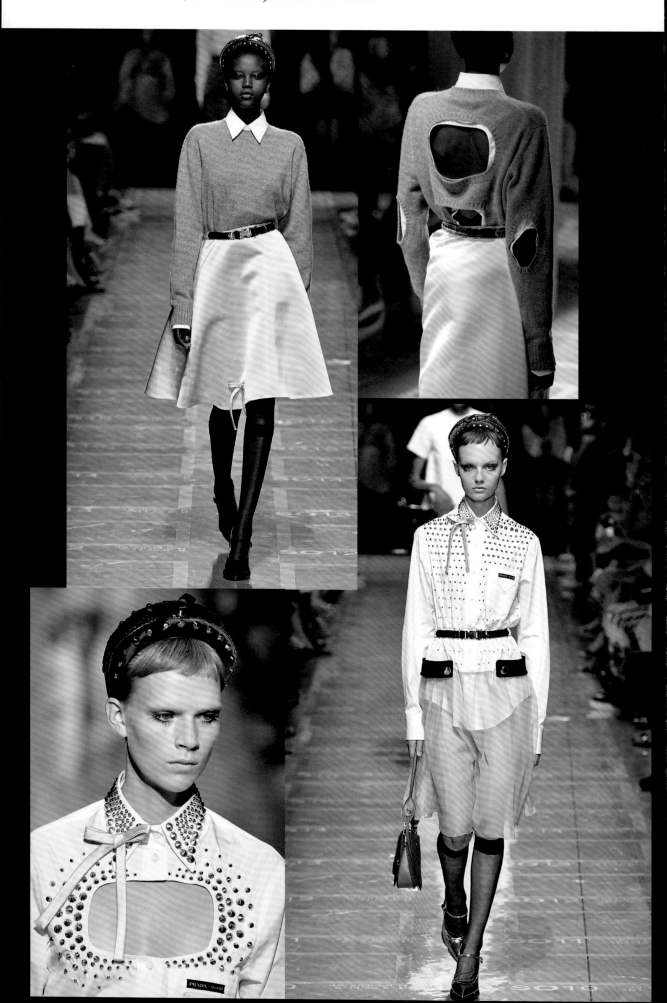

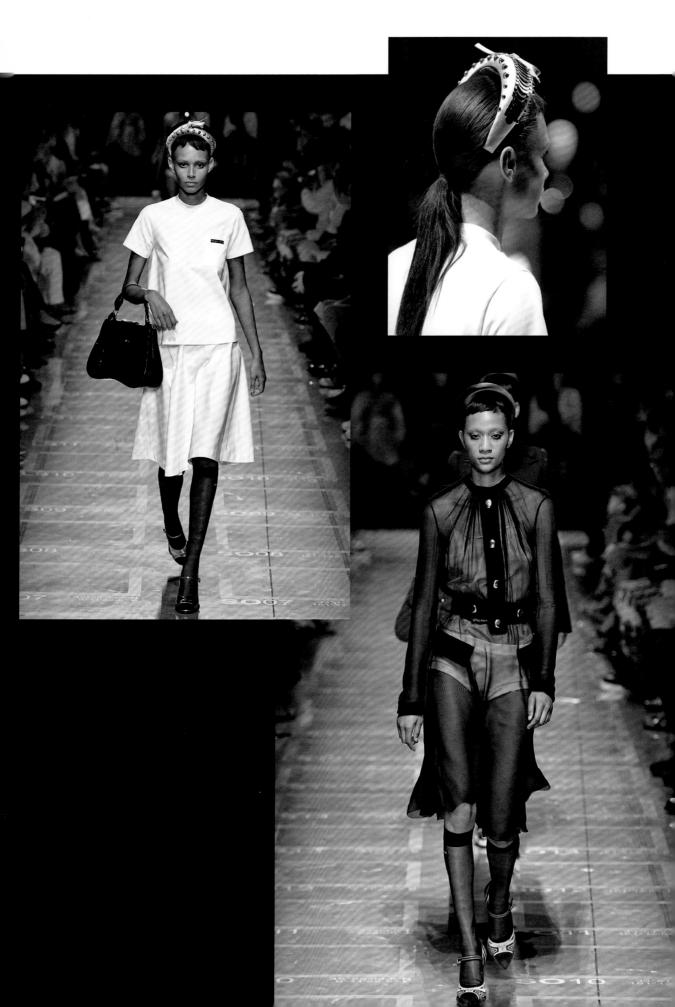

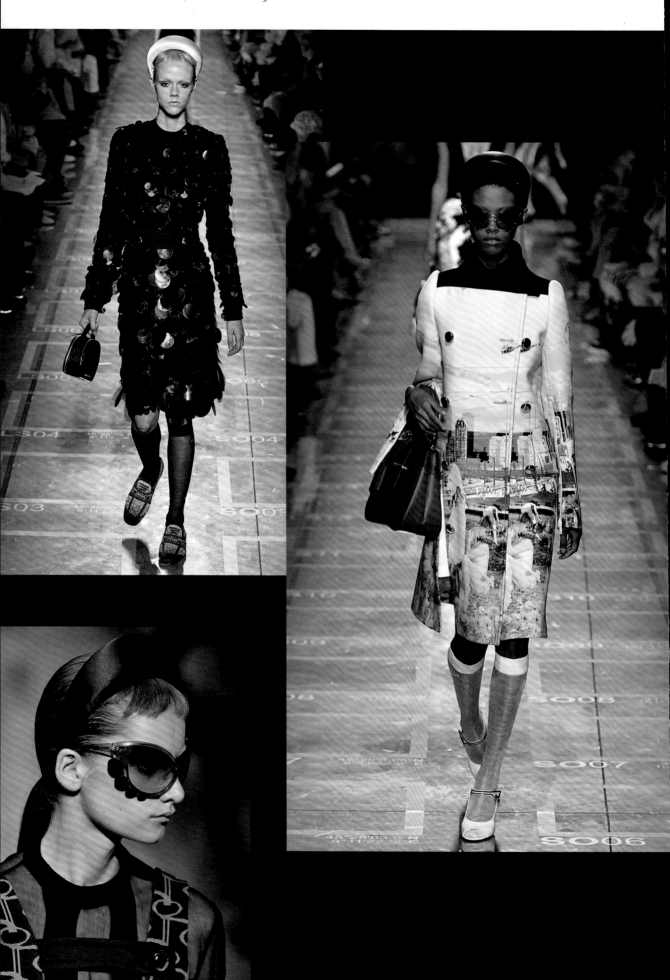

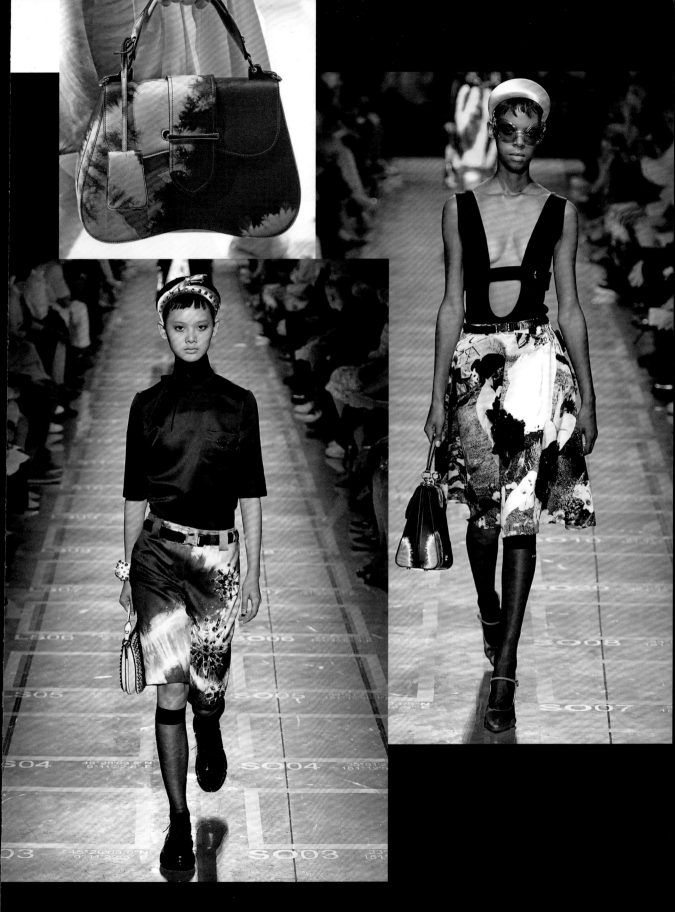

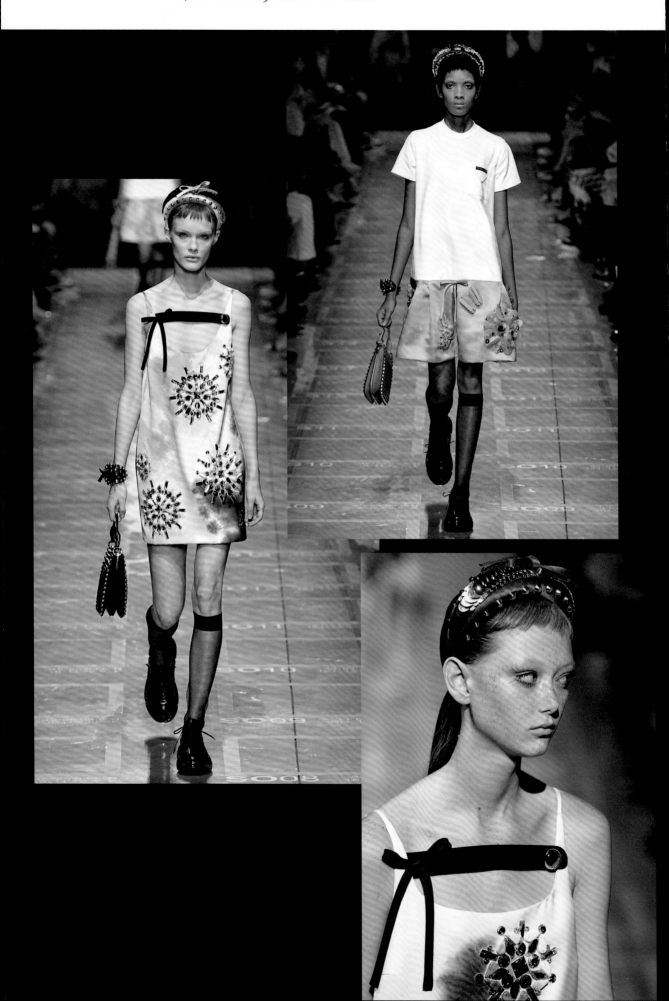

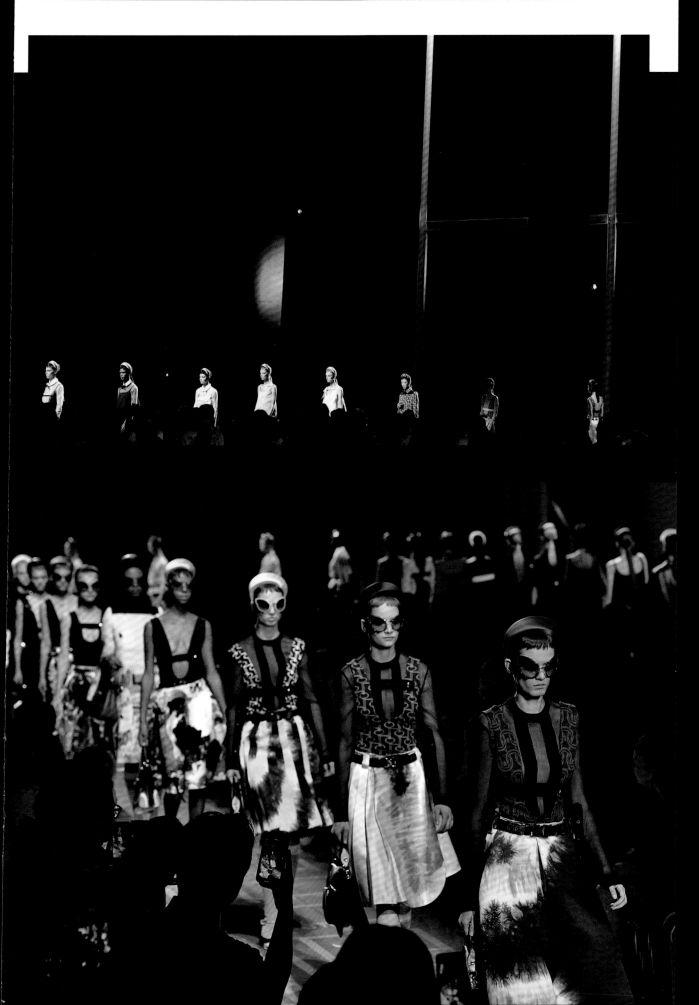

Bibliographic Note

In order not to disrupt the flow of reading, we have decided not to include references or footnotes in the main body of the text.

Sources for the quotations in the introduction and collection texts can be found below.

Tim Blanks:

'Prada Fall 2013 Ready-to-Wear', Style.com, 21 February 2013

'Prada Spring 2015 Ready-to-Wear', Style.com, 18 September 2014

Susannah Frankel:

'Miuccia Prada: The Feeling is Miuccia', *The Independent*, 21 February 2004

'The Autumn/Winter Collections', *AnOther Magazine*, Autumn/Winter 2005

'Spring Fashion', *AnOther Magazine*, Spring/Summer 2006

'Spot the Difference: Miuccia Prada the Creator of Ladylike Chic...', *The Independent*, 23 October 2006

'Spring Collections', *AnOther Magazine*, Spring/Summer 2007

'Metamorphosis', *AnOther Magazine*, Autumn/Winter 2007

'Miuccia Prada and Elsa Schiaparelli: In a league of their own', *The Independent*, 23 April 2012

'Miuccia Prada on Art, Sex and Collaboration', AnOthermag.com, 23 February 2017

'The Politics of Seduction at Prada A/W17', AnOthermag.com, 27 February 2017

'Miuccia Prada's Punk and the Need for Modern Militance', AnOthermag.com, 24 September 2017

Vanessa Friedman:

'At Prada: Airbrushing and the Woman', *The New York Times*, 27 February 2015

'At Fendi and Prada, Moving Beyond the Shoulder Pad', *The New York Times*, 23 February 2018

Alexander Fury:

'Miuccia Prada Likes to Disturb', *Document*, 15 November 2015

'Reflections and Inventions: Fantasy Meets Reality at Prada Resort', AnOthermag.com, 8 May 2018

Woody Hochswender, 'European Report: Fashion; Milan', *The New York Times*, 15 December 1991

Cathy Horyn:

'Tired of Luxury, Prada About-Faces', *The New York Times*, 3 October 2000

'The Mod Squad Saunters Back', *The New York Times*, 2 March 2001

'Whirling and Twirling, Prada Shows Its Skirts', *The New York Times*, 13 April 2006

'Prada: Lady Be Nice', *The New York Times*, 19 February 2008

'Fashion's Two Words for Fall: Toughen Up', *The New York Times*, 18 March 2009

'Ideas that Go Beyond Heritage', *The New York Times*, 24 September 2010

'"Ugly Beauty," the Sequel', *The New York Times*, 24 February 2012

Ruth La Ferla, 'Marketing the Millennium', *The New York Times*, 14 January 1990

Luke Leitch, 'Prada Resort 2018', Style.com, 7 May 2017

Suzy Menkes:

'Runways; As the Hemline Turns', *International Herald Tribune*, 25 September 1994 (reprinted in *The New York Times*)

'Miuccia Prada: "The Mistress of us all"', *International Herald Tribune*, 26 February 2006 (reprinted in *The New York Times*)

'Prada's wild, wonderful world', *International Herald Tribune*, 25 September 2007 (reprinted in *The New York Times*)

'Fashion Week', *The New York Times*, 24 September 2009

'Prada Bares Her Soul', *International Herald Tribune*, 20 September 2012 (reprinted in *The New York Times*)

Sarah Mower:

'Prada Fall 2003 Ready-to-Wear', Style.com, 27 February 2003

'Prada Spring 2005 Ready-to-Wear', Style.com, 29 September 2004

'Prada Fall 2010 Ready-to-Wear', Style.com, 25 February 2010

'Prada Spring 2019 Ready-to-Wear', Vogue Runway, 20 September 2018

Ingrid Sischy, 'The Rebel in Prada', *The New Yorker*, 7 February 1994

Roberta Smith, Holland Cotter and Jason Farago, 'Best Art of 2018', *The New York Times*, 5 December 2018

Amy M. Spindler:

'Sexy Austerity From Jil Sander', *The New York Times*, 11 March 1993

'Prada, D&G, Ferretti: Three Shades of Cool', *The New York Times*, 10 March 1995

'Busy Bees at Prada; Versace Goes Courting', *The New York Times*, 8 March 1996

'In Milan, the Mood Shifts to Romance',
The New York Times, 3 October 1996

Iain R Webb, 'Europe: As ye sew, so shall ye reap',
The Guardian, 8 March 1991

Women's Wear Daily:

'Prada Plans to Offer Line of RTW',
26 February 1988

'Prada', 11 October 1989

'Prada', 11 October 1990

'La Dolce Prada', 29 April 1992

'Milan: A Little Romance', 11 March 1993

'Milan's Wanderlust', 5 October 1993

'Milan', 7 October 1994

'Prada: The Junior League', 10 March 1995

'Milan's Risk Factor', 3 March 1998

'Boss Lady', 28 September 1999

'Milan: Ingenues and Seductresses', 2 March 2001

'Glamissimo', 4 March 2002

'If We Can Build It, Will They Wear It?',
by Cate T. Corcoran, 14 April 2004

'New Wrinkles', 24 September 2008

'Milan Collections: Prada', 21 February 2014

Fashion features that appeared in the *International
Herald Tribune* were also frequently printed in the
New York Times and can be found in the *New York
Times* online archive.

Collection Credits

A/W 1988–1989 Ready-to-Wear
Prada, Via Melzi D'Eril 30, Milan

S/S 1989 Ready-to-Wear
Prada, Via Melzi D'Eril 30, Milan

A/W 1989–1990 Ready-to-Wear
Prada, Via Melzi D'Eril 30, Milan

S/S 1990 Ready-to-Wear
Prada, Via Melzi D'Eril 30, Milan

A/W 1990–1991 Ready-to-Wear
Prada, Via Melzi D'Eril 30, Milan

S/S 1991 Ready-to-Wear
Prada, Via Melzi D'Eril 30, Milan

A/W 1991–1992 Ready-to-Wear
Prada, Via Melzi D'Eril 30, Milan

S/S 1992 Ready-to-Wear
Prada, Via Melzi D'Eril 30, Milan

A/W 1992–1993 Ready-to-Wear
Prada, Via Melzi D'Eril 30, Milan

S/S 1993 Ready-to-Wear
Prada, Via Maffei 2, Milan

A/W 1993–1994 Ready-to-Wear
Prada, Via Maffei 2, Milan

S/S 1994 Ready-to-Wear
Prada, Via Maffei 2, Milan

A/W 1994–1995 Ready-to-Wear
Prada, Via Maffei 2, Milan

S/S 1995 Ready-to-Wear
Prada, Via Maffei 2, Milan

A/W 1995–1996 Ready-to-Wear
Prada, Via Maffei 2, Milan

S/S 1996 Ready-to-Wear
Prada, Via Maffei 2, Milan

A/W 1996–1997 Ready-to-Wear
Prada, Via Maffei 2, Milan

S/S 1997 Ready-to-Wear
Prada, Via Maffei 2, Milan

A/W 1997–1998 Ready-to-Wear
Prada, Via Maffei 2, Milan

S/S 1998 Ready-to-Wear
Prada, Via Maffei 2, Milan

A/W 1998–1999 Ready-to-Wear
Prada, Via Maffei 2, Milan

S/S 1999 Ready-to-Wear
Prada, Via Maffei 2, Milan

A/W 1999–2000 Ready-to-Wear
Prada, Via Maffei 2, Milan

S/S 2000 Ready-to-Wear
27 September 1999; Prada, Via Maffei 2, Milan

A/W 2000–2001 Ready-to-Wear
Prada, Via Maffei 2, Milan

S/S 2001 Ready-to-Wear
21 February 2000; Prada, Via Fogazzaro 36, Milan
Hair: Orlando Pita
Make-up: Tom Pecheux
Music: Frédéric Sanchez

A/W 2001–2002 Ready-to-Wear
1 March 2001; Prada, Via Fogazzaro 36, Milan
Hair: Orlando Pita
Make-up: Tom Pecheux
Music: Frédéric Sanchez

S/S 2002 Ready-to-Wear
28 September 2001; Prada, Via Fogazzaro 36, Milan
Hair: Luigi Murenu
Make-up: Aaron de Mey
Music: Frédéric Sanchez

A/W 2002–2003 Ready-to-Wear
1 March 2002; Prada, Via Fogazzaro 36, Milan
Hair: Malcolm Edwards
Make-up: Val Garland
Styling: Katie Grand
Music: Frédéric Sanchez

S/S 2003 Ready-to-Wear
27 September 2002; Prada, Via Fogazzaro 36, Milan
Hair: Samantha Hillerby
Make-up: Charlotte Tilbury
Styling: Katie Grand
Music: Frédéric Sanchez

A/W 2003–2004 Ready-to-Wear
28 February 2003; Prada, Via Fogazzaro 36, Milan
Hair: Samantha Hillerby
Make-up: Charlotte Tilbury
Styling: Katie Grand
Music: Frédéric Sanchez

S/S 2004 Ready-to-Wear
1 October 2003; Prada, Via Fogazzaro 36, Milan
Hair: Guido Palau
Make-up: Miranda Joyce
Styling: Katie Grand
Music: Frédéric Sanchez

A/W 2004–2005 Ready-to-Wear
24 February 2004; Prada, Via Fogazzaro 36, Milan
Hair: Guido Palau
Make-up: Miranda Joyce
Styling: Katie Grand
Music: Frédéric Sanchez

S/S 2005 Ready-to-Wear
29 September 2004; Prada, Via Fogazzaro 36, Milan
Hair: Guido Palau
Make-up: Pat McGrath
Styling: Katie Grand
Music: Frédéric Sanchez

A/W 2005–2006 Ready-to-Wear
21 February 2005; Prada, Via Fogazzaro 36, Milan
Hair: Guido for Redken (Guido Palau)
Make-up: Pat McGrath
Music: Frédéric Sanchez

S/S 2006 Ready-to-Wear
27 September 2005; Prada, Via Fogazzaro 36, Milan
Hair: Guido for Redken (Guido Palau)
Make-up: Pat McGrath
Styling: Olivier Rizzo
Music: Frédéric Sanchez

A/W 2006–2007 Ready-to-Wear
21 February 2006; Prada, Via Fogazzaro 36, Milan
Hair: Guido for Redken (Guido Palau)
Make-up: Pat McGrath
Styling: Olivier Rizzo
Music: Frédéric Sanchez

S/S 2007 Ready-to-Wear
26 September 2006; Prada, Via Fogazzaro 36, Milan
Styling: Olivier Rizzo

A/W 2007–2008 Ready-to-Wear
20 February 2007; Prada, Via Fogazzaro 36, Milan
Hair: Guido for Redken (Guido Palau)
Make-up: Pat McGrath
Styling: Olivier Rizzo
Music: Frédéric Sanchez

S/S 2008 Ready-to-Wear
25 September 2007; Prada, Via Fogazzaro 36, Milan
Hair: Guido for Redken (Guido Palau)
Make-up: Pat McGrath
Styling: Olivier Rizzo
Music: Frédéric Sanchez

A/W 2008–2009 Ready-to-Wear
19 February 2008; Prada, Via Fogazzaro 36, Milan
Hair: Guido for Redken (Guido Palau)
Make-up: Pat McGrath
Styling: Olivier Rizzo
Music: Frédéric Sanchez

S/S 2009 Ready-to-Wear
23 September 2008; Prada, Via Fogazzaro 36, Milan
Hair: Guido for Redken (Guido Palau)
Make-up: Pat McGrath
Styling: Olivier Rizzo
Music: Frédéric Sanchez

A/W 2009–2010 Ready-to-Wear
1 March 2009; Prada, Via Fogazzaro 36, Milan
Hair: Guido for Redken (Guido Palau)
Make-up: Pat McGrath
Styling: Olivier Rizzo
Music: Frédéric Sanchez

S/S 2010 Ready-to-Wear
24 September 2009; Prada, Via Fogazzaro 36, Milan
Hair: Guido for Redken (Guido Palau)
Make-up: Pat McGrath
Styling: Olivier Rizzo
Music: Frédéric Sanchez

A/W 2010–2011 Ready-to-Wear
25 February 2010; Prada, Via Fogazzaro 36, Milan
Hair: Guido for Redken (Guido Palau)
Make-up: Pat McGrath
Styling: Olivier Rizzo
Music: Frédéric Sanchez

S/S 2011 Ready-to-Wear
23 September 2010; Prada, Via Fogazzaro 36, Milan
Hair: Guido for Redken (Guido Palau)
Make-up: Pat McGrath
Styling: Olivier Rizzo
Music: Frédéric Sanchez

A/W 2011–2012 Ready-to-Wear
24 February 2011; Prada, Via Fogazzaro 36, Milan
Hair: Guido for Redken (Guido Palau)
Make-up: Pat McGrath
Styling: Olivier Rizzo
Music: Frédéric Sanchez

S/S 2012 Ready-to-Wear
22 September 2011; Prada, Via Fogazzaro 36, Milan
Hair: Guido for Redken (Guido Palau)
Make-up: Pat McGrath
Styling: Olivier Rizzo
Music: Frédéric Sanchez

A/W 2012–2013 Ready-to-Wear
23 February 2012; Prada, Via Fogazzaro 36, Milan
Hair: Guido for Redken (Guido Palau)
Make-up: Pat McGrath
Styling: Olivier Rizzo
Music: Frédéric Sanchez

S/S 2013 Ready-to-Wear
20 September 2012; Prada, Via Fogazzaro 36, Milan
Hair: Guido for Redken (Guido Palau)
Make-up: Pat McGrath
Styling: Olivier Rizzo
Music: Frédéric Sanchez

A/W 2013–2014 Ready-to-Wear
21 February 2013; Prada, Via Fogazzaro 36, Milan
Hair: Guido for Redken (Guido Palau)
Make-up: Pat McGrath
Styling: Olivier Rizzo
Music: Frédéric Sanchez

S/S 2014 Ready-to-Wear
19 September 2013; Prada, Via Fogazzaro 36, Milan
Hair: Guido for Redken (Guido Palau)
Make-up: Pat McGrath
Styling: Olivier Rizzo
Music: Frédéric Sanchez

A/W 2014–2015 Ready-to-Wear
20 February 2014; Prada, Via Fogazzaro 36, Milan
Hair: Guido for Redken (Guido Palau)
Make-up: Pat McGrath
Styling: Olivier Rizzo
Music: Frédéric Sanchez

S/S 2015 Ready-to-Wear
18 September 2014; Prada, Via Fogazzaro 36, Milan
Hair: Guido for Redken (Guido Palau)
Make-up: Pat McGrath
Styling: Olivier Rizzo
Music: Frédéric Sanchez

A/W 2015–2016 Ready-to-Wear
26 February 2015; Prada, Via Fogazzaro 36, Milan
Hair: Guido for Redken (Guido Palau)
Make-up: Pat McGrath
Styling: Olivier Rizzo
Music: Frédéric Sanchez

S/S 2016 Ready-to-Wear
24 September 2015; Prada, Via Fogazzaro 36, Milan
Hair: Guido for Redken (Guido Palau)
Make-up: Pat McGrath
Styling: Olivier Rizzo
Music: Frédéric Sanchez

A/W 2016–2017 Ready-to-Wear
25 February 2016; Prada, Via Fogazzaro 36, Milan
Hair: Guido for Redken (Guido Palau)
Make-up: Pat McGrath
Styling: Olivier Rizzo
Music: Frédéric Sanchez

S/S 2017 Ready-to-Wear
22 September 2016; Prada, Via Fogazzaro 36, Milan
Hair: Guido for Redken (Guido Palau)
Make-up: Pat McGrath
Styling: Olivier Rizzo
Music: Frédéric Sanchez

A/W 2017–2018 Ready-to-Wear
23 February 2017; Prada, Via Fogazzaro 36, Milan
Hair: Guido for Redken (Guido Palau)
Make-up: Pat McGrath
Styling: Olivier Rizzo
Music: Frédéric Sanchez

Cruise 2018 Ready-to-Wear
7 May 2017; Osservatorio Fondazione Prada,
Galleria Vittorio Emanuele II, Milan
Hair: Guido for Redken (Guido Palau)
Make-up: Pat McGrath
Styling: Olivier Rizzo
Music: Frédéric Sanchez

S/S 2018 Ready-to-Wear
21 September 2017; Prada, Via Fogazzaro 36, Milan
Hair: Guido for Redken (Guido Palau)
Make-up: Pat McGrath
Styling: Olivier Rizzo
Music: Frédéric Sanchez

A/W 2018–2019 Ready-to-Wear
22 February 2018; Fondazione Prada,
Via Lorenzini 14, Milan
Hair: Guido for Redken (Guido Palau)
Make-up: Pat McGrath
Styling: Olivier Rizzo
Music: Frédéric Sanchez

Cruise 2019 Ready-to-Wear
4 May 2018; Piano Factory, Prada US Headquarters,
New York
Hair: Guido for Redken (Guido Palau)
Make-up: Pat McGrath
Styling: Olivier Rizzo
Music: Frédéric Sanchez

S/S 2019 Ready-to-Wear
20 September 2018; Fondazione Prada,
Via Lorenzini 14, Milan
Hair: Guido for Redken (Guido Palau)
Make-up: Pat McGrath
Styling: Olivier Rizzo
Music: Frédéric Sanchez

Credits included reflect the information available at the time of publication. We would be pleased to insert appropriate acknowledgments in any subsequent reprint.

Picture Credits

Acknowledgments

The author and the publisher would like
to thank Miuccia Prada, Verde Visconti,
Simona Chiappa and Irene Pollini for their
support in the making of this book.

Additional thanks from the author
to Alexander Fury and Anya Yiapanis.

Additional thanks from the publisher
to Kerry Davis and Don Ashby at firstVIEW.

Select Index of Clothes, Accessories & Materials

The page numbers below refer to illustrations.

Index of Models

Considerable efforts have been made to identify the models featured in this book, but in some cases we have been unable to do so. We would be pleased to insert an appropriate acknowledgment in any subsequent reprint.

Index

Cover bellyband: Spring/Summer 2019
Ready-to-Wear. Photo © Agostino Osio

Frontispiece (p. 2): from Autumn/Winter
2018–2019 Ready-to-Wear (see also p. 587)

Published in the U.S. and Canada in 2019 by
Yale University Press
P.O. Box 209040
302 Temple Street
New Haven, CT 06520-9040
yalebooks.com/art

Published by arrangement with
Thames & Hudson Ltd, London

Prada: The Complete Collections
© 2019 Thames & Hudson Ltd, London

Texts © 2019 Susannah Frankel

Series concept by Adélia Sabatini
© 2019 Thames & Hudson Ltd, London

Photographs © 2019 firstVIEW
unless otherwise stated

Design by Fraser Muggeridge Studio

Library of Congress Control Number
2019943495

ISBN 978-0-300-24364-2

Printed and bound in China by
C & C Offset Printing Co. Ltd

10 9 8 7 6 5 4 3